D1123436

VAN GOGH
and
GAUGUIN

Farrar, Straus and Giroux / NEW YORK

VAN GOGH and GAUGUIN

THE SEARCH FOR SACRED ART

DEBORA SILVERMAN

FARRAR, STRAUS AND GIROUX

19 Union Square West, New York 10003

Copyright © 2000 by Debora Silverman
All rights reserved
Distributed in Canada by Douglas & McIntyre Ltd.
Printed in the United States of America
First edition, 2000

JACKET ILLUSTRATION CREDITS: *Front cover:* LEFT: Vincent van Gogh, *Self-Portrait Dedicated to Paul Gauguin*, 1888, oil on canvas, 59.55 x 48.26 cm. Courtesy of the Fogg Art Museum, Harvard University Art Museums, bequest from the collection of Maurice Wertheim, class of 1906. Photograph by David Mathews. © President and Fellows of Harvard College, Harvard University. RIGHT: Paul Gauguin, *Self-Portrait: Les Misérables*, 1888, oil on canvas, 45 x 55 cm. Van Gogh Museum, Amsterdam (Vincent van Gogh Foundation). *Back cover:* LEFT: Vincent van Gogh, *The Sower,* 1888, oil on canvas, 64 x 80.5 cm. Kröller-Müller Museum, Otterlo, Netherlands. RIGHT: Paul Gauguin, *The Vision After the Sermon: Jacob Wrestling with the Angel,* 1888, oil on canvas, 73 x 92 cm. National Gallery of Scotland, Edinburgh.

Library of Congress Cataloging-in-Publication Data

Silverman, Debora, 1954–
 Van Gogh and Gauguin: the search for sacred art / Debora Silverman. — 1st ed.
 p. cm.
 Includes bibliographical references and index.
 ISBN 0-374-28243-9 (alk. paper)
 1. Gogh, Vincent van, 1853–1890—Criticism and interpretation. 2. Gauguin, Paul, 1848–1903—Criticism and interpretation. 3. Artistic collaboration—France. 4. Religion in art. I. Title.

ND653.G7 S447 2000
759.4—dc21

 00-037146

Designed by Gretchen Achilles

FOR JEFF

CONTENTS

ILLUSTRATIONS

VAN GOGH and GAUGUIN

INTRODUCTION

During the fall and winter of 1888, Vincent van Gogh and Paul Gauguin lived and worked together in Provence and changed the course of modern art. The relationship between the two artists, which came at a critical point in each of their careers, began as a plan for a new community of artist-brothers who would flourish in a harmonious condition of mutual support. While the two painters never achieved the goal of brotherly harmony, they nonetheless found their creativity spurred by association, and both settled into a productive and stimulating period. This remarkable experiment is remembered largely through the lenses of mythic melodrama, as in the scenes involving the flinging of plates and the squeezing of paint tubes in the film *Lust for Life.* Images such as these have reduced the collaboration between the two painters to an episode of personal incompatibility culminating in the violent incident, after an argument, when van Gogh cut off part of his left earlobe to spite Gauguin.

Yet their time together, despite the moments of undeniable volatility, was not dominated by them. Before and after they lived and worked together in Arles, van Gogh and Gauguin were engaged in written correspondence, and their last argument did not end their friendship. More important, the emotionalist rendering obscures the significance of van Gogh and Gauguin's relationship, propelled in part by a shared quest of utmost gravity to the two artists and their comrades in the late 1880s: how to discover a new and modern form of sacred art to fill the void left by the religious systems that they were struggling to abandon but that had nonetheless left indelible imprints in their consciousness, shaping their theories of life, attitudes toward reality, choice of subjects, and repertoire of artistic techniques. The sources of the meeting points and tensions in van Gogh and Gauguin's association lie, this book argues, in the different religious traditions that formed them, and the different mental frameworks and

stylistic practices that issued from them as each tried to absorb for painting a core of spiritual tasks hitherto fulfilled by the church he had encountered and resisted.

This book reconsiders the very different ways that van Gogh and Gauguin defined their art in the period just before, during, and after their collaboration in Arles, and identifies the roots of their incompatible artistic projects in a new source: their divergent religious legacies and educational formations. It provides a close comparative reading of major pictures produced by the two artists and of the ideas they expressed about them, in the light of research on the Protestant and Catholic origins of the differences between van Gogh's and Gauguin's artistic theories, self-definitions, and painting styles. The traditional emphasis on personal and temperamental differences between van Gogh and Gauguin here cedes to new evidence on the particular salience of religious and cultural impediments to their collaboration. The goal of the book is not to give a comprehensive account of both artists but to isolate how each expressed theologically specific assumptions, problems, and preoccupations in his painting, which deepened the differences between them even as they tried to work together on similar subjects in similar sites.[1]

The book grew out of another project, and evolved from a single interpretive biography of van Gogh to a dual study of the religious mentalities and visual forms of the two painters. In 1994 I was preparing the second half of a book tracing van Gogh's identification with craft labor and the particular Dutch Reformed culture and conflicts that shaped its development. Turning to the Arles period of 1888, I was exploring how van Gogh adapted new and old techniques as he familiarized himself with his new environment, responded to the strangeness and pervasiveness of Catholic popular piety in Provence, and continued to wrestle with unresolved dilemmas of his Dutch culture's specifically contested redefinitions of faith and works, nature and divinity, and immanence and transcendence. These themes and research remain at the core of the analysis and will be unfolded in the chapters that follow. I decided to reframe the book as a sustained duet, however, when I encountered unexpectedly rich materials on Gauguin and the period before and after his collaboration with van Gogh. I had planned to write two chapters on van Gogh's association with Gauguin along the lines of "Protestant modernist meets secular egotist"; instead I found a Gauguin as beset by religious problems and preoccupations as van Gogh, although he expressed those problems and preoccupations in a different register and with different consequences for his art.[2]

Gauguin is familiar to us in part as a voluptuary, and he has been presented, rightly, as a ferocious self-promoter, rapacious egotist, and ambivalent colonialist.[3] But I learned, much to my surprise, that he was also a product of a French seminary education, and that he was agitated throughout his life by enduring problems of his lapsed Catholic faith, an agitation unrelieved by the solace of the religion he rejected. In approaching the period of his association with van Gogh, I was struck by a particular expressive pattern of Gauguin's that was very different from van Gogh's, which provoked me to explore further the importance of his Catholic formation. This pattern encompassed, for example, a definition of material reality as inevitably corrupted, even perfidious; a language of sacrifice and the martyrology of the modern artist; and a linking of the infernal to the internal, where creativity was grounded in an expanded subjectivity and the necessary cultivation of the "hell fires of the mind."

I traced some of the sources of this expressive pattern to Gauguin's education in an Orléans Catholic junior seminary, where he was taught by the Bishop of Orléans, Monseigneur Félix-Antoine-Philibert Dupanloup, an important educational reformer. Dupanloup is well known to French historians as an architect of the Falloux Law, which assured the future security of French Catholicism, shaken by the Revolution of 1848, by revitalizing parochial education and legalizing state funding for it, an arrangement still in place to this day. During Gauguin's time, Bishop Dupanloup developed a new, more dynamic catechism that encouraged students to move beyond dry recitation to sacred silence, to engage in active interior interrogations of supernatural beings, such as angels, and to elicit a state of visionary release from a treacherous earthly world and the debasements of carnality. I was intrigued by how Gauguin may have assimilated from his seminary training certain mental habits and attitudes toward the visual that were profoundly discordant with those I had identified in van Gogh's formative period in his Dutch theological culture, and I suspected that these distinctive mentalities had implications for the form and content of their work. The results presented here, after additional years of research and close comparative scrutiny of letters and pictures, suggest that religious legacies provide a new point of entry with which to consider the tensions in van Gogh and Gauguin's collaboration, to offer new readings of some of their major paintings, and to assess the wider resonances of their debates about technique, matter, and memory as they tested the limits of painting as a figurative language.

At the heart of the analysis—an art story more than a personal story—are two contending approaches to pictorial practice with a paradoxical shared goal: to achieve spiritual ends through the

plastic means of pigment, canvas, and primer. Van Gogh is presented as a weaver-painter and manipulator of craft optical tools, who seeks sanctification in the labor forms of paint as woven cloth, crumbled brick, and plowed earth, and reclaims in Arles the challenges of a mid-nineteenth-century Dutch "modern theology" that placed special emphasis on the arts as evocative forms of an immanent divinity. Gauguin, by contrast, is presented as an ambivalent *pénitent*, or penitent sensualist, who turns to painting as a new site to pose and interrogate the fundamental and irresolvable question of the Catholic catechism—"Why are we here on earth?"—and explores, in 1888 and after, a dialectic of visionary ascent and carnal affliction. As we will see, van Gogh's labor theology presses him to maximize the materialization of the painting surface, working the image of work on the canvas; and his engagement with the ideas of the Dutch "modern theology" deepens his impulses to "render the infinite tangible," as he put it, embedding the sacred in the stuff of matter and the faces of ordinary people. Gauguin's quest for sacrality immerses him in developing stylistic practices to *de*materialize the physical surface of the canvas as much as possible, emulating the matte permeation of the fresco, for example, as he sought to efface the distance between a deficient material world and the ineffable world of dream and the divine, or devising unusual technical forms of chafing and parching to represent what he considered the lamentational condition of modern misery and one of its key sources: sexual suffering. While both van Gogh and Gauguin thus pursue this peculiar but, for them, absolutely essential project—of painting as a mediator of divinity—the ways they approach it are very different, corresponding to some elements of their distinctive theological cultures.

II

The book proceeds in six parts within a chronological and comparative framework. Ten of the thirteen chapters present close visual analyses, offering a kind of gallery of pairs of paintings—and in one case a pair of boxes—that van Gogh and Gauguin produced. The subjects and formal qualities of these sets of images are analyzed in relation to two contexts: the long-term resonances of van Gogh's and Gauguin's different religious formations, and the short-term movements of regional and Catholic revivals that marked the local sites of their experiments with modern sacred art in 1888 and after. The two

painters, as we will see, responded very differently to the abundant materials of Catholic popular piety and regional custom pervading the local settings in which they worked.

Parts One and Two of the book consider the period of van Gogh and Gauguin's exchange of ideas and pictures just before they worked together in Arles. Chapter 1 briefly treats the meeting of the two painters in Paris and their mutual reliance on van Gogh's brother Theo as their commercial representative after 1887. The main part of the chapter examines the self-portraits that van Gogh and Gauguin sent each other in September 1888, and takes a first look at the way these two canvases suggest different models of self, community, and divinity. Turning from self to peasant as the painters' subject, Chapters 2 and 3 compare two breakthrough canvases of 1888 that attempted, in different ways, to link visual representation to a sacred totality beyond the visible world. Chapter 2 discusses van Gogh's initial settling in Arles with one of the tools of his Dutch apprenticeship, his perspective frame, and reconsiders his Arles drawbridge pictures as a *series* and as a meditation on a craft mechanism in the landscape. The chapter then looks closely at van Gogh's canvas called *The Sower*, as he lodged what he called a "longing for the infinite" in a peasant figure in action. Chapter 3 sets Gauguin in Brittany, responding actively to a world of popular piety that van Gogh ignored in Arles, and contrasts the form, space, and subject of *The Sower* with those aspects of Gauguin's *Vision After the Sermon: Jacob Wrestling with the Angel*. Here the themes of ascent and visionary subjectivity that Gauguin explored in the painting, and his development of techniques of "abstraction" to compose them, are examined.

Part Three lifts to view some of the cultural building blocks of van Gogh's and Gauguin's divergent mentalities in chapters on their religious and educational formations. Chapter 4 examines the ethos of anti-naturalism at Gauguin's Orléans seminary, and Bishop Dupanloup's dual program of dolorous reckoning and transcendent release; the chapter suggests that this particular training shaped Gauguin's receptivity to idealism, to the practices of visual memory, and to techniques of introspection. Chapter 5 identifies three distinctive features of van Gogh's Dutch Reformed religious and communal culture that created powerful barriers to idealism and introspection: his parents' theology, which stressed the primacy of *enacted* faith, in imitation of Christ, and the sanctity of lowly labor; his education in a Tilburg high school under C. C. Huysmans, a painter and arts-and-crafts reformer who encouraged his pupils to integrate beauty into objects of daily use; and his exposure to the ideas of a wide-ranging theological controversy called "modernism," a religious reform movement that promoted

anti-supernaturalism and salvaged a space for an unknowable God in the expressive forms of painting and music. Chapters 4 and 5 juxtapose the different frameworks set by these historically specific Dutch and French formations, and suggest how they provided each painter with different resources for their experiments with a modern sacred art in 1888. Between these two chapters stands a comparison of two boxes: an allegorical "vanities box" made by Gauguin, and a box in which van Gogh stored a collection of interlaced balls of colored yarn.

Van Gogh and Gauguin's collaboration in Arles is the subject of Part Four. Chapter 6 traces van Gogh's sudden concerns about the imbalance of commercial success in his and Gauguin's careers as he awaited Gauguin's arrival. Chapters 7, 8, and 9, which analyze pairs of paintings that van Gogh and Gauguin produced together in and around Arles, examine the artists' explicit and implicit debates concerning thick and thin paint cover; line and color; active or attenuated brushwork; and painting from memory and detachment from the object world as the basis for representation. By comparing two canvases, Chapter 8, "Grape Harvests," provides an example of the way painting from memory could be configured by cultures. In his *Red Vineyards*, van Gogh, reimagining an empty vineyard scene he had observed, composed a canvas field teeming with laborers, dripping with oily gloss, and thickly layered with pigment. Gauguin transformed the same observed scene into an allegory of transgressive sexuality and desolation, his *Vendanges: Misères humaines* (*Grape Harvest: Human Misery*), and he exploited the friction of medium and support, among other unusual techniques, to formalize visually the suffering of his subjects.

Part Five demonstrates the theological coherence of van Gogh's and Gauguin's visual practices just after they separated. Chapter 10 explores Gauguin's repetitions in 1889 of the *misères humaines*—the derelict, afflicted female he had represented in Arles—and a cluster of religious paintings of Christ's torment and martyrdom. Van Gogh, by contrast, produced five versions of a portrait of Madame Roulin as a cradle rocker, *La Berceuse*, after Gauguin's departure, an image of maternal consolation and sacred realism. Chapter 11 suggests that van Gogh devised the *Berceuse* as a type of Protestant counterimagery to the dynamic supernaturalism he encountered in Provençal Catholic culture. Here evidence is assembled that shows how van Gogh adapted, for new purposes, specific sources from local popular piety, such as elements of Arles's Nativity theater and decorative arts, as well as a regional genre of votive imagery of female saints safeguarding the seas.

The two chapters of Part Six demonstrate how van Gogh and Gauguin continued to express their divergent religious legacies in their pictorial practice through the very last phases of their careers. Chapter 12 offers a new interpretation of Gauguin's massive mural of 1897, *D'Où venons-nous? Que sommes-nous? Où allons-nous? (Where Do We Come From? What Are We? Where Are We Going?)*, as a subversive catechism, and as a synthesis, in form and content, of the themes of sorrowful existence and transcendent release he had explored earlier. Van Gogh, by contrast, deepened his search for sacred realism in his last period, and sustained his commitment to the provisional, effortful methods of the artist's métier. The book ends with an analysis of the way van Gogh incorporated weaving forms and the spatial corridors of his perspective tool in some of his very late landscapes of Saint-Rémy and Auvers, a visual language of textrous grids, framed views, and the consolational presence of an incompletely immanent divinity.

III

I hope readers will come away from this book with a different view of van Gogh and Gauguin from the one they began with. Partly this will emerge from hearing the sound, tone, and clusters of association of the two artists' letters and from looking closely at particular art works; but it is sustained by linking both men to the density and historical specificity of the nineteenth-century world in which they were embedded, rather than by claiming them, retrospectively, as initiators of a twentieth-century modernism of expressionism and abstraction. I want to recover the strangeness of the nineteenth-century categories and consciousness of the two painters, allowing readers to consider, for example, how "modernism" was itself a term and movement within the institutions of organized religion in late-nineteenth-century Europe before it was associated with cultural production and the avant-garde. Van Gogh encountered a specific Dutch variant of this modernism and absorbed from it, as we will see, an ongoing preoccupation with a discourse of proofs and postulates of eternity and a theology of art as a privileged vehicle of divinity. This nineteenth-century specificity will also introduce readers to the way Gauguin's emphasis on painterly abstraction and flat surfaces was informed by a desire to "efface reality," as he once called it—moving matter to spirit through the paradoxical physical medium of paint—

which was related, in turn, to a particular French Catholic tradition that emphasized release from a corrupt earth and corrupt bodies.

The image of Gauguin as a romantic exile from civilization will be altered here by considering, for example, Gauguin the seminary student in a laboratory of French Catholic educational reform, and by discussing Gauguin's compulsion, in Tahiti, to write long, biblically erudite attacks on the institution of the Catholic Church. Strangeness, and a new historical meaning, will be elicited by restoring the missing halves of the core polarities in Gauguin's mental world, polarities that set him apart from van Gogh, so conspicuously uninterested in representing the nude and sensuality, and that persistently troubled his own extravagant eroticism: the pairing of profanation and perdition; ecstatic transgression and anguish; lust and desolation; mortification and morbidity. These polarities bound Gauguin to his hero Charles Baudelaire and to some of his 1880s French avant-garde colleagues, such as Auguste Rodin, Charles Morice, and Maurice Rollinat, who shared in combat with the Catholic legacy even as they existed deeply under its spell.[4] Reclaiming these polarities will allow us to gain access to the particular historical space where an artistic radical like Gauguin could explore a new language for art while he devised representations of "putrefaction," worried about the condition of "concupiscence," and evoked the conflicts of "lust," the special "struggle of flesh and thought," and the "grinding teeth" of "sexual suffering."

Surprises and ironies lace van Gogh's story as well. Cultural materials and artistic habits are presented here in order to shift the focus away from van Gogh's "genius"—a term he never used, as far as I know—and psychopathology. Here we find a van Gogh who rejects introspection and martyrology, who distrusts the claims of the artist's exceptionalism and singularity. Chapter 1, for example, shows van Gogh disturbed by Gauguin's agonized self-scrutiny and recommending a rest cure for his friend; later chapters trace van Gogh's exasperation at Gauguin's lamentational self-reflection and dramatic self-identification with a tormented Christ in Gethsemane. Van Gogh evoked instead the value of Christ's social activism and consolatory language. Some of the cultural sources of these assumptions are brought out, such as the new emphasis on Christ's aesthetic powers by promoters of the Dutch "modern theology," whose ambiguous project of naturalizing divinity without resorting to pantheism, and art's particular role in it, would inform van Gogh's Arles experiments and his tensions with Gauguin. And the mythic status of van Gogh as a detached, disconnected genius is tested against specific

strains of his Dutch formation that centered on what can be called the relational ego, a self defined in and through association with others.

Throughout, I emphasize the visual forms, tools, and textures of van Gogh's métier, his pursuit of art as a painstaking and rigorous craft, a product of arduous and methodical exertion rather than a sudden release of exalted vision. Instead of addressing the issue of the etiology of his disease, I explore, through van Gogh's dissonance with Gauguin, some of the cultural pressures and cultural terms that inflected his illness and found expression in his pictorial practice, from the drive to emphatic tangibility in his pictorial language of labor to the relentless pace of his visual production to the quest for a universal language of self-offering love and consolational force.

I intend the book as a bridge between specialists and a curious, non-expert public who read and think about art and go to see it. I have built parts of my analysis on excellent scholarly studies of van Gogh and Gauguin in three areas, which I have tried to integrate and direct to new purposes: art-historical and exhibition catalogue literature; writers who have documented the dating and sequence of letters and objects created by the two artists; and restoration and conservation experts, who have identified the technical qualities of surface, medium, and support explored by the two artists, such as, for example, the choice of canvas type; treatment of primer so as to soak in or sculpt the surface with pigment; or use of fully oiled paint or leaching out the oil before application.[5]

While I incorporated these writings, I brought them to bear on specific paintings and the issues of religious consciousness and contexts I emphasize here. For example, in thinking about van Gogh's experience in Arles as that of a Protestant painter in a Catholic countryside, I calibrated the timing of particular pictures as established by scholars with the local Catholic calendar, which suggested certain patterns of exclusion and selection. The coincidence of the weeks these experts assigned to the development of van Gogh's *Berceuse* with what I found to be the period of Arles's populist Nativity theater and ceramic displays led me to detect some new sources and meanings for this portrait. Similarly, in accepting the scholarly consensus that Gauguin considered his masterpiece *Where Do We Come From?* a "last testament," I was struck by the way the picture might have been related to the question format and the mapping of life and death in Gauguin's Catholicism (a seemingly obvious but unexplored issue), which led me to look anew at the circumstances of the painting's development and to interpret its themes and distinctive formal qualities in new ways.

In comparing the material qualities of the works themselves, I rely on the findings of the conservation specialists and try to extend their descriptions to open up a discussion of motive, medium and message, and cultural codes. Thus I learned, for example, that Gauguin ironed some of his finished canvases to make them smoother and flatter, and washed them to degrease the color and decrease the shine; he encouraged van Gogh to do the same. What led him to develop such extreme tactics of surface reduction? And can they be related to a drive to weaken materiality of its hold on consciousness? Van Gogh, as we will see, had a difficult time with these efforts to "matte" surfaces, although he experimented with some of them; but he was inclined toward different handling, aiming not only for thicker, textured brushwork but also for including such accidents as bits of eggshell, coffee grounds, and pieces of soot in his compositions. The eggshells were probably the remnants of egg-white coatings that experts have discovered van Gogh used in some Arles paintings as a varnish.[6] These habits of emphatic physicality suggest why van Gogh would not join Gauguin to embark on the "phantom ship" of the dream, liberated from the shackles of tawdry earthbound matter.

Whether or not readers accept the explanations, I hope they will *look* differently at van Gogh's and Gauguin's works as a result of this book. I offer visual analyses that suggest the coherence and continuity of van Gogh's craft practices of mechanism and facture, such as the way he left traces of his framing tool in his compositions or relied on the texture of woven cloth in his color planes and brushstroke. And readers will find examples of what I see as van Gogh's consistent drive to match the subjects of labor with labor forms, such as his designing a threshed grain in the canvas representing the thresher at work. Correspondingly, I present another way of looking at some of Gauguin's paintings, such as the particular application of pigment to coarse canvas to formalize flayed flesh, or the use of graded, fluid color to try to meld painting to the flush wall. Such formal analyses may provide readers with a language to describe technical differences between the two painters—van Gogh's pigment trowel and Gauguin's compressor; Gauguin's gilded fresco and van Gogh's colored kitchen towel, for example—but I also hope such visual accounts will open up the discussion of what made them possible, moving us toward a cultural history of art.

IV

By focusing on van Gogh and Gauguin, I want to raise a larger issue for reinterpreting modernism: we need to reemphasize the critical role of religion in the development of modernism, to bring religion back into the story of artists' mentalities and formations. Basic questions and research on religion and modernism are radically underdeveloped, especially for the decisive transitional period of the 1880s. We tend to oversecularize the avant-garde, and our approaches are too dependent on a model of modernism generated by the national context that gave the avant-garde its name and institutional practice in the nineteenth century: France. Here a succession of presumably defiant, anti-clerical, and deracinated groups of cultural innovators engaged in a century-long battle against bankrupt bourgeois philistinism. These French-inspired categories lose their hold and reliability, however, when we explore artistic production in nineteenth-century Britain, the Netherlands, and Germany, even as they trivialize the profound and enduring significance of religious legacies and conflicts for artists in the French context itself.

In highlighting religion, I suggest an attentiveness to the role of religiosity in generating the form, structure, and content of varied types of modernist expressive arts. Here I am less interested in charting the symbols and iconography of religious aspiration than in exploring the underlying resources and tensions generated by varying religious traditions in specific national contexts, and their varying conceptions of the status of the self, the value of the image, and the meaning of the visible world. This approach privileges religious legacies not as a matter of conventional religious practice, or the inclusion of overt, surface symbols, but as formative structures, or mental frameworks and filters, that are mediated through the institutions of educational formation. Considered in this way as habits of mind or "mental equipment," religious legacies may be analyzed historically as providing painters with particular resources and constraints, shaping in part the ways artists approach reality, how they consider the status of the sensual in their craft, the density of the artist's touch, the relation between perception and conception, and the vocation of the artist as a purveyor of meaning and value.[7]

In broadening the historical field to include religion as part of a social analysis of modernist art, we begin to encounter phenomena missed by the secular model of the avant-garde, such as, for example, the

way Protestant and Catholic traditions in distinctive national contexts may have shaped different kinds of artists' receptivity, or resistance, to idealism and abstraction in the 1880s. I've been intrigued in my research by a correlation between mid-nineteenth-century Catholic formation and the definition of abstraction; the first language and practice of abstraction emerges between 1886 and 1890 within circles of Parisian artists who shared a French seminary education, a site where supernaturalist Catholicism, idealist Neo-Platonism, and avant-garde symbolism came together in a dynamic cultural mix. The links here are not static or monolithic, but the question of their interrelation has not been posed, nor has the religious training of particular artists been incorporated into analyses of their radical breaks from naturalism. The painter Edouard Vuillard, for example, attended a Marist seminary, where he submitted to a regimen of hourly prayer to the Virgin; the writer Octave Mirbeau was schooled by the Jesuits; Auguste Rodin spent time in a Paris monastery. These internal strains and variations within French Catholicism, as well as their shared habits of inwardness and otherworldliness, must be specified; they can be treated with the nuance and historical complexity that scholars have shown in reconstructing the class ambivalences, shifting markers of social perception, and gendered assumptions of avant-garde painters and their visual forms.[8]

Before we attempt these kinds of accounts, however, we need to start with more basic questions, and with case studies. The questions may seem obvious, after the fact, but they haven't been posed. How, for example, did Vuillard's years of hourly supplication to a holy female figure relate to his art of the 1890s, marked by an almost obsessive concentration on a maternal figure—his own mother—who is the lone shape of embodiment amidst radically destabilized visual surfaces of disaggregated pieces of things, what Vuillard called the "intimate whirlwind" that he could re-create only bit by bit?[9] And how was it that van Gogh and Gauguin settled on labor and the dream to engage the sacred in 1888 and after, thereby exposing the pressure points of their theological cultures in transformation? I hope now to suggest some answers to this last question.

PART ONE

Toward
Collaboration

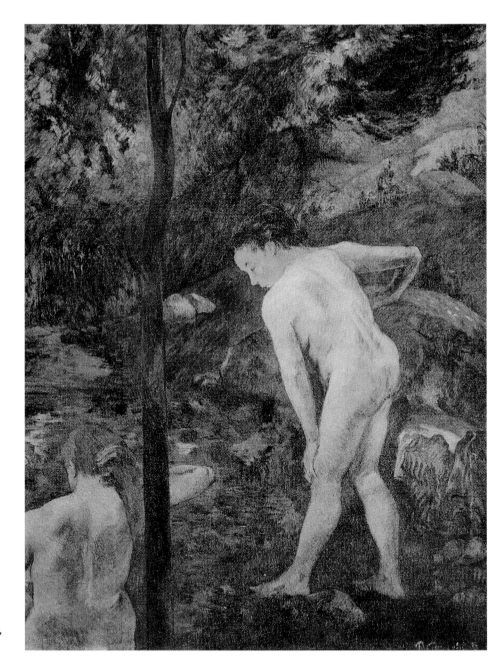

FIG. 1. PAUL GAUGUIN, *TWO GIRLS BATHING*, 1887, oil on canvas,
87.5 x 70 cm. Museo Nacional de Bellas Artes, Buenos Aires

Self-Portraits

There is no denying that we are the martyrs of painting.
PAUL GAUGUIN[1]

I have sought something other than a martyr's career, for which I am
not cut out.
VINCENT VAN GOGH[2]

PROLOGUE: CONVERGING LIVES AND ALTERED CAREERS, PARIS, 1886–1887

Vincent van Gogh had met Paul Gauguin when both painters were living in Paris. Van Gogh arrived in Paris in March 1886; he probably met Gauguin for the first time that fall, but it was in November 1887 that the two artists began to exchange work. Each of their careers was affected by their Paris friendship. For Gauguin, meeting van Gogh was a stroke of good fortune after a difficult period. Vincent introduced his brother, the art dealer Theo van Gogh, to Gauguin and his work, and it was due to Theo that Gauguin enjoyed a series of sales and notices in the Parisian art market and press. In December 1887 Theo chose four of Gauguin's paintings and five ceramic pieces on consignment for Boussod & Valadon, the gallery where he was employed, and sold one of the canvases, *The Bathers*, a few weeks later. In January 1888 Theo purchased three Gauguin paintings for the gallery and also exhibited there another, called *Two Girls Bathing* (Fig. 1), which received a favorable published commentary by the important avant-garde art critic Félix Fénéon. A few months later, Fénéon suggested that Gauguin's work was compelling enough to merit the planning of a small one-man show at the office of the *Revue Indépendante*.[3]

During the same period, such sales and publicity had eluded Vincent van Gogh. His arrival in Paris in 1886 followed a five-year apprenticeship in the Netherlands, with short interludes in Brussels and Antwerp. Van Gogh had come late to painting. It was only in 1880, at the age of twenty-seven, that he decided to become an artist, after spending a decade in other careers. Van Gogh had for seven years been an employee in the Goupil art-dealing company where his uncle was a partner, and then turned to a religious vocation, first as a teacher and Methodist lay preacher in England, then as a university

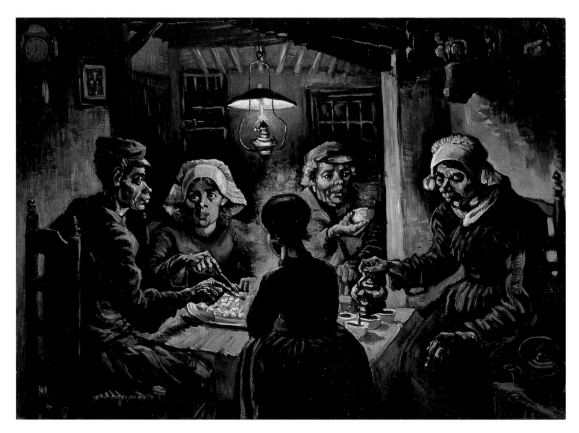

divinity school trainee in Amsterdam, and finally as an evangelist among the destitute miners of the Belgian Borinage.

In choosing to devote himself to art, van Gogh extended the goals of his religious evangelism, service and consolation, to his new calling. Along with them he brought to his new work a methodical exertion, approaching art as a rigorous craft. In The Hague between 1881 and 1883, van Gogh developed a program of disciplined self-instruction aimed at mastery of drawing; he patiently copied the lessons in popular art manuals and "how-to-draw" training books in anatomy, perspective, and figure composition. Initially placing his hopes on becoming a commercial illustrator, van Gogh honed his skills through dogged effort, submission to rules and relentless repetition, and a model of slow, steady progress.[4]

For the next two years van Gogh continued his self-directed apprenticeship, moving now to the

medium of painting. Redefining his goal, he emulated the mid-nineteenth-century French realist François Millet to become a painter of rural life and labor. Van Gogh adapted Millet's themes to the new settings and subjects of the countryside in the Brabant region of the Netherlands, where he returned in December 1883 to live with his parents. Here he developed an ambitious program of painting and drawing the full cycle of production of the local hand-loom weavers and subsistence potato cultivators at work. He depicted the latter in the activities of planting, bending, and digging their crop, and then partaking, as he commented, of the fruits of their labor, "honestly earned." *The Potato Eaters* of 1885 culminated his early efforts to devise a "real peasant picture" that would "teach something," representing what he celebrated as the redemptive burden and sanctification of lowly labor (Fig. 2). Van Gogh connected the arduousness of his own artistic labors—which he formalized in the painting by using a color he compared to a "dusty potato" and by putting in a coarse pigment crust—to the activities of dredging and digging that had produced the meal depicted, and to the worthiness of those who gathered at the table; such visual exertion might signal that he, too, had "honestly earned" and merited grace.[5]

Van Gogh was still struggling with the issues of earning and the value of his production when, through his brother, he began to sense that a new trend in painting had emerged. Wishing to see for himself what the so-called Impressionists were composing, he decided to move to Paris. By the time he arrived and moved in to Theo's apartment in Montmartre, the high period of Impressionism was already ending and the new generation of artists was seeking its way out of Impressionism, pursuing a number of different directions.[6] Van Gogh responded to this animated and transitional world with voracious energy, experimenting in all directions while adapting new lessons to his own idiom. Absorbing Impressionism and Neo-Impressionism simultaneously, he produced canvases as visual dialogues or conversations with the works of other artists. In this context van Gogh welcomed his burgeoning friendship with Gauguin, himself an ambitious artist seeking to make his own mark on the Parisian artistic community.[7]

Gauguin too had come late to painting, choosing a career in art after jettisoning one with more financial security. But the world that Gauguin gave up was very different from Vincent van Gogh's. From 1872 to 1883, Gauguin had lived in Paris at the center of an elite nexus of high finance and progressive art. Through his legal guardian, Gustave Arosa, a wealthy investor and art collector, Gauguin had been placed as a stockbroker's agent in the Paul Bertin Company. Here he prospered as an able

employee who quickly learned the benefits of trading on the side: in each of his first four years on the job, he more than doubled his yearly salary in bonuses from canny deals. In 1879, now working in another brokerage house, Gauguin earned 30,000 francs, "a fortune at the time."[8]

Throughout the period from 1872 to 1883, Gauguin combined his work as a stockbroker with collecting and practicing art. He became an early champion and patron of emergent Impressionism, buying works by Claude Monet, Auguste Renoir, Camille Pissarro, and Paul Cézanne. He also grew serious about his own painting. He met and worked alongside Pissarro in 1879; he and Pissarro spent the summer holidays of 1881 painting with Cézanne. Always audacious, Gauguin submitted a small landscape to the annual state Salon of 1876, where, surprisingly, it was accepted, though it received no special notice. But Gauguin's early ambitions and alliances were with the innovators of the 1870s, the Impressionists. Central to the Impressionist circle as both patron and student, Gauguin was a regular at the Café de la Nouvelle-Athènes, where he joined Manet, Degas, Renoir, and Pissarro, among others, for evening discussions. He was invited to contribute to all five of the remaining yearly Impressionist exhibitions from 1879 onward. In 1881 Gauguin sold three of his own paintings to the Impressionists' main art dealer, Paul Durand-Ruel, for which he was paid the hefty sum of 1,500 francs, at a time when a Monet sold for 35 francs and a Renoir for 31.[9]

By 1883 Gauguin was listing his occupation as artist-painter, and had left his position in the Bourse altogether. The crash of the Banque de l'Union Générale and the French financial crisis of 1882 may have been a catalyst to the shift, but Gauguin was already engaged in a double career by that time and indeed, according to some writers, was using his employment as a way to support his painting. He quickly descended from his elite world to near destitution. The crash sent Durand-Ruel abroad in search of new clients, and the internal art market, like the stock market, collapsed.

With a wife and five children to support and no salary, Gauguin spent the years 1883–1887 in great uncertainty, which included episodes of moving the family out of Paris to an apartment in Rouen; selling his life insurance policy for cash; working as a traveling salesman for a French tarpaulin manufacturer; and joining his wife and children in his wife's family's home in Copenhagen, Denmark. After a miserable six months there in 1884 and 1885, Gauguin returned to Paris with one of his children, Clovis, and earned daily wages as a bill poster for an advertising company in city railway stations. He managed to assemble a large group of paintings to show at the 1886 Eighth Impressionist exhibition. But he

was disturbed to find that Seurat and his Neo-Impressionist cohort had claimed the spotlight of public attention; they were celebrated by avant-garde critics, and many new painters rallied to the promise of a science of harmony applied to canvas. Intense professional rivalry also eventually led Gauguin to break with his former mentor and loyal supporter Pissarro. He resented Pissarro's enthusiasm for Neo-Impressionism and stopped associating with him, proceeding to cultivate and emulate Degas instead.

In the spring of 1887 Gauguin pursued a brief, far-flung adventure, attempting to benefit from the spectacular fortunes reported to be attainable in the French project of building the Panama Canal; he and a friend and fellow painter, Charles Laval, set sail for Panama, where Gauguin's brother-in-law held an administrative position. But the canal project was already beset by scandal, false reports, and horrific jungle conditions. Not only was there no money to be made, but Gauguin survived only by working as a navvy, digging on the canal line with pickax and shovel. He and Laval left Panama to spend a few months painting in Martinique. Their ability to work, however, was impeded by illness; both men suffered there from dysentery and malaria. Gauguin returned to Paris that November and moved in with one of his friends. His hopes for success were raised only when Theo van Gogh chose some of his works for display at his gallery.

These then were the circumstances that brought two men from different worlds, latecomers to art, to Paris. Neither remained in the city for long; within a few months they had each decided to leave for rural sites and subjects to paint. But their relationship would remain central to both, first through letters and then for a period, some months later, of living and working together.

In February 1888, Gauguin left Paris for Pont-Aven, Brittany, the same month that Vincent van Gogh relocated to Arles in Provence. From this point on, it was Theo van Gogh who was primarily responsible for the financial support of both painters. As a devoted brother and the only source of funds for Vincent, Theo sent him monthly—or sometimes semimonthly or even weekly—payments in cash or postal orders, averaging 200 to 300 francs per month; Vincent also expected Theo to represent him for possible sales and gallery showings. For Gauguin, Theo acted as a commercial agent and art dealer. Their eventual quasi-contractual agreement was that Theo would send 150 francs per month to Gauguin in exchange for Gauguin's production of one painting, which Theo would then try to sell. In Brittany as in Paris, Gauguin covered the rest of his financial needs by periodically extracting funding or loans from among his circle of generous friends, especially the artists Emile Schuffenecker and Meyer de Haan.

Vincent van Gogh first proposed the possibility of "combining" with Gauguin in a letter to Theo on May 28, 1888, in which he emphasized the practical advantage to Theo of sustaining only one artistic household for the two painters.[10] From the beginning, van Gogh's plan for a joint studio opened out to a broader cooperative venture in which he envisioned a number of painters joining forces in a spirit of fellowship and collaboration. But his initial presentation to Theo of the plan to associate with Gauguin indicates not only Vincent's perceptive understanding of Gauguin's many talents but also a recognition of the latter's capacities for self-promotion and manipulation. Vincent's letters register a shrewd mixture of friendship and wariness in approaching Gauguin for their Arlesian collaboration; they also highlight the pivotal role of Theo as the mediating figure in their essentially triangular relationship.[11]

GAUGUIN THE "SCHEMER" AND "SPECULATOR"

In suggesting his plan to Theo for a combined studio with Gauguin, Vincent adopted, uncharacteristically, the tone of the wise and watchful older brother, warning Theo not to yield to Gauguin's pleas for extra funding to pay off his extensive debts in Pont-Aven. "You can't send him what will keep him going in Brittany and what keeps me going in Provence," he pointed out. Though Gauguin had appealed to Theo for more funds to ease his illness and misery, Vincent cautioned Theo not to act out of compassion or as a healer; the most prudent plan, he advised his brother, would be for Gauguin to move to Arles. "Take the thing as a plain matter of business," Vincent urged Theo; if Gauguin joined him in Arles, the arrangement would be "advantageous" to all parties—to Theo, who would satisfy his wish to help Gauguin and "get him out of trouble" while also obtaining a canvas each month to offer for sale; to Gauguin, who would continue being supported; and to Vincent himself. A "comrade" would relieve his isolation and at the same time, as he noted to Theo, assuage some of his own worries that he spent "so much money on myself alone."[12]

Vincent continued to sound the note of mutual benefit when he broached the idea of collaboration to Gauguin. In a letter to his friend he discussed candidly the utility of shared costs, and the mutual advantages and obligations that the arrangement would entail. Here van Gogh approached Gauguin as an equal but also as a sober guardian of his own and his brother's shared interest. While he acknowl-

edged that both he and Theo "appreciated" Gauguin's work and were "anxious to see you settled down," he also admonished him with the same fact he had noted in his original proposal to Theo: "My brother cannot send you money in Brittany and at the same time send me money in Provence . . . If we combine, there may be enough for both of us, I am sure of it, in fact."[13]

Van Gogh cautioned Gauguin against repeating his entreaties to Theo for extra funds for Pont-Aven, noting that Theo "will only assure you that up to the present the only means we have found of coming to your aid in a more practical way is this combining, if it should appeal to you." He left unmentioned the attractions of Arles. Gauguin might or might not find that the Arlesian climate suited him; they would see to that later, "but business must come first." Part of that business, van Gogh notified Gauguin, was that if he did choose to come to Arles, he "must not forget the cost of moving and buying the bed," which would have to be paid for in pictures.[14]

Vincent's wariness intensified over the next few months. On May 29, in his second letter to Theo on the subject of the collaboration, he wrote that "it would be a *great risk* to take Gauguin, but we must aim at this," noting that being associated with him—"such a great talent"—would be beneficial for the van Gogh brothers, "a step forward for us." Here he again invoked the logic of pragmatic mutual advantage while also noting that attending to Gauguin was not without its difficulties. "Helping him would be a lengthy business," he wrote, but worthwhile in the long run.[15] In June, Gauguin, believing he had found a wealthy investor to offer 600,000 francs to establish a new art gallery specializing in Impressionist pictures, wrote to Theo that he imagined him as its natural director. On learning of this, Vincent sent a letter to Theo belittling Gauguin's plan, which he considered delusional: "This hope is a *fata morgana*, a mirage of destitution, the more destitute you are—especially if you are ill—the more you think of such possibilities. To me this scheme simply looks like another proof of his breaking down."[16]

By September Vincent had become more caustic. While exchanging friendly letters with Gauguin about their respective painting projects, he was growing more impatient, for Gauguin, who had agreed in July to join him in Arles, had still not made specific plans for the move. In the meantime Vincent had set about renting and furnishing lodgings for a joint studio, which he called the Yellow House, and had increased his requests for funds from Theo accordingly.[17] Gauguin continued to lament his debts and ordeals in Pont-Aven to both Theo and Vincent while also aggravating Theo with demands that he adjust the prices set for his pictures, even threatening to go to another dealer.[18] It was during one of

these episodes that Vincent wrote perspicaciously to Theo: "I feel instinctively that Gauguin is a *schemer* [*un calculateur*] who, seeing himself at the bottom of the social ladder, wants to regain a position by means which will certainly be honest, but at the same time, very *politic*."[19] Vincent reiterated that Theo must be "very firm" and clear in his dealings with Gauguin and should resist Gauguin's manipulations concerning other agents. Van Gogh nonetheless remained ready to welcome Gauguin as a comrade, and partly excused his friend's penchant for "scheming" as not only the natural corollary of his outsider status but also the result of habits learned during his many years as a stock-exchange agent specializing in high-stakes ventures. "I cannot blame Gauguin," van Gogh commented, "speculator [*boursier agent*] though he may be as soon as he wants to risk something in business."[20]

FROM ORDINARY COMRADE TO VENERATED MASTER

The sharp edges of van Gogh's presentation of Gauguin's ambitious maneuverings dissolved when he responded to a self-portrait Gauguin sent him, entitled *Self-Portrait: Les Misérables.* Even before he received the actual painting on October 7 or 8, van Gogh was overcome with awe when he read Gauguin's explication of the canvas in his letter of September 25.[21] In fact, he was so powerfully affected by Gauguin's description of the picture that he enclosed it in his letter to Theo, noting that Gauguin's was "a very, very remarkable letter" and that Theo should preserve it as "a thing of extraordinary importance." Van Gogh now proceeded to assign a new priority to Gauguin in his proposed association, asserting for the first time that the community of artists would need a governing master: "When it is a question of several painters living a community life, *I stipulate at the outset that there must be an abbot to keep order, and that would naturally be Gauguin*."[22] The new role being planned for Gauguin deepened still further as van Gogh assigned him—in the letter to Theo—the position of *chef de l'atelier*, "head of the studio." In this capacity, wrote van Gogh, Gauguin could "control the money as he thinks fit," as well as shape the tone and future direction of the community. Gauguin's dominating presence, as expressed in his letter about the self-portrait, confirmed his stature as what van Gogh termed "a very great master, and a man absolutely superior in character and intellect."[23]

Now van Gogh's wariness about Gauguin's capacity for manipulation gave way to an attitude of

devotion to the master. Vincent enlisted Theo, whose funding he expected to support the community studio, in the role of "dealer-apostle," urging him to be fully "committed to Gauguin body and soul."[24] Van Gogh's own role, as a fellow artist, was now to insure that comfort and solace be provided for Gauguin. The letter conveyed his eagerness to be the reverent helpmate to Gauguin, noting, for example, that he was readying the studio and the Yellow House with great anticipation, in the hope that it would "make a good impression on him from the moment he arrives," that he would "feel it" to be "all harmonious"—"a setting worthy of the artist Gauguin who is to be its head."[25] The goal of collaborative production van Gogh had articulated in July now ceded to an idea of collective obligation to restore Gauguin to his full capacities as a painter and a leader. He wrote to Theo:

> *The more Gauguin realizes that when he joins us he will have the standing of the head of the studio, the sooner he will get better, the more eager he will be to work.*
>
> *Now the more complete the studio, the more solidly established it is . . . the more inspiration he will have, and ambition to make it a living force.*[26]

In this full flush of admiration, van Gogh wrote to Gauguin, too, urging him in a new voice to come south. Now less the sober advocate of the cost-sharing plan than the deferential supplicant extending offers of hope, encouragement, and relief from misery, van Gogh prodded Gauguin to hasten his arrival; he assured him that he would discover restoration for both body and soul. The "refuge" and "shelter" of the studio in Arles would allow Gauguin, van Gogh wrote, "to feel more or less comforted after the present miseries of poverty and illness," and his material needs would be safeguarded. Van Gogh also tried to boost Gauguin's spirits, so dramatically wracked by external and internal anguish, by rather reticently noting that he himself had moved from despair to hope during the time in Arles:

> *I left Paris—seriously sick at heart and in body, . . . my strength failing me— . . . without the courage to hope!*
>
> *Now, however, hope is breaking for me vaguely on the horizon—that hope in intermittent flashes, like a lighthouse . . . And now I am longing to give you a large share in that faith.*[27]

Van Gogh concluded his letter with affirmations of Gauguin's special status. Having described the room and decoration he had prepared, van Gogh reminded him that Provence was the land of the poet Petrarch, and pointed out that it was he, Gauguin, who would be the modern equivalent of the ancient master when he relocated to Arles.[28] And van Gogh celebrated Gauguin's mastery in contrast to what he characterized as his own "sincerity" mixed with clumsiness:

I always think my artistic conceptions extremely ordinary when compared to yours . . . I forget everything in favor of the external beauty of things, which I cannot reproduce, for in my pictures I render it as something ugly and coarse, whereas nature seems perfect to me. The result of this is a sincerity, perhaps original at times, in what I feel, if only the subject can lend something to my rash and clumsy execution.[29]

As he continued the final preparations for Gauguin's arrival, anxious that nothing displease the admired *chef de l'atelier*, van Gogh redoubled his own efforts to produce canvases, assuming the stance of the apprehensive apprentice longing for the master's approval. He admitted to Theo: "Yes, I am ashamed of it, but I am vain enough to want to make a certain impression on Gauguin with my work, so I cannot help wanting to do as much work as possible before he comes."[30]

By October 1888, then, van Gogh aspired to heal and comfort Gauguin, offering him hope and refuge in the warm sun of Provence, underwritten by Theo's money. Now Vincent's impression of Gauguin as a "schemer" and "speculator" gave way to an image of him as an abbot and master; the pragmatic assessment of reducing costs and sharing expenses in a brotherhood of mutual advantage and reciprocal obligations ceded to the unconditional privilege of receiving and obliging the new *chef de l'atelier*. The terms of van Gogh's previous stance of vigilant restraint, protecting his brother's finances from Gauguin's presumptuous requests, and the judicious strategies of what he called pursuing "an art and a business method,"[31] were now reversed. As van Gogh enlisted Theo to join him, "body and soul," for Gauguin's recovery in Arles, he emphasized that while economizing might succeed or fail, it was "*the human, not the material side*" that took priority. Risks and expenses were now tolerable, even if imprudent, and van Gogh found reassurance in invoking a maxim he had earlier used during other periods of uncertainty: it will be endurable, he noted, "because one grows in the storm."[32]

THE BANDIT AND THE BONZE

What were the qualities of Gauguin's self-portrait and his description of it that provoked such a powerful reaction in van Gogh? And how did van Gogh maintain his own distinctive self-definition and stylistic practice as he deferred to his newly venerated comrade? The answers begin to emerge in a second element of van Gogh's response to the *Misérables* picture: he sent off to Gauguin one of his own recent self-portraits, of himself as a bonze (a Japanese priest). The canvas, entitled *Self-Portrait Dedicated to Paul Gauguin* (Fig. 3), extended to Gauguin an exemplary image of what van Gogh considered a sacred Japanese brother band devoted to a religion of nature. He inscribed the canvas "à mon ami Paul Gauguin" across the top and signed it "Vincent" along the bottom right.[33] Gauguin's *Self-Portrait: Les Misérables* (Fig. 4), by contrast, presented the artist as an exalted bandit, a victim of social oppression and an ecstatic cultivator of his own agonistic creativity. He brushed in the lower right his dedication "à l'ami Vincent" and signed it below. Van Gogh's account of his self-portrait invoked calm, self-offering service; Gauguin's celebrated a tormented genius, burned by the lacerating heat of inner vision. I want now to look more closely at these two self-portraits that van Gogh and Gauguin exchanged just before they began to live and work together in Arles, and at the expressive patterns of form and content that distinguish them. The self-portraits set the tone of the artists' relationship while also suggesting the different models of self, community, and divinity that shaped the broader tensions in their collaboration.

Interestingly, van Gogh's exchange of self-portraits with Gauguin had originated as a very different enterprise. During the summer of 1888, van Gogh's plans for Gauguin to join him were attached to other, more ambitious projects for an artists' community. Van Gogh had written to Gauguin and Emile Bernard requesting that the two artists paint portraits *of each other* and send the finished canvases to him in Arles.[34] At the time, he was engaged in readying the Yellow House to be the site of a group "studio of the south," modeling his utopian plans for the "fraternal community" on such disparate sources as Dutch craftsmen's guilds, Japanese artists' confraternities, monastic brotherhoods, and modern profit-sharing cooperatives.[35] Van Gogh's request for the portraits expressed the ethos of fellowship and interdependence he projected for the group venture, where singularity would cede to solidarity and

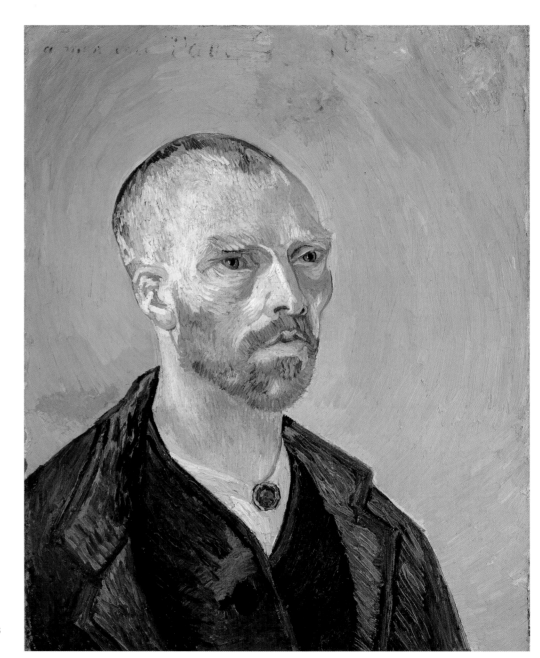

FIG. 3. VINCENT VAN GOGH, *SELF-PORTRAIT DEDICATED TO PAUL GAUGUIN*, 1888, oil on canvas, 59.55 x 48.26 cm. Courtesy of the Fogg Art Museum, Harvard University Art Museums, bequest from the collection of Maurice Wertheim, class of 1906. Photograph by David Mathews. © President and Fellows of Harvard College, Harvard University

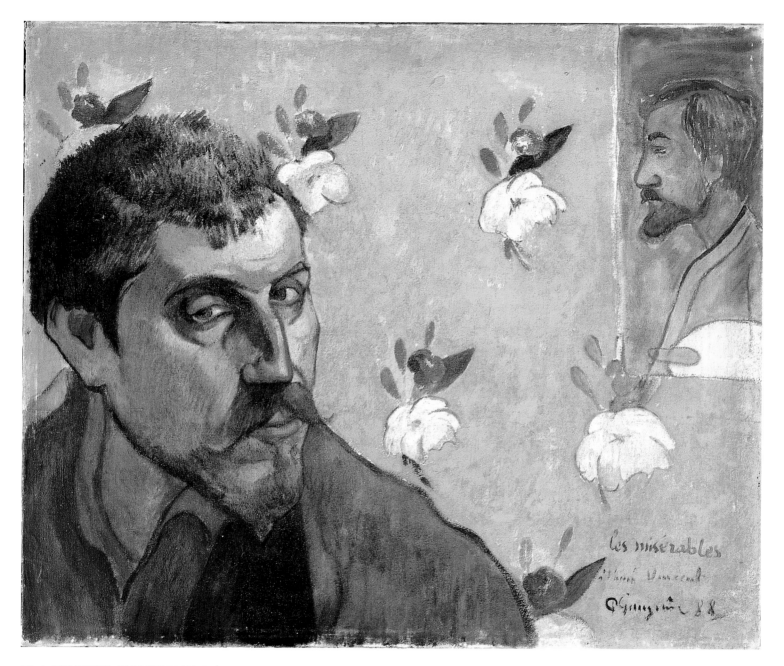

FIG. 4. PAUL GAUGUIN, *SELF-PORTRAIT: LES MISÉRABLES*, 1888, oil on canvas, 45 x 55 cm. Van Gogh Museum, Amsterdam (Vincent van Gogh Foundation)

where each artist would realize his best nature and art through collaboration: "Only by associating thus, each of us will be more himself, and union is strength."[36]

Moreover, the portraits of Bernard by Gauguin and of Gauguin by Bernard would initiate a group portrait gallery for the Yellow House, prefiguring the goals of complementarity and interchange to be practiced by the community of artist-brothers. The offering of an image of one artist by another would also harmonize with van Gogh's larger project of decorating the Yellow House with interlinked ensembles. Van Gogh planned to install in each of the rooms a coordinated group of paintings that would assume visual and thematic coherence from their interaction, rather than operating as discrete canvases.[37] The *group* portrait project, like the decoration of the Yellow House coinciding with it, thus constituted a stylistic analogue to the relational model of self and society that guided his plans. The "serene summits" of the great arts of the past, he wrote to Bernard, "are beyond the power of an isolated individual; so they will probably be created by groups of men combining to execute an idea held in common."[38]

The question of whether the route to artistic achievement lay within or beyond "the power of an isolated individual" and the status of "an idea held in common" were very much at issue for Bernard and Gauguin at the time van Gogh sent his request for their complementary portraits. Powerful impediments to the spirit of solidarity were already percolating in Bernard and Gauguin's collaboration while they were working together in Pont-Aven. Some time later the friction would ignite in the bitter battle over which of the two painters could be granted priority in the invention of the new style of "synthetism." In any event, both Bernard and Gauguin were unable to engage the other and execute the portraits van Gogh had requested. Bernard commented on being too intimidated by Gauguin to approach the daunting subject; Gauguin noted that he had difficulty developing his image of Bernard.[39]

Gauguin and Bernard chose instead to paint their own self-portraits, each including an insert showing the other artist at the back—Gauguin's *Self-Portrait: Les Misérables* had Bernard's profile attached to the back wall at the right, and Bernard's *Self-Portrait* had an appended panel showing Gauguin's face. Gauguin's rendering of Bernard in his self-portrait is a simple, perfunctory profile, minimally articulated, almost a shadow silhouette, with a red outline and a green wash of color. Even more telling than the simple rendering is the fact that Gauguin's long explanation of his painting did not mention Bernard at all.[40]

Though not what he had requested, the two paintings that reached him in Arles about October 8

pleased van Gogh.[41] In the letter that preceded the package, Gauguin described his self-portrait both as "a personal likeness" and as a representation of the predicament of the modern artist as a "wretched victim" inspired by Victor Hugo's Romantic hero, Jean Valjean, and given a new interpretation in identifying both external and internal sources of affliction.[42] Van Gogh responded to Gauguin's portrait by sending him his own self-portrait, which he too defined as both an image of himself and a statement of the modern artist "in general." Van Gogh presented himself, and the modern artist, not as a "wretched victim" but in the guise of a Japanese monk—"conceived," he explained, "as the portrait of a bonze, a simple worshipper of the Eternal Buddha."[43]

Other writers have taken note of the dissonant registers of composure and turbulence exhibited in the two paintings; some have interpreted the differences between van Gogh's self-portrait and Gauguin's as indicative of the divergent temperaments of "stoicism" versus self-indulgence, and of the discordant convictions of utopian "optimism" versus "social pessimism." Yet the choice of the two painters' self-presentations, and the visual forms that conveyed them, also crystallized deeper differences in van Gogh's and Gauguin's culturally transmitted assumptions about subjectivity, society, the salience of Christ, and the status of materiality in the artist's quest for mediating divinity.[44]

GAUGUIN'S TORMENTED PRISONER

Gauguin has presented himself, head cocked and eyes rolled to the left, peering out of a facial field cast in contrasts of dark, blue-green shadows and glowing scarlet patches on the nose, neck, and cheek. His large face and shoulders, pushed out to the canvas edges, are set against a flat, mustard-yellow floral background and the profile of Bernard. The brushwork and paint application display some variation. A thin, lightly painted wash covers the floral yellow wall, while some hatched, vertical striations mark the hair on the top of the head. But Gauguin has rendered the other area of hair, the beard and mustache below, as a smoothly blended, matte surface that bears little visible texture. The face as a whole sustains this muted surface and low impasto, with flesh-colored, blue-green, brown, and red paint absorbed and saturated into the canvas ground. In some areas of the face, the matte permeation of color appears blanched and chalky. Gauguin's left cheek and mid-forehead, for example, show small

pores or cracks, as if the absorbed paint has been further pressed down or graded, creating a thinly layered, clotted covering.

In letters to van Gogh and to his friend Emile Schuffenecker, Gauguin explicated the meaning of this self-portrait and its inscription, "les misérables," invoking the language of abstraction, detachment, and the ecstatic suffering of the *voyage intérieur*. To van Gogh he wrote:

> It is the face of an outlaw, ill-clad and powerful like Jean Valjean—with an inner nobility and gentleness. The face is flushed, the eyes accented by the surrounding colors of a furnace-fire. This is to represent the volcanic flames that animate the soul of the artist . . . The girlish background, with its childlike flowers is there to attest to our artistic purity. As for this Jean Valjean whom society has oppressed—cast out—. . . is he not equally a symbol of the contemporary Impressionist painter? In endowing him with my features I offer you as well as an image of myself a portrait of all the wretched victims of society.[45]

Some days later, Gauguin amplified these comments in his letter to Schuffenecker:

> I have done the self-portrait which Vincent asked for. I believe it is one of my best things: absolutely incomprehensible (for example) it is so abstract. Head of a bandit in the foreground, a Jean Valjean (Les Misérables) personifying also a disreputable Impressionist painter, shackled always to this world. The design is absolutely special, a complete abstraction . . . The color is far from nature; imagine a vague suggestion of pottery contorted by a great fire! All the reds, violets, striped by flashes of fire like a furnace radiating from the eyes, seat of the struggles of the painter's thought . . . Chamber of a pure young girl. The impressionist is pure, still unsullied by the putrid kiss of the Ecole des Beaux-Arts.[46]

Gauguin's artist was a victim of both social oppression, evoked by the prisoner Jean Valjean dragging his chain, and the corruptive contact with artistic convention—the "putrid kiss" of the Beaux-Arts and the debased shackles of this world. The artist's salvation lay in defiance and release from such sullying contact, breaking the chains that bound him to what he called the "vile existence that burdens me."[47]

Outlawed and insulated, Gauguin's artist was thrown back on the self, destined to cultivate both the liberations and the terrors of inner vision. The artist's physical form, according to Gauguin's description, bore the outer signs of the inner suffering that necessarily accompanied individual creativity. Like pottery baked in a kiln, noted Gauguin, his own face in the *Self-Portrait* was "flushed" and the eyes accented by colors that radiated furnace-fire heat. This fiery, infernal glow expressed the artist's inner affliction and exaltation, his soul animated by "volcanic flames" and his eyes flashing fire that captured the "seat of the struggles of the painter's thought." An accomplished ceramicist, Gauguin here called on the process of the furnace melting and transforming clay to evoke the heat and compression of the artist's inner vision, yielding a pigment construed as barely congealed glowing lava. Gauguin described the melting of substances in the firing kiln as a "stay in Hell," and emphasized that "the hotter the fires, the more the clay contracted." The evocation of the searing "volcanic flames" and the "furnace-fires" contorting the artist's soul allowed Gauguin to signal both the fluidity and the compacting purification—intense heat, and reduction—that attended the creative process.[48]

Gauguin's comments embraced the agony and exhilaration of the "hell fires in the mind" as the ground of existence for the modern artist. His *Self-Portrait* offered a visual analogue to the themes of modern creativity and the internalization of the infernal being tested at the same time in the evolving sculpture *The Gates of Hell* by Auguste Rodin in Paris. Rodin presented his crowning figure on *The Gates*, the *Thinker/Poet*, in a pose of taut immobility, noting that the inner compression of thought was expressed in the figure's physical tension. Both Gauguin's painter and Rodin's poet bore particular outer signs of the "struggles of thought," evoking shared assumptions that defined modern creativity as an irrevocable union of physical pain and psychological strain.[49]

Along with the infernal images of lava flow and furnace blasts Gauguin's *Misérables* summoned an element that linked creativity, inner suffering, and the self-sacrificing torments of the calvary, the *miséricorde* of the Passion of Christ. Allusions to the figure of Christ were built into the character of Jean Valjean, whom Hugo presented as a selfless victim who sacrificed himself for the larger good of the community and social justice.[50] Gauguin himself characterized Valjean as bearing "an inner nobility and gentleness."[51] Yet Gauguin's post-Romantic, and post-1848, hero could not share Valjean's gentleness or Victor Hugo's credo of the artist as *moraliste et politique*, obliged to realize the aesthetic ideals of harmony and the dream in social and political action.[52] Gauguin's actions unfolded in the inner

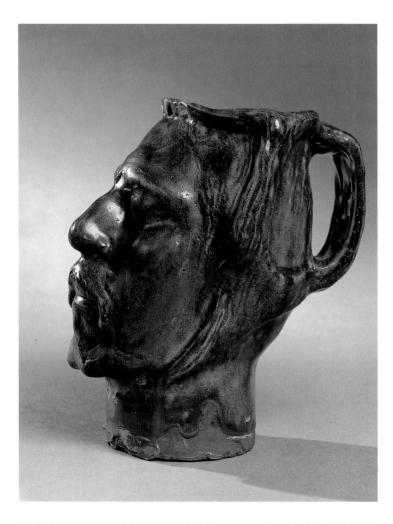

FIG. 5. PAUL GAUGUIN, *SELF-PORTRAIT JUG*, 1889, stoneware with colored glaze, height 19.3 cm. Kunstindustrimuseet, Copenhagen. Photograph by Ole Woldbye

world of the *misérable*, and he transformed the sacrifice of the Savior from the goal of transcendent community enlisted by Hugo to the new purpose of the expansion of subjectivity through willful self-immolation. Gauguin's *misérable* embraced a martyrdom in, and of, the psyche.

Gauguin invoked the theme of sacrifice explicitly when his letter to Schuffenecker about the *Self-Portrait* began with his assertion that he had "sacrificed everything" for his new direction in painting.[53] In the letter to van Gogh about the painting, there is another suggestion of the model of Christ. Here Gauguin's description of the artist as Jean Valjean is translated as "The face is flushed," inflamed by "a furnace-fire." In the original French, this line has a somewhat different connotation and context, evoked by the terms of blood and inundation—Gauguin wrote, "Le sang en rut inonde le visage" (roughly, "Boiling blood gushes over the face").[54] The bloodied head and the spurt of red connect the artist to the martyred Christ, an identification that Gauguin would persist in expressing. By the time he produced the *Misérables* self-portrait, Gauguin had defined himself as a "martyr of painting" and the artist's life as a "long" and mutilating "calvary," burdened by grief, anguish, and unending melancholy.[55] Some months later Gauguin would formalize this expressive pattern in a ceramic *Self-Portrait Jug*, with his own head as a molded cup streaked with scarlet lines like gushing and dripping blood (Fig. 5). In the 1888 *Misérables* the artist is inflamed and bloodied, wracked by agonized self-scrutiny that is also the source of his inspiration.[56]

Gauguin's *Self-Portrait: Les Misérables*, claimed by its maker to be an image of abstraction, deracination, and self-cultivation, was

received by van Gogh with a mixture of awe, sadness, and reproach. While he was overcome by the letter of explication preceding the arrival of the canvas, van Gogh's response to the image itself was more measured. He did not openly criticize the painting to Gauguin directly but did register his discomfort in a letter to Theo. "Gauguin looks ill and tormented in his portrait!" van Gogh noted; he "gave me absolutely the impression of representing a prisoner."[57] Significantly, van Gogh did not comment on the flushed face and radiating heat emphasized by Gauguin, but focused instead on the unnatural dark shading on the right side of the face: "Not a shadow of gaiety. Absolutely nothing of the flesh, but one can confidently put that down to his determination to make a melancholy effect, the flesh in the shadows has gone a dismal blue."[58] Gauguin's tribute to flesh color seared and baked by the "volcanic flames" of inner vision, like what he called the "cruel and monstrous" Last Judgment panels of reckoning and agony on Arles's Saint-Trophime Cathedral, held no appeal for van Gogh.[59] Instead he construed the self-portrait as a statement of "despair" and desperation, and he responded with a new resolve to protect and nurture his friend. "What Gauguin's portrait says to me above all things is that he must not go on like this"; "he absolutely must cheer up—or else"; he must "come back to a more serene life."[60]

Van Gogh claimed he would offer that serenity to Gauguin both through the consolation of the communitarian Yellow House and with the material comfort he and his brother would provide by selling more of his pictures. At a high point of what he called "hope . . . breaking for me vaguely on the horizon," van Gogh expected that Gauguin, too, would be relieved of his brooding misery and within "six months' time" would produce a new self-portrait, far from the tormented victim of 1888.[61]

Van Gogh thus tempered his lack of enthusiasm for Gauguin's picture by imagining a restorative future serenity for him in Arles. Yet Gauguin's suffering could not so easily be consigned to a temporary state of material deprivation and social isolation, for Gauguin indicated that he was not simply a victim of external oppression but a willing and active agent of his own internal violation. Gauguin's self-portrait indeed celebrated an ecstatic martyrology of visionary self-discovery as a condition of artistic creation, which had little resonance with van Gogh's abiding assumptions and cultural legacies. Van Gogh tapped these themes as he sent Gauguin his own *Self-Portrait*, prefiguring the hope, composure, and interdependence that beckoned.

VAN GOGH'S ANCHORED WORSHIPPER

Van Gogh had begun the Arles self-portrait as an unsigned study in mid-September and then decided to send it to Gauguin, with a new inscription, on October 4, a day after he received Gauguin's letter describing his dolorous *Les Misérables*.[62] Despite his letter denigrating himself as "ordinary" compared with Gauguin, van Gogh came to contrast his own picture favorably with Gauguin's, and wrote to Theo that "my portrait holds its own, I am sure of that." He continued, "When I put Gauguin's conception and my own side by side, mine is as grave, but less despairing."[63] The gravity of van Gogh's image emerges in the figure's steady, impassive gaze, focused on an area off to the right of the beholder, not quite meeting the viewer's gaze. Gauguin's self-portrait, by contrast, provocatively places the head turned and the eyes rolled to confront the viewer's. Van Gogh suggested a temper of gravity in what he described, with emphasis, as the "*almost colorless* . . . ash-colored" or "ashen gray" tones of his self-portrait, set "against a background of pale veronese green."[64] His choice of these cool, pale hues diverged sharply from Gauguin's use of red and violet-scarlet patches to convey furnace-fire heat erupting from within.

While he did not react to this aspect of the Gauguin work, van Gogh had himself relied on the metaphor and visual equivalent of furnace-fire heat in devising another one of his Arles paintings—*Portrait of Patience Escalier*, executed about a month before his exchange with Gauguin (Fig. 6). Van Gogh modeled the peasant's face, set off by a bright yellow hat, in intense orange hues and red accents along the cheeks and ears. With these colors, "the man I . . . paint" would be captured "in the full furnace of the harvest, under the noonday sun. Hence the brilliant oranges, like red-hot iron, and the tones of gold glowing in the shadows."[65] Explicitly following the format of "heads of the people" and labor types he had begun in Holland, van Gogh's Arles portrait of Patience Escalier assigned the intensity of "red-hot" furnace heat to the scorching sun, chafing skin, and grinding outdoor work. The peasant's skin appears coarsened and reddened, the result of beating sun and physical exertion. The flush on Gauguin's face, ear, and neck, by contrast, signals the explosion of the artist's internal fire, the marks not of solar power and external action but of an animated soul and the infernal but inspired "struggles of the painter's thought."

If van Gogh's own "ash-colored" self-portrait thus reveals a countenance neither blasted by the sun's rays nor bursting with inner heat, the painting carries its own form of animation, balancing the stated qualities of "gravity" and composure with controlled energy. Van Gogh's particular technical procedures of brushwork, paint application, and format for the bonze self-portrait were very different from those that Gauguin devised for his *misérable*. Van Gogh's stylistic choices enhanced the materiality of the artist's physical presence as it visibly drew the bonze outward to realms beyond the surface. Gauguin's techniques for representing the *misérable*, by contrast, discovered formal means to compress and diminish surface materiality, corresponding to the state of concentrated introversion cultivated by the subject.

Van Gogh rendered the face and head of his bonze self-portrait in vigorous, palpable brushstrokes, and he described the head to Theo as "modeled" in colors and "painted in a thick impasto."[66] The density and tactility of the head convey what Ronald Pickvance has called elsewhere van Gogh's "sculptural" approach to facture; here the head and parts of the face carry a thick, protrusive crust. An active, textured brush has laid in the closely cropped beard and mustache, whose shape and burnt-orange tones resemble the batches of harvested grain van Gogh depicted in the fields of Arles

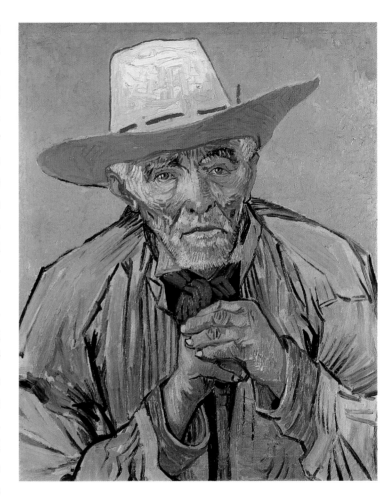

FIG. 6. **VINCENT VAN GOGH**, *PORTRAIT OF PATIENCE ESCALIER*, 1888, oil on canvas, 69 x 56 cm. Private collection

in June. The treatment of the facial hair is also reminiscent of the laced tactility of hair and face van Gogh enlisted in his 1887 "Neo-Impressionist" Paris *Self-Portrait* (Fig. 7), where he transmuted the shimmering smoothness of the pointillist microdot into brushwork bristling with sticks and ricks. Gauguin, by contrast, rendered his own beard and mustache like a color rubbing, with the paint surface slightly blanched and matted down into the absorbent ground. Although the hair on Gauguin's head in the self-portrait shows some hatched, striated brushwork, the paint was lightly and thinly applied, and divested of oily residue. Van Gogh's bonze, which depicted his then-*shaved* head, conveys more than

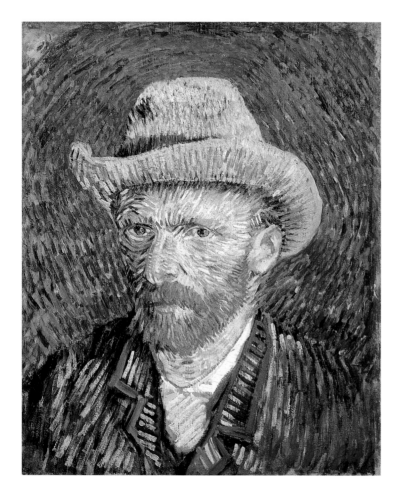

FIG. 7. VINCENT VAN GOGH, *SELF-PORTRAIT IN A GRAY FELT HAT*, 1887, oil on canvas, 44 x 37.5 cm. Van Gogh Museum, Amsterdam (Vincent van Gogh Foundation)

Gauguin's the physical presence of hair in a dense layer of what looks like carved stubble, saturated with the resin of the paint's greasy oil base.

The different handling of facial articulation in the two paintings can be seen most clearly, perhaps, in the area of the left side of each face, from cheek to eyebrow. Gauguin's left cheek (Fig. 8) is a muted, chalky layer of pressed flesh color, which sets off the eyebrow that is shaped by a dark outline; the rendering of the eyebrow has the character of a drawing with dark pencil or charcoal on pastel or plaster. Van Gogh's left cheek (Fig. 9) is molded, and the eyebrow is built up to create an almost three-dimensional shelf over the eye; if Gauguin's forms are present in chalky attenuation, van Gogh's cheek and brow bear the mass and density of modeling clay, which are raised off the surface of the canvas rather than lodged in it.

The interaction of gravity, tangibility, and animation in van Gogh's self-portrait extends to his distinctive treatment of the figure's dress and comportment, which also display striking differences from Gauguin's. Gauguin's rumpled, "poorly dressed bandit" is casually draped in a fluid layering of green cloaks, composed as curving sheets of color, with few visible brushmarks. Van Gogh's decorous bonze, by contrast, fits neatly into three layers of brown jacket, vest, and white shirt, each clearly demarcated by the outlines of blue piping along the edges of the jacket and vest. The costume color has been laid in with heavy, bold strokes, moving from a cascade of lighter brown pigment on the blazer to a darker brown area of the vest. Along the vest, van Gogh's brushstrokes are multidirectional, and some areas carry a clammy thickness and the high gummy gloss of layered oil paint. A conspicuous sediment from a caked drying of thickly laid oil pigment is also noticeable in the collarless white shirt that lies beneath the vest.

A circular ornamental medallion or brooch affixed to the white shirt of the figure below the neck completes the dignified costume of van Gogh's artist. The presence of the medallion suggests a ritual

or sacred vestment, signaling membership in a group bound by a common self-offering deference to the "eternal Buddha." The possible devotional significance of the brooch is heightened in the painting by its physical prominence, once even more accentuated: conservation experts have established that before the self-portrait was altered by restoration, the paint forming the brooch "was probably 2–3 millimeters thick," a "high impasto."[67]

The brooch sets off the upright open neck of the artist, which van Gogh composed in vertical swaths of the pallid "coolness" of white and flesh tones, highlighted by strokes of light emerald green. Gauguin's *misérable* also displays his open neck, framed, like the neck of van Gogh's bonze, by the V shape of his clothing. But van Gogh's "grave, but not despairing" bonze holds his pallid neck high, sealed by the densely layered colored brooch sitting so far off the canvas. Gauguin's head seems to bob improbably over his twisted neck, which exhibits a pressed, feathered, and diminished surface of high-keyed reddish color tones. Gauguin's scarlet neck signals the fires of calcination, the artist's kiln of torment and creativity. Van Gogh's ashen neck bears a ritual adornment that links him not to the consuming flames of subjectivity but to the outer realms of worship and the group.

A final, significant contrast in the two self-images emerges in the setting for the figures. As we have seen, Gauguin's alternately dark and flushed face is pressed to the canvas edges and set into a flat yellow floral wall. Van Gogh has set his figure in a special frame of radiating luminosity, which creates a visual field linking the artist to areas beyond the canvas. The dominating feature of his self-portrait is the way the figure's head glows, set off by a brightly lit circular area of pale emerald color, guided by large directional strokes. Many have referred to this peculiar format as a halo around the artist's head; a luminous aureole of white and veronese green does indeed radiate out and around van Gogh's head, creating arcing bands of colored light. The backlit coloring, arcing brushwork, and glowing face interact to suggest to the viewer the reverberations of light waves being emitted, as van Gogh visibly expands the sweeping circles of colored light beyond the edges of the canvas.

LEFT FIG. 8. DETAIL OF FIG. 4, PAUL GAUGUIN, *SELF-PORTRAIT: LES MISÉRABLES*

RIGHT FIG. 9. DETAIL OF FIG. 3, VINCENT VAN GOGH, *SELF-PORTRAIT DEDICATED TO PAUL GAUGUIN*

Van Gogh had explicitly been experimenting with what he called the "halo" effects of color in Arles. Initially he understood this as a lesson in the science of Neo-Impressionist color theory; he discussed in his letters how contrasting colors, when placed next to one another, created a halo effect of vibrating light, akin to an afterimage. By the time of the self-portrait as a bonze, however, van Gogh had shifted his conception of the halo from an experiment in optical color chemistry to a particular structure for a modern portraiture that would mediate through art the linkage of community and divinity. In this self-portrait, van Gogh moved closest to painting a circular and radiating halo, which he construed as laden with the possibilities of offering "comfort" and evoking "eternity":

> And in a picture I want to say something comforting, as music is comforting. I want to paint men and women with that something of the eternal which the halo used to symbolize, and which we seek to convey by the actual radiance and vibration of our coloring.[68]

We shall see in the chapters to come that this often-quoted statement of a picture's purpose, and the transformation of the halo integral to it, is more complex than it seems. Lying within it are a number of significant, and overlooked, sources and contexts, including van Gogh's own particularly Dutch legacies of a theology of art and color symbolism, and the popular Catholic piety newly available to him in Arles, which both fascinated and repelled him.

With rippling halo and sculpted, textured head, van Gogh's self-portrait as a Japanese bonze is thus "grave, but less despairing" than Gauguin's as it links gravity, and energy, to reverence, configuring a model of the self that is embedded in the larger totalities of nature, the eternal, and the social. Where Gauguin's view of the artist as a *misérable* replaced a hostile and encumbering world with the inexpressible ravages of inner vision, van Gogh's artist as a bonze drew meaning and structure beyond the individual ego in a series of devotional linkages outward—to the inexhaustible wonders of nature, to an invisible but immanent divinity, and to a fraternal community.

SOURCES OF VAN GOGH'S BONZE IN PIERRE LOTI'S NOVEL

How did van Gogh arrive at his self-definition as a bonze, a Buddhist priest? The themes sustaining the self-portrait derived from van Gogh's particular vision of Japan, which crystallized in Arles from his long-term immersion in literary renderings of Japan and his extensive collection of colored woodblock prints. Art historians have established that van Gogh encountered the figure of the bonze in Pierre Loti's 1887 novel *Madame Chrysanthème*, which he read in June 1888 and referred to often in his letters. One of the illustrations of bonzes in the Loti book probably provided van Gogh with a model for the physical features he included in his self-portrait, particularly the shaved head, round-necked white shirt, eyes, and nose.[69]

Yet the Loti book offered much more than a visual referent for van Gogh's bonze, for this figure played a particular *social* role in Loti's novel, one that corresponded to other elements of van Gogh's cultural assumptions and preoccupations. The bonzes always appeared in the book in groups, and were presented by Loti as convivial, ceremonious, artistic, and anchored in nature. In some ways they resembled the clerics of van Gogh's nineteenth-century Dutch homeland. Sustained by what scholars have defined as the peculiarly visual Calvinism of the Netherlands, the nineteenth-century Dutch artistic avant-garde comprised "preacher-poets" who recast European Romanticism with native themes, as well as art critics and collectors who included important ministers.[70] Like them, the Japanese priests in Loti's novel inhabited a sacred world far removed from asceticism and hermeticism.

A company of bonzes first emerged in *Madame Chrysanthème* as the leaders of a funeral procession, en route to deposit the corpse and palanquin in a burial ground "in the heart of the green mountain all peopled with tombs."[71] Reading the book in Arles, van Gogh was himself living close to another elevated burial ground all peopled with tombs—the famous Roman and Christian necropolis called Les Alyscamps, which he would soon begin to paint. Loti's bonzes resurfaced to preside over a dazzling festival at the "temple of the Jumping Tortoise," which drew a crowd of masked and colorfully bedecked men, women, and children to a "glittering sanctuary," all "lit-up" and "wide-open" to nature and the playful revelers.[72] Loti's description and the accompanying illustration of this scene captured the interpenetration of nature, the sacred, and the social in the image of an all-encompassing blazing light,

which emanated from the temple walls, glowed through the colored skins of bobbing paper lanterns, and enveloped priests and people in a shared radiance under the moonlit skies.[73]

Loti's bonzes also emerged as reverent artists and decorators, which accorded well with van Gogh's approach to a divinized nature. In recounting a visit to the interiors of their temple, Loti emphasized the "exquisite delicacy" and "simplicity" of the bonzes' rooms, connected by permeable bamboo curtains and coordinated in wood "of a pale yellow color." On the walls hung "a few masterly sketches, vaguely tinted in India ink," drawn on "strips of grey paper" without frames. "With a cunning paint brush" the bonzes dabbed ink onto paper to "trace little prayers." Even more impressive to Loti's narrator was the priests' incorporation of nature into their habitat. The interior rooms flowed continuously into a veranda, which opened out onto a view of a splendid miniature garden. Here a diminutive ravine, cascade, and bonsai trees were framed on all sides by the mountains, softened by silvery ponds with miniature water lilies, goldfish, and tiny tortoises on petite granite islands.[74]

If Loti's representation of the sacred, communal, and aesthetic roles of the Japanese bonzes nourished van Gogh's Arles self-portrait, his choice of a Japanese persona resonated with a number of other values that revealed his distance from the world of Gauguin's isolated, martyred artist. In letters written during the month he worked on the painting, van Gogh attributed the reverent naturalism practiced by the bonzes to all Japanese artists:

> If we study Japanese art, we see a man who is undoubtedly wise, philosophic, and intelligent, who spends his time doing what? . . . He studies a single blade of grass. But this blade of grass leads him to draw every plant and then the seasons, the wide aspects of the countryside, then animals, then the human figure . . . Come now, isn't it almost a true religion which these simple Japanese teach us, who live in nature as though they themselves were flowers? And you cannot study Japanese art it seems to me without becoming much gayer and happier, and we must return to nature in spite of our education and our work in a world of convention.[75]

The Japanese artist's devotion to nature expressed his place in a brotherhood of craftsmen, who, according to van Gogh's conception, lived modestly, "like simple workmen," in a "sort of fraternal community," where they "exchanged works among themselves very often."[76] Van Gogh absorbed from his

reading, probably from a text he admired—Louis Gonse's 1886 *L'Art japonais*—the idea that Japanese artists exchanged their works as gifts, as in the mutual offering of prints and drawings called the *souri-monos*.[77] This vision of Japanese painters as communal "tradesmen," "living close to nature" in a rhythm of mutual exchanges,[78] offers a striking example of van Gogh's projections and of his active remolding of his sources according to his own preexisting values.

The many Japonist texts that van Gogh assimilated in Paris and in Arles, including Gonse's book as well as the articles in Siegfried Bing's art magazine, *Le Japon Artistique*, had identified the themes of vital naturism and the interrelation of all media in Japanese aesthetic culture. Significantly, after the ravages of the revolutionary Commune of 1871, the French devotees of Japan pressed these themes into the service of a celebration of Japanese imperial and hierarchical culture, emphasizing that the unity of all the arts expressed the refinement, elegance, and cultivation of an integral noble elite, which could be emulated and adapted by the French aristocrats of the spirit who were advocating national design reform. These French writers associated the apogee of Japanese craft culture with aristocratization, and with the distinctively "feminine" qualities of delicacy and luxury, which they also attributed to another legacy favored for artistic emulation, the eighteenth-century rococo.[79] Van Gogh, however, did not assimilate the aristocratizing themes of Japonism emphasized by his French colleagues; he recast their texts to fit different cultural patterns. Van Gogh's own traditions of Dutch artist-clerics and Dutch craft artists trading prints for shoes and furniture at local markets shaped his picture of Japanese bonzes as communal artists and of Japanese artists as reverent naturalists. In his quest for a utopian community of brother-painters and for a modern form of sacred art, van Gogh transposed Japan from a society of imperial stratification to a collectivity of a religion of nature, from a center of feminine delicacy and distinction to a site of masculine association and fraternal laborers. The self-portrait drew these adaptations into a powerful visual statement, yielding, in response to the image of provocation and self-flagellation offered by Gauguin, a picture that attempted to join the material forms of paint and physical likeness to a new and unifying sacred language, "that something of the eternal which the halo used to symbolize," now conveyed by the "radiance and vibration" of color as it framed an identifiable contemporary individual.

Living in Arles, van Gogh would have witnessed the Catholic festivals of many saints, including that of Saint Vincent, the Provençal protector of the vineyards, whose designated feast day was accom-

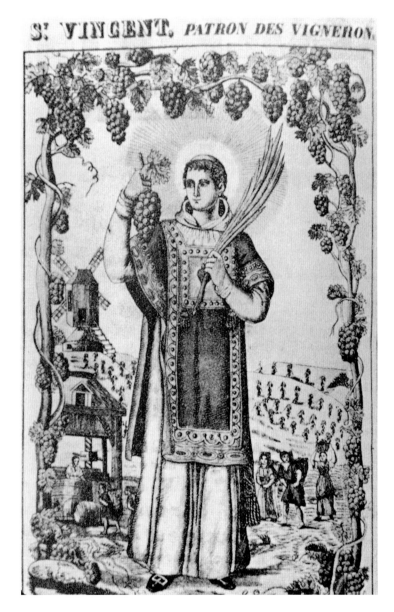

FIG. 10. SAINT VINCENT, PATRON SAINT OF THE VINEYARDS. Popular print, reproduced from Jean-Paul Clébert, *Les Fêtes en Provence* (Avignon: Aubanel, 1982)

panied by special blessings in the fields and by a profusion of prints depicting the saint with his halo (see, for example, Fig. 10).[80] Van Gogh's self-portrait as a bonze had its own halo, not that of a conventional Christian saint but rather an aureole of colored light that set the artist in a series of linkages "beyond the power of an isolated individual" as it reverberated outward to worship, to the interdependent work of the artists' fraternity, and to the concentrated study of a single blade of grass which yielded, bit by bit, the design of the whole fabric of creation.

CONCLUSION

In the month immediately preceding their work together in Arles, van Gogh and Gauguin devised different self-presentations and expressive forms. Gauguin's *Self-Portrait: Les Misérables* depicted the artist's victimization and celebrated his release from the "shackles" of a sullying material reality to an exalted inner world. The painting formalized Gauguin's defiant stance as a social outcast while it also glorified the artist's new self-definition in an expanded and insulated subjectivity, which yielded, from a burning kiln of affliction and redemption, an image Gauguin praised for its very inability to communicate: "I believe it is one of my best things," he wrote to Schuffenecker; "absolutely incomprehensible . . . it is so abstract."[81]

Van Gogh, in the meantime, awaited Gauguin in Arles beset by concerns of his production rather than perdition, experimenting with an art of portraiture and the halo, and placing his hopes in a relational ego. Distrustful of introspection, van Gogh presumed that Gauguin's agonistic self-scrutiny could be cured by a period of

rest and serenity in the south, followed by the challenge and "cheerfulness" of cooperative work.[82] His own painting presented not a victim but a worshipper; it offered a self-portrait as social dialogue, with the self constituted in and through association, in deference and reference to the larger totalities of nature, a company of brothers, and a realm of divinity.

Van Gogh would discover that Gauguin's cult of abstraction, subjectivity, and suffering had its roots in a theological culture for which he had little affinity. In their self-portraits, both painters did share the aspiration to link their physical likenesses to a permanent, essential world beyond the surface of appearances and to devise pictorial forms evocative of a sacred realm whose contours lay outside the boundaries of figurative language. Gauguin's self-portrait explored this dialectic of physicality and the sacred in an appeal to an "abstract," incommunicable, and transcendent purity, to the model of martyrdom and sacrifice, and to techniques of visual reduction signifying the compressive heat of insulated, singular subjectivity. Van Gogh's self-portrait, by contrast, linked the self and the sacred not in an ecstatic introversion of unbounded inner flames, but in an appeal to a relational ego extending outward to nature and community, to a model of comfort and eternity, and to techniques of embodiment and of an enveloping, and emitting, light.

For each artist, as we shall see, the link between subjectivity and the sacred expressed a distinctive conception of the Passion of Christ as a model for modern art, partly shaped by the different religious legacies that formed them. For Gauguin, the sacred fires of self-immolating creativity mobilized a model of Christ's singularity and martyrology. For van Gogh, the sacred light of self-offering to nature and community enlisted a model of Christ's humility as a laborer, consoler, and communicator. Both painters relied on a repertoire of stylistic forms appropriate to these distinctive models and self-presentations. Gauguin's self-portrait affirming a credo of descent into the self and ascent to transcendent purity discovered technical means to de-emphasize the physical materiality of the canvas surface, through muted brushwork, blended color, and chalky flattening, conveying the white heat of pressed flesh. Van Gogh's self-portrait, by contrast, chose the thick rather than the thinning brush, the tactile textures of grain, mud, and clay, and the encircling extension of pulsating light.

Shortly before painting the bonze and the *misérable*, in another pair of canvases, van Gogh in Arles and Gauguin in Pont-Aven had chosen not the self but preindustrial peasants as their first subjects for relating the visible world to evocative forms of divinity. In his *Sower*, van Gogh represented

peasant labor, working his image of work on the canvas in emulation of, as he said, the coarse solidity of colored earthenware; in his *Vision After the Sermon*, Gauguin depicted peasants engaged in spiritual rumination, composed in the forms he related to the stony smoothness of a fresco or the colored soaking of stained glass. It was in those 1888 paintings, to which I now turn in Part Two, that van Gogh and Gauguin first defined their different conceptions of modern sacred art.

Peasant Subjects and Sacred Forms

CHAPTER TWO Van Gogh's *Sower*

I do not invent the whole picture; on the contrary, I find it all ready in nature, only it must be disentangled.

VINCENT VAN GOGH[1]

Above all, don't perspire over a picture. A strong emotion can be translated immediately: dream on it and seek its simplest form.

PAUL GAUGUIN[2]

In the summer of 1888, van Gogh and Gauguin, in close contact through correspondence and deliberating the arrangements for their impending collaboration in Arles, each embarked on a distinctive program of pictorial experiments. Each painter construed the experiments as particularly challenging, emphatically modern, and singularly "symbolist," a term that both attached for the first time to specific works produced between July and November. Van Gogh's inaugural "symbolist" venture yielded *The Sower*, which presented a peasant laborer caught in the act of work, moving through a blazing, sun-saturated landscape as he tossed seeds from his bag into the plowed field that had been readied to receive them. Paul Gauguin charted out what he called "the path of symbolism" in September 1888 in a "religious painting," *The Vision After the Sermon: Jacob Wrestling with the Angel*. Close in size to van Gogh's *Sower* canvas but radically different in form, meaning, and function, Gauguin's *Vision* captured Breton peasant women frozen in silent prayer and meditation. Heads bowed, eyes closed, and hands locked together, they projected the contours of their inner vision onto a dream landscape, rendered, Gauguin explained, as an unmistakably "non-natural" color field of "pure vermilion."[3] The broad mass of bright red, enveloping the static figures as it signified the fluid externalization of their inner vision, provided a formal medium for Gauguin's goal—to depict the passage across the divide of material reality into the realm of the supernatural. (See Figs. 53 and 65.)

Underlying the divergent "symbolist" agendas represented by van Gogh's *Sower* and Gauguin's *Vision After the Sermon* were a number of common qualities. Both van Gogh and Gauguin located the subjects of their artistic experiments in preindustrial French peasant communities that were undergoing important regional and religious revivals in the 1880s. The two canvases signaled, as we will see in this chapter and the next, very different levels of attentiveness to identifiable features of the local contexts of

Provence and Brittany. But both painters related their peasant subjects to formal innovations, particularly the evocative power of color, as expressive vehicles of what Robert Goldwater has described as a characterizing feature of symbolist art: to move painting beyond anecdotal realism toward a more direct and more universal mode of discourse.[4] Finally, both van Gogh and Gauguin pressed their new syntheses of form and content into the service of a sacred, eternal, and invisible world beyond the self and the senses, attempting, paradoxically, to achieve spiritual ends through the plastic means of pigment, canvas, and primer.[5] While both van Gogh and Gauguin rejected institutional religious practice, they transported to their new rural settings, and to their emergent symbolism of 1888, the indelible stamp of their distinctive religious formations. Both painters linked their art and their identities to a larger, transcendent order, and both assigned to painting a new role, that of mediator of divinity.

The different forms of that mediation of divinity expressed in van Gogh's *Sower* and Gauguin's *Vision After the Sermon* exposed the disparities between the two painters' symbolist projects and between the religious legacies that shaped them. While both van Gogh and Gauguin linked their canvases to a "longing for the infinite," the 1888 paintings indicated that they were already positioned to proceed on "the path of symbolism" in two different directions: Gauguin by dematerializing nature in a flight to metaphysical mystery; van Gogh by naturalizing divinity, in the service of what he called a "perfection" that "renders the infinite tangible to us."[6]

This chapter and the following one take a close look at these two paths by presenting an intensive formal analysis of the two paintings in their local contexts, highlighting the artists' varying approaches toward their peasant subjects, pictorial structure, color, brushwork, and perspectival format. The striking stylistic contrasts illuminate van Gogh's and Gauguin's differing ontologies, their different assumptions about the physical world and the requisite physicality of the canvas, and their different forms of resistance or receptivity to "abstraction."

By sharpening the focus I want to expand the cultural ground, which has been left underemphasized in other interpretations of the two men and these two paintings. Rather than deepening the social, political, and psychological elements proposed by other writers, I will revisit the 1888 *Sower* and *Vision After the Sermon* by examining the ways that van Gogh and Gauguin defined them as *religious* paintings and by identifying the distinctive *theological* coherence of the visual styles and technical procedures that each artist designed to compose them. These two chapters suggest that the claims for a sacred art

tested out by van Gogh and Gauguin in *The Sower* and *The Vision*
set the stage for a collaboration that would be strained not simply
by personal and temperamental incompatibilities, but by a deeper
and more profound irreconcilability of religious cultures and men-
tal frameworks, which implied radically different conceptions of
the status of the self, the value of the image, and the meaning of the
visible world.[7]

ROMAN CITY, SACRED CITY OF EARLY CHRISTENDOM

To other visitors in 1888, Arles was renowned for a number of cel-
ebrated features that would elicit very little, if any, verbal or visual

FIG. 11. THE ARÈNES OF ARLES.
Photograph © 1936 G. L. Arlaud, reproduced
from A. Chagny and G. Arlaud, *Visions de
France: Arles et la Camargue* (Lyon: Arlaud,
1936)

response from Vincent van Gogh. An important Roman capital and port city founded by Julius Caesar,
Arles preserved major monuments of Gallo-Roman antiquity, such as the Arènes, the massive first-
century amphitheater, built to hold twenty thousand spectators in its tiered galleries (Fig. 11), and had
emerged during the mid-nineteenth century as a tourist site for ancient art and architecture.[8]

Sacred buildings and relics of early Christian civilization overlay Roman Arles to enhance its rep-
utation as being among the "elite of French national monuments."[9] Indeed, by the 1880s regional schol-
ars had assembled myriad sources to chronicle Arles's special status as "the holy city on the Rhône." An
archbishopric until 1801, Arles had outstripped the papal city of Avignon in its profusion of chapels,
convents, and churches. Each neighborhood had its own patron saint, as did each tradesmen's confra-
ternity—there were chapels for Saint Isidore, patron saint of field workers, and Saint Vincent, patron
saint of grape growers (Fig. 10), among many others.[10]

According to legends and early histories of Christianity, Saint Martha, sister of Mary Magdalene,
had journeyed to Arles with Saint Trophimus, and together they had converted the people to Chris-
tianity by miraculously causing a sculpture of a pagan goddess to topple to the ground.[11] These same
legends placed two Marys, *les Saintes Maries*—Mary Jacobé and Mary Salomé—and their servant Sarah
in a boat that carried them from Judea and landed miraculously, without sail or oar, along the coast of

the Camargue; from here they disembarked and set out to evangelize Provence (Fig. 12). Every year on May 24, pilgrims traveled to the Camargue to commemorate this miraculous arrival of the women saints and to glorify their continued thaumaturgical powers. In 1888, thousands of worshippers arrived at the church of Saintes-Maries-de-la-Mer to witness the display of relics lowered from the belfry tower shrine and to parade to the beach carrying elaborately decorated statuettes of the Marys in their model boat. Surrounded by a flotilla of painted fishing boats, the Marys were launched into the waters of the Mediterranean, symbolically reenacting the miraculous arrival of the women and their concrete spiritual presence in the lives of the faithful (Fig. 13).[12]

This corpus of ancient tradition, newly recovered in the nineteenth century, fed the flames of regional hubris. According to L.-J.-B. Bérenger-Féraud, a scholar and physician who compiled and inventoried Provençal lore and legends, Provence could boast priority over Rome in extending Christianity. Although Rome claimed the first apostle, he explained, immediately after the death of Christ it was to the shores of Provence that came "ten or fifteen of the closest friends of Christ, those who had really become his family in the somber days of the Passion."[13] This sacred company and its role in evangelizing Provence informed another contemporary's description of the Provençaux as the exceptionally "apostolic race."

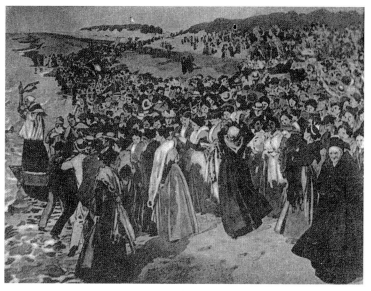

TOP **FIG. 12. LES SAINTES MARIES.** Reproduced from Jean-Paul Clébert, *La Provence de Mistral* (Aix-en-Provence: Edisud, 1980)

BOTTOM **FIG. 13. FESTIVAL AT SAINTES-MARIES-DE-LA-MER: PROCESSION TO THE BEACH.** Reproduced from Claire Tiévant, *Almanach de la mémoire et des coutumes, Provence* (Paris: Albin, 1984)

The legend of Saint Trophimus was inscribed in the portal of the cathedral bearing his name in the center of Arles, which also housed his relics (Fig. 14). The cathedral's twelfth-century carved doorway, tympanum, and cloisters formed the basis of its reputation as one of the finest Romanesque churches in Provence. The tympanum showed Christ, crowned in glory, flanked on one side by a procession of the Elect, advancing toward him, and on the other by the damned, chained together and being led away into the flames of hell. The twelve apostles, each with a carved oval plate as a halo, witnessed this Last Judgment procession from the lintel.[14] In the nineteenth century the cult of Trophimus as a saint coexisted with this spectacle of divine reckoning; Arlesians celebrated Saint Trophimus Day on December 29, and he was considered the patron saint of children as well as a special healer for victims of gout, with which he himself had been afflicted until he was suddenly cured during an apostolic mission.[15]

Outside the Arles town walls to the southeast was the ancient necropolis called Les Alyscamps, or the Elysian Fields. Originally a Roman burial ground positioned along the Aurelian Way, the Alyscamps was consecrated by the early Christians, and from the fourth through the thirteenth centuries it became the resting place of many important saints and was a reputed place of miracles and special holiness. According to thirteenth-century chronicles recovered in the nineteenth century, the Alyscamps was so important for Christian burial that citizens from as far away as Avignon would "place a corpse of some beloved dead into a rude coffin, fashioned like a barrel, and commit it to the Rhône." Floated downstream and containing money to pay the burial expenses, the traveling biers were said to have always arrived safely at their destination, unaided

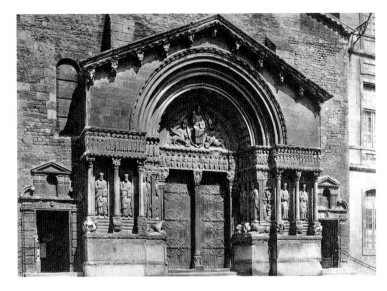

TOP FIG. 14. PORTAL OF THE SAINT-TROPHIME CATHEDRAL IN ARLES. Photograph © 1936 G. L. Arlaud, reproduced from Chagny and Arlaud, *Visions de France*

BOTTOM FIG. 15. LES ALYSCAMPS WITH THE SAINT-HONORAT CHAPEL. Photograph ca. 1860, reproduced from Rémi Venture, *Arles: Métamorphoses* (Marguerittes: Equinoxe, 1989)

by human hands and undisturbed by robbers.[16] By the end of the thirteenth century, the Alyscamps held thousands of tombs, sarcophagi had piled up on several levels, and nineteen churches and chapels dotted the grounds.

Although the Alyscamps languished soon afterward, two of the original chapels survived and continued to function as pilgrimage sites into the late nineteenth century. One was the Genouillade Chapel, built on the spot where, according to legend, Christ left an imprint of his knee when he miraculously appeared to the first bishop of Arles and the assembled congregation to bless the newly consecrated necropolis.[17] The Saint-Honorat Chapel also remained intact in the 1880s, marking the Alyscamps with its prominent illuminated bell tower, locally known as the *lanterne des morts*.[18] The presence of Saint Honorat, a fifth-century bishop of Arles, as one guardian of the cemetery's "holy plains" was still discussed in the nineteenth century; Bérenger-Féraud's 1888 *Legends of Provence* recounted how an attempt to transfer Honorat's relics from his Alyscamps chapel to another site roused all the souls of the dead, who set open their coffins and cried out that Honorat had been "left to them by God to insure their everlasting repose" and to "protect them against the evil spirit."[19]

The arrival of the railroad permanently altered the shape of the Alyscamps. While nineteenth-century Arles remained a predominantly agricultural area dedicated to the cultivation of grains, vines, and olives and the raising of sheep, its favorable position along the new Marseille-to-Paris rail route stimulated a new sector of production: the supply of engines and tracks. This industry sprang up outside the town walls, with the result that, between 1845 and 1856, portions of the original burial grounds were destroyed to make way for iron foundries and railway workshops.[20] Between 1865 and 1870, however, the disjointed necropolis was renovated, and the scattered tombs were reassembled along a "Sarcophagus Avenue," a dramatic alley forming a corridor of linear space, framed by tall poplar trees and terminating in accelerated convergence at the Saint-Honorat Chapel (Fig. 15).[21]

Within its transformed borders, the Alyscamps remained an arena for a preindustrial culture of religious piety and traditional folk custom. During the 1880s, for example, a peasant confraternity still arrived at the Genouillade Chapel on the first Sunday in May to complete an annual pilgrimage, a festival dating back to the sixteenth century. On the eve of the November 1 festival of Toussaint—All Saints—Arlesians at midnight mass expected Christ to return to the Alyscamps, where he would resur-

rect all the saints of Arles and convene them, in the presence of the angels, to recite the mass of the dead.[22] And the legends about the Saint-Honorat Chapel persisted, particularly about its tower as a beacon to the netherworld. With its new position as the terminus of a dramatic perspectival alley, the shining distant light was said to beckon its visitors to the *fanal permanent*, the torch flare of death.[23]

FRÉDÉRIC MISTRAL AND THE "PROVENÇAL VENDÉE"

Arles's status in the 1880s derived most of all from its relation to the Provençal Renaissance, a regionalist movement that aimed to preserve and promote Provençal language, literature, ritual, and customs. Spearheaded by the poet and polemicist Frédéric Mistral, the movement by 1888 had united writers, clerics, scholars, and ethnographers in celebration of a unique regional identity, designated in the exclusive terms of blood and soil, as "the Provençal race" or "the Latin race."[24] In the face of the Third French Republic's mounting of a vigorous anti-clerical campaign in the early 1880s and the state's initiatives to nationalize and systematize public education, Mistral exhorted his associates to resist the leveling brought by such republican "Francification." Mistral's varied projects included the publication of massive lexicons of the different dialects of the south, to combat official linguistic uniformity; the exertion of pressure to establish university positions and courses in Provençal literature and language; the compilation of voluminous almanacs detailing the tools, techniques, and customs peculiar to traditional agriculture in Provence; and the staging of folk festivals and theater productions of Provençal Shakespeare as well as Pastorales, updated versions of Catholic Nativity plays.[25]

The town of Arles and surrounding districts had a close affiliation with Mistral, as would be signaled some time later by the raising of a commemorative statue to him in Arles's central square, the Place du Forum (Fig. 16). A region of large landholdings, elite notables, and archaic agrarian practices, Arles and the areas immediately north of it have been called by historians the "Vendée of Provence" and the "white country," referring to the political differences between this area and the radical republican and socialist strongholds in other parts of the Bouches-du-Rhône department.[26] Arles's political complexion and Mistral's conservative, clerical pastoralism coincided in the decades after 1870, and the city

FIG. 16. STATUE OF FRÉDÉRIC MISTRAL IN THE PLACE DU FORUM. Photograph © 1936 G. L. Arlaud, reproduced from Chagny and Arlaud, *Visions de France*

FIG. 17. L'ARLÉSIENNE. Photograph Collection P. Richard, reproduced from Jean-Paul Clébert and Pierre Richard, *La Provence de van Gogh* (Aix-en-Provence: Edisud, 1981)

remained a central staging ground for Mistral. He made a particular point of praising Arlesian women as paragons of regional integrity: rather than adopting modern dress, Arlésiennes continued throughout the nineteenth century to wear the traditional local costume and *cambrasino* coif (Fig. 17).[27]

In addition to their other initiatives, Mistral and his regionalist comrades wrote poetry in their native tongue, hoping to inspire a new school of Provençal literature. Mistral produced lengthy lyric poems throughout the 1870s and 1880s, such as the 1875 *Lis Isclo d'or* (*Les Iles d'or*), combining narrative with didactic material on his region. This mixed genre extended the example of Mistral's earlier masterwork, *Mireille*, which linked a tragic epic of ill-fated lovers and miraculous apparitions of the Saint Marys to long poetic digressions on local labor techniques, from fishing and harvesting to basket weaving. He also composed and performed occasional declamatory poems, such as the 1878 ode "To the Latin Race." In it were crystallized the interdependent themes of Mistral's Provençal Renaissance— a bounteous earth, a redemptive peasantry, and Catholic fraternity. The poem's "luminous," "apostolic" peasants sow the seed and fashion God's wine beneath the cross and the sun's sacred cope.[28] Elsewhere, Mistral, dubbed "poet of the soil" and awarded the Nobel Prize in literature for his oeuvre, called Provence the "empire of the sun," a unique world defined by the crops, waterways, dialects, and visionary Catholicism of the *pays d'oc*.[29]

Ironically, it was not to be Frédéric Mistral, the renowned recuperator of Arlesian historical memory and custom, but a little-known painter from the Netherlands who would indelibly shape the significance of Arles for future generations in France and the world beyond. Despite Mistral's statue in the square, the "poet of the soil" is now completely eclipsed by the "painter of the south," Vincent van Gogh, who journeyed from Paris to Arles in late February of 1888.

DUTCH AFFINITIES

Why did he choose Arles? We do not know precisely; his letters register only a vague awareness of the region, and no established artistic community or other friends existed as a magnet to pull him there. Van Gogh may have seen a festival staged in an 1887 Paris exhibition featuring Arlesian costume and the special Provençal dance, the *farandole*, and he read novels and stories by Alphonse Daudet, a Nîmes-

born Parisian writer, whose texts evoked local sites such as the windmill on the road from Arles to Fontvieille. The sun of the south, its light and warmth, was certainly a main attraction. Whatever the reasons for the choice, van Gogh seems to have set off to Arles with a composite picture of his destination. The composite drew not only on Daudet's writings but also on van Gogh's interest in the Marseille-born painter Adolphe Monticelli, Eugène Delacroix's Mediterranean journey, and the brightly colored world depicted in the Japanese prints that van Gogh had collected in Paris.[30] Like Provence, Japan had been called the "empire of the sun"; the Goncourt brothers, whose novels van Gogh had read, used this very term to describe the "land of Nippon."[31]

Stepping off the train at Arles on February 20, 1888, van Gogh was greeted not by the restorative sun of the south but by weather conditions similar to those he had hoped to leave behind in frosty Paris: freezing temperatures and falling snow. But the clarity of the air, the ramparts of the Rhône-edged town center, and the vistas of broad, flat stretches of planted fields still offered van Gogh a striking contrast to the Parisian metropolis. His first reactions, recorded in a letter to Theo, linked Arles not simply to Japan but to Holland as well. At first glance he thought of a Dutch town, noting that "Arles doesn't seem to me any bigger than Breda." Breda, the home of his grandparents in the southern Netherlands, was, like Arles, a town with intact ramparts, bordered by water and flat, panoramic landscapes. In his letter he also mentioned the mountains marking the distant horizon and described the spectacle of the countryside terminating in snow-covered summits as being "just like the winter landscapes that the Japanese have painted."[32] A Japanese *ukiyo-ē* print come alive; a Dutch panoramic topography—these first recorded associations set the tone of van Gogh's early interaction with his new French environment.

Van Gogh was not oblivious to the historical spectacle of Roman and Christian Arles and the contemporary prominence of Arlesian Catholic culture, but they held little appeal for him. Soon after his arrival he took note, in the town center, of the "priest in his surplice" and the Arlésiennes in their distinctive regional costumes and traditional headdresses en route to Saint-Trophime Cathedral for communion. But the artifacts of Roman imperial power and the representations of Christian judgment seemed to him to "belong to another world." He described his reaction in a letter to Theo: "There is a Gothic portico here, the porch of St. Trophime. But it is so cruel, so monstrous, like a Chinese nightmare, that even this beautiful example of so grand a style seems to me to belong to another world, and I am as glad not to belong to it as to that other world, of the Roman Nero."[33]

TOP **FIG. 18. PLAINS AT LA CRAU.** Photograph by the author

BOTTOM **FIG. 19. CAMARGUE MARSHLAND.** Photograph by the author

The Arlesian landscape was another story: van Gogh found it enthralling. Exploring the countryside around Arles, he was inundated by associations to rural Holland, the world to which he had belonged "before Paris and the Impressionists." During his first months in Arles he began to feel an allegiance to a "second fatherland" as he developed a visual repertoire of the "many subjects here" that were "exactly like Holland in character."[34] Such subjects included pollard-lined strips of road, windmills, tree alleys, panoramic fields, and the canals and drawbridges around the city.

Van Gogh's sense of familiarity sprang from very real similarities between some features of the Arles environment and the Dutch physical world. Like the painstakingly crafted Dutch terrain, Arles encompassed a constructed nature, slowly accreted in a continuous process of reclaiming land from the sea. In the late nineteenth century, the term "hydrographic regime"—a description most commonly assigned to the Netherlands—was used to characterize the topography and cultivation of Arles.[35] Named by the Romans in derivation from *Arelate*, "city of swamps" or "place of the waters," Arles was originally a waterlogged marshland, secured to a cultivable base only by relentless drainage and irrigation.[36] Beginning in the fifteenth century, the area to the southeast of the city—the marsh of La Crau, for example—was slowly transformed from a soggy swamp into a broad, flat plain hospitable to wheat, vines, and grazing animals (Fig. 18). To complete the reclamation of La Crau in the late seventeenth century, the Arles town councilors had to enlist the services of a Dutch engineer, Van Hens, a representative of what the writer Henry Havard called that envied "nation of Penelopes" well practiced in the wizardry of wresting dry acreage from a liquid base.[37]

The vast domain to the southwest of Arles, the Camargue, remained through the nineteenth century a sparsely inhabited marshland filled with bogs and low-lying dunes (Fig. 19), not unlike parts of Drenthe and Zeeland in the Netherlands. Camille Mauclair, traveling through Provence in the late nineteenth century, compared the "desolate and captivating" alternation of lagoons and dunes in the Camargue to "the Dutch polders," an area "neither land nor sea"—"like Moerdyk, the banks of the Zuyderzee, and Texel."[38] But nineteenth-century Provençal engineers, as resourceful and persistent as their Dutch counterparts, continued to devise elaborate schemes for draining, pumping, and reclaiming land in the Camargue, and between 1850 and 1910 "at least 12,000 acres of arable land" were added there (Fig. 20).[39] The technical feats of drainage and irrigation in La Crau yielded the transformation of 9,500 acres of swamps and the fertilization of 19,500 acres of wasteland in the short eight-year period of 1881 to 1889.[40] Taking the nineteenth century as a whole, at least 50,000 hectares were recouped in the Arles, Crau, and Camargue area.[41]

FIG. 20. CAMARGUE ACREAGE. Reproduced from Daniel Philippe and Colette Gouvion, *France from the Air* (New York: Abrams, 1985)

The Provençal reclamation process involved installing a series of canals, so prominent a feature of the Dutch landscape. Canals began to slice through Arles and the surrounding countryside starting in the sixteenth century, channeling the waters along drainage corridors and creating a network of linear perspectives and recessional frames. The Canal de Craponne, for example, bordered Arles to the southeast, by the Alyscamps; another archaic canal, the Roubine du Roi, still compelled residents and visitors in the nineteenth century to cross a recessed waterway in order to enter the Arles town center, as its embankment ran right up to the main gates of the town at the Porte de la Cavalerie.[42] As in Holland, Arles water management was an additive project; new canalways were continually appended to the older network. The most significant nineteenth-century addition was a canal stretching from Arles to the town of Bouc on the Mediterranean. Along the canal were a number of bridges and locks, the first one—the Pont de Réginelle, known in van Gogh's time as the Pont de Langlois—just outside Arles to the southwest.[43]

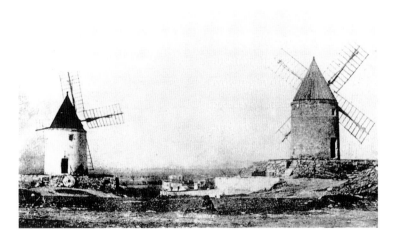

Despite all the work, Arles and its environs were, like the Netherlands, still very vulnerable to inundation. In the year preceding van Gogh's move to Arles, numerous Parisian newspapers and illustrations recorded the devastating flood of the Rhône in late 1886. Van Gogh was certainly aware of the damage to the areas around Arles and Avignon through his reading of the December 26, 1886, special issue of *Le Courrier Français* in his possession, which reported the deluge and solicited support for "les inondés du Midi."[44]

When van Gogh arrived in 1888, then, he encountered a surprisingly familiar world. In Arles and the countryside around it he discovered a Dutch-like world of wooden drawbridges, windmills, and dunes; of "cane fences" and "thatched roofs"; of canals and marshes; of "vast plains" and expansive fields, "infinite as the sea," yielding to remote horizons in panoramic "breadth."[45] On the outskirts of town he would have passed through the neighborhood of Les Mouleyrès, named for the many windmills that had ground grain (Fig. 21); each windmill had its own name, the one on the rue Mireille being called the Moulin de la Mousmée.[46] In nearby Fontvieille he visited and drew the windmill he had read about in Daudet's Provençal stories, *Lettres de mon moulin* (Fig. 22). As he walked from the Arles train station to the town entry at the Porte de la Cavalerie, he would have crossed the canal of the Roubine du Roi, where local women sat on makeshift rafts in the water doing their washing and then laid out the linens and garments to dry along the embankment (Fig. 23). The spectacle of the canal and its activities would have always been in clear view from the windows of the Yellow House that he rented in September, which fronted on the Place Lamartine opposite the Roubine and the Porte de la Cavalerie.[47] Linen-splayed ground in a canal-lined landscape evoked part of a

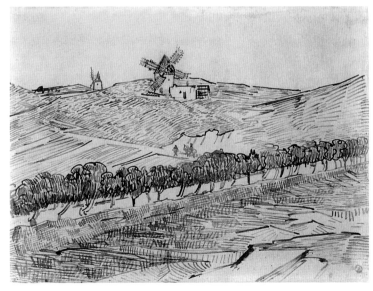

TOP **FIG. 21. LES MOULEYRÈS, ARLES.** Photograph ca. 1860, reproduced from Venture, *Arles: Métamorphoses*

BOTTOM **FIG. 22. VINCENT VAN GOGH,** *LANDSCAPE WITH ALPHONSE DAUDET'S WINDMILL AT FONTVIEILLE*, 1888, pencil, reed pen, and bistre on paper, 25.5 x 34.5 cm. Van Gogh Museum, Amsterdam (Vincent van Gogh Foundation)

scene depicted in one of van Gogh's favorite Dutch paintings, Ruysdael's *View of Haarlem*, and also recalled the view out his Zundert window of the bleaching fields behind the van Gogh family's parish house. And the laundresses' floating wooden platforms along the Roubine, with their visible interlocking slats and bracing posts sunk into the canal bed (Fig. 24), resembled the fleet of Dutch wickerwork rafts known as *zinkstukken*, which appeared along the waterways of the southern Netherlands and were used as staging platforms for bracing the ever-beleaguered sea walls.[48]

VAN GOGH'S TOOL KIT

If van Gogh's initial selection of subjects indicates how he responded to the new Arlesian setting with memories of the Netherlands, the technical repertoire that he applied to his subjects was also a combination of old and new. The bright light of Provence stimulated him to deepen his interest in the laws of color contrast, and, as art historians have emphasized, the move south prompted him during his first months to experiment with different kinds of brushstrokes. Van Gogh also attempted to use bolder, more saturated color tones, inspired by the vibrant clarity of southern light and the models of his Japanese woodblock and crepe prints.[49] Yet along with these new approaches came a reengagement with the tools and techniques of his earlier Dutch apprenticeship, a reengagement that has been underemphasized in accounts of his early months in Arles. For example, van Gogh resumed the reed pen drawing he had favored in Etten in 1881, now constructing his own thick and solid nibs from the reeds along the banks of Arles's

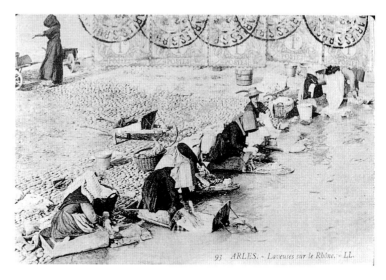

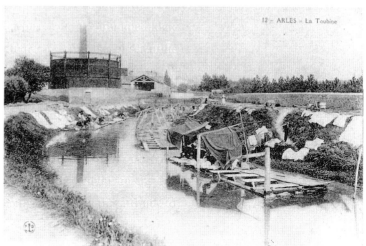

TOP **FIG. 23. ARLES LAUNDRESSES ON THE RHÔNE.** Postcard ca. 1900, reproduced from Jean-Paul Clébert, *La Provence de Mistral* (Aix-en-Provence: Edisud, 1980)

BOTTOM **FIG. 24. LAUNDRY RAFTS ON THE ROUBINE DU ROI CANAL.** Postcard ca. 1860, reproduced from Venture, *Arles: Métamorphoses*

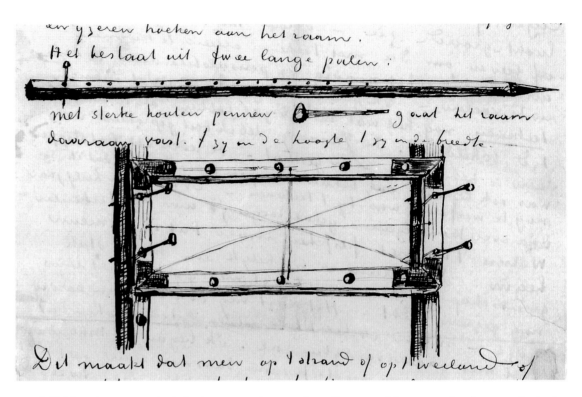

FIG. 25. VINCENT VAN GOGH, SKETCH OF A PERSPECTIVE FRAME, 1882. From a letter to Theo (LT 223). Van Gogh Museum, Amsterdam (Vincent van Gogh Foundation)

canals.[50] More important, in Arles he returned to regular reliance on his perspective frame, a device he had built in The Hague in 1882 with the aid of a carpenter and a blacksmith.

The perspective frame was an open rectangle made of wood, strung with thread in the pattern of a Union Jack, which could be attached to adjustable notches on two wooden poles and staked into the ground for outdoor sightings (Fig. 25). Looking through it like a window, the artist was trained to compare the proportion of objects nearby with those on a more distant plane, while the intersection of the threads pressed the eye to a point of convergence at the vanishing point. Adapted from Dürer's famous screen and from nineteenth-century popular art manuals, van Gogh's frame was an important resource throughout his Dutch period. It allowed him to organize blocks of flat, reliefless terrain and taught his eye to shoot down a corridor of space into the distance, an effect he compared to a telescope riveting his eye to a single point of focus.

Van Gogh's reliance on the frame yielded particular stylistic consequences. One is the distinctive

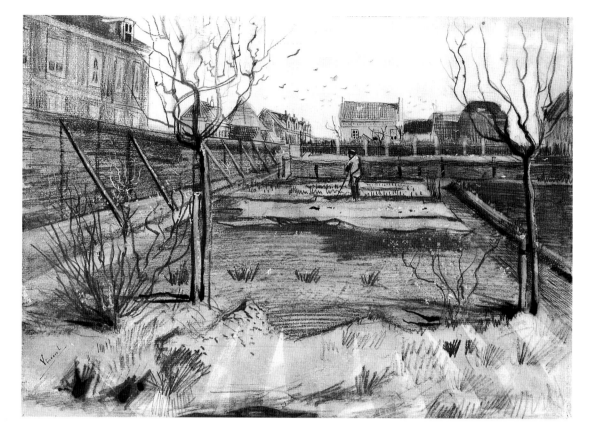

FIG. 26. VINCENT VAN GOGH, *FLORIST'S GARDEN ON THE SCHENKWEG*, 1882, black chalk, pen, washed, heightened with white, 23.5 x 33 cm. Rijksmuseum-Stichting, Amsterdam

format I call the "framed landscape," where the viewer's eye is led into the distance through emphatically bounded wooden posts. For his 1882 drawing *Florist's Garden on the Schenkweg*, for example, van Gogh was prompted by the frame to structure an accelerated rush of space in which near and far were juxtaposed along a linear alley (Fig. 26). By placing the two flanking trees as anchors to guide our eye into the distance until coming to rest at the small window of the building at the horizon, he replicated the experience of the bracketed "looking through" that he had practiced with the staked wooden posts of his frame.[51]

Van Gogh had occasionally used the frame in Paris, but it was in Arles that the device resurfaced as an instrument of composition and an ideal for artists and craftsmen.[52] He considered the frame an

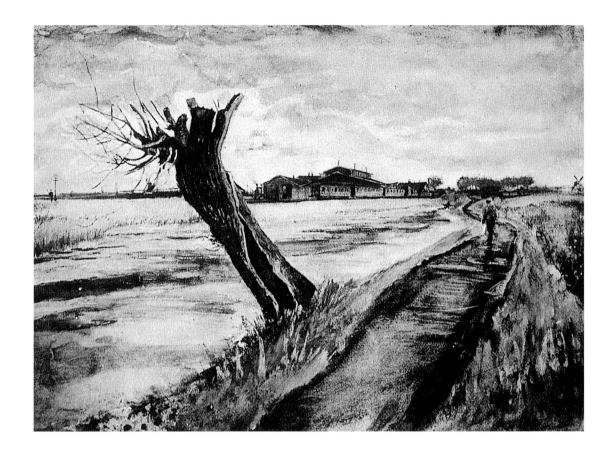

accessible form of popular artistic practice, a practical tool for an art defined as a patient, methodical métier rather than a state of exalted, unregulated genius. Within days of arriving in Arles, he wrote to Theo that the frame could unite artists in a common practice and skill, much as the "Germans, Italians and Flemish" had all relied on it in earlier periods.[53] In subsequent letters van Gogh asked Theo to send him a copy of a popular art manual he had consulted in his early training period, Armand Cassagne's *Guide to the Alphabet of Drawing*, originally published in the series *Le Dessin pour tous* (*Drawing for All*).[54] This renewed interest in his own foundational craft training extended to a hope for instructing others: he remarked to Theo that he needed a practical book because he might want to "give lessons in drawing."[55] In June, he indicated that he had indeed begun to give art lessons to a new friend, the

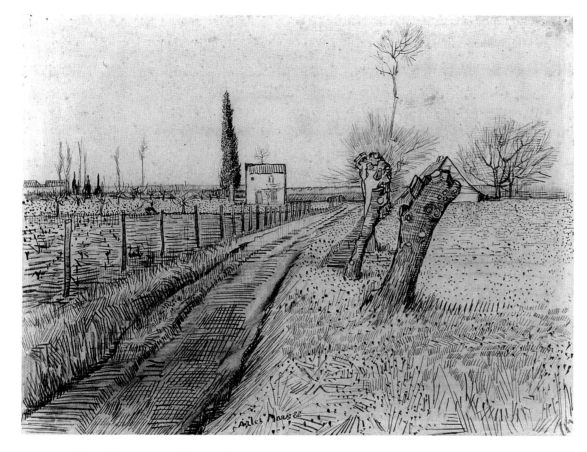

FIG. 28. VINCENT VAN GOGH, *LANDSCAPE WITH LANE AND POLLARD TREES*, 1888, pencil, pen, and brown ink on paper, 25.5 x 35 cm. Van Gogh Museum, Amsterdam (Vincent van Gogh Foundation)

Zouave soldier Lieutenant Milliet, training him to measure distance, establish proportion, and find a vanishing point by looking through the perspective frame staked in the open fields at La Crau.[56]

Van Gogh himself set to work in the Arles countryside by venturing out with his frame. As he explored the areas beyond the town walls, he was captivated by a scene with powerful Dutch overtones: pollard willows and lanes unfolding into the distance in a linear stretch of space. Roads slicing back into the distance bounded by pollards had been a favored subject in images produced in The Hague and at Nuenen, such as the 1882 watercolor *Pollard Willow by the Side of a Road* (Fig. 27). In the March 1888 Arles drawing *Landscape with Lane and Pollard Trees* (Fig. 28), van Gogh unwittingly copied, in flipped position, the Hague *Pollard*, with the tree bending away from the strip of road in the mirrored direction.

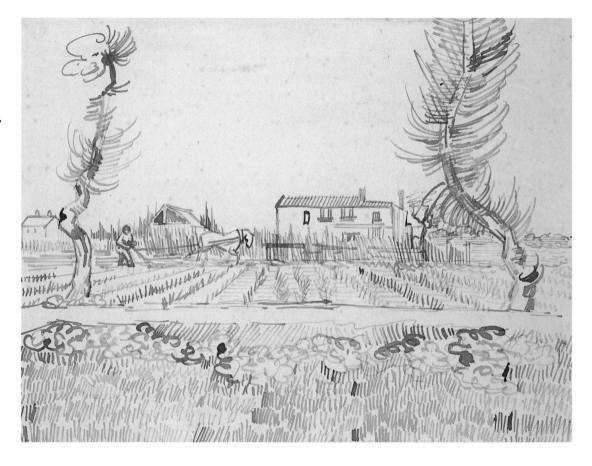

The perspective frame underlies the similarities between two other drawings, again one from The Hague and one from Arles. The "framed landscape" compositional structure that van Gogh had used in March 1882 for *Florist's Garden on the Schenkweg* (Fig. 26) was echoed in a March 1888 Arles drawing, *Landscape with Farm and Two Trees* (Fig. 29). In the new *Landscape*, the trees bordering the two sides of the drawing again form a passageway of optical movement into the distance to the farmhouse at the horizon. The viewer's eye—like van Gogh's own eye as it traversed the intersecting diagonal threads of his frame—is directed to the point of convergence, the farmhouse's rectangular window.

The major works in color that van Gogh produced immediately before he turned to his Arles *Sower*

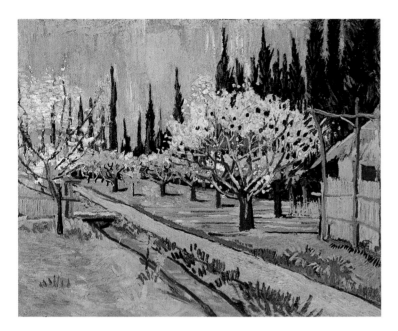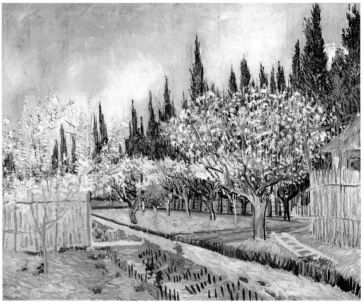

are all characterized by an interplay of new and old techniques. For example, in the first group of canvases he painted in Arles, the spring series of the flowering orchards (two of the canvases are reproduced here, Figs. 30 and 31), van Gogh tried out bold color schemes and varied brush applications while also calibrating linear runners and rows of trees according to the spatial coordinates set by his perspective frame.[57]

Another set of images, the late May and early June oil and watercolor works of the fishing boats at Saintes-Maries-de-la-Mer, also combined van Gogh's experiments in freer handling and greater color intensity with the insistent geometricity and alignment patterns prompted by his framing tool. He had taken a trip to Saintes-Maries on May 30, 1888, five days after the massive pilgrimage festival that took place there every year on May 24 and 25, during which statuettes of the female saints were launched in the Mediterranean, set in fishing boats painted and garlanded for the occasion. Van Gogh was able to travel to the coastal town in a stagecoach specially hired out at Arles for the weeks around the time of the ceremony.[58] Stripped of all supernatural presence, van Gogh's oil painting *Fishing Boats on the Beach at Saintes-Maries-de-la-Mer* (Fig. 32) composed a vividly colored "still-life of four boats" while also configuring a vibrant network of interlocking structures.[59] Deftly highlighting the interconnections

LEFT **FIG. 30. VINCENT VAN GOGH,** *ORCHARD BORDERED BY CYPRESSES*, 1888, oil on canvas, 32.5 x 40 cm. Private collection

RIGHT **FIG. 31. VINCENT VAN GOGH,** *ORCHARD BORDERED BY CYPRESSES*, 1888, oil on canvas, 65 x 81 cm. Kröller-Müller Museum, Otterlo, Netherlands

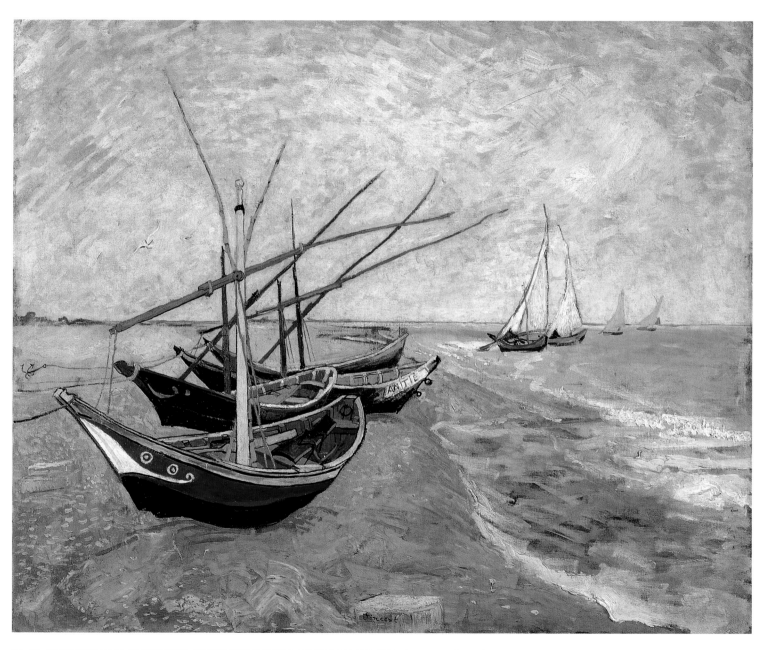

FIG. 32. VINCENT VAN GOGH, *FISHING BOATS ON THE BEACH AT SAINTES-MARIES-DE-LA-MER*, 1888, oil on canvas, 64.5 x 81 cm. Van Gogh Museum, Amsterdam (Vincent van Gogh Foundation)

among the boats, van Gogh painted the vertical and horizontal masts so that they all link at the center, forming a rectangle that is bisected diagonally by a green pole (Fig. 33). The rectangle, along with the extensions formed by the masts as they continue downward into the boats' hulls and upward toward the sky, strikingly replicates the shape of van Gogh's perspective frame staked for use on the shores of Scheveningen on the North Sea in 1882 (Fig. 34). Interestingly, van Gogh did not actually use the frame for this painting (or for the drawing that preceded it), but, bound by his long-term visual habits of interlock and of framed looking through, he re-created the frame and its diagonal threads in the painting's lines and intersections. The perspective frame was such an integral part of his way of seeing that he painted it in.[60]

THE DRAWBRIDGE SERIES

Along with spring orchards and the fishing boats of Saintes-Maries, one other subject summoned van Gogh's interest for a series of paintings and drawings during his first months in Provence: a wooden drawbridge—the Pont de Réginelle, then known as the Pont de Langlois after the bridgekeeper—just outside Arles on the Arles–Bouc canal. The long alley of the canal punctuated by locks

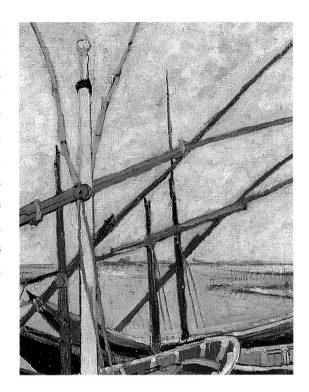

TOP FIG. 33. DETAIL OF FIG. 32

BOTTOM FIG. 34. VINCENT VAN GOGH, SKETCH OF HIMSELF WORKING WITH HIS PERSPECTIVE FRAME ON THE SHORES OF SCHEVENINGEN, 1882. From a letter to Theo (LT 222). Van Gogh Museum, Amsterdam (Vincent van Gogh Foundation)

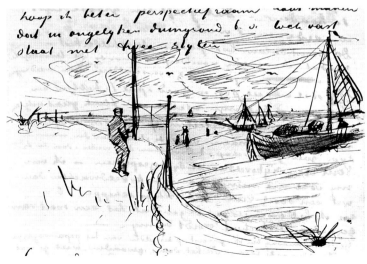

TOP **FIG. 35.** A DUTCH DRAWBRIDGE AT
HEUSDEN, SOUTHERN NETHERLANDS.
Reproduced from *Looking at Historic
Buildings in Holland*, ed. A. P. Smaal (Baarn:
Bosch Keuning, 1979)

BOTTOM **FIG. 36.** THE LANGLOIS BRIDGE.
Photograph ca. 1902. Van Gogh Museum,
Amsterdam (Vincent van Gogh Foundation)

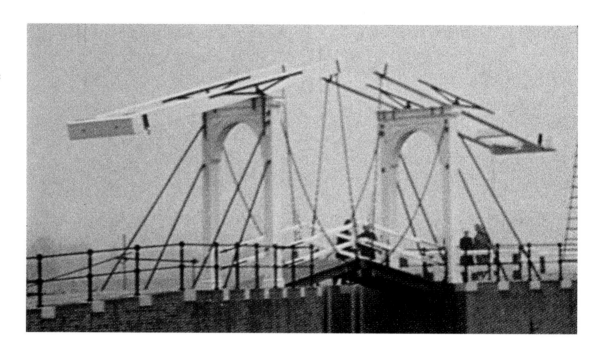

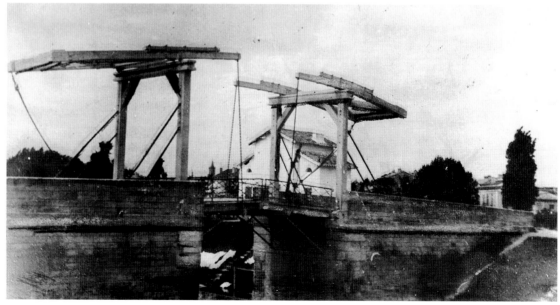

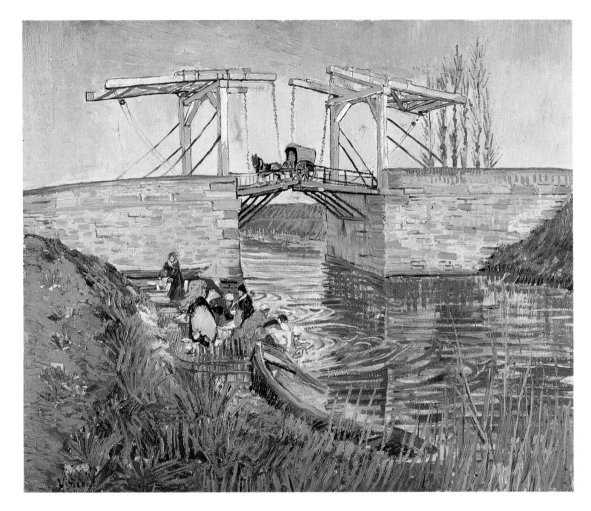

FIG. 37. VINCENT VAN GOGH, *THE LANGLOIS BRIDGE*, 1888, oil on canvas, 54 x 65 cm. Kröller-Müller Museum, Otterlo, Netherlands

and bridge evoked for van Gogh the Dutch countryside with its strips of waterway and its drawbridges opening and closing in kinetic linkage to allow for the passage of pedestrian and river traffic (Figs. 35 and 36).[61]

Van Gogh's depictions of the bridge have been considered a quaint exercise in nostalgia mingled with Japonist allusions. In my view, however, he approached the bridge in a serious and sustained manner that has been left unexplored by these assumptions. He studied the site from different vantage

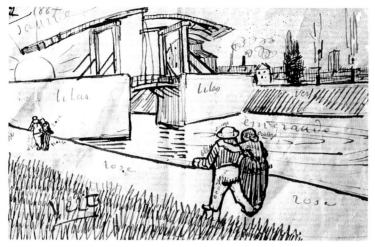

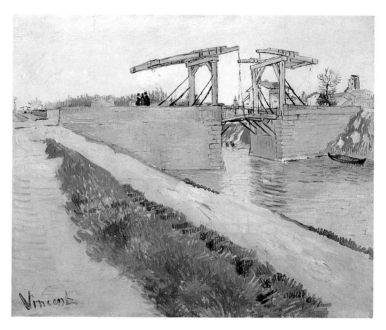

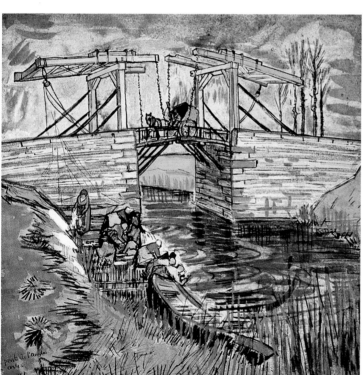

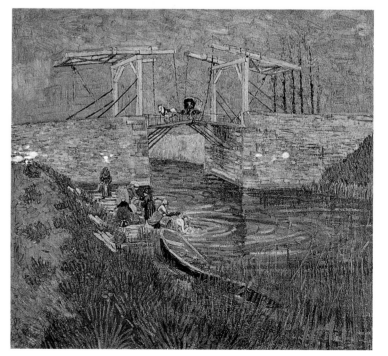

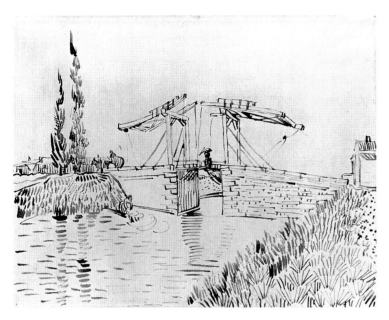

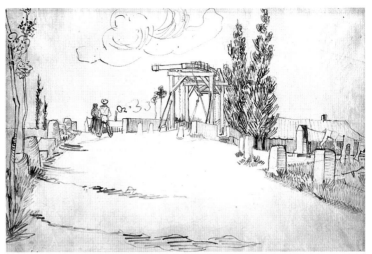

OPPOSITE, TOP LEFT FIG. 38. VINCENT VAN GOGH, *THE LANGLOIS BRIDGE*, 1888, sketch in a letter to Emile Bernard (B2), Van Gogh Museum, Amsterdam (Vincent van Gogh Foundation)

OPPOSITE, TOP RIGHT FIG. 39. VINCENT VAN GOGH, *THE LANGLOIS BRIDGE*, 1888, oil on canvas, 58.5 x 73 cm. Van Gogh Museum, Amsterdam (Vincent van Gogh Foundation)

OPPOSITE, BOTTOM LEFT FIG. 40. VINCENT VAN GOGH, *THE LANGLOIS BRIDGE*, 1888, watercolor laid in pen and pencil, 30 x 30 cm. Private collection

OPPOSITE, BOTTOM RIGHT FIG. 41. VINCENT VAN GOGH, *THE LANGLOIS BRIDGE*, 1888, oil on canvas, 60 x 65 cm. Private collection

TOP LEFT FIG. 42. VINCENT VAN GOGH, *THE LANGLOIS BRIDGE*, 1888, reed pen over india ink over traces of black chalk, 24.5 x 31.9 cm. Los Angeles County Museum of Art, Mr. and Mrs. George Gard de Sylva Collection

TOP RIGHT FIG. 43. VINCENT VAN GOGH, *THE LANGLOIS BRIDGE*, 1888, pencil, reed pen and ink, 35.5 x 47 cm. Graphische Sammlung, Staatsgalerie Stuttgart

BOTTOM LEFT FIG. 44. VINCENT VAN GOGH, *THE LANGLOIS BRIDGE*, 1888, pencil, 43.5 x 55.5 cm. Museum of Art, Rhode Island School of Design, Providence, gift of Mrs. Murray S. Danforth

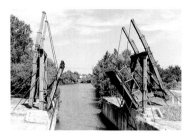

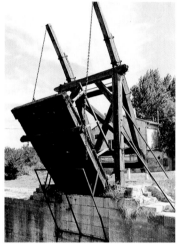

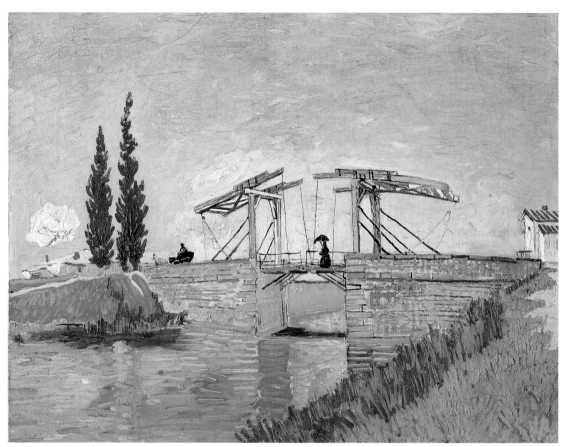

points, some with the aid of his perspective frame, and produced a total of nine completed images of the bridge in a six-week period, in different positions and in a full range of media. Four of the images (Figs. 37, 39, 41, and 45) are oil on canvas; one (Fig. 38) is a detailed pen sketch that he included in a letter to Emile Bernard; one (Fig. 40) is a watercolor laid in pen and pencil; and three (Figs. 42, 43, and 44) are drawings in pencil, reed pen, and pen and ink.[62] Each of the images registered van Gogh's attentiveness to the structure, function, and component parts of this craft mechanism in the landscape. Even in the fluid medium of watercolor, he included precise, discernible elements of the working bridge, from hardwood uprights, iron supports, and strapping braces to chain pulleys and moving diagonal frames. If

viewed together as a comprehensive unit—a *series* project—the nine bridge pictures emerge as a thoughtful meditation on the Langlois drawbridge as an operating device in the Arlesian landscape.[63]

Van Gogh's reengagement with his own artisanal device, the perspective frame, deepened his exploration of the drawbridge as a mechanism. By screening the bridge through his frame, he came to visualize some of the correspondences between the two devices, and he tended to select formats and features of the bridge that most closely resembled attributes of his frame. For example, in his images van Gogh consistently included—even when his viewing angle must have made it difficult to see them—the diagonal beams on the bridge wings, the parts of the bridge frame that swing out and become almost horizontal when the bridge is lowered to allow pedestrians to cross. The beams on the wings of the Pont de Langlois (the original bridge, destroyed in World War II, has since been reconstructed) form an X within an almost square frame (Figs. 46, 36); van Gogh, however, adjusted the frame around the X to echo more closely the shape of his perspective frame, and highlighted the crossing beams with bold colors or pen strokes (Figs. 47, 37, 43, and 40). In several of his depictions (for example, Figs. 37 and 40) van Gogh emphasized the other intersecting diagonals by freezing the bridge at the moment when he could lace together the diagonal tether lines of the moving wings with the opposite diagonal of the iron cables attached to the upright supports, carving bold X's that splay out on both sides of the composition.

Van Gogh's placement of figures on the drawbridge suggests another resonance with his perspective frame. In many of the images he sited a figure—horse and cart with driver (for example, Fig. 41) or pedestrian (Fig. 42)—at the exact center of the platform,

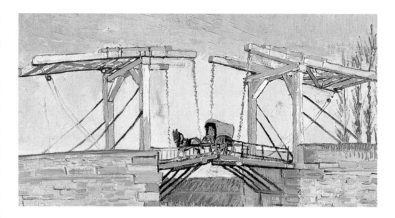

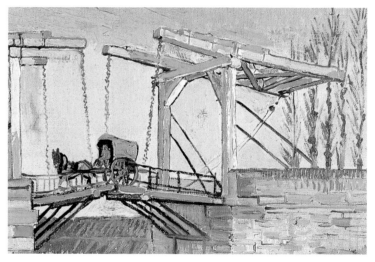

FIG. 47. DETAILS OF FIG. 37

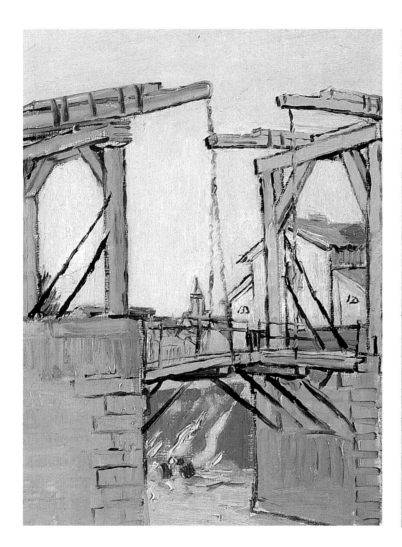

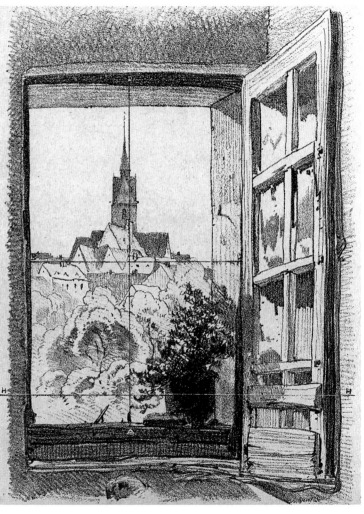

LEFT **FIG. 48. DETAIL OF FIG. 39**

RIGHT **FIG. 49. ARMAND CASSAGNE,** *LE DESSIN POUR TOUS (DRAWING FOR ALL),* applied perspective exercise: "Distance"

paralleling the converging median eyepoint rehearsed by the frame. These pivotal positions were further accentuated by his placement of suspended chains on either side of the figure.

In the Van Gogh Museum canvas (Fig. 39), the bridge itself has been used as a kind of substitute perspective frame: van Gogh has sited a steeple tower in the distance, projected through the middle of the bridge (Fig. 48). During his early training in The Hague with the "how-to" art manuals

of Armand Cassagne, whose instructions he had adapted for building his own perspective frame, van Gogh had encountered lessons on how to plot objects in the distance by using the handy recessionals and proportions provided by a frame. Cassagne's *Drawing for All*, for example, included an illustration of how a framing device, fitted over an open window, could be used to position a faraway steeple (Fig. 49). In pages of his Nuenen sketchbook of 1883–1885, van Gogh had practiced such a siting, with frame, window, and tower in view (Fig. 50). In Arles, he restated the Cassagne perspective exercise in a new setting, using the drawbridge as a frame to enclose the church tower and placing the tower at the intersection of the bridge's imagined threads.

The kinds of artisanal and functional concerns expressed in the Arles bridge pictures recall an earlier multimedia series in which van Gogh explored craft frames in operations of interlock: the Nuenen weaver series of 1884–1885. Here, too, van Gogh had highlighted the structure and component parts of the loom frames and had compared them to the forms and functions of his perspective tool. As he would later do in the bridge pictures, van Gogh had readjusted parts of the loom frames to resemble more closely

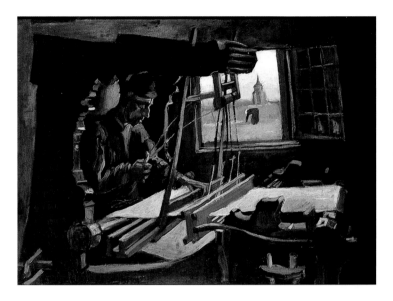

the pattern of diagonals strung across his frame.[64] He had also rehearsed his then newly won skill of siting a distant object by relating it to a craft frame, in this case the weaver's loom. In the 1884 *Weaver with a View of the Nuenen Tower Through a Window* (Fig. 51), we see the steeple tower from the Cassagne exercise manual projected at a legible distance through the open window of the weaver at work, with the paned window—as in Cassagne's exercise—to the right. In *Interior of a Weaver's Workshop* (Fig. 52), van Gogh has closed the window and sited the tower through the grid formed by its panes, angling down a crosspiece of the loom's frame to point emphatically at the tower.

THE HARVEST AND *THE SOWER*

During mid-June, as the Arles harvest cycle began, van Gogh turned his attention from landscapes and craft motifs to labor figures in the landscape. The choice of subject, a peasant sowing the fields, was inspired by the realist François Millet's *Sower* of 1850 and had been attempted by van Gogh a number of times between 1881 and 1884. The renewed interest in the theme in Arles reaffirmed van Gogh's

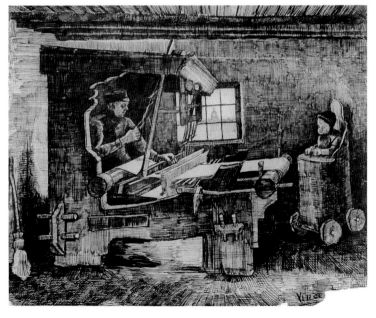

TOP **FIG. 51. VINCENT VAN GOGH,** *WEAVER WITH A VIEW OF THE NUENEN TOWER THROUGH A WINDOW*, 1884, oil on linen, 68 x 93 cm. Bayerische Staatsgemäldesammlungen, Munich

BOTTOM **FIG. 52. VINCENT VAN GOGH,** *INTERIOR OF A WEAVER'S WORKSHOP*, 1884, pencil, pen, brown ink, heightened with white on paper, 32 x 40 cm. Van Gogh Museum, Amsterdam (Vincent van Gogh Foundation)

commitment to depict the effort and strain of human labor and the integrity of humble people. The Arles *Sower* extended van Gogh's long-term attempt—earlier expressed in his depictions of laborers from the diggers of The Hague and Etten to the weavers of Nuenen—to realize what he defined as "the very core of modern art": "*a peasant's figure in action.*"[65] In accordance with this charge, van Gogh reworked the Arles painting to emphasize more effectively the active movement of the sower figure as he strode across the field (Fig. 53).[66]

The Arles *Sower* also extended van Gogh's persistent expression of personal identification with laborers, deriving partly from his Dutch Reformed Protestant belief that active work was the source of grace, and partly from his evangelical ideals for the sanctification of lowly labor. In 1884–1885 van Gogh considered the Nuenen peasants, wresting their daily bread from the earth by the effort of their own hands, and the weavers, crafting coarse colored cloth, to be the true servants of God—"useful," "honest," and "productive."[67] He had tried to emulate them by associating the arduousness of his own artistic activity with the work of the weaver at his loom or the peasant on the soil: "I keep my hand to the plow, and cut my furrow steadily," van Gogh claimed in 1885 as he celebrated the painting of rural life and his embeddedness "deep, deep in the heart of the country."[68] By construing his pictorial work in terms of peasant labor, he also ascribed to his own risky efforts at artistic self-training the assuring irrevocability of the agrarian cycle, which began with small seeds and ended with full crops. Relying on an analogy with the protracted but absolutely indispensable qualities of what he called his own artistic "ripening" process, he wrote to his brother Theo: "Remaining productive depends on the studies one has and continues to make . . . The more one drudges on them . . . the more easily one works later when it comes to making real pictures . . . In short, I consider the studies to be the seed, and the more one sows, the more one may hope to reap."[69]

In preparing the Arles *Sower* in 1888, van Gogh reiterated his identification with the rural agents of redemptive work and worthiness. Still convinced that "I keep looking more or less like a peasant"—except that "peasants are of more use in the world"—he set out in daily treks to the Arles cornfields, where he engaged in long hours of "hard, close work" in "the full sun."[70] The painter's strenuous effort and "vigor" matched the peasant's stamina under the beating sun. Describing his work on *The Sower* to Emile Bernard and to Theo, van Gogh recounted the exhausting challenges and his own artisanal ingenuity in

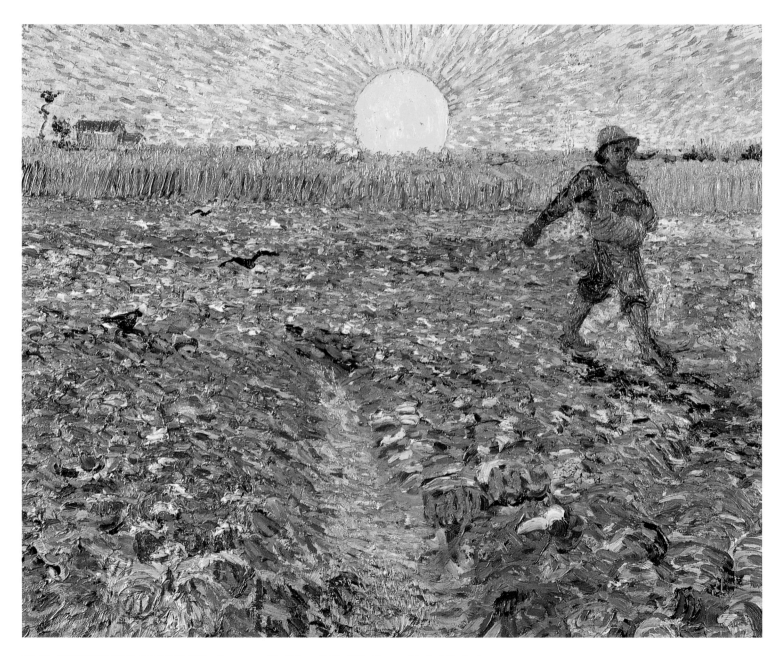

FIG. 53. VINCENT VAN GOGH, *THE SOWER*, 1888, oil on canvas, 64 x 80.5 cm. Kröller-Müller Museum, Otterlo, Netherlands

surmounting them as he continued to paint with the sun blaring and the "mistral raging."[71] To resist the blasts of the mistral winds, he devised a mechanism for insuring his easel's stability: he explained proudly to Bernard that he was able to complete *The Sower* only because he had staked his easel down, ramming the legs into the ground and then attaching them with rope to adjacent iron pegs driven deep into the soil.[72]

A final indication of van Gogh's continued identification with labor emerged in an Arles self-portrait. In *The Artist on the Road to Tarascon* (Fig. 54), van Gogh presented himself en route to the fields, in work clothes and broad-brimmed hat, his tools and frame strapped to his back. He described this state of readiness to Theo as being "laden with boxes, props and canvas"; to his sister Wil he wrote that he was "always dusty" and "bristlingly loaded, like a porcupine, with sticks" and "painter's easel" and a "yellow straw hat like a *hennekenmaaier's*"—the term for a Dutch or German seasonal field laborer who worked as a mower or harvester.[73] The stance of the artist in the *Tarascon* painting replicated, in mirror image, that of the sower in the fields. Each figure was depicted in an active, striding pose, arms swinging and legs angling wide, the sun casting a shadow.

FIG. 54. VINCENT VAN GOGH, *THE ARTIST ON THE ROAD TO TARASCON*, 1888, oil on canvas, 48 x 44 cm. Destroyed in World War II

Van Gogh's identification with labor extended beyond these verbal and visual types of association. The Arles *Sower* also reaffirmed his earlier pattern of turning to the art form itself to carry the weight of labor activity as he elaborated visual equivalents to the preindustrial work processes he so deeply admired. In Nuenen, by 1885, he had discovered stylistic techniques to create what he called "real and honest" images of the labor of peasants and weavers: he loaded the pigment in rough-hewn, bricklike applications, chose deep earth tones and mudlike coloring, and applied colors and paint strokes on the canvas so as to intersect one another, like the warp and weft of weaving a "rough tissue."[74] By composing paint forms as worked earth and coarse cloth, he had achieved painted surfaces

of rugged physicality, emphatically linking his visual efforts to the acts of laborers who had "honestly earned their food" and merited grace.[75]

The Arles *Sower* amplified these elements of van Gogh's insistent pictorial language of labor. He worked and reworked the image to give his brushwork a marked "firmness," and wrestled to build up a coloristic field of "heightened structural density," as Ronald Pickvance has described it.[76] The bristling, textrous qualities of the brush flecks of broken color, applied in multiple layers, gave the canvas its roughness, palpability, and animation. The physical exertion enacted on the canvas surface intensified in the furrow that sliced through the field and was exposed in the center of the picture, suggesting how van Gogh continued to seek formal mechanisms to reproduce particular labor activities, commenting, some time later, that though "I consider myself certainly below the peasants, . . . I am plowing on my canvases as they do on their fields."[77] The tangibility of the separated paint strokes, thickly applied to many elements of the composition—grain stubble, ripe stalks, flying seeds, and sun's rays—united in van Gogh's desire for a painting of a rural subject to "have a rustic quality," for it to "smell of the earth" and of "hard and coarse reality."[78]

TOWARD SYMBOLISM AND A SACRED ART

While *The Sower* expressed powerful continuities with his earlier ideals and practices, the painting also marked an important point of departure for van Gogh as he edged toward his collaboration with Gauguin. The composition coheres not only in its rough, textrous physicality but in its blazing, incandescent sunlight, which seems to blast through and saturate every pore of the canvas surface. In this combination of grounded peasant work and immaterial irradiation, van Gogh identified a new theory of art and attitude toward reality that he connected for the first time to "symbolism" and to the aspiration for a modern sacred art.

The letters about *The Sower* registered his distinctive definition of its "symbolic" features. Writing to Bernard, van Gogh noted that, at work in the fields, he was beset by "memories of the past" and "a longing for the infinite, of which the sower, the sheaf are the symbols."[79] Rather than assigning the

sower a discrete, literary meaning derived from the biblical parable, he interpreted the symbolic quality of the subject in the more elastic and inclusive terms of the "longing for the infinite," the aspiration for a permanent, eternal order beneath the surface of appearances.[80] This generalized yearning for a totality beyond the finite, and its link to art, extended his earlier conception of Millet. When in 1884 he first exalted "Father Millet" as his artistic ideal, van Gogh defined Millet's life and his paintings as invested with what he called that indefinite *quelque chose là-haut*—something out there, a realm of meaning and a source of a presence greater than (although embedded in) nature, the social, and the individual.[81] During his Dutch period van Gogh had considered his own emulation of Millet inadequate and clumsy; he tried again in Arles with a new method to approach that desired evocation of the *quelque chose là-haut*.

What visual techniques were now appropriate to convey this "symbol" of the infinite lodged in a peasant figure? Not the subject alone, claimed van Gogh, but the linkage of the subject to a new use of evocative, expressive color promised *The Sower*'s new symbolic status. Millet's *Sower* was "a colorless *gray*"; "what remained to be done" was a large-scale striding figure "in color."[82] In his ambition to "modernize Millet," van Gogh paradoxically turned to Millet's predecessor, Eugène Delacroix, whose complementary color laws van Gogh had studied for some time but had not programmatically applied to a major canvas.[83] It was from a religious painting of Delacroix's that van Gogh drew the color scheme for his own *Sower*. In writing to Theo as he worked on the picture, van Gogh suddenly juxtaposed Delacroix's *Christ Asleep During the Tempest* (Fig. 55) and Millet's *Sower* as "absolutely different in execution." He went on: "The Christ in the Boat—I am speaking of the sketch in blue and green with touches of violet, red, and a little citron-yellow for the nimbus, the halo—speaks a symbolic language through color alone."[84] In his innovative *Sower* van Gogh would apply Delacroix's "suggestive color"[85] to the Millet-inspired peasant subject, by composing the painting in two interlinking color zones of simultaneous contrast, the "upper half predominantly yellow and the lower part in complementary violet";[86] by continuing the bold use of color juxtaposition along a slender painted frame of yellow and violet;[87] and by transferring the luminous brightness of Christ's citron-yellow nimbus to the sun.[88]

It was significant that van Gogh experimented with this new "symbolist" melding of embedded peasant action and transfigurative blazing light as he emphatically resisted the pull toward idealism and

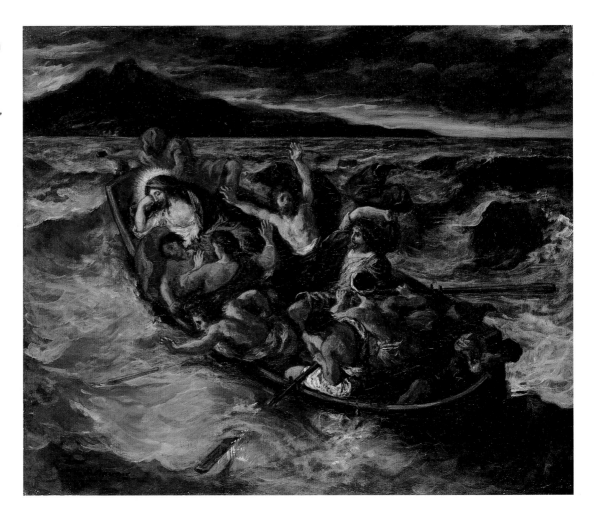

FIG. 55. EUGÈNE DELACROIX, *CHRIST ASLEEP DURING THE TEMPEST*, 1853, oil on canvas, 50.8 x 61 cm. The Metropolitan Museum of Art, bequest of Mrs. H. O. Havermeyer, 1929, the H. O. Havermeyer Collection (29.100.131). Photograph © 1984, The Metropolitan Museum of Art

the revival of religious art that was being tested by his closest colleagues in the avant-garde. During the months he worked on *The Sower*, van Gogh was engaged, through letters, in what was essentially a three-way dialogue with Emile Bernard and Paul Gauguin in Pont-Aven about the nature and function of religious art. Bernard, who was beset by a religious crisis, seems to have initiated the discussion and passed along van Gogh's reactions to Gauguin, who responded with his own positions on spiritual matters.[89]

EMILE BERNARD'S CATHOLIC MODERNISM

Bernard, van Gogh's comrade in Paris, had in 1886 discovered Brittany, where he had met and worked alongside Gauguin. Initially Bernard was enthralled with Breton costumes and archaic customs, noting in his memoirs that he felt transported back to his "beloved Middle Ages."[90] Yet Bernard also responded to the intense religious life of the region, evident both in the artifacts of archaic Christianity and in the manifestations of the contemporary Catholic revival that accompanied Breton resistance to the secularizing Third Republic.[91] During the summers of 1887 and 1888 Bernard experienced a conflicted return to the devout Catholicism of his youth. He decorated the walls and ceiling of his room in a Breton inn at Saint-Briac with what he called large "frescoes" representing scenes of the birth of Christ, such as *Adoration of the Shepherds, Adoration of the Magi*, and *The Circumcision*.[92] And, emulating a holy *pénitent*, Bernard took to the road and traversed much of western Brittany on foot, enduring frequent nosebleeds.[93] (One might view the nosebleeds as creating a link between his journey and the bloody stations of the cross of the Redeemer.) These little-studied critical events of 1887 and 1888 set the frame for Bernard's own modern artistic experiments, which mingled a heightened aestheticism with an admiration for the stylized reductions of traditional religious iconography, such as his *La Nativité: Adoration of the Shepherds* woodcut (Fig. 56), or his *Yellow Christ* painting and drawing.[94] They also structured his comments to van Gogh about the role of religious art as a resource for extending the boundaries of figurative language in painting, a goal they shared but approached in different ways.[95]

FIG. 56. EMILE BERNARD, *LA NATIVITÉ: ADORATION OF THE SHEPHERDS*, 1885/1889, woodcut. Fondation Doucet, Paris

Van Gogh's reactions to Bernard's ideas crystallized a theme that would deepen in the months ahead with Gauguin: his resistance to idealism, in which he included much of religious art. In early July, stimulated partly by discussions with Bernard, van Gogh began a large canvas of Christ with the angel in the Garden of Olives. He wrote to Theo soon afterward that he had destroyed the picture by scraping off the paint, asserting that he could not proceed "without models."[96] Writing to Bernard from Arles in late July, van Gogh urged his friend to forgo the fantasy and aestheticism of Baudelaire for true "perfection," "a complete thing" that "renders the infinite tangible to us."[97] Examples of the tangible infinite included, van Gogh recounted to Bernard, artists like Millet, Courbet, and the Dutch school, and departed from the realm of "invented," unreal things, ascribed here to religious painting. He quickly went on to offer exceptions for Rembrandt and Delacroix, whose work may have contained religious subjects but differed absolutely from "all the rest of religious painting." When Rembrandt painted angels, he rendered them as humanized supernatural figures he "knew" and "felt." In the case of Delacroix, the choice of a Christ figure was subordinate to the evocative form devised to represent him: "Delacroix paints a Christ by means of the unexpected effect of a bright-citron-yellow note, a colorful luminous note which possesses the same unspeakable strangeness and charm in a picture as a star does in a corner of the firmament."[98]

THE FESTIVAL OF SAINT JOHN THE BAPTIST AND ARLES POPULAR CATHOLICISM

While struggling to distance himself from Bernard's fascination with the spiritual resources of the Catholic Church as a vehicle for liberating the artistic imagination, van Gogh was surrounded by the concrete signs of that very devotional system. In the vibrant and demonstrative popular Catholicism all around him in Arles, every facet of rural life and rural labor was charged with sacred meanings and governed by the expected intervention of supernatural protectors. The miraculous agents were especially prominent during the Arles agricultural cycle, from February to October. In this period were concentrated the festivals of a panoply of saints, who were called upon to intercede in the structures of rural life and the cycles of rural production. Each saint had a specialty; each was assigned a particular part

or product in the agricultural process, and was symbolized by a specific tool, food, or accessory recognizable to all.[99]

Significantly, van Gogh devised his *Sower* during the very week of the festivals for the summer harvest, personalized in the Provençal cult of Saint John the Baptist. The timing of van Gogh's canvas and the form and content of his *Sower* suggest the disparity between his own mental and visual habits and the world of an exultant, supernaturalist popular Catholicism around him in Arles.[100]

Van Gogh worked on a number of harvest paintings during the week of June 13 to June 20; according to one authoritative account, the intense pace yielded almost ten canvases in that short time.[101] It was during this same week that he also painted the first version of *The Sower*, which seems to have integrated close observation of the field with a figure inserted from memory. The composition with its horizontal zones resembled works from his harvest series, especially *Wheat Field with Sheaves*.[102] But the figure of the sower reworked an earlier type of laborer derived from van Gogh's art-manual training and from Millet, and was probably not scrutinized at the scene—in Arles, the season for sowing would have been February or October, with the second and third weeks of June dedicated to the harvest. In numerous other paintings the same week, van Gogh himself portrayed harvest activities, including the traces of gathering, stacking, and carting the wheat sheaves and cornstalks.[103] The first try at *The Sower* on June 17 or 18 thus reconnected van Gogh to the rural sites and memories of Brabant, and also to his new attempt to link his painting to the "infinite" through what he called the "symbolic" allusions of "the sower and the sheaf."[104]

After a few days of severe rainstorms, van Gogh returned to work in the fields on June 24; he then made substantial revisions to *The Sower* during the next two days. The revisions included heightening the expressive force of the color by intensifying the saturation and contrast of the dominant yellows and purples; increasing the "structural density" of the canvas by adding more layers of thickly applied pieces of paint, which protrude off the picture's surface; and accenting the brightness and pivot of the sun and its radiating lines of light.[105]

The rays of the sun's arcing light on the morning of June 24 were eagerly awaited by the local harvesters not as a vague evocation of the "infinite" but as a specific sign of the arrival of Saint John the Baptist. The Arles sunrise on that day initiated the celebrations for Saint John and marked the practical

power of a heavenly agent to assure a bounteous yield for his earthly beneficiaries. Saint John the Baptist, "the most popular saint in Provence," was called the harvester; he appeared in proverbs and visual culture equipped with his distinctive implement in the cycle of production, the scythe. "Per Sant Jan lou voulame a la man" (For Saint John the scythe in the hand), declared a local calendar.[106] Special worship and processions with banners and sculptures of the harvester saint marked the day throughout the region. Other festivals came soon after. On June 25, the day of Saint Eloi, the special protector of field animals, rural laborers and their animals gathered in processions to the local church for a blessing. On June 29, the feast of Saint Peter was observed in the fields to celebrate the stacking and assembling of the first crops, which were tied with special fasteners recalling the saint's chains.[107]

Marking the summer solstice and mingling pagan, magic, and Christian elements, Saint John the Baptist's Day was celebrated in van Gogh's Arles with a variety of ceremonial and social rituals. Giant bonfires, called the fires or logs of Saint John, were lit throughout the region, followed by dances around them and special jumping contests over the fires for young men of marriageable age. The music of fifes and tambourines accompanied these festivities, the church bells of town and country rang out loudly, and children practiced the whistling sounds they could make with the annual availability of the *tourtouro*, the trumpet of Saint John.[108]

Special foods, herbs, and magical cures also appeared for June 24 and were associated with the saint's special powers. With the arrival of the first rays of the sun and before the full sunrise, the locals set out to collect the particular "herbs of Saint John," such as Saint John's Wort, that would be preserved for their curative powers. As the bonfires died down, a yearly ritual ensued of jumping over the logs and throwing in garlic cloves, which were collected the next day and eaten at the family meal. Garlics toasted by these fires were presumed to protect against fevers, especially in children. Even the ashes of the bonfire logs were saved; placed in cupboards and closets, they provided magical insurance against the ravages of storms. Provençal sorceresses, still active in the nineteenth-century popular imagination, were said to have special interest in the ashes.[109]

On the day of van Gogh's return to work in the fields, June 24, the sights, sounds, tastes, and collective life of Arles abounded with the exultant linkage of the natural and the miraculous. The bonfires and their ashes, the special herbs in the market, the mini-crosses that were positioned along the perimeters of the grain and corn fields, the pealing of church bells, the processions, the ritualized fireside danc-

ing—all offered concrete signs of the intervention of the martyred Saint John in the lives of his earthly partners at harvest time.

Van Gogh was fundamentally disinclined to respond to these collective eruptions of dynamic supernaturalism in Arles. His cultural formation, and the specific theological controversies that shaped it, had centered, as we shall see, on a vigorous "anti-supernaturalism," which nonetheless salvaged a realm of an unknowable divinity in and beyond nature. As he worked on his harvest canvases and his *Sower* during the local saints' festivals, he screened out of view any signs from the concrete symbolic system around him, devising instead an image that defined the symbolic as a generalized "longing for the infinite." Rather than the intercession from above affirmed by local harvesters exulting in the personalized cult of Saint John the Baptist, van Gogh proceeded with the model of emanation from below, embodied in a generic labor figure framed by a blazing sun, luminescent with the color once reserved for Christ's nimbus.

The Sower may have been, then, van Gogh's first attempt to devise a kind of Protestant counter-imagery to two models of representation, one avant-garde and one popular. The first, explored by Bernard and Gauguin in their painting, adapted Catholicism in the direction of transcendence and a release from materiality; the second, concretely expressed in the harvest rituals of Catholic Arlesians, assumed the personal intervention of divine agents in the visible world. Neither was acceptable to van Gogh. In his *Sower* he attempted a binding together of the sacred and the natural, creating an active laborer invested with spiritual force.

Van Gogh explored in Arles a type of visual "symbolism" in a theory and practice of embodiment and emanation. In *The Sower*'s depiction of redemptive work physically enacted by its peasant subject, technically emulated by the painter's coarse and effortful brush, and transcendently charged by its blasting illumination, the painting exemplified van Gogh's ideal of an art rooted in the indivisible union of the tangible and the infinite. The canvas's two sections, joining horizontal and vertical planes, composed the partnership of human action and celestial power; as the sower thrust new seeds into the barren clods of earth splayed across the central ground of the picture, the erect ripe stalks at the back, drenched by vitalizing sun, signaled the end of an irrevocable cycle yielding the fruits of labor expended. The painter, through his interlocking design and matched yellow dabs for seeds and shafts of sunlight, tied the two realms together and, as the agent of both germination and irradiation, absorbed the power of each. Van

Gogh's artist, like the sower, embodied matter. His was a nature not to be overcome but to be "disentangled" and realized. [110] And his artist, like the sower's sun, activated emanation of the eternal in the tangible; he flooded the picture plane with a dense, materialized light that penetrated every bit of ground and grain. *The Sower*'s paradigmatic status in van Gogh's symbolist goal of binding the infinite to the tangible was recapitulated in the process of preparing his own ground for artistic production in the laborers' fields. Resisting the mistral's blast by ramming, clamping, and tying his easel down with rope, stakes, and iron pegs, van Gogh applied his sparkling streaks of color to canvas anchored from flight, literally embedded in the soil.

Van Gogh's depiction of a redemptive peasant exalted by what he called "the good god sun" thus naturalized divinity in a context of intense supernaturalism, where the signs and rituals of the concrete intrusion of celestial agents and human workers were ubiquitous.[111] At the same time, van Gogh's *Sower* presented a labor figure as a general prototype, shorn of any discernible features of Provençal particularism, in a context where fixing the rural laborer as a uniquely regional type was a dominant political movement. Frédéric Mistral's poetry and chronicles lyricized the tools, costumes, and social customs distinctive to the peasant fieldworkers around Arles and La Crau and celebrated their folk individuation, unified by Catholic faith and regional community. Mistral rendered, for example, the feast of Saint Peter, which marked the tying of the sheaves in the fields, as well as the magical and pious ceremonies accompanying Saint John the Baptist's harvest time. Mistral identified the sun with the particularity of the many saints' days that it heralded, and with the exclusiveness of the "Latin race." What Mistral called the "empire of the sun" was assigned not to a universal space but to the "Latin race," that "luminous race" who "sow[ed] the seed" and "ascend[ed] toward hope . . . under the Cross."[112] In this setting, where the redemptive peasant had been reclaimed as a highly localized and regional figure, devoted to race and to Catholicism, van Gogh created his *Sower* as a generalized paragon of work, light, nature, and exertion.

Gauguin's *Vision After the Sermon*

Art is an abstraction; derive this abstraction from nature while dreaming before it . . . This is the only way of rising toward God— doing as our Divine Master does, create.
PAUL GAUGUIN[1]

Ah! my dear comrades, let us . . . take delight in our eyesight in spite of everything, yes, let's!
VINCENT VAN GOGH[2]

At the very time that van Gogh was probing new artistic forms, subjects, and procedures to render the tangibility of the infinite, Paul Gauguin was using his art to explore visionary incorporeality. Pictorial, personal, and theological factors converged to make van Gogh's *Sower* a symbolist image weighed down, held back from flight; these same factors, in Gauguin's case, combined to make *The Vision After the Sermon: Jacob Wrestling with the Angel* a symbolist image seeking release in the weightlessness of the dream, a process Gauguin later called "freeing painting from its chains"—"the shackles of verisimilitude" and materialism.[3]

Like his friend van Gogh, Gauguin developed his approach to a new "symbolist" painting in a rural setting. In February 1888, the same month that van Gogh left for Arles, Gauguin renounced the urban metropolis of Paris for a French preindustrial oasis, choosing to settle in the village of Pont-Aven on the southwestern coast of Brittany, in the department of Finistère. Like Arles, Pont-Aven was affected by a broader movement for regional identity and religious revival that mobilized many parts of France in the period after 1870.[4] But Brittany was a very different location for artistic activity from Mistral's Provence; Gauguin would find very different working conditions in Pont-Aven from those van Gogh encountered as a non-Provençal painter in Arles.

BRITTANY, 1888: DOMESTICATED WILDNESS

Van Gogh, as we have seen, set off for Arles on his own, beckoned not by other painters but by a set of idiosyncratic associations to Daudet, Japan, and Monticelli, and set up shop in Arles alone, eventually

befriending locals such as the postal worker Joseph Roulin and the soldier Lieutenant Milliet. Gauguin's initial attraction to Pont-Aven, by contrast, was less courageous and more conventional. Brittany was widely talked of for its "primitivism," and Gauguin knew Pont-Aven as an established and inexpensive art colony.

The writings of Chateaubriand had celebrated the allure of Brittany early in the nineteenth century. After 1870, Brittany was rediscovered by intellectuals and regional champions as a site of special mystery that was resistant to the leveling forces of the modern Republic. The professor and historian Ernest Renan published memoirs extolling the savagery, piety, and solemnity of his native Brittany in the *Revue des Deux-Mondes* from 1876 to 1882; Maurice Barrès traveled through the region in 1886 and glorified its simple churches and rough-sculpted calvaries (Fig. 57), asserting that he had located a preclassical haven of pure Gallic culture untainted by Latinity.[5]

In an established genre of state-sponsored academic painting, Brittany was a subject for art well before Gauguin lived there. Local artists began to detail the customs and costumes of village life during the Second Empire (1852–1869), following a style of picturesque realism and a new taste for identifying folk culture (Fig. 58). During the 1880s, depictions of Breton religious life and rituals expanded, corresponding to the recrudescence of popular religious practices in the decade of republican anticlericalism.[6] Receiving particular attention were the collective ceremonies and devotional cults of the Finistère region, among them pilgrimages, raisings of the cross, saint's-day processions (especially those dedicated to Saint Anne), and local pardon festivals, which can be seen in such canvases as Alfred Gillou's 1887 *Return to Concarneau of the Pilgrims from the Pardon of Saint-Anne-de-Fouesnant*, Jules Breton's 1891 *Pardon of Kergoat* (Fig. 59), and Pascal Dagnan-Bouveret's 1886 *Pardon in Brittany* and 1887 *Breton Women at a Pardon*.[7] The subjects were treated with a meticulous, almost photographic realism; the painters specified the pageantry, banners, and ritual costumes reserved for these many sacred occasions.[8]

In discovering Brittany, which he first visited in the summer of 1886, Gauguin thus joined the ranks of many painters and intellectuals who had been drawn to the region. By the 1880s, parts of Brittany and Breton customs had been discovered as tourist spectacles for an urban middle class ever on the alert for heightened and "exotic" diversity.[9] During this same decade, elements of Breton culture and customs were also the focus of local public debate and political resonance in the department of Finistère. In an era of expanding state pressures for centralization and secularization, clerical and regionalist leaders themselves invested new energies to preserve their unique local customs and premodern Catholic cults.[10] These efforts paralleled the interplay of ethnographic precision and lyrical spirituality mobilized by Frédéric Mistral for van Gogh's Provence, though Brittany did not produce a leader of Mistral's stature.

TOP **FIG. 58 ADOLPHE LELEUX,** *UNE NOCE EN BRETAGNE (BRETON WEDDING)*, 1863, oil on canvas. © Musée des Beaux-Arts, Quimper, France

BOTTOM **FIG. 59. JULES BRETON,** *PARDON OF KERGOAT*, 1891, oil on canvas, 122.6 x 233 cm. © Musée des Beaux-Arts, Quimper, France

In February 1888 Gauguin settled at Pont-Aven. The following month he wrote to his friend Emile Schuffenecker, celebrating the special power of the region: "I love Brittany. I find wildness and primitiveness there. When my wooden shoes resound on this soil of granite, I hear the muffled, dull, and powerful tone that I try to achieve in my painting."[11]

While he was responding to Brittany's "primitivism,"

Gauguin was cushioned by the trappings of civility and artistic company. The Breton locale he had chosen mingled the alluring severity and sacrality of artifacts of premodern cultures with the picturesque agreeability of a small town dedicated to the art of receiving travelers and painters on extended *séjours* (Fig. 60). In 1886, Pont-Aven, a port town set along the wooded hillsides of the River Aven, had only 1,516 inhabitants; Arles, ringed by the Rhône, had about 23,000.[12] At Pont-Aven Gauguin lived in one of a number of artists' colonies that dominated the local scene and defined its reputation; indeed, besides small-scale farming, milling, and fishing, the Pont-Aven economy from the 1860s on was driven by the hotel and innkeeper business that catered to painters.[13] In Arles, painters were anomalous, as was van Gogh's own position in the town; in Pont-Aven, Gauguin was part of an artistic community where models abounded and convivial meals were provided (Fig. 61).

Despite complaints about illness, mounting debt, and lack of funds throughout his Breton sojourns of 1886–1888, Gauguin's daily welfare was nonetheless assured in Pont-Aven at the inn of the Maison Gloanec, known as the "Bohemian home at Pont-Aven."[14] Here Madame Marie-Jeanne, renowned for her cooking and as a solicitous "protectress of painters," provided Gauguin with a suitable room plus two meals a day at a modest 60 francs a month. (Gauguin's tab kept mounting; Madame extended credit.)[15] The inn afforded not only decent, inexpensive lodging but a ready-made artistic community. It was there that Gauguin encountered Emile Bernard and enjoyed the company of the painters Charles Laval and Meyer de Haan, and other, younger disciples such as Paul Sérusier traveled to Pont-Aven explicitly to seek Gauguin's counsel and observe his painting technique.[16]

Along with the avant-garde sociability of Pont-Aven, some elements of the local popular culture, piety, and costume were attractive to Gauguin. While van Gogh strode through the fields of Provence outfitted as a Dutch laborer, Gauguin donned the special woven Breton vest (Fig. 62), and he carved, decorated, and wore Breton wooden clogs.[17] Spurred in part by the arrival of Bernard and his sister Madeleine during the summer of 1888, Gauguin became quite interested in local folk piety and Catholic devotional culture. Van Gogh neglected the ecclesiastical town center of Arles in favor of the countryside around it; Gauguin, by contrast, accompanied Bernard and Madeleine, herself dressed in Breton costume, to worship with the villagers at the Catholic church of Pont-Aven.[18]

GAUGUIN'S PRE-*VISION* PAINTING IN PONT-AVEN

During the months immediately preceding the *Vision* painting, Gauguin attended to local scenes and subjects and tried to discover his own stylistic language among the contending models he had absorbed from Pissarro, Cézanne, and Degas. The mid-June 1888 canvas *La Ronde des petites bretonnes* (*Breton Girls Dancing, Pont-Aven*) reveals how differently Gauguin approached the new rural setting as he, like his friend van Gogh, attempted to work through the lessons of the Paris they had left behind.

The painting presents three Breton girls dancing in a recently harvested field, with the church tower, roofs, and hills of the town behind them (Fig. 63). Unlike van Gogh, who largely disregarded local types and local costumes in his June canvases of the Arlesian harvest fields, Gauguin gave his subjects an immediately recognizable

FIG. 62. PAUL GAUGUIN IN A BRETON VEST. Photograph courtesy of Musée de Pont-Aven

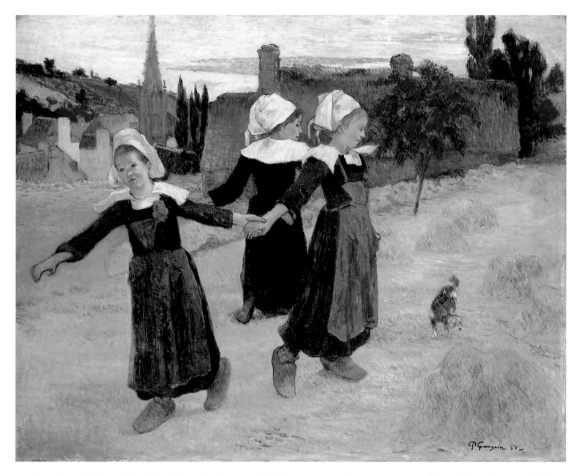

regional specificity, showing them in the special bonnets, collars, aprons, and wooden clogs typical of the area. Gauguin identified the dance as a *gavotte bretonne*, which was as characteristic of Brittany as the *farandole* was of Provence.[19] One scholar has suggested that Gauguin's dance may have been "inspired by the traditional celebrations at hay-making time,"[20] the type of festive and ritual practice that also marked Provence during the same season but went unrecorded in van Gogh's paintings. The presence of the labor that would have preceded such a dance is minimized by Gauguin in his focus on the charming trio of nonlaboring young girls—the "*petites* bretonnes" of the painting's title—and in the way these children dominate the casually arrayed harvested piles, which look like feathery clipped

grass rather than robust grainy stacks. The prettification of the worked matter is extended by Gauguin's placement of the little dog amidst the hay; the dog's diminutive, fur-covered face, with dashes of green, matches the lightly brushed mounds in color and delicacy.

Gauguin's painting of the dancing *bretonnes* lends credence to the suggestion made by some writers that Gauguin was at a bit of an impasse during the months immediately before *The Vision*.[21] The subject and its treatment did not depart significantly from the popular genre scenes of Brittany's picturesque customs that were being painted by Gauguin's academic colleagues, and the canvas proved readily marketable.[22] The technical ambivalence apparent in the painting, which represented Gauguin's attempt to navigate his own path among varied modern mentors, yielded an image that did not gel; the central figures, modeled on Degas, are set along the left side of the picture in a striped, colored hillside resembling those of Pissarro, as well as near a number of angular white houses reminiscent of Cézanne. The right side of the painting is animated by another type of brush, a wispy, tremulous stroke evocative of Cézanne and late Monet. At this point, then, Gauguin had not discovered his own idiom, which he would develop instead from other resources in *The Vision After the Sermon* as an anti-Impressionist "path of symbolism."

INTERIORITY AND "ABSTRACTION"

Like van Gogh, Gauguin related his innovative symbolist experiment of 1888 to preexisting ideals and practices. The subject of *The Vision*, described by Gauguin as a representation of the interior scene enacted within the praying peasant women's imaginations, had some precedent in Gauguin's earlier work. In 1881, for example, while exhibiting with the Impressionists and training alongside Camille Pissarro, Gauguin highlighted a distinctly anti-Impressionist motif in his oil sketch *La Petite rêve (Little Girl Dreaming)*, a depiction of his daughter Aline asleep, prefiguring "his later preoccupations with the world of the unconscious" and the "interior life of human beings."[23] This painting (Fig. 64), and a large canvas of the same subject in 1884, suggest the interplay of sleep and dream in the fanciful shapes that Gauguin placed on the wallpaper behind the child's head in both works, as if to indicate the chimerical animation of the dreamer's subliminal state.

FIG. 64. PAUL GAUGUIN, *LA PETITE RÊVE (LITTLE GIRL DREAMING)*, 1881, oil on canvas, 59.5 x 73.5 cm. Ordrupgaard, Copenhagen. Photograph by Ole Woldbye

But Gauguin's interest in states of consciousness did not gain overt visual expression until the Breton *Vision*; this interest percolated mainly outside his painting as a set of attitudes that surfaced in letters and artistic debates. As early as January 1885, in a letter to his friend Emile Schuffenecker, Gauguin registered an epistemology that set the framework for the exploration of different levels of reality that he would dramatize in *The Vision*. In that letter Gauguin proposed an art directed toward the mediation of a mystical, ideal reality beneath the surface of appearances, capable of conveying what he called "phenomena which appear to us supernatural, and of which, however, we have the *sensation*."[24] The letter as a whole presented a cerebral ideal of artistic creation, with the artist moving from idea and emotion to matter and motif, always eliciting what Gauguin called the "most delicate and by necessity the most invisible elements of the mind." This process defined a type of artistic production divested of external agonistic exertion: "Go on working, *freely and furiously*, you will make progress . . . Above all, don't perspire over a picture. A strong emotion can be translated immediately: dream on it and seek its simplest form."[25]

A later letter to Schuffenecker, written just before Gauguin began work on *The Vision*, shows him edging even further toward a subjectivist anti-naturalism as the core of modern art. In this letter of August 1888, Gauguin goaded his friend to subordinate nature to the imperatives of the artist's dream as a way of approaching divinity through ascent: "Art is an abstraction; derive this abstraction from nature while dreaming before it . . . This is the only way of rising toward God—doing as our Divine Master does, create."[26]

Gauguin's *Vision After the Sermon*, a religious painting situated in a dream landscape, would thus be a confirmation and extension of attitudes that had already been consolidated in his evolving aesthetic. Yet the painting would also represent a sharp and self-conscious break with his previous style, training, and subject matter, for it would deploy a new arsenal of visual forms to seek transcendence and the mediation of an ideal, supernatural realm extending beyond perceptual experience.[27] The

Impressionists, Gauguin would later explain, "heed only the eye and neglect the mysterious centers of thought."[28] Abandoning his Impressionist canon, Gauguin celebrated his *Vision* as his first step along "the path of symbolism," a path poised in ascent toward a dematerialized purity that he now proclaimed as "fundamental to my nature."[29]

GAUGUIN'S *VISION* AND APPARITIONAL CATHOLICISM

Stimulated in part by the summer exchange of ideas with van Gogh and Bernard concerning the status of a modern religious art, Gauguin completed his *Vision After the Sermon* (Fig. 65) by the end of September 1888.[30] He listed the painting in his notebook as *Vision du sermon—Vision of the Sermon*—and also referred to it there as *Apparition*; it later became known, however, as *The Vision After the Sermon: Jacob Wrestling with the Angel*. (I use this title here, bowing to common practice, although I would argue that Gauguin's own titles provide far more helpful clues for a full understanding of the painting.)[31] *The Vision* departed significantly from the sentimentalized charm and ready marketability of such earlier canvases as the dancing Breton girls, and indeed Gauguin ascribed to the painting technical and symbolic breakthroughs and an ambition of a different order. As Gauguin explained to Schuffenecker soon after he completed it, "I wished to force myself into doing something other than what I know how to do."[32] With *The Vision After the Sermon*, Gauguin initiated his symbolist project in the hushed solemnity of a religious meditation.

He chose as his subject a group of Breton women praying and experiencing a sermon, withdrawn into the scene of an interior vision inspired by it. Motionless figures at the left look down, with eyes closed, legs kneeling, and hands clasped in traditional prayer stance, some holding what appear to be strings of rosary beads.[33] Gauguin positioned a large central figure with her eye open, who appears to be looking up and across a diagonally bending tree to the site where the imagined inner vision is projected outward and enacted, as if it were really taking place in the distant landscape, showing Jacob locked in battle with the angel.[34] As Gauguin explained in a letter to van Gogh, "For me in this painting the landscape and the fight exist only in the imagination of the people praying after the sermon, which is why there is a contrast between the people, who are natural, and the struggle going on in a

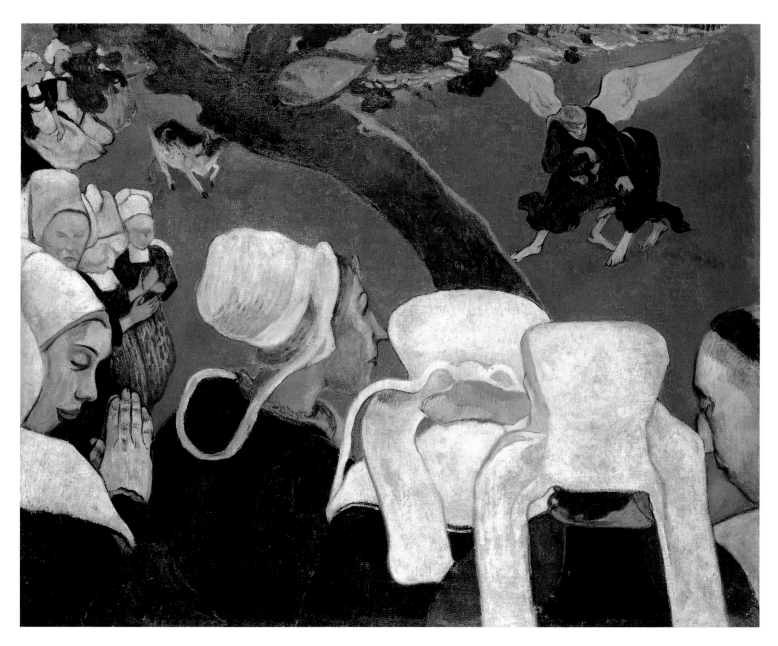

FIG. 65. PAUL GAUGUIN, *THE VISION AFTER THE SERMON: JACOB WRESTLING WITH THE ANGEL*, 1888, oil on canvas, 73 x 92 cm. National Gallery of Scotland, Edinburgh

landscape which is non-natural and out of proportion."[35] Thus at the very time that van Gogh devised his symbolist *Sower* as he resisted the phantasmic figurations of religious art, Gauguin constructed his symbolist *Vision* as a simulated mystical encounter between the natural and the supernatural, between the physical and metaphysical realms. The conduit between the two levels was afforded by the fusion of the artist's dream and the peasants' visionary faith.

Gauguin's choice of subject in 1888 was significant, as it emerged at the height of a widespread religious revival in particular regions of France, including an upsurge of devotional cults and an eruption of popular apparitional Catholicism. During the fall of 1888, for example, a young shepherd of the Forez Mountains, west of Lyon, claimed to have seen the Virgin Mary, who spoke to him of the need for prayer and penitence, up to twenty times. This event was only one of a multitude of miraculous appearances of the Virgin to humble peasants that emerged in rural France after 1850, a period that came to be known as *l'époque des apparitions*—"the epoch of apparitions."[36] The Marian visions were tolerated and sometimes even sanctioned by the official clergy in their efforts to counteract republican anti-clericalism and to recuperate dynamic popular forms into the center of a renovated Catholic Church. The new mix of official and popular ecstatic devotion crystallized in the unprecedented pilgrimage movement of the 1870s. That movement yielded the well-known annual Festival of Lourdes, at the site where the Virgin Mary was said to have appeared to the young Bernadette Soubirous in a grotto, as well as the less familiar but equally important pilgrimage to Paray-le-Monial, which celebrated the series of visions of the Sacred Heart of Jesus to Marguerite-Marie Alacoque, a seventeenth-century nun beatified in 1864 and worshipped by one million French pilgrims to Paray in 1877.[37]

The status of miraculous appearances of holy figures was still controversial during the 1880s, with important implications for Gauguin and his symbolist experiment with vision and the visual. All over France, from Reims and Grenoble to Lyon and Orléans, bishops and archbishops had established commissions to investigate the religious visions and their beholders, employing the techniques and categories of positivist knowledge to test the truth value of supernatural intrusion. This process, which involved scientific measurement, witness testimony, data collection, and modes of verifiability, yielded a new type of evidence—what were called "supernatural facts" or forms of supernatural realism.[38] While the clerics disagreed in their final endorsements of particular cases, their approach to understanding apparitions led them to open up for contemporary attention the plausibility of an encounter

between one level of reality and another, confounding the meaning of the "real" to allow for a direct, immediate dialogue between the natural and the supernatural orders. This exploration across the divide of the real and the ideal was given pictorial form in Gauguin's *Vision* painting.

GAUGUIN'S *VISION* AND BRETON PEASANT PIETY

While Gauguin's painting was situated in a new national culture of religious apparitions, it also had distinctive roots in the local Breton context in which he produced it. A close look at *The Vision* suggests that Gauguin responded avidly to precisely those devotional and festive occasions of rural Catholic community that van Gogh scrupulously avoided in Provence, and used them as a springboard to explore his own developing pictorial anti-naturalism from the shared resources of Catholic idealism.[39]

Among the most dramatic and widespread of the rituals of Breton popular piety were "pardon" ceremonies, annual pilgrimage festivals that were "usually held in honor of the patron saint of a local church."[40] The pardons could glorify a saint, recall a special miracle, and bless a particular activity, but their distinctive feature and their name derived from "the fact that they provided the pious with opportunities to earn forgiveness." The Pont-Aven pardon, "one of the most celebrated in lower Brittany during the last quarter of the nineteenth century," included the fulfillment of penitential vows by pilgrims, who earned penances by traveling on foot to the locale or by "circling the church" on their knees "while saying the rosary."[41]

The sacred acts of pilgrimage, worship, and public repentance characterizing the Breton pardons were combined, as in the rural festivals of Provençal popular piety, with elements of paganism, magic, and early Christian culture, as well as with secular social practices specific to the annual event. The Pont-Aven pardon, a two-day celebration traditionally held on the third weekend in September, coincided with the autumnal equinox and with rural planting and harvest cycles. So, too, in Arles, the Saint John the Baptist festival on June 24 marked the summer solstice and combined Christian elements with pagan solar and seasonal regulation. As in the Arles celebration, the Pont-Aven pardon featured the evening lighting of special bonfires, with special priestly blessings and ceremonies.[42] And the Pont-Aven fête proceeded from the sacred to the profane, including social practices to adjust the bal-

ance of the marriage market. The ceremonies began with a solemn pageant and procession to the church with banners, relics, and saints' statuettes, culminating in high mass; the later hours were devoted to wrestling matches, dances, and games, featuring, as in the jumping contests over the Saint John bonfires in Arles, courtship rituals for bachelors and unmarried women.[43]

Where van Gogh's *Sower* registered no traces of the Saint John fêtes, Gauguin's *Vision After the Sermon* has been considered to be filled "with images referring to Breton pardons in general . . . and that of Pont-Aven in particular."[44] A number of writers have tried to pinpoint the possible sources of Gauguin's subject in local devotional culture and customs. All have emphasized the distinctive white headdresses and costumes worn by the Pont-Aven women, which assign a particularity to Gauguin's subjects unavailable in the generic peasant figure of van Gogh's *Sower*. Some of these "contextual" readings have also emphasized the significance of Gauguin's inclusion of wrestling, one of the signature features of the pardon and publicized in popular prints of the event at the time.[45] While it is well known that Gauguin was inspired by Hokusai's Mangwa prints of wrestlers, one recent account suggests that Gauguin's Jacob and angel figures also appeared to be locked in a head-and-shoulder grip characteristic of the special Pont-Aven wrestling matches, itself adapted from a Japanese wrestling technique.[46] Although there were some nineteenth-century precedents in painting for depicting the subject of Jacob and the angel, scholars have suggested that Gauguin may have encountered the biblical scene in one of the popular mystery plays still performed in the area, or that he could have heard it referred to in a sermon on the Genesis passage during one of the pardon high mass services, though no evidence of such a sermon has been located.[47]

Perhaps the most convincing element of the impact of local devotion is the presence of the pious women depicted on their knees, some with rosaries, which evoked the special pardon ceremony of penitent, kneeling pilgrims circling the church.[48] A recent account suggests that Gauguin attended the Pont-Aven pardon festival in the company of Emile Bernard and his sister, as part of their shared exploration of Breton religious culture and early Christian arts. The timing of the ceremony in relation to the timing of the painting's execution, and the types of community action evoked in it, offer some convincing allusions by the *Vision* canvas to Breton-specific popular Catholicism.[49]

It would be wrong, however, to overemphasize the literal portrayal of Breton festive piety as a characterizing feature of Gauguin's painting, for the search for a single source goes entirely against the

grain of his creation. The painting is not a picturesque rendition of a local ceremony but a composite meditation on states of consciousness and levels of reality. Indeed, Gauguin devised numerous disruptions of space, scale, shape, and color to dislodge his image from specific grounding in a discernible anecdote or sequential narrative.[50] Taking an occasion of ritual action, Gauguin transformed it into a transcendent encounter across the divide of material reality, a sacred moment of contact, when the women, withdrawn from their physical senses, close their eyes to behold the ideal enacted. The transmutation from folk piety to interior vision was partly made possible for Gauguin by particular resources of his own Catholic heritage, which formed a bridge between his cultivation of a "symbolist" realm of meaning beyond phenomenal reality and the mystical supernaturalism of Breton religiosity. Van Gogh's *Sower*, by contrast, mobilized long-term cultural filters fundamentally *in*hospitable to what he called "sterile metaphysical meditations" to screen out the traces of Arlesian popular miracle cults, and explored a realm of divinity in light and labor.[51] Gauguin's *Vision* tapped the chords of his own anti-materialist religious training to project a common framework for painter and peasant in the experience of divinity through ascent from corporeal contingency to the ineffable, to the temporary exaltation of the dream possessed.

GAUGUIN'S TECHNIQUES OF TRANSCENDENCE

As in the case of van Gogh's inaugural symbolism, Gauguin explored new visual techniques, both compositional and coloristic, to convey the meaning of his distinctive symbolist venture. A radically flattened, vividly colored canvas, *The Vision After the Sermon* comprises two overlapping zones of pictorial space, devoid of a traditional middle ground and deliberately confounding traditional perspectival structures. In the foreground Gauguin has assembled the praying women along the edges of the canvas, with the central figure's riveted focus on the two biblical characters, who are disposed behind a large section of a tree that cuts a diagonal line across the canvas and bends upward to be sliced off at its top. Inspired by Japanese prints, Gauguin has employed the tree as an asymmetrical flattening device, and he has also used it inventively to act as a boundary marker separating the two levels of reality unified in the picture.[52] Gauguin's treatment of the tree exposes it as a fragile and permeable border

line, befitting his theme of the fluid interpenetration of reality and apparition. The tree lacks a visible base and appears to float; its one site of fixity is formed not by the anchoring middle ground but by the white bonnet of the female figure in the foreground, to which it appears to be stuck, further intensifying the compression of the picture space.[53]

A second element of Gauguin's intentional anti-perspectivism formalized the drift of the natural into the supernatural arena. In setting the scale and proportions of the figures, Gauguin scrambled the logic of illusionism, devised to suggest movement into the distance, in order to bring the distant realm closer, resulting in a picture space that tilts up and presses itself forward. This breach in traditional adjustments of scale is particularly apparent in the triad of the women in front, the cow at the left, and the angel and Jacob across the diagonal tree. Gauguin rendered the three women in front in very large dimensions, but the angel and Jacob in the distance do not diminish proportionally in relation to them. The cow, while closer to the women in space, appears much smaller in scale than the Jacob and angel figures in the far distance, resembling a miniaturized toy rather than a cumbersome animal. As Gauguin commented, "The cow under the tree is tiny in comparison with reality, and is rearing up."[54]

The cow's location and disposition recapitulate the elements of weightlessness configured elsewhere in *The Vision*. While the animal's body shares the women's visual space in the realm of what Gauguin assigned to "the natural," the head, rearing up and blocked from view behind the tree, had migrated to the realm of spirit claimed by Jacob and the angel. Like the tree, which hovers up above rather than adhering to the ground, the cow's fragile body and raised head float into the netherworld. Gauguin's transformation of a creature epitomizing lumbering phlegmatics into an airy messenger of incorporeality offers one of the most effective signs of *The Vision*'s thematics of supernaturalism.

Gauguin joined his departure from the rules of perspective and proportion to his most conspicuous innovation in *The Vision After the Sermon*: his deliberate use of an anti-naturalist color palette, applied in smooth, flat areas separated by distinct black outlines. The use of the black outlines around broad, unbroken color masses, resembling the enameling or stained glass of the Middle Ages—a technique referred to as "cloisonism"—works to heighten the intensity of the bright colors, as well as to add another factor contributing to the painting's flattened surface.[55]

Like the two spatial zones of the painting, Gauguin's color range divided along his stated binary pole of "natural" and "non-natural." Indeed, the contrast between the two levels of reality emerged in

Venez et adorons le cœur de Jésus victime de charité!

E.BOUASSE.J^{ne} ed^r IMP. HAMELIN. IMP. PARIS. 450 RUE MABILLON, 2.

Cœur de Jésus tout amour;
Cœur de Marie toute pureté.
Cœur de Joseph tout dévoué,
Je vous aime.

E.BOUASSE.J^{ne} ed^r IMP. HAMELIN. IMP. PARIS. 450 RUE MABILLON, 2.

the choice of a black-and-white sequence for the elements observed at the scene and multicolored tones for the imagined figures of eternity. The group of praying Breton women, Gauguin explained in a letter to van Gogh, wore "very intense black clothes" and "yellow-white bonnets, very luminous." The tree, rendered in a dark hue, ascended to brighter colors; as its upper foliage spilled over into the area near the angel and Jacob, Gauguin introduced a sparkling green, converting the density of leaves into the ethereality of "greenish emerald *clouds*."[56] Gauguin also inserted another color sign of the tree's dual position in the natural and non-natural realms of experience: while the edge of the tree nearest the women is outlined in black, the edge of the tree near Jacob and the angel glows in bright orange, reiterating the divergence of earthbound and celestial sites in the painting.

By far the most startling aspect of *The Vision After the Sermon* is Gauguin's use of a dazzling expanse of unreal red—"pure vermilion"—to render the heavenly ground permeating the picture plane as it fills the consciousness of the praying women. The radiant red field spreads in a broad, smooth mass of largely unmodulated color, thinly and evenly applied with a fluid brush that rarely broke the canvas surface. The use of this red is usually attributed to Gauguin's interest, shared with Bernard, in a number of sources—the intense saturated colorism of Japanese prints; the red color zones of stained glass windows; and the colored French popular prints associated with the town of Epinal. Gauguin's coloristic invention in *The Vision* may owe a larger debt to a particularly sacred type of Epinal prints than has been acknowledged.

Throughout the nineteenth century, Epinal prints were important elements of rural and urban popular culture. Beginning with Courbet, who adapted their flattened, horizontal format in order to develop a new language and a new audience for art in the transformative period of 1848, Epinal prints attracted avant-garde interest.[57] Gauguin's and Bernard's innovations were very different from Courbet's, related to new color models and the prints' religious functions.

Prints with sacred subjects and narratives formed one of the most popular and marketable of the categories after 1850. Among these, the depictions of the martyred Christ on the cross and the grieving Virgin Mary were prominent, and they featured intensely colored red pigments. The reds—

FIG. 66. SACRÉ COEUR REDS: BLEEDING HEARTS. Bibliothèque Nationale, Paris. Reproduced from Catherine Rosenbaum-Dondaine, *L'Image de la piété en France, 1814–1914* (Paris: Musée-Galerie de la Seita, 1984)

vermilion and scarlet—were newly available because of the technical possibilities of chemical dyes and advances in chromolithography. In the 1880s the intense colors were used for new subjects, such as images of bleeding hearts and spurting blood (Fig. 66) and the physical suffering of Christ's Passion, with blood flowing and drenching his body (Fig. 67). These types of prints gave visual expression to the newly emotionalized piety of the later nineteenth century, especially the cults of the Sacré Coeur and the heightened interest in contemplating the wounds and pain of the Savior.[58]

We do not know exactly which Epinal prints were collected by Gauguin, and no inventory has been done of the prints available to or in the possession of Gauguin, Bernard, and the Pont-Aven circle in 1888. But some clues are provided by the Epinal prints that were tacked to the walls of the Maison Marie-Henry in Le Pouldu, a seaside village near Pont-Aven where Gauguin and his friends lived and worked in 1889–1890.[59] Among these were a number of prints featuring the "Sacré Coeur de Marie," which rendered the profusion of blood in the new bright red colors, and the François Georgin Pellerin image of the "Mirror of the Sinner." In my view, Gauguin's adaptation in *The Vision* of the flatness and bright colors of popular art has a critical religious dimension and presents interesting correspondences to the spiritual aspirations he associated with the subjects he depicted in the painting.[60]

The highest point of luminosity in the picture, as well as its most saturated coloristic hub, lies in the angel and Jacob characters. According to Gauguin's description, Jacob's robe is "bottle green," while the angel is "dressed in violent ultramarine blue." The eye quickly settles on the angel's wings, painted with "pure number 1 chrome yellow"; the angel's hair modulates to "number 2 chrome," and its feet are "flesh orange."[61] The gradations of intense yellow to orange in the angel's wings, hair, and feet, reinforced by the flashing orange stripe of the tree edge and the brilliant red of the surround, combine to make the angel glow and radiate light and heat from a mysterious invisible source. This flushed figural treatment contrasts sharply with the cold, depleted faces of the praying women watching the angel; drained of color and highlighted with frosty white paint, the women appear as dissipated "masks of meditation" riveted to a blazing site of heated light.[62]

A religious painting born in repudiation of Impressionist sensory truth and celebrating new visual techniques of anti-naturalism, *The Vision After the Sermon: Jacob Wrestling with the Angel* captured the essence of Gauguin's emergent symbolism in a theory and practice of dematerialization. Indeed, the subject and form of *The Vision* provided a pictorial realization of Gauguin's new clarion call

FIG. 67. SACRÉ COEUR REDS: CHRIST'S BLEEDING BODY. Bibliothèque Nationale, Paris. Reproduced from Rosenbaum-Dondaine, *L'Image de la piété en France*

for modern art in August 1888—the call to art as an abstraction. "Derive this abstraction from nature while dreaming before it," he had written to Schuffenecker. The subjects of *The Vision After the Sermon* were caught enacting Gauguin's charge—the praying women were themselves engaged in the process of deriving an abstraction from nature while dreaming before it, taking the raw material of the sermon they had heard and the natural scene with which they were presented and transforming it according to the contours of their inner vision. The creation that resulted from their dream—Jacob and the angel—cast the women into the artist's role, as Gauguin conceived it. "This is the way of mounting toward God," Gauguin had noted, and the women are physically and spiritually poised in the picture plane to fulfill this act of ascent as they exercise the primacy of creative abstraction over nature. Gauguin's own formal strategies that he devised for *The Vision* mobilized new pictorial resources in the service of rising toward the ideal. His distortion of space propelled the presumably distant supernatural figures forward, while his invention of jarring color monopolized the visual field for a luminescence absolutely unavailable to the natural eye.

At the crossroads of 1888, Vincent van Gogh's and Paul Gauguin's inaugural symbolist projects revealed striking contrasts. Both linked their pictorial experiments of that summer and fall to a "longing for the infinite," yet each harnessed this aspiration to a radically different direction. Van Gogh set his sights down at ground level and across plowed fields, to "render the infinite tangible," by implanting the sacred in and through matter. Gauguin set his sights up to the heavens, mediated through the dream, to "rise toward God" by replicating divine creation above and beyond the contingencies and weight of matter.

DREAMING OR WORKING PEASANTS

The vehicle for both artists' evocative symbolism was the peasant figure, and both van Gogh and Gauguin initiated their formal experiments in preindustrial rural communities. Yet each painter construed the peasant in his own way, and each incorporated rural types into his innovative art very differently. *The Sower*, as we have seen, expressed van Gogh's abiding definition of modern art as inextricably linked to the active exertion of peasant laborers. In choosing to depict the world of humble labor, he

attached himself to those he considered the true servants of God, whose earthly production and sacred worthiness surpassed those of a self-taught painter struggling with inner and outer pressures for justification. Gauguin's peasants, by contrast, did not work, they dreamed; he approached them in *The Vision After the Sermon* not as expenders of outward bodily action but as compressors of inward mental space. The sower's generative stride amidst the grain deviated sharply from the passive stillness of the Breton women set in a landscape of their fecund imaginations. And even when they were engaged in physical work, the Breton peasants appeared to Gauguin not as agents of motion but as vessels of pious resignation, unmarked even by the signs of outdoor exposure. He wrote:

> *There is something medieval looking about the peasants here in Brittany . . . Their apparel, too, is little short of symbolic . . . Look how the bodice forms a cross in back, how they wrap their heads in headscarves, like nuns. It makes their faces look almost Asiatic,—sallow, triangular, dour . . . Still fearful of the Lord and of the parish priest, Bretons hold their hats and tools as though they were in church. That's how I paint them, not full of southern zest.*[63]

For van Gogh, as we have seen, *The Sower* amplified an abiding project of personal identification with laborers, resonating with his consistent pattern of associating the strenuousness and "vigor" of his own artistic work with what he considered the worthiness and productiveness of peasant labor in the fields. Stating that he would sow his studies and harvest completed works, and cut his furrow and plow on his canvases, van Gogh validated his painting project by assigning it the guaranteed returns yielded by the cycles of rural labor. And he further solidified his connection to the sower while he painted him, dramatizing his own forms of grinding exertion and dogged stamina. Driving his easel deep into the ground to resist the whipping gusts of the mistral, exposed to the blistering midday sun, and catching bits of dusty ground on his canvas nap and on his clothes, van Gogh made painting *The Sower* a self-conscious exercise in "sweat, soot, and soil."

Gauguin, by contrast, approached the peasant not as a vehicle for self-justification but as a tool for metaphysical and metapsychic extension, alighting on those at the base of the social system as spiritual fellow travelers in the artist's quest to propel the image toward the realm of purified, immaterial ideas and the source of divinity. If van Gogh exploited every opportunity to maximize the labor he

expended on *The Sower* and the labor of the sower he depicted, Gauguin, ever on the alert for what he called the "glimpse of the dream," promoted *The Vision* as an example of the free, immediate, and effortless transcription of the dissolving powers of mind over matter—a transcription that did not call for the artist to perspire, as he explained in his 1885 letter to Schuffenecker.[64]

FORMAL TACTICS OF REMATERIALIZATION AND DEMATERIALIZATION

Van Gogh and Gauguin mobilized the full repertoire of their pictorial techniques to realize their distinctive symbolist aspirations to the infinite, one poised toward embodiment and emanation, the other toward weightlessness and dematerialization.

As we have seen, van Gogh's stylistic development cohered as he discovered visual equivalents to emulate the preindustrial labor processes he associated with sanctification, and *The Sower*'s figural treatment, brushwork, and compositional structure carried the weight of labor to the canvas medium. Van Gogh altered and adjusted the pose of the sower, for example, to render his striding physical movement more convincing. The textrous physicality of his loaded brush unified the painting in intersecting horizontal and vertical units of stubby ground and nubby crops soaked through with radiant flecks of light. *The Sower*'s spatial organization and format maximized a visual interaction of density and movement enacted by the subject and reproduced by the painter's palpable and animated brush. The sliced furrow, cut by the painter and unfolding kinetically from the picture's front edges into the middle ground already traversed by the sower's procreative stride, immediately opened up the space and pulled the viewer dramatically into the background toward the distant blazing sun. The sun's position at the recessional center of the horizon indicates that van Gogh may have situated it with the aid of his perspective frame. Further evidence for this perspectively correct impulse underlying the structure of *The Sower* is suggested by van Gogh's original placement of trees flanking the sun, an instance of the "framed landscape" format that his frame encouraged. (He eventually painted over the trees as the painting developed, letting the sun stand alone as the riveted center.)

Now compare the figural treatment, brushwork, and compositional structure of Gauguin's *Vision*

After the Sermon. Where van Gogh reworked his sower to capture motion more plausibly, Gauguin's pursuit of translating "strong emotion" and the lineaments of the dream yielded immobile figures in trancelike stillness. The Breton women splayed out against the front edges of the canvas are all large heads and truncated bodies, in keeping with their dissociated state of pure consciousness split off from corporeal reality. The two women on the right side of the picture, with their backs to us, are altogether faceless, and their enormous white bonnets appear improbably anchored to their frames, resting, as if only temporarily, in a stasis of two sets of lowered giant wings suggested by the disposition of the bonnets' paired and oversize ribbon ties. The other earthly components of Gauguin's *Vision*, such as the floating tree with its vaporized leaves as "clouds" and the airily suspended and dainty cow, enhanced the panoply of figuration in Gauguin's *Vision After the Sermon* as an experiment in the subject and experience of transcending physical nature.

FRESCO BRUSH AND PIGMENT TROWEL

It is in the handling and application of brush to canvas that the two painters' emergent symbolisms attained their most tangible divergence. Van Gogh's loaded, sculptural brush composing *The Sower* announced his recurring expressive imperative to mark the canvas with the signs of a pictorial labor equivalent to actions of the subjects he represented; in contrast, Gauguin's smooth, attenuated brush forming *The Vision After the Sermon* aspired to evoke the fluid indeterminacy of the dream propelled from his subjects' inner consciousness.

Van Gogh's brush yielded a thick sediment of color by building up individual sticks of paint in the foreground field and bristling, abraded bars of ripe crop in the background. He reworked the canvas, as noted earlier, in order to reinforce *The Sower* as a surface of "heightened sculptural density"; the sticks, ricks, pulp, and fibrous blocks of the brushwork exemplified the ways van Gogh realized in his symbol of "a longing for the infinite" a record of what he called his "hand-to-hand struggle with nature," a nature wrested, wrestled, penetrated, and "disentangled" (Fig. 68).[65]

Gauguin's brush, by contrast, glided across *The Vision* to make a largely unbroken surface defined

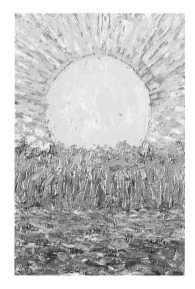

by rhythmic linear banding and broad, evenly applied masses of color. Pigment appeared to melt into the canvas rather than, as in van Gogh's *Sower*, augmenting it. The expansive areas of white tint defining Gauguin's Breton women's headgear, for example, spread across their assigned areas with the subdued delicacy of pastel or chalk rather than oil paint; the daring red of *The Vision*'s dreamscape appeared in brushed color, not molded but aqueous, level as a sheet of ice as it filled in unexpected crevices of the picture space with graded uniformity (Fig. 69).

Gauguin achieved the flush, lissome surface of *The Vision After the Sermon* as deliberately as van Gogh had applied *The Sower*'s paint for maximum density and concretion. By 1888, Gauguin had begun a series of formal experiments designed expressly to diminish the physicality of the canvas surface as much as possible. As the scholar Reinhold Heller has suggested, Gauguin devised a number of techniques—preparing the canvas with his own formula of a matte, white ground; using "thinned oil paint"; and experimenting with "a wax finish" rather than varnish—all directed to "mute the surface" and "enhance the flatness" of the image. The thin white ground, for example, created "a highly absorbent, chalklike surface," lessening surface texture as the paint soaked in and contributing to the effects of a smooth and chalky fresco.[66]

In these endeavors Gauguin extended the interests of his earlier circle of Impressionists in a decidedly anti-Impressionist direction.[67] Heller emphasizes Gauguin's engagement in developing formal methods to suppress materiality, pursuing what the painter called, paradoxically, the quest to "efface reality" in the plastic means of "forms and colors."[68] Gauguin's *Vision* was not only his first step along the "path of symbolism" but also the inauguration of his distinctive pursuit of canvas dematerialization. As Heller describes it: "The result of this combination [thin paint and chalky ground] is that no trace of a sculptured surface texture appears . . . With colors melting into the canvas itself, moreover, the physicality of the image disappears."[69]

Sculptured surface texture and physicality were precisely the formal vehicles that van Gogh exploited in his *Sower* brushwork in his ongoing quest to "render the infinite tangible." Gauguin's strategies to reduce these formal potentialities of oil paint brushed onto canvas in *The Vision* exemplified his very different ambition: to weaken materiality of its hold on consciousness, to invert outer and inner reality, and to repudiate the penetrative, entangling encounter with the embedded stuffs of nature in favor of a transcendent, divinized abstraction. This ambition expressed the idealist desire for the

symbolist dream world but was also propelled, as we shall see in the following chapter, by theologically specific impulses for purification, spiritual ascension, and visionary experience emphasized by Gauguin's Catholic formation.

COLOR IN NATURE AND BEYOND

Van Gogh's and Gauguin's choices of color also accorded with their different orientations toward the sacred. Van Gogh, we recall, sought in *The Sower* to modernize Millet with the evocative colorism of Delacroix's laws of simultaneous contrast. These laws, as van Gogh knew, had their roots in a scientific discourse posited by the French chemist Michel Chevreul, who urged painters to approximate the operation of colored light in nature by the juxtaposition of complementary hues. While van Gogh conceded some departures from these rules, his attempt to render *The Sower* in interlocking zones of violet and yellow complementaries, including their rearticulation along the painting's frame, indicated his interest in following the steps for an optically based formula for heightened luminosity. This naturalistic element of van Gogh's symbolist colorism had its analogue in his other stated inspiration from Delacroix for *The Sower*: his transfer of the radiantly yellow halo of Christ in the Boat to the glowing disk of his sower's sun, yielding a secularized source of vitalizing sacred light.

Gauguin's palette for *The Vision After the Sermon* moved sharply away from natural optical laws to an imagined supernatural effulgence. Rather than trying to match the interaction of colored light he had assimilated from Impressionism and the Chevreul model of complementary juxtaposition, Gauguin invented a new chromatic key modulated to the contours of inner vision and the wonders of a transcendent totality. This aspiration led him to a striking inversion of van Gogh's color choices. Van Gogh, redirecting the intensity of Christ's nimbus to the sower's domain, reserved the brightest color and fullest light for the sun saturating the fields, which he painted in the high-keyed "chrome yellow, number 1." Gauguin employed the exact same color—"pure number 1 chrome yellow"—for the angel's wings, reserving the radiant highpoint of his *Vision* for the unearthly realm of the supernatural. The surreal red of the dreamscape served only to further diminish the color of the human figures Gauguin placed in the foreground; the Breton women, a monochrome unit of black-and-white costume, and

with faces rendered in low flesh tones covered over with pasty white, visually paled in comparison with the incandescent technicolorism of their vision of the heavens.[70]

SPATIAL ZONES OF ENTRY AND OBSTRUCTION

A final feature of formal structure revealed the variation in van Gogh's and Gauguin's symbolist orientation in *The Sower* and *The Vision After the Sermon*. Compositionally, both paintings cohered in two major zones of space. Van Gogh's *Sower* consisted of a horizontal and vertical interlocking of plowed field in front converging with upright crops and sun at the back, mediated by the figure of the sower, who moved toward the viewer in a diagonal swath of space from back to front. As van Gogh lured the eye to retrace the steps of the sower, he also employed a second formal device to impel the eye into a corridor of space shooting dramatically into the distance—at the extreme front edge of the canvas, the furrow sliced and unfurled, creating a recessional thrust that immediately embedded the viewer in clods of earth as it directed the eye emphatically further into depth. Van Gogh's spatial organization thus constituted a three-tiered play on perspectival dynamics, which together operated to summon viewers into the picture plane and insert them in all levels of the animated, worked space: he coaxed the eye to follow the path of the sower; to propel down the runner of the furrow; and to alight unavoidably on the pivoted center of the sun at the exact horizon point at the back. Back to front, front to back, and diagonally across, van Gogh spatially incorporated viewers into the canvas and enlisted them as active participants in his artistic practice of sacred embodiment.

If van Gogh arrayed *The Sower* with conspicuous signposts of perspectival location, Gauguin's *Vision After the Sermon* dramatized a spatiality of obstruction. *The Vision*'s two zones, composing Gauguin's conception of different levels of reality, were decisively bisected by the tree, which acted not as an orienting passageway into the distance but as a visual hurdle to be cleared. Where van Gogh's sower moved toward viewers and simultaneously encouraged their eyes to be captured by the field's open furrow, Gauguin's women impeded viewers from entering their space. Backs toward the beholder and flat up against the edges of the canvas, the Breton women visionaries bore no signs of admission to their

inaccessible, mesmeric spiritual field. Their eyes closed and immobile, the women showed a meditative isolation from one another that was restated in their positioning as stalwart gatekeepers to beholders' desires for recessional penetration. Where van Gogh's *Sower* acted as a veritable manual for the workings of orthogonals and converging horizon lines, Gauguin's *Vision* deliberately shattered the rules of perspectival illusionism. The weightless cow, unanchored tree, and floating women at the left upper edges of *The Vision* all broke the ground of conventional pictorial organization; the biblical figures at the back of the picture, as has been noted, appeared to tilt up and out from their shallow assigned space. As with its inversion of color, Gauguin's *Vision* inverted the spatial ordering of van Gogh's *Sower*. Rather than pulling the viewer into a stretch of deep space toward a target, as van Gogh moved the beholder through the worked field to come to rest on the sun, Gauguin catapulted the background forward into the beholder's eyes, suppressing perceptual exertion for a sudden overtaking of material reality by the flow of the dream.

CHURCH FRESCO OR RURAL ALMANAC

Interestingly, Gauguin did not intend to sell his *Vision* painting; rather, upon its completion, he tried to donate the painting to a local Breton church, returning his depiction of popular piety to the site of his subjects' worship. "I wanted to give it to the Church of Pont-Aven," Gauguin wrote to van Gogh in September 1888. It "would be all right in surroundings of bare stone and stained glass."[71] If some of *The Vision*'s formal qualities of flatness, sheen, and chalky wash emulate a fresco, Gauguin's understanding that it would blend well with the "surroundings of bare stone" on the granite church walls deepens the resemblance.

Gauguin's assertion associating *The Vision After the Sermon* to the stained glass in the church also joins the form and content of his canvas to a devotional precedent in two significant ways. First, as scholars have pointed out, Gauguin may have been aware of specific resonances between his painting and the set of stained glass windows in the apse of the Pont-Aven chapel, which portrayed angels whose unscrolling wings and radiant color scheme also harmonized with these elements of *The Vision*.[72]

Second, more broadly, Gauguin made explicit statements about angels in church windows and the principles of modern decoration that could be derived from the interplay of light and color in stained glass. In an untitled and unpublished manuscript, most likely written, according to Daniel Guérin, between 1884 and 1889, Gauguin discussed the role of cathedral walls and stained glass windows, noting how painting in a cathedral melded with the surface of the wall rather than standing out from it. Gauguin presented the cathedral stained glass windows as dynamic agents of celestial light, "borne by angels, heavenly persons coming from the heavenly vault." Painting on the walls had to move into the surface of the wall, interacting with but not detracting from the elevated source of colored light:

> Let us go inside the cathedral, let's make the sign of the cross, a sign which it really deserves. Its windows are decorated with stained glass to which colored light is fundamental. For it is indeed there that the light should arrive in richly colored beams borne by angels . . . But the walls are and should remain walls . . . We believe we can establish a principle of decoration: on those walls, if there is decoration, see to it that not one centimeter of the surface of your painting stands out from its mural surroundings.[73]

In seeking a church home for his *Vision After the Sermon*, with its luminously colored matteness that he saw as in accord with both the bare stone walls and the stained glass of the Pont-Aven sanctuary, Gauguin invoked a doubly sacred function for the canvas. The passage from the unpublished manuscript suggests that *The Vision*, as partner to stained glass, could have acted as a wondrous filter of heavenly light, "borne by the angels"; as companion to the "bare walls," it had a frescolike translucence that could have fused with its sacred surround to transport the viewer into the realm of an exalted encounter with Jacob and the angel, effacing the distance between the visible world and the spiritual.

One could imagine how Gauguin's painting might have operated as part of a field of religious experience in which each aspect reinforced the others, in much the same way as the art historian Michael Baxandall has found for an earlier period, where sermon, gesture, and painting operated as indivisible and interacting paces in a communal choreography of worship.[74] While the priests at both the church in Pont-Aven and the one in the neighboring village of Nizon refused Gauguin's gift of his

Vision for placement in their chapels, his conception of its religious function highlights his determined attempt to link his artistic vision to the elemental visual faith he attributed to Breton peasants, and to explore new possibilities for modern forms of sacred painting, adapting the fresco and stained glass.[75]

Van Gogh's comments about his *Sower* also suggest his interest in a reciprocal connection with his peasant subjects. In construing a function for his symbolist experiment, however, he fastened not on the locus of worship but on the practice of work. As he described *The Sower* to Emile Bernard, van Gogh related his painting to a tradition of popular prints where images of labor combined prototypes of rural cycles with essential information on farming conditions: "I would much rather make naive pictures out of old almanacs, those old 'farmer's almanacs' in which hail, snow, rain, fair weather are depicted in a wholly primitive manner," he wrote.[76] In seeking to place *The Vision After the Sermon* in a village church where it would interact with private devotional meditation, Gauguin created a bridge connecting his work with what he called the "very rustic, very *superstitious*" simplicity of Breton peasant faith in a communal space.[77] Van Gogh's discussion of *The Sower*'s function pointed to another genre of word/image interaction: not as a collective stasis of sermon and visionary prayer, but as a community storehouse of information exchanged in pictures and texts for farmers' proficiency at cultivation.

CONCLUSION: FROM PAINTING TO CULTURAL FRAMEWORKS

Embodiment and emanation versus extension and dematerialization—multiple levels of the forms, meanings, and functions of van Gogh's *Sower* and Gauguin's *Vision After the Sermon* suggest the powerful differences between the two painters as they embarked on their experiments with symbolism. Van Gogh's art had evolved by 1888 into a symbolist project that can be called "sacred realism," a project of divinity made concrete and discovering the infinite in weighted tangibility. Gauguin's art had developed by 1888 into a symbolist project of transcendent idealism, predicated on release from the hold of inhospitable nature toward a purified realm of metaphysical mystery.

How can we explain this powerful disjuncture between van Gogh's and Gauguin's emergent symbolism? And how did the two painters' very different orientations toward the source of the sacred for

modern art create powerful impediments to their collaboration? Part Three will focus on one decisive factor in van Gogh and Gauguin's association and pictorial practice: the role played by their competing religious legacies. The terms of van Gogh's and Gauguin's divergent conceptions of art as sacred embodiment and as transcendent idealism were set in cognitive styles forged early and insistently by their distinctive religious and educational formations, which provided the two artists with different types of cultural resources and constraints, and partly shaped their different theories of life, attitudes toward reality, and approaches to the physicality of the canvas.

Catholic Idealism and Dutch Reformed Realism

CHAPTER FOUR A Seminary Education

It is . . . the purpose of Christian education to teach . . .
its pupils that the whole world is nothing.[1]

O World, do not flaunt your charms!
You do not enflame my desires.
What disgust, what sad tears
Must pay for your guilty pleasures![2]
MONSEIGNEUR FÉLIX-ANTOINE-PHILIBERT DUPANLOUP, BISHOP OF ORLÉANS

Long before he built an artistic theory around them, the themes of extension, fluidity, and detachment
aptly characterized some unusual features of Paul Gauguin's childhood. Born two weeks before the
bloody June Days of France's 1848 Revolution, Gauguin began his life in flight, his family propelled by
personal aspiration and political instability. His father, Clovis, a radical republican journalist for *Le
National*, and his mother, Aline Chazal, daughter of the radical activist Flora Tristan, decided to leave
France soon after Louis Napoleon was elected president of the Second Republic. In August 1849 the
young family embarked on a ship for Lima, Peru, where Aline's relatives lived and where Clovis hoped
to start a newspaper. But Clovis died suddenly at sea of a ruptured aneurysm, and Aline and her chil-
dren, Marie (born April 5, 1847) and Paul, moved in with Aline's great-uncle in Lima, Don Pio de Tris-
tan Moscoso, where they remained for four and a half years of Paul's early childhood.

In 1854 the family was again displaced—Aline returned to France with the children to accept an
inheritance and to reside with Clovis Gauguin's kin in the town of Orléans. Soon after their arrival, the
children's grandfather, Guillaume Gauguin, died; Aline, Marie, and Paul nonetheless stayed in Orléans
at the family residence under the guardianship of Clovis's brother, Isidore Gauguin. It was in Orléans,
between 1854 and 1864, that Paul Gauguin received his formal education, which shaped his mental
framework and his core attitudes toward reality.[3]

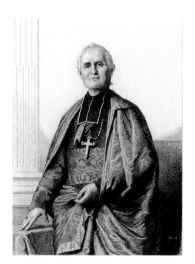

FIG. 70. THE BISHOP OF ORLÉANS, FÉLIX-
ANTOINE-PHILIBERT DUPANLOUP
(1802–1878). Reproduced from L'Abbé F.
Lagrange, *Vie de Mgr. Dupanloup* (Paris:
Poussielgue Frères, 1883)

ANTI-NATURALISM AND THE VISION IN GAUGUIN'S EDUCATION

After some time as a day student, Paul Gauguin continued his education as a boarder in a Catholic sem-
inary, the Petit Séminaire de La Chapelle-Saint-Mesmin, near Orléans. Here Gauguin engaged in what
he later called the "theological studies of my youth," which included Catholic liturgy, language, classics,
philosophy, and biblical literature.[4] Gauguin's courses in biblical literature were taught by the Bishop of
Orléans himself, the charismatic and well-known educational reformer Félix-Antoine-Philibert
Dupanloup (1802–1878), who had been a founder of the seminary (Fig. 70).[5] An architect of the Fal-
loux Law of 1850, which granted legal status to independent secondary schools for the first time since
1808, Bishop Dupanloup spearheaded a national campaign to transform French Catholic education
after the Revolution of 1848. He promoted this program first as a member of the Commission on Edu-
cation with Interior Minister Falloux from 1848 to 1850, and then through his massive and widely
known works, *De l'éducation en général* and *De la haute éducation intellectuelle*, each in six volumes,
which appeared between 1850 and 1863. The heart of Bishop Dupanloup's reforms lay in organizing,
with state support, a new infrastructure of Catholic secondary schools in the junior seminaries. The
seminaries were staffed not only by clerics but also by Jesuit teachers, who flocked back to France after
1850, when restrictions on their order, as on religious education in general, were lifted.[6]

An energetic activist in Orléans, Bishop Dupanloup sponsored the call to beatify Joan of Arc,[7] and
he also assumed the project of transforming education in his local diocese as his personal challenge.
The Bishop's influence on the Petit Séminaire de La Chapelle-Saint-Mesmin during the period of Gau-
guin's training there was extensive. Dupanloup lived near the seminary grounds and wrote some of his
treatises at a large work table in the salon of the central school residence; he started a program of walks
with his pupils to learn more about them outside the classroom. He supervised everything from cur-
ricula to building and chapel renovations, inaugurating a new corps of teachers in 1853 and new build-
ings in 1856. The changes were part of Bishop Dupanloup's plan to transform the Saint-Mesmin
seminary into a laboratory of a revitalized Catholic education, a virtual "ideal type" of the new national
system aimed at children in their critical preteen and teenage years.[8] Education, the Bishop believed,

was the key to recapturing the minds of French youth for a Church severely shaken by the dual menace of social revolution and excessive rationalism. "Children are the men of the future," he proclaimed.[9] "We will save the world if we give ourselves to the youth; let us mold these children into good Christians, and we will profoundly improve the present, and save the future!"[10]

Eleven-year-old Paul Gauguin was one of the youngsters on whom the Bishop projected the hopes of future French Catholicism. Gauguin's tenure at the Petit Séminaire exposed him to four central principles of Bishop Dupanloup's renovated Catholic teaching: idealist anti-naturalism; inwardness and imagination; identification; and a cultivation of interior vision, which subordinated the operation of sensory sight to the experience of divine light. These four principles were unified in their implementation in Dupanloup's most striking innovation: his transformation of the catechism. He altered it from a routinized recitation of articles of faith to a dynamic interrogatory encounter with the supernatural.

The "supreme purpose" of Bishop Dupanloup's educational mission was to seize the children's souls with the promise and irresistible appeal of man's supernatural destiny and otherworldly salvation. Centered on a dialectic of admonition and transcendence, his teachings alternated the indictment of a fallen world with a glorification of ascent to a higher realm.

On the one hand, Bishop Dupanloup emphasized a corrupted nature and transgressive human nature, and forewarned the children of an earthly existence fundamentally grounded in suffering, sorrow, and a dolorous reckoning with sin. He was particularly concerned with imparting to the children the dangers and defects of their own carnality, or "concupiscence."[11] The lure and transience of sensual pleasures yielded only desolation and putrefaction, graphically evoked in such chants as the "The Miseries of Life" and "On the Vanities of the World":

Mortal man, open your eyes, and see that misery
Pursues you, . . . and that all of life is a bitter source.[12]

Everything is only vanity, lies, and fragility . . .
In vain, to be happy, the young sensualist
Plunges himself in the sweetness of worldly seducers

and pursues enchanting pleasures . . .
Futile shadow, vile nothingness,
Sheer phantoms that vanish
As soon as they have lured him . . .
All succumb, all must be swallowed up in the tomb.[13]

Etched in the dualism of sensuality and affliction, Dupanloup's pedagogy dramatized the condition of the *enfant pécheur*, the child sinner, who had internalized the spectacle of descent to the pit:

How dreadful is my destiny! . . .
I see myself the prey and victim of hell,
And the criminal slave to a cruel demon;
If death takes me by surprise, I tumble to the pit,
And lose forever the eternal heritage.[14]

Bishop Dupanloup balanced these recitations of the treachery and impurity of material reality with descriptions of the magnificence of the heavens, accessible to the child's "open heart" and "expansive soul."[15] The vulnerable condition of the child sinner coexisted with the fortitude of the *enfant du ciel*, the child of the heavens, who could resist the lure of debauchery and exchange "fragile, instant" pleasures for the promise of eternal glory.[16]

Dupanloup sought to capture the children's consciousness with the wonders of their supernatural destiny and the joys of ascent to a celestial light, "to possess the heavens."[17] His celebration of the child's capacities for resistance to a tainted and ensnaring nature crystallized in two thematic patterns. One was the theme of "breaking the chains" that bound the soul to illusory worldly rewards. To be worthy of Christ's own *miséricorde* and torments, the child could emulate his sacrifice through penitence and practices of renunciation.[18] Second, Dupanloup glorified the child's focus on the heavens in a language of flight, freedom, and elevation. In his text *De l'éducation*, the Bishop characterized the children as "fallen from heaven"; they would recover their "wings" in an inner flight to "invisible regions" as they ardently sought the resplendent netherworld:

It is the duty of Christian education to reveal to those whom it is nurturing . . . how Christians, fallen from heaven, can find again . . . the road thither, and can reconquer . . . heaven's glory. It is, then, the purpose of Christian education to teach . . . its pupils that the whole world is nothing . . . that if they wish to quench their thirst for happiness (which longing is at the basis of their nature and which constitutes the immense ardor of their soul), it is at the foot of the altars of grace and the Gospel that they shall find wings with which to fly into invisible regions where they can hope . . . to possess God himself and to be united with Him in the splendors and delights of eternity.[19]

The longing of winged souls could never be stimulated solely by what Dupanloup called the "dry science" of reason.[20] Deeply anti-positivist, Dupanloup built his new Catholic education on a theory of the child as a dynamic, whole being, for whom learning must be treated as "a process of developing mental activity instead of injecting knowledge into the mind."[21] He elaborated a fundamental distinction between instruction, "which provides the mind with knowledge of things," and education, "which lifts up the whole soul" and "forms, at the same time the understanding, the heart, the character, and the conscience."[22] "Dry instruction" would only create "cold hearts" and divest the children of their claim to being a reflection of divine powers.[23] If nearness to God was the goal of education, it had to resemble the unitary ideals—moral, aesthetic, and spiritual—of divinity: "God is Supreme Truth, Beauty, and Goodness: but are not the True, the Beautiful, and the Good the essential object of intellectual and moral educational training? Do not the faculties which are to be educated resemble God? God is life, intelligence, and love; is the child taught else?"[24]

To launch young souls toward God, Dupanloup appealed to "the supernaturally infused" powers of imagination and self-expression. Stories, games, pictures, and hymns would allow children to "understand, feel, and imagine," to relate the things "they know, see, and do every day" to the life and experience of Christ. Dupanloup challenged the children to ask questions and mobilized their imaginations by insisting that they take an active part in the liturgy. Rather than being passive spectators, argued Dupanloup, the children had to "play a wonderful role in the divine drama."[25] One of these roles was that of sacred decorators—Dupanloup enlisted the children to adorn the chapel for special feast and festival days. Above the doors of the sacristy hung paintings depicting Saint John and the Virgin

and Child; by contributing their own works, the children would make the chapel their own and be irrevocably bound to the wonders of God:

> *A place which . . . [the child] has ornamented, which he has decorated himself, is a place he loves, because he has put something of his own there, and because . . . he sees himself there, and because it is in the nature of a child, as well as of a man, to love himself in his works. Here then is a means, an infallible secret, for attaching these young children to their Chapel . . . It is self-love, some will say: yes, but a good self-love; it is self-love made use of to turn the heart towards God and holy things; it is the art of making nature serve grace, of grafting the Christian onto the man.[26]*

The Orléans seminary program also turned imagination and expressive resources inward on the self. Daily prayers, confession, and private meditation were directed toward self-scrutiny and accountability for transgression. But self-reflection also reserved an arena for subjectivity of a less punitive, more expansive kind. Ernest Renan, during his teens another pupil of Bishop Dupanloup, later described in his memoirs the interaction of anxiety and imaginative flight cultivated by the junior seminary education. The clerical practices, Renan wrote, shaped habits of self-examination, generating intense curiosity and acute worry over sinful infractions. At the same time, the program carved out for Renan the realm of imagination; he noted that during meditations and chapel, he would "fall into veritable dreams."[27] This combination of "inward-looking-ness" and otherworldly fixation gave priority to the realm of the "ideal," setting in his mind that "Christianity is the summary of all that is ideal," and that all else is "secondary, lowly, almost shameful, *ignominia seculi*."[28] Jean Pommier, in the introduction to Renan's memoirs, went further than Renan himself, explicitly identifying the special resources of subjectivity and idealism dominating the seminary education. Extending Renan's analysis, this commentator characterized the junior seminary program as the "reign of the self"—*le je*—which honed techniques of introspection and self-examination among the young French pupils and favored the state of the *repli sur soi*, the "folding in on the self." The focus on introversion also facilitated, he wrote, "the surrender to dreams flooded with abstractions."[29] We will see later that when Ernest Renan turned from

religion to philosophy, he, like Paul Gauguin, would direct the resources of self-scrutiny and idealism to new secular purposes.

If art and self-development were pressed into the service of grace, Bishop Dupanloup's educational practice attached the children to divinity also by his own gift for identification with them, which he expanded into a primary element of Catholic teaching. Former students and other contemporaries of Dupanloup emphasized his unusual attunement to the children's inner lives and his capacity to elicit their best. Renan called the Bishop *un éveilleur incomparable*—"an incomparable animator" or inspirer.[30] "Every day," Renan explained, "Dupanloup put himself into immediate rapport with all of his students by an intimate interview" marked by "naturalness and abandon."[31] In *De l'éducation* Dupanloup advocated empathic identification as being essential to effective teaching, as well as providing a model of true faith. The difference in age and station between priests and children would dissolve in the totalizing spirit linking their hearts to God. "Make no mistake, gentlemen," Dupanloup noted, "we will obtain happy results only by identifying ourselves with the children, by becoming one with them, by creating together one voice, one heart, and one soul: *cor unum et anima una*."[32]

"OÙ ALLONS-NOUS?": BISHOP DUPANLOUP'S NEW CATECHISM

The new catechism implemented throughout the Orléans diocese and in Gauguin's seminary was at the heart of Dupanloup's reformed Catholic education.[33] To Dupanloup, the tripartite catechism, "a series of short questions about Catholic dogma," had deteriorated into a lifeless memory test.[34] He aspired to reanimate the catechism as the central node of moral education, a vehicle for rumination on the fundamental questions of man's origins and supernatural destiny. Rather than reciting arid formulas, children could find within the question-and-answer format of the new catechism an opportunity to exercise their curiosity and engage in abstract thought. Revitalizing the catechism was the fundamental means to "capture their souls for God."[35]

In presenting what he called the new "schemes of instruction" for the catechism, Dupanloup offered questions that progressed incrementally toward greater complexity as the students moved up in

school level.[36] Beginning with questions such as "What is grace? How many kinds of grace are there? Who is the Holy Spirit? Can we resist grace? How must we pray?," students moved through explorations of the "perfections of God" and Jesus Christ's "suffering" and "glorious life." The first-year course ended with the mystery of the incarnation and redemption. Here Dupanloup wrote of angels in vivid questions, such as "Who are they? What do they do?," and made probing queries about death: "What is Death?—Why is it?—Do we all die?—When shall we die?—How shall we die?—Does the soul die? . . . *Particular judgment*—Why?—When?—Who will judge? How?—Concerning what?"[37]

Dupanloup hoped that these metaphysical inquiries would yield, through "interior work," a "lifting up of the whole soul toward God."[38] He developed a sophisticated theory of memory and the role of the catechism in building an inner storehouse of association. He considered the catechism the foundational structure in the architecture of the children's memory; its clarity and force would be irresistible and leave a lifelong, indelible imprint. A "substitute for the family," the catechism would overtake the child's inner world, becoming the psychic home—*le foyer intérieur*—where the most intense emotions and assurances gathered, to be automatically lifted to mind without conscious mediation.[39] The striking clarity and concise terms of the catechism, the Bishop wrote, "capture the entirety of religion"; "ineffaceable, once engraved in memory, they remain there for life." Dupanloup predicted that even "men who had lost their faith" and were living "the most irreligious lives" would find themselves "instinctively, instantaneously," summoning the catechism to consciousness.[40]

In one of his texts on the catechism, Bishop Dupanloup emphasized the unique effectiveness of the interrogatory form, the technique of unfolding a series of declamatory questions. Here he highlighted a trio of questions that encapsulated the essence of all faith—the search for the meaning of the origin, existence, and destiny of man. These questions were "where the human species comes from" (*d'où vient l'espèce humaine*); "where it is going" (*où elle va*); and "how it goes" (*comment elle va*).[41] To isolate the three questions, Dupanloup quoted the noted philosopher Jules Jouffroy, who asserted that all Catholics could find a "solution" and "response to every important question that interests humanity" in the special format of the catechism absorbed in their youth.[42] Significantly, it was after he had lost his own faith that Jouffroy wrote the passages extracted by Dupanloup. Jouffroy had made his reputation as a writer and orator at the Collège de France by transposing the fundamental questions of his Catholic youth into a context without predictable answers. One example is part of Jouffroy's dramatic

lecture of 1840, which explored the fundamentally dolorous condition of earthly existence. His Catholic legacy was echoed, but transformed by the new condition of unanswerability: "Man is born in sorrow; from cradle to coffin, he endures the miseries of body and the afflictions of the soul; he aspires to power and remains weak; he is prideful and is humiliated . . . Who will give us the explanation for these sufferings? . . . What then is the destiny of man on this earth?"[43] In relying on Jouffroy, a lapsed Catholic who nonetheless affirmed in his writing and his orations the coercive power of the catechism's interrogatory format, Bishop Dupanloup underscored his own major point about its indelible stamp in memory.

In addition to writing on the interrogatory method, Dupanloup explored more precisely the process of the "interior work" he assumed would unfold through religious education and a revitalized catechism. In *De l'éducation*, Dupanloup characterized the child's "interior work" as a process of purification, distillation, and exaltation that moved from materialism to idealism, sight to light, and sound to silence. In a chapter called "The Word," the Bishop noted first that language was only a carrier of the idea—"the idea is always primary, and clothes itself in the word."[44] Seizing souls and raising them to God involved the penetration and infiltration of the inner world by the idea, to which Dupanloup assigned three levels. He described them as "the first, second, and third *jet*"—the French word for a spurt or ray. The first *jet* was like a vivid burst of light but was only preliminary; the second, a slower, permeating procedure, marked a quest for a "more perfect light." The third *jet* showed the idea "triumphant"; Dupanloup invested it with an incantatory appeal expressing an inexpressible exaltation—incorporative, extensive, pervasive, elevated, and resplendently clear: "It is the idea that seizes, possesses, extends, elevates, and deepens, illuminated by all the powers of the soul: it is perfection, the perfectly luminous idea."[45] As the idea exfoliated into all crevices of the soul, the supplicant moved from speech and sound to sacred silence. "Only in a great silence does God's grace descend into souls: *Non in commotione Dominus*," proclaimed the Bishop. In silence, the "penetrating conquest of the soul" took hold. The result of the three *jets* and the hushed surround of "mysterious, indefinable" silence yielded a state of being beyond the senses and having a direct, unmediated connection to God. In this "moment of the great conquests of grace," the spirit and the heart were so overwhelmed and uplifted that the senses remained "as if intertwined and suspended": "it is the silence of the heavens!"[46]

Dupanloup gave an example of this state of grace in remembering a young boy, "on his knees,

prostrate in adoration," with "his eyes fixed on the tabernacle." The body remained there, motionless and transfixed, for "more than two hours."[47] In a final analogy, Bishop Dupanloup presented this quest for the grace of pure inner light and silent sensory suspension as a spiritual harvest. The ground readied for the harvest was not the soil but the soul. Disengaged from worldly commotion, the inner work "necessitated sowing and plowing" to "implant God" in the soul, and finally "yielding the harvest."[48]

CATHOLIC THEOLOGY AND GAUGUIN'S MENTALITY

After at least four years in the Orléans Saint-Mesmin seminary, Paul Gauguin—now estranged from his mother, who bade him make his own way—set off in 1865 to sea, where he would spend six years, first as a sailor in the merchant marine and then as an enlistee in the French navy. During the long voyages taking him to Panama, to Africa, and twice around the world, Gauguin experienced many hours of solitude. Posted as a "seaman, third class" to the ship of Emperor Napoléon III's cousin, the *Jérôme-Napoléon*, Gauguin was a crew member on an 1870 voyage to Norway whose guests included Ernest Renan.[49] Renan, the former junior seminary student of Bishop Dupanloup, had by then become the controversial philosopher, linguist, and historian who had turned his training against the clerical establishment in his multivolume *Vie de Jésus*. The first volume, published in 1863, had sold sixty thousand copies in the first five months.[50] No existing evidence indicates that Gauguin and Renan had direct encounters on the ship, but as we shall see in Chapter 10, Renan's ideas and texts became central to Gauguin's later development as a painter and a writer of religious polemics.

On his return to Paris in 1872, as we saw in Chapter 1, Gauguin took up a position as a stock-exchange agent under the patronage of his godfather, Gustave Arosa, collected art, and began to paint part-time. Through Arosa's circle Gauguin had met a young Danish woman, Mette Gad, whom he married in 1873; by 1883 Mette had given birth to five children. That year Gauguin chose to relinquish his lucrative profession in finance for painting, jolting himself and his family out of the security of his substantial salary to dedicate himself full-time to art.

Gauguin's break from a conventional career path coincided with his intention to remove painting from the predictability of anecdotal realism and the sensory charm of Impressionism. In 1885 he dis-

cussed with his friend Schuffenecker his ideas about the links between emotional immediacy, dreaming, and representation, suggesting to him the possibilities of pictorial forms as expressive equivalents of emotional states.[51] In 1886 Gauguin embarked on the first of many trips to Brittany, where he was captivated by "the soul" of the region and its inhabitants. By 1888, Gauguin had found a form for his "way of rising toward God," his *Vision After the Sermon*.

Gauguin's few explicit comments on his Orléans seminary education are recorded in his journal *Avant et après*. He credited his special religious training with a number of benefits to his "intellectual development" and noted that he "made very rapid progress" from the time he entered the seminary at eleven. "It was there I learned . . . to distrust everything that was contrary to my instincts, my heart, and my reason," he wrote.[52] That triad—instinct, reason, and heart—recalls Bishop Dupanloup's charge to cultivate in children the dynamic, integral powers for "life, intelligence, and love" as resembling the unity of moral, aesthetic, and spiritual faculties of the Divinity.

At the seminary "I also formed the habit of concentrating on myself," Gauguin noted in his journal.[53] His inwardness accords with the "interior work in souls" that was the "supreme purpose" of Dupanloup's seminary teachings. Indeed, Gauguin often invoked what he called "internal worship" as a primary standard of measure for his definition of the self and the sacred. As he wrote to Bernard's sister Madeleine in October 1888, "to be *someone*, retain only the results of your independence and your conscience . . . Maintain a duty . . . based . . . always on sacrifice, having only *your conscience* as your judge. You must raise an altar to your dignity and your intelligence, and to nothing else."[54] This stance of interiority combined in the adult Gauguin the rigors of self-scrutiny with the more expansive habits of imaginative flight cultivated by the seminary's program of introspection. Gauguin transposed the interplay of censorious reckoning and expressive release available in his religious formation to a new key of artistic subjectivity, mingling exalted self-flagellation with the *voyage intérieur* as the site of unprecedented creativity.

Gauguin did not remain an adherent of Church doctrine, and he exchanged the uniform of the priests' school for the flamboyant costumes of capes, hats, and vests that advertised his uniqueness among the Parisian and Breton avant-garde. A modern painter, Gauguin openly defied conventional religion and engaged in biting polemical attacks on Catholic hierarchy and authority.[55] Yet his vigorous anti-clericalism and his rejection of institutional religious practice coexisted with a mentality indelibly

stamped by the theological frameworks and religious values that formed him. In turning from religion to art, Gauguin kept his sights fixed on the heavens, and he remained bound to an expressive pattern etched in the dualism of profanation and purity drilled in the Orléans seminary. The legacy of Bishop Dupanloup afforded the particular cultural space within which *The Vision After the Sermon* could emerge as a symbolist image of transcendent encounter.

The Bishop's description of the Christian condition as one of restive longing and ardent quest for access to eternal "invisible regions" had put Gauguin on the alert for an ideal totality beneath the surface of appearances. Dupanloup, graphically evoking the horrors of the pit against the splendors of the heavens, had considered his Christian children not simply spiritually lost but physically "fallen from heaven" and in need of retrieving the "road thither"; the road could be reached only by ascent and by recovering their "wings." Gauguin, one of the seminary's young fallen angels, absorbed the message of the terrestrial world as a site of loss and longing and saw the return to a non-natural realm of divinity as irresistibly appealing. He found his wings at the new altars of art and the self, reclaiming the road upward on his "path of symbolism."

GAUGUIN'S ANTI-NATURALISM AND ANTI-POSITIVISM

Gauguin's letters reveal his distrust of nature and material life, a distrust cast in the theologically charged language of corruption, contamination, and impurity. Writing to van Gogh of his "sullied [*sale*] existence," he described the artist as weighed down by tainted contact with a debased and tawdry world.[56] Gauguin's *misérable* painter was "pure," uncorrupted by the "putrid kiss" of the conventional academy, the Beaux-Arts.[57] Gauguin presented the impediments to virtue and value in the image of the chains, the state of being dragged down in a lower order, whose converse was a state of liberation in flight, elevation, and release. We recall the tormented modern artist of the 1888 self-portrait, dragging his ball and chain. In another passage, Gauguin contrasted the work of "down-to-earth *pompiers*," academic artists stuck in rendering the natural world, with his own new art, unmoored, set to "sail on our phantom vessels."[58]

Bishop Dupanloup had summoned his students, in canticles and recitations, "to break the chains"

of inevitable earthbound "miseries" and seek "the prize"—to "possess the heavens." Gauguin echoed this imagery of chain and transcendence to a paradoxical purpose of painting beyond the confines of materiality. Two passages in the letters summarize the ethos of indictment and ascent that echoed the Orléans theology. First, in a letter to Bernard's sister Madeleine soon after he completed *The Vision*, Gauguin warned her against "vanity" and "venality" and urged her to aspire to sacrifice and to fulfill only the demands of her own conscience. Here Gauguin asserted that "everything divine must not be a *slave* to matter, the body . . . *Every chain* springs from an inferior order, and to act as a slave is to disregard divine laws."[59] Second, Gauguin wrote to Bernard in 1889 of a resignation to suffering, to the artist's life as a calvary, and highlighted the irrevocably agonistic relation between mortal man and matter. "When you come right down to it," Gauguin declared, "painting is like man, mortal but always living in conflict with matter."[60] The task of painting, given this condition, was to set sail on phantom vessels toward the infinite, to "ascend toward God." Gauguin expressed this stance of abstraction from a sullied world by choosing to paint a visionary state in 1888, exploring shifting levels of reality, the melding of vision and the visual.

The anti-positivism of Dupanloup's educational reforms at Orléans created another building block in Gauguin's mentality. As Gauguin defined his emerging symbolist art in 1888, anti-rationalism emerged as a critical element. Gauguin's denigration of the limits of Impressionist "scientific" observation and his elevation of the "mysterious centers of thought" resonated with Dupanloup's critique of dry facts and accumulated knowledge, and his promotion instead of imaginative powers to vitalize children's minds and "lift up the whole soul." Gauguin's symbolist conception of art as an evocative form that offered intimations of a supernatural order by allusive, non-narrative means was also prefigured in Dupanloup's discussion of sacred language. Two decades before the symbolist writers announced their intention to reject narrative description and the false polish of literalism and to "cloak the idea in material form," Bishop Dupanloup urged priests to touch souls by conveying the immediacy of the idea, which was merely "cloaked" in the form of the word.[61] Only by abandoning the composed formal elegance of the orator could the power and primacy of holy truth be communicated, Dupanloup argued. Indeed, the goal of sacred language was to move from the expressible to the inexpressible, with speech inevitably yielding to the wonder of divine silence.

One essential part of Dupanloup's anti-positivist educational program called on the arts to

activate imagination and self-expression in the pious seminary child. We do not know if and how young Paul Gauguin participated in such activities as adorning the Saint-Mesmin chapel on saints' and other special days. Yet the model of sacred decoration reappeared as a motive force for his first symbolist painting when Gauguin aspired to hang *The Vision After the Sermon* in the church at Pont-Aven or Nizon. Gauguin's view that the painting would accord well with the stone and stained glass of a Breton chapel suggests that the Bishop's assumptions about the power of art may apply in Gauguin's case. When the child made the chapel his own by creating art for it, Dupanloup had asserted, he was being moved from self-love toward God, toward "holy things." Gauguin's turn to symbolism in 1888 reclaimed a site where an immutable faith was to be imprinted on the hearts of youth through the binding power of artistic production.

SEMINARY RESONANCES IN GAUGUIN'S *VISION* PAINTING

Let us take a final look at how the form and content of *The Vision After the Sermon* reconnected Gauguin to a number of specific features of his seminary education. It was no accident that his first experiment with symbolism took the form of an imagined encounter with the maneuvers of an angel. The Saint-Mesmin curriculum and catechism had encouraged a habitual shift from one level of reality to another and a fluent interaction with supernatural figures, elicited in interior visualizations and interrogations. The angel had a particularly charged position in the repertoire of inner worship practiced at the Orléans seminary. Bishop Dupanloup had considered the children he taught there, Gauguin among them, a group of fallen angels questing for re-ascent after recovering their lost wings; the Bishop's new catechism had encouraged active mental thoughts of angels.

The Vision tapped these chords as it re-created this early exercise of interior visualization and assigned it to the group of praying peasant women. Indeed, *The Vision After the Sermon* cohered as a double inner vision and double projection—the artist inserted himself into the women's minds, imagined their imaginations, and projected their divination outward. One might link this act to the tradition of Baudelaire's artist in the crowd, who claimed entitlement to "invade any soul at will" as the requisite raw material for his voracious creative imagination.[62] Yet such a reading would ignore the reli-

gious elements of Gauguin's modernity, and overlook the cultural resources that made it possible for him to think of artistic innovation in the form of a religious painting melding the artist's dream and the visionary faith of Catholic peasant women. In choosing the praying women as his collaborators in passing through the limits of the natural to the supernatural, Gauguin reasserted, in a new form, the totalizing idealism powering his religious education.

Dupanloup had highlighted identification as a central model of teaching and had appealed to a unitary solvent of faith that joined priest and children in spiritual experience that defied the boundaries of reason, age, and station. Gauguin reasserted this "union of souls and hearts" in *The Vision* and represented it as the artist's and peasants' common quest to "rise toward God" by dreaming, creating, and transcending nature.

Further traces of Saint-Mesmin religiosity emerge in Gauguin's placement of a single male figure joining the group meditation: the priest at the far right, cut off at the extreme foreground edges of the picture plane. Like the women, the priest has closed eyes, heavy lids, and trancelike stillness, and he is enveloped, as are they, in the glowing red expanse that joins the natural and the supernatural across the divide of the tree. The deportment of all the figures assembled in Gauguin's *Vision* corresponds to Bishop Dupanloup's description of the stages of spiritual exaltation, with its shift from matter to idea, sound to silence, and sensory sight to exfoliating inner light. Recall how Dupanloup characterized the progressive permeation of the soul by the *jets* of the divine idea, which began with a burst of light and ended in perfect clarity and concentrated luminescence. As the inner world yielded to divinity, according to Dupanloup, sensory suspension and mysterious silence took over, and the state of uplift was expressed by motionless transfixity and vision riveted to sacred beholding beyond the visible world.

The participants in Gauguin's *Vision After the Sermon* adopted the stance and qualities of this mesmeric fixity of vision beyond the senses; they resembled Dupanloup's supplicants, hushed and kneeling at the altars of grace as they quested for ascendance to the heavens. Suspended from the limits of time, space, and sensory perception, Gauguin's visionaries appeared as seized souls, possessed by the expansion of the divine ideal. The permeation of the radiant red ground into all crevices of the canvas provided a pictorial equivalent to Dupanloup's third *jet*—the overtaking of material reality by the brilliant, unmediated extension of resplendent divinity.

In Dupanloup's rendering, the priest, while ultimately sharing the incommunicable essence of

inner grace with his pupils and flock, was also the initiator of the ideal's inevitable "conquest of the soul." It was the priest who released the initial stages of the progressively incorporative *jets* by his reduced, unadorned words, which Dupanloup defined as bearing the proper "cloak" of the divine idea. The priest's work was complete when he joined the supplicants in silent, transcendent, inexpressible union with divinity. In including the priest, and in presenting him as being as absorbed as the women in trance-like devotion, Gauguin's *Vision* captured the passage from commotion to reverence, words to sight, that Dupanloup had ascribed to the work of an authentic priesthood. In choosing to depict the period of

FIG. 71. PAUL GAUGUIN, *DECORATED WOODEN BOX*, ca. 1884–1885, pear wood with iron hinges, leather, red stain, inlaid with two *netsuke* masks, 21 x 13 x 51 cm. Private collection

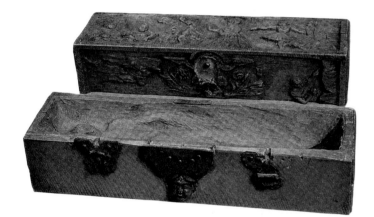

silent, visionary beholding following a spoken sermon, Gauguin recapitulated in pictorial form the particular quest for exaltation beyond the contingencies of language and sociality that the Bishop had promoted in the Orléans seminary of Gauguin's youth.

Significantly, Gauguin endowed the priest figure in the painting with his own distinctive features, and scholars have proposed, convincingly, that Gauguin is the priest.[63] If this is the case, Gauguin replaces Dupanloup as the initiator of and communicant in the all-encompassing power of the divine ideal. By transposing the artist into the priest as one among other visionary worshippers in his first symbolist painting, Gauguin was not simply exercising his tendency toward self-aggrandizement, for *The Vision*'s priest is not a privileged conjurer of an ideal heavenly world inaccessible to other human agents. Indeed, Gauguin has made the priest a partner in exaltation with his congregants, as Dupanloup proposed for the catechizer. In the *Vision* painting, the woman with hands clasped at the left edge, the central woman in profile staring across the tree to Jacob and the angel, and the priest at the right edge of the canvas are equal claimants on our visual attention, and are each uniquely poised in their own type of reversion from matter to a vision of the sacred ideal. Gauguin as priest/artist identified with the peasant women not as effortful physical workers in the fields

but as mesmerized collaborators in the visionary harvest of the soul. The flowing red ground of *The Vision After the Sermon* abounds in the spiritual fruits sown into Gauguin's interior world by his Saint-Mesmin seminary brand of Catholic idealism.

PLEASURE AND THE PIT: GAUGUIN'S DECORATED WOODEN BOX

If *The Vision* adapted the themes of a theology of ascent, Gauguin's art also engaged the more punitive and censorious anti-naturalism of his religious formation. During the period before his association with van Gogh, Gauguin expressed an enduring preoccupation with the themes of misery, profanation, and suffering, which he attempted to project into a repertoire of modern allegory. In 1884–1885, for instance, Gauguin produced a decorated wooden box whose form and symbols made visible a dialectic of earthly pleasure and desolation (Fig. 71).

Gauguin created the box as a jewelry case for his wife, Mette. He carved the front and top panels of the box with figures inspired by Degas's ballet dancers at the theater (Figs. 71a and 71b); on the back of the box, he attached two Japanese *netsuke* masks and carved a plaque with his signature (Fig. 71c). These motifs gave way on opening not to a space for holding jewelry but to a recumbent nude body resembling a mummy in a sarcophagus (Fig. 71d). Gauguin probably based the recumbent figure on his study of mummified remains in a Bronze Age wooden coffin he had encountered at the Copenhagen Museum when he was living in Denmark with Mette and their children.[64] He dramatically evoked the disintegration of an

a.

b.

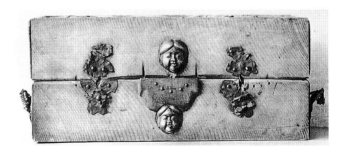

c.

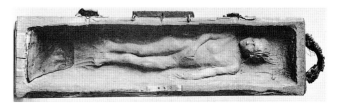

d.

entombed body by presenting the limbs in states of incompleteness and dissolution. A truncated hand marked the arm draped over the body's middle, and he carved only the upper half of an outstretched arm along the side of the figure, leaving the areas below the elbow indefinite, fusing with the wood from which it barely emerged in relief. These techniques gave the figure a quality of suspension and of merging with its material, graphically signaling the physical decomposition of the body in the box.

Gauguin's decorated box has been interpreted variously as evidence of incipient symbolism, as an expression of personal bitterness concerning his wife's vanity, and as a generalized *memento mori*, a sardonic meditation on the theme of the emptiness of worldly pleasures, the belief that "the wages of sin are death."[65] But what compelled him to produce such an unusual object, and why did he choose this particular visual form?

Allegorical impulses and the resonances of the Orléans Petit Séminaire provide a context for some partial explanations. Gauguin's box, a macabre interplay of sensuality and putrefaction, bears a striking affinity to the ethos of *contemptus mundi* in the teachings of Bishop Dupanloup. The juxtaposition of worldly pleasures carved on the outside of Gauguin's box and the tomb effigy on the inside, for example, corresponds to the vivid association of vanity and perdition coursing through the daily prayers and chants of the young seminarians. One canticle, "Sur les vanités du monde," contrasted the accumulation of gold and silver to the inevitable disintegration of matter in the tomb. Gauguin's box of death holding Mette's jewels provides a visual analogue to this dolorous admonition of his Catholic education:

> *Everything is only vanity, lies, fragility . . .*
> *All these brilliant externals, . . . these treasures,*
> *Everything dazzles; but all eludes us . . .*
> *What will become of them, for man who must die,*
> *These accumulated goods, this gold, this silver hoard? . . .*
> *For him, all of it ceases to be:*
> *The day of his mourning*
> *He has nothing but a coffin . . .*
> *All succumb, all must be swallowed up in the tomb.*[66]

Gauguin's paradoxical project of investing a material object, a decorative wooden box, with an evocation of the dissolution of corporeality in the pit, had its origins in a theological culture where the dramatic dualisms of pleasure and perdition, carnality and suffering, were vivid and integral parts of recitation and representation.

PRODUCTION AND THE MÉTIER: VAN GOGH'S YARN BOX

Vincent van Gogh's mental habits were also etched in dualisms, but his were of another order and another type. Before the two painters met, he, too, created a decorative box, highlighting a central ambition of his

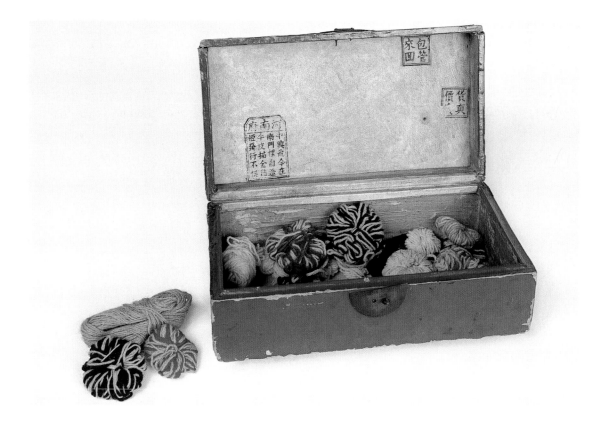

FIG. 72. VINCENT VAN GOGH, RED LACQUERED BOX WITH COLORED YARN. Van Gogh Museum, Amsterdam (Vincent van Gogh Foundation)

own artistic enterprise. Where Gauguin's box formed a macabre allegory of the "human vanities," van Gogh's 1886 box held the tools he needed for an artistic practice considered, fundamentally, as a craft project bearing tangible signs of production.

Van Gogh's box, a red lacquered container, bore calligraphic ink designs on the outside and was originally a Chinese tea box (Figs. 72 and 72a). Having kept the container, van Gogh used it to store his collection of balls of colored yarn. Emile Bernard described how he observed the yarn balls on his friend's studio work table in Paris, arranged in "unexpected interlacing tonalities."[67] One of the skeins was made up of yellow and violet threads laced together; another had shades of yellow, and others blue strands with yellow.

72a.

In studying the play of color tones with his colored yarn balls, van Gogh re-created the method used by Michel Chevreul, author of the most important books on color theory for nineteenth-century painters. Chevreul was the director of the Gobelins Tapestry Works, and he had systematized laws to maximize the iridescence of color through their contrast, based on his experiments with dyeing threads and testing their luminosity when placed next to other color-dipped threads. Chevreul recommended not only that painters conform to these laws of color but that his discoveries be adopted to raise the quality of many applied arts, especially the arts of weaving, tapestry making, and rug making under his direct supervision at Gobelins.[68]

Van Gogh had read and absorbed Chevreul's color theories while he was in Nuenen in 1884–1885, during the time that he studied the hand-loom weavers in his parents' village and depicted them in thirty-four images of varying media. Weavers made up eighty percent of Nuenen's working population in the 1880s; of the 440 in number, most were the so-called *bontwevers* who wove brightly colored, striped and checkered materials called *bontjes*. A few of the Nuenen weavers also wove checked kitchen towels.[69]

The months of daily observation of the weavers activated van Gogh's interest in applying paint as threads and color as fibers, to be placed on the canvas so as to intersect in the same way as the warp and

weft of woven cloth. This weaving of color extended van Gogh's pattern of identification with the craft labor of the weavers.[70] In executing the weaver series, van Gogh articulated the equivalence between his artistic work, what he had called his *métier*, and the work of the weaver at his loom, *le canut à son métier*. He expressed this equivalence by signing his own name on the wheel where the thread was released to the loom shuttle, and by presenting the weaver "drawing threads" in a position strikingly similar to that of an artist directing his pen across the surface of the paper (Fig. 73). He reinforced the identification between the two craft activities by comparing the artist's mechanical tool of his own construction, his perspective frame (Fig. 25), to the rugged frame of the weaver's loom. In the frontal *Loom with Weaver* of 1884 (Fig. 74), van Gogh's perspective frame is incorporated in the loom's frame in several ways: the threads of the loom are suspended in a pattern echoing that of the perspective device, and the wooden stakes supporting the loom's oblong frame are marked by a series of notches. The notches replicate the functional holes on van Gogh's perspective tool that served as adjustable points for fixing the wooden frame to the two poles. By highlighting the resemblance between his own tool and the weaver's, van Gogh visibly attached himself to the craft labor process depicted, uniting the distinctive feature of the frame of art with the frame of the loom.

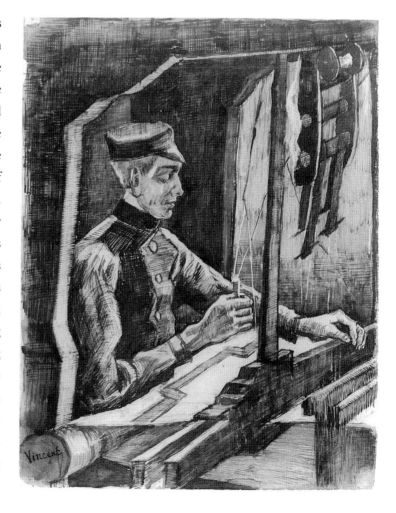

FIG. 73. VINCENT VAN GOGH, *WEAVER FACING RIGHT, HALF FIGURE*, 1884, pencil, pen and ink, washed with bistre, heightened with white, on paper, 26 x 21 cm. Van Gogh Museum, Amsterdam (Vincent van Gogh Foundation)

Van Gogh's linkage of the skilled artisan seated at his métier and the artist engaged in his craft went beyond such visually rendered analogies. In Nuenen, as he tackled the problem of color, van Gogh combined his scrutiny of the production of colored cloth with reading books on color theory. Thus he watched the weavers work as he absorbed painting theories whose origin and impact were themselves based on the saturation of color dyes on fibers and fabrics. *The Potato Eaters* of 1885 (Fig. 2), executed

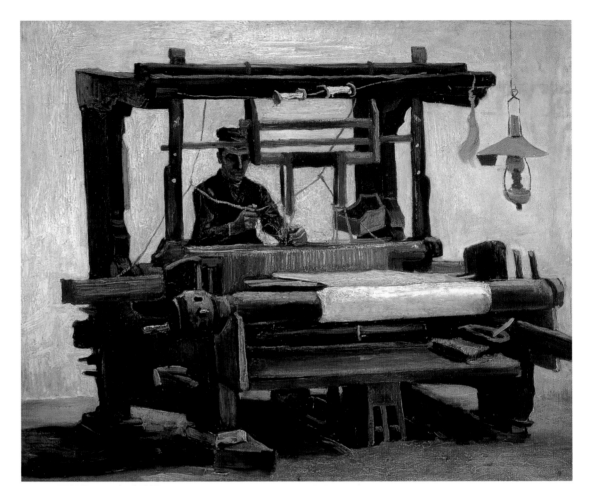

in the period immediately after the thirty-four weaver images, is the first painting that van Gogh explicitly linked to the process of weaving, explaining that the composition came together as he wrestled with the right pattern and color effects:

> When the weavers weave that cloth, . . . the peculiar Scottish plaids, then you know their aim is, . . . for the multicolored checkered cloth, to make the most vivid colors balance each other . . .

But for the weaver, or rather the designer of the pattern or combination of colors, it is not always easy to determine his estimation of the number of threads and their direction, no more than it is easy to blend the strokes of the brush into a harmonious whole . . .

All winter long I have had the threads of this tissue in my hands, and have searched for the ultimate pattern; and though it has become a tissue of rough, coarse aspect, nevertheless the threads have been chosen carefully and according to certain rules.[71]

Before van Gogh encountered Paris, the Impressionists, and Gauguin, his color theory had been fundamentally shaped by his direct experience of the Nuenen weavers' disposition of colored threads and his study of the laws of color contrast, laws originating in Chevreul's weaving chemistry and applied to painting. In Paris van Gogh absorbed new techniques while he amplified the preexisting lessons of paint as threads and color as fiber to be worked into the fabric of the canvas surface. In creating a decorated box to house his colored "woolly balls" in 1886, van Gogh reasserted the core of his craft stylistic practice and cannily investigated a new visual technique of weaving labor. Chevreul's book on the laws of color was well known to and adopted by many French Impressionists and Post-Impressionists, including Gauguin, but only van Gogh operationalized Chevreul's discoveries with the fiber materials on which they were based. As Gauguin worried about the fate of earthly corruption, van Gogh experimented with dyed yarns, reproducing color experiments devised by a chemist for weaving and painting.

Gauguin's allegorical tomb box, rooted in the experience of French Catholic culture but unrelieved by the consolation offered by traditional religious belief, expressed the modern predicament of worldly pleasure and desolation. Van Gogh's craft tool box of colored yarns represented a divergent mentality, one formed by the resources and dilemmas of his own Dutch Reformed religious culture. Van Gogh's box, far from the allegory of Gauguin's, expressed his persistent need to render an image so as to be as tangible, physically present, and textural as the canvas on which it was applied. By treating the canvas as woven cloth or worked earth, van Gogh attempted to reenact the labor process he associated with sanctification. It is to the sources of this particular mentality of embodied labor and production painting that we turn in the next chapter.

CHAPTER FIVE ## "A Passion for Reality"

I lose myself in You, Nature, . . .
Exclaim the glory of the centuries, . . .
Hear what Creation
Is singing!
REVEREND BERNARD TER HAAR[1]

The poet . . . cannot listen to the sea without thinking of the eternal,
. . . cannot see a seed fall on the soil without thinking of the
morning of the resurrection.
REVEREND ALLARD PIERSON[2]

By the age of seven, Paul Gauguin had been transported across the sea from Europe to South America and back again. In Peru, now fatherless, he had joined the loosely demarcated family constellation assembled by his maternal grandmother, Flora Tristan. Back in France, Gauguin's placement with a new set of relations was interrupted by his residential education at the Orléans Seminary of the Chapelle-Saint-Mesmin. By the age of seventeen he had set off for far-flung sea voyages in the merchant marine.

The social structure of Vincent van Gogh's early life was as deeply embedded as Gauguin's was uprooted. The boundaries of van Gogh's experience before the age of eleven were sharply delimited by the parish house and the local Reformed Protestant church of the small village of Zundert in the southern Netherlands region of Brabant. Here Vincent's father, Theodorus, served for more than two decades as minister to fifty-six Dutch Reformed believers. In 1850s Zundert, an intact theological and corporate culture erected powerful barriers to the development of free individualism; indeed, the very notion of a discrete, autonomous self detached from the web of kin, community, and divine dependence was barely conceivable in the society in which van Gogh grew up.

THE GROUP AND THE "PILLAR" COMMUNITY

Zundert's preindustrial economy centered on small-scale farming, which supported only precariously the needs of the local market. In 1850, half of the heath land around Zundert remained uncultivated, and many of the plots of land that were cultivated still relied on the primitive techniques of ox-drawn plows to ready the grain and potato crops. Peasants managing a minimal existence on these farms were

nonetheless more fortunate than the many landless rural laborers of Zundert, who survived by combining seasonal harvest work with winter basket-weaving and broom-making from the heath brush. Local commerce consisted of small retailers and handicraft workshops, including five tanneries, six wooden shoe shops, five linen-weaving ateliers, three brickworks, and five blacksmiths.[3]

Between 1850 and 1870, primitive farming techniques, poor soil conditions, and cycles of disease and crop failure meant that only a tiny minority of peasant families were self-sufficient; indeed, most were permanently dependent on church and civic authorities for subsistence.[4] As the Dutch Reformed minister of Zundert, van Gogh's father facilitated a variety of methods of exchange and distribution to offset economic hardship among his parishioners. Peasants unable to pay their tenant fees were regularly supported by church collections. Reverend van Gogh arranged with a carpet manufacturer in the nearby town of Breda to allow a number of Zundert widows to work as spinners of small amounts of yarn to be used in carpet-weaving, an arrangement that benefited Zundert's poor far more than it did the factory owner.[5]

The sociologist Johan Goudsblom has suggested that twentieth-century Dutch society is best characterized by the system of "pillarization," in which organized blocks of cross-class connection exist up and down the social scale by religious denomination. In Goudsblom's model, class hostility is subordinated to religious grouping, and social perceptions are framed by an individual's location within the pillar unit, rather than by consideration of each person as a discrete, circumscribed individual.[6] The pillarization model of social relations well describes the rural society of mid-nineteenth-century Zundert. Reverend van Gogh rested at the top of the pillar, actively binding together disparate parts of the social scale by a common religious commitment. This cross-class pillar was indeed an imperative in Zundert, where a tiny group of Reformed believers existed in an area dominated by a Catholic majority.

Two features marked the daily rhythm of the van Goghs' family life in Zundert, each of which situated the family unit in a social system very different from Gauguin's. The first was cross-class connection. Vincent van Gogh grew up in close interaction with the peasant laborers and craftsmen who formed the majority of the fifty-six believers in his father's tiny country parish. This interaction extended beyond the expected round of ministerial duties, for Reverend van Gogh had a concrete knowledge of agriculture, and the peasants relied on him for technical advice on drainage and soil projects, tree planting, and crop rotation.[7] Second, the boundaries dividing the family unit from the community, private

from public, were not sharply delineated—the parsonage was a spatial and social extension of the village church, and the van Gogh children were raised in a condition of high visibility and permeability.[8] An extensive network of kin also regularly expanded the domestic group, underlining the van Goghs' sense that one was never alone. Vincent's sister Elizabeth, called Lies, described in her memoir the unalterable presence of "the other" in the rituals of family life and the ambiguous sense of belonging and surveillance, comfort and pressure, that she experienced as she imagined someone always watching her through the half-length lace curtains of the neighboring houses.[9]

Paul Gauguin's formative models included his fiercely independent maternal grandmother, who titled her autobiography *The Wanderings of a Pariah,* and his radical republican father, who sought to preserve his threatened democratic ideal by voluntary exile far from his French homeland. From an early age Gauguin experienced long periods of isolation; he learned at Saint-Mesmin "to concentrate on myself"; and he resolutely pursued his mother's chilly injunction to make his own way in the world at large. Van Gogh's Dutch world, by contrast, formed a series of concentric circles of connection, a world both buffered and restrained by the primacy of group identity over individuation. The web of kin and community set van Gogh on his way in dense patterns of obligation and expectation. Echoing his sister Lies's image of being watched through neighbors' lace curtains, Vincent van Gogh imagined that "all eyes were upon" him as he made and remade his choices; his was a world where, as he once wrote in his letters, "we don't quite belong to ourselves."[10]

ENACTED FAITH AND VISUAL PIETY

The particular variant of van Gogh's parents' theology affirmed dissolution of the ego, self-surrender to Christ, and the sanctification of lowly labor. Reverend van Gogh was an adherent of a new reform movement called the Groningen School, which rejected religious rationalism and had rediscovered Thomas à Kempis as the basis of a revitalized emotional piety. The social gospel of the Groningen theology led Theodorus and Anna van Gogh to live a life of service in small rural communities and to invest productive labor with a special holiness. Adapting Kempis's notion of deeds over doctrine, van

Gogh's parents practiced a perpetual union of inner faith and outer action, a modern imitation of Christ expressed through humility and rural social service.[11]

The emphasis on life as enacted faith served as a strong inhibitor to introspection and to the "idleness" of speculation and self-scrutiny. The themes of work and action, and of the pragmatics of righteous living as the locus of divinity, were echoed in the poetry of the popular Reverend Petrus A. de Genestet, read by the young Vincent. While Gauguin, enclosed in the seminary walls, absorbed the meditations and habits of self-analysis, van Gogh encountered de Genestet's exhortation to his readers "to work, to think, to learn" and to be "practical people":

> . . . *Dare to live! do not torment yourself*
> *With too many thoughts . . .*
> *Devoted and happy, fresh and early*
> *Awake with the sun,*
> *Stretch your hands to the plow*
> *On the great field!*
>
> *Look around, but do not waste effort*
> *Speculating;*
> *Dear friend, do you have so much time*
> *For philosophizing? . . .*
>
> *Thinking kills and doing enlightens!*
> *Rise up! man needs to act . . .*
> *Strength, health, advice and assistance*
> *For the troubles of your soul,*
> *Are offered by God to you*
> *In the work, in the act*

He who, out of love, wants to give
 Heart and head to a sacred Duty,
Will find his God and peace and light
 In life itself . . . [12]

Another belief of the Groningen theologians, along with the holiness of work and action, was the importance of sight and the visual. They accorded a special place to a seeing God, and to sight as a vehicle for salvation. This nineteenth-century Groningen visual piety extended long-term Erasmian and humanist currents coursing through Dutch Calvinism, which maintained strong hospitality to the life of the senses, receptivity to nature, and affirmation of the image as a privileged form of description and sanctification.[13] For van Gogh and his family, nature was a site of engagement and wondrous beholding, to be enjoyed as the treasurehouse of God's infinite creation.

The van Goghs construed their God not as a punitive dispenser of the Last Judgment but as a source of light and love, an all-seeing surveyor whose dominion was expressed in receptive, penetrating sight. When Parson Theodorus characterized his Maker, he relied on the immediacy of the visual. He appealed to God as he who "creates light from darkness" and found reassurance in the divine regulation of the irrevocable cycle of day and night.[14] In comforting one of his congregants after the death of a family member, Theodorus did not allude to the benefits of the afterlife or the justice of divine reckoning; he simply told the man that "light will come, the Lord will see to it." Mother Anna's statements affirm God's mighty power as an omniscient eye and his faithful as objects of divine beholding. When Theo moved to Paris, his mother told him that he would always be in God's sight: "A heavenly Father watches and is everywhere and will look down upon you there like He did here." For both Theodorus and Anna, the seeing God who looked down upon his creation was a beneficent observer, not a wrathful destroyer; they regarded him as a merciful father, a personal "helper" who extended his "hand" to guide, a source of "blessing" and "protection."

The seeing God was also the divine creator, and the wonders wrought by the God of light and love could be best appreciated in and through nature. The van Goghs glorified nature as saturated with God's presence and purpose, beyond human comprehension but evoking reverence and exaltation. The believer in nature beheld the realm of sacred equivalences; every dimension of nature's inexhaustible

forms carried intimations of the invisible, transcendent totality. As the Almighty surveyed them from above, the van Goghs taught their children to notice everything from the shapes of clouds to the subtle arrays of color in the sunset skies, and to understand these sights as testaments to God's presence in their world.

One of Theodorus van Gogh's favorite poets, the Romantic pietist preacher Reverend Bernard ter Haar, captured this idea of the correspondence between visible forms and invisible design. In the poem "Song of Praise to Creation," Reverend ter Haar celebrated man's surrender to a nature charged with divinity. As he beholds nature's power and vastness, his human reason gives way to a submissive awe—a silent, emotional acceptance of unknowability:

> I lose myself in You, Nature,
> How my mental powers yield;
> I find myself back in the center,
> Around which the Universe turns,
> Exclaim the glory of the centuries,
> Proclaim!
> Or—be quiet, my toy, be silent!
> Hear what Creation
> Is singing!
> To fall silent is very meaningful here—
> And might be called reverence. [15]

As man relinquishes his reason to reverent listening and beholding, wrote ter Haar, he begins to see the signs that God placed in nature. Another of ter Haar's writings crystallized the pattern of correspondences between nature's rhythms and sacred orders, a pattern that the van Goghs were primed to witness on a daily basis:

> If the heathens saw in the sun a youthful Apollo;
> In the constellations deified heroes . . .

TOP **FIG. 75. VINCENT VAN GOGH, BOUQUET (JUVENILIA)**, 1863, watercolor, 15.5 x 13.5 cm. Van Gogh Museum, Amsterdam (Vincent van Gogh Foundation)

BOTTOM **FIG. 76. VINCENT VAN GOGH, THISTLE (JUVENILIA)**, 1863, black chalk, 18 x 14 cm. Van Gogh Museum, Amsterdam (Vincent van Gogh Foundation)

The view of the clear starry sky
Reminds the Christian of the dwellings of the house of the Father,
The sprouting of the grain of His Resurrection;
The rising of the sun of His Immortality.[16]

The van Goghs' reverence for nature was complemented by their interest in its visual representation. Image making and display were integral parts of the family's activities. Far from being anti-sensual, the modest country parish house in Zundert was hung with a variety of etchings, engravings, and mirrors. Anna van Gogh, an accomplished watercolorist, crocheter, and embroiderer, embellished the tables with patterned rugs and simple wickerwork planters. She even adorned the family Bible with a special bookmark of intricate patterns framing her husband's name. Anna and the children spent time drawing together when Vincent was a boy. Among Vincent's earliest surviving drawings are copies he made of his mother's illustrations of a bouquet of flowers and a thistle plant (Figs. 75 and 76); he was also a keen observer of insects.[17]

Vincent van Gogh's parents' theology thus accorded a powerful place to the visual while it also imposed constraints on idealism, introspection, and independent identity. The Groningen religious system, amplifying its Erasmian humanist roots, de-emphasized a transcendent spectacle of divine judgment and the reckoning of sin in favor of an immanent divine love and sacred sight. Nature and the physical world were treated neither as treacherous sites of temptation nor as diminished way stations to eternity; they were considered wondrous totalities of God's creation and the locus of righteous living and productive labor.

This type of Protestant visual piety sustained a very different stance toward the physicality of the corporeal world and its necessary purification than that which was transmitted through the Orléans Catholic seminary to Paul Gauguin. The daily routine of Gauguin's religious education taught him that the world was nothing and exhorted him to concentrate, through relentless self-inspection, on the ideal glories of a supernatural destiny. While Gauguin was drilled, with eyes closed, in spiritual exercises, van Gogh was directed in Zundert to a keen and reverent beholding of the infinite variety and splendor of God's "second Book" and to appreciate an array of visual images enlivening the family home. His parents and kin also pressed in him a suspicion of idleness and "self-will," and the imperative of enacted

belief, joining inner faith to outer action. These values imparted to van Gogh an enduring mentality of Protestant dualisms: of work and worthiness, profession and vocation, earning and deserving.

CORNELIUS HUYSMANS'S EDUCATIONAL REFORMS

Van Gogh's early education deepened his religious legacy of anti-idealism. While Gauguin boarded at the Orléans seminary, van Gogh was sent from Zundert in 1866 to a brand-new, state-sponsored secondary school in Tilburg, a textile town farther south in Brabant. The Rijks-HBS Konig Willem II, or King William II Upper School, was the product of a national commission to develop secondary education to meet the demands of a changing society. After the passage of the Secondary School Law in 1863, the town of Tilburg was identified as an appropriate site for a modern secondary school. Members of the Dutch royal family donated a former palace of King William II to be renovated for school grounds, and a new cadre of instructors was hired. Vincent van Gogh was a member of the first class of entering students when the Tilburg HBS opened its doors in 1866.[18]

Paul Gauguin's attendance at the newly opened Petit Séminaire de La Chapelle-Saint-Mesmin had been made possible by the Falloux Law and the renovation of French Catholic education in the aftermath of the 1848 political revolution. Vincent van Gogh also benefited from changes in educational institutions and pedagogy, but in the case of the Dutch secondary school reforms the aim was not to heal political divisions but to revitalize applied arts and industries. Designed as a nondenominational center for modern education, the Tilburg HBS had a curriculum that included multiple language study, natural sciences, and the arts. Whereas Gauguin absorbed Latin, philosophy, biblical literature, and the visual supernaturalism of Bishop Dupanloup's new catechism, van Gogh learned French, German, mathematics, biology, and the technical maneuvers of freehand and perspective drawing. The Tilburg schedule of classes assigned an unusually high number of hours per week to drawing instruction: in his first year in the program, van Gogh received four hours per week of drawing classes, second only to instruction in French and English, and more time than was reserved for classes in German, mathematics, and geography, which received only three hours each.[19]

The new Tilburg school boasted a well-equipped drawing studio directed by Cornelius C.

Huysmans (1810–1886), a former painter and renowned national figure and arts educator. Huysmans's teaching of van Gogh provides a striking analogue to Bishop Dupanloup's teaching of Gauguin. Both instructors were important mid-century educational reformers in their respective national contexts. Dupanloup had sought to recapture Catholic youth for "interior work in souls"; Huysmans's mission was to reclaim his students so that they might "learn how to see" and learn to integrate beauty into objects of daily use.[20]

In the decades prior to his teaching at Tilburg, Huysmans had established two critical areas of Dutch arts reform. First, he pioneered new techniques of drawing instruction. In 1840 and 1852 Huysmans published innovative drawing manuals in which he established a new copybook technique of step-by-step training in pencil drawing of landscapes, perspective, and the human figure.[21] These books, adopted by many schools and drawing institutes, won Huysmans national recognition and led to his appointment to a 1865 ministerial commission to implement the new Secondary School Law. Huysmans's function on the commission was to set the standards of examination for drawing and modeling, and his writings were pivotal in the passage of the new law that required secondary schools throughout the Netherlands to provide instruction in drawing.[22] For Huysmans the Tilburg HBS was a micro-laboratory of national reform in much the same way that for Dupanloup the Orléans seminary was a prototype of a national education project. When Huysmans was recruited to Tilburg, the Brabant schools supervisor, Dr. J. Bosscha, indeed made the appeal to him that he could turn the new school into a new "center of arts education."[23]

Huysmans directed reform in the teaching of drawing to a pressing practical task: to regenerate the Dutch applied arts. Beginning in 1853, he wrote a series of polemical articles in the premier national magazine, *De Gids* (*The Guide*), championing the cause of drawing reform in relation to industry and the industrial arts. Proclaiming that all the arts were one, Huysmans waged a one-man campaign to eliminate the division between fine and applied arts, proposing a national initiative for drawing instruction to nurture a feeling for beauty among the people, convey art to the workplace, and improve the production of Dutch manufactured goods. A kind of Netherlandish William Morris, Huysmans looked back not to the medieval period but to the fifteenth and seventeenth centuries as the pinnacle of quality, beauty, and utility in all the arts and crafts of the Low Countries, and called on his contemporaries to reclaim the unity of the arts in new standards and techniques for the production of beauti-

ful objects of daily use. Like others on the Continent, Huysmans formulated his campaign to regenerate the crafts partly in response to the revelations of the 1851 and other World Exhibitions, which portended the decline of Dutch artisanship in comparison to other suppliers for a newly expanding world market for the applied arts. Sounding the alarm led Huysmans the polemicist back to the classroom as the place to transform producers, production, and citizens.[24]

Bishop Dupanloup, as we have noted, heralded a dynamic theory of education and criticized a positivist model of accumulated knowledge. Huysmans, too, assailed the excesses of intellection and the lifelessness of rationalist "dry science," but with a different purpose. In aspiring to reunite head and heart, Dupanloup sought to elevate "the whole soul" toward divine truth, beauty, and goodness. For Huysmans, the remarriage of head and heart would provide the balance for the production of aesthetically pleasing applied arts commodities. If Dupanloup looked at Gauguin and the seminary children and saw the future of a French nation reborn in loyalty to faith and state, Huysmans approached his pupils as the future protectors of a renewed Dutch industry. He prompted his youngsters to rekindle the pleasure of seeing and to channel that pleasure into material form. In the four hours that van Gogh spent weekly in drawing classes, he engaged, according to Huysmans's plan, in keenly observing and rendering natural objects, transcribing models and plaster casts, and patiently copying drawings by earlier masters.[25]

One instance of Huysmans's pragmatic approach was his recommendation that students pour milk over their finished pencil drawings to "preserve the marks and remove the shine," perhaps adding a little coffee to the milk as a "varnish" to give the drawing "the color of India paper."[26] Van Gogh himself would later pursue his own "kitchen craft" approach to the art of drawing and color, what he referred to as his *cuisine de l'art.*[27] He trained himself as a draftsman by relying on artisanal manuals or "how-to" books, which used an incremental copying method similar to the one developed by Huysmans. As he developed his drawing skills in The Hague in 1882, van Gogh followed Huysmans's instructions exactly, noting that he threw milk over his pencil drawings to make "the shininess disappear."[28] Another time he reached for coffee grounds from his mother's cupboard to vary the shading of his drawings. Later, in Arles, he used egg whites as a glutinous layer to preserve his canvas pigments.

Huysmans's appraisal of imagination was much more muted than his French counterpart's. Viewing imagination as a lightning rod to the invisible world of the "divine drama," Bishop Dupanloup

actively encouraged it in his pupils. But like many of his Dutch compatriots, van Gogh's art teacher Huysmans had little patience for unfettered imagination detached from material application. His writings on design reform and drawing instruction affirmed imagination as a necessary but only partial element of the arts, whose regeneration would flourish only by the rebinding of head and hand, design and execution, imagination and application. In addition to figure drawing from the model and landscapes rendered at the site, Huysmans's own artistic practice included projects for decorative arts, such as colored banners, booths, and platforms constructed for jubilees and other festivals in Brabant.[29] His sketches for these occasions reveal a systematic adherence to Chevreul's laws of the color theory of simultaneous contrast, which paired colors—red and green, blue and orange, yellow and violet—for maximum luminosity and intensity. In Huysmans's festival plans, for example, he chose red and green for the ornaments on lanterns and poles (Fig. 77). This same theory and the consistent impulse toward practical application appeared in the unique box of colored yarn balls that Vincent van Gogh later assembled in Paris to rehearse his lessons in Impressionism.

As a young student under Huysmans's drawing instruction, van Gogh was exposed to a program that defined and celebrated artistic practice as a skill to be cultivated by all, perfectible through slow and steady steps toward craft mastery, ranging from the rudiments of figure drawing to landscape and perspective. One of his very earliest works, based on Huysmans's emphasis on figure drawing set in a contemporary social context, shows the careful accumulation of detail, costume, physique, and gesture to convey a precise labor type (Fig. 78). While the young Gauguin, one of Dupanloup's fallen angels, was directed to take flight from a fallen world and to envision otherworldly perfection, van Gogh learned from his art teacher Huysmans to realize beauty by applying the rules of a craft apprenticeship to his own encounter with the abundant natural world around him.

DUTCH CONTROVERSIES ON NATURE AND GOD, 1850–1880

From the age of seventeen to the age of twenty-three, Paul Gauguin was at sea, having left a religious training of *contemptus mundi* to take up a sailor's ceaseless passage from one world to the next. During the equivalent period of his young adulthood, from 1869 to 1878, Vincent van Gogh pursued careers

as an art dealer in The Hague, London, and Paris and as a theology student in Amsterdam. As he altered his life course from business to the clergy, van Gogh encountered the wide-ranging debates stimulated by the Dutch religious reform movement called "modernism," which monopolized the national stage with contending responses to its major rallying points—to design a new Protestant theology of "anti-supernaturalism" and to articulate a belief system rooted in nature, emanation, and human expressive consciousness. This profound and unresolved period of theological controversy exposed not only rival approaches to amending church doctrine but conflicting worldviews, what the Dutch called at the time the clash of *levensbeschouwing* and *levensrichting*.[30]

MATERIALIZING DIVINITY

How had the Dutch Reformed Church arrived at such a point of controversy? The dual challenges of science and a resurgent Catholicism had provoked the Dutch Reformed theologians to define their new doctrine. In the late 1840s, Reverend C. Z. Opzoomer had attempted to reconcile new scientific methods and faith by proposing a theology that banished miracle and mystery and was strictly regulated by the Newtonian rules of cause and effect. His opponent Reverend H. Scholten responded in 1848 in his *Doctrine of the Reformed Church* (*De leer der Hervormde Kerk*), a text that soon became known as the manifesto of Dutch modernism. Rigid scientism was incompatible with faith, Scholten argued; while affirming the empirical impulse to deny miracle, he preserved feeling as the source of piety and affirmed a monistic principle and the possibility of "revelation everywhere, and for all."[31]

In the two decades after 1848, a generation of Dutch Protestant modernist theologians all struggled to clear a path through what they considered the dualistic versus monistic impasse bequeathed by the Opzoomer/Scholten polemic. Equipped with varied theoretical tools, clerics such as D. Chantepie de la Saussaye, Sytze Hoekstra, and Allard Pierson all engaged in reevaluating the meaning of immanence and transcendence. They proposed a new form of natural supernaturalism, attempting, paradoxically, to bring a remote God nearer to nature and community while salvaging a space for divinity beyond human apprehension. De la Saussaye described this position as "naturalizing the divine without eliminating its divine character."[32]

Delicately balanced between the unacceptable alternatives of pantheism and atheism, the Dutch "young moderns," as they were called, absorbed the naturalizing impetus of the critical theologians by questioning scriptural infallibility and rejecting miraculous intervention. At the same time, while disavowing monism, these clerical reformers did not reject supernaturalism altogether. They sought to preserve a space for an omniscient divinity and a redemptive Christ while emphasizing that divine presence could neither be detected by the strictures of reason nor be banished to the remoteness of the heavens. In developing this stance, the modernist theologians engaged in complex discussions of standards of proof, verifiability, and the status of presuppositions in attempting to reconcile science and faith. They ultimately rejected the value of proof and disproof in exploring their new concepts of divinity, moving toward what one commentator called a startling "agnosticism within the Dutch Reformed church."[33] Here God, both immanent and transcendent, retreated to an arena beyond the confines of human reason and verifiability. His existence could be salvaged as a mere postulate, or assertion, that was to be neither proven nor disproven.

How, then, could an unknowable, indescribable, and invisible divinity be rendered accessible to a human spirit hungering for consolation and regeneration? The aesthetic faculties alone could approach and approximate the fullness of God. By 1864 modernist theologians reworked their delicate balance of natural supernaturalism as they embraced what they called a new "realism," placing special emphasis on the arts—poetry, painting, and music—as evocative forms and special vehicles of divinity. Representation and human expressive consciousness emerged as the singular mediators of the immanent and transcendent orders.

The writings of the Reverend Sytze Hoekstra set the tone for this 1860s Dutch theology of art. Celebrating nature as the site and source of religious devotion, Hoekstra also presupposed what he called a divinized "supersensible" reality beyond the surface of appearances. Man's approach to this supersensible reality, Hoekstra argued, could only be "expressed in the language of poetry."[34] The theologian and cleric Allard Pierson amplified this melding of ethics, aesthetics, and religious feeling as the basis for a new modernist realism in the Church. In his 1862 tract *The Significance of Art for the Moral Life* (*De Beteekenis der kunst voor het zedelijk leven*) and his 1863 book *Direction and Life* (*Rigting en leven*), Pierson identified what he called "a passion for reality" as the source of contemporary piety, and the singular role of art to evoke divinity.

PIERSON'S "PASSION FOR REALITY" AND BEAUTY AS TRUTH

Pierson's "passion for reality" was vigorously posed against the assumptions of traditional religion. He began *Direction and Life* with a lengthy critique of the sharp divisions between what he called God "up there" and humanity "here below," and ridiculed theological interest in attempting to specify the character and composition of the heavenly kingdom, such as the discourses on when and how God sent angels and other emissaries to and from his heavenly court.[35] Invoking a scientific and ironic voice, Pierson noted that the whole logic of heavenly ascent and descent was misplaced, as the earth's constant spinning on its axis meant that the clerics and the churches they preached in were "rotating, and it would be extremely difficult . . . to tell correctly what is above and what is below." Modern thought, and modern piety, stated Pierson, required conceding the limits of knowledge: "The world is a dot in an immeasurable universe, forever rotating, and we cannot conceive of that which is beyond the universe."[36]

While Pierson relied on empirical standards to challenge what he considered the muddled logic of the Old Calvinists, his "passion for reality" did not imply subjecting religion to the bar of scientific logic. According to Pierson, religious faith, incommensurate with plausibility and verifiability, had its source in the human need for wonder, exaltation, and dependence. The wellspring of religious feeling was equivalent to the feeling for beauty, and the aesthetic faculty alone formed man's devotional route to God. Poetry, for example, was a natural language of religion, an appropriately heightened response to a natural order steeped in God's love and wisdom. In *Direction and Life*, Pierson joined his doctrine of the "passion for reality" to a new religion of beauty within the Church, what he called the touchstone of *Rien n'est vrai que le beau*—"Only the beautiful is true." Pierson explicitly formulated this attitude to invert the traditional idealist model of *Rien n'est beau que le vrai*—"Only the true is beautiful."[37]

In another context, Pierson's banner *Rien n'est vrai que le beau* signified another, very different kind of modernism. In 1863, the year between the publication of Pierson's two works in the Netherlands, Edouard Manet exhibited his *Déjeuner sur l'herbe* in the Salon des Refusés, proclaiming his status as a Baudelairean "painter of modern life." In post-1848 France, Manet and Baudelaire embraced beauty as truth in liberation from history and tradition, as they recognized the shattered illusions of utopian politics and the artist's role as a harmonizing moral power. Radically independent, anti-

clerical, coolly detached, Baudelaire and Manet's modernism heralded *Rien n'est vrai que le beau* as a cult of artifice in an amoral universe. Where only beauty was truth, the artist was himself a work of art, rigorously adhering to a code of laws he created for himself.

Allard Pierson's religion of beauty was far removed from the Baudelairean posture that summoned art "to veil the terrors of the abyss."[38] A member of the mid-century Dutch avant-garde of the clergy, Pierson articulated his modern aesthetics within the Church and affirmed a Schleiermachian posture of dependence on God and Christ rather than a radical independence. In this context, Pierson's project of *Rien n'est vrai que le beau* had emerged not as a substitute for an inchoate and ungovernable reality exposed by the trauma of political debacle, but as a response to the crisis of a national theological culture beset by two decades of anti-supernaturalism. Art, in Pierson's modernism, was the necessary bridge between man's moral nature and God's perfect creation; beauty was an instrument of God's truth, delicately interposed between scientism and agnosticism. For Pierson, beauty alone was truth because "the truly beautiful alone can be regarded as the fitting expression of the most exalted emotions of the heart" that brought man closer to God.[39] The presence of a God of love inaccessible to cognitive apprehension could be elicited instead in the lofty emotions carried by expressive forms.

In *Direction and Life*, Pierson distinguished his aesthetic theology of modern realism from two forms of abstraction that were, in contrast, vigorously cultivated by Bishop Dupanloup in France during the same period. First, the "passion for reality" derided what Pierson called the "world of dreams" and the floating realm of "random figments of imagination."[40] He gave as an example of such fantasy the attempts to provide elaborate descriptions of the "heavenly court" that "no one has ever seen."[41] The contemporary pious mind required a tangible anchorage in the world rather than flights of imagination:

> *In our lives and in that of many of our contemporaries a moment has come . . . in which the mind complains of all the images and expressions that are made to dance like flies on a plate by poetry and imagination. We would rather wish some nutritious bread on this plate, saying to ourselves: what is there to grasp and hold on to?*[42]

Pierson's realism also challenged a second form of abstraction: the didacticism of religious art. Art, as the privileged mediator of an indescribable and immanent divinity, could only be rooted in

nature and human experience while disclosing that which was greater than nature. Pierson was particularly critical of Catholic art's concentration on suffering and martyrdom, what he described as its "starved, Gothic cathedrals" with their "unseemly multiplication of crucifixions and martyrs' sculptures, with hearts burning and pierced by many arrows." If Jesus himself were to walk around and behold these images, argued Pierson, "He would probably say: 'get rid of these things—you have made God's house into a house of torture.' "[43] All types of religious art that aspired to literalist, scriptural illustration violated both beauty and truth, according to Pierson. It was "not the duty of art to improve morality";[44] the artist was not a preacher or a "teacher":

> *The value of a work of art should be a function of art itself . . . Art is, in a matter of speaking, purely materialistic. Art that wants to ascend beyond matter and become, for example, Christian art is a fraud. The only higher sanctification art has to seek is to be found in the beauty, the harmony of forms that it brings to life.*[45]

JESUS CHRIST AS AN ARTIST

While disparaging the representation of biblical stories or episodes in the life of Christ, Pierson celebrated a theology that emulated Jesus Christ's powers as an artist. The status of Christ had been debated for two decades by Dutch theologians. The Groningen School of van Gogh's father, for example, had generated a Christocentric theology that accepted Jesus as both a historical figure and an embodied heavenly being. This position was unacceptable to the second-generation modernists, who had begun to assimilate the challenge of the Tübingen School and New Testament criticism. Allard Pierson redirected the debate from history to aesthetics. Setting aside the intractable questions of textual authenticity, authorship, and Christ's miraculous interventions, Pierson centered his modernist realism on the religion of Jesus as a religion of beauty. "Between the religion of Jesus and the pure sense of beauty there is an inseparable connection," wrote Pierson in *Direction and Life*. "Jesus' triumph over the world is in large part due to his sensitive and subtle pure sense of beauty."[46] Other religious reformers, the Groningeners among them, had emphasized the teachings of Christ over the institution of the Church, the

lived deed over doctrine. Pierson shifted the ground again from the content of Christ's teachings to the expressive forms he chose for communicating them: the "noble words," "aphorisms," "comparisons," and "metaphorical expressions." The "magic and power" of the language itself, not the meaning alone, constituted the majesty of Christ's message. *Rien n'est vrai que le beau*, according to Pierson, unfolded directly from the Savior himself.[47] The new theology of realism must evolve, therefore, by relinquishing interest in either representing life-denying images of Christ's suffering or presenting narrative descriptions of his life; it must strive instead to achieve the binding power of his expressive language.[48]

In following Christ's example of aesthetic force to move and "touch" people, Pierson highlighted three other qualities of modern realism: "truth, simplicity and naturalness." The agency of art as a sacred power lay in its capacities for embodiment and emanation rather than in its attempts to imagine a divinity that could never be seen. Observing and responding to nature, the artist acted as what Pierson called a "spiritual sensory organ," incorporating the comfort of Christ and the presence of divinity into the formal elements of color, line, and light.[49] Always the unequal but essential partner of a naturalized divinity, the artist realized in the material work of art "a perceptible form completely saturated by the spirit," the "dynamic unity of all the material and spiritual powers of man."[50]

This unity both encompassed nature and expressed more than nature itself. Pierson differentiated the artist's immersion in nature from the imperative of strict imitation. In his Rotterdam lecture of 1862, Pierson the Protestant minister commented on the implications of photography for art, sounding a theme common among secular art critics elsewhere in Europe, Baudelaire among them. Pierson noted that the invention of photography made human efforts to reproduce nature superfluous and liberated the artist to "absorb, interpret and evoke" nature as an ideal totality. Nature alone provided the "raw material" for a divinized realization by the artist's expressive force.[51]

Pierson's realism proposed that art, "the daughter of piety," communicated "the higher joy of life" and provided consolation and comfort to the human community.[52] In this way Christ's language and message were confirmed and incorporated into many media of artistic expression. Depictions of Christ's afflictions were explicitly rejected by Pierson; the "passion for reality" and the truth of beauty were to be found instead in paintings such as "Rembrandt's Burgomaster Six, Titian's Lavinia, van Dyck's housewife, Murillo's flower girls."[53] These images did not illustrate particular ethical or religious ideas; they offered material truth, "sympathy," and an evocative "awesome indefiniteness."[54] The paintings'

formal elements—their "tone of light," if "finely drawn, . . . broad in color and perception"—combined with human features to communicate; together, according to Pierson, paintings like Rembrandt's or Titian's could rouse "emotional and exalted experiences," the sense that "something profound and mysterious was about to happen." Such seemingly humble portraits conveyed, through their particularities, broader and more universal states of feeling, "such as joy, sadness, hope, gloom, or despair."[55]

Pierson ended his discussion of the "holy beauty" of painting by comparing it to music. The beauty of human truth and evocative form, he noted, approximated most closely the flowing, nonrepresentational qualities of music. As with the "hallowed" realism that repudiated prescriptive lessons, musical greatness, too, could never be consigned to an explicit moral message. "Few works of the great masters have, or can have, a motto or a title," stated Pierson; with "few exceptions, the works of Beethoven, Haydn, or Mozart are known by their numbers."[56] The power of art was that it allowed us to intuitively "suspect," while never defining, a heavenly "higher truth."[57] This type of evocative power was likened by Pierson, despite his disdain for Catholic Church figural art, to the "religious experiences that crowd our chest" when "we walk in the soft, pleasant light that breaks through" the "colored stained glass windows" of the "old and serious cathedral."[58]

In his critique of traditional dualistic Dutch Calvinism, Pierson had indicted the vertical schisms of earthly and celestial domains as anti-modern and empirically untenable. Yet in promoting a new theology of modernist realism, Pierson returned to the irresistible structure of high and low, terrestrial and heavenly, visible and invisible, to describe the need for holy beauty. Stepping into the void created by modern doubt, art salvaged faith, in a new, more indefinite form of an exalted, ever-nearer but ever-invisible infinitude:

> *Who among us has not felt the impact of art?*
>
> *We call her masterpieces heavenly, and they make us turn to heaven. Where, in our time, is the thinking person who escapes completely from all feelings of doubt, but where also is the thinker who remains unmoved by the creations of art, which make us almost see and feel the invisible world? Can the philosopher who can hardly confirm the existence of God keep himself from kneeling down when the Gloria in Excelsis, Praise be the Lord in Heaven, from Beethoven's Second Mass, confronts him with its threefold repetition? Who does not pray when*

Mendelssohn, in Psalm 51, makes Paul exclaim, "Lord have mercy with me according to Your kindness"? Who is not brought closer to the pure and loving One who entered this world eighteen centuries ago by beholding the Christ of Thorwaldsen, and who does not feel the secret hope of immortality awaken in his soul when hearing the poet sing, in the Lied der Glocke, of the seed that is hidden in the womb of the earth to ripen for the future?[59]

The symbol of the seed and the cycle of regeneration returned when Pierson affirmed the artist's singular role as the agent of connection between the infinite and the tangible, uniquely poised to hear and disclose "the secret language of nature." In the modernist quest for divinity, all of nature was charged with meaning, silent only until the artist's sympathetic power released its voice:

The poet . . . has a heart for the secret language of nature, who cannot listen to the sea without thinking of the eternal, who cannot see a seed fall on the soil without thinking of the morning of the resurrection. Make this string of poetry break in our souls and the stars tell nothing more or less than an astronomy book, the Spring will bring no joy and the Autumn no longing.[60]

The "well of religious life will dry up," cautioned Pierson, if this sacred interconnection of nature and the eternal, rural immanence and inexpressible transcendence, was severed; then an appalling stillness would set in, as the "great sea will be silent for us, and the grainfields and the stars [and] the buds of spring" will "speak no more."[61]

Pierson's charge to release the voices of nature through art's evocative power contrasted sharply with the quest of Gauguin's teacher, Bishop Dupanloup. The Dutch theologian, in the context of two decades of debates over the naturalization of divinity and the divinization of nature, sought to reanimate nature as an exalted unity, ringing out the sounds and symbols of a heavenly Creator approximated by art's plastic power. Ripening seeds, stars, fields, and sea, all found their voice, and breaking the silence was the key to modern redemption through representation. Dupanloup moved in another direction; his was the quest to approach a perfect God through soundless and solitary concentration. The life of grace began only "in great silence." In the hushed fixity of the soul, suspended from sensory experience, not nature's voices but purified inner light was released. Dupanloup thus affirmed what he

called "implanting God in the soul" as a spiritual harvest; Pierson looked to the fields and the seeds of rural life to materialize God in the soil.

VAN GOGH'S SYMBOLISM AND MODERN THEOLOGY

As van Gogh began his quest for a modern symbolist art in Arles, he activated multiple cultural resources of anti-idealism, tapping the themes of his mid-nineteenth-century Dutch formation that inextricably linked naturalism and the sacred. Social, familial, and religious experience had all heightened Gauguin's receptivity to abstraction and encouraged him to seek an art of spiritual truth liberated from the "shackles" of realism. Van Gogh's distinctive Dutch heritage predisposed him, by contrast, to resist the speculative flights of imagination and to seek out the presumed presence of an eternal and infinite divinity in and through the stuffs of matter. In Arles, as he devised *The Sower*, van Gogh stretched himself toward Gauguin's example, and toward the Paris avant-garde, experimenting with exaggeration, distortion, and expressive color. But he also continued to rely on the perspective frame, which regulated the natural scene as it brought the distance nearer, and he remained so bound to an immersion in the tangible sediment of the "worked earth" (*terre labourée*) that he bolted his easel posts into the ground and caught the dust of the fields on the nap of the canvas, using the abrasions as part of his *cuisine de l'art*. Like Pierson's modern man adjusting his inherited faith to the "passion for reality," van Gogh always approached art, and the need for the infinite, in terms of the Piersonian question "What is there to grasp and hold on to?"

The form and content of the symbolist *Sower* expressed three mutually reinforcing patterns in van Gogh's long-term values of embodiment. The peasant figure in action, designed as van Gogh recalled his upbringing in the Brabant countryside, reconnected him in a new form to the first—his parents' enacted faith and the regenerative sanctification of the cycles of rural labor. Memories of Brabant fields mingling with those of Arles also recalled a second pattern—the particular pedagogy of van Gogh's Tilburg art teacher, C. C. Huysmans, who had urged his students to behold and scrutinize the spectacle of nature, while he also cautioned them to discipline their impulses in service to the patient accrual of craft skill.

Yet it was the third pattern in van Gogh's resources of embodiment that set the framework for his specific definition of a symbolist art beginning with the Arles *Sower* of 1888. The combination of an active human figure, radiant and textrous paint, and the evocative forms of "the infinite" that van Gogh attributed to *The Sower* corresponded to particular features of the Dutch modernist theology of art. This theology, with its disavowal of religious subjects and its emphasis on expressive representation, anticipated within Dutch church circles of the 1860s some of the themes associated with the secular avant-garde symbolism of the 1880s. Van Gogh's approach to an art extending beyond nature's appearances absorbed the currents of the dominant aesthetic debates of his theological culture. His conception of symbolist art as "sacred realism" in 1888, which glorified a modern art rooted in nature's physicality while intimating the eternal, transposed into pictorial structure the Dutch modernist theology of realism, which had isolated the indivisible linkage of tangibility and the infinite and had identified the artist as the activator of emanation and exaltation in and through a divinized nature.

RESONANCES OF DUTCH MODERNIST THEOLOGY IN VAN GOGH'S THOUGHT

Van Gogh's own belief system, like those of many young men and women of his generation, was fundamentally altered by the wide-ranging polemics of the modern clerics, and his adult conception of divinity redefined a traditional transcendent God in culturally resonant ways. During the year he spent as a theology student in Amsterdam in 1877, his conceptual patterns began to shift as he absorbed key ideas from Dutch religious modernism. His letters registered the specific themes of anti-supernaturalism and echoed the clarion call of the new generation of clerics: the necessity of adapting faith in accord with modern life.[62]

As theologians debated the plausibility and authorship of Scripture, van Gogh's clerical studies stimulated his own commentaries on sacred texts, including ruminations on the status of the angels. Van Gogh cast this discussion in terms of the prevailing debates coursing through his theological culture: While we "know that there is strength from above," he noted, "we are not like men of old," for "we should not see an angel."[63] He restated the modernist clerics' critique of miracles, and the shifting

balance of old and new faith, when he wrote some time later that "people nowadays no longer believe in fantastic *miracles*, no longer believe in a God who capriciously and despotically flies from one thing to another, but begin to feel more respect and admiration for faith in nature."[64]

Accompanying the Dutch theologians' shifting alignment from heaven to earth, from ancient miracle to modern community, was, as we have noted, a new focus on contemporaneity, the summons to discover distinctive spiritual truths for a distinctively modern condition. Van Gogh engaged the challenge of adapting the old faith to new needs in a discussion of the Bible in a letter to his sister Wil in 1887. He asserted an emphatic presentism, considering the Bible a lofty but outdated source—a part of history. His conception of the Bible as historical artifact rather than immutable gospel, and his search for spiritual ideas to suit the requirements of modern experience, caught the themes of two decades of Dutch theological contention:

> I myself am always glad that I have read the Bible more thoroughly than many people now-adays, because it eases my mind to know that there were once such lofty ideas. But because of the very fact that I think the old things so beautiful, I must think the new things beautiful *à plus forte raison. A plus forte raison,* seeing that we can act in our own time, and the past as well as the future concern us only indirectly.[65]

In the letter van Gogh went on to register his skepticism about the possibility of divine agency. The terms in which he cast his ideas were not simply personal meandering on his own shifting belief, but the shared discourse of a generation of young Dutch Reformed citizens pressed by the new theology to acknowledge the implausibility of an interventionist God from on high. Echoing the clerics' debates, questions, and doubts, van Gogh did not write authoritatively to Wil of the *impossibility* of such a type of divinity; he asserted only that when tested by the standard of human reasonableness the type emerged as rather questionable:

> I find it difficult to assume, for my own consolation, or to advise others to assume, that there are powers above which interfere in things personally in order to help and comfort us. Provi-

dence is such an extremely queer thing, and I solemnly assure you that I most decidedly do not know what to make of it . . . [T]he stories about the above-mentioned providence—[are] stories which so very often don't hold water, and to which so many objections might be raised.[66]

The modernist project of naturalizing divinity also coaxed van Gogh, beginning in the Amsterdam period, to develop a more elastic definition of the deity. His automatic appeal to the eyes of a "Heavenly Father" began to cede to the broader quest for the *quelque chose là-haut*—"something on high," an indeterminate power beyond the self. Van Gogh's expanded definition of divinity was accompanied by a modification of the hierarchy of dualism. Where his early piety separated the "feeling for nature" from the "feeling for God," with God "higher still," he later echoed the moderns' emphasis on shifting the ground of faith from the vertical to the horizontal arenas. He even occasionally referred to God and nature interchangeably as "nature *or* God."[67] However, like the reformist clerics who "rejected supernaturalism without fully accepting naturalism," van Gogh's own religiosity preserved a space for an invisible, vertically placed divinity, and he continued to mix his attentiveness to a sacred nature with the need to search for "strength from above," to "*lift up*" his "heart to heaven."[68]

Another strain of the Dutch theological controversies appeared in van Gogh's early thought as he redirected his piety from heaven to earth: the multimedia or equivalence theory of revelation. As we have seen, from Scholten's monistic principle of revelation everywhere to Pierson's particularly aesthetic route to the sacred, the Dutch religious reformers celebrated a new and inclusive view of the possible links between man and God, which appended poetry to prayer, music to meditation, art to worship. If the Word of God was called into question by the indisputable discrepancies among various parts of Scripture, the feeling for God could be elicited in limitless ways by human endeavors.

In his letters, van Gogh, echoing this modernist discourse, increasingly attributed to books and pictures qualities that were hitherto assigned only to God. "There are many things one must believe and love," he wrote. "There is something of Rembrandt in the Gospel, or something of the Gospel in Rembrandt . . . The best way to know God is to love many things."[69] Like Pierson, van Gogh now privileged beauty as divine truth, highlighting art as a unique mediator between nature and a suspected but unknowable God. The awe and exaltation elicited by artistic forms emerged for van Gogh, as they had

for Pierson, as the only appropriate vehicles to approximate the presence of divinity. In a theological culture beset by the irresolvable debates proving or disproving God's existence and acts of supernatural intervention, van Gogh lent his voice to the controversy, concluding, as Pierson had, that aesthetic power alone could deter agnosticism:

> *Someone loves Rembrandt, but seriously—that man will know there is a God, he will surely believe it . . . To try to understand the real significance of what the great artists, the serious masters, tell us in their masterpieces, that leads to God; one man wrote or told it in a book; another, in a picture.*[70]

Van Gogh's choice of Rembrandt, in addition to Shakespeare and George Eliot, corresponded to Pierson's own examples of "holy beauty," of artists who combined human truths and expressive forms. Van Gogh considered these kinds of works both "humble and simple" and "truly sublime."[71] The Piersonian theme of art's distinctive role in offsetting unbelief through expressive form recurred when van Gogh sometime later commented on one of his own early efforts at illustration, pointing again to an aesthetic "proof" of divinity: "In this print I have tried to express . . . what seems to me to be one of the strongest proofs of the existence of *quelque chose là-haut* in which Millet believed, namely the existence of God and eternity."[72]

During his difficult early period, then, particular elements of the Dutch theology of natural supernaturalism had offered van Gogh critical resources as he modulated his inherited forms of piety. Religious modernism provided him with the intellectual tools for linking sacred human action to nature and to art, and for highlighting the artist's unique role as an agent of revelation, approximating the aesthetic power of Christ. As van Gogh began to develop his own artistic symbolism in Arles in 1888, he returned to specific themes and tendencies of the Dutch theology of art and adapted them to new forms and purposes. In his emerging theory of "sacred realism," he redirected to his artistic practice the unity of the "passion for reality" and "evocative form" that had marked clerical attempts to shore up belief subverted by modern doubt and obsolete dualisms through the totalizing powers of art.

DUTCH MODERNISM IN ARLES

Traces of the Dutch modernist debates on nature, Christ, the limits of reason, and expressive art resurfaced during van Gogh's first months in Arles. Not only was he struck there by the topographic similarities to Holland, he was also pressed to return to ideas he had explored "before Paris and the Impressionists,"[73] including the theological probing of reality and divinity, the visible and the invisible. During the period in which he developed the symbolist *Sower*, van Gogh engaged in a series of otherworldly investigations and ruminations on what he called the "unlimited possibility of future existence."[74] These explorations reconnected him to the central themes and unresolved problems of Dutch modern theology, which he deftly recast in his own queries on the meaning of eternity, the status of immortality, and the role of art in approaching a suspected but unverifiable God.

The deaths of his cousin Anton Mauve and his uncle in the late winter and spring of 1888 stimulated van Gogh's reflections on natural supernaturalism and the limits of human knowledge of "a life beyond the grave."[75] He returned to his earlier reflections on the desire for, but the impossibility of, a standard of "proof" for the existence of God and eternity. Expressing his shock over Mauve's death in a letter to his sister Wil of late February 1888, he noted that he found it "so hard to imagine that such a person can cease to exist." But he went on to maintain, echoing the theologians before him, that human logic and precepts of plausibility were inadequate, an inappropriate tool for engaging in "supernatural researches" about the "existence in the hereafter." Better to remain grounded in work and practical action, he argued; "the painter ought to paint pictures—possibly something else may come after that."[76]

Yet the contours of that "something else" continued to bother van Gogh, much as the critique of supernaturalism had left the modernist theologians with a nagging desire for the "supersensible." During the summer of 1888 he resumed his discussions with his brother and sister concerning the "future life" of artists and the possibility of immortality, which he cast in the discourse of proof and a geography of the heavens. Here is "the eternal question," he wrote to Theo in July: "Is the whole of life visible to us, or isn't it rather that this side of death we only see one hemisphere?"[77] We can "only surmise" the "existence of this other hemisphere of life," he wrote to Wil a short time later; but then, again to Theo, it cannot be disproved either, for "there is nothing to be said *against* the unlimited possibility of a future

existence."[78] These letters sparked van Gogh's thinking of death as a journey to another topography, regulated by similar directionals as movement in the earthly hemisphere. Perhaps the stars are like the "black dots on a map," "representing towns and villages," he proposed to Theo, and we arrive there by "celestial locomotion," as we reach a town by train.[79] Concluding his ruminations on his uncle's death, van Gogh observed that the appearance of calm and gravity in the deceased convinced him of "*one proof of a life beyond the grave.*" We are left "not knowing" with any certainty, but we can propose it, he argued, just as we can see the way that a "child in the cradle has the infinite in its eyes."[80]

These reflections, and the rhetorical emphasis on standards of proof and possibility, expressed the core issues and habits of debate among the modern theologians. When van Gogh declared to Theo his questions about the "future life," his Arles statements reverberated with broader cultural resonance and historically specific meaning among his Dutch contemporaries: "Is that all, or is there more to come?" he asked.[81]

Van Gogh drew his friend and fellow painter Emile Bernard into his theological deliberations. During the June weeks when he devised the Arles *Sower* as a visual expression of a "longing for the infinite," van Gogh wrote letters to Bernard taking up the problem that had set off the Dutch crisis in the 1850s: the need to modernize faith by proposing a new relation between science and belief. Cornelius Opzoomer had begun the campaign to reconcile religion and science by opposing supernaturalism and subjecting divine acts and scriptural texts to the tenets of natural law. While his position was vigorously rejected by his opponents, theologians such as Scholten, Pierson, Hoekstra, and Chantepie de la Saussaye retained scientific empiricism as a critical tool in their campaign against dualistic tradition and miracles as they argued that the roots of piety and the nature of God lay beyond the limits of rational mastery. Van Gogh's 1888 letters to Bernard reclaimed this particular Dutch polemic of science and faith while staking out his own new position within the framework set by the theology of natural supernaturalism. While Gauguin was exploring the mystery of visionary contact in Brittany, van Gogh's Dutch habits and mentality led him in Arles to propose to Bernard a natural science of the heavens and a natural history of the butterfly as a template for a new theory of resurrection, rebirth, and the immortality of the soul, of eternal life in another realm beyond the visible.

One letter to Bernard acknowledged the material difficulties of painters on what van Gogh called "this thankless planet." As the earth was only one planet among many, however, painters might have an

afterlife in other parts of the solar system. Invoking a butterfly's stages of transformation, van Gogh argued that this afterlife was a plausible postulate and, in any case, could not be *disproved*:

> But seeing that nothing opposes it—supposing that there are also lines and forms as well as colors on the other innumerable planets and suns—it would remain praiseworthy of us to maintain a certain serenity with regard to the possibilities of painting under superior and changed conditions of existence, an existence changed by a phenomenon no queerer and no more surprising than the transformation of a caterpillar into a butterfly, or of the white grub into a cockchafer.
>
> The existence of the painter-butterfly would have for its field of action one of the innumerable heavenly bodies, which would perhaps be no more inaccessible to us, after death, than the black dots which symbolize towns and villages on geographical maps are in our terrestrial existence.[82]

Reverend Allard Pierson, in expanding the clerical dialogue distinguishing what could be detected and proven from what could be suspected and presupposed, had also invoked the science of the solar system. He employed it to deprecate a traditional religion fixed in the dualisms of a distant heavenly court above and terrestrial supplicants below. The earth, Pierson had argued, was always spinning on its axis, and rotated like "a dot in an immeasurable universe." In conceding these empirical facts as a prerequisite for a modern religious realism, Pierson had concluded with a lesson about the limits to knowledge, that "we cannot conceive of that which is beyond the universe." Van Gogh, too, affirmed the limits to knowledge of the immeasurable universe beyond the visible, but he could not resist the impulse to surmise and domesticate its characteristics, ever ready, from perspective-frame practice to theoretical speculations, to bring the distance nearer, to render the infinite accessible. In propelling the lines, forms, and colors that artists use to "other planets and suns," van Gogh amplified Pierson's framework and used the logic of realism to break through the barrier of knowability, extending to the realm of the "outre-tomb" the postulate of natural, supernatural existence. In the process he transformed the butterfly into an emblem of secularized resurrection among the stars and planets.

The idea of the painter-butterfly served a personal purpose for van Gogh as well as extending the

formative debates of his Dutch theological culture. He explicitly identified himself with insect meta-morphosis. A book he read and admired, *L'Insecte* (*The Insect*) by Jules Michelet (1858), had inspired this personalizing link between the artist and the process of metamorphosis. "How many times have I passed from the larva to the chrysalis state and to a more complete state, which . . . has set me on the way to achieve a new circle of metamorphoses," Michelet joyously proclaimed. Van Gogh's expressions of identification were more tentative and pessimistic. He focused on the larva stage as a phase of death and degradation that was nonetheless a necessary preparation for emergence in a new state. In contrast to Michelet's affirmation, van Gogh's tone was uncertain. To Bernard he wrote, "I, too, should like to know approximately what I am the larva of, myself; . . . where will this butterfly emerge from the chrysalis?"[83] At earlier points in his career, van Gogh had legitimized his slow progress, or career dis-appointments, in the themes of organic life. When he decided to leave his missionary work as a popu-lar evangelist for art, for example, he had explained to Theo that he would now be engaged in a slow, cumulative process of incubation and transformation, which might not appear worthwhile and pro-ductive but was nonetheless a constructive phase of readiness, similar to "the molting time for birds." In Arles in 1888, van Gogh experienced new disappointments and shortcomings, particularly in his inability to match his intensive pace of production with any possibility of sales. He discovered in the butterfly model a form of reassurance and validation: that his consistent call to perseverance through privation had an organic analogue in the inevitable metamorphosis of a lowly, ingesting, and wormlike creature into a glorious, active, and soaring form.

In concluding his letter to Bernard, van Gogh moved from the butterfly-painter to a more gen-eral statement on the status of science and faith, consolidating his own unique solution to his culture's theological quandaries. The provocative and engaging form in which he presented his proposal to Bernard corresponded to other attempts to popularize and simplify modernist debates, such as two works of Dutch writer-preachers that van Gogh had read. Conrad Busken Huet's best-selling *Letters About the Bible*, for example, had transformed the debates on scriptural authenticity, natural science, and Reformed religion into a dialogue, cast as a series of letters exchanged between a fictional brother and sister, Reinhout and Machteld. Poet-cleric P. A. de Genestet's *Leekedichtjes* (*Layman's Poems*) had also given voice to the different theological positions of the period in such poems as "Monism," "Deter-minism," "Dualism," and "Mediated Theology" ("Vermittlungstheologie"), the last of which explored

how "my science and my faith" might "live together" or teach "what is true and holy, and what is not."[84] In his Arles conversation with Bernard, van Gogh's version of the science-and-faith dilemma offered a deft, amusing integration of the two poles:

> *Science, scientific reasoning rather, seems to me an instrument with a great future.*
>
> *For look: the earth was thought to be* flat. *Indeed, it was true: between Paris and Asnières, for example, it still is today. But that hasn't prevented scientists proving conclusively that the world is* round. *And no one contests it.*
>
> *In spite of this there's still an idea that life runs* in a flat progression *from birth to death. But life too is probably* round, *and far greater in extent and capacity than the hemisphere which we know at present.*
>
> *Future generations will probably enlighten us on this interesting subject: then will be the turn of Science, if she likes, to draw conclusions more or less parallel to the sayings of Christ, dealing with the other half of our existence.*
>
> *However, all we really know is that we are painters living a real life and that we must go on drawing breath as long as we have breath to draw.*[85]

Like Pierson, van Gogh rejected the linearity of ascent, of God "up there" and humanity "here below." Van Gogh, however, offered a new twist on science in the service of modern religious realism. If science had already shown that the earth, presumed to be flat, was really round and spinning, it might, in time, discover that life too was a circular, regenerative totality. In empirical terms this was an inference that could be neither proven nor disproven but that awaited a future possible discovery. Van Gogh's tone was ironic, noting that science and scientific reasoning would go far in the future (*ira bien loin dans la suite*) only to arrive at conclusions parallel to the sayings of Christ that had inspired believers for centuries. Here van Gogh inverted the scientism that the theologian Opzoomer had aspired to: rather than bringing Scripture and faith under the sway of natural law, van Gogh anticipated that science would follow the course set by Jesus Christ and corroborate his spiritual truths.

Like his Arles letters to Theo and Wil that wrestled with the contours of the infinite, van Gogh's comments to Bernard about the afterlife of artists shifted awkwardly to a return to the real world, to

nature and work. Despite his interrogation of the invisible, van Gogh asserted "I know nothing about it" to Theo; to Bernard his musings on a possible "round life" concluded with the idea that "all we really know is that we are painters living a real life" and must go on. At the same time, in reinstating the coordinates of the visible, van Gogh also expressed in Arles a conception of the role of the artist as the mediator between nature and a suspected but unknowable eternity, corresponding to the modernist theology that privileged the sacred power of art to evoke the divine totality.

Reverend Pierson, in rejecting art's strictly imitative functions as superfluous in the era of photography, had highlighted the artist's expressive force to release the voices of nature. By listening, absorbing, and interpreting, artists "make us almost see and feel the invisible world," animating seeds, sea, fields, and stars as carriers of "the eternal." From early on, even before he became a painter, van Gogh, like the modernist theologians, had construed art as what he called *"l'homme ajouté à la nature* [man added to nature], nature, reality, truth, but with a significance, a conception, a character, which the artist brings out in it, and to which he gives expression, *'qu'il dégage,'* which he disentangles, sets free and interprets."[86] In 1882 in The Hague, as he struggled with his new illustrator's craft, van Gogh reiterated his belief in a nature and daily life saturated with the ineffable:

> *If one feels the need of something grand, something infinite, something that makes one feel aware of God, one need not go far to find it. I think sometimes I see something deeper, more infinite, more eternal than the ocean in the expression of the eyes of a little baby when it wakes in the morning, and coos or laughs because it sees the sun shining on its cradle. If there is a* rayon d'en haut, *perhaps one can find it there.*[87]

That ineffability, van Gogh assumed, could be given voice through the artist's expressive force:

> *At times there is something indescribable in those aspects—all nature seems to speak . . . As for me, I do not understand why everyone does not see it and feel it; nature or God does it for everyone who has eyes and ears and a heart to understand. For this reason I think a painter is happy because he is in harmony with nature as soon as he can express a little of what he sees.*[88]

In Arles, as he tackled *The Sower* and considered anew the "longing for the infinite," and "life beyond the grave," van Gogh wrote again of the bridge between nature and eternity as "a child in the cradle," which, "if you watch it at leisure, has the infinite in its eyes."[89] In evolving his particular form of modern art in Arles, van Gogh viewed nature as "exalting and consoling," realized and completed by the artist's powers of expression.[90] *The Sower* belonged to a repertoire of images that he would continue to identify as separating the "possible and the true" from the "ideal and the abstract," finding his raw materials "in nature, only it must be disentangled."[91] His friends Gauguin and Bernard moved in a different direction, toward an expanding conceptual approach: imposing the artist's prior idea or dream on nature. By contrast, van Gogh, like Pierson's artist, was poised to observe, absorb, and interpret humble truths and nature's forms as vessels of that indefinite, inexpressible eternity.

VAN GOGH'S CHRIST: *AGIR-CRÉER* AND EVOCATIVE FORM IN ARLES

The aspiration for the infinite in and through nature brought van Gogh back to the figure of Jesus Christ, who had been so prominent in his early formation but had yielded to a more elastic notion of *quelque chose là-haut*. At the moment when van Gogh began his quest for a symbolist *Sower* in Arles, he invoked two models—Millet's peasant figure ("a colorless gray") and Delacroix's Christ. He celebrated Delacroix's Christ for the "colorful luminous note" of the "nimbus, the halo," that "speaks a symbolic language through color alone." He described this bright citron-yellow "aureole" as possessing "the same unspeakable strangeness and charm in the picture as a star does in a corner of the firmament."[92] In his *Sower* van Gogh transferred this luminous brightness from Christ's halo to the blazing sun at the back of the striding figure.

Within a few days of writing to Theo about the role of Delacroix's Christ in planning his *Sower*, van Gogh launched his critique of religious art in a series of letters to Bernard. The first letter, as discussed above, included van Gogh's imaginative reconceptualization of the ties binding science and faith and his musings on the afterlife of artists. This same letter engaged in a characterization of Jesus Christ as an aesthetic force, corresponding to Pierson's realist theology that shifted the ground of the *Imitatio* from self-surrender and resignation to the "holy beauty" of evocative form.

Van Gogh began his comments in response to Bernard's reading of the Bible. Initially he cited a conventional idea of Dutch Reformed piety, noting that the Old Testament was a prefiguration of the New—"the Bible is Christ, for the Old Testament leads up to this peak." Yet van Gogh was now quite critical of the Bible, commenting to Bernard that he had long restrained himself from recommending that Bernard read it, as it distressed him and bred in him a sense of "outrage" by "its pettiness and folly." But he went on. What remained compelling to him, what he considered a core of "consolation" in the Bible—"like a kernel inside a hard shell, a bitter pulp"—was Christ.[93] The kernel of consolation in a hard shell recalled the figure of Christ presented in one of van Gogh's favorite early books—the populist and impoverished Christ of John Bunyan's *Pilgrim's Progress*, who comforted the lowly and lived among them, "like a precious stone in a hard and grimy crust."[94] Bunyan's Christ juxtaposed an exalted inner essence with a debased social state—Christ's "grimy crust" captured his condition of ragged poverty and rebuke by those unable to see his grace. Van Gogh's Christ now indicated the painter's impatience with the saga of strife, submission, and compensatory salvation in another world to offset worldly suffering that had claimed his earlier religious consciousness. He now saw Christ as an inner core of value within a destructive scriptural tradition.

Van Gogh's Arles letter then proceeded to describe the essential appeal of Christ. Like Pierson, van Gogh eluded the difficult issues that had dominated the debates about Christ for two decades—the status of Christ's historicity and credibility as Testament author. Van Gogh defined Christ neither as a suffering martyr to be emulated nor as a teacher of doctrine to be revered, but as an artist:

> Christ alone—of all the philosophers . . .—has affirmed, as a principal certainty, eternal life, the infinity of time, the nothingness of death, the necessity and raison d'être of serenity and devotion. He lived serenely, as a greater artist than all other artists, *despising marble and clay as well as color, working in living flesh. That is to say this matchless artist . . . made neither statues, nor pictures, nor books;* he loudly proclaimed that he made . . . living men, *immortals . . . This great artist did not write books either; surely Christian literature as a whole would have filled him with indignation, and very rare in it are literary products that would find favor in discerning eyes beside Luke's Gospel or Paul's Epistles—so simple in their hard, militant form. Though this great artist—Christ—disdained writing books on ideas (sensations) he surely dis-*

dained the spoken word much less—particularly the parable. (What a sower, what a harvest, what a fig tree!, etc.)

And who would dare tell us that he lied on that day when, scornfully foretelling the collapse of the Roman edifice, he declared, heaven and earth shall pass away, but my words shall not pass away.

These spoken words, which, like a prodigal grand seigneur, *he did not even deign to write down—are one of the highest summits—the very highest summit—reached by art, which becomes a creative force there, a pure creative power.*[95]

Van Gogh considered Christ a greater artist than all others because his was the power of *agir-créer*, "action-creation"—his work, and his words, made "men" rather than objects. In celebrating Christ as an aesthetic force, van Gogh reaffirmed a central feature of the religion of beauty within the Dutch church that had formed him. Reverend Pierson had isolated the expressive power of Christ's language as a key to its persuasive force; van Gogh, immersed in his symbolist *Sower*, highlighted the qualities of Christ's choice and style of spoken words—the form of the parable of the sower, for example—as "a pure creative power." Both Pierson and van Gogh posed this model of Christ's aesthetic power against the literalism of an art that chose Christ as a subject for representation or didactic presentation. Rather than re-create the afflictions or lessons of the Savior, both painter and preacher glorified the discovery of formal elements of the arts that would emulate Christ's creative power to move, touch, and console through a union of humble truth and evocative form. Pierson looked to the faces of Rembrandt, to his ineffable but saturated light, and to the "awesome indefiniteness" of painting and music to indicate the contours of his theology of modern realism, defining art's unique capacity to elicit universal states of feeling, from joy and hope to sadness and despair. Van Gogh transferred the luminousness and "unspeakable strangeness" of Christ's citron-yellow nimbus to the sun behind an active human laborer to launch in Arles his symbolist art as sacred realism, to render the infinite tangible.

In his earlier period, such as when he painted *The Potato Eaters*, van Gogh considered his dark, haggard peasants the most deserving of eternal light and life, and he presented a promise of a future redemption by the anticipated passage from darkness to light. In *The Sower*, he configured a present redemptive incandescence. The thick and loaded brushwork, visual equivalents of the labor van Gogh

admired, emphatically showed his work. Yet he also aspired in *The Sower* to find formal means to convey the infinite, to evoke the presence and comfort of an invisible totality that moved beyond the active laborer and beyond the artist vigorously working the image of work depicted. The combination of rough texture and blazing light, crusted pigment and glowing irradiation, now fused the artist as weaver with the artist as mediator of transcendent light. Built into this experiment in embodiment was art's triple power to channel the "exalting and consoling" powers of nature, to provide comfort to the human community, and to evoke the immaterial infinity that related all individuals to an eternal, sacred wholeness beyond the self. Van Gogh's blending of these particular qualities at the threshold of his symbolist art carried his Dutch modernist theology of realism into painting, a distinctive pictorial structure to bind, through representation, the immanent and transcendent orders.

Portraiture emerged as central to van Gogh in this particular variant of natural supernaturalism. In September 1888, just before Gauguin's arrival in Arles, van Gogh wrote to Theo of the importance of portraiture, which combined all the elements of a modern sacred art:

> *And in a picture I want to say something comforting, as music is comforting. I want to paint men and women with that something of the eternal which the halo used to symbolize, and which we seek to convey by the actual radiance and vibration of our coloring.*[96]

This often-quoted statement takes on new meaning in the light of theologically specific themes and the dilemmas left unresolved by the decades of the modern movement within the Reformed Church. Van Gogh provided a new form, and a new solution, for what the theologians before him attributed only to painters like Rembrandt: the melding of human faces, consolation, modernized haloes, and the musical power of color.

RELIGIOUS LEGACIES

Paul Gauguin, gripped by the polarities of worldly suffering and transcendent release, adapted Bishop Dupanloup's catechism to a new, modern imagery of profanation and exaltation in his allegorical box

and his *Vision* painting. Others among a generation of lapsed-Catholic artists, such as Auguste Rodin, Maurice Rollinat, and Octave Mirbeau, also tried to find expressive forms for a panoply of human vices and modern values rooted in the experience of Catholic culture but unrelieved by the consolation offered by traditional religious belief. They also shared the ethos binding the infernal to the internal as the condition of artistic creativity, joining theological codes to psychic costs.

Vincent van Gogh moved from Paris to Provence with his own set of concerns shaped by a specific Protestant culture of visual piety, production pressure, and modern theological controversy. As he encountered Arles, van Gogh screened his new rural environment through the lenses of Holland, tending to select and mold those Arlesian elements that bore the closest affinity to Dutch topography and devices, from panoramic fields to canals, drawbridges, and tree alleys. The Arles world also sparked other memories and the renewal of ideas before Paris, which included his explorations of natural supernaturalism, the status and meaning of Christ, and the theology of Dutch modernism. While van Gogh lived in Arles in a world saturated by Catholic popular piety and surrounded by rituals, processionals, reliquaries, statuettes, and festivals of saints, he had little response to these activities, although similar events in Pont-Aven riveted Gauguin's imagination and provided him with the raw materials for a symbolist embarkation to the realm of the visionary. Instead, van Gogh reanimated in Arles another, very different set of ideas exploring the links between eternity and the natural world, between the infinite and the tangible.

In attempting in his *Sower* to lodge the "longing for the infinite" in a laboring figure, van Gogh extended and transformed the "passion for reality" that theologians like Scholten and Pierson had advocated as the basis for a renovated faith in a modernizing world. At the same time, van Gogh's emphasis on the evocative power of color as the basis of his symbolist realism achieved a route to emanation through art that the theologians had identified as the privileged source of the sacred in the era of critical rationalism. Van Gogh's Dutch theological model of Christ as a creative force and as a curative, consoling power to be emulated by the artist's forms underlay the Arles symbolist experiments of *The Sower* and the self-portrait as a bonze. Placing himself in the stance of a worshipper in the self-portrait, with radiant color emitting light around the head, van Gogh reached out to "comfort," to consolation, and to communication and connection at a new level—"like that something of the eternal which the halo used to symbolize."

This particular theology of evocative forms coexisted with other Dutch legacies. Van Gogh's historically specific assumptions of enacted faith, art as craft, and anti-idealism provide some of the cultural building blocks to explain how it was that he came to adapt a former tea box to store colored yarns in as part of his new artistic practice, while none of his Parisian colleagues expressed any interest in reconstituting, in fabric, the weaving chemistry underlying Chevreul's theories. And Gauguin, by contrast, was busy making a box to allegorize a modern variant of the idea that "the wages of sin are death."

While van Gogh thus defined art as the new venue of Christus Consolator, Gauguin moved closer to another model—that of identifying with Christ, and with Christ's torment and martyrology. Here the artist's personality, not the artist's forms, were primary as the agent of emulation, and the full force of this connection could never be communicated, for the intensity of suffering was always to be "incomprehensible." The artist became not the agent of God but the new *homme des sacrifices*,[97] as Gauguin called him. Within months of their work together in Arles, Gauguin would begin to portray himself in a way that van Gogh would find abhorrent—as Christ himself.

Collaboration in Arles

CHAPTER SIX Economics

Art, it is my capital.
PAUL GAUGUIN[1]

While I go on spending, I bring nothing in.
VINCENT VAN GOGH[2]

Paul Gauguin expressed little explicit enthusiasm for van Gogh's plan for an artists' community. By May 1888 Gauguin was well ensconced in Pont-Aven, and through the summer months he avoided the question of relocation and association. In early July he accepted the proposition that he come to Arles, but still he made no plans to leave Brittany. Emile Bernard and his sister Madeleine arrived in Pont-Aven in August, and Gauguin was reluctant to forgo their companionship; he was also intensely focused on clarifying his evolving ideas about art as an abstraction. In September, still in Pont-Aven, Gauguin proceeded to experiment with the new style and subject of *The Vision*. The self-portrait as a *misérable* completed later that month expressed both the promise and peril of this new direction, with the artist bearing the cost of rejection by those unable to appreciate what Gauguin called his "mysticisme *terrible*."[3]

It was only in October 1888 that Gauguin finally decided to leave Brittany. The catalyst was finances—on October 4, Theo van Gogh, acting as Gauguin's dealer, sold 300 francs' worth of Gauguin's pottery at the gallery and sent him the proceeds with the stipulation that he buy a rail ticket to Arles. Gauguin assented, writing back to Theo that "the 300 francs completely changes the state of things" and that he would depart at the end of the month.[4]

Gauguin recorded no indication that his decision responded to any of Vincent van Gogh's ideas and proposals. The initial comradely plan of combining and economizing suggested by van Gogh struck no chord in Gauguin, and he did not pursue it in their correspondence. Further, he offered no explicit response to van Gogh's acclamation of his *misérable* self-portrait or to van Gogh's worshipful entreaty of October 3 that he come to Arles as an exalted master to be healed and revitalized. His only comment on van Gogh's dramatic missive was offered not to van Gogh at all but to Emile Schuffenecker, and in an extremely perfunctory manner. After receiving the letter Gauguin sent it on to Schuffenecker with the

neutral prologue: "I am sending you a letter from Vincent, from which you will see where I stand with him, and all that is planned at present."[5]

Gauguin proceeded to go to Arles, then, with clear eyes, stripped of the brotherly love and communion extended by van Gogh, and acting in accord with the spirit of the shrewd *calculateur* that van Gogh had initially discerned in him. In explaining his decision in letters to Schuffenecker, Gauguin never mentioned Vincent, indicating only that he could not refuse an offer to be supported by his dealer. "At the end of the month," he wrote in his October 8 letter, "I leave for Arles where I think I'll stay a long time, since the purpose of my stay there is to make it easier for me to work without worrying about money until he [Theo] has managed to launch me."[6] Gauguin attributed a similar calculus of self-interest to Theo's motives to sponsor him in Arles. He boasted to Schuffenecker that while his new symbolist path might be "full of dangers," it would also succeed:

> *Pay close attention: right now among artists a very strong wind is blowing in my favor; I know this from certain things that have slipped out and, believe me, no matter how fond of me he [Theo] is, he wouldn't go to the expense of supporting me in the Midi just for my good looks. Being a cold Dutchman he has appraised the lay of the land and intends to push things as far as they can go and exclusively.[7]*

Vincent van Gogh misperceived Gauguin when, in response to the *misérable* self-portrait, he shifted from being wary of the schemer to compassionately embracing the "tormented prisoner," thinking these were discrete phases of Gauguin's personality. For Gauguin, the econometric and the dolorously redemptive went hand in hand in 1888, as they did at other parts of his career; the aspiration for metaphysical mystery, agonistic self-discovery, and commercial self-promotion all coexisted. While he perceived art and life as a relentless "conflict with matter," affirming in 1888 that "everything that is divine must be released from the chains of enslavement" to the material and corporeal world, Gauguin was nonetheless savvy and well grounded in matters of money and marketing. The techniques of introspection and "inner worship" drilled in the seminary and the ontology of sacrifice and transcendent purity reemerged in Gauguin's artistic ethos of wretched self-flagellation and merciless self-

aggrandizement, irrevocably binding his experiments in the art of abstraction to his ventures in the marketplace of speculation.

GAUGUIN'S DUAL THREAT TO VAN GOGH'S PICTORIAL LABOR

Gauguin's arrival in Arles generated two significant dilemmas for van Gogh, which had profound conceptual, personal, and stylistic consequences. The first was the dilemma of the market and the limits of the identification with labor as a foundational justification for van Gogh's practice. His emerging reverence for Gauguin came at the same time as his growing painful recognition of his own lack of success in the marketplace. Considering his artistic conceptions "ordinary" and "clumsy" in comparison with Gauguin's, he also contrasted his severe shortcomings in the art market with Gauguin's quite different position. These contrasts, intensified by Gauguin's commercial sponsorship by Theo, triggered a short-lived but profound revision in the terms in which van Gogh conceived his work and worthiness and his relationship to his brother.

This chapter explores the critical moment, just before Gauguin's arrival in Arles, when van Gogh attempted to redefine the standard of measure for his artistic project from an anticipated worthiness of redemptive labor to a present accounting of commercial value. The traces of this redefinition emerged clearly in the startlingly capitalistic language and logic of van Gogh's letters to Theo in that period. The appearance of this new thematic pattern, its precise timing and duration, and its consequences for van Gogh's relationship with Theo have never been attended to in accounts of van Gogh's experience in Arles.[8]

Gauguin's arrival crystallized a second dilemma for van Gogh—the dilemma of abstraction. During their collaboration, Gauguin challenged van Gogh to follow him in the pursuit of the dream, imagination, and the mystery of the infinite, and to explore new visual techniques of dematerialization suited to evoking them. Although van Gogh experimented with expressive color and attempted to modulate his brushwork, he resisted Gauguin's charge to relinquish the model and diminish his anchorage in nature, and he reaffirmed his canvas strategies of tactility while taking them in new directions. Part

Four's remaining three chapters will analyze a number of paintings that van Gogh and Gauguin produced during their time together, highlighting the incommensurability of their distinctive modernist projects even as they worked side by side on the same sites and subjects. As the two painters interacted and shared ideas and studio space, they adapted new insights to their own expressive idioms and the religious legacies that framed them.

THE RUPTURE IN VAN GOGH'S LABOR IDEAL

In the month before Gauguin's arrival, van Gogh's letters reveal a new and increasing sense of distress, guilt, and tension over his failure to sell pictures. Up to this point during his stay in Arles, he had been sustained and reassured by his ideology of "salvation by association," selecting rural labor or craft devices as his subjects, affirming that the work he expended producing a picture matched the exertion of the harvesters in the fields, and discovering pictorial forms to emulate the weight, tangibility, and tactility of the rural cycle or craft structure represented. Throughout the spring and summer months he had professed a robust enthusiasm for his prodigious work in Arles as he mapped the landscape, framed the drawbridge and the fishermen's boats, and encompassed visually all stages of labor in the fields, from sowing to harvesting and stacking the grain. The presence and effectiveness of the labor done by others nourished his ongoing validation of his own work and worthiness by association. "I consider that I am after all a workman," he wrote to Theo, noting that like the basketmakers and weavers, he could tolerate solitude by absorption in an "occupation" and "handicraft." A bit later he suggested to Theo that "painters ought to live like workmen," emulating the productivity, "regularity," and industriousness of "a carpenter or a blacksmith."[9]

Van Gogh's sense of self-justification through his identification with laborers became more pronounced during the harvest series, when he reveled in the pace of his own productivity as he completed, for example, ten paintings in the seven days between June 13 and June 20.[10] He wrote to Theo that "during the harvest my work was not any easier than what the peasants who were actually harvesting were doing."[11] On June 24 van Gogh also wrote to Bernard describing the effort, strain, and

exhausting but satisfying energy of what he called his "day of hard toil" in the fields and its equivalence to the activity of the laborer who worked them:

> *The fact is that I am so worn out by work that in the evening . . . I am like a machine out of gear, so much, on the other hand, has a day spent in the full sun tired me out . . . I have seven studies of wheatfields . . . The landscapes yellow—old gold—done quickly . . . and in a hurry, just like the harvester who is silent under the blazing sun, intent only on his reaping.[12]*

As van Gogh's own "harvested" work accumulated, he dispatched it on a regular basis to Theo in Paris; Lieutenant Milliet, for example, delivered a roll of thirty-six paintings to Theo in mid-August 1888.[13] At this stage, van Gogh was not preoccupied by the marketing of his pictures, and neither he nor Theo pressed the issue of sales or salability. Theo kept the pictures at his apartment and showed them to friends and fellow painters of Vincent's, and Vincent sustained a sense of buoyancy from the conspicuous quantity of his production and the tangible record of his growing mastery.

The expectation of Gauguin's arrival abruptly exposed the fragility of van Gogh's logic. Despite his assertions of long-term patience for artistic ripening and the guarantee of divine reward secured only in the ordeal of toil and perseverance, van Gogh began to acknowledge that, unlike the harvester, he was not "earning his bread in the sweat of his brow"; he was not enjoying the fruits of his labor in the present. Van Gogh's singular focus on productivity had obscured his view, and he attempted for a brief period to shift his primary assessment of his work and worthiness from the theology of earning and deserving to the economy of market value.

Two factors converged in the fall of 1888 to facilitate this shift. The first, as I have mentioned, was that Gauguin's impending arrival set van Gogh's own negligible record of picture sales into stark relief. Van Gogh's discussions with Theo from May to September about the terms, conditions, costs, and possible prices for work Gauguin might do in Arles attested in a concrete and detailed way to the disparity of the two painters' salability, and triggered corresponding changes in van Gogh's conception of his relationship to the market and to his brother. Second, as van Gogh involved Theo in his plans for a "studio of the south," his financial demands on him increased dramatically. The corporate brotherhood

and subsequent sponsorship of *maître* Gauguin necessitated extensive initial expenses, for which van Gogh enlisted and relied on Theo's monetary support. The requests for funds accelerated in pace and scale by September, generating a heightened sense of guilt and apprehension over his enormous indebtedness to his brother.

The month before Gauguin's arrival, then, witnessed van Gogh's crushing recognition of his own failure to break into the art market and of his ever-expanding dependence on his brother's unconditional solicitude. In response to his new understanding, van Gogh tried to restructure his relationship with Theo along the lines of a business contract, attempting to work out a calculus of the projected monetary value of his picture productions. This new capitalistic logic temporarily displaced the invocation of artisanal industriousness and agrarian exertion as the governing rationale of van Gogh's pictorial labor.

THE NEW ARRANGEMENT

In preparation for Gauguin's arrival, van Gogh began to outfit the four rooms in the Yellow House. He had rented the rooms back in May, at a rate of 15 francs per month, but they were in dilapidated condition and uninhabitable. On September 8 Theo sent a lump sum of 300 francs so that van Gogh could refurbish the house, and he proceeded in the week that followed to buy two beds, twelve chairs, a small table, a mirror, and an extra mattress.[14] By September 22 he had purchased a dressing table for his room and outlined to Theo the expected additional expenses for the necessary accoutrements for Gauguin's room, such as a dressing table and a chest of drawers, and a big frying pan and a cupboard for the downstairs.[15]

At the same time, van Gogh's expanding habits of what he called "painting very thickly" resulted in a very rapid pace of using up tubes of paint, and he wrote to Theo on September 27 that he "urgently" needed to order "an additional 200 francs' worth of paints, and canvases, and brushes." He itemized these supplies in a list in the letter, including an order for twenty-six tubes of paint of various colors and five meters of canvas.[16] A request for monies for both house and paint supplies was repeated in a new list to Theo just six days later, on October 3, in the letter enlisting Theo as an apostle to Gau-

guin the *misérable*. Here van Gogh told Theo that "before Gauguin comes I want to buy some more things—the following," for a total of 402 francs:

Dressing table and chest of drawers	40 fr.
4 sheets	40
3 Drawing boards	12
Kitchen range	60
Paints and canvas	200
Frames and stretchers	50

Van Gogh admitted to Theo that this list was "a lot" and claimed that none of it was absolutely essential, but he went on to describe how the items were nonetheless necessary and justifiable. About the order here for yet another large quantity of paints—200 francs' worth—van Gogh explained to Theo, "Yes, I am ashamed of it, but I am vain enough to want to make a certain impression on Gauguin with my work, so I cannot help wanting to do as much work as possible before he comes."[17]

These examples indicate that in less than one week—September 27 to October 3—van Gogh requested 602 francs from Theo. Typically Theo had been sending Vincent 50 francs per week in Arles, varying slightly from 200 to 300 francs per month, and recovering no funds from sales. During the period from late September to October, by contrast, Gauguin was writing to Theo to negotiate prices for his Brittany pictures, which were beginning to sell and attract a small but wealthy clientele. By the third week of October, when he departed for Arles, Gauguin had received word from Theo that a group of his Pont-Aven paintings, sent to Paris, were being "admired by everyone," and Theo had dispatched two large sums to Gauguin as proceeds from sales at the gallery: 300 francs for pottery, and 500 francs for the canvas *Bretonnes*, sold to a M. Dupuis, the same client who had purchased Gauguin's *Bathers* in December 1887.[18]

As they were positioned in inverse directions along the route to a symbolist mediation of the infinite and the tangible in their painting practice by September 1888, van Gogh and Gauguin were also splayed out by that time at opposite ends of the marketing spectrum, while both were being coordinated

by Theo. By October 1888, Gauguin was beginning to see his first flush of success, generating interest, activity, and profit from some of the Pont-Aven pictures at Theo's gallery. A circuit had been set in motion between the painter and the dealer, with a gathering pace of delivery, feedback, and sales revenue moving from Brittany to Paris or vice versa. Van Gogh, at precisely the same time, was a self-generating engine of production, divested of the gratifications of public exhibition or sales, while dramatically expanding the amount of money he received from his brother.

The problem of his own productivity without results triggered two reactions he expressed in his letters to Theo during September and October. The first was a record of guilt and unworthiness for all that Theo offered him. "I do not think my pictures worthy of the advantages I have received from you," van Gogh noted to Theo on September 17. "I am afraid of overburdening you"; "My only fear is of asking you for too much money"; and "While I go on spending, I bring nothing in," he continued in letters of the next weeks.[19] On October 8, a few days after running out of funds by overspending on orders for "too many" frames for his pictures, van Gogh had to write Theo again for more "necessary purchases" and admitted that he had lived for four days "mainly on 23 cups of coffee and bread which I still have to pay for."[20] His letter to Theo acknowledged:

> *Thinking and thinking these days how all these expenses of painting are weighing on you, you cannot imagine how disquieted I am . . . If I were not so horribly and continually tormented by this uneasiness, I should say that we were getting on, because my work will get better.*[21]

Van Gogh deflected his growing sense of guilt in a second traceable set of responses during these months: he devised what he considered a new plan to pay Theo back for the monies steadily offered him in Arles. This new emphasis on "payback" asserted a calculable exchange of a certain quantity of goods—pictures—for a certain amount of funds disbursed. In mid-September, as he began refurbishing the Yellow House, van Gogh first proposed the contours of this quasi-contractual arrangement to Theo:

> *My plan is all complete, I will try to paint up to the value of what you send me every month, and after that I want to paint to pay for the house. What I paint for the house will be to repay*

you for previous expenditure . . . I long to prove that I pay my debts, and that I know how much I want for the goods which this blasted painter's profession keeps me working at.[22]

Van Gogh was setting himself a rather onerous pair of tasks: first, to pay back any new monthly sums Theo was sending him by painting "up to" the value of those payments; and second, to pay Theo back (by painting) for the additional costs of the house, which he considered "repayment" for "previous expenditure." At the end of the letter van Gogh added a third level of reimbursement, noting that Theo had already invested a certain "floating capital" such as would be required for the establishment of any painter's studio, but that he, Vincent, had "eaten that up" during his "unproductive" years. "But now that I am beginning to produce something, I shall pay it back," he concluded emphatically.

Here then was the beginning of van Gogh's new attempt to regularize his relationship with Theo as an exchange of goods for monies proffered, and as bounded by a system of investment and return, or what he would later call "trying to balance the outlay with the output."[23] The contractual premise of producing work that would be worth "up to the value" of Theo's monthly allowance represented a variation on the theme of Gauguin's arrangement with Theo, which stipulated a monthly schedule of 150 francs in exchange for at least one picture. Van Gogh added to his own "contract" the self-imposed demand that he also *repay* Theo for prior investments by painting even more, setting in motion a spiral of contradictions generated by a program fixed on repaying investment in production, *past and present*, with more production, uninterrupted by the leavening presence of any sales.

Van Gogh's payback scheme continued to appear in the weeks following his initial letter, the weeks immediately preceding Gauguin's arrival. On September 22, as he acknowledged the receipt of 100 francs from Theo, van Gogh wrote him that "I am obsessed with the idea of painting such decorations for the house as will be worth the money spent on me during the years in which I was unproductive."[24] A few days later he again tried to balance the cost of objects purchased against a quantity of paintings, noting to Theo that "I must work like a team of mules as long as the autumn lasts if I want to recover what our furniture has cost."[25] On October 3, in the same letter that glorified Gauguin and also itemized the additional 402 francs he needed for the house and paints, van Gogh isolated the double bind he had constructed for himself, writing to Theo: "As for me, I want two things, I want to earn

back the money which I have already spent, so as to give it to you, and I want Gauguin to have peace and quiet in which to produce, and to be able to breathe freely as an artist."[26] These "two things"—earning back for Theo what he had already spent, and enlisting Theo to provide Gauguin with a harmonious environment—were highly incompatible, as the spending pace to insure the latter was constantly accelerating, at the very moment that van Gogh committed himself to earning back his prior accumulated expenditures. During the next two weeks the weight of these inconsistencies deepened as van Gogh conceded to Theo that his "list of necessary purchases was growing," but he nonetheless wrote to him on October 22 itemizing the need for seventy tubes of paint and ten meters of canvas, and repeated his intentions to repay the debt: "Well, the money you are giving me, and which I keep on asking for more than ever, I will pay it back to you in work, and not only for the present but for *the past as well.*"[27]

By October 24, just after Gauguin's arrival, van Gogh realized the full weight of the fallacy of his plan. How could he possibly achieve his goal of paying back debts while escalating dramatically his requests for more and more funds from Theo, intended to subsidize not only himself but his friends and colleagues in the "studio of the south"? In his letter to Theo on October 24, van Gogh's tone and message were dispirited and clear, and he acknowledged explicitly—perhaps unavoidably, given that Gauguin was now in Arles—that undercutting his contractual plan was the gnawing issue that his pictures were "not selling":

> *I myself realize the necessity of producing even to the extent of being mentally crushed and physically drained by it, just because after all I have no other means of getting back what we have spent.*
>
> *I cannot help it if my pictures do not sell. Nevertheless there will come a time when people will see that they are worth more than the price of the paint and my own living, very meager after all, that is put into them.*
>
> *I have no other desire nor any other interest as to money or finance, than primarily to have no debts.*
>
> *But, my dear boy, my debt is so great that when I have paid it, which all the same I hope to succeed in doing, the pains of producing pictures will have taken my whole life from me, and it will seem to me that I have not lived. The only thing is that perhaps the production of pic-*

tures will become a little more difficult for me, and as to numbers, there will not always be so many . . .

I believe that the time will come when I too shall sell, but I am so far behind with you, and while I go on spending, I bring nothing in. *Sometimes the thought of it saddens me.*[28]

Part of van Gogh's inevitable recognition of the implausibility of his payback plan derived from his attempt to assign monetary value to his pictures based on what they *would* be worth *if* they sold. These hypothetical estimations, communicated in the same letters to Theo during September and October, expressed van Gogh's new desire to have his brother feel that he was "making a profit on the money you invest."[29] Yet van Gogh's projections were quite fantastic. When he initiated his "contract" to paint up to the value of what Theo sent him, for example, and to "prove" that he could "pay his debts," van Gogh asserted that "altogether I think I can be almost sure of bringing off a set of decorations which will be worth 10,000 francs in time."[30] By September 27, as he ordered more supplies from Theo, van Gogh maintained that "if I polish off a size 30 canvas every two or three days, I shall make several thousand francs on it."[31] The day before Gauguin's arrival, van Gogh described to Theo how the benefits of collaboration would exceed the mere practical issue of sharing expenses; if he and Gauguin joined forces, their "nominal capital" worth would also double, and they "ought to be good for" 10,000 each.[32] This figure, he noted, tallied nicely with his determination to "do 10,000 francs' worth of paintings for the house." Van Gogh arrived at this figure, strangely, not by referring to the going rate for Gauguin's pictures, at sums between 300 and 600 francs, but by reference to what he considered *Seurat's* large paintings to be worth. He was sure, he wrote to Theo, that Seurat's *Poseuses* and the *Grande Jatte* should be set at "5000 apiece at the lowest," and that, beyond this, perhaps Seurat would even "join hands with us"—with himself and Gauguin.[33] Despite van Gogh's opinion, the Seurat paintings eventually sold for only 1,200 francs each.[34] And his suggestion that Seurat join hands affirmed his own admiration for Seurat while it also brazenly ignored Gauguin's well-known loathing for the Neo-Impressionists, whom Gauguin derided as "the salesmen of the little dots."[35]

When van Gogh clearly confronted the irresolvable contradictions built in to his payback plan, he also acknowledged the inflated measure of his calculations and struggled to adjust them. In the letter of October 24 in which he admitted to Theo the crushing weight of his debt, van Gogh attempted a new

assessment, with desolating results. Instead of assigning large sums to his pictures, he now tried to esti-mate what he would owe in monetary terms for a lifetime of artistic production with pictures valued at *100* francs each. The capitalistic logic now turned from an affirmative projection of investment and profit to a dismal specification of an I.O.U. amount for an accumulation of a whole career's sponsor-ship by Theo:

> *But, my dear boy,* my debt is so great . . .
>
> *But in money matters it is enough for me to realize this truth—that a man who lives for 50 years and spends 2000 a year has spent 100,000 francs, and must bring in 100,000 francs again. To do* 1000 pictures at 100 francs *during one's life as an artist comes very, very, very, hard . . . at times our task is very heavy. But there is no changing that.*[36]

Theo responded to van Gogh's calculations with utter resistance, urging his brother to go on working, "even without selling anything." The idea that Vincent "owed him money" and wanted to give it back was absolutely unacceptable, he wrote, and it pained him deeply.[37] "You have repaid me many times over, by your work as well as by your friendship, which is of greater value to me than all the money I shall ever possess," Theo wrote to Vincent some time later.[38]

TURNING AWAY AGAIN FROM THE "SCUFFLE FOR MONEY"

Soon after Gauguin's arrival in Arles, van Gogh's two-month-long attempt to quantify the worth of his pictures and to rationalize his relationship with Theo along contractual lines subsided from central focus. Although the ideas of paying Theo back and trying to "earn" what he spent surely did not dis-appear, the later occasional mentions lacked the insistence and temporal concentration of the com-mercial language and logic that had erupted immediately before Gauguin came to Arles.[39] If van Gogh was always conscious of what he would call "the fatal question of money," he ceased to engage in the frantic effort of projecting "capital worth" that he attempted that fall.[40] These postures had been unleashed in a very particular context, structured by the convergence of four factors in this short and

critical period: van Gogh's apprehension over Gauguin's arrival; his new reverence for Gauguin as master artist and martyred *misérable*; his awareness of a new tempo to Gauguin's commercial successes; and the central role of Theo as the impresario of these sales. Paradoxically, van Gogh wielded his new ideas by adopting the language and outlook of the *calculateur* Gauguin, whose econometric speculations van Gogh had shrewdly identified before he celebrated Gauguin's status as the venerable *chef de l'atelier* instead.

But it did not take van Gogh very long to acknowledge that his proposals for a payback scheme and his roster of hypothetical prices offered to Theo were absurdly unfeasible, and he returned to the dominant and most compelling form of justifying his artistic project—in the terms of the patient, steady accumulation of a body of work, of progress through production and visible productivity. He wrote to Theo in late October that they should avoid selling and "the scuffle for money";[41] he was now resolved that his work should "mature quietly, like wine in the cellar." In November he restated his often-invoked image of the dogged and resolute producer, asserting that "I do not give in, but plod on quietly; . . . so, perseverance." And even though "we cannot deny or forget the money question," van Gogh explained to Theo some months later, now "I content myself with thinking that by working industriously, even without thinking about it, I may make some progress."[42] Turning from the market back to his usual form of self-validation, van Gogh again construed his artistic labor as an ordeal of tenacious and stalwart diligence that would yield an eventual restitution.

With Gauguin's arrival on October 23 and his stay through the end of December, van Gogh turned wholeheartedly to the task of living and working with his admired colleague. As he had modulated his wild projections for the market, van Gogh also adjusted, but more slightly, his extremely reverential attitude toward Gauguin. He remained deeply impressed with Gauguin, but his initial reactions after Gauguin arrived in Arles suggest a diminishment of the adoration evident in the aftermath of the *misérable* picture, and a less supplicating posture. He noted to Theo that Gauguin "is very interesting" and "astonishing as a man," and "I have every confidence that we shall do loads of things with him." On learning that Gauguin had been a sailor for many years, van Gogh commented that he sustained "an awful respect" for Gauguin and "a still more absolute confidence in his personality."[43]

If the final arrival of Gauguin in Arles healed the rupture in van Gogh's theology of art as labor activity and made Gauguin more human in van Gogh's eyes, the period of their association provoked

a new challenge at the core of van Gogh's stylistic practice. Buoyed by new sales and public favor, Gauguin was emboldened in Arles to extend his recent Breton experiments in the art of "abstraction," and exhorted his friend van Gogh to join him in exploring the liberating terrain of subjective imagination. Van Gogh's own deepening use of expressive and exaggerated color facilitated a common ground of interest, but the two painters soon reached an impasse formed by their divergent attitudes toward the value of the object world, the status and density of the artist's touch, and the balance between observation and conception. The arena for speculative flight now shifted for van Gogh from the attempt at capitalist accounting to the allure of a representational system without a model. Both of these forms of abstraction championed by Gauguin, van Gogh approached, and then resisted, mobilizing the social, theological, and psychological resources embodied in his pictorial language of redemptive labor.

The *Alyscamps* Paintings

Van Gogh worried about Gauguin's receptivity to Arles after the extended stay in Brittany, and the trip south and initial settling in did prove jarring. Having traveled by train—a trip taking over fifteen hours—Gauguin arrived in Arles before dawn on October 23.[1] He found his way to the "all-night café" frequented and painted by Vincent; the owner recognized Gauguin from the *misérable* self-portrait and directed him to the Yellow House.[2] The two men soon set up a system for managing their joint expenses and for sharing the housekeeping, with Gauguin responsible for the cooking and van Gogh the shopping.[3]

Gauguin dispatched a letter to Theo van Gogh confirming his arrival and indicating that he would need some time to discern and absorb the character of the region before beginning serious work. This "incubation period," as he later described it, was necessary to grasp the "sharp flavor of Arles and its environs." Gauguin distinguished his own posture of composed analysis of his new surroundings from the stance of immediacy and facility of other painters, who released their response to a new site with the "tip of their brush."[4] The process of "initiation" and reflection corresponded to Gauguin's notion that the power of painting lay precisely, as he had written to Vincent a month earlier, in protecting himself from being "surprised by the motif" and in allowing the totality of the pictorial forms and colors to generate a "sensation that leads me to a poetic state whereby the painter's intellectual forces are disengaged." Countering van Gogh's idea of searching for discrete poetic motifs, "I find *everything* poetic," Gauguin wrote in this September letter; "I glimpse poetry in the corners of my heart that are sometimes mysterious to me."[5] These philosophical, subjective, and introspective elements of Gauguin's attitude toward painting and the motif nourished his stance of an "incubation period" in Arles, an incubation that set him to discern the new contour of the outer world as he analyzed and fortified

the internal armature designed to perceive it. The value that Gauguin granted to self-cultivation and attentiveness to the artist's inner states as part of the initiation process in Arles was very different from his friend van Gogh's.

Gauguin rather keenly identified the core of van Gogh's particular response to Provence, recording in his memoirs that among his first impressions of encountering van Gogh in the Yellow House was that "in Arles the quays, bridges, boats, the whole south of France became another Holland for him."[6] Gauguin, however, had little inclination to see Arles the same way. The flat terrain and canal-lined strips that so animated his friend only irritated Gauguin. Engaging in long discussions with van Gogh and describing Pont-Aven to him, Gauguin conveyed and even seemed to convince Vincent that Brittany was "marvelous country," far superior to Provence. Van Gogh wrote to Theo about October 28 that what Gauguin "tells me about Brittany is very interesting . . . Certainly everything there is better, larger, more beautiful than here. It has a more solemn character, and [is] especially purer in its totality and more definite than the shriveled, scorched, trivial scenery of Provence."[7] A few weeks later Gauguin lamented to Emile Bernard, "I am quite out of my element here in Arles. I find everything—the scenery, the people—so petty, so shabby."[8]

The physical and social conditions of Gauguin's habitat did indeed change radically as he moved from Pont-Aven to Arles. The small Breton port town with its lush, wooded hillsides gave way to the major city along the Rhône, with its dense population and mix of rural and industrial centers. In Arles, Gauguin was abruptly stripped of the ambiance he had come to take for granted in Pont-Aven, where he had been able to take part in stimulating conversations with fellow painters and disciples and rely on the comforts of the Gloanec Inn, "bohemian" though it was. While he was unable to resist the assurance of the monthly financial support arranged by Theo van Gogh for his stay in Arles, Gauguin bristled at the significant contraction of the social world that he discovered there. And he made it clear that he did not share Vincent's enthusiasm for the company he kept in town, deriding van Gogh's local non-painter friends, such as Lieutenant Milliet and Joseph Roulin, as ordinary, "shabby," and uninteresting.[9]

Despite Gauguin's initial disorientation, he and van Gogh set to work, and the two men engaged in what is recognized as a very productive period that was useful to them both.[10] Van Gogh and Gauguin explored Arles during their first month together and chose to paint some similar subjects. As they

worked side by side, three issues crystallized at the center of van Gogh's and Gauguin's different approaches and stimulated their debates: thick or thin paint surface; active or attenuated brushwork; and the degree of fantasy tolerable in painting from memory and the imagination.

The Alyscamps necropolis was the first site that the two painters tackled simultaneously. Van Gogh left no record of having visited the ancient burial ground prior to Gauguin's arrival, and he had never painted it. Overlaid with the remains of Roman and Christian cultures, the Alyscamps was, as we have seen, still a holy place in nineteenth-century Arles, where Christ's knee print and convocation of saints were recalled every year on the eve of All Saints, and where legends abounded about the relics and octagonal bell tower of its Saint-Honorat Chapel. Tall poplar trees and sarcophagi formed the dramatic alley dominating the site, which, by 1888, bordered the PLM railroad workshops.[11]

Van Gogh approached the setting as a source of seasonal studies of "autumn landscapes," and he produced a total of four canvases here during the last days of October and early November.[12] During the same period Gauguin executed two paintings of the Alyscamps. The canvases of this site by the two painters indicate the pattern of their friendly gestures and their divergent stylistic, social, and theological allegiances.

FRAMING LABOR, ACTIVE BRUSH: VAN GOGH'S VERTICAL *ALYSCAMPS*

Van Gogh described his upright canvas of the Alyscamps as the "avenue in its entirety," "all in yellow" (Fig. 79).[13] Standing "in the avenue itself" and looking toward the terminus at the Saint-Honorat Chapel, van Gogh presented a bold and brightly colored linear alley of tombs and trees. This compositional mode extended, with some variation, his long-term and persistent habit of "framed looking," shooting the eye through a corridor of space bounded by flanking trees or other regularly placed recessional motifs anchored in the landscape. In Nuenen in 1884, for example, he had painted a similar tribute to the autumn season in his *Avenue of Poplars*, where a path demarcated by rows of tall, orange-lit trees stretched back to set a frame for a boxy, horizontal dwelling in the distance (Fig. 80).[14] In Arles, the physical structure of the Alyscamps, and the views possible within it, corresponded closely to these

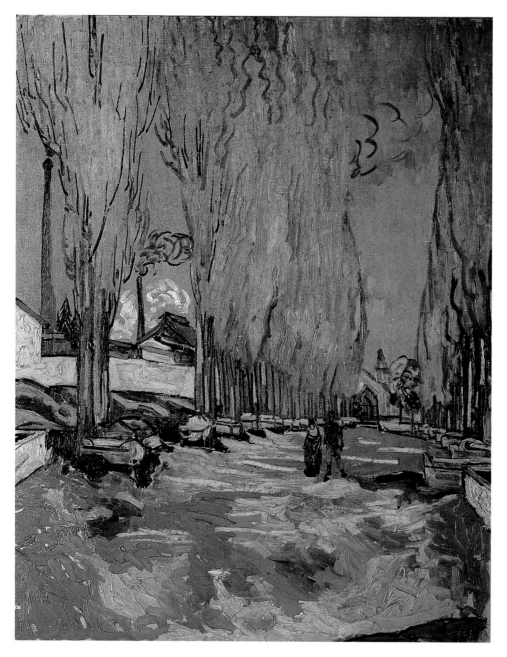

types of directional beholding conditioned by van Gogh's perspective frame, though, prior to Gauguin's arrival, he had preferred to ruminate on the visual effects and spatial patterns of his frame in the secular settings of Arles's fields, canals, and drawbridges.

There are actually two oil versions of van Gogh's upright vista of the Alyscamps alley of the poplars and tombs. One (Fig. 81) conforms more closely to the framed and directed view of van Gogh's earlier types of perspective pictures. The painting's leafy trees give way to a single base at the back, framing a backlit area accented by white paint over a darker horizontal patch. This vaguely rendered patch of space forms the distant Saint-Honorat, which is not recognizable in this version. While this terminating marker is thus very different in its loose sketchiness from the legible cottage enclosed by the arc of trees in the 1884 Nuenen avenue (Fig. 80), van Gogh has nonetheless still organized the picture as a dramatic V-shaped composition, with a conspicuous destination for the viewer's eye. He has enhanced this arrangement of a single optical hub in a linear corridor by centering

FIG. 79. **VINCENT VAN GOGH,** *LES ALYSCAMPS*, 1888, oil on canvas, 89 x 72 cm. Private collection

the walking male foreground figure in the exact plane fronting the arc shaped by the trees at the back.

In the other vertical oil *Alyscamps* (Fig. 79), van Gogh departs in a significant way from the single-point focus favored by his framed vistas. Instead of driving the viewer along to one central pivot at the back, van Gogh has composed a scene with a double viewpoint, encompassing two sets of frames. In this canvas he simultaneously directs the eyes back and diverts them off-left. In a middle plane a couple is walking toward us along the avenue, flanked by poplars and sarcophagi, with the Saint-Honorat Chapel set off in the distance; on the left side of the canvas, a screen of trees opens to frame part of a boundary wall and a set of angular structures behind it—the factory chimney and workshops of the PLM railroad company. Photographs of the Alyscamps of the period indicate that the rows of poplars were evenly disposed and relatively unbroken along the boundary wall, with some small spaces (Fig. 82). Van Gogh, however, widens the gap on the left so as to depict a clearing between the vertical columns of these trees, which displaces the linear runner of the avenue toward the chapel and offers a second, emphatically framed view of the sites and traces of human labor. The bluish smoke emitted from the chimney and a white patch of smoke beneath it are inserted in the middle of the opened aisle of the trees, exposing the industrial workshop next to the burial ground. This spatial arcing is further emphasized by the eye-

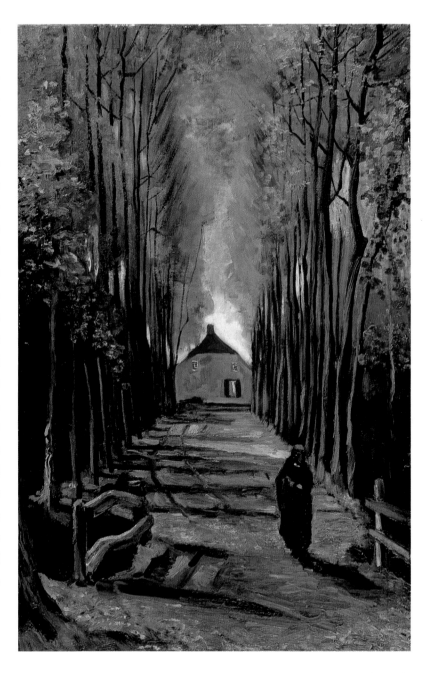

FIG. 80. VINCENT VAN GOGH, *AVENUE OF POPLARS*, 1884, oil on canvas, 99 x 66 cm. Van Gogh Museum, Amsterdam (Vincent van Gogh Foundation)

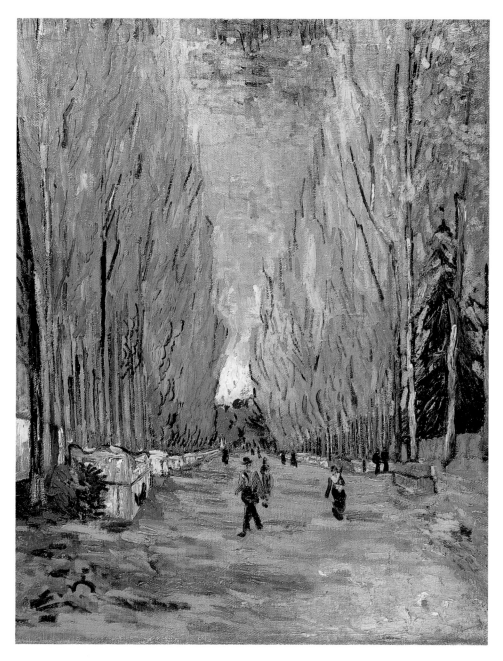

catching red roof of the enclosed shed structure, which parallels in brighter coloring the triangular shape of the Saint-Honorat Chapel roof seen off to its right in muted pale blue.

The vigorous verticality of the canvas is deepened by van Gogh's use of blazing yellow-orange coloring for the poplar foliage, which shimmers upward to be cut off at the top. The wide avenue below recedes in echoing swabs of orange, peach, yellow, brown, and rust pigment that appear arbitrarily, suggesting falling leaves. The brushstrokes are varied and irregular. Broadly streaked and daubed areas are visible in the right and left foreground edges, while thicker, mottled brown, yellow, and orange paint strokes appear in the ground fronting the strolling couple. White paint crust protrudes from the surface of the tomb cut off at the right edge of the canvas. These dense, resinous areas evoke the robust impasto of van Gogh's admired painter of the south, Adolphe Monticelli (Fig. 83), who inspired him in Arles to lay in the paint "very thickly."[15] Some strokes applied to the right fore- and middle ground indeed appear to have a "buttery consistency," like "modeling paste."[16]

FIG. 81. VINCENT VAN GOGH, *LES ALYSCAMPS*, 1888, oil on canvas, 92 x 73.5 cm. © Christie's Images Ltd., 1999

The couple shown walking toward us are treated very summarily, sketched in oil dabs of red and black, recalling the figures legible from only a few spots of color who appeared at river's edge or along the platform in van Gogh's drawbridge series. The red highlight on the man's pants shown here provides a clumsy but nonetheless effective accent to his state of movement, with legs astride in the pose so favored in van Gogh's attentiveness to figures in action and "en route." The blocky strolling couple repeat in figural form the overall angularity and geometricity of the composition, especially prominent in the shape of the trees, chapel, tombs, and work sheds. Van Gogh has even molded the meeting of the vertical tree trunks and the angled tombs into steplike patterns of intersection, creating a recessional network of L-shaped runners along the ground. Photographs of the necropolis show the tombs as flush with the trees in a single vertical line; van Gogh has rearranged them in this canvas so that they interlock with the tree poles, each horizontal unit having a vertical partner.

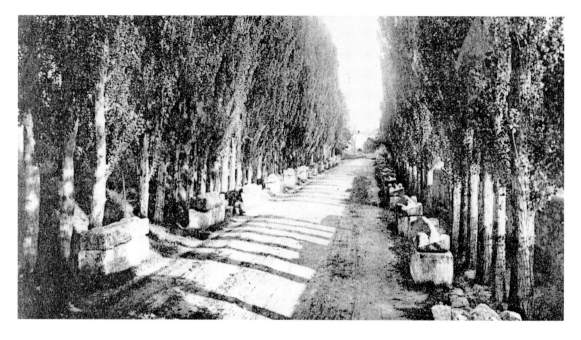

TOP **FIG. 82. ARLES, LES ALYSCAMPS.** Photograph Collection P. Richard, reproduced from Jean-Paul Clébert and Pierre Richard, *La Provence de van Gogh* (Aix-en-Provence: Edisud, 1981)

BOTTOM **FIG. 83. ADOLPHE MONTICELLI**, *BOUQUET*, ca. 1875, oil on wood panel, 69 x 49 cm. The Phillips Collection, Washington, D.C.

ELYSIAN STASIS, DELICATE HANDLING: GAUGUIN'S VERTICAL *ALYSCAMPS*

Gauguin's upright painting of the Alyscamps (Fig. 84), of a size and format nearly identical to van Gogh's double-focus version, differs significantly from it in form and content.[17] Positioning himself not inside but outside the tree-lined avenue,[18] Gauguin does not present the linear corridor; rather, he shows an undulating, varied landscape on a vertical rise, tilting upward to reveal the Saint-Honorat octagonal tower in the distance. Three women appear along a hilly mound in the middle ground, wrapped in cloaks, inert, and stationed facing painter and viewer. The women are discernible as Arlésiennes from their costume—black cloaks, bonnets, and white collars. Like van Gogh's Alyscamps figures, Gauguin's trio emerge as legible from a minimum of markings. The facial features of the women, like those of van Gogh's couple, are not delineated; their faces are flesh-colored pigment masks, their hands are points of flesh, and their legs are completely covered.

FIG. 84. PAUL GAUGUIN, *LES ALYSCAMPS*, 1888, oil on canvas, 92 x 73 cm. Musée d'Orsay, Paris. Photograph © RMN-Hervé Lewandowski

Van Gogh's mottled and impasted passageway offers a striking contrast to Gauguin's delicately measured rendering of space and form. Employing the "small, hatched, vertical brushstrokes" that scholars ascribe to his debt to Cézanne,[19] Gauguin has applied the color sparingly, in lean, light, and thin striations. His meticulous and sparse brush has defined some color areas cumulatively, as in the tufted softness of the green moss in the middle ground. A flaming red-orange bush off-right, by contrast, emerges from a filmy pigment layer that barely covers the canvas support visible beneath it. The white sediment crusting the tomb at the right edge of van Gogh's version highlights a very different preference for paint handling, one that would not so much wash color into the canvas support, as Gauguin's handling did, but mold an intrusive carapace elevated from the canvas backing.

Both van Gogh and Gauguin associated Provence with Cézanne, and their distinctive paintings of the Alyscamps express their dissimilar sources of admiration for him. Gauguin, as has been noted, was "haunted by Cézanne throughout his stay in the south of France," and he affirmed the power of his mentor in his methodical, fluid brushwork and ponderous, classicizing evocations.[20] Gauguin displays a further debt to Cézanne in his *Alyscamps* by employing the tree trunk at right as a framing edge to the canvas, with leafy foliage rendered diagonally so as to create an arching canopy over the group of three women. Cézanne frequently structured his landscapes with this type of compositional device, positioning trees to edge the canvas and directing a sweep of foliage to echo the planar positions of other elements in the picture (Fig. 85).[21] Gauguin had already relied on this Cézannian technique in his 1887 painting *Two Girls Bathing* (Fig. 1), where the line of foliage from a central tree repeated the plane, direction, and movement of the crooked elbow of the large bather in the lower left. Commenting on this painting when it was exhibited in Paris early in 1888, the art critic Félix Fénéon had explicitly linked Gauguin's

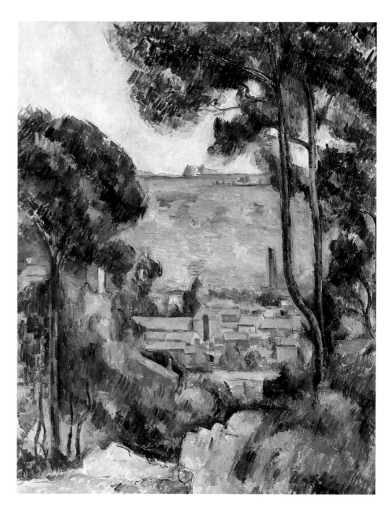

FIG. 85. PAUL CÉZANNE, *L'ESTAQUE*, 1882–1885, oil on canvas, 71.1 x 57.7 cm. Fitzwilliam Museum, Cambridge

composition to Cézanne.[22] *Les Alyscamps* inscribes the presence of Cézanne, then, in the light, measured paint application, and the preference for particular kinds of planar tactics and divisions.

Van Gogh, by contrast, celebrated Cézanne for his personal sincerity but criticized his technical strategies. Cézanne's paintings, he wrote to Theo from Arles, carry the exemplary tones of an artist deeply rooted in his region, who "is absolutely part of the countryside, and knows it so intimately."[23] Van Gogh hoped that his own "love for this country" would lead him to follow Cézanne's model of such an authentic apprehension of the unique color tones of Provence, especially what he called Cézanne's ability to convey its "harsh side"—the "sky drenched with heat," the "scorched countryside," and the permeating presence of "old gold."[24] Van Gogh found Cézanne's methods and his touch deficient, however. In a late-summer letter to Bernard, he denigrated what he called Cézanne's "timid, conscientious brush stroke" and asserted the distance between his own effortful style and Cézanne's:

> Aren't we seeking intensity of thought rather than tranquility of touch? But under the conditions of working spontaneously, on the spot, and given the character of it, is a calm, well-regulated touch always possible? Goodness gracious—as little, it seems to me, as during an assault in a fencing match.[25]

THE SHARED SEARCH FOR EXPRESSIVE COLOR

The kinetic aggressiveness of application versus the methodical, well-regulated touch, a comparison that van Gogh saw in the difference between his and Cézanne's canvases, reemerges as an apt characterization of the divergent surface effects of his and Gauguin's *Alyscamps* paintings. The issue of active, loaded brushwork emerged as a central point of tension between the two men as they worked together. Van Gogh's insistence on dense, painterly impasto exasperated Gauguin, and he criticized van Gogh's "messing" or "tampering" with paint strokes. He wrote to Bernard some weeks after the paintings of the Alyscamps that "Vincent and I agree on very little, especially regarding painting . . . As to color, he likes the accidents of thickly applied paint as Monticelli uses it, and I detest the worked-over surface [*le tripotage de la facture*]."[26]

What the two painters do share here, nonetheless, in their initial ventures together in the necropolis, is their interest in expressive and arbitrary color. Van Gogh's flanking rows of trees act as orange flares, signaling their autumnal season by their intense and exaggerated tones. Gauguin's vivid orange trees and flashing red-orange bush also heighten the color key beyond the scenic materials observed at the site, and he painted the tree trunk at right with blue pigment, not in the brown hue in which it now appears. Some commentators attribute these "heady" and "inflamed" colors in Gauguin's *Alyscamps* canvas to the "effect of Arles" and, by extension, to van Gogh's influence on his palette.[27] Others argue that "Gauguin's palette hardly changed" during his stay in Arles, and that he extended to the south, without major deviation, the color choices, stylistic experiments, and theoretical preoccupations he had pursued in Brittany.[28]

In portions of Gauguin's *Alyscamps* we can see some convincing evidence for the view that he transported his Breton concerns to Arles. Gauguin's rendering of the tree trunk in blue pigment, for example, formalizes his famous declaration to Paul Sérusier a few months earlier, in the Bois d'Amour near Pont-Aven, that subjective perception overruled fidelity to nature. "If you see a tree blue, then paint it blue," Gauguin had commanded the young painter, who proceeded to cover a cardboard box with bold, flat blocks of bright colors and on his return to Paris wielded it as both a weapon and a banner rallying the young avant-garde to the new cult of "abstraction."[29] Gauguin's *Alyscamps* itself bears some affinity with Sérusier's composition, known as *The Talisman*, particularly in the undulating patch of white paint that appears, without mediation, in the lower left corner amid the curving blue and green areas of the banks. And the coloristic liberty taken in the *Alyscamps* painting was already a prominent feature of the ethos of anti-naturalism that Gauguin had ascribed not only to *The Vision* but to other canvases produced shortly before his departure for

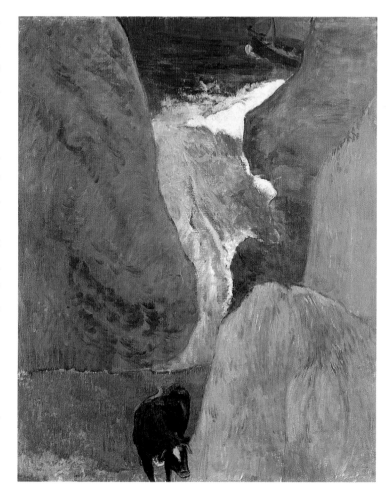

FIG. 86. PAUL GAUGUIN, *SEASCAPE WITH COW AT THE EDGE OF A CLIFF*, 1888, oil on canvas, 72.5 x 61 cm. Musée des Arts Décoratifs, Paris. Photograph by L. Sully Jaulmes

Arles, such as the boldly tilted composition and blazing orange pigment seen in the 1888 *Seascape with Cow at the Edge of a Cliff* (Fig. 86). Félix Fénéon may have had this painting in mind when he characterized Gauguin's goals in this way: "Reality for him was no more than a pretext for his far-away creations; he reorganized the raw materials reality provided, and spurned trompe-l'oeil."[30]

The two upright *Alyscamps* engage van Gogh and Gauguin in tackling a similar subject and exploring a mutual interest: extending the boundaries of expressive color. And the two canvases also indicate how both painters shared—to use part of Fénéon's characterization—a generalized disdain for trompe l'oeil and a desire to reorganize the raw materials reality provided. By the fall of 1888 van Gogh had himself defined, in letters and pictures, his own goal of departing from what he described as the limits of "photographic accuracy" or the "eye-deceiving" illusionism of trompe l'oeil.[31]

Yet the *Alyscamps* paintings also demonstrate the very different methods van Gogh and Gauguin employed as they resisted naturalism. Van Gogh's canvas coheres in two types of grounding, those of mechanism and of facture. The corridor effect of the Alyscamps avenue amplifies van Gogh's long-term habits of directed looking and bracketed views through his perspective frame, which have their echoes here in the alley of trees and framed views of shed and chapel. The composition's jagged angularity differs from the curving canopy effects created by Gauguin, which expand the lessons of Cézanne, and from the general pattern of undulation in Gauguin's canvas. More important, van Gogh accentuates the physical presence of his picture in his brusque and irregular touch. Kinetic effects of working the paint are conspicuous here, an unabashed recognition of the vigorous action of hand on brush that yields a multidirectional and grimy mix of tar, crust, and color. To van Gogh, this palpability of facture, mobility, and varying surface density inextricably links the canvas to the painter's rapid "working on the spot"[32] and responding physically to the process of "disentangling" in his "surrender to nature."[33] He rejects the "calm, well-regulated touch" and captures the autumnal intensity of the Alyscamps through heightened color and changeable ground.

Gauguin, by contrast, proceeding with that very "tranquility of touch" spurned by van Gogh, renders a calm, cool, controlled image as Elysian as it is autumnal. Scholars have characterized Gauguin's "highly cerebral" and "conceptual" approach to the process of painting in 1888–1889, and his *Alyscamps* partakes of this impulse.[34] Here, indeed, he evokes a repertoire of classical referents and allegiances, which always coexisted in his style with his widely recognized medievalizing primitivism and cloison-

ism. For example, the hilly site moves up and back to the bell tower of Saint-Honorat, which Gauguin places as if it were an elegant edifice in a Poussin landscape rather than a humble Romanesque structure. He also treats the three women as if set in a frieze. When Gauguin sent the canvas to Theo van Gogh some weeks later, he included a title for it as *The Three Graces at the Temple of Venus,* ironically transforming the Arlésiennes in their regional costume into classical deities in the necropolis.[35]

Gauguin's lean, systematic handling sets his canvas apart from the exuberantly kinesthetic attack of van Gogh's. The stasis of his figures is matched by the delicacy and sparse coating of Gauguin's brush, which builds up tones from cumulative wisps of color. While the surface of the *Alyscamps* canvas is more variegated than the large blocks of color areas attempted by Gauguin's cloisonism, he is persistent in his emphasis on the smooth glide of the brush, meticulously controlled. The awkward linearity and eruptive brush in van Gogh's *Alyscamps* makes this canvas, then, a curious but predictable partner to Gauguin's of the same subject. The contrast in style and paint application recalls, in some ways, the one that emerged when van Gogh painted side by side with Signac on the outskirts of Paris. There van Gogh transposed the shimmering micropatterns of the pointillist brush into what his friend Emile Bernard called his peculiar *zébrures* ("zebra bars"), or thickly laced ricks, unable, despite an earnest enthusiasm, to re-create the velvety dot of Neo-Impressionism.[36] Now, in Arles, van Gogh's initial encounter with Gauguin crystallized the disparity between a modernism inspired by Cézannian meticulousness and the composure of attenuated surfaces, and a modernism animated by what van Gogh called "a palate for crude things, for Monticellis, for common earthenware."[37]

VAN GOGH'S HORIZONTAL PAIR OF *ALYSCAMPS* PAINTINGS ON BURLAP

Despite van Gogh's reaffirmation of Monticelli and Delacroix in Arles, Gauguin's presence did provoke him to move his brushwork in his colleague's direction—toward regulation and diminishment of surface density. During the same weeks that he painted the two vertical *Alyscamps*, van Gogh produced a pair of horizontal pictures of the same site (Figs. 87 and 88), which show his attempts at reducing impasto and creating a more matte paint surface. While these canvases may suggest that he was responding to Gauguin's disapproval of his usual messy handling (*tripotage*), they nonetheless express

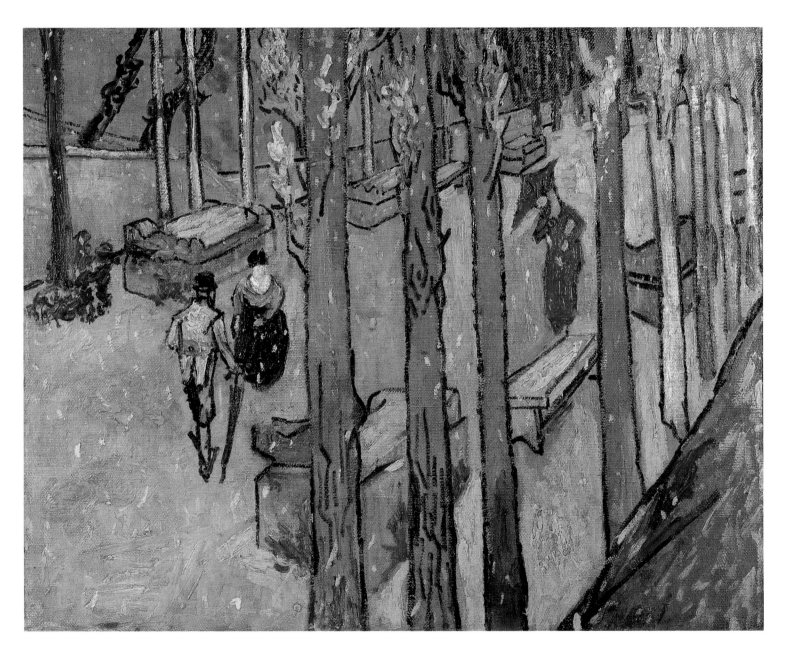

FIG. 87. VINCENT VAN GOGH, *LES ALYSCAMPS*, 1888, oil on canvas [burlap], 73 x 92 cm. Kröller-Müller Museum, Otterlo, Netherlands

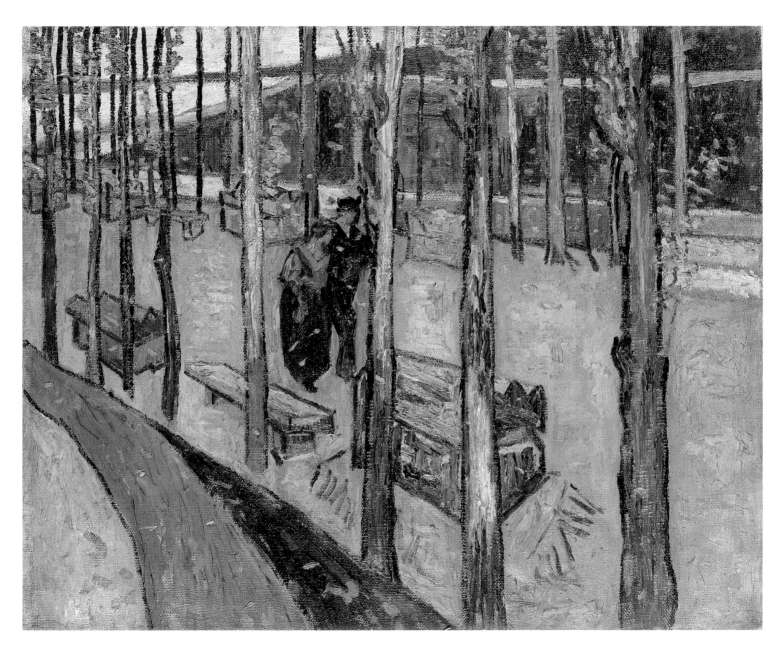

FIG. 88. VINCENT VAN GOGH, *LES ALYSCAMPS*, 1888, oil on canvas [burlap], 72 x 91 cm. Private collection

other consistent elements of van Gogh's own idiom, which set him in a different framework of assumptions from that of the friend he admired and tried to emulate.[38]

The two horizontal canvases form a pair, and were produced together as a decorative set.[39] Van Gogh described them in a letter to Bernard as "two studies of falling leaves in an avenue of poplars"; the letter's postscript, written by Gauguin, indicated that the horizontal pendants were hanging in Gauguin's room.[40] The two works share an unusual high vantage point, and both set figures in frames through the trees. Van Gogh wrote to Theo that in the one canvas (Fig. 88) he presents "little black figures of lovers" "in the avenue"; in the Kröller-Müller canvas (Fig. 87) he depicts "the same avenue but with an old fellow and a woman as fat and as round as a ball."[41] Colors are intense and exaggerated: the "lovers" canvas has violet tree trunks with yellow/orange ground; the Kröller-Müller one includes bright blue trees and an orange/yellow avenue.

Van Gogh's pendant *Alyscamps* are painted on burlap, from a section of what van Gogh described to Theo as "twenty meters of very strong canvas" (*toile très forte*) that Gauguin had just purchased. Gauguin himself described the canvas as "very coarse sackcloth" (*toile à sac très grosse*).[42] New research indicates that Gauguin bought the heavy canvas in Arles partly to economize—per meter, the burlap cost 50 centimes in contrast to commercial canvas at 2.5 francs[43]—but also to extend his technical experiments with varied types of canvas supports, and to test out what he considered might be the greater adhesive qualities of paint when applied to primer on this heavy, durable cloth.[44] Van Gogh, who had pursued independently his own line of thinking about the possible effects of pigment and primer on coarser canvas in the spring before Gauguin's arrival, was certainly receptive to joining his colleague in trying out the new, thicker support type.[45]

In his comments van Gogh described the "lovers" horizontal painting as "poplar trunks . . . cut by the frame where the leaves begin," and where the "tree trunks are lined like pillars along an avenue where there are rows of old Roman tombs . . . left and right. And then the soil is covered with a thick carpet of yellow and orange fallen leaves."[46]

The association of elements of nature with textile products had long-term and multiple sources in van Gogh's mental world, nourished by literary and theological texts in which the linkage between nature and a sacred, material fabric played a prominent role. Early in his adult life van Gogh selectively assimilated poetry and prose works by such diverse writers as Longfellow, Spurgeon, Goethe, Breton,

and Carlyle, who intersected in their presentation of nature imagery in terms of cloth—of grass, ground, and sky as blanket, carpet, canopy, vesture, cloak, and garment. These expressive forms endured as a vital storehouse of connections.[47]

In Arles, van Gogh engaged this pattern of ideas directly as he considered the making of his own pictures, whose status as a woven craft product had long been infused with associations formed by the practical apprenticeship of learning the métier of painting as he had observed the Nuenen weavers produce their colored cloth. Van Gogh's discussion of the "carpet" in his *Alyscamps* canvas complements a series of images he produced in mid-July in Arles where he also compared a scene of the profusion of nature with carpets. In the painted study *Garden with a Weeping Willow* and the pen-and-ink drawing *Garden with a Weeping Tree* (Figs. 89 and 90), van Gogh represented the Arles public gardens, where "freshly-mown grass had been spread out in regular rows to dry in the sun."[48] Writing to Bernard with an enclosed sketch, he stated that "maybe there is something like 'shaggy carpets woven of flowers and greenery' by Crivelli or Virelli, it doesn't matter much which."[49]

In these particular images, as he invoked the literary allusion, van Gogh also attempted to reproduce textrous effects in brush and ink. The painted version shows varied, vigorous brushwork, with dense dabs of bright pink, red, and yellow standing out from the brushes along the left side and back plane. The foreground signals

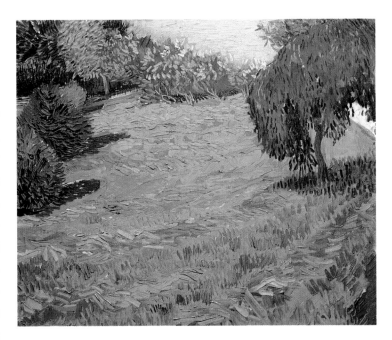

TOP RIGHT **FIG. 89. VINCENT VAN GOGH,** *GARDEN WITH A WEEPING WILLOW*, 1888, oil on canvas, 60.5 x 73.5 cm. Private collection, Zurich

BOTTOM RIGHT **FIG. 90. VINCENT VAN GOGH,** *GARDEN WITH A WEEPING TREE, ARLES*, 1888, brown ink with traces of charcoal or graphite on wove paper, 24.5 x 32.1 cm. The Menil Collection, Houston

the alternation of the rows of mown grass and ground through the different directions of brushstrokes and color, partly composed of alternating horizontal and vertical strokes. One writer suggests the painting indeed "recalls a decorative carpet composed of colours and elegant shapes"; this seems apt, though the attribution of elegance seems misplaced—"shaggy carpet" is closer. The drawing of the same scene, which van Gogh sent to Theo in early August, has the most sustained visually rendered textrous elements, with the cut grass disposed like "interlaced skeins" threading through the ground.[50] Here the uncut lawn sections follow more consistently than the painted version the alternation of stroke and pattern to contrast and intersect with the skeinlike threaded parts, with the ground rendered in vertical ink markings and the cut lawn in unraveling horizontal flow. The blocking of ground and mowed grass follows the form of a basket weave, resembling the coiled interlock of the baskets of fruit van Gogh had attentively rendered in some of his Paris and Arles still lifes.[51]

In the horizontal *Alyscamps* van Gogh's allusion to a carpet is not matched, as it was in the garden pictures, by brushwork that replicates the tangibility and form of fabric. There are some areas of hatched brushstrokes in the colored leaves, especially in the pattern of paint in the right portions of the strolling-couple canvas. But overall in both horizontal *Alyscamps* canvases van Gogh is muting his impasto and restricting his tendency to apply paint in dense, almost relief-like layers. The burlap support shows through the thinly applied pigment, but van Gogh largely resists the impulse to rearticulate the coarse weave of the fabric in his own interlocking strokes or hatched intersections. Some scholars suggest that the thin paint here is one of several indications of Gauguin's influence on van Gogh's style and technique; the areas of influence are described as the canvases' "matte paint, applied sparingly over a thin ground"; the undulating paths edging the two canvases; and the large blocks of colored areas outlined in black, resembling Gauguin's cloisonism.[52] Gauguin's example of a modulated, thinning brush, combined with the heightened absorbability of the burlap, did plausibly encourage van Gogh to subdue the physical palpability of his brushwork in this pair of pictures. But as van Gogh took up the challenge to diminished impasto, he also reaffirmed other dimensions of his pictorial language that expressed, and would continue to expose, the powerful barriers between him and Gauguin. *Les Alyscamps* may register the traces of a partly Gauguinian interest in diluted paint cover, but these pendant pictures are also structured by at least three distinctive features of persistent concern to van Gogh independently of Gauguin and, indeed, despite him. These three features are the insistence on framed

looking, the significance of Daumier, and the principle of comple-
mentarity of canvases and color application.

FRAMED LOOKING AND JAPONISM IN THE *ALYSCAMPS* CANVASES

Some of the peculiar spatial effects in van Gogh's two horizontal
Alyscamps—the oblique angles, tilted planes, and "truncated
trees"—derive not from Gauguin but from the model of Japanese
art, which deeply affected both artists. Van Gogh's reliance on a
screen of trees, and their cut-off angles and patterns, for example,
has precedents in Japanese prints by Hokusai and Hiroshige, among
others, with which van Gogh was familiar.[53] Another quality sug-
gestive of Japanese prints is the depiction of the woman in red with
a parasol appearing in the Kröller-Müller canvas, though van
Gogh's figure is an awkward version of the more elegant and
sharply delineated features of the parasol-bearing figures familiar
to him from Japanese prints.[54]

Yet the Japanese influence on van Gogh in these canvases is,
like Gauguin's influence, more complex and mediated than has
been acknowledged, for van Gogh adapted Japanese models to his
abiding logic of framing and geometricity. His own large collection
of Japanese prints shows patterns of interests that partly shaped his
principles of selection. One pattern of interest was in fabric, evident
in the many prints in his collection that depicted the processes of
textile production as well as those that took the unusual form of the
crépon, or crepe print. Van Gogh collected both flat, colored wood-
block prints and the less well known crepe prints, which dyed

FIG. 91. YOSHITOSHI, *THE COURTESAN KŌBAI COMPARED TO KUSUNOKI MASATSURA*, 1879, *crépon*, 26 x 19.5 cm. Van Gogh Museum, Amsterdam (Vincent van Gogh Foundation)

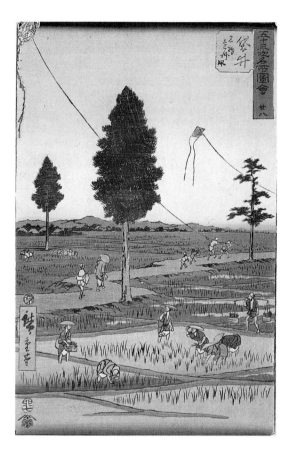

brightly colored scenes on nubby, rubbery paper stretched in a special process to resemble crinkled cloth, akin to the feel and elasticized consistency of a washcloth (Fig. 91). A second pattern of interest was in the framing of art. Van Gogh's own long-term habits of directed looking, and the craft mechanics of situating objects in his perspective frame, heightened his interest in Japanese prints that emphasized playful perspectives of near and far (Fig. 92); varied stances of "looking through" (Fig. 93); and the presence of framing devices in the prints themselves, such as the keyhole placed in Hiroshige's plum tree or the bracketing structures made by the kite poles, screens, tree limbs, and bamboo rods visible in prints in van Gogh's collection (for example, Figs. 94 and 95).[55]

LEFT **FIG. 94. HIROSHIGE,** *THE AUSPICIOUS TANABATA FESTIVAL IN THE CITY,* FROM *A HUNDRED VIEWS OF FAMOUS PLACES IN EDO,* 1857, *nishiki-e,* approx. 34 x 22.5 cm. Van Gogh Museum, Amsterdam (Vincent van Gogh Foundation)

RIGHT **FIG. 95. TOYOKUNI,** *AN ACTOR AS KATANAYA HANSHICHI,* 1885, *nishiki-e,* 36.3 x 25 cm. Van Gogh Museum, Amsterdam (Vincent van Gogh Foundation)

The horizontal *Alyscamps* canvases reengage this layering of Japanese models with van Gogh's enduring preoccupation with siting objects through a frame. Here the Japonist "truncated trees" also act as poles or braces that locate the figures firmly within their boundaries. The lilac trees in Fig. 88 act, among a pattern of other angles, as rigid beams for the couple walking; in the Kröller-Müller canvas the bright blue trees flank the red-parasol woman in a central fix. When Gauguin essayed his own type of truncated and blue trees in an Arles canvas soon after, the result was not a set of trees as stable frames but as bending and bowing contours; the figures in his canvas are not *located* through the tree parts but are cut off as if sliced down the middle.[56] These techniques of Gauguin's unfold from the interaction of

his own variant of Japonism with his mentors Degas and Cézanne, who had themselves alighted on Japan for different reasons from van Gogh's and had discovered in Japanese arts new ways to extend their concerns with asymmetry, obliqueness, and figural distortions.

VAN GOGH'S CELEBRATION OF DAUMIER

The horizontal *Alyscamps* pictures depart from Gauguin's aesthetic in another way—their evocation of van Gogh's celebration of Daumier. Van Gogh's move to Arles, as we have seen, rekindled his affinity for a medley of mid-century realist artists and writers of keen interest to him "before Paris and the Impressionists," and Honoré Daumier figured prominently among them. Although Daumier's connection to Provence was loose (Daumier hailed from Marseille), van Gogh construed Arles as a country that "is a Daumier come to life," and Daumier lithographs, sent by Theo from Paris, hung in his Arles studio. Shortly before Gauguin's arrival, van Gogh wrote him that "very often the figures here are absolutely Daumier."[57] Gauguin did not respond directly to van Gogh's enthusiasm at that moment, but his own trajectory had already taken him far from the world of mid-century realists that he had seen in the Arosa collection in his Paris days as a young stock-exchange apprentice and art lover. Ronald Pickvance has suggested that some of the figures in van Gogh's Arles paintings "can be seen as translations of Daumier," and he notes that the *Alyscamps* pictures are very suggestive of Daumier, especially the man with his pointed umbrella who appears to have been "transferred" from the world of Daumier's prints of Ratapoil, the sly trickster; Pickvance calls van Gogh's man "a Ratapoil in motion."[58]

Soon after the *Alyscamps* paintings, Gauguin wrote to Bernard indicating the difference between the way he and van Gogh approached Arles that directly invoked Daumier: "It's funny, here van Gogh sees Daumier-type work to do, but I, on the contrary, see another type: colored Puvis mixed with Japan."[59] Another letter to Bernard a week or two later put the case more strongly, and exposes the divide between the models the two painters admired: "Vincent and I don't agree on much, and especially not on painting. He admires Daumier, Daubigny, Ziem, and the great Theodore Rousseau—all of whom I can't stand. And, on the other hand, he detests Ingres, Raphael, Degas—all of whom I admire."[60]

Gauguin's comments define what can be identified as the divergent stylistic allegiances of a romantic and realist repertoire versus a classical one.[61] They also signal another important element of van Gogh's Arlesian practice, of which Daumier was a part, regarding his long-term adherence to the fluid interplay of drawings, prints, and paintings. Gauguin was not a prolific draftsman, and he kept the boundaries between drawing and painting sharply delineated. Gauguin extended this distance by treating his drawings as "secret notes," inaccessible to critics, and also by eliminating traces of drawing if they were used in preparatory stages on the canvas.[62] For van Gogh, not only were drawings central to his pictorial practice, but he engaged in active interchange between prints, drawings, and paintings. Van Gogh's drawings occasionally had the same status as his paintings, with the two operating as versions in different media of the same subject.[63] Unlike Gauguin, van Gogh frequently maintained the pencil marking and underdrawing that helped him structure his canvases, even periodically preserving the pattern of vertical, horizontal, and diagonal lines signaling his use of his perspective frame for plotting visual coordinates.[64]

The permeable boundaries between paintings, prints, and drawings partly flowed from van Gogh's Dutch visual culture, where media of replication—prints, etchings, engravings—had long vied in status with oil paintings. Further, van Gogh's formative apprenticeship in the arts was steeped in the rich world of nineteenth-century print culture, from his familiarity with the pages of Goupil's albums, to his cutting, pasting, and mounting lithographs from illustrated magazines for his own study collection in The Hague, to his patient copying and training in Cassagne's "how-to-draw" manuals. In Arles, it should be emphasized, van Gogh returned to both Cassagne and Daumier—asking Theo to send the *ABC de dessin*, and soliciting the Daumier lithographs that he tacked up on the walls of his studio.[65] These kinds of reengagements contributed to his incompatibilities with Gauguin. While Gauguin, like his comrade, had his own interest in certain types of print culture and in visual techniques that broke from the "classical" repertoire, his approach to figure drawing, and his attitude toward the fundamental subordination of drawing to painting, ratified foundational assumptions of the world of Ingres, Degas, and Cézanne. These precedents from the Beaux-Arts to the Impressionists were very far removed from the artisanal manuals, print media, and illustrated books from which van Gogh derived his artistic training, and which he continued to adapt to his own practice.

COMPLEMENTARITY IN VAN GOGH'S *ALYSCAMPS* PAINTINGS

Van Gogh's adherence to a principle of complementarity in the *Alyscamps* paintings formalizes a final divergence between the two painters. This principle operates at a number of levels; emphasizing reciprocal interaction and interdependent units, it was fundamental to van Gogh's assumptions and pictorial preferences and emphatically spurned by Gauguin.

Van Gogh's study of the laws of contrasting color had already preoccupied him in canvases like *The Sower, Fishing Boats at Saintes-Maries,* and numerous Arles portraits. Now, in the horizontal *Alyscamps* with the couple walking, van Gogh paired lilac trees with yellow ground and included a "subsidiary blue and orange"; the pendant Kröller-Müller canvas shows the bold contrast of blue and orange (Figs. 88 and 87).[66] In Arles, as we have seen, van Gogh had deepened his resolve to follow the Chevreulian pairs of colors that, according to optical science and weaving chemistry, enhanced one another by contrast. The Paris exposure to Neo-Impressionist painting, which systematized Chevreul's laws, along with van Gogh's earlier forays into color theory, came together in Arles to produce new enthusiasm for finding a language of expressive color anchored in the harmonics of complementary contrasts.

Gauguin, on the other hand, regarded Chevreul's rules as spurious, naive, and exasperating. During their time together in Arles, one of Gauguin's goals was indeed to detach van Gogh from what he considered his friend's irritating fervor for such simplistic recipes for maximizing luminosity through the juxtaposition of color "opposites." Gauguin registered his irritation in his memoirs, and it was clear that the desire to wrest his friend away from Chevreul's program had at least two sources. First, by 1888 Gauguin considered it too scientistic; he saw it as rooted in an empiricism of "the eye" that he sought to rebalance toward art that flowed more freely from what he called "the mysterious centers of thought." Second, by 1888 Gauguin was animated by intense professional jealousy of Seurat and Signac and expressed deep animosity toward Neo-Impressionism. To observe his friend continuing so earnestly to endorse Neo-Impressionist color principles was vexing, and Gauguin sought to supplant the Neos in van Gogh's loyalties as much as he hoped to supersede them as the new leader of the French avant-garde.[67]

The juxtaposition of color pairs was only one element of the relational model that underlies van

Gogh's *Alyscamps* pictures and sets them apart from Gauguin's work. Van Gogh conceived these works, as has been noted, as "companion pieces": they were designed to hang together, side by side, and were of nearly identical size and shape. The two horizontal canvases complemented the first pair of companion pieces of the *Alyscamps* discussed above, which were also of nearly identical vertical format. The impulse toward paired horizontals and verticals in these four canvases corresponds to another set of matchings van Gogh attempted in Arles. He had been interested since the spring in creating a set of canvases "representing the four seasons," and he even associated certain pairs of contrasting colors with particular seasons, as he had begun to explore while still in Holland. The orchards in bloom had captured the spring, and the paintings of the Alyscamps are likely attempts at the autumn season, with its color scheme and falling leaves.[68]

The pairing of the *Alyscamps* paintings has been analyzed as indicating van Gogh's interest in creating "decorative series" in Arles. But the design of these pendant canvases expresses much more than the aesthetics of decoration; it crystallizes the larger structures of complementarity in van Gogh's mental world and pictorial practice. Hung together, the two horizontal paintings interact in a number of ways, gaining meaning and impact in and through their association. First, the coupling of color units within each picture—violet and yellow in one, blue and orange in the other—allows van Gogh to interlink them when side by side as interdependent elements of a larger color field of Chevreulian matches that extend from one canvas to another, deepening the possibilities for what he called a month earlier the "mingling," "opposition," and "mysterious vibrations of kindred tones" inherent in the schema of "complementary colors."[69] Second, the mutual enhancement of color combines with the relation of format and design in the two canvases. The matching horizontal scale of the pictures, and their animating screens of framing tree poles, announce their companion status. In a further structural correspondence, the two paintings, when placed side by side, almost align in their sections of path and bank. With the paintings matched in this way, the trees connect and form a large V shape that moves recessionally back to a convergence at a middle plane in what could be a single elongated canvas of the Alyscamps. Finally, the two canvases act as companion pieces in content and meaning. An interlocking dualism of movement and destination operates in the pendants. In the Kröller-Müller canvas, van Gogh "looked toward the exit from the avenue; in the other, he looked toward Saint-Honorat."[70] The figures in each canvas are thereby shown marking these dual positions. This correspondence of entry and exit, movement in and

out, deepens the other layers of association linking the pictures as a sequence and mutually interdependent field of composite color, format, and meanings. And, as a set that depicts one of the seasons—autumn—this series reaches out to a pattern of connections that implies its place in a quartet, in the cycle of seasons that gives it unity and alternation.

The relational forms and clusters of complementarity at work in van Gogh's *Alyscamps* typify the deeper disparities hindering his collaboration with Gauguin. While van Gogh attempted in these paintings to emulate Gauguin's diluted, smoother, and less broken handling, their adherence to color contrast, mechanisms of framing, and a logic of relational interdependence set the lessons of Gauguin's thinning brush within the larger structures of van Gogh's abiding and distinctive practices. Gauguin's sparse, muted brushwork was partly intended to act as a formal agent to release the power of matter and to weaken connecting anchors of the object world; his project, initiated in Pont-Aven, aimed to efface the distance between the artist and an ineffable, incorporeal purity. As van Gogh attempted in the paired *Alyscamps* to clean up what Gauguin called the muck and mire of his messy *tripotages*, he tempered his "Monticellisms" while reaffirming the tactics of Chevreul, of Daumier, and of woven form.

Grape Harvests

Is it the southern sun that thus puts us in heat?
PAUL GAUGUIN[1]

In every man who is healthy and natural there is a germinating force
as in a grain of wheat.
VINCENT VAN GOGH[2]

Van Gogh did not maintain a long-term interest in adopting Gauguin's smooth and minimally impasted brushwork. More enticing to van Gogh, and more critical in his relationship with Gauguin, was Gauguin's provocation to amplify the role of memory and imagination in his painting. In the spring and fall before Gauguin's arrival, van Gogh had already explored his own definitions of the appeal and function of imagination, writing to Bernard in April, for example, that "the imagination is certainly a faculty which we must develop."[3] Yet these discussions always ended with van Gogh's affirmation of a clear distinction between exaggeration and invention—between taking expressive liberties after "surrendering to nature" while "working directly on the spot," on the one hand, and making "abstract studies" that are dangerously removed from "the possible and the true," on the other.[4] Just before Gauguin's arrival in October, for example, van Gogh wrote to Bernard that he had produced two paintings and then, because "the form had not been studied beforehand from the model," destroyed them. "I cannot work without a model," he wrote, for "my attention is so fixed on what is possible and really exists that I hardly have the desire or the courage to strive for the ideal as it might result from my abstract studies."[5]

Gauguin's arrival provided van Gogh with both the desire and the courage to experiment in new ways. Gauguin challenged his friend to push the limits of exaggeration all the way to invention, and van Gogh observed this process at first hand soon after Gauguin appeared: Gauguin produced, as his very first work in Arles, a canvas of female figures in a Martinique landscape, culled from a synthesis of imagination and of memories and drawings from his trip there two years earlier.[6] A short time after they began working together, van Gogh registered traces of his new endorsement of painting from memory, spurred by Gauguin's example. He wrote to Theo around November 12 that "I am going to set myself to

work from memory often, and the canvases from memory are always less awkward, and have a more artistic look than studies from nature, especially when one works in mistral weather."[7] By the end of that month van Gogh remarked to Theo that "Gauguin, in spite of himself, and in spite of me, has more or less proved to me that it is time I was varying my work a little. I am beginning to compose from memory, and all my studies will still be useful for that sort of work, recalling to me things I have seen."[8] The new impetus to paint more explicitly from memory also had a practical urgency: the rain-soaked weather of some of the November weeks forced the two painters indoors, giving Gauguin's propensity for memory painting—what he called *peinture de chic* or *peinture de tête*—an added advantage.[9]

FROM VINEYARDS SEEN TO HARVEST SCENES: THE PAIR OF GRAPE HARVEST PAINTINGS

During these first two weeks of November, van Gogh and Gauguin engaged in a shared experiment with composing from memory as they worked partly indoors and side by side. While out on an evening walk near Arles, they had observed a scene together, which van Gogh described in a letter to Theo: they beheld vineyards soaked red and violet after the rain, and sparklingly yellow where the earth "caught the reflection of the setting sun."[10] Van Gogh and Gauguin each produced a painting inspired by this scene, recalling it from memory and reconfiguring it according to their respective technical strategies and cultural mentalities. Other accounts of the two paintings have been cursory, and mention issues of color, style, and symbols. I want to provide a close comparison of the paintings that integrates analyses of form, meaning, and making with the resonances of the divergent religious legacies that van Gogh and Gauguin expressed in them.[11]

Both painters chose to represent the vineyard seen as a harvest scene. Van Gogh, calling his version *The Red Vineyard*, depicted a sun-drenched field animated by a large group of laborers in the process of gathering the fruit of the vine (Fig. 96). Gauguin initially listed his canvas as *La Vendange ou La Pauvresse (The Grape Harvest or the Poor Woman)*, but later settled on the title *Vendanges à Arles: Misères humaines (Grape Harvest at Arles: Human Misery)*. Gauguin's painting presented a central female figure seated on the ground and staring out, head in hands and knees akimbo, with three other figures nearby (Fig. 97). Each painter indicated some endorsement for the version of the other, and the

FIG. 96. VINCENT VAN GOGH, *THE RED VINEYARD*, 1888, oil on canvas, 75 x 93 cm. Pushkin Museum, Moscow

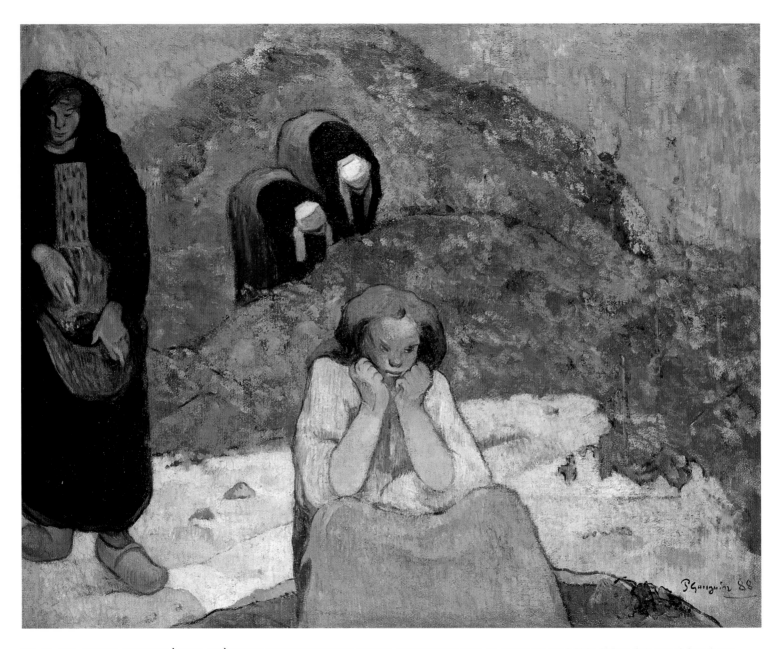

FIG. 97. PAUL GAUGUIN, *VENDANGES À ARLES: MISÈRES HUMAINES (GRAPE HARVEST AT ARLES: HUMAN MISERY)*, 1888, oil on canvas [burlap], 73.5 x 92.5 cm. Ordrupgaard, Copenhagen. Photograph by Ole Woldbye

resulting vineyard canvases may represent a high point of mutual appreciation and, to some extent, mutual influence.[12] Each painter considered his own picture an important achievement relative to his other recent paintings, and a significant contribution to his own evolving style and oeuvre. Van Gogh selected his *Red Vineyard* as one of a very few he sent to Theo that he wished to have framed immediately, while Gauguin went further and wrote excitedly to Bernard as soon as he finished his picture that the *Vendanges* was his "best canvas of the year," an approbation he had assigned only a few months earlier to his breakthrough picture, *The Vision After the Sermon*.[13]

The forms and figures that unfolded as van Gogh and Gauguin rendered their memory paintings of the Arles vineyards reveal that even as they attempted to work more closely together, the differences between them deepened, exposing the constitutive power of their discordant theological cultures. These differences, traceable in a close analysis of the two canvases, emerge not only in their divergent content, compositional structure, and stylistic handling, but in the ways each painter channeled his enduring preoccupations with the condition of the self, the value of nature, the contours of redemption, and the status of materiality in his conception of the subject and the sacred. It is only an attunement to this deeper register of contrasting cultural frameworks that allows us to begin to understand how it was that Gauguin chose to treat the harvest—the moment of maximal exchange between man and a beneficent nature—as a study of misery, an opportunity to survey nature as a source of suffering, and the wretched debasement of human agents consigned, irresistibly, to partake of it. Correspondingly, the multiple socio-theological codes shaping van Gogh's ethos of painting as *agir-créer* need to be assigned a place in the interpretive field as we account for *his* vineyard picture, which amplifies in memory the repletion of the harvest, at the other end of the spectrum from Gauguin's, by filling the picture with multiple figures, tools, and stages of the work process in action.

GAUGUIN'S *VENDANGES* AND PEASANT INTERIORITY

Gauguin's initial paintings in Arles, such as the *Alyscamps* landscape, had stimulated his dialogue with Cézanne and revealed his ongoing debt to certain elements of classicism. Yet a competing cluster of concerns soon surfaced. As Gauguin turned to the imagined group in the *Vendanges à Arles: Misères*

humaines, he reengaged the anti-classical strain at the heart of his experiments with primitivism, abstraction, and cloisonism that he had generated in the rural setting of Pont-Aven. In part, the *Misères humaines* picked up where Gauguin had left off in his *Vision After the Sermon*, transporting to Arles rural figures engaged in varying acts of interiority and spiritual rumination.

In *The Vision*, Gauguin depicted peasant women caught in a moment of ecstatic contact between the natural and the supernatural as they behold a sacred apparition of Jacob and the angel. In the *Vendanges*, Gauguin's peasant women are riveted not by the projection of an exalted vision but by the dejection brought on by knowledge of human delinquency. Gauguin's focus on the inner state and spiritual condition of peasant figures, and the stylistic forms he devised to express them, were inextricably tied to the particular values of anti-naturalism that had dominated his seminary formation, where instructors honed and applied Bishop Dupanloup's techniques of introspection to two major ends: the visionary release from a deficient material world to the transcendent perfection of the divine; and the dolorous reckoning with the defects of a human nature corrupted by sensuality and vanity. In *The Vision* Gauguin tapped the chords of subjectivity and the visionary ideal; in the *Vendanges: Misères humaines* he evokes the lamentational self-consciousness of human vice and carnality.

Gauguin's painting shows a seated woman partly cut off at the front center of a canvas that recedes to a rising shelf of reddish purple enclosing a pair of bending women. A fourth, standing woman, with Breton clogs and black cape, edges the left side of the picture. There is some evidence that Gauguin may have been trying out some of van Gogh's ideas about color contrast, especially in the pairing of yellow and purple in the upper zones. But Gauguin directed this possible debt to an overriding concern with the power of imagination, a concern that settled against the grain of van Gogh's primary assumptions. Gauguin explained in a letter to Bernard how he engaged in bold and willful distortion of the motif by deliberately inserting figures from Brittany, recognizable by their native costume and headdresses, into the Arles landscape:

> *Purple vines forming triangles against the upper part which is chrome yellow. On the left a Breton woman of Le Pouldu in black with a gray apron. Two Breton women bending down in light-blue dresses with black bodices. In the foreground pink earth and a poor woman with orange hair white blouse and green skirt mixed with white . . . It is a view of a vineyard which I have*

seen at Arles. I have put Breton women into it—so much the worse for accuracy! [*tant pis pour* l'exactitude!].[14]

The explicit projection of Breton figures in the Arles *Vendanges* emerged in another element— Gauguin treated the face of the seated woman as "a head type" that had already appeared in one of his earlier Pont-Aven paintings, *Still Life with Fruits*, dedicated to Charles Laval.[15] Thus Gauguin imposed on the Arles scene a figural repertoire culled from a composite of his Breton period, pressing at the edges of invention and imagination in his memory painting.

Formal qualities of the *Vendanges*, as well as Gauguin's written comments, suggest that he also extended some of the stylistic techniques central to his Breton cloisonism in this Arles canvas. For example, in the letter to Bernard, Gauguin stated that "the whole was made with bold outlines filled with virtually uniform tonalities,"[16] a description that exemplified one of the characterizing features of the cloisonist method Gauguin attempted in Pont-Aven, dividing the canvas into broad color areas demarcated by bold and visible lines. Traces of these outlines appear around the four female figures. But the techniques of paint application in the Arles *Vendanges* depart markedly from the fluid, largely unbroken brush that Gauguin applied to the color field of *The Vision*; they also contrast sharply with the delicate, Cézanne-like striations of his *Alyscamps*. In his harvest painting Gauguin not only brushed in paint but scraped and scratched pigment across a harsh, abrasive canvas of coarse sackcloth with a palette knife, devising a form and content that intimated an allegory of isolated guilt and the unruly desires that generated it.

Gauguin himself gives us clues to the meaning of the figures and their sorrowful plight. His goal, however, as he wrote to Schuffenecker, was not to fix a particular message with literal description, like "a painted novel." What he attempted, rather, was to explore new modes of "suggestion" through a combination of form, color, and symbol. He emphasized in his letters about the *Vendanges* that mystery and indeterminacy sustained the power of the painting, which he considered a catalyst of the *au-delà*, the invisible realm of the beyond. In what he called a "magnetic current of pure thought," the *Vendanges* expressed a force field where time was transformed, condensing "all of life past" and the "life to come."[17]

The ambiguity of setting and figure emerges in the position of the central seated woman, who seems perched on a dark foreground while also being flat up against a white middle area and a billowing

triangular rise of reddish purple. Hunched up with her head resting in curled hands, the woman appears off-kilter and misaligned; we see her right elbow resting on her knee and skirt while the left elbow floats above and away from the balance-providing knee. The orange-red hair around the woman's head is strangely weighted and molded, with dark, shadowy areas where the ears should be.

Gauguin described the imagined figure as a "poor woman, totally bewitched in the open fields of red vines."[18] Here, as in other references to this female figure, his use of the words *une pauvresse* signals not the social condition of poverty but a state of spiritual transgression and desolation. In a second letter Gauguin calls her a "poor despondent" woman being looked at by the standing figure, who regards her sympathetically, "like a sister." He goes on to associate this passing figure cloaked in black with death, noting that "black symbolizes mourning."[19]

The seated woman's rumpled appearance, with her flowing hair and missing Breton cap and bodice, combined with Gauguin's remarks, have led commentators to agree that the misery that afflicts her is sexual in origin.[20] The association of nature's bounty with heat and lust in the Arles landscape was not limited to this canvas; in a second painting that Gauguin created soon after the *Vendanges*, entitled *Woman in the Hay with Pigs: In the Full Heat of the Day*, Gauguin re-created the harvest site as a staging ground of invented sexuality (Fig. 98). Here, also on the rough, burlap-like canvas, he depicted a peasant woman wearing her cap but nude to the waist with outstretched arms as if ready to copulate with the fields before her. The backside view of a pig near her accents the bestial sexuality suggested. In the *Vendanges* painting, the despairing female ponders the aftermath of her "bewitchment in the open fields" in a state of abandonment and dolorous reckoning.

THE *VENDANGES* AS SEXUAL ALLEGORY

The visual sources and symbolic cluster that Gauguin assigned to this memory painting reconnected him to the aspiration for a modern allegory and its specific theological framework. Gauguin provoked the links between debauchery, desolation, and death by posing the central woman to resemble a mummified tomb figure. He adapted the stance of the seated, hunched-up female from a Peruvian mummy, a gruesome figure in a fetal burial pose, that he had seen in the Paris Ethnographic Museum at the Tro-

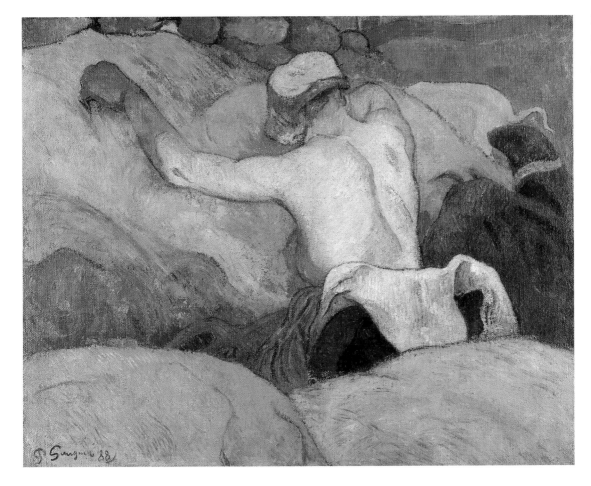

FIG. 98. PAUL GAUGUIN, *WOMAN IN THE HAY WITH PIGS: IN THE FULL HEAT OF THE DAY*, 1888, oil on canvas [burlap], 73 x 92 cm. Private collection

cadéro (Fig. 99).[21] This trepanned mummy provided Gauguin with a visual prototype, just as mummified remains had been a source for his decorated wooden box of 1884–1885 (Fig. 71). In the jewelry box, Gauguin had composed a startling variation on the theme of earthly riches and devastation, fashioning a container for dazzling ornaments that yielded to the figure of a disintegrating corpse. In the vineyard *Misères* of 1888, Gauguin evoked the dialectic of sensuality and reckoning, reaffirming a core pairing accentuated in Bishop Dupanloup's seminary teaching. By associating the dejected, brooding woman with the burial mummy, Gauguin reinvented the fields of Arles as a dramatic visual allegory of

carnality and its consequences. The woman who had been "totally bewitched in the open fields" was now despondent, contemplating her isolation and the irreversible shift from temporary pleasure to shame and affliction. By seating the woman in the position of the mummy, Gauguin could project her thinking forward, as he had implied her condition arising from her actions in the immediate past: the misery of the *pauvresse* would end in her being stripped bare of unruly flesh, like the cavernous mummy reduced to its intact, hunched-up ossuary.

In addition to the significance of the mummy, a second layer of evidence connects Gauguin's Arles *Vendanges* more closely to theologically specific categories of his religious formation. The subtitle appended by Gauguin to the painting, *Misères humaines*, evokes the abiding ethos of the Catholic *miséricorde*, the anguish and grief of earthly life as a calvary. The self-portrait as a *misérable* mobilized these assumptions as it adapted them to the new condition of the artist's creativity. In the Arles *Vendanges* canvas, Gauguin engaged the *misères* as a collective human predicament and transported it to painting. The Orléans seminary had introduced Gauguin to a vision of the dismal "infirmity" of mortal life; included in the Dupanloup canticle book is the chant "Misères de la vie présente," whose central figure is charged to open his eyes and see, thereby recognizing the source of human suffering in the inevitable lure of ephemeral worldly sensualism:

FIG. 99. PERUVIAN MUMMY FROM THE ANDES, ca. 1100–1400. Collection Musée de l'Homme, Paris

> *Mortal man, open your eyes, and see that misery*
> *Pursues you, and follows you in every site,*
> * . . . all of life is a bitter source . . .*
> *We are weak, the sensual pleasures of this world*
> *Make such rapid incursions in our hearts,*
> *That nothing can form a powerful impression*
> *Unless it flatters and charms our senses.*
> *When even a tiny breath alights on this fragile body,*

This is all of our misfortune,

For even the innocent are not without blemish,

Nor the most contented without sorrow.

Serenity is completely beyond our power.

None below on this earth can enjoy it,

It descends from the heavens with our innocence,

And with it disappears.

As these two treasures were indivisible,

They vanish in a moment;

And the same sin that makes us all guilty,

Makes us also all unhappy . . .

Only death breaks that which links you

To this long infirmity . . . [22]

The specific dangers of concupiscence resurfaced in Gauguin's consciousness when he attached to the *Vendanges* a last title, *Splendeur et misère*, which he listed in his notebook. With this title Gauguin conveyed suggestive clues to the central figure's plight as seduced and abandoned. Gauguin was at one level no doubt thinking of Balzac and his *Splendeur et misères des courtisanes*. But the dialectic of seduction and misery was also a core model in Gauguin's seminary education, and had been described in precisely this way in some of the Orléans recitations. Gauguin had already evoked this key pairing in the juxtapositions of his sculptured wooden box, where panels of ballerinas displaying their diaphanous costumes opened up to a carving of a perishing corpse. Now, in inventing "splendor and misery" as an Arles harvest scene, Gauguin reaffirmed the governing power of this polarization in his mental world and artistic practice, painting in from his cultural "imagination" the link between corporeal pleasure and the spectacle of the coffin. Gauguin's "sisterly" figure in the "color of mourning" near the seated woman accented this inseparable unity of carnal action and thanatal dissolution. In the Orléans seminary context, Dupanloup's canticle had joined seduction to misery and to the graphic prefiguration of death:

Everything is only vanity, lies, fragility . . .

In vain, to be happy, the young sensualist

Plunges himself in the sweetness of worldly seducers

* and pursues enchanting pleasures . . .*

Futile shadow, vile nothingness,

Sheer phantoms that vanish

After they have lured him . . .

On the day of his mourning,

He has nothing but a coffin.[23]

TOOLS OF PENITENCE: SACKCLOTH AND PALETTE KNIFE

Gauguin's choices of content for his Arles memory picture—invented Breton women; suppressed action and internal meditation; allusions to transgression and grief; and the condensation of time and states of being—all contributed to his extension of the project of "abstraction," moving the image, as he called it, from anecdotal description to more suggestive and generalized allusions, and to the contours of a modern allegory powered by Catholic dualisms. To realize his goals, he needed new technical procedures. In a later letter, Gauguin wrote to van Gogh about the *Vendanges* that he had been "led to search for a synthetic form and color in this order of abstract ideas."[24] The stylistic experiments that Gauguin engaged to convey these particular "abstract ideas" yielded a provocative melding of form and content: he developed what I would call penitential tactics of artistic practice to match the lamentational condition of the *misères humaines* he shared in and represented.

Displaying some of the techniques of synthesis and simplification he had attempted since Pont-Aven, Gauguin reduced the picture plane to a number of basic elements, explaining to his friends that the format for the composition followed the simple shape of a "parabola" or a "triangle."[25] The flat space, tilting up and forward like a shallow shelf, deepens by the placement of the *pauvresse* right up against the edge of the picture plane. Her position acts to obstruct movement into depth, as did the assembly of figures sliced along the edges of the *Vision* painting. These spatial qualities indicated that

Gauguin tried again in the Arles *Vendanges* canvas to scramble the logic of perspective and recession, driving the surface forward and out to defy the expectations of the viewer for entry into depth.

But the most radical feature of Gauguin's technical approach lay in the paint handling, and the startling interplay of pigment medium and support. The *Misères humaines* was one of a number of pictures that Gauguin painted on cuts from the heavy canvas roll he purchased in Arles, of a coarse jute weave he called "sackcloth." He treated the surface in three distinctive ways.[26] First, rather than smoothing out or covering over the nubby knots of the cloth, Gauguin revealed its rough texture, not only leaving the canvas bumps and knots visible but relying on them as an essential element of the composition.[27] Second, the harsh, exposed cloth interacted in a special way with the paint cover. The heavier canvas allowed for greater absorption of pigment, an effect Gauguin was seeking, which he enhanced by using his experimental thin, white ground. Coarse cloth and light ground enabled Gauguin to achieve the effects of a matte, blanched, opaque appearance as he applied color, for the "extremely coarse canvas could be used to absorb the greasy base of oil paint," allowing the oil from the paint layer to penetrate into the porous support.[28] Third, Gauguin deepened the permeation of the pigment by employing a palette knife, scraping and pressing in the paint across the surface as it exposed the abrasive canvas skin to which it adhered.

These technical procedures—highlighting the knotted weave; minimizing pigment gloss in a blanched, degreased color that melded with its thirsty support; and compressing the paint with the palette knife—interacted to yield a dramatic visual field. The main area of the vineyards appears parched, caked, and clotted, in sharp

FIG. 100. DETAILS OF FIG. 97. Photographs by the author

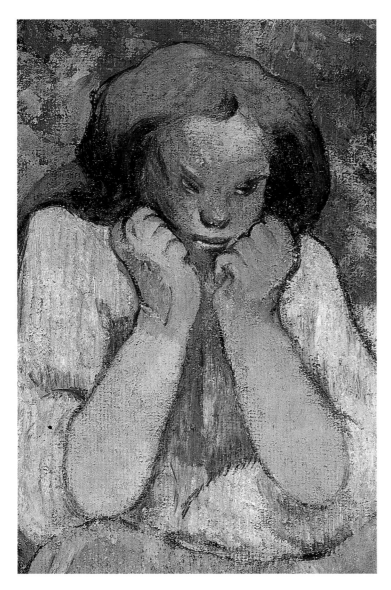

FIG. 101. DETAIL OF FIG. 97

contrast to what van Gogh recorded in his letter as a rain-drenched and sunset-soaked landscape. In Gauguin's imagined harvest, the section behind the head of the seated woman, for example, shows an uneven, blotchy overlay of bluish purple that cleaves to the red ground like scabs or dry paste (Fig. 100). While the hooded figure in black is treated with a smoother, almost glazed color, the central, seated woman's face and raised arms expose the coarse sacking through a thin veil of painted flesh (Figs. 100 and 101). The sinking in of flesh to the visible harsh weave conveys a tactile sense of chafed and scoured skin, inlaid with irritant. The striated lines marking the woman's blousy white shirt intensify the effect of grazed skin; Gauguin marked these cloth surfaces with raked and scoring lines, as if flaying the flesh through it.

Gauguin's distinctive materials and handling joined form and content at two levels, binding the artist creating the image to the predicament of the woman he depicted. First, Gauguin alluded to a particularly sexual quality of his visual practice in formalizing the *Vendanges.* On completing the painting, he included it with four others to send to Theo van Gogh for possible sale in Paris. In the letter about the package Gauguin explained that the Arles vineyard and *Woman in the Hay,* both on the heavy canvas, "might shock potential buyers": "These last two are, I believe, rather masculine, even . . . crude. Is it the southern sun that thus puts us in heat? If these [canvases] scare off the collector, don't worry about setting them aside; I cherish them."[29] The disheveled vineyard woman, the *pauvresse,* had been "totally bewitched in the open fields"; the bestial woman in heat in the hay, half nude, was set as if to plunge into union with the fields. Gauguin, working the coarse sacking with these depictions and allusions to sexual activity, reclaimed for the

painter as he painted a state of sexual energy he ascribed to his subjects. The crudeness and "masculine" qualities of the sackcloth canvases engaged him in formal equivalents of "being in heat"; if the women in the paintings were animated by instinctual drives, so too was the painter aware of transmitting his own libidinous power in his technical procedures. This involved Gauguin, as he intimated to Theo, in a predatory relation to his figures. But it also led him to develop a particular stylistic repertoire evocative of sexual domination, formalized in techniques to maximize penetration, permeation, and pressing in of pigment to a visibly abraded cloth whose tangible friction was deliberately preserved as part of the composition.

Yet if Gauguin claimed to share the heat and sensuality of his harvest subjects and developed visual traces to evoke them, his sexualized practice of painting formalized not pleasure and rapture but desiccation and isolation. Gauguin's blanched, clotted, and scabious spatters of pigment scraped on flesh and fields provided startling visual equivalents for the themes of carnality and affliction he explored in the *Misères humaines*. As the brooding woman was caught not in the thrall of physical abandon but on the rack of dolorous reckoning, Gauguin conveyed in visual language the lure of and resistance to his physical materials. Leaching out the oily gloss, parching the ground, and compacting the paint layers, Gauguin expressed the strenuous challenge of wresting materiality from its hold on consciousness, maintaining the palpable knots of the canvas jute even as he tried to flatten, reduce, and attenuate the paint cover. Gauguin, like the woman he chose to represent in the turning of splendor to misery, was condemned by corporeal nature to suffer, and in the *Vendanges* he found new visual forms to express his ongoing theological mentality that pitted man, like painting, in a mortal "conflict with matter."

That inexorable conflict yielded a striking painting from the unlikely spectacle of the Arles grape fields at sunset. Gauguin's distinctive procedures of exploiting the raw sacking in contact with paint compression, chafing, and scourging offered a technics of repentance anticipated by the sorrowful woman as she recognized her transgression. Gauguin's flaying and grating actions with the palette knife transposed the experience of sacking on skin to the domain of the canvas surface. This displaced penitential process was unwittingly achieved when, soon after it was completed, some foreground sections of the *Vendanges* began to flake off as a result of the taut parching of the pigment on harsh cloth. The paint flakes created a mix resembling colored ash, stripped from the sacking.[30]

PRODUCTION AND INTERDEPENDENCE IN VAN GOGH'S *RED VINEYARD*

Like his friend Gauguin, van Gogh painted his Arles *Red Vineyard* from memory, engaging the new claims of synthesis, simplification, and more daring, non-naturalistic color. His inclinations toward invention and "abstraction" yielded an image teeming with laborers set in a radiant and copious nature. Gauguin's vineyard-as-penitence painting, sustained by a theology of corruption and redemptive suffering, differed in form and content from van Gogh's vineyard-as-production painting. Van Gogh's subjects and technical repertoire expressed the abiding imperatives of his own Reformed religious mentality, driven by the dread of idleness and the anxiety of unearned value rather than by the scourge of carnal depravity. As he strove to complement Gauguin's harvest view with his own, van Gogh created a scene not reduced to a focus on interiority but inflated to a panorama of energetic labor and its visual equivalents. His grape gatherers were not, as Gauguin's were, regulated by an ominous symbol of death, but by the emitting beams of the sun, woven in bright yellow paint.

Van Gogh's vineyard presents a rich sweep of space, unfolding dramatically into the distance. While he has taken many liberties with the composition, one feature closely resembles the account given in his letter reporting the scene: the sun is setting and its rays are caught in glowing reflection in the wet ground beneath. Van Gogh reimagines the empty fields, though, as brimming with human activity, with figures gleaned from his memory and the scores of canvases in which he depicted peasant workers in and around Arles. Gauguin, brazenly casting off "accuracy," recounted having deliberately transported Breton peasant women to his Arles vineyard. Van Gogh's creativity moved in another direction: without mentioning it explicitly, he reassembled in his vineyard all of the varied types and stages of rural work he had encountered in his time in Arles and had explored in individual canvases. *The Red Vineyard* forms a composite, a gallery of local laborers dispersed in other harvests and in other settings, imaginatively reunited for the grape gathering. Van Gogh presents his synthetic company of Arlesian types in different phases of this harvest, providing a comprehensive picture of the work process involved.

Twenty-one figures are perceptible from front to back in the receding field. All are legible from a minimum of simple markings that van Gogh used in many Arles canvases as a condensed notational

system for the human figure, which emerged as a basic shape from a few spots of color, the use of black, and bold outlines. The women in the middle planes of the picture are the most discernible from this summary treatment, while the figures that give way to the distant fields at the left appear as tiny sticks or dabs of black paint. However, even in these minute, antlike treatments, van Gogh applies enough shape to detect the bend and contact of arms to earth. The closer female figures lack facial features but are readable, in action, as they appear: as rudimentary angular color blocks amidst flamelike plantings. On the right, set between two vine posts, we notice the headdress and white shawl of the Arlesian costume on a woman reaching across; she resembles the washerwomen van Gogh set on the rafts by the Roubine du Roi or included in the Langlois Bridge series along the banks of the canal. The middle ground shows women in less regionally specific clothing who are seen bending, standing, hauling, and plucking grapes off the vine, again all legible actions from a minimum of means. The first figure on the left, with her back to us, holds a basket with another one adjacent; to her right we see a figure bent over and head down, raising a basket, which bears a dash of yellow across the bowl. Five figures behind this woman reach, bend, and pull. Their postures and clothing are given witty variation, such as a bright green blouse on one and red on another; one has a crook in the back, another is rotund. All of these summary figures indicate van Gogh's use of the technique of simplification for a pictorial economy of action and animation. The reductive, bending figures in Gauguin's vineyards, also emergent from a minimum of lines and color, are inserted and lost in a billowing red shelf; their activity and purpose as harvesters is inscrutable. The main action of the *Vendanges* canvas is in the interior world of the seated central figure and her elusive and allusive passing partner. Van Gogh's grape-gathering women are not lost in thought but absorbed in the exertion of their work.

Three figures farther back in the picture plane resemble those from other sites, as if transplanted from others of van Gogh's Arles canvases. A standing woman with a parasol appears, an Arlesian type mediated by Japan that caught van Gogh's attention in Provence; he mentioned this figure in his letters and illustrated her in a drawing to Bernard.[31] She resembles most closely the Arlésienne with parasol that van Gogh positioned along the path of the tombs in his painting of the Alyscamps.

A sticklike figure formed out of a few black touches stands in a floodlit expanse fronting the sun. This figure looks like some of the men walking in the Alyscamps, whom van Gogh had similarly rendered from a few flecks of paint and line, or like his tiny ink-spot male hikers shown en route to Mont-

majour. The position of this male figure in the field, with the giant disk of the sun blazing behind him, is also reminiscent of *The Sower*. Near this figure van Gogh has placed a horse and cart with a driver, who can be seen hauling a basket handed up to him by another figure below, arms reaching up to meet his. A man with horse and cart had appeared in other Arles landscapes, such as the one moving through the large Montmajour drawing. The large, panoramic *Harvest at La Crau* of June (Fig. 102) had featured an empty blue cart in the middle ground, a tribute to Millet, as well as a man with horse and cart legible in the right background. Here the man played an important role in the harvest cycle, as van

Gogh presented him, in miniature, in the process of transferring the cut sheaves to a granary, completing the cycle of the work process conveyed in other stages in the same canvas.

In *The Red Vineyard*, van Gogh again concentrates the different phases of the work cycle in one painting by positioning laborers engaged in various activities in the ripened fields. He deepens the temporal condensation of the image by including the sower-like figure at the right and the man with horse and cart in the center, suggesting the past and future of the phases of the grape harvesting that dominates the canvas with such immediacy. The sower-like figure with arcing sun alludes to the prior planting; the man with cart waiting for the yield will transport it to storage, market, and tables. Gauguin, we recall, stated that his Arles *Vendanges* was a force field of "life past" and "life to come," achieved through the allusiveness of form and content and the artist's "magnetic" powers of "pure thought." His temporal compression evokes the states of the suffering woman's soul as she moves from iniquity, to guilty self-scrutiny, to final judgment in the pit, like her mummy prototype. Van Gogh's synoptic force in his *Vineyard* conveys not the inner condition of the subjects' souls but the phases of their productive actions, moving not from delinquency to reckoning but from planting to nourishing goods.

TOOLS OF MÉTIER: SOAKING LIGHT AND LOADED BRUSH

Like Gauguin, van Gogh devised distinctive technical strategies to formalize the meaning of his memory picture. He employed particular patterns of spatial organization, light effects, and brushwork to convey a visual language of dynamic activity and divinized nature concordant with his group portrait of busy harvesters. Where Gauguin had developed tools and techniques of penitence painting, van Gogh used tactics suited to his production painting. In his *Red Vineyard*, while he followed Gauguin's call to extend his experiment with memory painting, van Gogh departed emphatically from his friend's challenge to suppress and discipline his brushwork.

Van Gogh invested his vineyard with dynamic recessional force, relying on linear movements into the distance. The viewer's eye is drawn immediately to a swooping diagonal arc from the front left edge to the far right townscape at the back of the canvas, animated by the directional drive along the sunlit canal and the marking standing figure.[32] Corridors of space pulsing from front to back also operate

through the pull of the sun at the low horizon, and by the rhythm of the working figures. They are positioned in plotted intervals, which, if not precisely regular coordinates, nonetheless offer a sequential unfolding by size and plane, becoming progressively smaller as they recede along legible alleys.

All of these devices providing destination, proportion, and movement into depth contrast sharply with Gauguin's *Vendanges*. His flattened shelf of space tilts up and out, with no visible terminus, as the triangle of the reddish fields is abruptly cut off at the top of the canvas, and the seated *pauvresse* at the front edge of the picture plane further obstructs movement into visual depth. While not as sharply linear as some of his "framed landscapes," van Gogh's *Red Vineyard* nonetheless manipulates a perspectival logic, offering varied optical scans of the multiple labors represented. Rather than a figure blocking our view, van Gogh offers the beholder, at the front end of the canvas, a deft invitation to mobility by rendering a furrow of cleared ground, which opens up the space toward the first set of figures in action. A similar type of visual direction appeared in the sliced furrow in van Gogh's June *Sower*, which brought the viewer immediately into the action of the picture.

Van Gogh's vineyard, flooded with colored light and saturated hues, skillfully evokes a spectacle of nature's partnership with human labor. Sun and rain, twin agents of nature's generative powers, dominate and permeate the canvas. A white-yellow center crust of sun, emitting darker yellow and orange rays, vibrates across the top of a low, incandescent horizon, while a shimmering soaking through of the rain reflects back from the glossy ground. Saturation and irradiation combine as if to set the field afire with rich, resinous reds and purples offset by yellow, orange, and black streaks, barely dry and exposing their oily essence.

Gauguin's parched, clotted vineyard deliberately dulled the color sheen and blanched out the pigment grease of colors, and he excised all signs of the sun and rain engulfing the evening scene observed. No reflected light marks the surface of his *misères*, and no source of light appears. The brightest areas of Gauguin's canvas emerge in the seated woman's raked blouse and the pale white terrain behind her, a rocky, dry, and barren surface on which the mourning figure, glazed in black, hovers. Van Gogh's drenched, glowing vineyard is, by contrast, nourished by the nimbus of the sun, whose force and halo effects resemble the divinized power he attempted in *The Sower*, when he wrote of transferring Christ's aureole to nature. Maximizing the intensity of colored light, van Gogh's *Red Vineyard* worked to con-

vey human figures not isolated by sin but connected as a community of labor to nature's sacred, sustaining cycles.

Van Gogh's thick, irregular brushwork provides a final divergence with the form and content of Gauguin's vineyard painting. In his paired Alyscamps scenes, van Gogh experimented with a leaner, muted, controlled application, allowing the pigment to soak into a coarse canvas support of the type that Gauguin exploited to such startling ends in his *Vendanges*. In *The Red Vineyard* van Gogh does not use the heavy sacking; rather, he has chosen a conventional canvas, and he lays on the paint in his more habitual way: in thick patches, freely applied. Here the whole arsenal of the *tripotage* returns in force, reemphasizing visually the bursting energy and bounty embodied in the scene. A medley of paint streaks, dashes, lines, and clumps boldly breaks the surface, loading parts of the canvas with relief-like impasto and color sediment. Areas of particular density concentrate in the sunlit pool at the right, a yellow hub of small horizontal strokes; the sun and sky, heavily impasted, with yellow-green paint visibly smeared in wickerwork bands at the left; and the center of the vine field, cascading with red-orange layers that crust with paint even as they appear to tumble down.

In Gauguin's *Vendanges*, the viewer's attention is drawn to the particular tactile activity created by the interaction of exposed, knotted sacking and thin, matted paint cover, conveying a vivid sensation of irritation, like abrasion on skin. Van Gogh's stylistics of animation centers not on the relation of medium and support but on the buildup and diversity of brushstrokes on the surface. These construct a tangible pigment texture to vines, sky, and costume by the vigorous layering of the brush. Paint, not pressed down, juts out like sticks in parts of the picture. In the sky, the cloth canvas is overlaid with a heavy sheath of strokes that reweave the canvas in paint lines of interlocking warp and weft. Gauguin's handling in the *Vendanges* is driven by the dialectic of conquest, attempting to subdue the power of materiality while disclosing the inherent pain of sensual contact. Van Gogh's handling in *The Red Vineyard* expresses another dialectic, that of exaltation in the cycle of productive nature, while emphasizing that the pace and vigor of visual labor could approximate, if never match, the labor and fruit of the fields.

VAN GOGH'S SEXUALIZED PRACTICE OF ART

Van Gogh, like his friend Gauguin, associated sexuality with some aspects of the fertile fields he rendered, but with very different meaning and consequences for his vineyard canvas. Gauguin, as we have noted, identified the crudeness and virility of the look of his painting, linking the southern sun to his own state of being in heat and the physical desires of his "bewitched" subject. Form and content yielded an evocation of sexual contact and its conflicts, the unending lure and misery of lust. Van Gogh's *Red Vineyard* engaged sexuality not in the framework of debauchery and reckoning but in the mentality of production, where "virility" and "vigor" on the canvas signified the presence and power of the male seed.

Since the late summer in Arles, van Gogh had defined in his letters what he called "spermatic painting" or the "creative sap" that materialized the artist's potency. Writing to Emile Bernard from Arles in August, van Gogh advised his friend not to deplete his energies with too much sexual activity, so that his painting would be "all the more spermatic." He went on to extol the virtues of the seventeenth-century Dutch artists whose "peaceful, well-regulated habits" produced "virile" works, "so full of male potency"; these same exemplary, energetic artists, van Gogh wrote, were also married men who produced children.[33] For some years before his time in Arles, van Gogh had identified in the cycle of nature's growth—sowing, ripening, and harvesting—a central form of reassurance for his own artistic production as well as his hopes for generativity through physical love. In the fall of 1887, for example, he wrote: "In every man who is healthy and natural there is a *germinating force* as in a grain of wheat. And so natural life is germination. What the germinating force is in the grain of wheat, love is in us."[34]

As physical love eluded him, van Gogh displaced his hopes for generativity onto his painting. He noted in a letter to Theo that "if a man is frustrated in his physical power, he may create thoughts instead of children"; the power to create would provide for posterity in his pictures, his substitute progeny.[35] Yet this hope was always tinged with doubt, for as van Gogh worried over the accumulation of his pictures without sales, he was also plagued by fears of depletion and the sterility of his production. Soon after he wrote so optimistically to Bernard about the energies of spermatic painting, he wrote Theo that he felt "the possibility of going to seed and of seeing the day of one's capacity of artistic creation pass, just as man loses his virility in the course of his life."[36]

Living and working alongside Gauguin, van Gogh encountered a significant challenge to his idea of painting as the source of germination and generativity. He was immediately impressed by Gauguin's imposing physical stature and soon recognized that Gauguin was drawn to and "very successful with the Arlésiennes."[37] Van Gogh aimed to enlist Gauguin in his plan for them to "live like monks," so as to preserve their energy for painting, as he had suggested to Bernard. He tended to visit local prostitutes for sex about every two weeks; Gauguin had no such spartan regimen. Despite this, van Gogh had to acknowledge that Gauguin was "very powerful, strongly creative," and that his sexual passions did not undercut his energy for painting.[38] More difficult for van Gogh to accept was Gauguin's successful production of posterity through children: his friend, van Gogh wrote his sister Wil, had "found a means of producing children and pictures at the same time."[39] Unlike the serene Dutch painters van Gogh celebrated, whom he characterized as married men who restrained their appetites and thereby generated both "virile" works and healthy progeny, Gauguin with his reckless ways nonetheless yielded pictures, children, and mastery with women outside his marriage.

Van Gogh's letters to Theo registered a growing sense of awe mixed with jealousy over Gauguin's sexual potency. He wrote to Theo in November about Gauguin's appeal to the local women, his marriage, and his brood of "pretty children"; this was followed by a comparison unfavorable to the brothers van Gogh: "*We* aren't so gifted in that respect."[40] Some time later this theme of the brothers falling short of their procreative colleague returned: "[Gauguin] is physically stronger than we are, so his passions must be stronger than ours. Then he is a father, he has a wife in Denmark, and at the same time he wants to go to the other end of the earth."[41]

Van Gogh's unfavorable comparison of his own physical prowess with Gauguin's coincided with the added news of Gauguin's successful sales record. The catalyst to Gauguin's travel to Arles, as we have seen, was provided by Theo's successful sale of some Pont-Aven paintings in October. In early November, at the very time that Vincent and Gauguin were working together at sites around Arles, Theo reported that he had exhibited some of Gauguin's Brittany paintings in the mezzanine rooms of the Boussod Gallery, where he worked, with extremely positive results. Degas was "very enthusiastic" at what he saw there; sales of three Gauguin paintings yielded a total of 1,200 francs.[42] As a result of this information, Gauguin prepared a roll of his new Arles canvases—including *Alyscamps, Woman in the Hay with Pigs*, and *Vendanges*—to dispatch to Theo in Paris to catch the wind of sales opportunities.[43]

Vincent was delighted for his friend, but was also aware that the paintings he himself produced on these same subjects would be lovingly admired by Theo and then propped up against the walls of his apartment, without a public audience.

Gauguin's continuing commercial recognition, combined with van Gogh's observation of his unchecked erotic adventures, may have deepened the impulse van Gogh had already expressed to display his own potency in a "spermatic painting." *The Red Vineyard* does carry some of the qualities that could be associated with this kind of sexualized visual practice; the tangible body of the canvas may have shared in van Gogh's attempt to formalize in paint thickness the presence and power of his own "creative sap." Whether or not there is a direct connection to a rivalry with Gauguin, the sexual dynamics of van Gogh's visual practice in *The Red Vineyard* diverge sharply from those that Gauguin identified for his *Vendanges*. Gauguin linked his form and content to sexuality as predation, loss, and death. Van Gogh associated the form and content of his *Vineyard* with the hopes for interdependence and the bringing forth of new life.

Like many of the Arles pictures, van Gogh's *Vineyard* extends expressiveness within a primary commitment to the laws of paired, complementary contrasts of color, a commitment that Gauguin derided but did not succeed in displacing. In this canvas, van Gogh identifies his play with red and green; violet and yellow; and subsidiary zones of blue and orange. Van Gogh regarded his *Red Vineyard* not as a discrete image but as a pendant to another canvas, *The Green Vineyard*, done earlier in Arles. Thus, as in the pendant *Alyscamps* paintings, the logic of the color contrasts moves outward from individual canvases to composite wholes or ensembles of multiplying units, which heighten and complete one another only in and through their association.

This fundamental definition of individual color units, each essential, each maximized and completed only in reciprocal interaction with another color unit, expressed a formal equivalent of van Gogh's relational model of self and the sacred. In his self-portrait as a bonze, van Gogh presented a self located in a larger totality of nature and divinity. In his Arles theories of portraiture, van Gogh spoke of a picture as "comforting," as offering "that something of the eternal" by a halo created by radiant, vibrating colors, the effect of the "glow" set off by an interacting pair of complementary contrasts.[44] To these social and theological foundations of relational assumptions van Gogh added his own longings for love and union in a couple, which he explicitly attached to his theory of color. In a letter to Wil from

Arles in July, he described his technique and ideas about the laws of complementary colors. After discussing the essential pairs—"blue and orange, lilac and yellow, green and red"—van Gogh went on: "These are fundamentals . . . quite enough to show you . . . that there are colors which cause each other to shine brilliantly, which form a *couple*, which complete each other like man and woman."[45] Van Gogh returned to this correspondence of color and physical love at the end of his famous letter to Theo about eternity and the halo of color:

> *I am always between two currents of thought, first the material difficulties . . . and then the study of color. I am always in hope of making a discovery there, to express the love of two lovers by a wedding of two complementary colors, their mingling and their opposition, the mysterious vibrations of kindred tones . . . To express hope by some star, the eagerness of a soul by a sunset radiance.*[46]

In his *Red Vineyard*, van Gogh's definition of a "spermatic painting" and his principle of complementary colors as a mingling couple, like man and woman, combined to evoke a sexualized visual practice whose essence was love, unity, and totality. The interdependence of loving partners, displaced to color parts that "caused each other to shine brilliantly," added another layer of meaning to *The Red Vineyard*'s radiance, where van Gogh celebrated the richness of a bounteous nature in connection with a collaborative labor community that gathered it. Gauguin's *Vendanges*, by contrast, evoked a sexuality of battle and pain, where unreflected light, blanched color, and chafed skin formalized the thanatal isolation and requisite penitence he considered the inescapable consequence of passionate acts. Van Gogh's generative hopes directed him to another kind of picture. His luminous color pairs, mediators of the eternal and surrogate lovers, composed one bar of an ascending scale of complements in the *Vineyard*: harvesters and conveyors; sower and halo; sun and rain; the infinite and the tangible. While confined to the compensatory arena of the canvas, the painter participated in the life-affirming, relational order by imagining his seed bringing forth new life through paint, which, in fact, it has done for van Gogh as for no other artist in history.

FIG. 103. PAUL GAUGUIN, *WOMEN FROM ARLES IN THE PUBLIC GARDEN: THE MISTRAL*, 1888, oil on canvas, 73 x 92 cm. Mr. and Mrs. Lewis Larned Coburn Memorial Collection, 1934.391.

CHAPTER NINE Remembered Gardens

Gauguin and van Gogh pursued a final joint effort in Arles to extend an art liberated from the model. Soon after they transformed the Arles vineyards into two corresponding canvases, van Gogh and Gauguin produced identically sized studio paintings of an invented scene set in the public gardens at Arles. Van Gogh's canvas represented the most radical experiment he would attempt in painting explicitly from memory and the dream, prodded by Gauguin to increase imaginative elements in his picture-making. Yet, even as he did so, van Gogh was reinstating the model. Though he found himself intrigued by the "artistic look" of working from memory, he never felt at ease with Gauguin's encouragement "to work often from pure imagination."[1] At the very moment that van Gogh pushed his art to elicit conceptual materials, at the furthest remove from nature and observation, he was simultaneously returning to portraiture at an intensive pace. During November he took time away from painting alongside Gauguin to enlist the entire family of his friend Joseph Roulin, a postal service worker, to sit for him as subjects. From these encounters van Gogh created a virtual portrait gallery of "the whole family."[2] Nonetheless, he did produce a canvas that was, like Gauguin's, inspired by the Arles park, and the differences that emerged in the two paintings revealed to the two artists themselves their deepening incompatibilities and divergent directions.

SYMBOLIST CLASSICISM IN GAUGUIN'S GARDEN PAINTING

Gauguin's *Women from Arles in the Public Garden: The Mistral* (Fig. 103) took its motif from a site near the Yellow House. The Arles garden's identifying bench, pond, and path are present but barely recognizable

in Gauguin's arbitrary, flattened, and unmodeled rendering. A silent women's processional moves from back to front in the picture, from distant green path to large foreground bush. The bush, rendered in feathery brushwork, bears the date and Gauguin's signature, and breaks the space and figural form of the two closest women; an adjacent bright red fence creates a second barrier for the viewer. The bush, which displays at its right a definable eye, looks like the profile of a lumbering monster. Some believe Gauguin shaped it to resemble his own profile.[3] Gauguin thereby invests a natural form with a mysteriously animate quality, alluding to his earlier conviction that there are "supernatural phenomena" of which we nevertheless "have the *sensation*."[4]

At the back left of the painting, a fragile tree is intimated only by its gossamer branches, divested of trunk and anchorage. The delicate leaves melt into a green bench under it. The bench, cut off at the top of the painting, tilts up, suspended, its wispy legs as weightless and insubstantial as the delicate cow at the same upper left portion of *The Vision After the Sermon*. Gauguin applies the paint in lean, thin layers and light strokes. Unlike the *Vendanges*, this image is painted not on the heavy sacking but on commercial canvas, and Gauguin does not dramatize visually any interplay between pigment surface and medium, preferring an overall muted and diminished surface. He alternates here between visible brushstroke and single color areas, such as the red fence and slightly mottled green path. The yellow-orange cones, which might have been "shrubs packed in straw against the frost,"[5] bear very little sign of the dense bristle van Gogh always rendered to catch the dry fibrous quality of straw; Gauguin's cones are brushed in as fluid, flattened wrappers. The shawls of the women also carry little surface texture, washed in as smooth, attenuated covers that suppress visual engagement with the canvas weave. The cloaked women, moving toward the mysterious bush, are treated by Gauguin as an elusive "cloak for the idea" rather than as weight-bearing figures and material textures. The second woman in the procession indeed wears a shawl whose emphatic thinness is registered by an almost transparent brushwork that allows the matte canvas underneath it to show through. The canvas cloth was whitened and evened out by the application of Gauguin's special chalky ground, effecting a double layer of attenuation—neither the shawl as painted nor the canvas beneath it registers a tangible sign of its fabric material.

Gauguin did not assign an overtly allegorical meaning to his *Women in the Garden*, nor did it bear the agonistic forms of his denunciations of the flesh attempted in the *Vendanges*. This painting reengaged Gauguin's "abstraction" in fundamental dialogue with his classicism, which already set him apart

from van Gogh's basic artistic grammar and assumptions. As noted in Chapter 7, Gauguin had realized as soon as he arrived in Arles that van Gogh saw Arles through the lenses of Holland; Gauguin also contrasted his friend's seeing "Daumier-type work to do" with his own vision of "colored Puvis mixed with Japan."[6] For Gauguin, Puvis de Chavannes, the Parisian mural painter who presented friezelike figural arrangements in chalky colors, offered a special model of a modern fresco art, and he placed Puvis with the members of a gallery of his revered masters of classicism, Ingres, Raphael, and Degas.[7] Although he too valued Puvis, van Gogh's primary allegiances in Arles affirmed the earlier generation of mid-century French realists—Millet, Daubigny, Daumier—and the crusted, bright, bulky paint handling of Monticelli, which differed greatly from Puvis's pallid layers that blended with the wall.[8]

Gauguin's *Women in the Garden* adapted his symbolist ambitions to the traditional and modernizing strains of classicism he associated with a contemporary muralist like Puvis. These artistic models interacted with Gauguin's avid response to the classical heritage of Roman Arles. The visible layers of that heritage in Arles were of little interest to van Gogh but stimulated Gauguin. Recall, for example, that to his Alyscamps painting of the Saint-Honorat Chapel and the Arlésiennes he attached the title *The Three Graces at the Temple of Venus*, despite the architecture's early medieval origins and sacred role in the Christianized burial ground.

In *Women in the Garden*, Gauguin deepens the blend of classicism and modern synthesis. In the letter in which he noted that Arles provoked in him the call to a "colored Puvis mixed with Japan," Gauguin went on to characterize the Arlesian women as living models of classical shape and form: "The women here with their elegant headdresses, their Grecian beauty, and their shawls with pleats like you see in the early masters, remind one of the processions on Greek urns. At any rate, here is one source for a beautiful *modern style*."[9] In *Women in the Garden* he joins that classical simplicity to symbolist mystery and allusiveness: the procession of women is silent, lugubrious, and moves along a corridor of unreal floating space, sustaining the indeterminacy and suggestion he saw as the core of his art.

In linking Puvis, classicism, and his underscored "modern style," Gauguin may have been attempting once again to vanquish his archrival, Georges Seurat, whom van Gogh continued to emulate and whom Gauguin despised partly out of uncontainable jealousy. The highest praise for Seurat's master canvas of 1886, *A Sunday Afternoon on the Island of the Grande Jatte* (Fig. 104), was lavished by the critic Félix Fénéon, who heralded the painting as the breakthrough of a new style, combining clas-

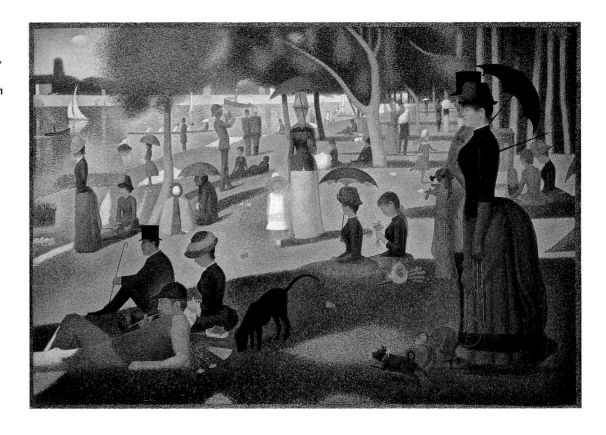

sicism and modern optical colorism in an unprecedented modern synthesis. Seurat's canvas also showed a procession of sorts, and Fénéon captured his celebration of the painting as a "modernizing Puvis," a frieze of contemporaneity, with modern figures at leisure, in contemporary dress, and incorporating a technical science of harmonic stasis. Gauguin infused his *Women in the Garden* with his own ambition to offer a "modernizing Puvis," and he may have considered his painting an alternative *Grande Jatte*. Gauguin's canvas evokes classical equilibrium disturbed by his symbolist aims of ambiguity and unfixed mystery.

VAN GOGH'S MEMORY PICTURE

While Gauguin appreciated the women of Arles for their "Grecian beauty," van Gogh, by contrast, wrote that as he learned "to see the beauty of the women here," he had to "think again and again of Monticelli," the Marseille painter of dense, vibrant color. He *must* think of Monticelli, van Gogh noted, "because color plays such a tremendous part" in their beauty: "I do not say that their shape is not beautiful, but that is not their special charm. That lies in the grand lines of the costume, vivid in color and admirably worn, in the *tone* of the flesh rather than the shape."[10] Gauguin's *Women in the Garden* presented the female figures as subdued shapes of black and white, with a bit of blue. When van Gogh looked out in Arles, he noticed not the black and white elements of the regional costume and *cambrasino*, but a riot of color and fabric. He channeled these nonclassical dimensions of what he defined as the special beauty of the women of Arles into his imagined landscape bursting with textiles and textured color, entitled *Memory of the Garden at Etten* (Fig. 105). His mother and one of his sisters appear in the scene, recalled from memory and set as strollers in the park opposite his Yellow House.

"Gauguin gives me the courage to work from [my] imagination, and certainly things from the imagination take on a more mysterious character," van Gogh wrote to Theo as he described his work on this painting.[11] He claimed that the *Garden* picture was a "memory of our garden at Etten, with cabbages, cypresses, dahlias, and figures."[12] Yet the painting is more of a composite image than a scene from Etten, extending beyond the limits of a specifiable site and a single, definable memory. Other writers have noted that the garden evokes three motifs together—two remembered from van Gogh's Dutch homes at Nuenen and Etten, with a third site, the gardens of Arles, overlaid on the earlier two.[13]

In addition to its conflation of disparate motifs, van Gogh's canvas reveals unusual technical qualities and suggests his incorporation of some of Gauguin's distinctive spatial and compositional tactics. Departing from his habitual tendency to invite the viewer into deep space, van Gogh lines the front edges of the canvas with a profusion of flowers and plants, as well as the torsos of the two women walking. These form a barrier pressing right up against the picture plane, not unlike Gauguin's border of Breton women in *The Vision* or the bush and fence in his *Women in the Garden*. More explicitly Gauguinesque is van Gogh's compression of the picture plane and rejection of his usual perspectival logic.

FIG. 105. VINCENT VAN GOGH, *MEMORY OF THE GARDEN AT ETTEN*, 1888, oil on canvas, 73.5 x 92.5 cm. The Hermitage, St. Petersburg

Here all traces of "framed looking," of recessionals and linear corridors, are absent; van Gogh renders instead a meandering path that tilts up and is cut off abruptly at the upper zone. Cypress trees bunch up unexpectedly behind the two women walking. Another cypress in the upper left area is flipped to the side and seems to spin, unanchored in any visible ground. Van Gogh's active, visible brushwork, which characteristically operates as a directional force pulsing to deep space, is here reversed. The vigorous patterning of touch moves forward, accelerating out toward the viewer rather than drawing us in and back. Van Gogh claimed in a letter that all of these techniques gave the painting the quality of a dream, with a sense of a jumble and discordance out of contact with reality. "The bizarre lines, purposely selected and multiplied, meandering all through the picture, may fail to give the garden a vulgar resemblance," he explained, "but may present it to our minds as seen in a dream, depicting its character, and at the same time stranger than it is in reality."[14]

Seeing "as in a dream" was Gauguin's imperative, and was at the center of his 1888 declaration defining art as an abstraction. Van Gogh's *Memory of the Garden* may have been the only time he explicitly rendered what he described as a dream image. Yet, even in this most Gauguin-like example from van Gogh's oeuvre, powerful dissonances emerge, setting van Gogh's inclinations and visual forms in another realm from the kind of "cerebral" process and practices that Gauguin espoused as the route to the ideal. Van Gogh's particular venture into the realm of mystery and "pure imagination" materialized three features that diverged from the dynamics and purpose of Gauguin's *Women in the Garden*: the fastening on memories of real things and real people, who could be rearticulated by internal scrutiny when no external models were presented; the weight and density of paint as fabric and costume; and the tenacious insistence on complementary color theory, aimed at giving the painting a shared communicative purpose beyond the twists and turns of subjective imagination. This purpose, at the heart of van Gogh's Arles experiments with evocative form, identified "comfort" as the creative effect of the *Memory*'s expressive color, moving out from the individual image to a more direct and universal mode of discourse.

COLORS AND FABRICS

Van Gogh provided his most extensive discussion of the painting and its purpose in a letter to his sister Wil, whom he identified as one of the figures. He wrote that he imagined her as the younger woman, while the older figure he likened to their mother. In each case, van Gogh noted, the figures and their likenesses were conveyed not so much by an exact physiognomy but by the colors he chose to suggest their personalities. He went on to particularize the garments of the two women and the color contrasts embodying them:

> The younger of the two ladies who are out for a walk is wearing a Scottish shawl with green and orange checks, and a red parasol. The old lady has a violet shawl, nearly black. But a bunch of dahlias, some of them citron yellow, the others pink and white mixed, are like an explosion of color on the somber figure . . . Let us suppose that the two ladies out for a walk are you and mother; let us even suppose that there is not the least, absolutely not the least vulgar and fatuous resemblance—yet the deliberate choice of the color, the somber violet with the blotch of violent citron yellow of the dahlias, suggests mother's personality to me.
>
> The figure in the Scotch plaid with orange and green checks stands out against the somber green of the cypress, which contrast is further accentuated by the red parasol—this figure gives me an impression of you like those in Dickens novels, a vaguely representative figure.[15]

Yellow and violet; green and red; blue and orange—van Gogh arrays combinations of complementary contrasts in his dream garden and envelops his family members in them. He renders the faces of his mother and sister in dense, thick layers, which show cracks from the weight of the laid-in pigment. The two women's shawls, made dynamic by dots and checks, intersect in a vibrant color field, with the mother's individual unit of violet offset by citron yellow expanded by the interaction of her dark blue mantle against Wil's dominant texture of bright orange plaid.

Van Gogh's presentation of his mother and sister in brightly colored cloaks culminated, in a new form, a special kind of conversation he had been having with Wil about the nature of color theory and

its relation to the applied arts and fabrics. After he arrived in Arles, it was to Wil in particular that van Gogh attempted to clarify his newfound enthusiasm for the laws of complementary contrast, which he reminded her he had first absorbed in Nuenen but understood anew in the bright light of Provence.[16] It was to Wil in late June that he wrote about the essential pairs of colors discovered by Chevreul, colors that in juxtaposition "cause each other to shine brilliantly," like the coupling of man and woman.[17] In the same letter van Gogh went on to connect this theory of color to the applied arts, which had been espoused by Chevreul when he first developed it in the context of the Gobelins Tapestry Works. "Colorings, wallpaper, and whatnot can be made much prettier by paying attention to the laws of color," wrote van Gogh to Wil, echoing the chapters of Chevreul's book in which the chemist-administrator explored the application of his theory to wallpaper, clothing design, and fabricized wall coverings.[18]

It was to Wil again that van Gogh turned when he expanded on his statement to Theo that he considered the beauty of the women of Arles to reside in their choice of color and costume. He delighted in specifying to Wil how enthralled he was by the women's "gaily multicolored clothes," the women and girls "with green, red, pink, Havana-yellow, violet or blue stripes, or dots of the same colors. White scarves; red, green and yellow parasols."[19]

Van Gogh continued in his Arles letters to reserve for Wil detailed discussions of colors, hues, and tints, connecting them to the media of their application. In one letter, written in September, he noted the way colored light cast "pinkish violet" tones through an "enormous yellow lantern," corresponding to the laws of complementary contrasts, and he compared the painter's task of arranging "resplendent" color to the métier of the jeweler as he deftly composed his "precious stones." This linkage amplified Chevreul's proposition that the laws of color theory be implemented in many of the applied arts, and van Gogh went on to mention to Wil the linkage of the laws of color contrast in painting and clothing design: "Arranging the colors in a picture in order to make them vibrate and enhance their value by their contrasts is something like arranging jewels properly or—designing costumes."[20]

When van Gogh formalized his *Garden* dream picture by presenting his sister Wil in a Scottish shawl, he provided a visual analogue to the ongoing written bulletins he shared with her about color theory, luminous contrasts, and their application to multiple material surfaces, especially fabrics. Further, his identification of Wil in her "Scotch plaid" with orange and green checks, modulated with red and green, as a figure "like those in Dickens novels" offered a final, if unwitting, allusion to the associ-

ation of art, color, and weaving. In 1885, after multiple depictions of the Nuenen hand-loom weavers at work, van Gogh had explicitly linked his own artistic practice to the process of weaving, explaining in a letter to Theo that the composition came together as he wrestled with the right pattern and color effects:

> But for the weaver, or rather the designer of the pattern or the combination of colors, it is not always easy to determine his estimation of the number of threads and their direction, no more than it is easy to blend the strokes of the brush into a harmonious whole . . .
>
> All winter long I have had the threads of this tissue in my hands, and have searched for the ultimate pattern; and though it has become a tissue of rough, coarse aspect, nevertheless the threads have been chosen carefully and according to certain rules.[21]

One source of this statement, which van Gogh embellished and adapted, was Charles Dickens's preface to *Little Dorrit*, where he compared the art of his writing to the craft of weaving and interlocking patterning. Van Gogh melded Dickens's analogy of the artist's integrative craft to Chevreul's weaving chemistry and the theory of color as expressive powers of interdependent pairs.

WEAVING TACTICS

Memory of the Garden at Etten amplified van Gogh's symbolist conception of evocative form while it also demonstrated the powerful obstacles to the cult of incorporeal mystery promoted by his confrère Gauguin. Indeed, in this canvas, one of van Gogh's most "abstract" compositions, he reaffirmed and extended the core principles of his weaving painting. Despite the picture's attempt to enlist the Gauguinesque tactics of obstructed horizon and obliterated recessionals, van Gogh's dense, tangible, and textrous paint application and his enduring fascination with the fibrous quality of the canvas medium exposed the distance between his *Memory of the Garden at Etten* and Gauguin's *Women from Arles in the Public Garden*.

Gauguin, we have noted, invented numerous procedures to smooth down and matte his paint sur-

face, which enabled the thin colors to melt into the chalky medium. Van Gogh, by contrast, executed *Memory of the Garden at Etten* by building up a thick, patterned deposit of laced color strokes. While the shawls draped on the figures in Gauguin's female processional in the Arles garden look like thin veils, the shawls in van Gogh's *Memory* reconstitute the physicality of weaving pigment and support. In the *Memory* painting's rendering of the surface, van Gogh displays important elements of continuity with his embedded craft practices as well as new ways, through color theory, of linking the infinite with the tangible, a realm of meaning and significance beyond the material forms of his paint.

In part, the *Memory* painting drew van Gogh back to the depiction of woven subjects, a preoccupation since his earliest apprenticeship. Van Gogh packed the shawls of his *Memory* picture with implicit reminiscences of shawls he had rendered in his Hague drawings, such as the 1882–1883 pencil and lithographic chalk drawing *Girl with a Shawl* (Fig. 106) and the 1882 pencil, ink, and watercolor *Old Woman with Walking Stick and Shawl* (F913). There, in the medium of black and white, van Gogh had sought visual techniques to maximize the coarseness and texture of his own paper surfaces, which he hoped would look as grainy, nubby, and abrasive as the objects he was representing.[22] In *Girl with a Shawl*, for example, the right side of the figure shows the woven shawl as visibly bumpy and creased in the paper surface, so that the raised grain of the paper matches the woven quality of the material presented. This technique is used again in other drawings where the figures' clothes are marked by similar scraping and creasing, visibly emphasizing the link between the wove paper and the cloth depicted.[23]

Van Gogh's emphasis on the colored checks and his inclusion of Wil in a "Scottish shawl" also recall the explicit lessons of the Dutch hand-loom weavers; his "Scotch plaid" of checkered colors evokes cloth he had observed being woven in Nuenen. The *Memory* picture reengages van Gogh's abiding linkage, activated by the study of weavers' work, of paint as thread and color as fibers, to be placed on the canvas so as to intersect one another. *Memory of the Garden at Etten* also reclaims the technique that accompanied van Gogh's persistent presentation of woven objects: the articulation of texturally heightened paint surfaces as pictorial equivalents to the woven clothes represented. The entire surface of the *Memory* canvas sustains a thick, raised, and grainy deposit, replicating the woven qualities of the shawls depicted in the image and reemphasizing in its coarse facture the woven canvas surface on which it was applied.

Yet the *Memory* painting also adapts van Gogh's early weaving tactics to new impulses he

FIG. 106. VINCENT VAN GOGH, *GIRL WITH A SHAWL*, 1882–1883, pencil, pen and ink, black crayon on watercolor paper, 50 x 31 cm. Van Gogh Museum, Amsterdam (Vincent van Gogh Foundation)

FIG. 107. THÉO VAN RHYSSELBERGHE, *PORTRAIT OF MARIA SÈTHE*, 1891, oil on canvas, 115.5 x 163.5 cm. Koninklijk Museum voor Schone Kunsten, Antwerp

absorbed in Paris and Arles, impulses that revitalized his commitment to Chevreul's color theories. Through the Neo-Impressionists van Gogh deepened his investment in the laws of complementary colors. In Arles these laws remained fundamental to him, so much so that Gauguin was unable to depose them. The *Memory* painting reveals the height of Gauguin's impact on van Gogh by its spatial "meandering" and explicit culling from a "dream," but it is also a dramatic testament to van Gogh's peculiar forms of Neo-Impressionism and the color theories on which they were based, which Gauguin vehemently rejected.

The vigorous patterning in the *Memory* painting's shawls and orange path can be seen as resembling Neo-Impressionist points that have been enlarged by van Gogh's habitual swathed brushwork. Seurat, Signac, and the Neos had systematized a rigorous and scientific form of Chevreul's laws, breaking down color elements to their smallest units and placing each unit next to its color complement. Van Gogh, adapting the technique according to his ideas about weaving, re-created the laws of color in the interlaced yarn balls he let loose on his Paris work table. When van Gogh painted alongside his new friend Paul Signac, he turned the techniques of divisionist painting into the structures of weaving painting. While Neo-Impressionist color theory did facilitate van Gogh's new, brighter palette, he was unable to articulate the microdots of the pointillist optical mixture. The figures and clothes painted by Signac and his circle, for example, offered luminous delicacy (Fig. 107); van Gogh's "Neo-Impressionist" canvases, on the other hand, bristled with a brushwork of sticks and fibrous blocks (Fig. 7). Van Gogh gestures in his *Memory* painting toward the Neo-Impressionists' pointil-

lism but he fails to reproduce their shimmer. If the Neos' art has been compared to the elegant *petit point* of tapestry,[24] van Gogh's is closer to the coarse, abraded textures of the peasant woven plaids or colored kitchen towels, where physical tangibility on the canvas surface signals the link to a craft use-object.

PAINTINGS AS MUSIC

The meaning and significance of the *Memory* painting, and its divergence from Gauguin in even this most Gauguin-like of van Gogh's pictures, is not limited to its dense, coarse facture or to its character as a craft variant of Chevreul's color laws. For van Gogh related *Memory of the Garden at Etten* to his ongoing Arles project of sacred realism, the search for a "symbolic language that speaks through color alone."[25] In writing to Wil about the painting, van Gogh highlighted a nonrepresentational force to the image, a force that emanated from the choice of its color arrangements, interdependent with the subject represented: "One can make a poem only by arranging colors, in the same way that one can say something comforting [*des choses consolantes*] in music."[26] This idea echoed van Gogh's statements to Theo two months earlier, when he wrote that paintings should contain "that something of the eternal which the halo used to symbolize," which would "say something comforting, as music is comforting," and would convey that comfort by the "radiance and vibration of our coloring."[27]

Now van Gogh shared with Gauguin, and with Seurat, the ambition to discover formal elements of painting as expressive catalysts; they all sought to move the image away from figurative motifs and identifiable subjects as the sole carriers of meaning. In this common quest for pictorial equivalences to emotional states, both van Gogh and Gauguin assumed that color and form could have direct and evocative capacities, and they were both led, on this basis, to define an analogy between painting and music, the most nonrepresentational of the arts. But while they shared an aspiration to develop autonomous means of expression through formal elements of painting, the source and purpose of this new language differed sharply for van Gogh and Gauguin. These differences corresponded to the divergent "paths of symbolism" chosen by the two painters as they worked in Arles: Gauguin linked his interest in a

suggestive, "musical" painting to the search for transcendent release and expanded subjectivity, while van Gogh considered the music of his colors to be a means of imparting spiritual comfort and self-offering love.

Gauguin had explored ideas about the direct, expressive force of color and line in an 1885 letter to Schuffenecker; this same letter included his early charge to painters to work "freely and furiously," as if in a dream. The qualities Gauguin isolated here captured many of his departures from naturalism: he celebrated the "mystery" and "dreaming" of painters he admired, calling them "mystics" through form.[28] In a later text of "Notes on Painting," Gauguin made explicit the links between music and a type of painting that elevated nuance and suggestion over literal description; here the painter emerged as a composer, through his colors, of "harmonious tones corresponding to the harmonies of sounds."[29]

For Gauguin, the appeal of music was its flowing nonspecificity, its capacity to transport the listener to an alternative world. Here the mystery of the "supernatural" and the cult of inner vision could be released, governed by the infinite subtleties of individual "sensation."[30] For the painter of *Women in the Garden*, the *misérable* self-portrait, and *Misères humaines*, the music of pictorial elements was a paradigm for the indeterminacy and exalted expansiveness of the artist's subjectivity, which could never be fixed, predictable, or reduced to a single or literal meaning. The allusive, the enigmatic, and the abstract were the qualities cultivated so as to communicate the incommunicable singularity of the artist's imagination. By regarding pictorial forms as expressive forces like music, Gauguin maintained a posture of the artist's superiority, while offering to those initiates who were capable a means of approximating, but never matching, the depth and breadth of the artist's persona. The greatest praise that Gauguin reserved for his works of evolving anti-naturalism centered on their emphatic indecipherability. The creative effect that he celebrated in his 1888 *Self-Portrait*, for example, continued as a standard of measure—the unusual lines, colors, and patterns rendered the canvas "incomprehensible" because it was "so abstract."[31]

Van Gogh linked visual forms and comprehensibility in an inverse direction. His comparison of painting to music, centered in color theory, expressed a promise and possibility for a universal language that would extend communication and connection at a new level. In the *Memory* canvas he appealed to a music of colors in order to transmit comfort, to "say consoling things." For van Gogh, the evocative forms of pictorial elements maximized the possibilities for inclusiveness; they unleashed a binding

power to a totality beyond the individual. The expressive intensity of color arrangements pervading this, his dream painting, implied social and collective obligation and responsiveness, aimed not to advance the hermetic indecipherability of the artist's ego but to convey the simplest of messages in combining color pairs, woven texture, and sorrowful family faces: "Be comforted and consoled."

Considering solace a primary feature of the music of color had a distinctive, culturally specific resonance and exemplified van Gogh's deep and ongoing adaptation of the Dutch modernist theology of art. Other French painters admired by van Gogh who affirmed the collective potential of a new language of symbolist art did not highlight the terms of comfort and consolation; rather, they looked to harmony and order as their incorporative artistic ideal. Van Gogh's Neo-Impressionist comrades shared with him, and not with Gauguin, an assumption of a social and collective agency to the evocative forms of painting, the expectation that color, line, and direction could summon generalizable, and universal, emotions. But the sources and purpose of this language were distinct from van Gogh's, pointing to the particular cultural world of French technical rationalism rather than to Dutch theological aesthetics.

Seurat and his cohort, relying on the psycho-physical experiments of the scientist Charles Henry, believed they had discovered laws of beauty and their exact emotional valence. These experiments generated the painters' conviction that they could apply, through a science of color pairs and rhythmic, linear directions, a set of absolute correlations between visual form and emotional states of pleasure or pain. This new expressive system made it possible to propose that painting could concentrate the greatest possible harmony in the aesthetic domain and provoke corresponding states in the viewers, thereby possibly extending a transformative, maximal harmony to the social order. In becoming affiliated with the radical movement of anarcho-communism, the Neo-Impressionist painters discovered a political analogue to their quest for total harmony in the canvas, endorsing a variant of revolutionary transformation celebrating the integrity of individual units in a composite whole. Charles Henry himself extended his experiments from painting to the industrial arts, developing a tool, the "aesthetic protractor," which he proposed could be used to educate craft workers and to create the most harmonious lines, colors, and angles. Paul Signac wrote excitedly to van Gogh about Henry's new applications to craft arts in April 1889, conveying to him an enthusiasm for mobilizing the new science of harmony for social reform.[32]

But, in 1888 and after, van Gogh's search for a universalizing expressive color did not resonate

with the Neo-Impressionists' quantifiable science of pleasure and pain, nor did he join his theory of painting to an ideal revolutionary future that could be anticipated or elicited by it. Unlike his friends' radical anarchism, Van Gogh's own communitarian impulses assigned comfort and consolation in the present as the binding power of artistic form, propelled not by the resignation of the believer but by the yearning for spiritual presence craved by the agnostic.

Such a yearning, and the fear of agnosticism, had led Dutch modern theologians two decades earlier to place special emphasis on the arts as the new vehicles of consolational power amidst contested models of divinity. For Reverend Allard Pierson, as we have seen, only the formal elements of painting, poetry, and music were adequate as a means to convey the ineffable and "supersensible" divine presence; the indefinite, expressive power of music, color, and rhyme could approximate the shared emotional communion once assured by unquestioning religious devotion. In seeking a new model of divinity between immanent nature and the remoteness of the heavens, Pierson had also redefined Christ as an artist, whose curative, consolational powers coursed through the forms of his language. Christ, according to Pierson, spoke evocatively, movingly, and touched people directly in the parable, a union of humble truths and "magic" poetry.

Van Gogh's theory of symbolic color, and his particular drive to "say consoling things" through the unmediated power of evocative forms, realized the ambitions of the Dutch theology of art in the new world of Arles and in the company of Gauguin. Absorbing the comfort of Christ into formal elements, as Pierson had aspired to do, van Gogh redirected that consolational power outward, in hope of unleashing contact, connection, and spiritual unity. Gauguin's presence *was* manifest in van Gogh's dream picture, *Memory of the Garden at Etten,* but his Dutch family figures also returned, woven with the textures of a particular theological culture poised in the balance between realism and abstraction.

Theologies of Art After Arles

CHAPTER TEN Gauguin's *Misères*

Dream, those who are willing and able.
PAUL GAUGUIN[1]

We *must* work as much and with as few pretensions as a peasant if
we want to last.
VINCENT VAN GOGH[2]

The weeks of early December 1888 provoked heightened tension between the two painters. Gauguin's letters and memoirs indicate a growing recognition of his fundamental disagreements with van Gogh on artistic methods and mentors and allude to exhaustingly intense debates and arguments. Gauguin described to Bernard how van Gogh would mingle praise for his work with declarations "that this is wrong and that is wrong"; Gauguin would feign agreement "just to have some peace and quiet."[3] Even in their steady pace of work, Gauguin noted, there was a sense of incipient eruption: "between the two of us, one a volcano, the other, seething, too, but within, a struggle was brewing."[4]

There is some evidence that Gauguin was eager to leave Arles but felt trapped by the favorable financial arrangement with Theo as well as by the auspicious market and clients that Theo seemed to be gathering for his works. At the same time, Gauguin's writings suggest some sincere depth of feeling for van Gogh, who had won Gauguin over with his "heartfelt protestations of friendship," selflessness, and "deep tenderness, or, rather, the altruism of the Gospel."[5] By the end of the second week of December, however, an exasperated Gauguin wrote to his friend Schuffenecker to expect him in Paris and informed Theo of his plan:

> *Everything considered, I am obliged to return to Paris. Vincent and I simply cannot live together without trouble, due to the incompatibility of our temperaments, and we both need tranquility for our work. He is a man of remarkable intelligence whom I esteem very highly and whom I leave with regret, but I must repeat, it is necessary that I leave.*[6]

A week or so later, however, Gauguin had changed his mind, and his ambivalence that jostled concerns for self-interest with consideration for his friend's needs emerged clearly as he explained the situation to Schuffenecker:

> *You are waiting for me with open arms. I thank you but unfortunately I am not coming yet. I am in a very awkward position here; I owe a great deal to [Theo] van Gogh and Vincent, and although there is a certain amount of discord, I can't hold a grudge against an excellent heart that is ill, that is suffering, and that needs me . . . At any rate I am staying here, but my departure is always latent.*[7]

Van Gogh, for his part, was alternately volatile, dismayed, encouraged, and deflated by Gauguin's presence in December. He registered in his letters to Theo the growing vehemence of the arguments between him and Gauguin, noting that their discussions of paintings after a visit to the Montpellier Bruyas collection were "terribly *electric*," leaving "our heads as exhausted as a used electric battery."[8] He recognized that his contentiousness was having a draining effect on Gauguin, and he sensed the possibility of Gauguin's departure, writing to Theo that "Gauguin was a little out of sorts with the good town of Arles, the little yellow house where we work, and with me."[9]

Van Gogh also grew progressively more dispirited with Gauguin's memory project. Some time later he would describe to Bernard his efforts to follow the "charming path" of "abstraction" as reaching an impasse, "a stone wall."[10] After a few more unsuccessful experiments, van Gogh recognized his fundamental discomfort with Gauguin's directive to move from model to dream, and he rebalanced his production toward his favored repertoire of embedded subjects, which he had continued to create alongside the memory canvases. By early December van Gogh had accrued a new series of portraits, laboring figures, and still lifes. One set of portraits, two canvas versions of the Arlésienne Madame Ginoux, was directly provoked by Gauguin, who had made a drawing and a portrait of her in the local Café de la Gare. Gauguin considered his model part of the "vulgar local color" and seated her in his painting in front of "three whores" and other locals he derided.[11] Van Gogh invested the same model with dignity, painting her with the accessories of thought and propriety: books in one version, umbrella and gloves in another.[12]

One of the van Gogh portraits of Madame Ginoux (Fig. 108), as well as a new *Sower* (Fig. 109), was produced on the very heavy, coarse canvas that van Gogh had used in the earlier horizontal *Alyscamps* pair. Unlike the *Alyscamps* experiment, these images received vigorous handling and visibly woven brushstrokes that complemented the looser weave of the exposed support. The bodice of the Arlésienne, for example, is nubby and uses the canvas texture as part of the figural brushwork, while the yellow background above Madame's right side displays the warp-and-weft interlock of yellow pigment. In the new *Sower*, the figure courses through the rough canvas field throwing seeds that look like threads running lengthwise in a carpet. The glossy sediment of the figure's black color glistens with the saturated density of oily tar, defying the parched and matte treatment that had attracted Gauguin to this type of canvas with its peculiarly absorptive qualities.

Van Gogh's new *Sower* is often attributed to the influence of Gauguin and *The Vision*, because of the diagonal tree that slices through the center. But Gauguin employed this device to divide the zones of the "natural and the non-natural"; his tree floated between the immobile peasant women on the one side and the wrestler and angel on the other. Van Gogh's tree is bending toward the moving sower alongside it, and both are set in a legible field of interlocking checkerboard planes of planting. The categories of natural and non-natural are vital for van Gogh, but they are embodied and transmitted in his distinctive idiom—not through an evocation of transport from earth to vision, as in Gauguin's image, but in his habitual placement of the giant disk of the sun directly over the head of the laboring figure, the aureole of Christ's luminosity transferred to human

FIG. 108. VINCENT VAN GOGH, *L'ARLÉSIENNE (MADAME GINOUX)*, 1888, oil on canvas, 93 x 74 cm. Musée d'Orsay, Paris. Photograph © RMN Gérard Blot

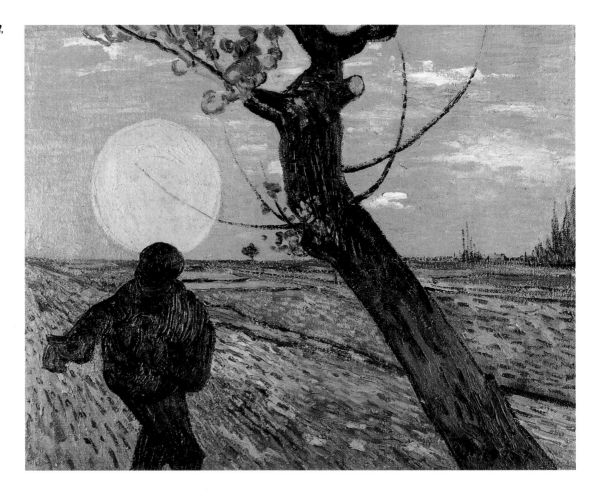

activity and production. Van Gogh's Japonist tree also sprouts crossing branches, one of which slices diagonally through the sun's center.

Van Gogh was heartened by Gauguin's praise for some of the sunflower pictures he had painted for the Yellow House, and his December letters to Theo displayed his customary resoluteness in the face of difficulty—he wrote to Theo of his determination for "perseverance" and his plan to "plod on quietly," patiently accumulating his work.[13] Yet his desire for calm and regular pacing was undermined by more news that intensified his sense of inadequacy: by mid-December Theo reported an enthusiastic

response to the new roll of Arles canvases sent by Gauguin and the sale of another of his Brittany pictures to a M. Clapisson; additionally, Gauguin received invitations to exhibit his work in Paris and at Les Vingt in Brussels.[14] Van Gogh, who had his own hopes for Les Vingt and a Paris showing, was pleased for his friend but agitated by the continued evidence of commercial response to Gauguin.

Rain fell incessantly in Arles the week before Christmas, which forced van Gogh and Gauguin to remain indoors and undoubtedly led to increased friction between them.[15] Van Gogh was prevented from painting landscapes at the moment that he was abandoning his enthusiasm for Gauguin's "cerebral" painting; Gauguin was forced to listen to an unbroken sounding of van Gogh's ideas and critiques. Many factors thus converged the week of December 19 to create a number of eruptions. One evening at the café, as Gauguin recounts in his memoirs, van Gogh threw his glass at Gauguin. Then, on December 23, after another argument, van Gogh followed Gauguin to the Place Victor Hugo and brandished a razor. Gauguin decided to spend the night at a hotel. When he returned to the Yellow House the next morning, he was informed that van Gogh had cut off part of his left ear and delivered it to one of the women in the local bordello. Van Gogh's friend Joseph Roulin had taken him home, and soon afterward van Gogh was sent to the hospital. Gauguin telegrammed the news to Theo, who spent Christmas in Arles caring for his brother and then returned with Gauguin to Paris. Theo left his brother assured that the Roulin family and the local Protestant pastor, Reverend Salles, would monitor his condition. Though the situation initially appeared critical, after two weeks' time van Gogh was much improved and able to write and paint again, though he was now distrusted and considered a nuisance by some of the neighbors.[16]

While the notorious ear episode marked the end of van Gogh and Gauguin's time together in Arles, it did not signal the end of their friendship, which, though not without strain, endured through their exchange of letters until the time of van Gogh's death. As he convalesced in Arles that January, van Gogh's clear-eyed assessment of his comrade as a *calculateur* of his own self-interest resurfaced. Upset over the increased expenses for their last month, van Gogh wryly commended Theo for paying Gauguin off and "settling his bill," for otherwise the former stock agent might marshal his old speculator tactics and exploit the two brothers financially. Van Gogh went on to criticize Gauguin's illusions, disloyalty, and lack of responsibility, noting that he was "carried away by his imagination" and "practically irresponsible."[17] But his letters to Theo about Gauguin are not marked by rancor or bitterness, only by

a sense of regret mingled with a perceptive, and occasionally droll, realism about Gauguin's limitations as a friend and collaborator, given his self-aggrandizing tendencies. This came across when van Gogh characterized Gauguin as the "Bonaparte tiger of impressionism," whose "vanishing, say, from Arles would be comparable or analogous to the return from Egypt of the aforesaid Little Corporal, who also presented himself in Paris afterward and who always left the armies in the lurch."[18]

As van Gogh and Gauguin's friendship evolved in the aftermath of their time together in Arles, so did their search for a modern sacred art. The recognition of their differences that had begun to emerge in Arles became more obvious to both as they broadened their experiments with painting as a mediator of divinity in the period immediately following their separation, stimulated by their association and resonant with the different forms of their particular Protestant and Catholic legacies of the visual. This chapter explores a cluster of works by Gauguin in 1889 that, taken together, have theological coherence and mobilize the lamentational impulse of his Arles work to a sustained expression of human suffering and personal martyrdom. The increasingly conspicuous inclusion of religious content in the art of Gauguin and Bernard in 1889 provoked van Gogh to a vigorous reaction against this direction and to a clarification of his own very different position, the subject of Chapter 11.

After the debacle with van Gogh, Gauguin spent the year alternating between Paris and rural Brittany. A cluster among the important works of 1889 depicts elements of Breton Catholic popular devotion; presents the personal Passion of the artist as a martyred Christ; and perseverates on the *misères humaines* as a dialectic of carnality and perdition. As Gauguin amplified these themes of visionary release and dolorous reckoning that had shaped his symbolist project of 1888, he also continued to develop visual techniques appropriate to express them. Style, meaning, and function in 1889 indicate Gauguin's abiding adaptation of the anti-naturalism of his Catholic formation into a new visual language of modern allegory, transcendence, and affliction.

MISÈRES HUMAINES AND THE CROUCHING FEMALE IN 1889

Gauguin's preoccupation in early 1889 with the themes of misery and corrupted flesh is traceable in his startling production of numerous variants of the Arles *Misères humaines*, which he had considered—

along with *The Vision After the Sermon*—his most important painting. Living in Paris and Brittany in the winter and spring of 1889, Gauguin represented the crouching female figure in a number of different media and in deliberately allegorical form, all evoking the prototype and expressive gravity of the trepanned Peruvian mummy.

One of Gauguin's major ambitions for 1889 was to exhibit his work at the Paris World's Fair, which would run from that May to November. He prepared a number of new pictures for the occasion, including three new versions of the seated female type of the grape harvest, to be displayed with the Arles *Misères humaines*.[19] This quartet propelled the representation of human misery as a seated, afflicted female to the center of public attention as a cornerstone of Gauguin's artistic project.

The first of the three new *misères* was a watercolor and pastel entitled *Breton Eve* (Fig. 110). Gauguin signed and dated the image, attaching an inscription to it in creolized French: "Eve: Pas écouter li . . . li . . . menteur"—"Eve: Don't listen to the . . . the . . . liar." Here a seated, hunched-up female figure, head in hands, is set in a vague shelf of space against a tree, which envelops her head without visible mediation; a menacing snake hovers behind. The colors are applied in fluid blocks, outlined in black, like adjoining pieces of a puzzle. The palette chosen departs from the natural, edging the fantastic. The ground is bright blue-green, along with an enigmatic wrap of blue with speckled red around the right side of the tree; Eve has blue hair or head cover, and the ground is not the hue of terra firma but also an intense, glassy aqua. The black tree contrasts sharply with the emphatically chalky white of the figure, with pastel laid in to incise her legs and frame with strip marks suggesting skin peeling.

Gauguin positioned this Eve in the stance of the grape harvester of the Arles *Misères* painting but with important differences that intensify the allegorical character of the image. In the new version, Gauguin presented a crouching *nude* figure, stripped of the vestiges of a harvest setting, clothing, or natural location. He included the central figures in the biblical drama of paradise lost, identifying Eve and the snake in the tree behind. Naming her Eve signaled, as others have noted, Gauguin's symbolic ambition and an evocation of the fall, the certainty of death, and resignation to sin.[20] The open mouth of this figure also claimed her closer resemblance to the features of the gruesome Peruvian mummy and its gaping scream. Finally, Gauguin enhanced the new *misères* by his formal techniques: spatial compression and ambiguity; the use of abstract, coiling shapes and arbitrary colors; and the representation of the woman's skin as pulverized powder, carrying her desolation through to the surface of her frame.

FIG. 110. PAUL GAUGUIN, *BRETON EVE*, 1889, watercolor and pastel on paper, 31 x 33 cm. Collection of the McNay Art Museum, San Antonio, bequest of Marion Koogler McNay

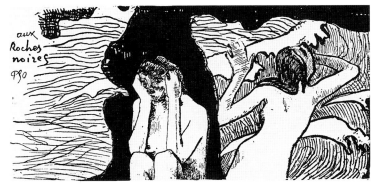

LEFT **FIG. 111. PAUL GAUGUIN,** *MISÈRES HUMAINES (HUMAN MISERY),* 1889, zincograph on canary-yellow paper, 28 x 22.5 cm. Private collection

RIGHT **FIG. 112. PAUL GAUGUIN,** *AT THE BLACK ROCKS,* **FRONTISPIECE OF THE CATALOGUE OF THE VOLPINI EXHIBITION,** 1889. Private collection

Gauguin's second *misères* for the 1889 fair more closely paralleled the Arles canvas. This was a lithograph—or, more accurately, a zincograph, laid in on zinc rather than stone—that was printed on bright yellow paper and included in an album of ten prints. Entitled *Misères humaines (Human Misery)*, the print (Fig. 111) features the seated, disheveled figure of the canvas. In this variant, a man stands to the side of the brooding woman while a partially hidden female figure in the background observes the couple with an expression of wide-eyed dismay. Some writers have suggested that Gauguin made the implied sexual conflict of the Arles *Misères* more explicit here by including a man next to the rumpled woman and by depicting a surreptitious observer in the distance, who appears shocked by what she sees.[21]

The third of the recurring *misères* appeared on the cover of the catalogue for the independent exhibition that ultimately came together as the forum for presenting the works of Gauguin and his friends to the public at the 1889 Paris World's Fair. Denied space in the official art halls, Gauguin, Bernard, Laval, and Schuffenecker, among others, created their own makeshift galleries along the walls of the Café des Arts run by a Mr. Volpini, whom the painters persuaded to sponsor them. The catalogue for the exhibition, entitled "Groupe Impressioniste et Synthétiste," included a frontispiece illustrated by Gauguin with a paired set of nudes: a female *misère* front and center in the seated, crouching position of woeful rumination; and a second nude, with her back to the viewer, turned toward waves of the sea (Fig. 112). The way the figure is pivoted to meet the waves recalls the stance and open arms of the half-nude *Woman in the Hay with Pigs* (Fig. 98) that Gauguin created in the same weeks as the Arles *Misères* painting. The

LEFT **FIG. 113. PAUL GAUGUIN,** *LA VIE ET LA MORT (LIFE AND DEATH),* **1889, oil on canvas, 92 x 73 cm. Mahmoud Khalil Museum, Giza. Photograph by Jacqueline Hyde**

RIGHT **FIG. 114. PAUL GAUGUIN,** *ONDINE (IN THE WAVES),* **1889, oil on canvas, 92 x 72 cm. The Cleveland Museum of Art, 1999, gift of Mr. and Mrs. William Powell Jones 1978.63**

pairing of plunging nude and brooding meditator in the 1889 print brought together these symbolic partners of 1888 and reengaged them in Gauguin's dualistic conceptual field of sensuality and suffering.

Reviews of the 1889 Volpini exhibition highlighted the "archaism and exoticism" of Gauguin's contributions and the brightly colored, and flattened, decorative style of the "synthetist" group as a whole.[22] Yet Gauguin's quartet of *misères*—the quartet of Eve, zincograph, catalogue cover, and grape harvest canvas—also signals his allegorical ambition in 1889 and its long-term theological foundations.

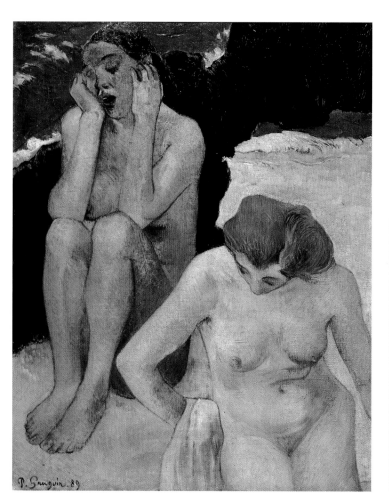

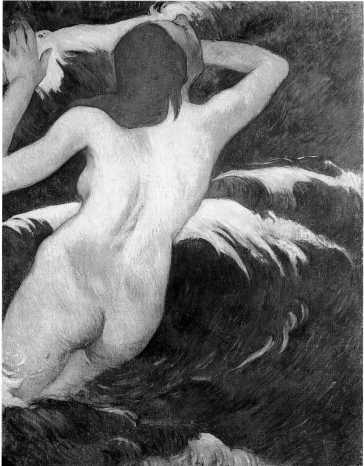

Further evidence of Gauguin's preoccupation with the *misères* figure surfaces in three other images produced during the same period in 1889. Two of these (Figs. 113 and 114) were large-scale vertical canvases of exactly matching size that appear to have been created as pendants, with corresponding themes.[23] One (Fig. 113) carried an explicitly allegorical title, *La Vie et la Mort* (*Life and Death*), represented by two seated nudes who dominate the picture space, set along what seems to be a rocky beach. One figure, presumably the Life type, is drying herself off, echoing the poses and actions of Degas's women bathers. But the Death partner is a signature Gauguin repetition—Eve again, as Eve is *la misère*, the "pauvre desolée" of the Arles *Vendanges*. Here she is a scumbled, whitened, corpselike body, sitting with legs up, elbows perched, and holding her head in her hands with open-mouthed dejection.

Gauguin painted this *Life and Death* canvas along with *Ondine* (Fig. 114), also called *In the Waves*, which was exhibited among the paintings at the Café des Arts. *Ondine* features a large, contorted nude with bright red hair caught in green waves. The female figure in this painting, along with the seated *misère* of the pendant *Life and Death*, provided the sources for Gauguin's catalogue frontispiece (Fig. 112), with the two figures transferred from canvases to a single print.

Gauguin's final *misère* of 1889 transposed the seated woman in the harvest painting to a cropped rendering of her face, head in hands, which he again entitled *Misères humaines* (Fig. 115). This time

FIG. 115. PAUL GAUGUIN, *MISÈRES HUMAINES (HUMAN MISERY)*, 1889, pen and ink, brush, and watercolor on tracing paper mounted on secondary support of recent manufacture, 20.5 x 38.5 cm. Foundation Dina Vierney-Musée Maillol, Paris

FIG. 116. WOODEN CHRIST, CHAPELLE DE TRÉMALO, FINISTÈRE, 17th century, 250 x 150 cm. Photograph Editions d'Art "Jack"

Gauguin employed pen and ink and watercolor on tracing paper; the image was mounted to a secondary support. Remnants of fields are suggested by shapes on the right, while the woman herself stares down, lost in her thoughts. This version closely resembles the zincograph print in the appearance of the woman, and was probably done about the same time, in January or February of 1889.[24]

CHRIST'S SUFFERING, BRITTANY, 1889

The repertoire of the *misères humaines*, with its evocation of the inseparable union of pleasure, guilt, and desolation, represented one element of Gauguin's artistic production after he left Arles. The five new images carried the themes of the grape harvest picture into varied media and deepened the allegorical impetus through Gauguin's choice of the nude. A second feature of Gauguin's work in the immediate aftermath of Arles centered on his reimmersion in Breton popular Catholicism as an imaginative resource for his painting. Of the many fascinating dimensions of this reengagement and transformation, those that have significance for Gauguin's relationship to van Gogh and to van Gogh's provocative resistance are of particular interest.

Gauguin produced a cluster of images of Christ's suffering and torment in the fall of 1889, inspired by particular artifacts of Breton folk piety. He had returned first to work in Pont-Aven, but rather than enjoying the camaraderie of the town's charming hostelries, as he had in 1888, he now scorned what he considered its touristic commercialism and its invasion by second-rate artists. Accompanied by his friend and fellow artist Meyer de Haan, Gau-

guin withdrew in October to the remote fishing village of Le Pouldu, some fifteen miles southeast on the rocky Breton coast. The painters took up residence in a small inn run by Marie-Jeanne Henry, where they paid one franc per day for room and meals.

Gauguin's letters describing Le Pouldu, inhabited by fewer than two hundred fishermen, farmers, and seaweed gatherers, emphasized its desolation and "lugubriousness."[25] These themes expressed Gauguin's own mood and condition, and the Breton archaism he now chose to render was changed significantly from his repertoire of 1888. The festive Pont-Aven folk culture of the *Breton Girls Dancing*, the depiction of young boys wrestling, and the enthralling spectacle of peasant women's visionary piety now turned to a new type of rural experience. In the fall of 1889 Gauguin focused his painting on imagining the anguish, grief, and loss evoked by the presence of Christ's body on the cross.

In part, Gauguin's choice of mournful subjects corresponded to his own feelings of despair and discouragement. Anticipating public acclaim, Gauguin was taken aback by unfavorable press comments and was still haunted by Seurat, whom critics continued to invoke favorably in comparison to him. More wounding was the utter lack of sales: not a single one of Gauguin's seventeen contributions found a buyer at the 1889 exhibition. Gauguin was forced again to live on credit and the handouts of his wealthy friend de Haan, and he was unable to send money to his family in Denmark.[26] Reeling from these rebukes, Gauguin responded with new intensity to the devotional objects around him in Brittany that represented the dolorous condition of sacrifice and the Passion of Christ.

FIG. 117. **TORSO OF THE WOODEN CHRIST.** Photograph by the author

For his large 1889 canvas titled *The Yellow Christ*, Gauguin drew directly on an artifact of Breton religious art: a seventeenth-century polychromed wood sculpture of Christ on the cross that hung in the small Trémalo Church near Pont-Aven (Fig. 116). The wood Christ is really more ivory-colored than yellow but appears yellowish against the bluish walls of the chapel.[27] The elongated figure has a bulky crown of thorns painted dark green, wavy brown hair and beard, and heavily painted eyebrows that accent the downcast but visibly open eyes, one of which drops a tear (Fig. 117). Despite the crude

FIG. 118. PAUL GAUGUIN, *THE YELLOW CHRIST*, 1889, oil on
canvas, 92 x 73 cm. Albright-Knox Gallery, Buffalo, New York;
General Purchase Funds, 1946

and broad forms, Christ's face is remarkably expressive. A conspicuous feature of this Christ figure is the tautness and rigidity of the muscles and rib cage, which evoke through the carving method the stiffening of a stretched body and bolted limbs; a second is the graphic presence of blood, which spurts out from an open wound on the figure's right, staining the undercloth, and flows out in red-painted streams from the palms of Christ's nailed hands.

For his *Yellow Christ* (Fig. 118), Gauguin transformed the Trémalo sculpture in a number of significant ways, all directed to renewing his quest for modern sacrality through anti-naturalist painting. Enlarging the Trémalo figure and moving it from chapel interior to the outdoors, Gauguin planted the colored Christ in a landscape that deliberately exploited the "ambiguity of the real and the imaginary," the natural and the supernatural.[28] The hilly town of Pont-Aven is recognizable rising in the distance, and women in Breton costume sit at the base of the cross, joining, without mediation, a contemporary order and a transcendent one.

The interest in the movement from one level of reality to another within a single visual field had been the keystone of Gauguin's *Vision After the Sermon*, and some writers have noted similarities between *The Yellow Christ* and *The Vision*. Spatial scrambling is evident again, with intense compression of near and far in *The Yellow Christ*, as well as acutely heightened and arbitrary color choices to emphasize departures from visual observation. Gauguin explained that he used glaring "vermilion" in *The Vision* in order to evoke a supernatural realm; high-keyed sulfur yellow and fiery orange appear in *The Yellow Christ* as the means of conveying the release from worldly anchorage. Also reminiscent of *The Vision* are the positions and costumes of the three sitting Bretonnes, cut off at the front and left of *The Yellow Christ* in the same ways that some of the seated women were in *The Vision*.

Yet *The Vision After the Sermon* used its tactics of "abstraction" for activating the intrusion of vision into the visual, depicting an exalted moment of contact with the sacred order. There Gauguin dramatized, through the peasant women's mesmerized concentration, the biblical scene when Jacob challenged God and won his own name. In *The Yellow Christ*, the prayerful women, again motionless and rapt, are seated at the foot of the cross, engaged in the tragedy of sacrifice and loss. The evocation of an eternal order beyond appearances belongs not to the biblical patriarch and his Judge, as in *The Vision*, but to the New Testament women grieving for the Son, who has assured collective salvation through his own suffering and physical annihilation.

In moving from wood sculpture inspiration to *The Yellow Christ*, Gauguin pursued his own evolving techniques of flattening, simplification, and reduction. While he maintained the extremely elongated arms that characterized the Trémalo Christ, Gauguin diminished the physical corporeality of his Christ as much as possible. Outlined in blue, Gauguin's figure is a flat, almost cut-out figure of simple contours. The torsion of muscles that so prominently marked the sculpture is stamped out, except for a wispy line of bluish black running down the right leg. The bulky crown of thorns atop the wood figure is leveled out in Gauguin's rendering, and the head is almost melted into the cross behind, rather than pushing out with crown from it. The arms of Gauguin's Savior, also lacking the Trémalo figure's stiffened muscles bursting at the surface of the skin, are a planar flow of yellow that obliterates any sign of the spurting blood staining the forearms of the wood figure. The rib cage of Gauguin's Christ lacks definition, and the middle of the body bears a small vertical line to suggest the gaping open wound on the same spot on the Trémalo Christ, where blood streamed down the body to the loincloth.

One of the most unusual qualities of Gauguin's *Yellow Christ* is the brushwork and handling of color. There is some variation in the application of pigment, which is delicately laid in thin layers in some areas, with traces of visible brushstrokes in, for example, the glowing red trees and the women's hands, set afire by the painter with unnaturally crimson skin. The treatment of Christ's body is the most attenuated area of Gauguin's brushing on the canvas. The yellow color saturates the support and appears matted down, lacking texture and modeling, and almost fuses with the canvas as if a single, unitary surface.

Gauguin achieved this flattened integration of color wash in *The Yellow Christ* by special means. According to scholars, the upper third of the painting carries traces of newsprint; Gauguin "evidently used the technique of blotting the surface with wet newspaper . . . to dull the glossiness of the oil pigment." This method of blotting, like leaching out oil and washing his canvases, created a blanching and smoothing down of the pigment surface, enhancing matte and effectively "disguising the medium of oil painting."[29] By blotting and pressing down the yellow oil paint to blend with the support, Gauguin drained the viscous resin of oil paint to achieve the absorbent, chalky finish of a fresco. Here Gauguin used again the tactics of canvas dematerialization he had been attempting since the Breton *Vision* and had dramatized in Arles. His experiments with more absorbent ground, thinned paint layers, and ironing over the finished canvas, for example, were all devised to diminish the physicality of the canvas sur-

face as much as possible and, paradoxically, to move painting from the visible to the invisible. These technical strategies of suppressed surfaces had aimed to obliterate the distance between physical reality and the "noncorporeal" realm of the divine. In the *Vision* painting, Gauguin had combined a non-natural color scheme, an unmodulated paint cover, and the chalky absorption of pigment in order to navigate across the divide of the natural and the supernatural, a moment of ecstatic contact with otherworldliness. In *The Yellow Christ*, form and content were again joined for the goal of visual and spiritual transcendence of the confines of physical materiality. This time, the flight to the netherworld was achieved not by the active exaltation of visionary experience but by the martyrdom of a discarded body; the release to metaphysical purity came through suffering.

The theme of transcendence through suffering, and the techniques of dematerialization designed to represent it, emerged in a second painting of Gauguin's from the fall of 1889, *The Green Christ* or *The Breton Calvary* (Fig. 119). Like *The Yellow Christ*, this startling canvas was adapted from a specific source in Breton devotional culture—in this case, the stone calvary sculpture standing outside the village church at Nizon (Fig. 120). The Nizon chapel had been one of the two sites where Gauguin had hoped to place his *Vision After the Sermon* in the fall of 1888; a year later, he focused on the outdoor sculpture to create an image of anguished grief as the vehicle of pictorial "abstraction."

Gauguin's statement about the painting conveys clearly his new preoccupation in Brittany with the sorrowful condition of the human community, concentrated in the representation of Christ's sacrifice. In letters about *The Vision* Gauguin had referred admiringly to what he termed the "rustic" and "superstitious" "simplicity" of Breton faith, which he presumed offered the pious peasants a privileged access to divinity—a dynamic, unmediated passage from this world to the next. Now, invoking these same terms in relation to his calvary painting, Gauguin wrote that the rustic, superstitious simplicity of the Bretons expressed a capacity to endure "desolation" and a resigned acceptance of suffering. He described his *Breton Calvary* and its expressive intent to Theo van Gogh: "Brittany—simple superstition and desolation . . . I have sought in this picture that which fully breathes of belief, passive suffering, a primitive religious style and the cry of a majestic nature."[30]

Like *The Yellow Christ*, Gauguin's *Breton Calvary* revealed significant adaptations as he moved from sculpture to canvas. The ancient Nizon calvary monument functioned as a three-tiered layering of narrative moments in the Passion. Its lofty peak showed Christ on the cross, and the visual unity of

FIG. 119. PAUL GAUGUIN, *THE GREEN CHRIST (THE BRETON CALVARY)*, 1889, oil on canvas, 92 x 73 cm. Musées Royaux des Beaux-Arts de Belgique, Brussels

the piece emerged from the interplay of the towering vertical column with two sets of figures placed at horizontal wings, one along the base and another circling the Crucifixion. These figures represented Saint Peter and Saint John, among others, and the sculpture signaled on its front that it was erected to enlist the saints' help in warding off an epidemic of the plague.[31]

Gauguin took the intrusion of sacred personages in a contemporary setting in a wholly different direction for his religious painting. Slicing off the calvary's winged figure groups and the top scene of Christ on the cross, he concentrated on the group of three women shown at the base of the sculpture holding the dead Christ, and reconfigured them as a unit in a landscape. He juxtaposed this holy group with a local woman in what he called a "Breton costume," and he placed a dark half-shape at her left, a "passive lamb."[32] To the melding of a local woman and the dolorous sculpture Gauguin joined a third element—the rocky dunes and waves of Le Pouldu. In his letter to Theo, Gauguin noted that the hills behind showed "a cordon of cows disposed as a calvary."[33] The cows appear as tiny spots along an improbably luminescent hillside of yellow-green. Gauguin's *Breton Calvary* thus splices together an ancient calvary monument observed at Nizon, near Pont-Aven; a modern Breton woman in regional costume; and a village shore miles away from Nizon, at Le Pouldu.

As he had for *The Yellow Christ*, Gauguin exploited technical strategies of anti-naturalism for the calvary painting. Most dramatic are his use of color and his flattening of the sculpture group. Gauguin's painted Pietà holds the viewer with a curious shade of green wash, set off by the brighter yellow, pinks, and orange tones of the surrounding landscape. The gray sandstone sculpture at Nizon was characterized by a rough, irregular surface, which alternated heavy stonecarving with pockmarks and disfigurement, the corrosive effects of centuries of whipping wind and rain. Gauguin transformed the jagged, uneven stone relief he observed into the smooth contours of his colored lines and a level sheet of green pigment. He recast the solemn mourners as graded facings of simple shapes.

FIG. 120. STONE CALVARY AT NIZON, 11th century. Photograph Hervé Boulé, reproduced from Bertrand Quéinec, *Pont-Aven, cité des peintres* (Rennes: Editions Ouest-France, 1988)

THE DINING ROOM AT LE POULDU: GAUGUIN'S "JOAN OF ARC"

Religious iconography, and the celebration of a "credo" of spiritual purity, appeared in a group project of decorative painting orchestrated by Gauguin. Despite his letters' expressions of despondency and

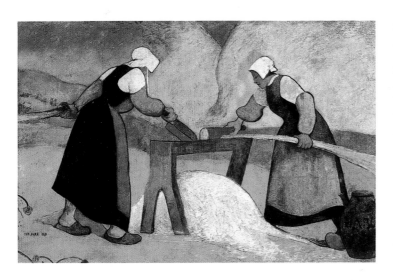

FIG. 121. JACOB MEYER DE HAAN, *BRETON WOMEN SCUTCHING FLAX*, 1889, wall mural, 133.7 x 202 cm. Photograph Fine Art Gallery, San Diego

isolation, Gauguin was never really alone at Le Pouldu. He lived and worked alongside Meyer de Haan, and later they were joined by a number of other artists and acolytes. From October through mid-December of 1889, Gauguin and de Haan painted the walls of the dining room of the Marie-Henry Inn, where they were staying. The following summer, two other painters, Charles Filiger and Paul Sérusier, arrived at the inn and added their panels to the ensemble.[34]

Van Gogh had planned his Arles Yellow House as a group studio, joining artist-brothers together as a utopian community. During the time of Gauguin's stay with him, van Gogh consolidated his visual program of complementarity and interdependence through his production of interlinking canvases and commitment to the laws of color contrasts, which necessitated the relation and juxtaposition of partners for their realization. He had tried out his color pairs and connecting canvases in sets of paintings arranged as decorative groups for adjoining rooms of the Yellow House, which would express in the pictorial order the ideal of individual units bound to a composite whole that he hoped would be achieved in social practice. These ensembles of expressive color and linking formats were attached to the representation of ordinary objects, subjects, and sites around Arles. Among the canvases van Gogh planned as units for different rooms were the pair of horizontal *Alyscamps* paintings, with their blue and orange and yellow and violet complements (Figs. 87 and 88); the *Night Café* with its jarring red and green next to the *Bedroom* with its serene blue and orange; and sets of portraits of subjects from different walks of life, such as a pairing of peasant and poet with contrasting, and intermingling, dominant hues of orange and blue.[35]

The result of a group effort, the painted walls at Le Pouldu stood as a poignant counterpart to the integral ensembles van Gogh had imagined but never realized for his Yellow House. His plans remained a single artist's blueprints for a totality required by the laws of evocative form and expressive color, but not accomplished by their human analogues. The Marie-Henry room allied different artists to varied media in an eclectic mix of styles and purposes. But the resulting ensemble, unlike van Gogh's, abounded with allegories, adaptations of explicitly Christian symbolism, and the forms and prototypes of church decoration, especially fresco and stained glass.

While framed paintings were not absent, the main area of the Marie-Henry dining room comprised murals painted on the walls and set in on wood doors, under mantels, and on glass panes. A large panel by Meyer de Haan, *Breton Women Scutching Flax*, presented two blocky figures set against rounded pillows of hay as they put mallets to fiber (Fig. 121). Of the decorative ensemble at the inn, de Haan's was the only image involving peasant production rather than peasant piety or play. The women in the mural appeared absorbed in their task, which was rendered in a curiously fluid way, with the flax that was being fed along a fragile sawhorse cascading smoothly, meeting the mallet as if pouring through it, and lacking any sign of the fibers' coarse consistency or resistance to being pummeled. The fresco form, setting the paint into the wall, enhanced the flatness and melted quality of the pigment, which was laid in around black outlines, a tribute to the cloisonist approach de Haan absorbed from Gauguin.[36]

Along the wall to the left of de Haan's fresco was a panel of Gauguin's, which became known as Joan of Arc (Fig. 122). De Haan himself noted the very different quality of the two rural scenes,[37] but they were nonetheless integrated visually by the two painters as they worked together. The most obvious integration was a curling, ornamental plant vine that wound its way from the lower left corner of de Haan's field to the lower right of Gauguin's panel, linking the two murals over a wood strip that separated them (Fig. 123).

The "Joan of Arc" fresco, one of a number of works that Gauguin produced for the inn, suggests Gauguin's enduring interest in exploring the links between vision and the visual. The artist depicts a peasant girl, an elongated figure in a Breton costume, standing near a shore with rudimentary spinning accoutrements in her hands—distaff in one, flax in the other. A winged angel in a yellow cloud flies toward her, bearing a staff. Behind the peasant girl are the shoreline and rising green dunes

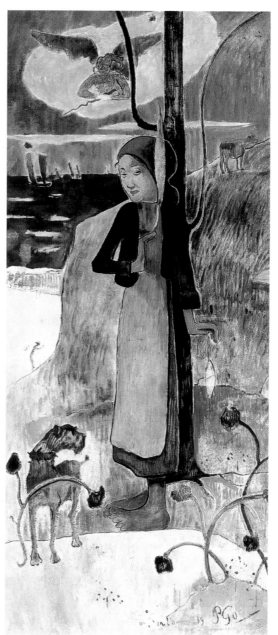

FIG. 122. PAUL GAUGUIN, *BRETON PEASANT GIRL SPINNING BY THE SEA ("JOAN OF ARC")*, 1889, wall mural, 116 x 58 cm. Private collection

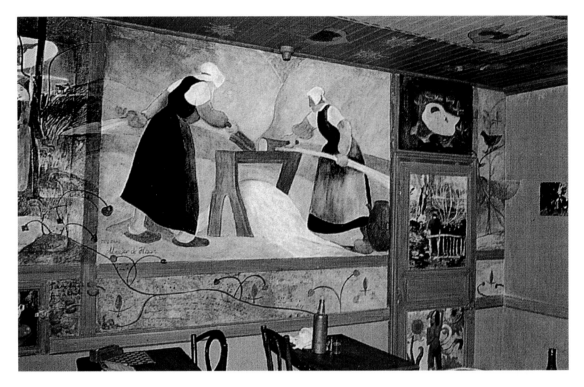

that resemble the backdrop of *The Green Christ*. A cow is visible here, as in the *Green Christ* painting, in which a modern figure in regional costume, elements of a Breton landscape, and a sacred scene were also joined. Gauguin's "Joan" rests against a tree with stylized curving branches; the branches act to unite the lower and upper zones of the image, as the one on the left ascends to converge and overlap with the yellow cloud and the angel's left wing.

There is still some debate over the figure as Joan of Arc, since the name was appended later and Gauguin never referred specifically to her as Joan. Significantly, when Gauguin wrote to van Gogh describing this mural, he wrote of "a peasant girl spinning at the edge of the sea" with "her dog and her cow," omitting any reference to the dominant angel. The omission is consistent with his tendency not to emphasize the religious content of his art that spring and fall, a tendency shaped by his recognition of van Gogh's fundamental reservations concerning the inclusion of traditional miraculous figures in modern painting.[38]

Despite the lack of evidence for Gauguin's own title for the mural, its dominant feature remains the relation between the young woman and the angel above, intensified by the bright yellow cloud. Here we see again Gauguin's attempt to depict in a single visual field the meeting of the natural and the supernatural. A debate among art historians has centered on whether Gauguin intended the angel he depicted as bearing a sword for Joan of Arc to fight the English, or whether the presumably militant angel signifies a more generalized theme of the expulsion from paradise.[39] This debate obscures at least two critical issues, which set the tone for Gauguin and van Gogh's continuing divide over the appropriate forms of a modern sacred art.

The first is the very inclusion of the angel itself, and its connection to Gauguin's fluency in adapting traditional biblical figures to the form and meaning of modern painting. The Orléans seminary where Gauguin was educated, we recall, highlighted a cult of angels, made interior dialogues with them a part of prayer and meditation, and held up the angel as children's ideal—their quest was to fix their eyes on heaven and recover their wings in flight to divine perfection. In Gauguin's breakthrough symbolist religious painting of 1888, *The Vision After the Sermon*, a scene of Jacob wrestling with the angel had provided the emblem of passage from one level of reality to another, through the medium of rural religiosity. The "Joan of Arc" mural of 1889 reclaimed the link between a human figure and a celestial creature, united in the picture plane and merging the boundaries between the natural landscape and a transcendent order. Angels, as we have seen in the letters from van Gogh's formative period and again in his discussions with Bernard from Arles, were banished from the center of modern thought and modern art; van Gogh explicitly derided the conception of despotic divinities flying above impulsively, and favored instead what he called the rule-bound regularity of a methodical God who embedded his design in nature, to be unfolded by human exertion.[40]

Second, the "Joan of Arc" fresco reaffirmed Gauguin's engagement with visionary experience. One obvious, and surprisingly unmentioned, aspect supporting those who consider Gauguin's image a depiction of Joan of Arc is that the young peasant woman may be experiencing a vision. She is positioned in a static, concentrated pose, and the activity hovers above her in the arriving angel-messenger. Gauguin's figure shares certain generalized features with other Joans of Arc that inundated French visual and literary culture in the period of nationalist revival after 1870. The Salon painter Jules Bastien-Lepage, for example, produced a large-scale painting of Joan of Arc in 1879 which shows the

young peasant woman in the woods, caught unexpectedly by a miraculous appearance. Her work winding yarn has been suddenly interrupted, as her stool is overturned and the skeins left dangling. Frozen, she stands looking out and above the beholder as the celestial action hovers behind her (Fig. 124).

In my view, however, Gauguin's choice of a Joan of Arc for the walls of the inn relates more specifically to his early Orléans education than to the culture of the nationalist revival generally. The seminary's emphasis on visionary experience and a local Joan of Arc cult led by Bishop Dupanloup, Gauguin's teacher, set the fresco in a new context and indicate the distance between the Le Pouldu inn and the program of coloristic harmony that van Gogh aspired to for his Yellow House series of interlinking landscapes and portraits.

Gauguin's fresco of the young girl spinning by the sea with an angel appearing had striking affinities with a description of Saint Joan publicized by Dupanloup. Well before the nationalist revival reignited her cult across France in the 1870s, Gauguin's teacher was

FIG. 124. JULES BASTIEN-LEPAGE, *JOAN OF ARC*, 1879, oil on canvas, 254 x 297.4 cm. The Metropolitan Museum of Art, gift of Erwin Davis, 1889 (89.21.1). Photograph © 1988, The Metropolitan Museum of Art

an ardent devotee of the maid of Orléans; in fact, Dupanloup pursued her celebration from the time he was appointed bishop. In 1855, a few years before Gauguin enrolled in the Saint-Mesmin junior seminary, Dupanloup promoted the first pilgrimage to the small village birthplace of Joan of Arc in Domrémy, along the banks of the Meuse; the Bishop himself attended a later pilgrimage there sometime before 1868. In 1869, Dupanloup offered a series of panegyrics to Joan of Arc in the Cathedral of Orléans, one of which was published in that year as *Joan of Arc*.

Dupanloup's text glorified Joan as a "humble, pious" girl, "meek," "gentle, and good." He stressed her "pastoral lowliness" and devotion to her chores, linking her rural simplicity to her visionary receptivity. The Bishop described Joan as wearing a "red peasant costume" and stressed her dexterity as a spinner—she "spun very well" on both "spinning wheel and distaff." The spinner Joan was a dutiful tender of flocks and also cared for cows, and she frequented the outdoors, along the "swelling hills sloping

down to the Meuse." There, by the shore, "the first supernatural voice spoke to her." Dupanloup defined the ushering in of the voices in terms of a burst of bright light; like "the words uttered at the appearances of Angelic messengers" in the Gospels, those heard by Joan "pour into the soul such light and peace," "so clear, so luminous."[41] The notion of sound converted to bright light recalls the Bishop's description of the third *jet* of luminosity that would emerge during the most concentrated interior state of children's meditations.[42]

Gauguin's Joan of Arc shares the setting of rural piety and vision. Like Dupanloup's Joan, Gauguin's wears a red peasant apron and headdress and stands along swelling hills sloping down to a shore. Both Joans hold a distaff and experience an angelic messenger in a burst of bright light. To be sure, the painter has infused his image with many other diverse elements and sources, identified by other writers, which transform the legacy of Orléans in new directions. For example, we know that Gauguin was fascinated by the Javanese dancers at the Paris World's Fair of 1889, as well as by a bas relief from the Temple at Borobudur featured in the exhibits; the stylized pose of his Joan figure suggests an attempt to adapt some of these new figural positions. The impact of other colonial exhibits at the fair, including the colonial peoples themselves, also partly accounted for Gauguin's Joan bearing brown-skinned feet and hands. Japonist elements are evoked by the boats at the back of Gauguin's horizon, while a new interest in Egyptian hieraticism has also been mentioned as part of this mural's unusually syncretic qualities. The conspicuously sacred features and meaning of Gauguin's Le Pouldu fresco have, however, been overlooked.[43]

The "Joan of Arc" mural was joined at the inn by other images with explicitly Christian themes and derivations. Charles Filiger, who turned to painting after a Jesuit education in Alsace, was absorbed in devising a modern form of devotional painting. Drawn to Gauguin's orbit in Pont-Aven in 1888, Filiger joined the painters at Le Pouldu and added his contribution to the decor in the summer of 1890: a fresco of the Virgin Mary and another panel of a flying angel bearing a garland.[44] Filiger considered his artistic work to be infused with the intense fervor, as he called it, of the "secret prayers of the ancient Christians."[45]

FIG. 125. *LOST PARADISE (PARADIS PERDU)*, ATTRIBUTED TO EITHER PAUL GAUGUIN OR PAUL SÉRUSIER, 1890, oil on canvas, 46 x 55 cm. Yale University Art Gallery, Gift of Mr. and Mrs. Benjamin E. Bensinger, B.A. 1928

THE *LOST PARADISE* FRESCO AT THE INN

A final inset for the ensemble at Marie-Henry's provided another example of the presence of angels in the artistic schema. This time the angel appeared not as an emblem of the power of vision and transcendent perfection, but as an agent of divine reckoning for transgressive deficiency. A large wall paint-

ing over an entry door in the hallway by the dining room was entitled *Paradis perdu* (*Lost Paradise*), depicting the biblical expulsion from the Garden of Eden (Fig. 125). On one side are a figure of Eve, the tree, and the serpent; on the other is a seated angel on a cloud over the heads of Adam and Eve. The cloud acts as a propulsive force, chasing the shamed couple forward, out of Eden.

Without explicit evidence, opinion is still divided over whether the painter of this mural is Paul Sérusier, who joined Gauguin, de Haan, and Filiger in the summer of 1890, or Gauguin himself. A major exhibition catalogue on Gauguin's development illustrates the *Lost Paradise* panel and attributes it unreservedly to Gauguin.[46] The noted Sérusier scholar Caroline Boyle-Turner does not consider the work to be by Sérusier, arguing that there are no stylistic or thematic links to any of Sérusier's other works of the period, nor is there any mention by Sérusier, an avid letter writer, of his having produced such a panel, though he provided other information on his stay at Le Pouldu.[47] Robert Welsh, who has studied the Le Pouldu decorations most intensively, leaves open the possibility that the *Lost Paradise* fresco could have been done by Gauguin, and I would like to add further evidence to this line of argument in relation to Gauguin's theological consciousness and techniques.[48]

First, the panel corresponds to Gauguin's attempts to grapple with allegorical and biblical themes in 1889, from his Breton Eve and the serpent (Fig. 110) to the martyred Christ on the cross (Figs. 118 and 119). The theme of temptation, transgression, and suffering had long had powerful resonance for Gauguin, and he had identified the figure of Eve as a sinner more explicitly in 1889 as part of his expanding repertoire of the *Misères humaines*. Further, the panel operates within the framework of Gauguin's abidingly dialectical mentality of transcendence and affliction. The angel in the cloud above the head of Gauguin's Joan of Arc, sent to celebrate the purity and virtue of the pious young woman, offers a striking counterpart to the celestial militant punishing the couple from the cloud depicted in the *Lost Paradise* panel. Together the two frescoes tap the themes of visionary release and doleful reckoning inscribed in Gauguin's mental system.

A final set of stylistic clues suggests that the *Paradise* panel could be by Gauguin's hand. Robert Welsh has proposed that the strange-looking bush in the right foreground resembles a very similar one in another 1890 painting of Gauguin's that depicts the temptation of Eve in paradise in another way, the *Eve exotique*.[49] I would add three other kinds of visual parallels to this. The stylized, curling tree that acts to divide the *Paradise* fresco in two was a favored device of Gauguin's, and it organizes

the picture plane into two zones here. The strange spots of paint circling the tree near the serpent in the center also resemble the irregular blotches and spots of color that Gauguin had applied to the snake and tree in his *Breton Eve*. Finally, Gauguin made a later image with the exact same title as this one: as an inside back-cover illustration for his polemical essay on religion and modernity, "L'Esprit moderne et le catholicisme," which I will discuss in Chapter 12. Gauguin's inset for his text, a woodcut print entitled *Paradis perdu*, showed Eve and the tree as the trigger for the expulsion from the Garden.[50]

LAST JUDGMENT PANEL AND THE WAGNER "CREDO" INSCRIPTION

The visual explorations of levels of reality and the dualism of purity and corruption expressed by some of the panels received an added literary force in the decorative ensemble. The winding vine that linked de Haan's labor scene of scutching flax with Gauguin's "Joan of Arc" mural continued down onto a rectangular panel, where an inscription was painted over the vine (Fig. 123). This text, known as "Wagner's Credo," was thought by some to have been placed there by Gauguin, but most likely it was the work of Sérusier to mark the completion of the decor in the fall of 1889, a kind of dedication affirming the meaning of the totality and the artists' goals.

Sérusier's letters indicate that the text, by the musician and artistic rebel Richard Wagner, did signify a collective doctrine, what he called "notre crédo à nous."[51] The sense of shared goals and the place of sacrality in those goals was endorsed by Gauguin, who wrote later that the Breton group considered themselves "the disciples of a new religion," "fortified in their faith by mutual affection."[52] Gauguin had himself been copying out passages from texts by Wagner from the start of his time at the inn in October, and the "credo" as inscribed on the walls constituted a commitment to spiritual purity and an indictment of worldly materialism.[53]

Wagner had been celebrated in France from the 1840s for many reasons, and writers and painters from Baudelaire to Signac had been drawn to the ideals of synesthesia and the *Gesamtkunstwerk* as particularly meaningful for their artistic innovations. The Wagner panel underlining the decorative ensembles painted at Le Pouldu did not exalt the unity of all the arts—as synesthesia did—and the har-

mony of society and the individual prefigured in such a totality. Instead, it asserted a curious message in the midst of a dining room and its painted walls: the release from a debased and treacherous natural world. The legend complementing the painting program used particularly harsh language to evoke the sordidness and degradation of earthly pleasure and avarice, and the reckoning that surely awaited those who "trafficked" in art. As an alternative to this worldly indictment, the wall text concluded with the glories that awaited those dedicated to artistic purity, elicited in a vision of the transcendent perfection of an ideal, celestial order:

> I believe in a last judgment where all those who in this world have dared to traffic in a sublime and chaste art, where all those who have sullied and degraded it with the baseness of their desires, by their vile lust for material pleasures, will be condemned to terrible suffering.
>
> I believe, by contrast, that the faithful disciples of great art will be glorified, and, enveloped in a heavenly tissue of light rays, perfumes, and melodious chords, they will return to lose themselves for eternity in the heart of the divine source of all harmony.[54]

GAUGUIN'S *CHRIST IN THE GARDEN OF OLIVES*: MARTYRDOM AND ABSTRACTION

The widening gulf between a transcendent ideal and a corrupt and treacherous world, and the artist's lessening capacity to mediate between them, received a striking treatment in the fall of 1889 in Gauguin's *Christ in the Garden of Olives* (Fig. 126). This painting completed the cluster of images that reengaged Gauguin, in the year after he left van Gogh in Arles, in themes that had particular resonance with his theological formation. Gauguin shared his new *Christ in the Garden of Olives* with van Gogh through their correspondence, provoking van Gogh's strong disapproval and clarifying to both painters their divergent routes taken along the "path of symbolism." Part of van Gogh's dislike of the painting stemmed from Gauguin's bold and unmistakable presentation of himself as Christ, moving his identification of the artist as modern martyr to a new level.

Gauguin's painting highlighted the section in the Book of Luke just before the betrayal, showing Christ's anguished recognition of his isolation and rejection. The large-scale oil canvas is divided into

FIG. 126. PAUL GAUGUIN, *CHRIST IN THE GARDEN OF OLIVES*, 1889, oil on canvas, 73 x 92 cm. Collection of the Norton Museum of Art, West Palm Beach, Florida

two zones by a central demarcating tree, which positions a sorrowing Christ at the left corner and enrobed disciples moving into the distance at right. Space is compressed and jumbled, with an emphatic flattening by the tree pole and its cut-off, curling branches; the large, hulking figure of Christ; and the out-of-scale diminutive disciples, who seem to move into the distance but are swallowed up by a swath of terrain that presses forward to the front of the picture plane. Gauguin also scrambles together eclectically chosen motifs from nature. Swaying palm trees from early exotic travels jut out at the back, for example, planted on rolling banks that resemble the dunes and shoreline of Le Pouldu.

The most arresting feature of the painting, however, is the pocket of glaringly bright red color for the hair and beard of Christ, accentuated by its contrast with the dark blue and brown tones dominating the rest of the canvas. Gauguin inserted his own distinctive features, especially his nose, for the face of Christ.

Gauguin provided explicit evidence that he considered himself the tormented and abandoned Christ in the garden at Gethsemane. "I have painted my own portrait," he explained to one commentator. But the painting also represented "the crushing of an ideal, and a pain that is both divine and human. Jesus is totally abandoned; his disciples are leaving him, in a setting as sad as his soul."[55] Betrayal and misery are also the themes Gauguin used to describe the painting to a friend, the writer and art critic Albert Aurier, when he jotted down some notes on a calling card: "Christ: special sorrow of treason and of the heart applying to the Jesus of today and tomorrow . . . The whole [forms a] *somber* harmony. Somber colors and supernatural red."[56]

Now it was not the case in November 1889 that Gauguin's "disciples" were leaving him; he was surrounded by fellow painters at Le Pouldu. Nonetheless, deep feelings of despair underlay his painting. His letters of this period are filled with the theme of defeat and disillusionment, and the sense of diminished hopes for his art of "abstraction." To Bernard he invokes the terms of the calvary and Crucifixion as he writes that he "is nailed" to the cross (*cloué*) by poverty, debt, and lack of recognition. Stung by critics and lack of sales at the 1889 fair, Gauguin is desolate at his reversal of fortune, lamenting to Bernard that during the entire year since he left Arles, he has sold only one picture, for 925 francs, and lives in a state of misery and uncertainty.[57] The theme of the calvary recurs when Gauguin writes to Bernard how he feels mocked and jeered by the public:

> *Of all my struggles this year, nothing remains save the jeers of Paris; even here I can hear them, and I am so discouraged that I no longer dare to paint, and spend my time dragging my old bones along the beaches of Le Pouldu in the cold North wind . . . let them look carefully at my recent things . . . and they will see how much there is in them of resigned suffering.*[58]

The association of the artist with Christ, consigned to life as a calvary, filled with sacrifice and the challenge of the *misères*, had been invoked by Gauguin from the time he first defined his breakthrough

art of "abstraction" in 1888. The Orléans seminary training, in part, had shaped Gauguin's fluency with a dialectic of inwardness and otherworldliness and with the ideal of transcendent purity, which he had transmuted to his art of ascent and anti-naturalism. But the new portrait of himself as Christ in the Garden of Olives represented a significant shift in the terms of Gauguin's identification with Christ as a model for his art. We can see this shift in Gauguin's writings and by comparing his use of the color red in his 1888 *Self-Portrait* and *Vision After the Sermon* with the 1889 Christ canvas. In both discursive and visual traces, Gauguin expressed the new contraction of the ideal order, present but insulated and incapable of transporting one level of reality to another. Van Gogh found this new concentration on the artist as tormented Christ, redeemed only out of the world of human community, to be maddening and distortive; the codes of his culture demanded not focusing on becoming another Christ as martyred idealist, but adapting to nature and modern expression Christ's communicative powers as consoler and comforter.

Gauguin's letters and statements in the fall of 1888 had appropriated the language of Christ's torments for the life of the artist in a messianic register, emphasizing suffering and sacrifice in the service of a new ideal that would eventually, but assuredly, triumph. In the first flush of defining his credo of abstraction, Gauguin embraced the "path of symbolism" as "full of dangers," but ultimately "what is good wins recognition."[59] He portrayed himself in this phase as the "man of sacrifices," but also presumed that the will to sacrifice was, as he wrote to Schuffenecker, "a transformation which had not yet borne fruit but will one day."[60] This fundamental mixture of privation and vindication infused Gauguin's statement presenting Christ's calvary as a model for the life of the artist, a life burdened and flayed, but energized by passion. Just before he painted *The Vision* in September 1888, Gauguin wrote of being goaded to eventual triumph by affliction, which made him defiant in the face of trials: "It is a long Calvary to be traversed, the life of an artist, and perhaps that's what makes us live. The passion vivifies us and we die when it has no more nourishment [to give us]. Let's leave these paths filled with bushes of thorns, which nonetheless have their wild poetry."[61]

A year later, Gauguin no longer paired Christ's martyrdom with exaltation; now he linked it to resignation and defeat, culminating in *Christ in the Garden of Olives* as his own self-portrait. The visual forms of abstraction that Gauguin devised for this painting extended those he had developed over the past year but also altered their meaning and function. This alternation is evident in the link between

subjectivity and suffering presented in the 1889 Christ canvas as compared with the *misérable* self-portrait of 1888, and in the modified range of supernatural presence evoked in *Christ in the Garden* as compared with the 1888 *Vision*.

Gauguin's calling-card notes indicate that he considered the color range as a key expressive force of the Christ painting, divided into what he described as "somber colors and supernatural red" (*rouge surnaturelle*). This division echoed Gauguin's bifurcation of "natural" and "non-natural" color zones in *The Vision*, and confirmed the central role he had isolated for color as an element of visual "abstraction" since his 1888 self-portrait, where he had identified the color as "far from nature."[62] The anti-naturalism of the color choices had indeed compelled Gauguin to write letters guiding his friends to understand the meaning of those canvases, acknowledging to Schuffenecker that the 1888 self-portrait was "incomprehensible . . . it is so abstract." About the new Christ painting in 1889, Gauguin wrote along similar lines to van Gogh that "it is not intended to be understood," and discussed the colors of the landscape and the "vermilion hair" of Christ.[63]

The red colors "far from nature" that appeared in the 1888 *Self-Portrait: Les Misérables* also carried associations, as we saw in Chapter 1, of Christ's torments as the plight and privilege of the modern artist (Fig. 4). In this case, Gauguin's explicit identification was with Victor Hugo's hero, and he endowed the noble outcast, Jean Valjean, with his own features. Ill-clad in a rumpled garment similar to his 1889 Christ's, Gauguin's *misérable* was a "wretched victim" of social oppression but also the defiant champion of "artistic purity." Resisting the "putrid kiss" of official art, the progressive painter withdrew unsullied to embrace the inner fires of creativity. Here Gauguin joined evocations of Christ's martyrdom to an affirmation of inner suffering as the ground of existence for the modern artist. The use of unnatural red colors, clustered on the artist's face and neck, signified his exalted state of affliction and self-discovery, a willful and defiant self-immolation for artistic liberation. Licked by the "volcanic flames" of the mind, the head, cheeks, and neck glowed with the flush of boiled blood that suffused outward—the "sang en rut [qui] inonde le visage." And the unnatural "streaks of red" by the eyes, as Gauguin affirmed, captured the flashes of contorting heat animating the artist's soul in the furnace-fires of his subjectivity. These reds radiated the painful but inspired "struggles of the painter's thought."[64]

In the 1888 self-portrait, then, Gauguin's association of his condition to Valjean and to Christ expressed a martyrdom of defiance and opposition. The abstract red color range evoked, as Gauguin

exultantly wrote, lava flow, furnace blasts, and rushing blood that tested the artist to triumph as he exchanged external oppression for internal liberation. And the afflictions of the inner world were turned back on oppressor and viewer by the oppositionist painter, who was steeled by suffering and resolute in his stance of hostile superiority.

Gauguin's shift from Valjean to the figure of Christ in the 1889 painting of the Garden of Olives transposes the artist's martyrdom from the stance of exhilarated creator to wretched and sorrowful victim. While positioned at the left of the canvas like the *misérable*, Gauguin's Christ is turned away, his body limp and crumpled. No eyes lock the viewer's like those of the earlier challenging gaze, as now the painter-Christ is shown lost in the moments of his greatest despair. Gauguin renders his Christ face drained of color, with pale flesh brushed for eyes and cheeks. Here no furnace flames of searing inner purity glowed outward from beneath the skin; no red streaks mark the eyes, the outer sign of the inner struggle for the artist's ideal. The prominent red, by contrast, the red *surnaturelle*, is laid in as a molded cap around Christ's head, circling it tightly. The same red flows from mustache into beard, and reddened patches mark the sleeves of Christ's cloak.

It has been claimed that the supernatural red evokes Christ's bloody sweat in the garden, as recorded in the Book of Luke and, more generally, alludes to the "whole agony of the passion."[65] Some contemporaries of Gauguin readily recognized what one critic called the "Christ with blood red hair."[66] Where the unnatural red in the *misérable* signified the interplay of martyrdom and ecstatic self-discovery, the abstract red of Gauguin's 1889 Christ expressed suffering and the defeat of the ideal, with the sacred *surnaturelle* as the prefigured blood on the head of the Savior rebuked, a hunched and limp body to be redeemed only by sacrifice.

A final shift is registered in Gauguin's vermilion Christ. In 1888 it was a similarly intense vermilion color that had inaugurated Gauguin's experiment with an art of abstraction, the red transfiguring the visual to a celestial *Vision After the Sermon*. Here the pigment composed a radiant red field, filling all the crevices around it in a diffuse, aqueous flow. The permeating color signaled the expansive overtaking of the boundaries of the natural by the non-natural, the release to a transcendent ideal. During this euphoric phase, Gauguin embraced the artist's capacity to mediate the heavens through the dream, elicited by the peasant women's piety in their shared act of ascent. Poised on the road to symbolism,

Gauguin had boldly asserted his art of abstraction as vying with God: "This is the only way of rising toward God—doing as our Divine Master does, create."[67]

In the 1889 Christ painting, Gauguin no longer vies with God but becomes the martyred Son, and the place of the ideal, supernatural order formalized by the abstract red significantly shifts. Once a pervasive cover infusing the whole of the landscape, the vermilion *surnaturelle* is now confined to Christ's head, where it rests as a tight cap hugging the sides of his desolate face. No red field spills over the divide of two zones of the landscape marked by the central tree in Gauguin's *Garden of Olives* of 1889. Where *The Vision* enveloped the setting in red across the barrier of the tree slicing its middle ground, in 1889 Gauguin renders the visual form of the transcendent order as sealed off from incursion into the scene as a whole. The brilliant, unnatural red composes only Christ's head and beard and spills over as flecks and streaks along his cloak sleeves, evoking what might be the sweated drops of blood described in the gospel. The ideal, sacred order can no longer be summoned as vision, but is condensed and concentrated in Christ's isolated state of suffering, withdrawn from this world, to be released only by death.

If, as suggested in Chapter 3, the intensity and peculiarity of Gauguin's vermilion red corresponded to types of red tints newly disseminated in the Epinal prints of Christ's bleeding heart, then Gauguin's 1889 painting shows an interesting reversal. In *The Vision After the Sermon*, the reds spurting blood and staining Christ's shirt in the prints were employed to express the radiant contact with divinity through a communal, transporting piety. As Christ in the Garden of Olives, Gauguin returns the blood of Christ, the red "abstraction" of the symbolist artist, back to Christ's cloak and ragged body, exemplifying the contraction and withdrawal of the ideal to a realm of misery, sacrifice, and loss.

GAUGUIN'S CHRIST, RENAN'S JESUS, AND DUPANLOUP'S THEOLOGY

Gauguin's representation of a personalized, tormented Christ was made possible partly by the subversive cultural work of Ernest Renan, whose 1863 *Vie de Jésus* had brought modern historical scholarship to bear on the life of the Savior, refashioning him as a suffering, mortal man.[68] Gauguin was quite familiar with the Renan book and would discuss it extensively in a long postscript to a polemical essay

he wrote on modern Catholicism some years later. The painter Emile Bernard gave an explicitly Renanist interpretation to Gauguin's 1889 *Christ in the Garden of Olives* self-portrait.[69] A number of Gauguin scholars have suggested some general connections between Gauguin's painting and Renan's text by pointing to the power of Renan's historicizing treatment, which provided vivid details of Christ's "lived" experience and thus may have facilitated capacities to personalize in such a form as Gauguin's self-identification with Christ.[70]

There is another strain in Renan's book that offers a more particular and compelling correspondence between the painter and the philosopher. Not only did Renan present heartrending details of Christ's agonies, he reconceptualized Christ as a carrier of what he called "abstraction," a champion of pure mind and of the absolute ideal, detached from worldly intrusion. This surprising theme of Christ as an idealist in flight from a corrupted world paradoxically coexisted with the positivist and humanist thrust of Renan's project to resituate Jesus in a historical context. Before turning to van Gogh's reactions to Gauguin's depiction of Christ, I want briefly to explore this convergence of "abstraction" in Renan's book and Gauguin's 1889 painting and to suggest their common roots in the Catholic anti-naturalism of Bishop Dupanloup's educational system.

Jesus, in Renan's account, lived for an idea, and acted to impose the purity of that idea on a world inhospitable to it. He proclaimed, wrote Renan, the fundamental and "celestial ideal" of the "royalty of the spirit" and the "kingdom of God."[71] "Resolutely devoted to his idea," Christ rejected all the lures of worldly vanity, not only accepting a life of poverty but "subordinating everything to such a degree that the universe barely existed for him."[72] In Renan's analysis, Christ was an idealist, nourished by the wellsprings of an expansive inner world of thought. This reversion from outer to inner world Renan characterized as Jesus' "total abstraction" from a tainted and sullied world. Repudiating earthly interests, Renan's Jesus is the "individual who has taken the greatest step toward the divine," setting his path to ascend "the columns that reach toward the heavens" and finding his place atop the highest one.[73] Renan presented these qualities of Christ's purity, withdrawal, and ascendant idealism as the true essence of his bequest to the modern world:

> *The sentiment that Jesus introduced to the world is still our own. His perfect idealism is the*
> *highest principle of the disinterested and virtuous life. He created the heavens from pure souls,*

where one can find all that can only be sought in vain on earth: . . . sanctity fulfilled, the total abstraction from the stains of the world, freedom, finally, that existing society excludes as an impossibility, and that has its full amplitude only in the domain of thought. The grand master for all those who take refuge in this ideal paradise is Jesus . . .

In him is concentrated all that is good and exalted in our nature.[74]

The language of ascent, of the bifurcation of terrestrial and ideal realms, of the amplitude of mind, condensing ideal purity in abstraction from a contaminating world—all these bind Gauguin to Renan through the shared encounter with Bishop Dupanloup's Catholic training. Renan, as noted in Chapter 4, experienced the profound anti-naturalism of his Catholic seminary formation and discovered in the habits of self-scrutiny inculcated there a powerful resource for subjectivity, a space for flight to the dream, and what Pommier so aptly called a *repli sur soi*, a folding in on the self.[75] When Renan turned against the official church, he nonetheless wielded some of the intellectual armor he had first absorbed in clerical form from Dupanloup. His radical revision of Christianity, boldly pursuing a historicist account of Jesus "as though he were an ordinary mortal,"[76] sustained the cult of inwardness and otherworldliness instilled in the cloister, transposed to a secular key. Renan's Christ was reborn as an idealist, powered by the fullness of mind and pure freedom even as he was rejected by a hostile world. Gauguin as Christ, withdrawn in suffering and insulated in his cap of iridescent vermilion, offers a kind of pictorial equivalent to Renan's Jesus of soaring freedom and pure intellection, a realm of the ideal that could only supplant the existing world, not be integrated with it. In the heart of two projects—the historian amassing the full weight of scholarly evidence, the painter filling a canvas surface with brush, color, and line—two anti-clerical modernists re-created the idealist and individualist legacies of their French Catholic education.

VAN GOGH'S GETHSEMANE AND RENAN, SPRING 1889

Before learning of Gauguin's self-portrait as Christ in the Garden of Olives, van Gogh had himself been summoning thoughts of Gethsemane, suffering, and the writings of Renan. The months just after

Gauguin's departure from Arles were a period of great difficulty for van Gogh. Gauguin's exit had left him dejected, as well as having to come to terms with dashed hopes for a collective studio in the Yellow House. Despite his efforts to return to a calm state of regular work, some of van Gogh's neighbors signed a petition to have him confined to the Arles hospital, fearing another violent outburst. After a local police investigation, he was forced to leave his studio and home on the rue Lamartine at the end of February 1889. He remained in residence at the Arles hospital until May 1889, when he decided, with Theo's approval, to move for an initial three-month period to an asylum in the nearby town of Saint-Rémy.[77]

Van Gogh absorbed his new condition with remarkable equanimity; his Arles letters to Theo van Gogh and to their sister Wil from February through April of 1889 express little in the way of complaint and despair. The lamentational tone of Gauguin's self-scrutiny after Arles was largely absent from van Gogh's letters, despite circumstances that could have lent themselves to cluster around such a sensibility. Van Gogh wrote to his siblings in this period with a sense of sober realism and wry humor, accepting his situation and describing his stretches of productive work that alternated with a number of unexpected crises marked by fainting, lassitude, and loss of memory. He had only praise and admiration for the resident doctor, whom he called "the worthiest man you could possibly imagine to yourself, the most devoted, the most courageous," and he expressed compassion for the "good women and men" who were his fellow patients. Van Gogh wrote amusedly to Theo and Wil of the worthy doctor's misguided attempts to regulate kissing by warning the residents that "love is a microbe"—to be avoided as an infection. "Certainly kissing is rather indispensable, otherwise serious disorders might result," van Gogh noted.[78]

It was in the midst of this phase of adjusting his work and thoughts to the new realities of the Arles hospital that van Gogh invoked Gethsemane, the place of Christ's anguish and sorrow. He did so, significantly, not as a way to characterize his own state of confinement or distress but to capture the predicament of his sister Wil, who was in the Netherlands at the time nursing a terminally ill woman ravaged by cancer. In a letter to Wil of mid-April, van Gogh wrote, "I think it very brave of you, Sister, not to shrink from this Gethsemane," and tried to comfort her as she encountered the "terrible mystery of these sufferings."[79] The agony of Christ in the garden, which Gauguin had mobilized to dramatize his own sorrowful self-involvement as the tormented and forsaken male genius artist, was here adapted by van Gogh as a metaphor for a woman's anguish as she tried to soothe the mortal pain of another.

In the same letter we see a deepening of the distance between Gauguin's self-dramatizing martyrdom and van Gogh's own very different approach to the meaning of his troubles. The evocation of Wil's Gethsemane did eventually lead van Gogh to consider his own predicament and the state of his affliction. But no new Christ, calvary, or crucifixion appeared here; by contrast, van Gogh acknowledged that he would likely experience more suffering in the months ahead, but then went on to vigorously reject the two stances so elaborately cultivated by Gauguin in 1889, heroism and martyrdom:

> *It is very probable that I will have to suffer a great deal yet. And to tell the honest truth, this does not suit me at all, for under no circumstances do I long for a martyr's career. For I have always sought something different from heroism, which I do not have, which I certainly admire in others, but which, I tell you again, I consider neither my duty nor my ideal.*[80]

Van Gogh prefers modesty, modulation, and self-subordination even in his assessment of his own debilitating illness. We recall Gauguin in this period, deliberately seeking out the "desolate," "lugubrious" Breton landscapes as templates of his own despair and disillusionment, emphasizing in his letters his own mournful calvary, and culminating his lamentational self-involvement by representing himself as Christ in Gethsemane, anguished and insulated in his ideal. Van Gogh could be said to have been closer to the Christ model than his friend Gauguin, who, despite expressions of extravagant moroseness, was still sustained by the company and generosity of friends and fellow painters in the spring, summer, and fall of 1889. Van Gogh in this same period had been abandoned by Gauguin; forced out of his residence by unfriendly neighbors who mocked his foreignness as a Dutchman and labeled him a madman; relocated to the confines of the Arles Hôtel Dieu and then to the cloisters at Saint-Rémy; and obliged to acknowledge his illness and accommodate the pace and schedule of his work to it. Faced with these circumstances, van Gogh embraced what he called the "petit travail de chaque jour" with equanimity and humor; his values and resources led him not to lament his condition but to accept it, with irony and wit, and to take a wider view with some perspective: "Well, it is not always pleasant, but I do my best not to forget altogether how to make contemptuous fun of it. I try to avoid everything that has any connection with heroism or martyrdom; in short, I do my best not to take lugubrious things too lugubriously."[81]

Van Gogh's allusions to Gethsemane and his comments on suffering led him in this same letter from Arles to appeal to Renan, in a final striking contrast to Gauguin. Van Gogh had read a version of Renan's *Vie de Jésus* in 1875, and he had copied out passages from Renan's text, along with those from other writers, as a poetry album he created as a gift for Theo that year. The version read by van Gogh—entitled, simply, *Jésus*—was a popular edition, stripped of some of the exhaustive scholarly notes and rendered in a more accessible and simplified language. Van Gogh's excerpts included those that expressed spiritual ideas in rural and agrarian metaphors, such as a description of the realm of the spirit as a "seed that is scattered, which takes root as a tree that forms shade for the world, and in whose branches birds make their nests." Also highlighted in van Gogh's early reading of Renan was the theme of "the religion of humanity" and the presentation of a social, activist Christ who spoke to ordinary people in the simplest language, and who was "the apotheosis of the weak, love of the people, the experience of the poor, the recovery of all that is humble, true, and simple."[82]

Van Gogh did not reread *Jesus* after that early time, and he referred to Renan only once in his letters before recalling him in two striking ways during the period of his confinement in Arles in April 1888. In a letter to Theo just after the one to Wil, van Gogh reasserted his Renan theme of Christ as a humanist consoler. Writing to Theo about his desire for physical love despite the Arles doctor's warnings about "love as a microbe," he commented: "Isn't Renan's Christ a thousand times more comforting than so many papier mâché Christs that they serve up to you in the . . . churches? And why shouldn't it be so with love?"[83]

Second, and a bit more surprising, is van Gogh's particular emphasis on the expressive forms, and force, of Renan's language. In the April letter to Wil, as noted above, he moved from thinking of Wil's difficult task as a Gethsemane to considering his own situation and the need for distance from any stance of personal martyrdom. It was after this pair of thoughts that van Gogh invoked Renan and his texts. Here he did not allude to Renan's vivid account of Christ's distress or to the agony and desolation of Gethsemane; in fact, he did not mention Christ at all in the letter. He concentrated instead on the qualities of Renan as a writer. Van Gogh credited Renan with opening up for him the natural beauty of the Provençal landscape, rendered as a plausible and inviting space for the enactment of sacred history. Further, van Gogh isolated Renan's aesthetic powers, the beautiful *sound* of the words the writer chose as evocative forms of representation. He wrote to Wil:

I haven't reread the excellent books by Renan, but how often I think of them here, where we have olive trees and other characteristic plants, and the blue sky . . .

Oh, how right Renan is, and how beautiful that work of his, in which he speaks to us in a French that nobody else speaks. A French that contains, in the sound of the words, *the blue sky, the soft rustling of the olive trees, and finally a thousand* true *and* explanatory *things which give his History the character of a Resurrection.*[84]

Van Gogh applauded Renan for a certain realism, his ability to capture the "characteristic" types of plants, trees, and skies plausibly inhabited by a company of ancient peoples. But it was the beauty and sound of the words that, to van Gogh, vivified the landscape and conveyed the truth of Renan's account. Van Gogh did not mention the way Renan's narrative described Christ's Passion, mistreatment, and Resurrection; instead he redefined Renan's book as itself bearing "the character of a Resurrection," fueled by the combination of its historical embeddedness and its expressive, aesthetically powerful language. It was Renan's text, not Christ's body, that was the site of Resurrection, in van Gogh's understanding, a text that offered an abundance of "true and explanatory things" in evocative forms that sounded for the reader the rustling of olive trees and caught the tone of blue skies. Later van Gogh restated this quality of Renan's language by noting to Theo that "we are moved by the sound of the pure French of Renan," for Renan used "beautiful words plentifully and pleasurably . . . the words are beautiful there."[85]

Attributing divinity to books and pictures had been proposed by Dutch modern theologians and adapted by van Gogh, as we saw in Chapter 5; so, too, was an emphasis on Christ as an artist, whom van Gogh reaffirmed in Arles as "a pure creative power," to be emulated through artistic expression and a "passion for reality." In recalling Renan's *Jesus,* van Gogh identified the work not as a history or a dramatization of individual suffering but as a modern embodiment of Christ's communicative powers, whose truthful and beautiful words were the model for a resurrection through art, making the past present. Renan's gripping psychological portrait of Christ as a mortal man tormented, and the currents in his work suggesting Christ as an absolute idealist devoted to the amplitude of pure thought, may have provided Gauguin with the intellectual tools with which to devise his own portrait as the new Christ in the Garden of Olives. But the themes of anguished isolation, and the resolute insulation of the ideal as

Christ's legacy, held no appeal for van Gogh, even in the state of his own wrenching personal difficulties. Van Gogh's early mental filters and his Arles memory of Renan acted to reject imitation for emulation, and to assert Christ not as the apotheosis of a new *repli sur soi* but as the catalyst for extending comfort and consolation in the world of nature and human experience through the plenitude of communication in beautiful, simple, and pleasurable forms.

VAN GOGH'S ATTACK ON GAUGUIN'S AND BERNARD'S NEW RELIGIOUS IMAGERY

Gethsemane applied to nursing the sick, attenuated self-scrutiny, memories of Renan's Christ as comforter and of Renan the writer as poetic naturalist—these features of van Gogh's ideas set the terms for his vehement criticism of Gauguin's *Christ* in the late fall of 1889. In the next chapter I will turn to an exploration of the art van Gogh produced after Gauguin's departure, when he worked through the challenges of both avant-garde and local Provençal Catholicism by devising a new type of sacred, consoling realism in portraiture, woven forms, and popular prints. In the concluding

FIG. 127. PAUL GAUGUIN, LETTER TO VINCENT VAN GOGH WITH SKETCHES OF *SOYEZ AMOUREUSES* AND *CHRIST IN THE GARDEN OF OLIVES*, 1889. Van Gogh Museum, Amsterdam (Vincent van Gogh Foundation)

section of this chapter, however, I want to pause to view van Gogh's response in his letters to the increasing turn to religious subjects by both Gauguin and Bernard in 1889, and his emphatic definition of the fundamental dissonance between modern experience and biblical models. These letters have often been cited, but they have not been related to the continuity of van Gogh's ideas nor to their connections to the specific Dutch cultural setting in which debates about modern faith and representation had abounded. The terms in which van Gogh mounted his arguments against his colleagues' new use of religious iconography resonated with the themes of the movement to modernize the passions in the Dutch theology of art, which had also partly shaped his artistic program of "rendering the infinite tangible."

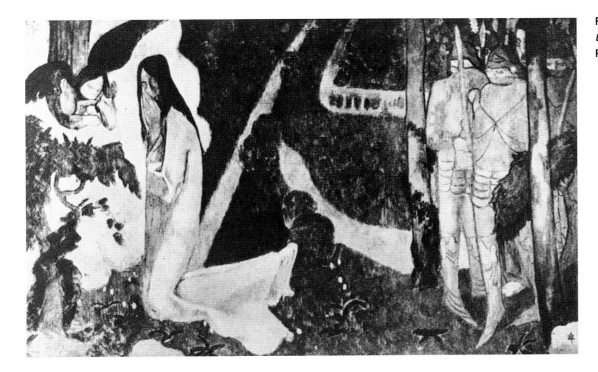

Van Gogh expressed concern for Gauguin's unrelieved mood of despair in this period, writing to Theo of his friend's sorrows and noting how unfortunate it was "for so powerful a man to be almost helpless."[86] But his compassion for Gauguin's misfortunes did not extend to approval of his choice of religious imagery. In the first weeks of November 1889, Gauguin had written a long letter to van Gogh from Le Pouldu (Fig. 127) that included descriptions and sketches of two works, one of which was his painting *Christ in the Garden of Olives*.[87] At that same time, Bernard wrote to van Gogh communicating his own renewed attempts at religious art and said that he was sending along photographs of his biblical themes, including his version of a painting entitled *Christ in the Garden of Olives* (Fig. 128).[88] Van Gogh responded to each of these missives with exasperation and some anger, the sharpest expression of his divergent approach to binding the visual and the sacred since the beginning of his association with these two comrades.

The long letter he wrote to Gauguin is lost, but van Gogh restated some of its contents in letters

to Theo. "I am not an admirer of Gauguin's *Christ in the Garden of Olives,*" van Gogh wrote, nor was he pleased to hear of Bernard's recent work; "I have never taken any stock in their biblical interpretations."[89] Particularly enraging to van Gogh, given his own immersion in observing the olive trees and olive gatherers that surrounded him in Saint-Rémy, was that his friends painted their Christs in the garden "with nothing really observed."[90] The pictures looked as if the painters had "never seen an olive tree," nor asked the essential question "Who are the human beings that actually live among the olive . . . orchards?"[91] Van Gogh affirmed that "of course with me there is no question of doing anything from the Bible," and he told Theo that "I have written to Bernard and Gauguin too that I consider that our duty is thinking, not dreaming, so that when looking at their work I was astonished at their letting themselves go like that."[92]

Van Gogh linked his attack on the new Christs in the garden to a discussion of rejecting biblical models while searching for their modern equivalents. He reminded Theo of his admiration for the way Rembrandt, Delacroix, and even the Pre-Raphaelites had handled religious subjects, but, he wrote, "Stop there! I do not want to resume this chapter."[93] Such a return to religious subjects pointed to "decline rather than progress." In contrast to his friends' "astonishing" regression, van Gogh claimed absorption in nature as the guide to modern forms of expression. Here he affirmed an approach that was the reverse of his comrades'—moving from nature to composition rather than imposing the artistic idea on nature. You must "learn to *know* a country" first, noted van Gogh, "to work assiduously from nature" without presuming beforehand what it is you choose to do.[94]

Van Gogh explained to Theo that he himself was just beginning, after patient, repeated, and diligent experience of the landscape, to capture the characteristics of the local olive trees in a series of images. "It is perhaps better to attack things with simplicity than to seek after abstractions," he commented. Clarifying his divergence from his colleagues' religious works with their erudition and implausibility, he remarked: "What I have done is a rather hard and coarse reality beside their abstractions, but it will have a rustic quality, and will smell of the earth." Painters "*must* work as much and with as few pretensions as a peasant if we want to last," he emphasized. "You work as if you were making a pair of shoes, without artistic preoccupations."[95]

Yet van Gogh's celebration of rural simplicity did not propose a naive realism as the alternative to his friends' religious fantasies. He expressed a different route to the sacred from the mystical martyr-

dom now represented by the avant-garde Catholics, a route that nonetheless bound the real and the eternal in its own distinctive ways. The letters criticizing the *Christ in the Garden* paintings by his friends allowed van Gogh to explore the possibility of a painting of his own that could evoke spiritual truths through nature and human figures. In defining how to move forward from the religious art of the past, he maintained that "if I stay here, I shall not try to paint Christ in the Garden of Olives, but the glowing of the olives as you still see it, giving nevertheless the exact proportions of the human figure in it, perhaps that would make people think."[96] Glowing olives and the proportions of a human figure offered a plausible and truthful rendering of an inhabited landscape, a modern setting that might suggest a sacred past and present to the viewer, much in the way van Gogh considered Renan's landscape descriptions "a Resurrection."

A final trace of van Gogh's alternative to Gauguin's Christ emerged in his statement that his images, laden with "coarse reality" and the "smell of earth," would express what he called the essential "symbolic language" of their subjects, such as the olive tree or the cypress particular to Provence. Here van Gogh invoked Millet, whom he called "the voice of the wheat," hoping that his own olive trees would also speak through his pigment.[97] Where Gauguin captured the grieving, silent Christ in the garden, van Gogh affirmed the artist's power to release the voice of nature, a totality charged with meaning beyond the visible. His stance echoed that of Reverend Allard Pierson, who had challenged the artist to ring out the sounds and symbols of a divinized nature in new forms of representation. Van Gogh's rejection of the depiction of Christ by his fellow artists reengaged the Dutch modernist ideas of the artist as activator of the "secret language of nature," who chose the leaves, stars, and grainfields as the source of eternity in the ground and tangibility of the real.

Van Gogh concluded his critique of the new religious subjects in a letter to Bernard in December. In his earlier discussions with Bernard in 1888, van Gogh had warned against the "sterile metaphysical meditations" he regarded in the appeal to explicitly biblical compositions. Now van Gogh attacked Bernard's *Christ in the Garden of Olives* as a "nightmare," "bizarre and highly debatable": "My goodness, I mourn over it, and so . . . I ask you again, roaring my loudest, and calling you all kinds of names with the full power of my lungs—to be so kind as to become your own self again a little."[98] He, too, cherished the Bible, van Gogh acknowledged, but not as a static template or source of subjects. Reaffirming a key idea of the new Dutch theology, he wrote that modern reality, and modern passions, had over-

taken biblical foundations for emotion and meditation; the Bible was a historical artifact and could be only an "abstraction" to contemporary individuals:

> *Undoubtedly it is wise and proper to be moved by the Bible, but modern reality has got such a hold on us that, even when we attempt to reconstruct the ancient days in our thoughts abstractly, the minor events of our lives tear us away from our meditations, and our own adventures thrust us back into our personal sensations—joy, boredom, suffering, anger, or a smile.*[99]

As these "modern sensations, common to us all, predominate," declared van Gogh to Bernard, your "Biblical pictures are a failure."[100] He proposed, in contrast, a route to elicit such shared emotional states through the combination of observed motifs and evocative forms. Van Gogh described to Bernard two canvases he was then working on, one a view of the park at the Saint-Rémy asylum, featuring the large trunk of an enormous tree, struck by lightning and sawed off, and composed in tones of red-ocher, black, and green; the second a painting of a "sun rising over a field of young wheat," rendered in yellow and violets, with lines fleeting away toward a "white sun surrounded by a great yellow halo."[101] These two canvases, van Gogh explained to his friend, modernized biblical texts in unprecedented ways, affording a new universal language of feeling that was conveyed in earlier times by the New Testament accounts of the life and Passion of Christ, but which now demanded modern equivalents: "I am telling you about these two canvases . . . to remind you that one can try to give an impression of anguish without aiming straight at the Garden of Gethsemane; that it is not necessary to portray the characters of the Sermon on the Mount in order to produce a consoling and gentle motif."[102]

Van Gogh had developed these ideas about landscape after assembling a series of female portraits to which he attributed a specifically consolational and spiritual function. These portraits, multiple images of Madame Augustine Roulin as a cradle rocker, represented van Gogh's final tribute to Gauguin; they also culminated van Gogh's development of a Protestant counterimagery to the dynamic supernaturalism he had uneasily encountered in Provençal Catholic culture. In the next chapter I will look closely at the portraits and the ideas van Gogh expressed about them as modern sacred art.

CHAPTER ELEVEN Van Gogh's *Berceuse*

During the months after Arles when Gauguin was producing multiple images of a misery-laden, isolated female, Vincent van Gogh embarked on his own major project of repetition: he created five nearly identical versions, in oil, of a maternal image to which he attributed great significance. All the portraits that made up this series were of Madame Augustine Roulin, seated in front of brightly colored wallpaper and holding a cradle rope to rock her baby daughter (Fig. 129). Between late December 1888 and May 1889, while Gauguin featured a range of desolate females hunched in the fetal pose of a Peruvian burial mummy, van Gogh explored his image of regeneration and maternal comfort, which he named *La Berceuse*. Van Gogh's extensive commentary in his letters about the form and meaning of the portrait, including proposals for its setting and intended popular audience, suggests that he considered *La Berceuse* the apotheosis of a consolational painting, with consolation conveyed through the unity of radiant, complementary colors, interlinked canvases, and familiar, humble subjects. In *La Berceuse*, van Gogh identified the expressive force of consolation in a new site: explicitly evoking the format of traditional religious art, he devised a plan for *La Berceuse* as the central panel of a triptych, flanked by glowing beacons of the sunflowers on each side.

This chapter will look closely at the development of the *Berceuse* paintings as a series and within a triptych ensemble, in relation to three overlapping themes. First, *La Berceuse* absorbed van Gogh's experience of loss, rupture, and change in his most significant personal relationships, not only with Gauguin but with his brother Theo and the Roulin family. These numerous personal disruptions coincided with the weeks celebrating the Nativity in Arles, a period dominated by particular types of craft, commercial, and theatrical culture concretizing the tender inclusiveness of the holy family. Second, van Gogh's *Berceuse* responded to the challenge of Gauguin's techniques of "abstraction" while adapting

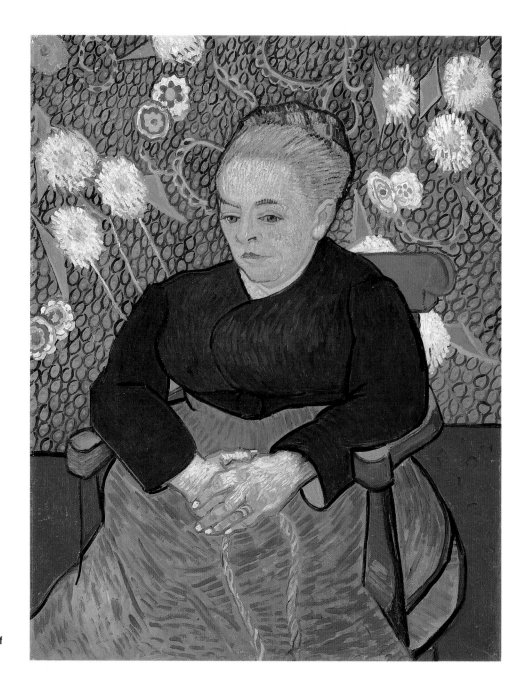

FIG. 129. VINCENT VAN GOGH, *LA BERCEUSE*, 1889, oil on canvas, 92.7 x 72.8 cm. Museum of Fine Arts, Boston, bequest of John T. Spaulding

them to his own idiom of portraiture, popular prints, and textrous brush. Third, *La Berceuse* drew on long-term elements and new sources for its visual and symbolic coherence. Among the new sources were those van Gogh absorbed from local Catholic popular culture in and around Arles, such as a Nativity play he attended and a genre of votive imagery of female saints safeguarding the seas. These regionally specific resonances in the portrait, which have never before been identified, add powerful new evidence to a general claim that *La Berceuse* is a type of devotional image or Madonna-like icon. The chapter ends, then, by interpreting the *Berceuse* series as a secular and particularly Protestant devotional imagery, built, paradoxically, on materials van Gogh absorbed from Provençal Catholic culture. The dual pressures of Gauguin's fresco art of redemptive suffering and the concrete supernaturalism of popular Catholic piety propelled van Gogh to develop his own form of modernist sacred realism in 1889.

TIMING

La Berceuse grew out of a portrait group of the entire Roulin family that van Gogh began in late November 1888 and pursued in the first weeks of December. Van Gogh embraced this work, as mentioned earlier, as an antidote to his difficulties with Gauguin's bid to devise images from the imagination. In his letter to Theo of about December 4, van Gogh noted that he needed much more practice to master this tricky direction of Gauguin's; by contrast, he wrote enthusiastically that he had just "made portraits *of a whole family*," that of his closest friend in Arles, the postal employee Joseph Roulin—"the man, his wife, the baby, the little boy, and the boy of sixteen." These posed subjects brought van Gogh back to an anchored ground of human likeness and contact. His letter expressed relief and excitement. "You know how I feel about this" and "how I feel in my element," van Gogh commented to Theo about the family portraits.[1] At least two of these canvases were depictions of Madame Roulin and the new baby, Marcelle; van Gogh also painted at about this time some smaller canvas versions of the healthy, pudgy infant, gazing out intently at the artist and viewer.

La Berceuse thus began as an extension of the portrait gallery of the Roulins, but this portrait was very different, and developed as a series on its own, with distinctive forms and allusions. The timing and

circumstances of van Gogh's creation of this image are critical features of its unique qualities. He started working on the new portrait of Mme Roulin before Christmas, most likely during the weeks before the violent conflict with Gauguin on December 23. He returned to complete the painting in January, as he was convalescing, and it was during this period that he expressed a cluster of ideas about the finished painting in a series of letters written about January 23. By the end of January, van Gogh had made a second and a third version of *La Berceuse*, and he started a fourth on February 3. He completed the fourth one about February 22, after a two-week period when he was rehospitalized for "mental distress." Van Gogh produced a fifth copy of the painting at the end of March. The month that elapsed from the fourth to the fifth repetition included another period of internment in the Arles hospital and the painful interlude of being locked out of the Yellow House by local police, goaded by suspicious neighbors.[2]

Van Gogh's engagement with the *Berceuse* series thus had an obvious and pivotal position as it spanned the period before and just after his Arles mental crisis. But the paintings were also situated in a period of momentous change in van Gogh's three sustaining relationships, whose simultaneous disruptions themselves contributed to his breakdown and intensified the image as a psychological hub of healing and consolation. Before turning to a description of the paintings and the ideas van Gogh associated with them, I must briefly trace these changes, which converged in the month of January 1889, as van Gogh was completing the first version and two additional copies of the painting. These affective changes set one immediate context for the evolution of *La Berceuse*, and they provoked van Gogh to join the personal to the sacred in images of a cradle-lulling mother and wife.

RUPTURED RELATIONSHIPS

The abrupt separation from Gauguin provided one of the altered relationships percolating in the production of the *Berceuse* portraits. As we saw in Chapter 10, van Gogh did not express bitterness at Gauguin's departure, and the two painters resumed their correspondence. Van Gogh's January letters to Theo show irony and some humor in pointing out Gauguin's irresponsibility and "Bonaparte-like" desertion of the troops; they also include some comments of praise and approval for Gauguin's new plans.[3] A letter van Gogh sent to Gauguin about January 4, just after he left the hospital the first time,

conveyed to his friend "words of a very deep and sincere friendship" and wishes for his "prosperity in Paris."[4] Van Gogh's great disappointment about the split was registered, however, in his sense that Gauguin's exit shattered the hopes for a community of artists in the Yellow House, and he felt a great sadness, he wrote Theo, that "the union broke up."[5]

Gauguin's departure also reminded van Gogh of Gauguin's generativity, and especially of his status as a family man. Van Gogh wrote to Theo on January 17 of Gauguin's superior physical strength and passion, channeled to productive effect as he was "a father," with "a wife and children," as well as a maker of pictures.[6]

Family, legacy, and shifting the balance of interdependence were also troublingly at issue for van Gogh as he faced the news in January that his brother Theo planned to marry. On January 2, as he adjusted to Gauguin's absence, van Gogh wrote Theo that he "read and re-read" a letter about Theo's meeting with his prospective in-laws, the Bongers. On January 9, Theo's fiancée, Johanna Bonger, wrote directly to Vincent announcing the engagement.[7]

Van Gogh responded to the tidings with great pleasure as well as with apprehension at being displaced. The January weeks he worked on *La Berceuse* were also those in which he expressed new urgency about his future financial reliance on his brother, guilt over increased expenditures, and fear that Theo would direct his emotional and financial priorities away from him. Van Gogh was eager to specify to Theo, for example, that with Gauguin's departure he expected to return to their prior arrangement that Theo send him 150 francs per month, though he soon adjusted this to a request for 250 francs.[8] Van Gogh combined these claims with statements of guilt over the unrecoverable expenses that Theo had laid out for the Yellow House, as well as added sums that had mounted during his hospitalization.[9] He channeled these misgivings by resurrecting the payback plans he had had just before Gauguin arrived in Arles: van Gogh announced that he would "pay back the money invested" in the making of his pictures either "in goods" or by eventual sales, so that Theo would be compensated. "I will give you the money back or give up the ghost," he wrote to Theo on January 28. With the impending marriage, van Gogh even proposed that Theo and his new wife establish their own commercial art house, and that he, Vincent, would assume what he called "the position of a painting employee, as long as there is enough to pay one," thereby installing himself in his brother's new household and his employ.[10]

These indications of van Gogh's financial concerns and proposals to join the engaged couple as a

brother-"employee" reverberated with van Gogh's unease over Theo's attachment and future with a new family. Van Gogh mixed an appreciation of what he called the "tender-hearted" Johanna with a wistful recognition that there would be others bearing claims on Theo's support and that Theo would no longer be alone, thus putting an end to a parallel between the brothers that had always comforted van Gogh. "With your wife you will not be lonely anymore," he noted in a January 19 letter; and then, "when you are married, perhaps there will be others in the family."[11] While Theo would remain unconditionally loving and supportive to Vincent, and Johanna would in fact be inordinately sensitive to the special status of the brothers' relationship, the realignment of attachments provoked by Theo's engagement added another level of emotional weight to the evolution of *La Berceuse*.

A final event sealed a third level of personal significance for the painting. Van Gogh discovered in mid-January that Joseph Roulin would be leaving Arles, as he was being transferred to Marseille for a higher-paying job in the government postal service he had worked in for so many years.[12] The rest of the Roulin family—mother and three children—would remain in Arles, to join the father at a later time. The impending loss of his most loyal friend in Arles was an unexpected and added blow to van Gogh.

An employee of the postal service at the Arles train station, Joseph Roulin had likely first met van Gogh at the Café de la Gare, and he and his family lived a few blocks from the Yellow House. Van Gogh admired his tall physique, his ardent republicanism, and what van Gogh described as a Socrates-like wisdom and patience.[13] Van Gogh vividly portrayed in a letter to Wil how Roulin refused to have his new baby baptized in church, insisting on baptizing the child himself at a christening feast that the family had at home.[14]

Joseph Roulin played a pivotal role throughout van Gogh's time in Arles, but especially after the rift with Gauguin. It was Roulin who took responsibility for van Gogh's hospital stay and recovery from his injuries. Mme Roulin and Joseph were his first visitors while he was in the hospital, and it was Joseph Roulin who, through letters, kept Theo apprised of van Gogh's progress and who accompanied him back to the Yellow House on his release. And Roulin kept van Gogh company during those first weeks back from the hospital, January 7 to 20, when he was still fragile but resuming his painting.[15]

Roulin's letters to Theo show earnest affection for Vincent and happiness at his recovery; he always referred to him as "mon ami Vincent."[16] Van Gogh considered Roulin a critical anchor in this period and wrote to Theo appreciatively on January 2, 7, and 17 that "Roulin has been truly kind" and

"has often kept me company"; he "has been splendid to me, and I dare say that he will remain a lasting friend."[17] But Roulin left Arles for the new position in Marseille on January 21.

Joseph Roulin's departure affected van Gogh deeply. He wrote to Theo of Roulin's devotion as a father and husband, noting that "both he and his wife are heartbroken" over the separation.[18] Observing the family at close range prompted van Gogh to associate the Roulins with his own parents. He wrote to Theo that "as a married couple our parents were exemplary, like Roulin and his wife." Memories of his mother in Zundert were included in the January letter that also discussed Theo's impending marriage and the painful fragmentation of the Roulin family unit.[19]

The period of genesis of the first *Berceuse* and the next two versions was thus one of unprecedented transformation in van Gogh's immediate web of personal relations. The ideal of an artists' colony shattered as the collaboration with Gauguin came apart; Theo was embarking on a new phase in his life; and what van Gogh considered his surrogate family in Arles, the Roulins, was dispersing. In his letters that month van Gogh was absorbed by themes of family, marriage, and future forms of connectedness as he saw his own financial and emotional anchors slipping away.

These psychological shockwaves were important elements in van Gogh's frame of mind as he devised and copied the portrait of Mme Roulin as a cradle rocker. But van Gogh approached the image to resolve an urgent set of visual problems that followed from his interaction with Gauguin. *La Berceuse* represented van Gogh's most explicit attempt to incorporate some of Gauguin's technical innovations while deepening his own distinctive search for a universal language of expressive forms. In *La Berceuse* van Gogh sought to connect what he considered a musical range of color tones with the immediacy and crudeness of popular prints, affording two kinds of direct, unmediated access to a consolational force he aimed to be conveyed by the image.

STYLISTIC FORM AND CONTENT

The composition reveals a number of interesting features, which I will highlight in what is considered to be the first version of the portrait—the *Berceuse* in the Boston Museum of Fine Arts (Fig. 129). The other four, in the most likely chronological order, are the painting in the Chicago Art Institute; the

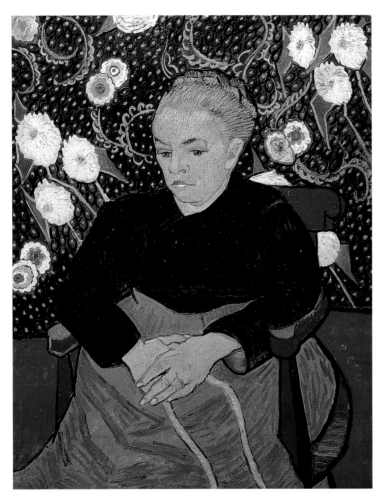

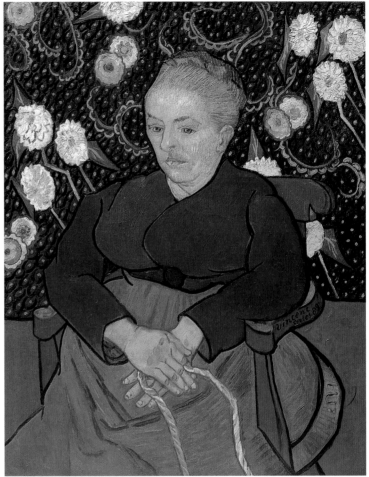

LEFT **FIG. 130. VINCENT VAN GOGH**, *LA BERCEUSE*, 1889, oil on canvas, 92.7 x 73.8 cm. Helen Birch Bartlett Memorial Collection, 1926.200. Photograph © 1999, The Art Institute of Chicago, all rights reserved

RIGHT **FIG. 131. VINCENT VAN GOGH**, *LA BERCEUSE*, 1889, oil on canvas, 92.7 x 73.7 cm. The Metropolitan Museum of Art, The Walter H. and Lenore Annenberg Collection, partial gift of Walter H. and Lenore Annenberg, 1996 (1996.436). Photograph © 1994, The Metropolitan Museum of Art

Annenberg Collection portrait; the Stedelijk version; and the final repetition in the Kröller-Müller collection (Figs. 130–133).[20] All five versions share the frontal pose and wallpaper surround, although there are slight variations in color, brushwork, and, in one case, the direction of the folding hands.[21] The formal qualities I will explore in the first version are present in the other four as well.

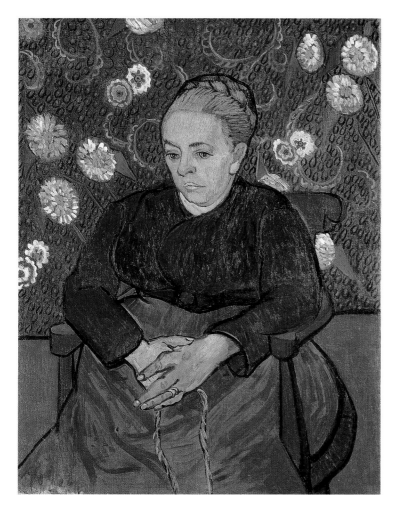

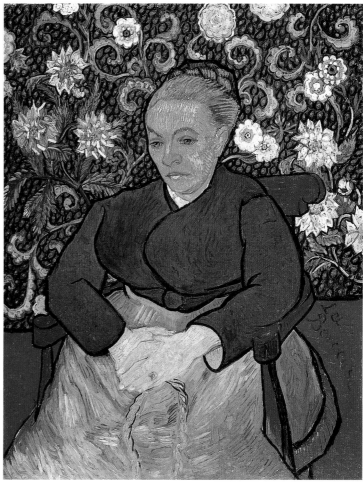

The painting sustains a tension between flatness and relief in its surface treatment. On the one hand, van Gogh composed Madame Roulin simply and synthetically. The figure is outlined in black, most noticeably in the areas around the head, shoulders, and bodice, which gives it a partially flattened, cut-out quality. This is especially marked in the way the black contours form a kind of level inset for the head against the back wallpaper. A black paint line also marks the division between the floor and the background wall, as well as the borders of the chair and Madame's skirt. Van Gogh fills some of these

LEFT **FIG. 132. VINCENT VAN GOGH,** *LA BERCEUSE*, 1889, oil on canvas, 91 x 71.5 cm. Stedelijk Museum, Amsterdam, on loan to the Van Gogh Museum

RIGHT **FIG. 133. VINCENT VAN GOGH,** *LA BERCEUSE*, 1889, oil on canvas, 92 x 73 cm. Kröller-Müller Museum, Otterlo, Netherlands

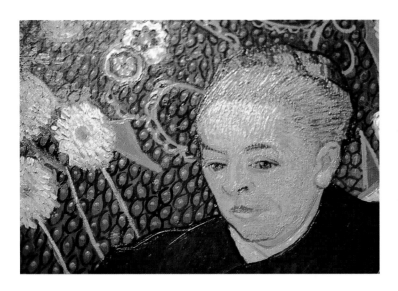

areas inside the outlines with a single range of color, such as what he called the "vermilion" base "simply representing a tiled or stone floor" and the figure's olive-green bodice.[22] The bright red flooring is coated with color and shows a relatively unbroken surface, devoid, for example, of the gridding that might define a tile floor. Van Gogh rubbed in the title "La Berceuse" in cursive script over the red paint on the lower right. The left area of the red floor does, however, show some hatched brushmarks. And throughout the painting van Gogh followed his abiding insistence on the pairing of complementary colors for his choice of pigments, with particular emphasis on the association of red and green.

Van Gogh's use of black outlines and the filling of single colors within them have rightly been attributed to the impact of Gauguin, and *La Berceuse* announces in these ways the most extensive emulation of Gauguin's style. The black contour and uniform color field, as mentioned earlier, were hallmarks of Gauguin's cloisonism, in which color masses were enclosed within black borders as in enameling or stained glass.[23] But van Gogh took these techniques in very different directions from Gauguin, who sought attenuated surfaces and thin washes of color to compose his allegorical female nudes of 1889. Van Gogh, by contrast, alternated relatively flat, unbroken surfaces with thick, relief-like areas of dense paint and robust physiognomy as he attempted to capture the character of the subject seated before him.

If the top of the head with its black outline suggests a level inset, the plaited crown of hair and the face and neck of the figure protrude off the canvas in thick, dense, glossy paint layers. The face and hair bristle with texture and tangibility; the extension of skin to hair even appears as would a cover of fur (Fig. 134). Van Gogh applies orange, yellow, and red strokes to mold the hair in an active, directional packing that loads the surface in a raised, brittle, and resinous glow. The horizontal web of hair at Mme Roulin's left temple meets the forehead in a yellow paint crust that van Gogh overlays with vertical yellow streaking, creating a hub of intermeshing, like a knitted brow. The luminous face is colored in a heavy, ruddy glaze of chrome-yellow layers, resembling the chafed, sunblasted head of the Arles peasant van Gogh composed as bearing on his skin the furnace-fire heat of the Arles fields some months

earlier (Fig. 6).[24] To depict the eyebrows of Mme Roulin, van Gogh has lightly hatched the surface with delicate brown interlocking brushstrokes, visibly marking a set of horizontal lines overlaid with vertical combs.

In the dense yellow paint pack of the face, van Gogh has set some red paint strokes along the left cheek to break up the field, echoing the crimson lips he carefully defined just below. Adhering to his laws of contrast, van Gogh has placed a dab of bright red paint in the corner of Madame's green left eye; this enhances the visual interest of the eyes, in which van Gogh has carefully rendered the pupils.

The wallpaper behind Mme Roulin swirls with activity and multiple surface effects. Provençal wallpaper most likely covered some areas in the Roulin home, but van Gogh has taken liberties in his handling. A swath of bright bluish green is covered with a profusion of small, linking darker blue ovals, each one dotted with a sedimented circle of orange.[25] This micropattern of orange spots and blue in each inlet of the wallpaper extends the complementary pairing of red and green that animates the composition as a whole. A third layer of visual momentum is splayed across this second tier in the flower motifs that van Gogh painted in thick and floating bunches. The white and pink clusters, which van Gogh referred to as dahlias, bear heavy impasto and bend kinetically toward the left. Other shapes abound, some with a red paint ring and yellow inside; others, neither flowers nor stems, are trellis-like curls that coil about the sitter's head. A cluster of white floral sprays with two green stem wings appears behind Mme Roulin, as if connected to her chair, adding to the propulsive activity moving about the wall.

Van Gogh painted Mme Roulin's upper body in dark olive clothing, outlined in black, with some brushing in of a lighter olive shade marking the center. He continues this darker range in ballooning curves to the waist. The lower part of the figure, with Madame's expansive bright green skirt, is more streaked and striated over the broad paint cover. Here van Gogh applies vertical marks down to the hands, below which arcing strokes follow the contours of the body.

The hub of the whole picture rests in Mme Roulin's folded hands. Here the Gauguinesque outlining and single, unmodulated color mass technique utterly breaks down, as a welter of hatches, streaks, and color lines press against the borders designed to contain them. Van Gogh composes Mme Roulin's hands as quite large, even distended, and her fingers appear big and knobby. Her left index finger shows swollen bumps; her middle finger reveals the jagged joints. The rough and oversize hands were also a feature of van Gogh's portraits of Joseph Roulin. In presenting both husband and wife in

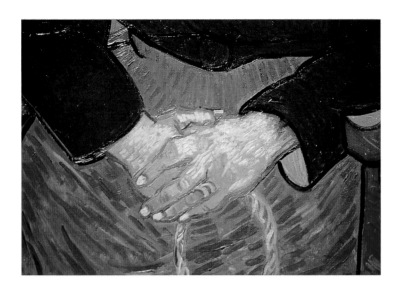

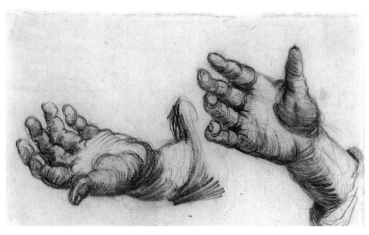

this way, van Gogh connected them to other humble people, especially the peasants in *The Potato Eaters*, whose distended hands were also a deliberate exaggeration. Mme Roulin's bulky, knobby hands express, in another color range, the value that van Gogh had explored in his early series of studies of gnarled, swollen, and roughened hands leading up to those of the subjects of *The Potato Eaters*—"hands that showed they had worked" (Figs. 135 and 136). In *La Berceuse*, Mme Roulin's powerful, well-worn hands attach to the cradle rope, linking her beyond the frame to the site of her work and duties.[26]

Whereas Madame Roulin's hands are joined to her activity as cradle rocker and her eyes look resolutely outward, think of the hands and eyes in the female figures that Gauguin created in 1889. The Eve figure in his *Breton Eve* watercolor and pastel (Fig. 110) is hunched up, closed off, her eyes hollow sockets; with her arms and hands pulled up to close off her ears, her body is coiled around the woeful wail at the center of her being and of Gauguin's association with the allegorical *misère*. A similar stance of tense closing off is evident in Gauguin's nude figure in *La Mort* (Fig. 113); her eyes, too, are hollowed out and carry no capacity for Mme Roulin's outward gaze. The hands in Gauguin's *Breton Eve* offer the most striking contrast to those in *La Berceuse*. Gauguin's nude sufferer shows flimsy, malformed, flattened arms and hands, lacking definition in the fingers and composed as a propping support to the lamentational head. The strength, activity, and connectedness of Mme Roulin is expressed by van Gogh in her weathered, distorted hands, with full definition of parts from joints to cuticles, and wedding ring visible. Where all the figural elements and surface treatment

pull inward in Gauguin's chalky, featureless Eve, the force of figure and surface in van Gogh's portrait moves outward, with locking eyes and heavy, productive hands.

FORM, CONTENT, AND MEANING: VAN GOGH'S COMMENTARY

Van Gogh provided unusually extensive commentary on the meaning and associations of *La Berceuse* in the period he created and repeatedly copied it. His letters of late January highlight a cluster of themes suggesting how he moved from portrait to symbolic ensemble and from an impetus for personal healing to a search for a universal language of spiritual comfort and expressive color.[27]

Van Gogh first discussed the title of the painting and its dual meaning in a letter of about January 23 to a Dutch colleague, the painter A. H. Koning, who had sent him New Year's greetings. He wrote that he had on his easel "the portrait of a woman," her "hands holding the rope of the cradle." As he explained, "I call it 'La Berceuse,' or as we say in Dutch . . . 'our lullaby or the woman rocking the cradle.' "[28] The French term *berceuse* has a dual connotation, meaning both the woman who rocks the cradle and the lullaby she sings beside it.[29] The letter to Koning emphasized the color choices and interactions, from the green dress ranging from olive to malachite; to the orange hair in plaits; to the chrome-yellow complexion of the figure. Van Gogh noted the vermilion background of the floor and the green, orange, and blues of the wallpaper, all carefully "calculated." He concluded his comments on *La Berceuse* to Koning by alluding to a musical analogy, stating that "whether I really sang a lullaby in colors is something I leave to the critics."[30]

The same day as he wrote to Koning, van Gogh sent a letter to Gauguin in which he explored the meaning of *La Berceuse*. This letter indicates how the painting was bound up with the debates and discussions of the Arles months with Gauguin, and it also registers van Gogh's remorse and hopes for reconciliation. More wide-ranging than the letter to Koning, the one to Gauguin integrates allusions to the multiple fissures in van Gogh's personal relationships—his relationships with Gauguin, Theo, the Roulins—with his evolving ideal of the independent, musical power of his visual forms and the possible consolational force of the picture for ordinary people as well as artist-brothers.

Gauguin had written to van Gogh in the weeks just after their quarrel, and van Gogh's letter marked his own attempts at restoring their friendship. He began the letter evoking the theme of loss and departure, reporting that he was now alone in the Yellow House and absorbing the *départ des amis*. His use of the plural, *friends* exiting, represented Joseph Roulin's departure just after Gauguin's, and van Gogh proceeded to give Gauguin a vivid picture of the last days Roulin spent with his family before his relocation to Marseille for his new job. Van Gogh related the poignant scene of Roulin singing to his baby Marcelle, in a voice "with a strange timbre" that sounded to van Gogh like "the voice of a cradle-rocker or a heartbroken nurse [*de la voix d'une berceuse ou d'une nourrice navrée*]," which then shifted to another tone, "like a trumpet of France." Before he discussed art in this letter to Gauguin, van Gogh characterized Joseph Roulin as a tender *berceuse* who sang a sorrowful song to the baby he was about to leave behind.[31]

Van Gogh went on to describe the painting of Madame Roulin that he was now completing. He emphasized its formal qualities as a unity of interacting color tones, "the reds going to pure oranges, rising even more in the flesh colors as far as the chromes, merging into pinks and combining with olive and malachite greens." As an "arrangement of colors," van Gogh asserted, "I have never invented anything better."[32] By highlighting this aspect of the painting, van Gogh affirmed an interest that he and Gauguin had in common. But van Gogh's search for a language of colors settled, as it had throughout his relationship with Gauguin, in the terrain of interdependence and the intermingling of colors with one another, an adaptation of Chevreul's laws of contrast. Van Gogh's letter relied on the terms at the heart of Chevreul's system—the terms of the mutual "exaltation" of colors (*couleurs . . . s'exaltant*) and his own habit of imagining colors uniting in complementarity and contrast as in marriage (*les roses . . . se mariant aux verts*). Earlier in Arles, van Gogh had identified the study of color tones as encompassing "a wedding [*un mariage*] of two complementary colors, their mingling and opposition, the mysterious vibrations of two kindred tones."[33]

After characterizing the portrait as an arrangement of colors that enhanced one another, van Gogh reported to Gauguin their intended expressive effects, the particular force of their evocative forms. Here he sounded a new theme as he deepened his long-term Arles quest for a consolational painting, the link between *La Berceuse* and sailors at sea: "I believe that if one placed this canvas, just as it is, in a fishing boat, even from Iceland, there would be those who would feel in it the *berceuse*."[34] As

we will see, the association of the *berceuse* to sailors and their ship derived partly from van Gogh's memory of a novel, Pierre Loti's *Pêcheur d'Islande*, that he and Gauguin had discussed together in Arles. Here it is important to note that van Gogh imagined the painting stirring immediate emotions among ordinary people, those seamen who "would feel in it the *berceuse*." Because of the word's dual connotation, this feeling could be either the presence of the woman rocking the cradle or the tones of the lulling song she sang. At the end of this passage in the letter to Gauguin, van Gogh explicitly connected *La Berceuse* to music, the direct, unmediated force of which could bring solace to those in distress: "Ah, my dear friend, to make painting into what the music of Berlioz and Wagner has already been before us: a consoling art for broken hearts!"[35]

Music, color, and the conveyance of comfort had engaged van Gogh in his Arles self-portrait and other portraits, when he wrote that the "radiance and vibration of coloring" would offer "something of the eternal" and "say something comforting, as music is comforting."[36] In writing about his *Memory of the Garden at Etten* painting he had compared the evocative forms of the colors to a poem, suggesting that both forms, like music, "could say something comforting."[37] Gauguin, who shared with van Gogh the search for an independent expressive force of color, did not employ a discourse of consolation as an intended creative effect. In the dining room at Le Pouldu, for instance, Gauguin would associate himself with Wagner in an ensemble where an inscription heralded the composer as a spokesman for a new kind of Last Judgment, dividing the artistic elect from the damned. Van Gogh's vague knowledge of Wagner, filtered through his Dutch theology of art as a binding power of solace, linked the musician to the painter in another way, as developing healing forms to console the afflicted. *La Berceuse* enabled him to approach this ideal of musical comfort and color in a new, more integrated way, in the unity of form and content, as he composed both the mother singing and the song itself, evoked in—as he mentioned to Koning—"a lullaby of colors."

Van Gogh clarified the meaning and function of his *Berceuse* in a final set of late-January letters, these to his brother Theo. Here he expanded the social and spiritual features of the image as his own personal crisis intensified. These letters defining the inclusive, solace-bearing forms of *La Berceuse* were also those in which he revealed to Theo his own unrelieved sense of guilt over the financial imbalance of "outlay and output" and discussed his memories of their parents, the Roulins' "exemplary" marriage, and Theo's engagement and prospects for a new family. Deepening the association of *La Berceuse*

FIG. 137. **VINCENT VAN GOGH,** *PORTRAIT OF JOSEPH ROULIN*, 1888, reed quill pen and brown ink and black chalk, 32 x 24.4 cm. J. Paul Getty Museum, Los Angeles

with sailors and the sea, he wrote Theo about the consolational force of the painting if set in a fishing boat, exploring further the comments in his letter to Gauguin. The painting would provide rest, comfort, and consolation, qualities associated with traditional religious art, especially for sailors. Van Gogh suggested that sailors could be reassured by such an image of a mother rocking a cradle as they pitched and swayed in their huge, cradle-like boats at sea:

> *I have just said to Gauguin about this picture that when he and I were talking about the fishermen of Iceland and of their mournful isolation, exposed to all dangers, alone on the sad sea—I have just said to Gauguin that following those intimate talks of ours the idea came to me to paint a picture in such a way that sailors, who are at once children and martyrs, seeing it in the cabin of their Icelandic fishing boat, would have that old sense of being rocked come over them and remember their own lullabies.*[38]

The power of the painting to trigger the feeling of being rocked and sung to was directly tied to its particularly popular forms, as van Gogh now explained to Theo. The crude, bright colors and summary treatment of the figure "resembles a chromolithograph from a cheap shop."[39] As the replicas of *La Berceuse* multiplied in the next weeks, van Gogh repeated to Theo that they were like the "chromos in the little shops,"[40] though he claimed that such colored penny prints were "technically infinitely better painted" than his picture, which lacked "correct" proportions and deviated from an exact "photographic" likeness of its subject.[41] Nonetheless, van Gogh believed there was a suitable fit between his

painting and a popular audience, as he explained to Theo in justifying the simplicity and directness of its format, color, and subject. "After all," he commented, "I want to make a picture such as a sailor at sea who could not paint would imagine to himself when he thinks of a woman ashore."[42]

Earlier in his career, van Gogh had aspired to emulate the black-and-white illustrators of the British popular magazines, training himself in what he called "a noble calling"—the provision of an "art of the people for the people" through the print genre of labor types, known as "heads of the people."[43] In Arles he had renewed interest in this genre; his portraits of Joseph Roulin, for example, brought the new element of color to the distinctive "heads of the people" format, where the figures bore the characteristic vocational costume and insignia of their trade. Van Gogh's insistent presentation of Roulin with his uniform and cap, boldly labeled "POSTES," referred back to such prints as Hubert Herkomer's *Coast Guardsman*, in which the subject wore a special hat marked "GUARD" (Figs. 137 and 138). While he was learning drawing in The Hague in 1882–1883, van Gogh had clipped out and saved the *Coast Guardsman* and another print of Herkomer's, of a brewer's drayman in his marked shirt and cap, from the British magazine *The Graphic*. By linking his *Berceuse* to the cheap, colored chromos, van Gogh deepened his long-term engagement with an art "of the people for the people," and he considered the form and subject of his picture to be accessible and recognizable to ordinary people. Now inflected with his new theories of musical color and emotional force, van Gogh's *Berceuse* broadened the immediacy of the image in a style whose subject announced by her costume, wedding ring, and cradle rope her role as a wife and mother.[44]

FIG. 138. HUBERT HERKOMER, *HEADS OF THE PEOPLE: THE COAST GUARDSMAN*, FROM *THE GRAPHIC*, SEPTEMBER 20, 1879

While the painting was never actually placed in a ship's cabin, the portrait did have an immediate response from the ordinary people whom van Gogh depicted. Van Gogh showed Joseph Roulin two copies of his wife as a *berceuse*, "which pleased him very much."[45] Van Gogh also gave one of the three versions to Mme Roulin, who took the painting with her when she went to live temporarily with her mother in the country. Van Gogh noted, wryly, that "she had a good eye and took the best one."[46]

The navigational, musical, and popular elements of *La Berceuse* that van Gogh highlighted in the letter to Theo included one last feature, which directed the picture to a new level of meaning as a type of sacred realism. He wrote to his brother that the picture might be grouped with another set of canvases that he cherished and had also copied—the *Sunflowers*. "I picture to myself these same canvases between those of the sunflowers, which would thus form torches or candelabra beside them, the same size, and so the whole would be composed of seven or nine canvases."[47] Van Gogh tried out such a grouping, putting two versions of *La Berceuse* between four bunches of the flowers, and showed the arrangement to Joseph Roulin.[48]

The *Sunflowers* had special significance to van Gogh and, like *La Berceuse*, were inextricably tied to Gauguin. Van Gogh had decorated Gauguin's room in the Yellow House with canvases of sunflowers, and these were among a small number of van Gogh's paintings that Gauguin explicitly praised. After their separation, the two painters still discussed the paintings, and van Gogh intended to give one to Gauguin, noting that as other artists' works had distilled the peony and the hollyhock, he had succeeded in capturing the sunflower.[49] Earlier in Arles van Gogh had applied to one of the sunflower canvases his developing theories of the visual "halo" generated by the interaction of complementary colors, and he had written to Emile Bernard that he was thinking of decorating the Arles studio with six sunflower pictures, "in which the raw or broken chrome yellows" would "blaze forth" from their interacting backgrounds and painted frames, creating "effects like those of stained-glass windows in a Gothic church."[50]

If van Gogh had imagined his sunflowers glowing like stained glass, his new idea of setting them on each side of *La Berceuse* deepened the religious resonance of the image. In the January letter to Theo, van Gogh's notion of the assembling sunflowers as "torches or candelabra" around the image of Mme Roulin suggested a triptych or even polyptych, as he mentioned a series of "seven or nine canvases." A letter to Theo a few months later explicitly identified the format as a triptych.

Van Gogh noted in this letter that *La Berceuse*, evoking the simple "chromos" of "the common people," might well appeal to them, which would affirm that they were "perhaps more sincere than certain men about town who go to the Salon." Thinking of how Gauguin had liked the sunflowers, he now suggested that Theo might give him and Bernard copies of *La Berceuse* "as a token of friendship." The paintings' appeal to both painter-friends and popular audience converged in the next passage, where van Gogh returned to the idea of an ensemble of flanking flowers and female cradle rocker:

> *You must realize that if you arrange them in this way, say "La Berceuse" in the middle and the two canvasses of sunflowers to the right and left, it makes a sort of triptych. And then the yellow and orange tones of the head will gain in brilliance by the proximity of the yellow wings.*[51]

Such a triptych, he reminded Theo, might find a home in a ship's cabin, where its bold colors and forms would be perceptible and gain coherence:

> *And then you will understand what I wrote you, that my idea had been to make a sort of decoration, for instance for the end of a ship's cabin. Then, as the size increases, the concise composition is justified. The frame for the central piece is the red one. And the two sunflowers which go with it are the ones framed in narrow strips.*[52]

The red frame for the portrait would provide the complementary pair for the red and green dominating the composition, while the saturated chrome yellows of the sunflowers would set *La Berceuse* aglow, especially enhancing the radiant *éclat* of the head by a surround of brilliant colored light. Van Gogh showed the interrelation of the three canvases in a sketch set into the middle of his letter to Theo (Fig. 139). The handwriting wraps around the illustration, alternating blocks of words and image. The visual plan is presented as an integrated three-panel design, with the size and framing of the triple canvases exactly matched and aligned so that the paintings seem attached to one another, as if by the hinged notches that typically join triptych wings to their central segment in traditional religious art. Van Gogh's three panels are further unified by overlaps from one panel to another. One stem of the sunflowers in the vase at right, for example, spills over the divider and reaches into the space of the seated

cradle rocker. And part of the wallpaper backdrop of the painted *Berceuse*, hinted at in the drawing by inked curves and arabesques, moves out across the left partition, a visual connector to the sunflowers panel on the left.

Gauguin, Sérusier, and de Haan had also used a formal device of curling vines and coils to integrate the different panels of their ensemble at Le Pouldu (Fig. 123). In that setting, as we have seen, the decorative vine crossed over the boundaries of the wall frames to unify a set of murals declaiming a Last Judgment and depicting visionary experience and banishment from Paradise. Van Gogh's planned triptych of cradle rocker and glowing sunflowers with its version of crossing over the boundaries from one panel to another affirmed consolational power in human presence and nature's forms, a balm to isolation and a beacon of light, love, and lullaby memories.

To the themes of consolation and comfort that van Gogh assigned to his triptych arrangement we can add the theme of gratitude. Van Gogh later wrote to the critic Albert Aurier that his sunflowers "express an idea *symbolizing gratitude*."[53] As others have noted, the symbolism of gratitude "is closely

connected to *La Berceuse*," and the flowers carry this meaning "only in conjunction with *La Berceuse*: they are a tribute to her."[54] The purpose of the "brilliant yellow warmth" of the pair of flanking sunflowers "was to underscore the feeling of gratitude the painting was intended to convey."[55] Following these interpretations, the three canvases can be viewed as embodying both formal and symbolic coherence. The interacting color schemes intensify one another, with the tones of the woman's head made increasingly resplendent "by the proximity of the yellow wings"; van Gogh's drawing suggests the bending and turning of some of the flowers toward the central female figure, while one of her panels spills over an edge to connect with her neighbor. Finally, the sunflowers as symbolic partners surround the *berceuse* with gratitude and tribute.

Van Gogh's friend Emile Bernard highlighted a final symbolic element of the triptych—love—in a memoir in which he discussed the meaning and motives for *La Berceuse*. Bernard reiterated van Gogh's link between the painting and fishermen at sea, noting that the portrait would recall to the sailors the "hymns of childhood, hymns which bring rest and consolation to a hard life." Bernard went on to explain the special setting van Gogh intended for the ensemble: "He . . . painted *The Berceuse* with the intention of offering it either to Marseille or to Saintes-Maries for placement in a tavern frequented by sailors. Two great sunflowers were to serve as pendants, because he saw in their intense yellow the supreme clarity of love."[56] Sailors coming from and going to rough seas could be fortified and brightened by the triptych's lustrous colors, interacting forms, and simple subjects.

Gauguin, as we recall, had wanted to offer his *Vision After the Sermon* to the Breton churches at Pont-Aven or Nizon, where he thought it would harmonize with the "bare stone" and stained glass of the chapel. Van Gogh construed the density and interplay of the sunflowers' pigments as themselves embodying the effects of stained glass. Unlike Gauguin, who saw the smooth and uniform color mass of his canvas as melting into a chapel surface, van Gogh saw his sunflowers as "blazing forth" off their backgrounds in "raw," "broken," and textured colors that composed not the serene translucence of stained glass but a dense, opaque color field, and he envisioned his female portrait, with its symbolism of love, consolation, and gratitude, in a sailors' bar.

RELIGIOUS RESONANCES

Triptych, glowing floral torches or candelabra, carriers of gratitude and solace—these descriptions by van Gogh have led most interpreters to emphasize that *La Berceuse* is a variation on an altarpiece Madonna, a type of devotional image. While acknowledging these views, I want to reconsider *La Berceuse* in the light of new sources that have conspicuous relevance to its status as a religious image: the world of popular Catholic culture surrounding van Gogh in Arles and Saintes-Maries, specifically the realms of Nativity theater and votive imagery, which left their traces even as van Gogh deftly pressed them into the service of a Protestant modernist religious realism.

Van Gogh himself provided some evidence for the idea that the painting was a secular icon in a later letter to Theo, when he characterized the *berceuse* as a modern equivalent of early Christian "saints and holy women," *saints et saintes femmes.* "I must tell you," van Gogh asserted, "—and you will see it in '*La Berceuse*' . . . —if I had the strength to continue, I should have made portraits of saints and holy women from life who would have seemed to belong to another age, and they would be middle-class women of the present day, and yet they have had something in common with the very primitive Christians."[57] Note that van Gogh alluded here not to a Madonna but to a group of early Christians, male and female. This emphasis, combined with van Gogh's idea of offering his triptych to a setting in Saintes-Maries-de-la-Mer or Marseille, provides critical clues to specific local contexts of *La Berceuse*'s development. First, the interaction of saints, holy women, and middle-class men and women "of the present day" had particular visibility in the decorative arts and musical theater of Arles during the time that *La Berceuse* evolved. Every year from December through February, Arles's public culture was inundated by the representation, in varied media, of a modern regional community symbolically assembled to greet the newborn baby Christ being rocked in his crib. As part of a special genre of popular Nativity arts in the Midi, Arles's streets displayed handmade crèches in which clay figurines of local types in contemporary regional costume were placed in the company of the three kings to welcome the Christ child and his family. Live theatrical versions of this mixing of modern local types and sacred figures were also featured in Arles in a seasonal Nativity genre called the Pastorale, performed by traveling acting troupes. A cross between musical comedy and Nativity play, the Arles Pastorale presented the comic

misadventures of local types as they made their way to the manger to admire the baby Savior. Performances around the crèches and in the Pastorale featured special songs and chants, some of which were locally known as *berceuses*, to the baby. Finally, van Gogh's allusion to saints, holy women, and sailors' consolation in his *Berceuse* evoked certain links to another local context: the coastal pilgrimage town of Saintes-Maries-de-la-Mer. Here particular cults of female saints and holy women abounded, especially cults associated with the lives and fates of sailors at sea. A popular visual culture joining gratitude to a holy female figure flourished here in a special genre of navigational votive imagery celebrating the protection of sailors during their dangerous voyages.

Within these two local contexts—the Nativity culture of Arles and sailors' votives at Saintes-Maries—*La Berceuse* can be seen as a synthesis of van Gogh's distinctive project of sacred realism and as the culminating response to the dual challenge of Gauguin and of Arlesian popular piety. If *La Berceuse* was one of the most Gauguinesque of van Gogh's paintings, it was also the most receptive to the pressure and fascination of the vibrant Catholic culture around him. Earlier in Arles—in his *Sower*, for instance—van Gogh excluded from view all traces of the festive rituals of the Catholic labor calendar that unfolded before him that summer season. During the Christmas period of *La Berceuse*, the welter of cultural materials concretizing tender familial unity amidst his own illness and losses may have provided a new psychological receptivity to the supernaturalist Catholicism that had hitherto been so emphatically screened out; whatever the reason, elements of Catholic culture percolated into the image of *La Berceuse* and this time were absorbed and transformed. Yet, as he had assimilated Gauguin's techniques of flat outlining and color masses and alternated them with his abiding language of texture and modeled relief, so too van Gogh adapted the new materials of popular piety to a powerful secular alternative, embodying the expression of human consolation at the heart of the Dutch Reformed theology of art.

Before we take a detailed look at the local contexts, two other elements need to be explored briefly as significant elements of van Gogh's *Berceuse*, for the immediacy of the Provençal social ground interacted with other factors, both visual and literary, that shaped the form and meaning of the painting and ensemble plan. *La Berceuse* offered a composite, an in-gathering of multiple sources and memories mobilized in a loose chain of associations. One of the links in the chain evoked visual precedents from van Gogh's encounter with fifteenth-century Flemish art; another emerged from the literary text

others have identified as central to *La Berceuse*, Loti's *Pêcheur d'Islande*, though I will suggest the ways van Gogh *mis*remembered the book in his associations of it with the painting.[58]

FLEMISH SACRED REALISM AND *LA BERCEUSE*

The large seated figure of Madame Roulin surrounded by vases of flowers has suggested to some writers a generalized comparison to "a Madonna on an altar between two floral offerings."[59] Van Gogh's Dutch Reformed legacies and his primary allegiance to seventeenth-century Dutch realist art produced strong impediments to a broad repertoire of connections to altared Madonna images. Yet, although he disfavored religious art, he did absorb and retain a particular familiarity with a specific tradition of enframed Madonnas from fifteenth-century Flemish painting. During the period from 1875 to 1887, van Gogh lived in the varied cities of London, Paris, Brussels, Antwerp, and Amsterdam. His avid study in the museums and art collections of those cities included early Netherlandish triptych panels and triadic arrangements joining sacred and contemporary figures that remained in his storehouse of memory and association. These images usually remained subordinate to van Gogh's fundamental points of reference, the seventeenth-century Dutch artists from Koninck to Rembrandt. When religious ideas and debates about religious art preoccupied him in Arles, however, the Flemish masters of his earlier encounters resurfaced and provided him with certain resources for *La Berceuse*. These resources did not offer a direct correspondence or single stylistic influence but instead served as particular examples of genre and format, as well as a resonant model of Northern painters as skillful craftsmen especially expert in the physical materialization of the textures of the world.

In his letters van Gogh mentioned the brothers Jan and Hubert van Eyck, Hans Memling, and Quentin Matsys; he had encountered paintings by these and other fifteenth-century Flemish masters in his museum explorations. Taken together, these images exemplified a provocative precedent, in another form, of sacred realism, which, as Johan Huizinga and Ernest Panofsky first suggested, visualized a new and uneasy balance between the naturalistic order and the religious figures set and described within it. Some of the paintings in the Antwerp, Brussels, Paris, and London collections that van Gogh visited suggest four affinities with *La Berceuse*.

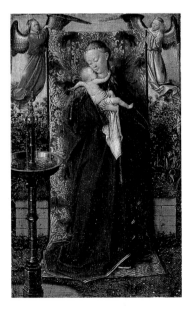

FIG. 140. JAN VAN EYCK, *VIRGIN AT THE FOUNTAIN*, 1439, oil on panel, 19 x 12.2 cm. Koninklijk Museum voor Schone Kunsten, Antwerp

First, richly detailed floral canopies enlivened the space behind these northern Madonnas. Jan van Eyck's *Virgin at the Fountain* (1439), seen by van Gogh at the Musée Royal des Beaux-Arts in Antwerp, presented a standing Madonna and child in a compressed space framed by a back panel of brocaded cloth that was held by flanking angels and embellished with gilded vines, stems, and flowers. The decorative naturalism of the fabric echoed in the surround of a garden filled with spring flowers (Fig. 140).[60] In the seated Flemish Madonna types encountered by van Gogh, decorated floral canopies formed colorful textile backdrops for the figures' thrones. In Hans Memling's *Virgin and Child with an Angel, Saint George, and a Donor*, at the London National Gallery, a glowing array of long-stemmed pomegranate plant bouquets provided the painted backing for the maternal figure (Fig. 141).[61] Perhaps the most glorious and most vividly rendered of the floral textile canopies enhancing the Virgin appeared in van Eyck's *Madonna of Canon van der Paele with Saints Donatian and George* (1434–1436), a copy of which hung in the Antwerp museum visited by van Gogh.[62] Here the seated Virgin, folded in a crimson cloak with brocaded edging, is set in a green, red, and gold backing and overhang sprayed with delicately rendered flowers and leaves (Fig. 142). These early Netherlandish floral and botanical sprays around the Madonna figures, with the stems and buds leaning in tropistically toward the Virgin, bore some affinity with van Gogh's lushly arrayed backdrop spotted with dahlias and vines in his *Berceuse*, and with his plans for the sunflowers on either side, bending toward the central female figure. Van Gogh's seated figure was positioned, however, against the naturalism and stylized patterns of wallpaper in a working-class home, though he envisioned placing the painting, with its accompanying sunflowers, in a sailors' tavern. The enthroned Flemish Madonnas' naturalistic splendor embellished very different, luxuriously brocaded canopies.

Second, the color schemes of the Flemish masters familiar to van Gogh emphasized basic contrasts in striking interplays of primary hues. In the representations of the Madonna and saints, the color fields of red and green and of red and blue were often predominant. Van Eyck's *Madonna of Canon van der Paele* enveloped the Virgin's blue robe in the massive folds of a red mantle, whose exposed inner lining played off the surface with its deep green pigment. A complementary patch of red lining and green trim appeared at the left base of Saint Donatian's blue and gold cope. The green and red pairing was repeated in the color scheme of the carpet underneath the Madonna figure and interacted with the glowing tones of her clothing that spilled over onto it. The brocaded floral canopy composed a third

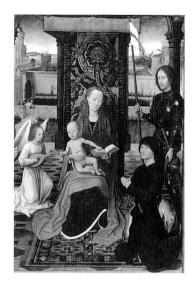

FIG. 141. HANS MEMLING, *VIRGIN AND CHILD WITH AN ANGEL, SAINT GEORGE, AND A DONOR*, oil on panel, 54 x 37 cm. © National Gallery, London

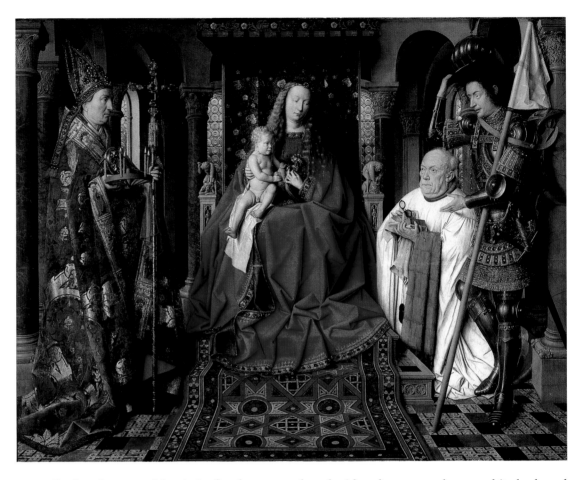

zone of red and green pairing in its floral patterns, dotted with red, green, and some white buds and leaves.[63]

Music and musical sound evoked by painting offered a third affinity between *La Berceuse* and the Flemish sacred precedent. The Memling panels featured music-making angels whose instruments, such as the lute played by the angel in the *Virgin and Child* of the London collection, suggested "the joyful choirs of the heavenly realms" as well as popular hymns sung to the Virgin extolling her kindness and mercy.[64] Van Gogh's *Berceuse* designated the music of a lullaby sung by the maternal figure while also

absorbing the transcendence of a heavenly choir into the music of color, with expressive forms alone conveying the binding consolation and love associated with the female figure.

In the fifteenth-century Flemish model, all these elements—the floral naturalism framing the Madonna and child, the interplay of color pairs, and the presence of music—had automatic symbolic value in a shared religious system. The flowers on the throne canopies—the pomegranate, the lily, or the columbine, for example—were specifically associated with attributes of the Virgin, as were the color pairs of red and green or red and blue reserved for her in the story of the Passion. Van Gogh's *Berceuse* had no such overt symbolism or system of correspondences. But this earlier art did make available to him a form of a sacred realism, which introduced secular materiality in a new way. The Flemish masters amplified the human, familial, natural, and man-made characteristics of the terrestrial sites inhabited by the holy figures they represented.

Paintings van Gogh viewed by the van Eycks, Memling, Matsys, and Robert Campin (the Master of Flémalle) assigned Madonnas to meticulously rendered domestic interiors, to private spaces with distinct views of the city beyond, or in or near gardens teeming with recognizable varieties of plants and flowers. Often small in scale, many of these panels or triptychs were used for private devotion in private homes, and were transportable for a variety of secular spaces. The intimate, devotional naturalism of this Flemish painting also put new emphasis on the holy family as a nuclear family and on the role of Joseph as an earthly father, chaste husband, and shared partner in the upbringing of the Christ child. The cult of Joseph as a saint was initiated in the fifteenth century and struck its deepest roots in the early modern Netherlands, where Erasmus's school, the Brothers of the Common Life, published the first account of the life of Saint Joseph by 1490. Flemish painters were simultaneously exploring the presence of Joseph in depictions of the holy family. In the paintings of Robert Campin, one of which van Gogh saw in Brussels, the role of Joseph as a father and husband was given visual form, corresponding to the new humanizing, familial piety.[65]

Van Gogh's encounter with and memories of the Flemish masters thus hovered around those images in which the natural world was lovingly rendered, and where tender relations among members of the holy family had invested the Nativity with a new human face, including that of the fatherly figure of Joseph. Their reverberations may have been all the more powerful in the Christmas period of *La*

Berceuse as he observed the Roulin family's poignant good-byes and Joseph Roulin's singing to and playing with the baby Marcelle.

The consummate skill and dextrous craftsmanship with which the Flemish masters realized their humanizing sacred pictures was the compelling theme of a book that van Gogh had read and that shaped his ideas and memories about them. Eugène Fromentin, a painter and art critic, had in the 1870s rediscovered and redefined northern art. First in a series of articles and then as a book published in 1876, Fromentin's *Masters of Past Time: Dutch and Flemish Painting from van Eyck to Rembrandt* celebrated Rembrandt, Rubens, Ruysdael, de Hooch, Cuyp, and other seventeenth-century painters; he also glorified Jan van Eyck and Memling as the inspirational source of this distinctive tradition of northern "realism." Fromentin's chapters on van Eyck and Memling highlighted their scrupulous attentiveness and powers of materialization, a capacity to render in color, texture, and surface finish the special qualities of every type of worked matter, from fur to wood furnishings to velvet, brocaded, or woven fabrics, to tile floors and oriental carpets. In an extensive description of the *Madonna of Canon van der Paele with Saints Donatian and George*, for example, Fromentin marveled at the way van Eyck captured the "thick, wrinkled and crevassed" face and skin of the aging donor, as well as the meticulous patterns in the Persian carpet. Both van Eyck and Memling, according to Fromentin, displayed unparalleled "manual gifts" and obtained "perfect truth by the skill of the hand." Their painting, he noted, "compares with the art of the goldsmith, the enameler, the engraver."[66] Van Eyck's artisanal mastery made him more adept than the weaver, marbler, or stained glass window-maker he emulated: "When he paints a carpet he weaves it with a better choice of coloring. When he paints marble he comes nearer to the polish of marble, and when he makes the opal-tinted panes of his stained glass windows glisten in the shadow of his chapels he is perfect at still-life deception." Here, "the craftsmanship is perfect."[67]

Fromentin privileged the language of "handicraft" and skill in his book as he attempted to define the distinctively national qualities of Netherlandish art. Van Gogh read the book in 1884, "with great pleasure," just at the time he was learning the rudiments of his métier and the laws of color.[68] Fromentin's book, like Chevreul's, was one of the texts van Gogh read during the months he was preparing his weaver series in Nuenen. Van Gogh's letters make explicit reference only to Fromentin's treatment of the later, seventeenth-century Dutch painters. But Fromentin's discussions and illustrations of Memling's triptych panel and the triadic assemblage of van Eyck's van der Paele Madonna pro-

vided a conceptual frame for the art of the Flemish primitives that van Gogh absorbed in his extensive museum study and urban residences. The sacred realism of the enthroned, serenaded Madonna in Flemish painting echoed in new form in the seated, enframed, and lullaby-singing *berceuse*.

THE ANDRIESKERK MARIS STELLA: SACRED CLOISONISM

A closer link to a type of Flemish devotional art is plausible for *La Berceuse*. When van Gogh lived in Antwerp in 1885–1886, he walked the city and discovered the Andrieskerk, the Church of Saint Andrew, in the poor fishermen's quarter. Here a large-scale "Maris Stella" stained glass window impressed him deeply, one of the rare instances in which the interior of a church sanctuary engaged his attention (Fig. 143). Van Gogh described the window panels in detail in a letter to Theo. The sixteenth-century window presents the Virgin Mary as Maris Stella (Latin for "Star of the Sea"), "protectress of mariners in distress."[69] The dark lower half of the window depicts a large ship in rough seas, tipped up and foundering on the rocks. Above the masts, in brighter colors, hovers a Madonna and child, standing on a cloud base and surrounded by two angels. One angel holds a cross, the other a ship's anchor. Van Gogh's characterization focuses especially on the color zones of the window:

FIG. 143. THE MARIS STELLA WINDOW, ANDRIESKERK, ANTWERP, 16th century. Reproduced from A. M. and Renilde Hammacher, *Van Gogh: A Documentary Biography* (London: Thames and Hudson, 1982)

There is a painted window which I think superb—very, very curious. A beach, a green sea, . . .
a sparkling blue sky of the most beautiful tones of blue, greenish, whitish, deeper, higher of tone.

An enormous three-master, quaint and phantasmal, stands out against the sky, diffusion
everywhere, light in the dark, dark in the light. In the blue a figure of the Holy Virgin, bright
yellow, white, orange. Higher up the window reappears dark green, with black, with fiery
red . . . It is very beautiful.[70]

Along with the dark and light color zones identified by van Gogh, the Maris Stella window comprises three vertical segments, divided by leaded strips. The middle section draws the eye to the standing Madonna and child. Instead of wearing a legible crown, the Virgin's head extends from hair to irregular orbs of yellow, creating both bulky coronet and billowing aureole. Two winged angels fill the panels flanking the Virgin. The one on the right, kneeling and holding an anchor, is turned toward the central figure. The companion angel on the left is positioned outward, raising a gilded and jeweled cross. Neither angel is distinctly contained within the panels enframing the Virgin. The lower part of the anchor held by the angel at the right moves across the vertical divide into the middle, meeting the folds of the Virgin's mantle. And one wing of the cross-bearing angel spills over the divide near the middle of the Virgin's cascading robes.

The Maris Stella window has never been mentioned in relation to *La Berceuse* or to van Gogh's planned triptych project. Yet it made a deep impression on him when he saw it in 1886 and it bears some interesting affinities to the later ensemble as a visual and sacred precedent. The contrasting colors and spatial disposition of the upper part of the window, with Virgin and pendant angels, evoke van Gogh's later arrangement of the female figure and her flanking sunflowers. Offsetting the red and green that contrast in the upper and lower portions of the Virgin against the ship, the angels' color fields of blue, yellow, and white heighten the central Madonna with her radiating yellow orbs and red, gold, and blue robes. The angels are turned to move and bend in relation to the Madonna figure. The angel on the right is shown in profile so as to turn toward the Virgin, and his anchor correspondingly tilts to emphasize her space and position. The angel on the left turns out, but his cross is also angled so as to echo and frame the Virgin in parallel fashion. And elements of both flanking figures—such as the wing and the anchor—move across the boundaries of the delimited dividers to inhabit the space of the Madonna.

In his drawing plan for his triptych (Fig. 139), van Gogh had directed some of his pendant sunflowers to lean toward the *berceuse*, while floral arabesques behind her moved across the boundaries of the wood strips meant to divide the three canvases. His ambition to enhance the brilliance of the central figure by the intensity of the color of the sunflower "wings" was also prefigured in religious form in the interacting color fields of the angels and their Maris Stella. Van Gogh had suggested that his sunflowers, crucial elements of his triptych, could "blaze forth" off their backgrounds—the chrome yellows of the blossoms against the deep to royal blues around them—creating effects similar to those of "stained-glass windows in a Gothic church"; as proposed pendants to his *Berceuse*, he hoped they would offer consoling forms for sailors in their ship's cabin, or in their tavern. Despite his general disinclination to use religious art as a model, van Gogh had admired a stained glass window set dedicated to the celebration of a maritime Madonna. As he undertook a visual project that associated a consoling female figure, sailors, and the sea, the Antwerp windows may have provided raw materials for a secular and naturalizing adaptation in *La Berceuse*. The "cloisonist" influence of Gauguin blended again with another building block.

MARIS STELLA II: PIERRE LOTI'S NOVEL

In imagining his maternal figure in a maritime setting, however, van Gogh would filter a memory of the Antwerp Maris Stella through a more recent encounter with a devotional image of the Madonna as "Star of the Sea." During the last weeks they spent together in December in Arles, van Gogh and Gauguin discussed a novel about the travails of sailors at sea, the 1886 *Pêcheur d'Islande* (*An Iceland Fisherman*), by Pierre Loti. Despite the title, the novel's characters were fishermen from northwest Brittany who embarked each year on the difficult and dangerous journey to the cod fisheries off the Icelandic coast. Loti filled the book with evocations of the Catholic popular piety that reconciled the sailors and their families to a life of hardship and uncertainty, especially their worship of a special patron and protectress, the Virgin Mary, Star of the Sea.

The ship of the "valiant seafarers" was named *La Marie, Star of the Sea*, in homage to the Virgin "who protected the ship that bore her name."[71] At the very beginning of the novel, Loti described how

the sailors' "infinite solitude" and vulnerability were relieved by the presence of a crude faience figurine of the Madonna that was "fastened on a bracket against the midship partition, in the place of honor":[72]

> *She was a bit old, the protectress of these sailors, and painted in a naive style. But ceramic people last a good deal longer than real men; her red and blue robe still created a small effect of freshness in the midst of all the somber grays in this poor wooden cabin. She must have heard more than one ardent prayer in hours of anguish; they had nailed two bouquets of artificial flowers and a rosary at her feet.*[73]

The men appealed to their faience Virgin for their safety and sought solace from her; the statue, through forty years of Icelandic voyages, remained "smiling perpetually between her branches of artificial flowers."[74] In addition to this worship on the ship, the sailors' community also celebrated their patron saint in ceremonies vividly depicted by Loti in other chapters, such as their exultant singing of hymns to her in the annual ritual of the ship's departure, when the crew brought a statuette of the Virgin from her chapel and set her in a makeshift altar among the rocks along the quay.[75]

As we have seen, van Gogh's letters about his *Berceuse* referred directly to the fishermen of Iceland and his talks with Gauguin about them. Loti's accounts of the Breton sailors' pardon ceremonies and rituals surely resonated with Gauguin's experience and fascination with the region. Van Gogh made no comment on those elements of the book; the traces of his reading of it melded his admiration for Gauguin as a sailor with Loti's fictional account, and he compared Gauguin to the Breton sailors in the novel.[76] More important, van Gogh's ideas about placing his cradle-rocker portrait in a fishing boat were stimulated by Loti's treatment of the sailors' ceramic protectress set in their cabin. In one of the first accounts of the portrait, van Gogh mentioned placing the canvas in an Icelandic fishing boat.[77] His subsequent letter to Theo reported that his talks with Gauguin about the isolated, dangerous journeys of the Icelandic fishermen had given him the idea that he paint a picture so that "sailors—who are at once children and martyrs—seeing it in the cabin of their Icelandic fishing boat, would have that old sense of being rocked come over them and remember their own lullabies." In its summary handling and bold, crude colors, like "a chromolithograph from a cheap shop," such an image would be accessible to

sailors, and van Gogh then imagined his shipboard *Berceuse* enhanced as a decorative set, framed by the sunflowers as "torches or candelabra" around it.[78]

Most interpreters of van Gogh's *Berceuse* have identified Loti's book as a source for his image, and some have suggested that he turned Loti's evocation of the sailors' veneration of the faience Madonna into a secular devotional image or even an altarpiece with naturalized icons. There are indeed striking affinities between van Gogh's *Berceuse* figure, surrounded by sunflowers, and Loti's rendering. Loti's ceramic protectress was crudely and brightly painted, with bold red and green in "native" popular style that stood out against the somber grays of the ship's corridors. Van Gogh considered his *Berceuse*, with its blunt, summary facture and sharp contrasts of red and green, to be arresting and immediately visible for the end of a ship's cabin.[79] Loti's holy figurine was set between branches of artificial flowers; *La Berceuse* rested between the canvases of the sunflowers. A rosary chain was attached to the base of the ceramic figure; the *berceuse*'s cradle rope has on occasion been thought to resemble one.[80]

Yet the links between van Gogh's and Loti's holy female figures have been too narrowly and simply construed, for van Gogh's *Berceuse* departed in fundamental ways from the Catholic devotional model he may have adapted from Loti's Maris Stella. First, van Gogh considered his *Berceuse* an active agent of consolation and love, conveyed through the physical likeness of a mother and through her singing and sensorial embrace. Although *Pêcheur*'s sailors sought solace also, they approached their Madonna figurine as a talismanic presence from whom they could summon supernatural assistance to avoid shipwreck, storms, and the dangers of the fathomless waters. Van Gogh assigned the source of solace and fortitude of his *Berceuse* to visual and aural memory stimulated by a portrait of a mother singing to her baby; he wanted to provide a picture "such as a sailor would imagine when he thought of a woman ashore," an equivalent of lived connection and human relationship.

Second, Loti presented the capacities of the sailors' sacred patroness, and the fullness of human love, as fundamentally limited and deficient, powerless before the terror and destruction of an indifferent nature embodied in the sea. In the book the men projected their fears and hopes to the Madonna figure, which Loti presented as perpetually smiling, no matter what the circumstances. In other scenes of veneration, the sailors sang hymns of praise and salutation to the Star of the Sea while she surveyed them from her grotto altar with her "lifeless eyes."[81] Van Gogh inverted the musicality in the relationship and

rendered it dialogic. His *berceuse* was not a static, "lifeless" object of chants and supplication but was designed to evoke the lullabies and rocking rhythm of childhood; he imagined his female figure singing *to* sailor and viewer, a lullaby of memory through color and maternal presence.

Finally, van Gogh's consoling, relational *berceuse* departed significantly from Loti's *berceuse* in a way that suggests a fundamental misreading or misapprehension of the novel's sorrowful and lamentational theme. In *Pêcheur d'Islande* the Madonna Star of the Sea was *not* a *berceuse*, either singer or cradle rocker. It was, rather, her adversary that Loti identified as a *berceuse*—the everlasting sea, who rocked (*berçait*) the sailors and was their *grande nourrice*, "the great nurse." Loti's *berceuse* was both soother and "Moloch," an agent of death, despair, and desolating loss. The lovers' reunion anticipated in the narrative was ultimately prevented by this "great devourer of the generations"; in the furious clamor and drowning that ends the book, the sea took back the sailor Yann, whom "she had rocked in his babyhood," keeping him "for herself alone."[82] Van Gogh's associations to the Loti book included ideas of an "old song of a nurse" (*vieux chant de nourrice*) like that sung by "the cradle-rocker who lulled the sailors" (*berceuse qui berçait les marins*).[83] Van Gogh's *berceuse* and her singing offered love and comfort. Loti's *berceuse*, on the other hand, did not sing to and rock the sailors; she annihilated them, removing them forever from human attachment and transcendent protection. As he resisted the *misères humaines* explored in his friend Gauguin's art, van Gogh's *Berceuse* significantly avoided the elements of anguish and suffering so prominent in Loti's novel, while absorbing from it the theme of iconic comfort for a sailors' cabin.

NATIVITY CULTURES IN ARLES

The themes of musicality and maternity that van Gogh attributed to his *Berceuse* did not resonate with the dolorous piety of Loti's Breton sailors, nor could these themes be limited to the confines of a single text or visual source. But a festive, affirmative, and imaginative folk culture of Catholicism did surround van Gogh in Arles as he developed his *Berceuse* series as a secular devotional ensemble. During the two months that van Gogh undertook and copied *La Berceuse*, the social world around him was transformed into an annual staging ground for celebrating the Nativity. Here special creators of applied

arts, theater, and music devised artful representations of the newborn baby Christ tended by doting parents, Mary and Joseph.

These spectacles, distinctive to the region, were not solemn pageants or processions organized by clerics; they were exuberant expressions of a nineteenth-century popular and commercial culture that, for two months each year, united public and private life as a community *devant la crèche*—before the crib. Families and local groups constructed, for home and town spaces, miniature sets called "crèches," which featured clay figures portraying the Nativity story; elaborate musical theater productions brought the story to life, featuring tender songs to the baby Savior. In Arles and its environs, both the decorative crèches and theatrical versions operated on a witty anachronism: the Nativity story was set not in Bethlehem but in modern-day Provence, and it unfolded not only before the three kings and the holy family but among representatives of a range of local types, identified by their vocationally and regionally specific costumes and accessories. The timing of van Gogh's *Berceuse* coincided exactly with the height of this popular crèche culture in Arles. He was not only surrounded in Arles by the crèches themselves but van Gogh also attended and commented on one of the Nativity musicals just as he was completing his third *Berceuse* canvas and was granting it growing symbolic and spiritual significance.

During the first weeks of December, as van Gogh was painting the whole Roulin family and venturing a new portrait of Madame Roulin, a special corridor in the Arles marketplace was being readied for the annual arrival of the "santons," the miniature painted ceramic figures that peopled the local crèches. Artisan retailers of the figurines installed their wares and announced the new characters to join the gallery of local types to be assembled in the Nativity sets. The arrival of the santon merchants always coincided with Saint Nicholas Day, December 6, the official start of the two-month period devoted to *faire la crèche*—creating and displaying the sets showing the newborn Christ and his modern welcomers. The crèche process developed in intervals. The models with their installed figurines were prepared just before Christmas, and some other figures were added later—on January 6, for instance, to mark the day of the Epiphany, the statuettes of the three magi and the shepherd's star were placed in the crèches. The crèches were dismantled exactly forty days after Christmas, February 2, known as Candlemas, the day commemorating Jesus' presentation at the Temple.[84]

The term "santons" derived from the Italian *santoni*, or "little saints," the name for the Nativity figures that decorated church altars beginning in the twelfth century. Adopted in southern France during

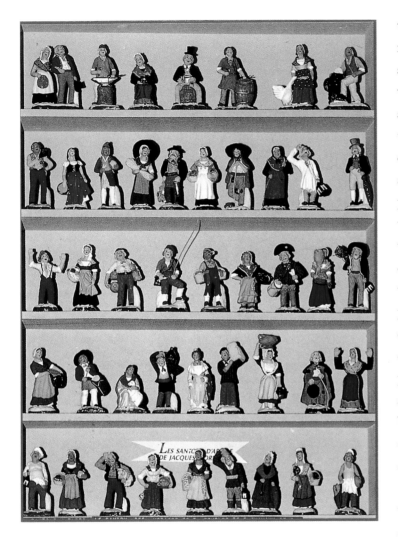

the Counter-Reformation, the crèches with their Nativity figurines flourished in seventeenth- and eighteenth-century Provence in sacred settings and became a distinctive tradition of the region, with specialized artisans creating the models from carved wood and spun glass. During the late eighteenth century the crèches and figures moved from church to public and domestic spaces, and the cast of characters expanded to secular and local types. New materials and local workshops produced these santons, using painted papier-mâché, cardboard, cork, and even glued bread crumbs. But the most popular material was the native red clay, carved and fired to create ceramic figurines, which were painted and outfitted with costumes and tools. By the mid-nineteenth century, the ceramic santons were run off serially, fired in molds, and painted in bright simple colors; rather than being draped in fabrics and materials for their costumes, the santons were now smoothly painted around their diminutive frames, with the figures' accessories also carved in and painted over the clay surface (Fig. 144). Local workshops in towns such as Aubagne, Aix-en-Provence, Arles, and Marseille were celebrated by the mid-nineteenth century as santon specialists and engaged in competitions for their inventive and charming creations.[85]

By the Christmas season in van Gogh's Arles, the santons and their crèches had emerged as a thriving folk art, mixing the sacred and the secular, religious occasion and commercial opportunity, and family ritual and affirmation of regional identity. Public crèches were complemented by handmade crèches installed by families in their homes, and children looked forward to the yearly ritual of arranging, in papier-mâché, cardboard, or wood, the proper backdrops simulating their local town or village as the miniature stage for the holy family and their modern santons. A typical crèche of the 1880s (Fig. 145) would have included the white stone and red-tile-roofed houses of the Provençal type; a windmill

FIG. 145. A PROVENÇAL CRÈCHE.
Collection Musée de Vieux Marseille

or a well, with tiny cypress trees and local grasses, moss, and flowers strewn around it; local market streets with shop signs in view, from the baker to the grocer; and a cave or stable for the Nativity proper, with the baby Jesus lying in his cradle and Mary, Joseph, and the animals nearby. The Nativity scene itself, which always included the canonical three kings, could also be sprinkled with figures culled from other parts of the New Testament or from folk religion, such as Saint Martha, Mary Magdalene, or saints like Lazarus, Peter, and John.[86]

By mid-century, the santons attending the holy family were not little saints at all but representative local types distinctive to rural and municipal Provence (Figs. 146–153). Historians have called the

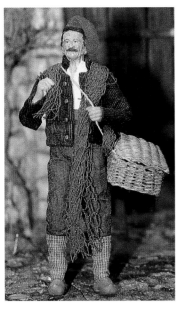

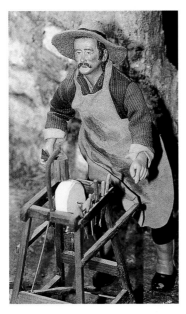

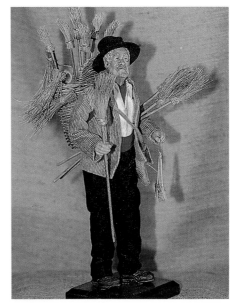

TOP LEFT **FIG. 146. FISHERMAN SANTON.** Private collection

TOP CENTER **FIG. 147. KNIFE-GRINDER SANTON.** Private collection

TOP RIGHT **FIG. 148. BROOMMAKER SANTON.** Collection Musée de Vieux Marseille

BOTTOM LEFT **FIG. 149. INK-SELLER SANTON.** Collection Musée de Vieux Marseille

BOTTOM CENTER **FIG. 150. FISHMONGER SANTON.** Private collection

BOTTOM RIGHT **FIG. 151. CHEESE-SELLER SANTON.** Private collection

crèches and their figurines a "collective mise en scène" of regional life, expressed by the startling blending of the sacred with the everyday.[87] The shepherds so important to the religious story had their place in the scene—according to the New Testament, it was to the shepherds that the angels first announced the birth of the baby Jesus—but the santon-shepherds were dressed in the cape and hat of the sheepherders of Arles and the Camargue. A game hunter, with his rifle and catch of the day, joined the assembly for the Nativity, as did many other artisans with their wares and costumes: the knife-grinder with his wheel; the miller slung with sacks of grain; fishermen with their nets, boats, and baskets; and glaziers carrying their back-pack frames. Female stock characters included a laundress; a spinner with her distaff; and the cheese, egg, and fish sellers at the local market. A santon figurine called the "woman at the cradle"—*la femme au berceau*—matched the sacred crèche theme of the cradling of the baby Jesus with a modern secular Provençal mother who sat rocking her baby. These women santons all wore regional dress, with long skirts that tucked at the waist, layered long-sleeved blouses, and shawls. The cradle woman described by one account wore an orange jacket and blue kerchief strewn with eyelets of white flowerettes.[88] By the 1850s, new characters of Provençal folk culture had been integrated into the

FIG. 154. SANTON TYPES. Reproduced from G. Arnaud d'Agnel and Léopold Dor, *Noël en Provence: Usages, crèches, santons, Noëls, Pastorales* (Marseille: Laffitte, 1975)

santon company of artisans and merchants, such as the regional musicians playing the special tambourin drum and fife. Gypsy families with their caravans and wagons also took their place as santons in the crèche microcosm of the Provençal world.[89]

As a flourishing form of nineteenth-century popular art, the santons and crèches possessed certain visual and technical qualities. First, they relied on an economy of means and vivid, bright colors. The painted and fired figures were carved simply; while three-dimensional, their patterns looked like cutouts with a few synthetic planes (Fig. 154). The frames were evenly covered with distemper or oil, which soaked and bound the clay with a smooth color cover. The reddish clay showed through the paint layers applied over it, making the figures' faces look especially ruddy.

The effectiveness of the diminutive physiognomies depended in large part on the application of vivid blocks of contrasting colors that specified their types and costumes. Writers on the santons mentioned their "dazzling" and "brilliant" palette, which exploited the "warm colors of the Midi" to great force. In discussing one *santonnière* as a "remarkable colorist," for example, a critic exclaimed that "in the humble domain in which she applies her brush, her manner is that of Monticelli," noting further that "she seems to paint with precious stones: her reds, greens, and yellows glisten like rubies, emeralds, and topaz; her blues resemble medieval lapis lazuli, recalling those of beautiful illuminated manuscripts."[90]

Second, the crèches and their santons succeeded through a cunning combination of realism and abstraction. Some figures were based on portraits, which santon artists might have created by sketching the faces of ordinary citizens in the streets or adapted from the depictions of more famous individuals such as the

Provençal poet Charloun, the entomologist Fabre, or even Frédéric Mistral himself.[91] Naturalism and illusionism reigned in the backdrops, where local flowers, wallpapers, moss, and tiles were affixed from the immediate surround.[92] But the likenesses of the figurines themselves were always synthesized to a type, and they cohered as a genre between prototype and portrait. The santons' realistic but generalized features made them instantly recognizable, beyond the confines of a single individual.

Third, the crèches and santons composed a visual spectacle enhanced by other media. During the weeks before and during Christmas, multicolored candles were lit every night inside the family crèches, creating luminous effects and delighting the children. Later these colored candles were replaced by multicolored electric lights installed in the crèche to set off the figures in the shadows.[93]

Finally, music complemented the lights and colors of the crèches. A tradition of singing special chants, called Noels, in front of the church crèches had developed in seventeenth-century Provence; in the centuries that followed, popular songs developed for the family crèches and for the season of the special protection of newborns—*les nouveaux-nés*—by the Virgin. These songs were called *berceuses*. Some, like the local "Berce, berce, la poupée de chiffons," sang to the baby about his fisherman father and his mother who would nurse him.[94] Others, more specific to the crèches, included modern Noels centered around the crib of Christ, like those written by the Provençal regionalist Theodore Aubanel in 1865. His "Berceuse," or "Bressarello" in the Occitan dialect, presented Saint Joseph tending the baby as he sang to him of music-making angels around the cradle. "Go to sleep," Joseph soothed. His song warned the baby that his sweet mother was busy mending his little shirt, and his cries, if they interrupted her work, would leave him a shirt with holes in it![95]

Van Gogh developed his portrait of Madame Roulin as a *berceuse* while the popular culture around him exploded with modern, humanized representations of the Nativity and the joys of family tenderness. He probably began his secular maternal image independently of Arles's crèche culture, but as he produced multiple copies of his *La Berceuse* in January and early February and broadened the web of meanings he associated with it, elements of that culture had particular and provocative resonance and seeped into his consciousness.

There are some striking correspondences between van Gogh's painting and the world of the santons. First, the figure of the *berceuse* had powerful significance for both the painter and the Catholic folk culture that transported through miniature arts the totality of its community to join the newborn

baby Christ at cradleside. Second, to give his image the immediacy and accessibility of popular art, van Gogh used techniques of reduction and coloration that were similar to those characterizing the santons. Van Gogh considered his portrait vividly colored and broadly painted, "like a chromolithograph in a cheap shop." Alternating flatness and texture, his female figure has some aspects of a cutout, as in the upper part of the head inset in the wall. While three-dimensional in form, the santons, as we have seen, were designed with simple contours and elemental lines, with pattern drawings akin to the outlines of cutouts. The santons, too, relied for their expressive force on broad masses of painted color areas with heightened contrasts. Like the santons, van Gogh's painting belonged to a genre between portrait and prototype; his likeness of Madame Roulin was meant to be both individualized and capable of offering a generalized image for ordinary people, such as that "a sailor might imagine when he thought of a woman ashore." And van Gogh's late-January letter mentioning his idea of grouping the *Berceuse* series between sunflower paintings, which would "form torches or candelabra beside them," recalled the multicolored shimmering candles set around the grouped figurines in the crèche around the cradle baby, including the figurine of the *femme au berceau*, the modern woman in Provençal dress at the cradle.

A final set of connections is suggested by Mme Roulin as a citizen of Arles and a participant in its Nativity culture. While Joseph Roulin, we recall, was a republican, Boulangiste, and anti-clerical, the family did have a christening and feast for baby Marcelle at home; it is likely that Mme Roulin and the children set out and prepared their family's crèche with santons and colored lights. Van Gogh spent much of his convalescence after leaving the Arles hospital from January 7 to January 20 in the company of the Roulins, with Joseph Roulin departing for Marseille January 21. If the family had installed a crèche, he would have seen it at their home, along with those in the streets of Arles. Joseph Roulin's singing to his baby evoked by van Gogh's letters, in which Joseph sang in the voice of a tender *berceuse*, was situated in a local culture and special season where Saint Joseph sang to his baby in chants called *berceuses* and was a central figurine in every Nativity crèche.

In the gallery of female miniatures in the crèche, Mme Roulin would have recognized women like herself: local women going to market, wearing their caps, kerchiefs, and long skirts, or the woman rocking her baby's cradle. The wallpaper pattern in the Roulins' home seen at the back of van Gogh's portrait caught the arabesques, eyelets, and flowers that typified Provençal fabrics and design; these same

patterns appeared on the clothing of the santons, or on the wallpaper swatches that were glued in to some of their mini-rooms in the crèche sets (see, for example, Figs. 150–153). The rounded contours and simple outlines shaping van Gogh's boldly colored figure of Mme Roulin shared the formal economy that guided the creators of santons. The ruddy packing of paint layers in van Gogh's image of Madame's face and hands bore some of the features of the santons' physiognomies, where red clay emanated through the paint cover on face and hands. In the crèche culture, these styles and figures were directed to simulate a vital and intimate encounter between human agents and their supernatural protectors; in van Gogh's case, *La Berceuse* and its pendants aimed to naturalize transcendence through the miracle of human partnership.

Although he did not comment in his letters on the crèches of Arles, van Gogh did leave a written record of his encounter with a local theatrical version of the Provençal Nativity, which interacted directly with the themes and timing of his maternal portrait and its expanded meanings. In addition to the seasonal crèche installations, the period of December through early February witnessed the annual performances of Pastorales by regional acting troupes throughout Provence. These Nativity plays had originated in the seventeenth century as southern variants of mystery plays, expressed as a sacred liturgical chant in front of public crèches at Christmas time. By the eighteenth century, marionette renderings of the Nativity had developed in the region, called "talking crèches," and by the 1820s the full-scale dramatic Pastorales had emerged. These plays were essentially the santons brought to life, unfolding their misadventures as they bumbled their way to greet the baby Christ in the manger. Mixing the story of the angels, the magi, and the holy family with local characters such as the miller, mayor, and farandole musicians, the Pastorales combined music and dance with serious interludes and comic relief. The plays grew more elaborate and renowned from the 1840s on. Four hundred carpenters, set designers, and crew members worked on the 1844 Marseille production of the *Pastorale Maurel*, for example; story lines embellished plots far removed from the simple greeting of the holy family to include twists and turns of mistaken identity and romance.[96]

As a regionally specific genre, the Pastorales were written and performed in the Occitan dialect with some parts spoken in French, such as the lines of political officials or, on occasion, the declamations of the angels. Immensely popular, the plays delighted audiences with comic stock characters caricatured from local types, such as Pistachié, the inept lecher, and Barthoumieu, the simpleton whose

MARGARIDO PISTACHIÉ ET GIGET PISTACHIÉ

FIG. 155. ACTORS FROM THE *PASTORALE MAUREL* PRODUCTION IN MARSEILLE. Reproduced from d'Agnel and Dor, *Noël en Provence*

love of drink outpaced his consideration for his fiancée, Margarido (Fig. 155). These three alternated slapstick predicaments, from falling into a well to misleading the entire group journeying to Bethlehem by unwittingly taking the homeward-bound road when they were almost all the way to their destination. Actors who specialized in playing the parts of these particular characters were precious commodities throughout Provence, and local towns vied to have them perform at their theaters during the Pastorale winter season.[97]

In the January 28 letter that van Gogh wrote to Theo about his *Berceuse*, he also reported that he had gone the day before to the Folies Arlésiennes theater and had seen a performance of a Provençal Pastorale, "representing, of course, the birth of Christ." Van Gogh characterized it very aptly as "reminiscent of the Christian theater of the middle ages" while "mixed up with the burlesque of a family of gaping Provençal peasants."[98] The play that van Gogh attended, *Riboun: Pastouralo, Opéra coumique en 5 ate (Pastorale, a Comic Opera in 5 Acts)*, had been announced on January 13 in the local Arles paper, the *Forum Républicain*.[99] The unpublished play was to be performed by the "Orphéon des Alpines" acting troupe of Eyguières, a nearby town, the newspaper reported; the authors were the Perret brothers, the music was by M. A. Verandy, and fifty choristers as well as dancers would participate.[100]

1 Riboun (lou fou) ; 2 Galipan (Baile di boumian) ; 3 Bloundet (fleu-de Riboun) ; 4 Telin (brulaire de vin) ; [...] 5 Justino (sourceiro) ; 6 Fougasso (gardo cuenge...)[...]

FIG. 156. **CHARACTERS FROM THE** *RIBOUN PASTORALE*. Drawing reproduced from A. and E. Perret, *Riboun Pastouralo, Opéra-coumique en 5 ate* (Aix-en-Provence: Makaire, 1925)

The *Riboun Pastorale* epitomized the popular and syncretic genre of the nineteenth-century Provençal Nativities, combining burlesque and farcical elements with epiphany and sacred commemoration. The subplot involved the coming together of two families—the mad Riboun and his stolen child, Bloundet, and the sorceress Justino and her lost son, the gypsy leader Galipan—and their redemption (Fig. 156). The family sagas were interspersed with comic escapades, such as scenes of shepherds given to drink; the rustics collecting a ham, olives, and two live chickens to present to the holy family; and the pompous speeches of the local mayor. The play included many musical numbers and an extravagant battle between Saint Michael and the Dragon. Throughout, Christ was described as the God of the humble, "born on straw like a poor person." The climax of the story took place at the crib of baby Jesus, when order was restored and divided families were reunited. The sorceress, first to arrive, beseeched Jesus to return her lost son; the gypsies, plotting to steal the infant Jesus, were foiled by her; Riboun was reunited with Bloundet, his stolen son; and Galipan recognized his mother, the sorceress Justino, and begged her for forgiveness and for pardon before the crib. A final musical number with the whole cast singing at the crib ended with the now-reformed sorceress in a solo that the angels lost in the stars were singing to the glory of God (Fig. 157).[101]

FIG. 157. MUSIC FROM THE FINALE OF THE *RIBOUN PASTORALE*. Reproduced from Perret,
Riboun Pastouralo

Van Gogh was not comfortable with the Occitan dialect, spoken by many of the main characters in the *Riboun*, but the combination of music, pantomime, special effects, and spectacle made the story generally comprehensible. He was very affected by the music, especially the singing of the "old peasant woman" in the play, the sorceress Justino. He wrote to Theo of the woman's transformation through song and her encounter with the baby Savior. Clearly "dishonest" and "treacherous" in much of the play, van Gogh wrote, she was ultimately, and movingly, regenerated:

> *Now in the play that woman, led before the mystic crib, began to sing in her quavering voice, and then the voice changed, changed from the voice of a witch to that of an angel, and from an angel's voice to a child's, and then the answer came in another voice, strong and warm and vibrant, the voice of a woman behind the scenes.*
>
> *It was amazing.*[102]

The beauty and vibrancy of the drama and the music enabled van Gogh to be comforted personally. "It was the first time I slept without a bad nightmare," he wrote to Theo the next day.[103] His attendance at the Pastorale also brought him face to face with a collective spectacle of joyous greeting and singing at a baby's cradle, with a mother reunited with her own son as she celebrated the miracle of the newborn Christ.

The letter in which van Gogh described this Pastorale and his reactions was also the one in which he chronicled the third version of the *Berceuse* painting, expressing his ideas that the canvas might convey solace for sailors in their isolation, elicit a "sense of being

rocked," and recall "childhood lullabies." The Arles Pastorale offered at this critical moment of van Gogh's evolving *Berceuse* a theatrical version of a modern sacred Nativity, culminating in a scene of collective redemption at the baby's cradle. The musical climax of the transformation of the witch into an angelic mother contributed to van Gogh's own sense of being soothed from his usual nightmares; it may also have shaped his associations of the musicality of *La Berceuse* and the painting's role as an agent of consolation. A few days later, van Gogh commented in a letter to Theo that "the dialect of these parts is extraordinarily musical in the mouth of an Arlésienne" and that "there's an attempt to get all of the *music* of the color here into *La Berceuse*."[104] The music of the color in Arles had a very particular local grounding in the Nativity theater of a community's miraculous adoration; van Gogh adapted its themes to a devotional art in the presence of a maternal portrait.

The crèche culture and the Pastorale made another, more amusing appearance in van Gogh's thinking. Toward the very end of the letter to Theo about the play, van Gogh noted that he would not consider going to the tropics, much as this idea, suggested by Gauguin, was appealing to him. "Personally I am too old and (especially if I have a papier-mâché ear put on) too jerry-built to go there," he wrote, using the term *trop en carton* for "too jerry-built."[105] Papier mâché and *carton* were the terms and materials used throughout the popular visual culture of the Arles Nativity, a makeshift, "jerry-built" world of sets, backdrops, figurines, and costumes for sacred and local characters. Van Gogh, joking about his ear, thought of his own condition as if he were one of the fabricated figures of the season— a santon who needed an ear put on, or a jerry-built, pieced-together character from the *Riboun Pastorale*.

HOLY WOMEN AND SAINTES-MARIES-DE-LA-MER

Along with the spiritual force and consolatory function that van Gogh assigned to his *Berceuse*, the painting hints at his response to a final element of the Catholic popular piety he encountered in Provence. Three of his comments suggest the ways he saw the painting as a secular devotional imagery, a type of sacred realism: his characterization of *La Berceuse* as a modern equivalent of the "saints and holy women" of early Christianity; his idea of surrounding the female with blazing sunflowers sym-

bolizing love and "gratitude"; and his notion of placing such a "triptych" in a sailor's tavern, such as in the coastal town of Saintes-Maries-de-la-Mer. This particular fishing town was dominated by the popular cults of female saints, whose miraculous intervention in the lives of sailors and ordinary people saturated its visual culture, annual pilgrimage, and daily rituals. Van Gogh had visited Saintes-Maries in late May and early June of 1888 and had registered little awareness of the conspicuously sacred features of the town. A year later, as he explored a new language of solace for sailors in his *Berceuse* series, traces of the town's popular Catholic culture of gratitude and love for saintly women surfaced, adapted to a new humanist alternative.

The pilgrimage town of Saintes-Maries-de-la-Mer celebrated the miraculous journey of three women—Mary Jacobé, Mary Salomé, and their servant Sarah—at the dawn of Christianity. The women had been part of a holy company of Christ's relatives and disciples who had traveled together to Provence. According to legend, the servant Sarah, left behind on the shore, was distraught as she watched the others launched in the crowded, oarless boat by the enemies of Christ. She called to join them, and one of the Marys then flung out her cloak, allowing Sarah to walk across the water to reach the others. The women propelled their craft by holding their long robes like sails to the wind, piloted by an angel, until they arrived safely at a coastal town.[106] While others dispersed, the two Marys and Sarah remained in the Camargue and erected a simple shrine to the Virgin on the shore and were later buried there.

From the sixth to the twelfth century, the tomb and shrine became the objects of a cult, attracting pilgrims from near and far and renowned as a place of miraculous healing. Throughout this period, the little town that grew up with the shrine was called Notre-Dame-des-Barques (Our Lady of the Boats).[107] After incursions by the Saracens, a massive barrel-vaulted Romanesque church was built on the site of the original sanctuary, assuming the shape of a ship to commemorate the women's arrival. In 1448 King René discovered bones beneath the church and identified them as the remains of the two Marys; relics of Sarah were exhumed shortly after. The king had a new structure built at the eastern end of the church to house the sacred deposits, a lofty tower made up of three chapels superimposed on one another. An adorned double ark enshrined the relics of the Marys, which was set in an airy roof chapel above the choir. Sarah's remains and an altar were placed in a crypt below the sanctuary. These fif-

teenth-century additions provided architectural focus for an officially sanctioned cult of the women as saints, which flourished through the end of the nineteenth century.[108]

The annual pilgrimage festival of May 24–25 formed the central event in this cult of the holy women. Located at the secluded tip of the Camargue, Saintes-Maries was not yet linked to any railway network. Arles provided a principal transport hub for the scores of pilgrims assembling from all over Provence for the festival.[109] The desolate road to the coastal town, known as *la route des Saintes*, crossed the Camargue for thirty miles, threading through a vast, largely uninhabited terrain, described by travelers as a "moody prairie-like country choked with sands and tufts of spiky grasses," a "salt-caked and sandy desert" broken by marshes and "stagnant lagoons."[110] Contemporaries considered a Saintes-Maries pilgrimage the equivalent of the pilgrimage at Lourdes, while less touristic; so far out of the way, and inaccessible by rail, the Provençal fête attracted thousands of *dévots* who were less contaminated than the crowds at Lourdes by the spectacle of voyeurism and less inhibited by the regulations of the official clergy.[111] Writers marveled at the sudden shattering of the Camargue's usual arid stillness by the crush of people and convoys during the third week of each May. "A steady stream" of carts, covered wagons, horse-drawn carriages, and omnibuses made their way along the single road, jostling with the processions of walking pilgrims singing hymns, bearing colored banners, and shouting encouragement to the companies of the sick and disabled who craved a miraculous cure that had for centuries been associated with the relics of the holy women enshrined in the local church and exposed during the annual ceremonies.[112]

The two-day festival culminated in a parade to the beach. The pilgrims carried large figurines of the women saints, dressed and decorated with special jewels and elaborate costumes, in a model boat (Fig. 158). When the figurines arrived at the water, they were surrounded by a group of garlanded fishing boats, blessed and sung to, and launched into the Mediterranean (Fig. 159). Frédéric Mistral, attending the pilgrimage, suggested that the boat ceremony epitomized the miraculous reversal of the order of nature. He noted, "On the vast open beach and amidst these visions illuminated by a clear sun, it seemed to us, truly, that we were in paradise."[113] An American observer of 1892, reacting to the ecstatic singing of the pilgrims and their sense of closeness and connection to their supernatural protectors, commented that "there is no faith like this in Protestantism."[114]

The persistence of the devotional cult of the Saint Marys emerged not only in the popularity of the annual May pilgrimage and festival but in a profusion of nineteenth-century sources celebrating the direct intervention of the holy women in the events of daily life and the travails of ordinary people. Popular proverbs extolled the blanket remedies available in the women's curative powers, advising readers that

> . . . *If a lizard, wolf or horrid snake*
> *Ever should wound thee with its fang, betake*
> *Thyself to the most holy saints,*
> *Who cure all ills and harken all complaints.*[115]

Frédéric Mistral presented the main character of his 1859 Provençal masterwork, *Mireille*, as witnessing the miraculous reversal of a young child's blindness after an appeal to the holy Marys; at the culmination of the work, Mireille herself heeds the counsel to go to "Li Santo" to seek relief from her misfortunes. After a terrible journey on foot across the Camargue, Mireille finally arrives in the church and calls upon the holy Marys for help; they appear to her in a vision offering strength, comfort, and release from worldly adversity.[116]

These literary renderings coexisted with other types of nineteenth-century chronicles confirming the effectiveness of procuring

TOP **FIG. 158. FESTIVAL AT SAINTES-MARIES-DE-LA-MER: DECORATED STATUETTES OF THE MARYS.** Photograph Silvester, reproduced from Michelle Goby, *La Provence: Art et histoire* (Paris: Arthaud, 1980)

BOTTOM **FIG. 159. FESTIVAL AT SAINTES-MARIES-DE-LA-MER: THE DECORATED MARYS IN THEIR BOAT AT THE SHORES OF THE MEDITERRANEAN.** Reproduced from Freddy Tondeur, *Camargue secrète* (Société d'Editions Géographique et Touristique, 1963)

supernatural aid from the holy women of the Camargue. Reports circulated in 1845 that the Saint Marys delivered a small town in the Gard from a devastating illness besetting its inhabitants; after a delegation from the town traveled to the church in the Camargue and implored the saints to save their city, the fevers dissipated in twenty-four hours. In 1865 the village of Saintes-Maries was itself said to have been saved from raging sea waters by an appeal to the exalted *patronnes*. A procession to the beach with the reliquaries provoked, it was reported, a slow but eventually complete calming of the waters and the salvation of the entire population.[117]

These narratives of miraculous protection were complemented by abundant visual representations of the saintly women's powers. The walls of the battlemented church at Saintes-Maries were crammed with "ex-voto," or votive, paintings, a genre of popular religious art that offered thanks to a saint or the Virgin, thanks "often made by grateful Catholics who attributed their preservation or recovery from misfortune to the invocation of such intercessors."[118] The format for the nineteenth-century ex-votos typically divided the composition into two painted zones, the upper zone depicting a floating, haloed supernatural figure credited with the rescue, and the lower zone recording the calamity endured by a particular person, such as illness, fire, falling in a well, being kicked by a horse, or crushed by a wagon wheel. An inscription along the base of the image reiterated in words the link between the two pictorial levels, indicating the date, type of disaster, and name of the victim, whose ability to donate the panel was attributed to a miraculous deliverance directed by the heavenly figures (Fig. 160).[119]

As in a number of other Provençal coastal towns, a special genre of ex-votos flourished in Saintes-Maries to chronicle the ravages particular to the maritime life. Here images of shipwrecks, storms, and

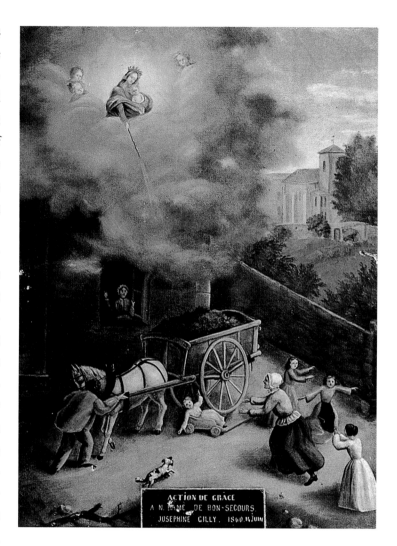

FIG. 160. EX-VOTO "ACTION DE GRÂCE," oil, 36 x 29 cm. Notre-Dame de Bon-Secours à Carcès. Photograph Anne Boiteux

COUP DE VENT ESSUYÉ PAR LE TROIS MATS LE MAZAGRAN DANS LA MER DE L'INDE LE 17 NOVEMBRE 1849 À 10 HEURES DU SOIR À — 150 LIEUES DE RODRIGUE.

TOP **FIG. 161. DETAIL OF A NAVIGATIONAL EX-VOTO, "JH ANDRÉ BREST, 1825,"** wood, 29 x 36 cm. Collection Musée Ziem

BOTTOM **FIG. 162. NAVIGATIONAL EX-VOTO, 1849,** oil, 44 x 52 cm. Notre-Dame de Bon-Port à Antibes. Reproduced from Bernard Cousin, *Ex-Voto de France: Images de la religion populaire et de la vie d'autrefois* (Bourges: Desclée De Brouwer, 1981)

capsized boats occupied the lower zone. Skilled marine painters and draftsmen were increasingly commissioned for these votive images during the nineteenth century in order to invest the sailing vessels with realistic precision and plausibility. The Virgin or the Marys appeared in the upper zone of these pictures as miraculous terminators of the catastrophes besetting the ships and sailors below (Figs. 161 and 162).[120]

At Saintes-Maries-de-la-Mer the two Marys were often the protectresses of choice in the votive paintings, hovering in the celestial skies in their humble, sailless boat while the human disaster unfolded below. An 1837 panel, for example, displayed Jean Vien, inscribed as thirty-three years old, fallen from the window of the granary where he worked, while the two female saints in their boat assured his recovery (Fig. 163). Jacques Lombard and Maria Laugier of Arles offered an ex-voto in 1866 to extol the miracle that enabled their son Charles, represented in the lower zone being kicked by a horse, to regain his health.[121] Other nineteenth-century painted panels showed the two saints in their boat in the upper left-hand corners, with the foreground dominated by individuals affected by accidents of rural life and labor that were to be reversed by their miraculous saviors. These images form only a small part of the large collection of ex-votos in the church of Saintes-Maries-de-la-Mer, which figured with the collections at Martigues, Bouc-bel-Air, and Marseille as among the most substantial of the Provençal region.[122] By the late nineteenth century, the number of ex-votos on the walls of the Saintes-Maries church was so extensive that the painted panels gave way to other, more informal types of offerings, which were deposited in a glass case specially installed to receive them in the entryway to the chapels.[123]

Thus word, image, and festive pilgrimage interacted to invest the town of Saintes-Maries-de-la-Mer with powerful symbolic and sacred significance in the popular culture of nineteenth-century Provence. The involvement of the heavenly figures in the lives of their earthly *dévots* was celebrated across the media of the visual and applied arts and in the special postcards, commemorative prints, and figurative applications in the pilgrimage festival itself. The votive paintings crammed on the walls of the Saintes-Maries church displayed the women saints bounding through the skies in their airborne celestial ship, coming to the rescue of ordinary persons beset by varied misfortunes. A mobile sculpture of a little boat holding the haloed two Marys and Sarah hung over the nave of the church to greet the worshippers, and the larger model of the two figures and their boat offered concrete focus for the outdoor pilgrimage ceremonies at the shores of the Mediterranean.

FIG. 163. EX-VOTO WITH THE SAINT MARYS AT A GRANARY, 1837, paper, 27 x 47 cm. Reproduced from Bernard Cousin, *Le Miracle et le quotidien: Les Ex-Voto provençaux, images d'une société* (Aix-en-Provence: Sociétés, Mentalités, Cultures, 1983)

As noted in Chapter 2, van Gogh had made the trip from Arles to Saintes-Maries-de-la-Mer on May 30, 1888, traveling there aboard one of the special carriages for hire that were added to the route during the week of the pilgrimage festival. He stayed five days, hoping to produce seascapes and landscapes in the Mediterranean light.[124] He had arrived in Arles that spring absorbed by memories of the Netherlands while enthralled by the new vistas of open sky and crystalline, changeable color. The journey across the Camargue had "moors and flat fields like Holland," as he wrote to Emile Bernard.[125] Once at Saintes-Maries, van Gogh thought of his seafaring uncle Jan, the Dutch navy officer; he was reminded as well of the Dutch shores of Scheveningen, and of cottages on the heath at Drenthe.[126] These projections mingled with van Gogh's astonishment at the brilliant light of the Saintes-Maries coast, and the way it clarified the laws of color contrast. In the night skies he saw cobalt blue with "sparkingly gemlike" stars, like colored jewels: "rubies, sapphires, lapis lazuli."[127] He worked on drawings at the beach with a newfound quickness and facility; he experimented here as well with bold washes of color.[128]

The three paintings and nine drawings that van Gogh produced during his stay at Saintes-Maries

omitted any traces of the local devotional culture, the saints, and the festival. Among them were three images of the same subject, the *Fishing Boats on the Beach*, one a reed pen drawing, one a watercolor, and one an oil on canvas. The oil painting, discussed in Chapter 2 (Fig. 32), showed four brightly colored hulls joined by the grids and frames of their overlapping poles and masts. Van Gogh composed the boats in these patterns of intersection; he also applied to them the laws of complementary colors. Adhering through his color notes to the principle of contrasting pairs, van Gogh painted the boats to maximize luminosity by reciprocal interaction, highlighting especially the interplay of red and green and of blue and orange. These visual forms of complementarity corresponded to the workings of another kind of interconnection, signaled by the "AMITIÉ" inscribed on the third boat; the emphatic structural and coloristic interdependence formalized in van Gogh's painting offered a powerful visual equivalent to the operation of "friendship" in the social arena.

In a setting so deeply shaped by a model of friendship and community bound to divine assistance and miraculous interventions, van Gogh poignantly celebrated another kind of *amitié*. One week before he drew his boats on the beach, these same fishing boats had composed a colorful flotilla of veneration. The painted, bejeweled, and costumed statuettes of the two saint Marys had stood in their model boat and were set to sea. Their splendid material

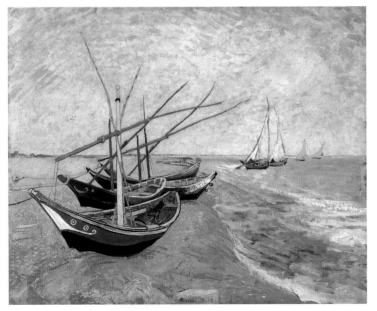

ᴛᴏᴘ **FIG. 164. SAINTS MARY JACOBÉ AND MARY SALOMÉ IN THEIR BOAT.** Reproduced from Goby, *La Provence*

ʙᴏᴛᴛᴏᴍ **FIG. 165. VINCENT VAN GOGH,** *FISHING BOATS ON THE BEACH AT SAINTES-MARIES-DE-LA-MER*, 1888, oil on canvas, 64.5 x 81 cm. Van Gogh Museum, Amsterdam (Vincent van Gogh Foundation)

presence was considered to be charged with vitalized, miraculous powers that overtook their status as representations, facilitating the release from the visible world to the ineffable radiance of apparition and celestial vision.

Van Gogh's boldly colored "still life" of the boats on the beach, by contrast, celebrated a sensory vitalism and the embeddedness of craft objects and their implied human operators. At Saintes-Maries-de-la-Mer, van Gogh isolated *the* distinguishing symbol of the women saints and *the* particular location of a jubilant pilgrimage ceremony completed a week earlier, and he divested them of any of the traces of the supernatural agents with whom they were absolutely inseparable in this place, at this time. Van Gogh's boats of Saintes-Maries were emptied of the holy women (Figs. 164 and 165).

By the time he produced *La Berceuse* in 1889, both personal crisis and the search for a universal language of consolation coaxed van Gogh from negation to a different, more flexible stance toward the holy women of Saintes-Maries. As he shifted his ideas about *La Berceuse* from portrait to prototype, from single to multiple copies, and from a discrete canvas to an interlinked triptych, the model of female saints and holy women in Provençal popular culture offered a powerful resource. Sailors at Saintes-Maries-de-la-Mer, as we have seen, sustained a specialized genre of navigational votive images, which represented the miraculous rescue of their ships by the Saint Marys, and professed, in visual form, their gratitude to their heavenly protectors. These images celebrated the concrete and personal connection between heavenly figures and their human beneficiaries while emphatically locating the source of value and dominion in the traditional realm of the "on high": the celestial figures hovered in the skies and worked their supernatural intervention from above.

When van Gogh proposed setting his ensemble of *La Berceuse* and the sunflowers in a sailors' tavern at Saintes-Maries, he also invoked the themes of emitting love and gratitude, but he did so through the horizontal continuum of a familiar face and flowers (Figs. 166–168). The shift from vertical to horizontal models of divinity had been one of the major cultural processes of van Gogh's Netherlandish formation. For van Gogh, two decades of subversion by Dutch modern theologians had loosened the hold of the vertical hierarchy of divinity while leaving unresolved the specific means of restriking the balance of an immanent nature and a transcendent God. Of the competing attempts to "naturalize divinity," van Gogh's preferences lay with Allard Pierson, who emphasized emulating the unifying and consolational forms of Christ's language. From the time he attempted the Arles *Sower* as a figure bridging work and

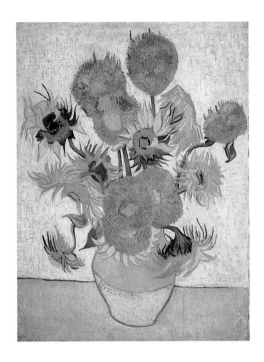 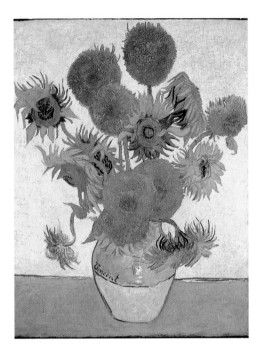

LEFT **FIG. 166. VINCENT VAN GOGH,** *STILL LIFE: VASE WITH SUNFLOWERS*, 1889, oil on canvas, 95 x 73 cm. Van Gogh Museum, Amsterdam (Vincent van Gogh Foundation)

CENTER **FIG. 167. VINCENT VAN GOGH,** *LA BERCEUSE*, 1889, oil on canvas, 92.7 x 72.8 cm. Museum of Fine Arts, Boston, bequest of John T. Spaulding

RIGHT **FIG. 168. VINCENT VAN GOGH,** *STILL LIFE: VASE WITH SUNFLOWERS*, 1889, oil on canvas, 95 x 73 cm. The Courtauld Collection, Tate Gallery, London

the infinite, van Gogh had explored varied ways to discover, through art, an evocation of a sacred wholeness that could relate the individual to a totality beyond the self. He painted into *La Berceuse* multiple layers of interdependence and consolational force in the body and surround of a female figure: through the binding imperative of complementary colors, both within the portrait canvas and between it and the sunflower pendants; the vigorous pigment packing of face and hands, which jumped off the picture plane to the viewer; and the interconnected parts of the canvases as a triptych, whose links would keep expanding to the set of nine that van Gogh imagined.

With *La Berceuse*, van Gogh's quest for mediating the infinite and the tangible did not completely block out the vibrant sights and sounds of the popular culture of Catholic supernaturalism that enveloped him in Arles and the towns he visited. Like the sailors' ex-votos at Saintes-Maries, van Gogh's *Berceuse* joined a symbol of gratitude to a sacralized female figure who offered solace to sailors. This was not a gratitude for already accomplished and presumed acts of miraculous reversals of the order of nature, but rather a gratitude for comfort and consolation offered by human agents on earth, in bind-

ing companionship and hope, freed of the expectation of direct celestial intervention but comforted by the anticipation, or memory, of an embrace. Moving from negation to naturalization, van Gogh came to locate in his synthetic maternal portrait a humanist alternative system of meaning to that of the saintly women shown piloting the heavens in the popular art of the local votives. His *Berceuse* culminated his art of sacred realism, shorn of miraculous rescues and visionary ruminations but nonetheless vested with spiritual force and the consoling function associated with religious art.

Modernist Catechism and Sacred Realism

CHAPTER TWELVE # Gauguin's Last Testament

My soul is not irreligious . . .

O! Sorrow, thou art my master!
PAUL GAUGUIN[1]

It does me good to do difficult things. That does not prevent me from
having a terrible need of—shall I say the word—of religion.

Sometimes religious thoughts bring me great consolation.
VINCENT VAN GOGH[2]

In the last phase of their careers, both Gauguin and van Gogh continued to express key elements of their distinctive religious legacies in their pictorial practice. This concluding section, Part Six, explores an episode of artistic work in a very late period for each painter—1897–1898 for Gauguin, 1889–1890 for van Gogh—when both men were struggling with illness, bouts of despair, and financial difficulty.

By 1897, Gauguin, now destitute and desperate in Tahiti, felt himself "called by death, and sought to reply," as his friend Charles Morice later commented.[3] His reply, which took two forms, drew him back more explicitly than at any other time to the specific themes and challenges of his Catholic formation. First, Gauguin wrote a series of polemical essays in 1897–1898 criticizing the institution of the Church and calling for a new and modern Catholic spirit. These writings reveal Gauguin's vigorous anti-clericalism, his quest for modern faith, and the abiding imprint of his Catholic education in his governing assumptions, language, and habits of argument. Second, Gauguin resolved to create a masterwork as his last testament. He titled it *D'Où venons-nous? Que sommes-nous? Où allons-nous?—Where Do We Come From? What Are We? Where Are We Going?*—and likened it to fresco art; it unfolded an allusive, modern allegory on massive swaths of sackcloth canvas. In it Gauguin reengaged the fundamental theme at the heart of Bishop Dupanloup's teachings, the theme of man's supernatural origin and destiny, and rendered it in the interrogatory form of the catechism he had been drilled in as a seminary student. At the end of his career, in a distant colonial site, Gauguin defied conventional religion even as he transposed to the domain of art the core of spiritual tasks that had been hitherto defined by the institution of the Catholic Church, exploring, in visual form, the central questions of human existence and eternity.

The answers Gauguin ventured in his *Where Do We Come From?*—explored in this chapter—suggest

that the painting synthesized the themes and styles of his earlier efforts to work through religious legacies in his art. A close reading of this canvas's form and content, combined with Gauguin's commentaries about its meaning as well as his accounts of the unusual process he claimed to have undergone in producing it, shows that *Where Do We Come From?* recapitulated core elements of the 1888 set of the *Self-Portrait: Les Misérables; The Vision After the Sermon;* and the *Vendanges: Misères humaines.* In 1898 Gauguin reclaimed the model of ecstatic martyrology that had powered the artist's creativity in his 1888 self-portrait, and he reasserted the language of the artist's inspired, "volcanic" fury, liberated from the "chains of material reality" and the sterile regularity of métier. The Tahitian canvas also reaffirmed Gauguin's quest for transcendent release to the realm of the *au-delà,* the ideal, ineffable order beyond the surface and the senses; in *Where Do We Come From?* he found new ways to navigate the links between the natural and the non-natural first unfolded in *The Vision.*[4] Finally, Gauguin restated the predicament of men and women as *misères* in the 1898 painting, both by repeating the seated figure type from the 1888 *Vendanges* and by situating the scene on the medium of sacking. But Gauguin's representation of the inevitable conflict with matter and carnality was now modulated, less injurious. The afflicted figure was part of a cycle of life depicted, and the surface effects composed by the painter incorporated the knots of sackcloth but covered them in a smooth glaze of pigment—they did not break the skin. Gauguin's testament painting relinquished the isolated agony of his *Christ in the Garden of Olives* and offered a more communal vision of shared questions and redemptive suffering.

Van Gogh, by contrast, greeted the continuing difficulties of his last year in a more modest and unself-dramatizing fashion. He claimed no ambition for a final, singular masterpiece but continued painting in the steady, provisional process of accumulating work and making incremental progress. First at Saint-Rémy and then at Auvers from May 1889 through July 1890, he deepened his hopes for sacred realism and turned them primarily to landscape, producing series of ordinary pieces of nature that could embody and emanate divinity and convey elemental human feelings. Where Gauguin's final period openly derided the patient methods of the artist's métier, van Gogh spent his last year reaffirming the craft core of his artistic practice and mobilized three procedures guiding his conception of his art. First he immersed himself in copying, returning to some of the prints that had shaped his artistic apprenticeship, especially those by Millet. Second, he relied again on his perspective frame, and he invented new ways of framed looking as a format for some of his wheatfields when he did not use the

actual tool, yielding a new set of "framed landscapes." Third, he composed some late "woven land-scapes," as I call them, emulating the interlocking grids and checkerboard color blocks of weavers' "Scottish plaids" and laying in paint with a textured warp-and-weft brush pattern.

The stabilizing functions of mechanism and facture, the frame and the loom, in van Gogh's pictorial language of labor began to break down in this last period, however. The book's final chapter explores examples when van Gogh tried, as he had earlier, to replicate the perspective frame's anchoring posts as guides into his landscape, but now they arced inward, occasionally obstructing rather than clearing the view into the distance. The weaving brush and fibrous blocks of some of the late landscapes were somewhat too kinetically charged and rolling, rather than contained within their predictable grids. Nonetheless, it was van Gogh's abiding commitment to his métier, and to the model of the relational ego, that continued to shape the activities of his last period. He was beginning in 1890 to find opportunities for exhibiting his work, though he continued to give pictures away as gifts and tributes to friends and ordinary people who were his occasional portrait subjects. And, as he did so, he vigorously resisted the claims proposed by an important critic in 1890 that his was an art of superior, expressive exceptionalism. Gauguin, by contrast, discovered in that year a new route to commercial success, and to pay for a move to Tahiti, by shrewdly managing a publicity campaign defined by art critics and literary notables, to which we will now briefly turn.

INSIDER OUTCAST

Gauguin would spend nine of his last eleven years, 1891–1893 and 1895–1902, in Tahiti, financing his relocation to the distant French island colony by a combination of savvy marketing, well-placed connections in the world of avant-garde and government circles, and the appeal of his art and persona, part of which had religious sources and significance.

Many writers have documented how deftly Gauguin manipulated his own self-image to launch himself anew in Paris after 1890. He showed little emotion after van Gogh's death that July, and he did not attend the funeral. Driven by jealousy and "undisguisedly selfish" motives, he opposed Bernard's plan for a retrospective of van Gogh's works.[5] Theo van Gogh's illness and death in October of that year

showed Gauguin "at his most heartless"; he considered Theo's demise "a personal affront," as it left him without commercial representation.[6] Gauguin responded by cultivating a fresh source of both publicity and ideological affinity among the champions of the new Symbolism in literature. Some poets and writers rallied to Gauguin's painting as a visual analogue to their own reaction against naturalism in literature and to their search for a new language that could evoke an essential order beneath the surface of appearances.

Gauguin began frequenting the gatherings of Symbolist writers at the Café Voltaire in November 1890. It was here that he met Charles Morice, a young poet and polemicist for the new movement. Through Morice he met Stéphane Mallarmé, considered one of the founders of literary Symbolism, and he attended Mallarmé's weekly Tuesday-evening salons that winter. Having decided to leave France for Tahiti, Gauguin needed funding, and he arranged to stage an exhibition and sale at the Hôtel Drouot in order to underwrite the move at the end of February 1891.

To publicize the sale, Gauguin engaged in what scholars have described as a campaign of flattery, cajoling, and strategic maneuvering that spanned the realms of influence in art, journalism, and official culture. He asked Mallarmé to intervene for him to request that the writer Octave Mirbeau prepare an article about him. Mallarmé agreed, characterizing Gauguin to Mirbeau as a courageous and despondent "refugee from civilization." Mirbeau's acclamatory essay appeared in the *Echo de Paris* one week before the sale, followed by a longer version three days later in the daily newspaper *Le Figaro*; this version also served as the preface to the catalogue of the sale. The day of the sale, Gauguin's interview with the journalist Jules Huret appeared in the *Echo de Paris*. A few weeks later, Albert Aurier, another poet and art critic, published a celebration of Gauguin in the *Mercure de France* as "the blessed, inspired seer" of the new symbolism in painting.[7]

Building on his notoriety, Gauguin wrote letters to government officials and influential intellectuals to solicit further support, among whom were the republican deputy and arts administrator Antonin Proust and the philosopher-historian Ernest Renan.[8] In March 1891, Gauguin requested funding from the Minister of Public Education and Fine Arts for a "government-sponsored artistic mission to Tahiti"; the politician Georges Clemenceau endorsed his request, and by the end of the month it was determined that he would receive funding "to study and ultimately paint the customs and landscapes

of [Tahiti]."[9] Through the office of the Director of Fine Arts, Gauguin was issued a ticket for passage on a ship from Marseille to Tahiti, and he was also given an official recommendation to the Under-Secretary of State for the Colonies.[10] Gauguin left France that April 1, hailed as both a visionary exile from civilization and an emissary of the French state.

Some of Gauguin's contemporaries recognized in his clamoring for public attention a capacity for quite merciless self-aggrandizement. They were well aware of the way in which Gauguin supplied information selectively to his reviewers and interviewers, and credited him with pursuing the marketing tactics of modern artistic self-promotion, in which the artist's personality was a crucial element of production and commerce. Van Gogh had recognized Gauguin's impulses for scheming and self-interest. By 1891, Gauguin's capacities as a *calculateur* had expanded to ruthless proportions. He had absorbed vital lessons from his early mentors and colleagues and discarded them, along with breaking off friendships with many artists, from Bernard and Schuffenecker to Camille Pissarro. Pissarro, disgusted in 1891 with Gauguin's "shameless" exploitation of others, called him *effroyablement ambitieux*, "terrifyingly ambitious," and went on to say that Gauguin knew exactly how to "get himself elected a man of genius," which included the need to "crush whoever stands in [his] path."[11]

Yet Gauguin's appeal to the Symbolists who championed him in 1891 was not due simply to his deft skills at manipulation and self-promotion. His art work, and his persona, struck deeper chords among the writers, with whom Gauguin shared basic philosophical and aesthetic principles: an idealist posture linked to the cultivation of inner vision and the denigration of base materiality; and the probing of new expressive forms capable of suggesting an ineffable, invisible world of meaning and value, beyond the confines of conventional language and narrative representation.[12] There are many dimensions to these connections between Gauguin and his critical promoters among the literary Symbolists. The aspect of their mutual affinity that is most important for our story—and which has been overlooked—is the shared framework of religious attitudes and language that shaped the critics' representation of Gauguin, and their formation, like the painter's, in the institutions and culture of French Catholicism.

The poet and critic Charles Morice (1861–1919), Gauguin's entrée to the literary avant-garde, was to remain a close friend throughout the Tahitian period, and it was Morice who took on the task of

editing and publishing Gauguin's Tahitian journal *Noa-Noa* in 1897. Like Gauguin, Morice developed an idealism tinged with mysticism in his artistic project, and it had important early roots in his Catholic seminary education.

The son of austere Catholic parents, Morice attended the Catholic Junior Seminary of Saint-Jean in Lyon and then studied philosophy with the Jesuits. Rebelling against the intransigence of the Church and the wishes of his family, Morice took up a career in Paris as a poet and journalist, joining the staffs of the little magazines spawned by the avant-garde in the late 1880s. He became an important theorist of literary Symbolism, defining its key assumptions as a battle between mysticism and positivism in his 1889 book, *La Littérature de tout à l'heure*. Morice's career as a writer centered on probing the relationship between religion and art. Initially his works expressed a strong anti-clericalism, and he proposed what he called a new "credo" of the "religion of art" to replace the spiritual core of the Gospels. Anti-rational and idealist, this "credo" found its home in Symbolism, where, as his biographer noted, Morice turned his former religious "mysticism to the service of art." In his later period, Morice's themes became more explicitly religious, and in 1911 he wrote a novel about a vision of Christ's reappearance in modern Paris, called *Il est réssuscité!* He reconverted to Catholicism soon after.[13]

Gauguin's second literary champion, Octave Mirbeau (1848–1917), represented Gauguin in a particular way in his seminal 1891 articles: he emphasized the identification between Gauguin and Christ. Mirbeau, a journalist and novelist from Normandy, was educated at the Jesuit boarding school at Vannes in Brittany, a training he later described as a terrorizing "abomination" that "chained his spirit" and "dehumanized his body."[14] Many of Mirbeau's novels attacked religious institutions while exploring themes of modern perversion and the torment generated by them, such as *The Calvary* (1887), *Sebastian Roch* (1890), and *The Torture Garden* (1898).[15]

Gauguin's appeal to Mirbeau struck some of these chords of secularized religious suffering. Presenting Gauguin as "anxious, and tormented by the infinite," ever seeking the realm of the *au-delà*,[16] Mirbeau discussed Gauguin's search for luxuriant sensual pleasures in far-off "sacred Edens" and his eclectic "spiritual aspirations" that generated a new, personal art mixing "barbarous splendor," "obscure symbolism," and "Catholic liturgy." But he also noted how Gauguin's work "always emanated the bitter and violent aroma of the poisons of the flesh."[17] He characterized Gauguin's art around this antimony, as bearing both a quest for the mystery of the infinite and a shock of doubt and sorrowfulness: this was

an oeuvre, Mirbeau wrote, that was "cerebral" and "dolorous," which "at times soared to the heights of a mystical act of faith," while at "other times was lost in the frantic shadows of doubt."[18] In Mirbeau's account, Gauguin was thus a "painter and poet, apostle and demon," and one whose art "agonizes" (*un art . . . qui angoisse*).[19] The centerpiece of this art and man to Mirbeau was the anguish and martyrdom of the painter as Christ, "crucified by public hostility."[20] Mirbeau's admiration for the personal Passion of Gauguin led him to purchase a canvas exhibited at the Drouot sale for his personal collection: Gauguin's self-portrait as the "Red Christ," *Christ in the Garden of Olives*.[21]

The last of three writers who publicized Gauguin's art in 1891 was the young critic, theorist, and poet Albert Aurier (1865–1892). A seminal article in the *Mercure de France* by Aurier, the most philosophical of Gauguin's admirers, consecrated Gauguin as the leader of symbolism in painting. Aurier's poetry shared a common theme with Gauguin's painting: the identification of the artist as Christ, tormented by an ignorant public and martyred to his vision. In "L'Oeuvre maudit," for example, Aurier presented the "misunderstood artist" as "the accursed, the excommunicated, dragging our unrecognized masterpieces like a ball and chain."[22] Here the artist was not only a passive, rejected martyr but a rancorous superior being and ferocious blasphemer, which Aurier rendered in startling, graphic language. Aurier's band of accursed creators "howled" and "vomited" their "blasphemous cries toward Heaven"; they peopled the tombs of the cemeteries and relished the "blood spurting through the holes in their tattered clothes," thus "bearing witness to their immolations by staining the terrain of their desolations."[23] Another of Aurier's poems, "La Montagne du Doute," dedicated to Charles Morice, took up the theme of the calvary and the sorrowing Christ at Gethsemane, again given a modern rendering, with Jesus as artist-dreamer sacrificed to his ideal.[24]

Aurier's celebration of Gauguin just before Tahiti centered less on the graphic agonies of the painter's Passion than on the exalted realm of the ideal to which he aspired. The article invoked a varied mix of sources and themes, of which three are especially important here, as they inhabit the particular cultural space where Catholic supernaturalism, idealist Neo-Platonism, and avant-garde French symbolism interacted in a dynamic mix. First, Aurier glorified Gauguin as a visionary, whose "gift" of seeing with an "inner eye" gave him "noble" and "spiritual" powers of illumination and revelation. He identified Gauguin's art as part of what he called "the agony of naturalism," and as "the preparation of an idealist, even mystical reaction."[25] Gauguin's was a superior vision; his "great genius" removed him

from the tawdry realities and constricted sights of what Aurier caustically called "the popular herd."[26] Second, in the language of Platonic idealism and Christian corruption, Aurier indicted sensory and material reality: he wrote of "our lamentable and putrified nation" and of prisoners breaking their chains for the "ecstasy in contemplating the radiant skies."[27] Finally, Aurier provided provocative praise for Gauguin's religious painting. He mentioned Gauguin's landscapes, also, but singled out as "magisterial works" the *Calvary (Green Christ)*, *The Vision After the Sermon*, the *Yellow Christ*, and "the sublime *Garden of Olives*, in which a red-haired Christ seated in a desolate site seems to convey through his tears the expressible sorrows of the dream, . . . the betrayal of contingencies, the vanity of the real and of life."[28] Aurier also highlighted the theme of erotic misery in Gauguin's art objects, such as his ironic wood carving "Soyez amoureuses et vous serez heureuses" (Be in love and you will be happy), in which, as Aurier stated, "lechery in full power, the struggle of flesh and thought, and all the suffering of sexual voluptuousness twist about and, so to speak, grind their teeth."[29] Aurier's representation resonated with the theme of transgression and mortification that Gauguin had explored since his 1884–1885 vanities box; Aurier also emphasized the alternate pole of what he considered Gauguin's luminous, immaterial, and exalted quest for transcendence.

GAUGUIN'S TREATISE ON CATHOLICISM, 1897–1898

Gauguin's Tahitian period engaged him in wide-ranging activities and artistic work, governed by an uneven relationship with a European audience and market. We tend to associate this period with a lush and sensual exoticism, in which, as art historians have emphasized, Gauguin assimilated new Polynesian materials with a range of European sources drawn from his favored predecessors, such as Degas, Manet, and Ingres.[30] Another element of continuity in the Tahitian setting is less familiar: Gauguin's enduring religious conflicts and preoccupations, which drew him back, from 1897, to the spiritual world and mental habits of his Catholic seminary training. These habits of mind were expressed, paradoxically, as Gauguin immersed himself in debates concerning the meaning of modern faith and mounted a vehement criticism of institutional Catholicism.[31]

In the summer of 1897, Gauguin began to write a series of polemical texts on religion, which he

added to, on and off, for the next six months.[32] Bedridden with an eye infection and his body oozing with eczema sores, Gauguin was shunned by the locals, who thought his skin ailments were leprosy. His financial situation was desperate. He had been classed as indigent by the local officials, and his credit was no longer accepted. He was distraught by the news that the favorite among his five children, his twenty-year-old daughter Aline, had died of pneumonia. "I have just lost my daughter. I no longer love God," Gauguin declared. "Each day, as memories came back, the wound opened more deeply, and at the moment I am completely discouraged," he lamented.[33] Gauguin was also haunted by thoughts of his own death. In September he suffered the first in a series of heart attacks and wrote in a letter to his friend Daniel de Monfried that "I see nothing but Death, which delivers us from everything."[34] In November he wrote Charles Morice that "my days are numbered. God has finally heard my voice imploring . . . total deliverance . . . The carcass resists, but it must crack."[35]

Haunted by death, then, Gauguin in his essay explored what he called matters of "Art, the Catholic Church and the Modern Spirit."[36] Here Gauguin took on the essential dilemmas of human existence as he attacked the Church for sustaining a dogmatic and "petrified" response to the human need for the sacred, what he called the "unfathomable mystery" that is God. Gauguin lambasted institutional Catholicism for distorting the spirit of the Gospels and "draining away their truly religious substance." This substance could be gleaned by returning to the "Bible's genuine teachings" and "the doctrine of Christ," which, Gauguin argued, were in accord with modern ideas of freedom, reason, and brotherhood. In wielding sacred texts' true teachings as weapons against the Church, Gauguin also called for interpreting them not literally, as did Catholic authorities, but as "symbolic form, which materializes the absolute Idea."[37]

Gauguin's ideas in these religious writings were unsystematic, but three issues are important to our story. First, he stated explicitly that they were informed by his early studies. He noted in his memoirs that "remembering certain theological studies of my youth, and certain later reflections on these subjects," he had been inspired to dispute the Church's monopoly on the spirit. According to Gauguin, it was the rigidity and dogmatism of the Catholic Church that had "made it the victim of hatred and skepticism."[38] A new type of faith could presumably be possible by reforming those abuses, and Gauguin challenged himself to do so by proving that the Gospels were commensurate with reason and the modern spirit. His desire to engage Catholic authorities in debate and disputation led him eventually to

send an emended copy of his manuscript to the French bishop posted to the South Seas, who responded perfunctorily and sent him back a tract on the Church's history as a missionary force, without making any reference to Gauguin's text. The bishop's rebuff was much like the dismissive reactions of the local Breton priests at Nizon and Pont-Aven when Gauguin tried to donate his *Vision* painting to their parishes in 1888.[39]

Second, Gauguin's approach to his polemical writings exhibited skills and mental habits accrued in his youthful studies. His mode of argument and his exegesis of texts were impressive, if idiosyncratic, echoes of the scriptural exercises and rhetorical training he had learned at Saint-Mesmin. The late religious writings revealed Gauguin's familiarity with a range of passages from the Old and the New Testament and his capacity to mobilize them with erudition and precision. He used citations, with chapter and verse, from Ecclesiastes, Isaiah, and the Gospels of Matthew, Mark, Peter, and Luke, among many others. Gauguin also referred a number of times to the parable of Jacob's ladder for his own interpretation of "ascent" and the status of the soul.[40]

Most important, Gauguin framed his ambitious project as a meditation on three questions, which he called "the ever-present problem: *Where do we come from? What are we? Where are we going?*" These questions, he asserted, captured "the riddle of our nature and our destiny."[41] Gauguin's goal in these late writings thus revisited, in a new way, the fundamental themes of man's origin and destiny that were at the heart of his theological formation. At the Saint-Mesmin seminary at Orléans, questions such as these were central to the interrogatory drills of the new catechism. Gauguin's three questions corresponded closely to a trio highlighted by Bishop Dupanloup: "where the human species comes from" (*d'où vient l'espèce humaine*); "where it is going" (*où elle va*); and "how it goes" (*comment elle va*).[42] Now Gauguin's treatise reasserted these foundational questions in an irreverent indictment of the Church, announcing that he would explore the "doctrine of Christ in its natural and rational meaning," in contrast to the irrationalism of institutional Catholicism.

Gauguin's anti-clerical writings posed only questions and provided neither answers nor any of the solutions offered by conventional religion. But the constitutive force of his religious system was detectable in the way that his mental world reclaimed the interrogatory style as a vehicle for exploring the most basic issues of man's existence as he confronted what he considered to be his own imminent death. Gauguin unwittingly confirmed Dupanloup's assertion that the catechismic formulas were so irresistible in their

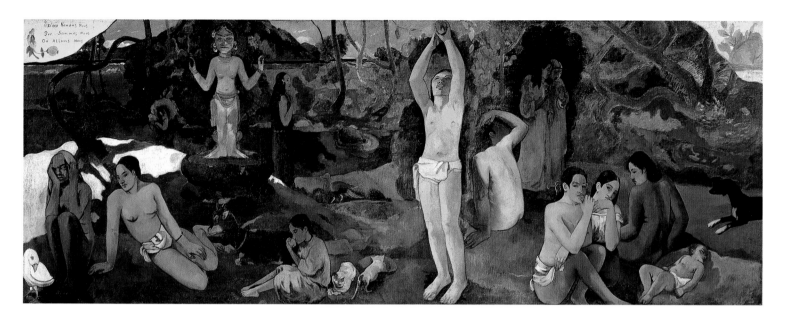

power and clarity that even "men who had lost their faith" and were living "the most irreligious lives" would find themselves "instinctively" summoning the formulas to consciousness.[43]

MODERNIST CATECHISM AND THE PAINTING

The most enduring power of Gauguin's Catholic religiosity emerged not in polemical texts but in pictorial form. In December 1897, after suffering another heart attack, Gauguin decided to create a last testament painting before dying. He claimed he worked day and night, in a feverish pitch of "painting and dreaming," producing the monumental canvas *Where Do We Come From? What Are We? Where Are We Going?* According to his letters, upon completing the painting Gauguin tried to commit suicide; he "took himself up into the mountains, swallowed a large dose of arsenic, and waited to die." The attempt failed, and Gauguin reported that after a night of vomiting and "terrible suffering," he returned home.[44]

Gauguin's immense, friezelike painting depicted thirteen figures along a riverbank on a canvas four and a half feet high and twelve feet long (Fig. 169). Gauguin himself provided extensive commentary in

FIG. 169. PAUL GAUGUIN, *D'OÙ VENONS-NOUS? QUE SOMMES-NOUS? OÙ ALLONS-NOUS? (WHERE DO WE COME FROM? WHAT ARE WE? WHERE ARE WE GOING?)*, 1897–1898, oil on canvas, 139.1 x 374.6 cm. Museum of Fine Arts, Boston, Tompkins Collection

his letters on the circumstances and meaning of the canvas, which offered in some ways a visual parallel to the themes and questions of his wide-ranging religious writings of 1897. In one summary of the painting, for example, Gauguin described how he had completed "a philosophical work on a theme comparable to the Gospels."[45]

Where Do We Come From? is a syncretic and multivalent image whose full range of symbols and styles cannot be addressed here. Previous scholars have rightly emphasized the mythic and metaphysical ambitions underlying Gauguin's attempt to produce such a masterpiece.[46] But evidence from Gauguin's writings and a drawing related to the painting provide compelling clues for the specificity of Catholicism in the painting's form, meaning, and function, an aspect of the painting that has been conspicuously absent from other accounts. I want to suggest how Gauguin's *Where Do We Come From?* culminated his search for a modern sacred art in a subversive catechism, presented in the visual form of a fresco.

Two sources evoke the long-term power of Gauguin's catechismic consciousness in the development of *Where Do We Come From?* The first was Gauguin's letter to his friend Daniel de Monfried in February 1898, where he provided a partial explanation of the meaning of the painting. As he had said about earlier works, Gauguin stressed to de Monfried that his image was allusive and ambiguous, unrestricted by a discrete narrative description or the literalism of conventional symbols, as would be found, he noted, in a mural by Puvis de Chavannes. Nonetheless Gauguin felt compelled to decode his massive panel in the letter to his friend; his exegesis encompassed the great questions of human origin, existence, and destiny, and the mystery of the infinite beyond language and self-consciousness.

Gauguin read the painting from right to left, presenting a cycle of birth, life, and death. At the lower right, wrote Gauguin, were a sleeping baby and three seated women. Behind them two robed figures "confided their thoughts to one another"; a large crouching figure near them raised its arms and "stared in astonishment at these two, who dare to think their destiny."[47] Concerning these same two figures Gauguin later told Charles Morice that they "are recording near the tree of science their note of sorrow caused by this very science."[48] The central standing figure in the painting was reaching up and out of the picture plane "picking fruit," suggesting the Edenic theme of the sorrowful passage from innocence to knowledge. The idol at the back left panel, its arms pointing up, seemed to Gauguin "to indicate the Beyond."[49] The sequence of the cycle was completed at the painting's far left, where Gauguin depicted what he called "an old woman, nearing death." She was seated, knees up and head in

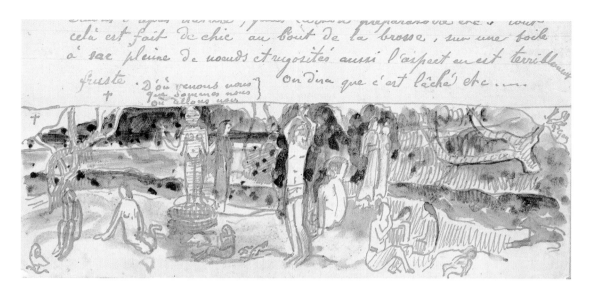

FIG. 170. PAUL GAUGUIN, DETAIL OF A LETTER TO DANIEL DE MONFRIED WITH A DESCRIPTION AND SKETCH OF *D'OÙ VENONS-NOUS? QUE SOMMES-NOUS? OÙ ALLONS-NOUS?* Musée du Louvre, Département des Arts Graphiques, Paris. Photograph © RMN–Gérard Blot

hands, and "appears to accept everything, to resign herself to her thoughts." The woman's silent acceptance of her fate was joined symbolically to a strange white bird at her feet, which, Gauguin commented, was holding a lizard in its claws, and "represents the futility of words."[50]

The probing of life's sorrow, ascent to the beyond, and resignation to death had been recited, in interrogatory form, in Dupanloup's seminary. The Bishop had also disparaged what he called the "dry science" of reason, hoping to open the souls of his young charges to the ascendant unity of sacred silence.[51] In adapting these themes Gauguin inserted an explicitly Christian reference to his set of questions. In the letter to de Monfried explaining the meaning of his canvas, Gauguin drew a pen-and-ink rendering of it so his friend could follow along (Fig. 170). Just above the drawing he listed the three questions the canvas addressed, each on a separate line but joined by a curling bracket. To the left side of the three linked questions Gauguin placed a cross. A second cross appeared in the upper left corner of the ink drawing, while the upper right corner showed a fish, sign of Jesus Christ, and, under it, Gauguin's signature. In the massive canvas there are no crosses in these areas. In the left corner of the painting, above the old woman, an inscription listing the three questions appears, with a flower and a bud; the right side shows a tree with its canopy shading a resting fawn. These corners are painted in glowing chrome yellow, contributing to an effect that Gauguin described as being "like a fresco with damaged

corners applied on a golden wall."[52] The verbal recitations of the catechism were now transposed in an unprecedented way to the language of painting, with questions announced and explored in the echoes of a sacred fresco.

The structure of the catechism and its new form surfaced in a second way. In his later letter to Charles Morice, Gauguin responded to some criticism, after the painting was exhibited in Paris in 1898, that its message was not clearly discernible. Gauguin restated to Morice that his picture deliberately rejected conventional allegory for a more allusive and multiple system of meaning, dispensing with reliance on literal translations of ideas into symbols on the Puvis model. He then clarified again to Morice what he considered his picture's meaning to be. This time Gauguin presented a breakdown of questions and answers, providing under each question some sections of the canvas that constituted a reply. In Bishop Dupanloup's catechism instructions, the question-and-answer format had predominated; for example, the discussion of "Redemption: In what consists this mystery?" was followed by sections of response, such as "reasons for this mystery"; and the question "Does the soul die?" was followed by "immortality of the soul proved by the goodness of God," and so on.[53] Gauguin relied on this style of thought as he engaged the cosmic questions of life and death in visual form, considering elements of the canvas to be elusive, open-ended replies. He wrote to Morice:

In this large painting:

Where are we going?

 An old woman nearing death.
 A strange, stupid bird finishes.

What are we?

 Daily existence.
 The man of instinct wonders what all this means.

Where do we come from?

Brook.
Child.
The communal life.[54]

Gauguin's modernist catechism turned to visual representation as the new site for exploring material and spiritual questions, directing the patterns of his theological formation to anti-clerical but not "irreligious" purposes. In a radical departure from his tradition, however, Gauguin's interrogations did not presume the solace and redemption offered by the set of prescribed answers for the believing Catholic. He characterized the painting in another letter as evoking a human existence filled with "suffering" alleviated by only "*imaginary* consolation," the result of "our *inability* to plumb the mystery of our origin and future."[55]

Gauguin claimed that he embraced personal suffering and the heights of visionary explosion as he produced his enormous canvas. He worked as if in the grip of a dream, he wrote, releasing all his energy in a "passion so dolorous, in terrible circumstances, and a vision so clear" that the image took shape from mind to brush, unmediated by preparation, planning, or corrections.[56] Harking back to the language of the *Misérables* self-portrait he had sent van Gogh in 1888, Gauguin celebrated the ecstatic torments of the artist's *voyage intérieur* as the condition of creativity that unleashed his last testament mural. Afflicted and exalted, he seized an inner state of expressive force that erupted like lava from a volcano. In 1888, "volcanic flames" had stoked the fiery "struggles of the painter's thought," joining agony to exhilaration for the unique creator. In 1898, Gauguin described his creative process to de Monfried in a similar way:

It is all done from imagination, at the tip of the brush . . .

At the very moment when the most intense emotions fuse in the depths of one's being, at the moment when they burst forth and when thought comes up like lava from a volcano, is there not something like an explosion? The work is created suddenly, brutally if you like, yet is it not great, and superhuman in appearance?[57]

Two other elements of the artist's subjectivity emerged in Gauguin's discussion of *Where Do We Come From?* First, he affirmed the priority of inner vision, which moved from dream to canvas with eyes shut to the sensory world. About the genesis of the painting he wrote to the critic André Fontainas that it flowed out, at night and in "total silence," as "my eyes close, to *see without comprehending* the dream in the infinite space before me."[58] Second, in spurning observed reality for the dream-landscape, Gauguin glorified the immediacy of his artistic process, unimpeded by the shackles of verisimilitude. In writing to de Monfried, Gauguin defended the ambiguous scale of his figures on the large canvas by indicting what he called the "stupid precision that chains us to material reality."[59] He contrasted the impulsive "surging up" of his vision with conventional artistic methods, which he characterized in a language of pollution, of things that reek or stink: "This [canvas] does not reek [*cela ne pue pas*] of the model, the métier, or of those purported rules—from which I have always freed myself."[60]

Art historians have been keen to point out that Gauguin's claim of having created the massive canvas in one feverish release does not stand up to scrutiny. A drawing of *Where Do We Come From?* was later found, and it is believed that this drawing may have been a preparatory sketch along the lines of those types of planning techniques that Gauguin maligned in his letters.[61] In some ways, the unmentioned drawing was part of Gauguin's tendency to disguise his preparatory process; his "secret notes" contrasted sharply with the ways van Gogh incorporated the pencil marks and draftsman's lines of his perspective frame in numerous canvases. More important, Gauguin's comments in the letters about his anguished and visionary creative process had thematic coherence and evoked some key features and language of Gauguin's long-term artistic ideology. The volcanic lava of creativity, churning within the artist-prisoner of 1888, erupted again in the artist-exile, as did Gauguin's early exhortation to work "freely and furiously," without "sweat," since "strong emotion" could "be translated immediately," governed by the dream. And the chains that shackled the artist to a debased material reality still had to be broken in 1898 as they had a decade before. In 1888, Gauguin as *misérable* repelled the "putrid kiss of the Beaux-Arts"; in 1898, it was the "stink" of rules and "métier."[62] The liberties of form and indeterminate meaning in his *Where Do We Come From?*, Gauguin explained, were imperative, for the essence of painting was "immaterial and transcendent," designed to express the inexpressible.[63]

The dream mediated by the artist as *Where Do We Come From?* brought together, in the single canvas, the key themes explored separately by Gauguin in the period of his interaction with van Gogh

in 1888. The painting tapped the chords of visionary release and dolorous reckoning hitherto split apart along the polarities of Gauguin's theological formation. The techniques and figures of the 1897 mural suggested that Gauguin offered a new synthesis of a modern sacred art in an expressive register of penitence and partial consolation for the inevitable suffering in human existence.

The linking of natural and non-natural realms that had shaped Gauguin's 1888 *Vision After the Sermon* appeared again in *Where Do We Come From?* In the letter to de Monfried Gauguin wrote that the idol on the left, with upturned hands, "seemed to indicate the *au-delà*," the release to the Beyond. Some writers have suggested that the idol may be the ancient Polynesian goddess Hina, "who attempted to secure life after death for man."[64] Near the idol was another figure directed upward. Gauguin's large central figure was shown stretching, arms reaching up, but in picking the fruit from the tree he was initiating the anguish of the Fall, intimated by Gauguin's description of the sorrowful self-consciousness of the two talking, clothed women hovering behind him.

The quest for an ideal "Beyond" was impeded not only by the figure reaching for knowledge and self-consciousness but by the brooding old woman waiting for death. Her hunched-up position echoed the numerous seated types of female *misères* that Gauguin had explored in 1888 and 1889, from the *Vendanges* to *Breton Eve* and *La Mort* (Figs. 97, 110, and 113). In his testament painting, however, Gauguin's female *misère* awaited her imminent death at the end of a cycle of life disposed sequentially in the panel. Unlike the rumpled young woman in the *Vendanges*, agonized by guilt and carnality, the *misère* in the mural was an old woman who accepted her fate and completed the story. Linking her with the Peruvian mummy on whom she was partly modeled seemed more fitting than linking young women in their prime to the burial figure.

In the visual forms of a fresco on sackcloth, Gauguin composed a pictorial equivalent for the synthesis of his dual themes of transcendent flight and the travails of carnality. The cool, glowing paint was applied thinly and evenly on the vast swath of rugged canvas. Visible brushstrokes and hatched surface were absent as the color appeared to unroll across a graded, horizontal wall scroll. The thin paint and explicitly fresco-like golden corners echoed Gauguin's long-term quest to discover technical strategies of dematerialization to match his exploration of transcendent themes. In earlier phases, as we have noted, Gauguin employed special absorbent grounds and even ironed his canvases to suppress their surface density and enhance their flatness and smoothness. *The Vision After the Sermon*, with its areas

FIGS. 171 AND 172. DETAILS OF FIG. 169. Photographs by the author

of chalky, filmy, and aqueous color, had attempted to blend like a fresco with the cool stone and bare walls of a chapel (Fig. 65). In *Where Do We Come From?* Gauguin returned to the fresco ideal in new form, devising a mural-like frieze that could itself act as the wall or fuse with the wall as he aspired to efface the distance between the material world and the yearned-for immaterial ideal.

But the surface effects of *Where Do We Come From?*, unlike those of *The Vision*, rested not in fluidity and attenuation but in the particular interplay between medium and support, the thin paint and visible sackcloth. After the Arles period of 1888 Gauguin had largely abandoned the use of the unconventional, coarse canvas, but he returned to it for his 1897 testament painting.[65] Here he brushed in paint to permeate the rough cloth, incorporating the knots and nubs in his matte surface. But the relation of pigment to canvas was very different from that of the sackcloth precedent of the 1888 *Vendanges: Misères humaines*, in which he had explored an allegory of lust and afflicted flesh. There he had exploited a parched and blanched paint cover by partly degreasing his oils; and he had used a palette knife as a compressive force across the paint, yielding a field of scabby nature and grated skin.

Where Do We Come From? heralded a different message and expressed it with a different formal structure of coarse canvas to paint cover. The colors on the surface do not appear dry, parched, or lacking in resin; vegetation is lush and unmarred by scorching. The mural bears a sheen, especially present along the shiny, golden bodies of the nude or partially nude figures. No palette knife scraped abrasions of rough sacking to these skins; the paint along the hands and limbs of Gauguin's 1898 figures are encased in what appear as delicate glazings or paint coagulates that act to buff the

knots and nubs from frictive chafing (Figs. 171 and 172). The critic Roger Fry, discussing the whole painting, aptly referred to its "peculiar subtlety of tone and splendid, *lacquer-like* quality of surface."[66]

Charles Morice called Gauguin's mural a masterpiece and a "Credo of artistic faith," "extraordinarily personal in its ardent, dolorous, and mystic purity."[67] Gauguin's image formed a credo in another way, as an evocation of his Catholicism and its replacement in a new visual language. In his testament painting Gauguin absorbed for art a core of spiritual tasks hitherto assigned to the institution of the Church: of asserting the fundamentally dolorous nature of human existence; of exploring the sorrows of self-consciousness and vice to which man and woman were inescapably consigned; and of offering through representation a partial, "imaginary consolation" and vision of redemptive suffering.

Van Gogh's Métier

I feel more and more that we must not judge of God from this world,
it's just a study that didn't come off . . . All the same, . . . this good
old God took a terrible lot of trouble over this world-study of his.

I work on very quietly . . . [T]he great thing is to gather new vigor in
reality, without any preconceived plan or Parisian prejudice.
VINCENT VAN GOGH[1]

While Gauguin sought a last masterpiece of transcendence, van Gogh affirmed in his final year a modern sacred art embedded in nature, communication, and the steady, effortful process of the artist's craft, his métier. Gauguin had initiated his project of art as an "abstraction" by proclaiming the painter as the new Divine Creator, dreaming and thus "rising toward God." In his culminating work, *Where Do We Come From?*, Gauguin celebrated the expansive uniqueness of the artist's vision so unilaterally as to repress the existence of a drawing of its planning and preparation. Van Gogh's late period, like his earlier ones, by contrast, explicitly rejected the model of the painter's visionary singularity in visual practice and in written texts. Like the God he imagined as an artist who blundered his way through studies that "didn't come off," van Gogh continued to pursue his Truth provisionally—repeating, correcting, trying to get things right.

A renewed engagement with popular prints and with creating a visual language of craft labor materialized in 1889–1890 as van Gogh deepened his search for sacred realism. The tools and technics of the perspective frame and the textrous color grids of weaving were mobilized in new ways to structure some of his late landscapes; he considered them evocative forms of an immanent divinity in their blending of embodied nature, coloristic force, and labor methods. Gauguin's contempt for métier and his cult of mystery and incomprehensibility corresponded to his fundamental assumption that painting, as modern sacred art, was only a meager gesture across the gulf of "inconsolable" human suffering and sorrow. Despite his illness, van Gogh spent part of his last year expanding his search for a universal language of comfort and communication in the palpable presence of framed, plowed, and woven landscapes.

"TIME FOR STUDY": COPIES, PRINTS, AND PAINTINGS

In the period after *La Berceuse*, van Gogh painted intermittently while he was voluntarily confined to a hospital in the town of Saint-Rémy northeast of Arles, the Asylum of Saint-Paul-de-Mausole. A former monastery, the asylum was a Catholic hospital run by nuns and staffed by male doctors when van Gogh was a patient there from May 1889 to May 1890. As we saw in Chapter 10, his letters from this period exhibit a general tone of forbearance and resignation, to "take things as they come" and to work with "new vigor in reality" when he was able to.[2] Van Gogh also noted that on occasion, when he did suffer, "religious thoughts" brought him "great consolation."[3] He distinguished these thoughts from what he considered the delusional religiosity of some of the women patients who were devotees of the apparitional cult of the Virgin at Lourdes: "What annoys me is continuing to see these good women who believe in the Virgin of Lourdes, and make up things like that, and thinking that I am a prisoner under an administration of that which very willingly fosters these sickly religious aspirations, whereas the right thing to do would be to cure them."[4]

Van Gogh wrote these comments to Theo in September 1889, just about the time that Gauguin finished painting one wall of the inn at Le Pouldu with an image of an apparition of an angel behind a spinning peasant girl, sometimes called Joan of Arc. While he was no devotee of the cult of Lourdes, Gauguin was nonetheless deeply engaged in exploring the visionary world beyond sensory nature. By late November 1889, van Gogh had become angered by what he described as the "spurious mystifications" of Gauguin's and Bernard's biblical subjects, especially their Christs in the Garden of Olives, considering them a "dream" or a "nightmare," with "nothing really observed"; he even likened one set of figures in Bernard's *Adoration of the Magi* to sufferers of epileptic seizures. Van Gogh contrasted his friends' non-natural paintings with his own return to simple, rustic motifs, such as the olive trees and the cypresses unique to Provence. His intense study of these parts of nature, and his multiple depictions of them, would yield both a truthful "smell of earth" and evocative modern equivalents of biblical emotions.[5]

During his hospital stay, van Gogh combined this study and painting of landscape with a return to basic training in the rudiments of his craft. His work was facilitated by the hospital staff, who gave him an extra room in the men's ward for a studio.[6] Echoing his long-term ethos of perseverance and

"ripening" his skill through practice and repetition, van Gogh made a virtue of necessity; confined to the hospital, he could practice figures and drawing. "Misfortune is good for something," he wrote to Theo, "you gain time for study."[7] He reassured himself, as he had in the past, that his efforts were cumulative, part of an ongoing process toward mastery. He wrote to Theo and his mother that it takes "ten years to learn the profession" of painting, so he might now, since he had begun his turn to art in 1880, be preparing to enter the next phase.[8]

To study figures and refresh his skill at seizing the "essential" form, van Gogh embarked on an ambitious program of copying from prints. In part he pursued this for lack of live models, but the venture also reconnected him to the habits of his earliest apprenticeship and to an artist whose prints he had repeatedly copied to develop his drawing: François Millet. In Saint-Rémy, however, van Gogh copied prints by painting them in colors on canvas rather than drawing them on paper, creating a new medium for popular art.

In the fall of 1889, van Gogh proceeded to paint twenty canvas versions of images from two series of Millet's, *The Labors of the Field* and *The Four Hours of the Day*. Van Gogh also painted copies of three lithographs by Eugène Delacroix, including a Pietà, whose Mater Dolorosa he gave the likeness of the Mother Superior at the Saint-Rémy hospital, and whom he said possessed "the good sturdy hands of a working woman."[9]

The Millet sets were part of a storehouse of black-and-white prints and reproductions that van Gogh had repeatedly worked from in different phases of his career. *The Labors of the Field*, a set of ten drawings of rural laborers that Millet had originally created for *L'Illustration* in 1852, were engraved by Jacques-Adrien Lavieille a year later and widely published over the next three decades (Fig. 173). Van Gogh had become familiar with them during his years as an art dealer in the house of Goupil, which had a thriving business in publishing albums of prints after major painters; Millet and the Barbizon School were among their most prevalent choices. When van Gogh first decided to become an artist in 1880 he had Theo send him this Millet series; this set and other Millet prints formed, along with the popular art manuals by Cassagne and Bargue, the foundation of van Gogh's training. He copied the Millet *Labors of the Field* set again in Etten in 1881, and he reworked them in Nuenen in 1884. Van Gogh most likely had a large sheet of this Millet series in his own collection of prints and reproductions, and it was such a sheet that he would use for the 1889 copy endeavor in the Saint-Rémy setting.[10]

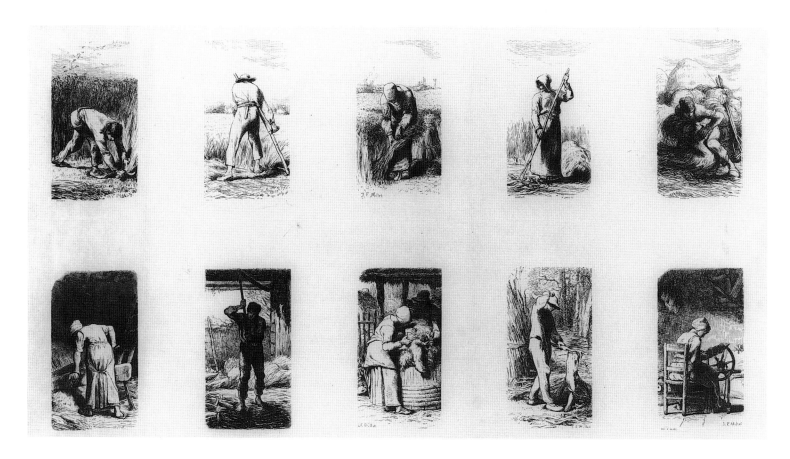

In 1889, when van Gogh did return to his Millet prints to copy, he set them in front of himself as if they were figures or models posing for him; they "pose for me as a subject [*comme un motif*]," he wrote Theo.[11] The idea of using prints or drawings as painting motifs was quite unusual, and van Gogh sought ways to justify it. The study process of copying drawings or prints in the same medium was a well-rehearsed practice of van Gogh's artisanal methods, but copying a print for a canvas called for a rationale; it reversed the conventional hierarchy of making prints after paintings. It was not surprising that van Gogh would do so, as he had long shown some impulses for a reciprocal interaction between prints and paintings, occasionally making paintings after his own prints or drawings rather than using these as studies for a final finished version in oil on canvas. This interdependence was related to van

FIG. 173. JEAN-FRANÇOIS MILLET, *THE LABORS OF THE FIELD*, wood engraving by Jacques-Adrien Lavieille. Van Gogh Museum, Amsterdam (Vincent van Gogh Foundation)

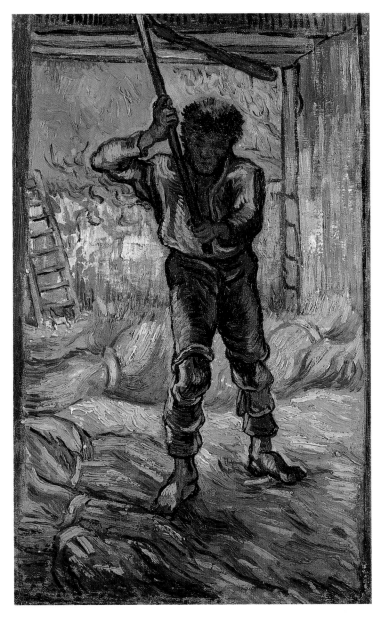

Gogh's tendency to approach the canvas as a provisional medium, less a surface to catch the sudden release of the artist's flash of inspiration than a site for working through, a repeated exercise in paint of getting things right, balancing the essential motif and the artist's transformation of it, often in multiple tries or a series. In his Saint-Rémy copy practice, van Gogh came to defend his painted versions of prints as interpretive exercises, not simply duplications or derivations. Improvising color from the black-and-white images before him, van Gogh explained, allowed him to be taught things by the template, and to provoke a new variant. "It seems to me," he wrote to Theo, "that painting from these drawings of Millet's is much more *translating them into another language* than copying them."[12]

Van Gogh's translations of Millet transformed the prints not only through color but through texture as well. The ten engravings of *The Labors of the Field* together formed a full cycle of rural production, an appealing sequence for van Gogh. His versions provided emphatic visual equivalents for the labor processes depicted. Van Gogh's *Thresher* (Fig. 174), for example, altered the relative serenity of the Lavieille engraving (Fig. 175) and enlivened the surface as a bristling pattern of color. Unlike Millet, who separated the figure from the ground of his work by demarcating separate areas of dark and light, van Gogh united his thresher to his activity with a swath of yellow color and enveloping cascades of grain sheaves. The clothing and face of Millet's man were indistinct; van Gogh, by contrast, matched the rough circular bands of coarse grain on the corn stalks with the rough bands clasping the thresher's legs. And

FIG. 174. VINCENT VAN GOGH, *THE THRESHER* **(AFTER MILLET), 1889, oil on canvas, 44 x 27 cm. Van Gogh Museum, Amsterdam (Vincent van Gogh Foundation)**

the palpable presence of the grain stuffs being pressed was rearticulated visually in the canvas by van Gogh as he shifted the hair of Millet's figure from an ordinary tuft to a set of stubbed and spiky points, and by using an unpainted oval of canvas grain as the visible ground for the thresher's face.

Van Gogh's reworking of Millet in his copies was also evident in his "translation" of the engraving *Night: The Watch* (Fig. 176). Van Gogh sent this version to Theo, thinking of it as a tribute to Theo's pregnant wife, Johanna. The Millet engraving bears a delicate hatching of black and white emitting a central light with downy softness (Fig. 177). Van Gogh's canvas is imbued with blazing light, colored with intense violet, orange, and lime green, and worked into a heavily textured surface. The fabric quality of the surface reproduced in the artist's working hand the activities of basket weaving and sewing engaging the two major figures around their sleeping baby. Upon receiving the painting, Theo wrote his brother that "it is a real success"; of the canvases just sent, this was "one of the things I love the most."[13]

As he rendered his Millet translations, van Gogh expressed new enthusiasm for the role of reproductions in disseminating art to the people. We have seen how van Gogh compared his *Berceuse* to the colored "chromos" of the cheap shops, and thought of hanging one version of it in a sailors' bar. When he worked on the Millet paintings, he hoped such copies might find a public home: "I should very much like to see Millet reproductions in the schools. I think there are children who would become painters if they saw good things."[14] Van Gogh hung the set in his own room in Saint-Rémy, and he continued to have ideas about expanding the realm of art for the people. In November, when he began to express in his letters his rejection of Gauguin's and Bernard's religious imagery, he wrote of his own desire for an unpretentious art of slow, patient work, like a peasant's or a shoemaker's, exclaiming to Theo, "Instead of grandiose exhibitions, it would have been better to address oneself to the people, and work so that everyone could have in his home some paintings or reproductions which would be lessons, like the works of Millet."[15]

Significantly, van Gogh expressed his enduring ideas about extending the popular audience for art, and about the importance of prints and even painted reproductions, at a time when he was beginning to have some of his own work accepted for exhibition. In November 1889 he was invited to participate in the Brussels Salon of the progressive art group Les Vingt, and he chose a number of canvases to send there through Theo, including the Arles *Red Vineyard*. The following March, while still at Saint-

FIG. 175. JEAN-FRANÇOIS MILLET, *THE THRESHER*, wood engraving by Jacques-Adrien Lavieille. Van Gogh Museum, Amsterdam (Vincent van Gogh Foundation)

FIG. 176. VINCENT VAN GOGH, *NIGHT: THE WATCH* (AFTER MILLET), 1889, oil on canvas, 72.5 x 92 cm. Van Gogh Museum, Amsterdam (Vincent van Gogh Foundation)

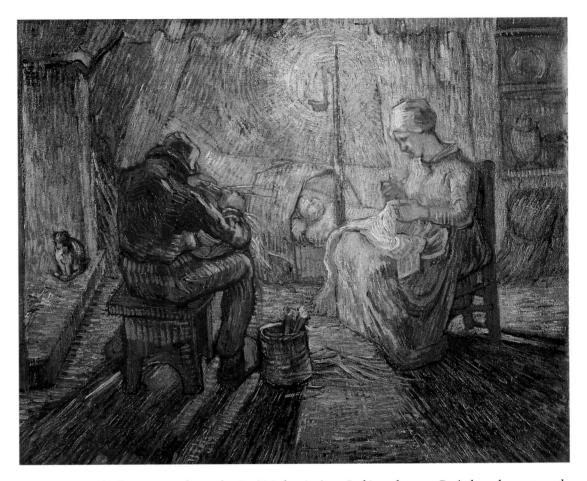

Rémy, van Gogh also sent works to the Société des Artistes Indépendants, a Paris-based avant-garde forum. While these opportunities were thus opening up to him, van Gogh maintained his commitment to the possibility of popular art and a popular audience beyond the specialized exhibition halls, formalizing this possibility by sustaining a rich link to the replicative medium of prints, using labor subjects, and emulating labor forms. His late ideas of an art for the people, composing paintings or reproductions that "would be lessons," were very far from Gauguin's ideas and practice; for him, the lava-burst of the artist's dream could never be replicated or contained, and he maintained a strict separation of paintings and drawings, guarding some as "secret notes" to distance their connection to can-

vas inspiration and suppressing others as tainted by métier. The conception of art as a lesson, earnestly considered by van Gogh in the simplicity of Millet's labor types and their emulators, was vehemently rejected by Gauguin; Gauguin's deliberately ambiguous symbolism made his work an art for the initiated only. Its meaning might be suggested only if the hermetic code of the artist's vision was cracked by the words of the creator himself.

FRAMED LOOKING AND THE PERSPECTIVE FRAME, 1889–1890

The interdependence of art and work continued to structure some elements of van Gogh's style in his last year as he pressed his art to embody redemptive production, a dual imperative that the visual image

act simultaneously as tangible craft product and as evocative sacred presence. One method of formalizing product and presence emerged in van Gogh's continuing use of his perspective tool. The wooden frame, and the habits of seeing and compositional patterns it favored, persisted after Arles as one constitutive element of van Gogh's images of 1889, and he also devised a plan for a new and improved construction for an adjustable perspective frame in his very last weeks of work in Auvers in 1890.

Van Gogh most likely did not have his perspective frame with him when he was admitted to the

Saint-Rémy asylum; if he did—which is not impossible, as he seems to have had, for example, his print collection with him—it is unlikely that the device was up and operating. But with or without the frame itself, van Gogh was drawn to spatial views and structures that corresponded to its prompts. During his first month in the hospital, he produced two gouaches of interior spaces, *The Vestibule of the Asylum* and *The Corridor in the Asylum*.[16] The vestibule image offered one framed scene, a hall with arched double columns and ceiling ribbing yielding to a view of a garden, reemphasized by flanking open doors (Fig. 178). *The Corridor in the Asylum* offered a distant vista, brought nearer to the viewer by an accelerated rush of space (Fig. 179). Multiple arches rippled back into the distance to frame a doorway terminus. The dramatic bounded view shooting down the corridor to an endpoint recalled van Gogh's training with his bracketing perspective frame, which taught him to shoot his eye "like arrows from a bow" into the distance. In the 1889 gouache the corridor's arches acted as recessional prompts, echoing the posts of the frame and creating a propulsive directional for the viewer. The hospital corridor recomposed in an interior scene the types of outdoor framed linear views to a distant terminating structure which van Gogh had responded to throughout his career, such as the 1884 *Avenue of Poplars* and *Les Alyscamps* of 1888 (see Figs. 79, 80, and 81).

A more poignant evocation of the perspective frame emerged in van Gogh's landscape of November 1889, *Wheatfield with Rising Sun* (Fig. 180). This canvas was one of a series that van Gogh painted of a wheatfield enclosed by a wall. He was able to see the walled field, as he wrote Theo, through the iron-barred windows of his room in the hospital; above the wall he could watch the daily sunrise.[17] Van Gogh studied the site outdoors, when he was able to, and from inside his room. The view from inside offered him a ready subject matter, organized into a gridded pattern through the iron bars (Figs. 181–183).

The broad, colorful canvas of the sunlit field did not adhere to the pattern of a single corridor, but it did carry some elements of the particular type of framed looking that van Gogh had practiced with his tool. The view through the window recalled to van Gogh a perspectival mode; he wrote to Theo that it was "a perspective like van Goyen."[18] Van Goyen, the seventeenth-century Dutch landscape artist, had specialized in expansive, linear stretches of space yielding to a distant horizon. When van Gogh first started using his perspective frame in 1882, he had also looked out to a view through a window and compared it to a stretch of space like van Goyen's, and the training drilled by his frame enabled him to

FIG. 180. VINCENT VAN GOGH, *WHEATFIELD WITH RISING SUN*, 1889, oil on canvas, 71 x 90.5 cm. Present whereabouts unknown

organize blocks of reliefless terrain into linear recessions like those he admired in his Dutch predecessors. "Just imagine me sitting at my attic window as early as four o'clock in the morning," van Gogh had written to Theo in 1882 from The Hague, "studying, with my perspective frame, the meadows and the yard . . . Over the red tile roofs a flock of white pigeons comes soaring between the black smoky chimneys. Behind it all, a wide stretch of soft, tender green, miles and miles of flat meadow; and over it a grey sky, as calm, as peaceful as Corot or van Goyen."[19]

Van Gogh's view of the field through his gridded window at Saint-Rémy re-created, in a new setting, the central role of the window as a frame in his artisanal perspective self-instruction. When he first started to learn the rules of perspective in The Hague in 1882, he practiced seeing objects near and far by setting up his self-made perspective frame at his attic window. Looking out, he was delighted by tracking lines of flight and stretches of space in the distance,

TOP LEFT **FIG. 181. VIEW THROUGH VINCENT VAN GOGH'S WINDOW AT THE SAINT-RÉMY ASYLUM.** Reproduced from Jan van Keulen, *Met van Gogh in de Provence* ('s-Gravenhage: Staatsuigeverij, 1987)

TOP RIGHT **FIG. 182. VINCENT VAN GOGH, SKETCH OF HIS WINDOW AT THE SAINT-RÉMY ASYLUM.** Van Gogh Museum, Amsterdam (Vincent van Gogh Foundation)

FIG. 183. VINCENT VAN GOGH, *WINDOW OF VAN GOGH'S STUDIO IN THE ASYLUM*, 1889, black chalk and gouache on pink Ingres paper, 62 x 47.6 cm. Van Gogh Museum, Amsterdam (Vincent van Gogh Foundation)

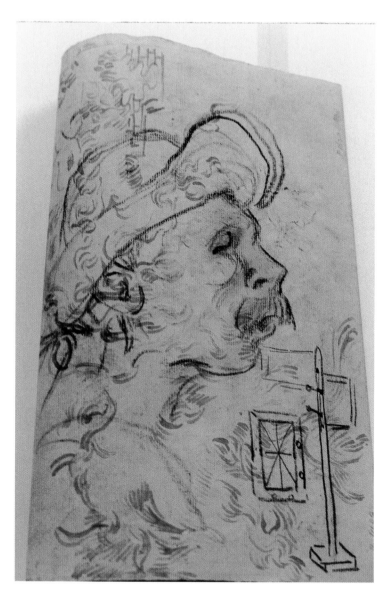

FIG. 184. VINCENT VAN GOGH, AUVERS SKETCHBOOK PAGE WITH NEW PERSPECTIVE FRAME.
Van Gogh Museum, Amsterdam (Vincent van Gogh Foundation)

which cohered into manageable patterns afforded by the threaded frame.[20] The framing tool that inspired van Gogh from the manual by Armand Cassagne, as noted in Chapter 2, was itself a window, divided into four equal squares for creating a visual fix in the distance; Cassagne's exercise book, familiar to van Gogh, rehearsed the siting of a distant tower through an open window (see Fig. 49). Along with creating his own variation of the adjustable wooden frame, van Gogh also remained playfully interested in the gridded window itself as a framing device, whether by painting in a tower seen through the weaver's paned window in 1884 (see Figs. 51 and 52) or by collecting Japanese prints that showed actors looking through or being seen through barred windows sliced into linear boxes that framed them (see Fig. 95).

In the Saint-Rémy *Wheatfield with Rising Sun*, van Gogh again stationed himself at a window that could, in part, act as a substitute frame. It was a window of confinement, but he studied his motif through the bars in a resonant and positive way, exulting to Bernard that the canvas evoked the beauty of the scene of the sun rising over the wheat and offered a peaceful, "consoling and gentle motif." Van Gogh also identified the linear movement animating the field toward the wall as *des lignes fuyantes*, "lines fleeting away."[21] The tracking of lines in flight had been operationalized by the perspective method of framing through the geometric units of a window, and the 1889 canvas afforded that type of pulsed recessional space in a new way. Van Gogh accentuated runner lines cutting through the field longitudinally, offering a late reminder of directional corridors that he had found so riveting throughout his career.

The allure of the frame and its central place in van Gogh's art surfaced in a final way. After he moved from Saint-Rémy to the

northern town of Auvers in May 1890, van Gogh began a new sketchbook. Among its leaves was a sheet with a drawing of a peasant head with hat and mustache, and below the head was a drawing of a perspective frame (Fig. 184). Van Gogh drew two frames, actually. One, to the left, depicted his long-used frame, distinctively threaded in the pattern of a Union Jack and marked by the notches along the edges for adjustable pegging. A second image showed that van Gogh was still trying to refine the frame. In the 1882 version that he had constructed with a blacksmith and a carpenter, there were two wooden stakes on which to mount the frame at different heights for outdoor siting (see Figs. 25 and 34). The 1890 drawing showed a design for a single post for mounting the frame, and there were now two possible attachment positions, one vertical and one horizontal; presumably the position could be changed as the motif suggested. This multipurpose pole with variable notches offered a new option for seeing through the frame in upright stance in addition to the horizontal stretch of the original version. Van Gogh's 1890 sketch, also showing a base for the mounting pole for sturdy changeovers of the frame's position, reaffirms his craft tendencies and his tinkering experimentalism.[22]

WEAVING PAINTING, 1889–1890

The consistent partner to the frame in the métier of van Gogh's art was the métier of the weaver's loom. Watching the weaver at his loom in the Nuenen cottages in 1884–1885 provided van Gogh with his first laboratory of color and months of close scrutiny of artisanal production. Throughout the very late phases of his career he continued to try to emulate craft weaving in his visual forms, and memories of and associations to Scotch plaids and colored cloth appeared in his letters. In Paris, as we have seen, van Gogh discovered bright colors while he transformed Neo-Impressionist velvety dots to dense and bristling "zebra bars" of pigment on canvas, and he experimented with color effects by unrolling his laced skeins of dyed yarn balls along his work table. In Saint-Rémy and Auvers, van Gogh devised another repertoire of technical forms, from brushwork to compositional structures, that evoked the warp and weft of weaving and exploited the interaction of paint with canvas as a woven surface rewoven in pigment parts. Gauguin's quest for sacred art culminated in a penitential medium, formalizing in a thin and smooth coating of paint on sackcloth the sorrowful but insistent journey to

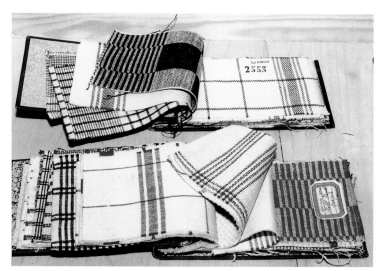

transcendence. Van Gogh's very different course culminated in the sacrality of art through an identification with labor, handling the canvas medium as a site for thick and thin paint cover to materialize production and to replicate weaving. His late work attempted to render the image to be as tangible, physically present, and textural as the canvas on which it was applied.

In the later periods of van Gogh's career he was consistently attracted to woven objects as subjects for composition—baskets of fruit with plaited bands carefully articulated, the rough strands of cane and wicker chairs, and shawls and textured clothes are all part of this repertoire of objects bearing woven materials. The thatched cottages of Auvers also appealed to him in 1890, reminding him, as he wrote to Theo, of the dwellings of Brabant, which he had depicted earlier in dark, muddy pigment. The Auvers cottages offered him new opportunities to work through in brighter colors the plaited and piled thatch of the modest rural structures outside of town.[23]

LEFT FIG. 185. VINCENT VAN GOGH, *WILD FLOWERS AND THISTLES*, 1889, oil on linen, mounted on canvas, 67 x 47 cm. Private collection

RIGHT FIG. 186. BRABANT WEAVERS' SAMPLE BOOKS. Tilburg Textile Museum. Photograph by the author

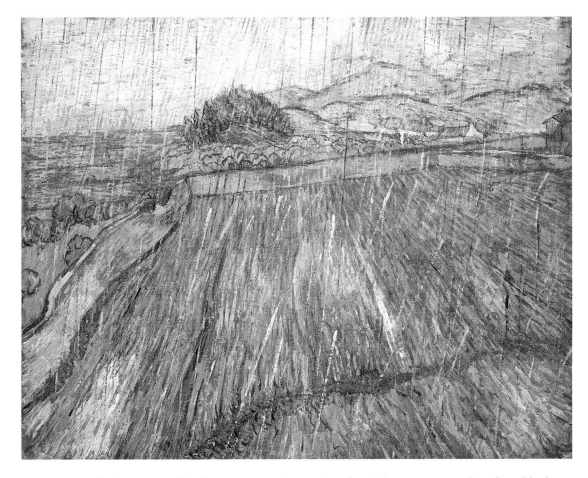

FIG. 187. VINCENT VAN GOGH, *RAIN*, 1889, oil on canvas, 73.5 x 92.5 cm. Philadelphia Museum of Art: The Henry P. McIllhenny Collection in memory of Frances P. McIllhenny

Van Gogh also engaged in the very unusual practice of painting on untreated surfaces like linen towels and cotton bedsheets, using the woven texture of the cloth as part of the composition. The still life *Wild Flowers and Thistles* of June 1890 (Fig. 185), for example, was painted on a red-striped linen hand towel.[24] The red stripe of the border was similar to the stripes on the towels made by Nuenen weavers, as shown in one of the sample books from the 1880s (Fig. 186). The November 1889 *Rain* was painted on an untreated cotton sheet (Fig. 187). This canvas, now in the Philadelphia Museum of Art, is usually compared to Japanese prints of falling rain familiar to van Gogh, such as those of Hiroshige, who used "slanting lines to suggest the effect of rain."[25] Van Gogh had three prints of this kind in his

FIG. 188. VINCENT VAN GOGH, *ROSE WITH MALLOWS*, 1890, oil on canvas, 42 x 29 cm. Van Gogh Museum, Amsterdam (Vincent van Gogh Foundation)

own collection.[26] However, his painted variant of the flat, colored woodblock prints contrasted sharply with the Hiroshige precedent in its raised and visible texture, further intensified by the laying in of the paint on the unprimed cloth medium. The painting showed particularly clearly how the flimsy, gauzy cloth surface catches the paint on the nap, and how van Gogh left the canvas weave open in many areas adjacent to his own interlocking woven brushstrokes.[27]

Van Gogh relied on weaving techniques for one consistent pattern of his late brushwork. As in some earlier portraits, interlocking brushstrokes appeared in the backgrounds of some still lifes, such as the warp-and-weft-like paint stripes applied on the left side of the 1890 *Rose with Mallows* (Fig. 188). He also emphasized this woven background in the brushstrokes of *Wild Flowers and Thistles* (Fig. 185). One of his series of 1889 *Olive Trees in Saint-Rémy* reveals his use of weaving strokes to rake in paint to shape the ground of the trees, alternating a horizontal swath of ground with a vertical comb (Fig. 189).

Weaving provided the compositional structure for a group of late landscapes. In letters of 1889 and 1890 van Gogh occasionally likened his canvas effects to those resembling "a piece of Scotch plaid" or "the combination of tones in those scotch tartans."[28] He wrote of searching for a style that unknotted his lines by an "interlocking of the masses," and noted the appeal of immense plains, "checkered at regular intervals."[29] In Saint-Rémy and Auvers, he repeatedly rendered broad, flat plains as fibrous checkerboard blocks of intersecting colors. Paintings such as the 1889 *Wheatfield with Rising Sun* (Fig. 180), the 1889 *Field with Poppies* and *Landscape with Carriage and Train* (Figs. 190 and 191), and the 1890 *Wheatfields* (Fig. 192) shared the legacy of weaving in van Gogh's

FIG. 189. VINCENT VAN GOGH, *OLIVE TREES IN SAINT-RÉMY*, 1889, oil on canvas, 44 x 59 cm. Van Gogh Museum, Amsterdam (Vincent van Gogh Foundation)

visual language of work. Individual sections of the canvases display the regularity of the brushstrokes of warp and weft, deliberately interlocking. The strokes of paint look like fibers of colored thread, woven together in iridescent patterning. The format of the paintings embodies fields of woven cloth, in multicolored checkered planes of intersecting units.[30]

In *Wheatfield with Rising Sun* (Fig. 180), the framed and consoling landscape, van Gogh threaded a horizontal bolt of paint through the near middle ground, much like the braided rows of grass in the 1888 Arles *Garden with a Weeping Tree* (Fig. 90). *Field with Poppies* and *Wheatfields* (Figs. 190 and 192) combined textural effects that moved from foreground to background in ways that suggest the stages

FIG. 190. VINCENT VAN GOGH, *FIELD WITH POPPIES*, 1889, oil on canvas, 71 x 91 cm. Kunsthalle Bremen

FIG. 191. VINCENT VAN GOGH, *LANDSCAPE WITH CARRIAGE AND TRAIN*, 1890, oil on canvas, 72 x 90 cm. Pushkin Museum, Moscow

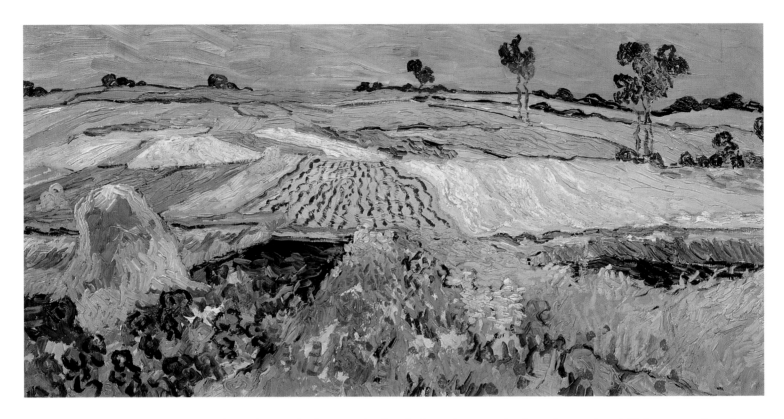

FIG. 192. VINCENT VAN GOGH,
WHEATFIELDS, 1890, oil on canvas,
50 x 101 cm. Österreichische Galerie
Belvedere, Vienna

of weaving on the loom. In both paintings, for example, the paint strokes shift from wavy bunches to straightened lines to rectangular color blocks as the canvas proceeds from front to back planes, creating a visual equivalent to the feeding of colored threads through the frame to the loom shuttle, resulting in a checked pattern on a piece of cloth. In *Field with Poppies*, the tree clumps in the foreground resemble coiled skeins of yarn about to be unrolled; in *Wheatfields* the wavy black lines of the middle plane recall strings of yarn. *Field with Poppies* offers a distant plane of contiguous boxes where, unraveled and threaded through the midfield runner, the paint strokes reemerge in raised and textured sections of warp-and-weft hatches. These woven forms in the painted planes claim van Gogh as a weaver of the fields, plying his brush/shuttle to transform tangled bundles of paint fiber into regularized textrous grids of cultivated earth on canvas.

GRIDS AND SPIRALS

The continuity and coherence of van Gogh's weaving and framing practices coexisted with more well known elements of his late work, the swirling forms and the irregular handling. The visual language evoking woven fields and framed, directional landscapes clearly had stabilizing functions for him as he reworked familiar habits in new settings and accepted the interruptions caused by his illness. But we can see in the late work a competition between the anchoring resources of the gridded frame and woven facture and the impetus to dynamic, even vertiginous visual movement beyond the bounds of linear regularity. Van Gogh's continued reliance on the perspective frame did yield canvases like his *Wheatfield with Rising Sun* (Fig. 180), with its unequivocal passage to the border wall and puls-

ing linear runners to the distance. But a similar view of the field from his hospital window a few months earlier shows a skewed field, tilted up and bent out of shape; the field itself lacks the fibrous sectioning of the earlier canvas, while the boundary wall seems upended and moving off the surface (Fig. 193).[31]

Other images deepen this interplay between the persistence of van Gogh's framed landscape and its disruption. Two Saint-Rémy paintings from October 1889 are obstructed views through trees, a format clearly related to van Gogh's earlier use of trees as framing devices, replicating on the canvas or paper the act of seeing through the bracketing wooden poles of his perspective tool. Remember the flanking "pointer" trees in the 1882 *Florist's Garden on the Schenkweg* and those of the 1888 *Landscape with Farm and Two Trees*, or the spatial corridors delimited by the alleys of the 1884 *Avenue of Poplars* and the 1888 *Alyscamps* (Figs. 26, 29, 80, 81, 79). The 1889 *Poplars at Saint-Rémy* (Fig. 194), by contrast, represents a pair of rangy trees that act not as sturdy guideposts into the distance but as crooked shafts in a jumbled landscape, susceptible to tumble. Van Gogh's typical "framed" view through a pair of flanking tall trees appears, in diminished form, in the location of a blocky house between the poplars, windows and chimney peeking through. But rather than offering a clearing of recessional space to a distant

LEFT **FIG. 194. VINCENT VAN GOGH,** *POPLARS AT SAINT-RÉMY*, 1889, oil on canvas, 61.6 x 45.7 cm. The Cleveland Museum of Art, 1999, bequest of Leonard C. Hanna Jr., 1958.32

RIGHT **FIG. 195. VINCENT VAN GOGH,** *THE WALK: FALLING LEAVES*, 1889, oil on canvas, 73.5 x 60.5 cm. Van Gogh Museum, Amsterdam (Vincent van Gogh Foundation)

horizon site, the trees here are off-kilter, and the faraway house presses forward, uneasily grounded.

A second oil of the same month, *The Walk: Falling Leaves*, again provides no passageway through an alley of trees but instead shows a tangle of tree limbs pushed up to the edge of the picture plane (Fig. 195). In the center of a narrow space between two trunks appears a slender X created by the crossing trunks of two other

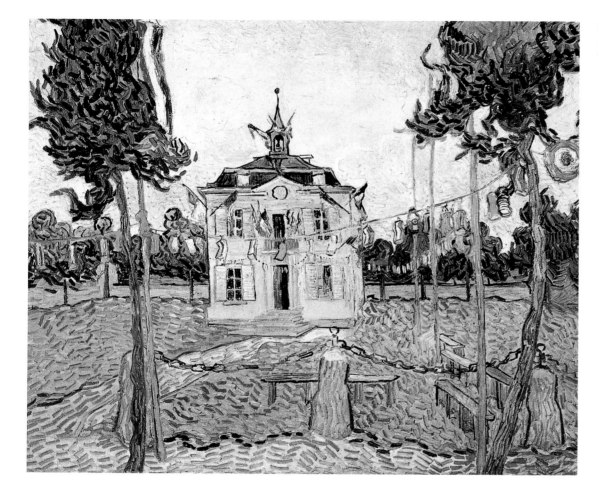

FIG. 196. VINCENT VAN GOGH, *TOWN HALL OF AUVERS ON JULY 14*, 1890, oil on canvas, 72 x 92 cm. Present whereabouts unknown

trees. The diagonal pattern filling the area between the two trees in the foreground resembles van Gogh's perspective frame collapsing inward. The flanking tree posts do not supply a stretch of space through which the slicing X can re-create the vanishing point at the distant horizon; the view through is thwarted.

The movement in van Gogh's paintings from clear passage to an obstructed view through the frame was not, however, progressive and unidirectional, for van Gogh continued to alternate between them, with the frame sustaining its presence and constitutive power until the very end.[32] We have seen

FIG. 197. VINCENT VAN GOGH, *LANDSCAPE WITH HOUSE AND PLOUGHMAN*, 1889, oil on canvas, 33 x 41.4 cm. The Hermitage, St. Petersburg

how van Gogh's last sketchbook indicated that he was busy at work redesigning his frame in Auvers. He also painted a very late canvas in 1890, *Town Hall of Auvers on July 14* (Fig. 196), which reclaimed his earlier habit of positioning elements of the composition to suggest component parts and the act of seeing through his perspective frame. In *Town Hall* the inward arcing of the pair of trees in *The Walk* is corrected, and the trees are now stretched out to form guideposts for the building set clearly behind it, accented by echoing poles. Across the space between the flanking trees is suspended a colorful rope line from which the Bastille Day decorations of flags, lanterns, and banners are hung. Van Gogh could not resist the opportunity to arrange the dangling line of decorations in a particular way. A bright dab of paint marks a yellow lantern at the exact center of the town hall structure, meeting the balcony above the door and centering the middle window. The dangling line suspended between the trees recalls the sectioning threads of van Gogh's perspective frame, mounted on its wooden poles; the exact midpoint found by the interesting threads within the frame would have been the window. If diagonal lines were drawn across the canvas, this would be the place to which the eye would be pressed; van Gogh painted in the convergence, flagged in yellow, not to be missed.

The regularity and stasis of the woven facture and format in van Gogh's late work were unsettled by other visual tactics of mobility. If the framed landscapes compete with those in which the view is obstructed, the woven fields of Saint-Rémy and Auvers coexist with canvases where the checkerboard blocks of color are clearly painted but seem about to roll down steep hillsides, parallel to the upended boundary wall of the second *Wheatfields* discussed above (see Fig. 193). In the startling Hermitage painting, *Landscape with House and Ploughman* of October 1889 (Fig. 197), van Gogh chose a bird's-eye view that joins intersecting color blocks to uneasy vertiginous activity; the chunks of land appear to slide downward, uncontained by linear grids or woven intervals. This type of view was, however, unusual. The broad, expansive, woven fields of Saint-Rémy and Auvers were more dominant, rendered in panoramic, checkered sections, fibrous color, and interlocking units. Some of these paintings, like the Auvers fields in Fig. 192, are kinetic, yes, but in the way spreading a blanket is kinetic, the soft unfolding of a multicolored swath over the canvas ground. The voices of the weavers and of the artist-craftsman resonated in a late letter from Saint-Rémy when van Gogh summarized his efforts to Bernard:

Sometimes by erring one finds the right road. Go make up for it by painting your garden just as it is . . . Being able to divide a canvas into great planes which intermingle, to find lines, forms which make contrasts, that is technique . . . it is a sign all the same that you are studying your handicraft [ton métier] *more deeply, and that is a good thing.*

However cumbersome . . . the times we are living in, if anyone who has chosen this hand-icraft pursues it zealously, he is a man of duty, sound and faithful.[33]

Van Gogh's insistent naturalism and the insistent physicality of his canvases may, as Meyer Schapiro suggested, be necessary counterweights to the terror of psychic disturbance—the reference to real objects and the canvas's emphatic concreteness may have functioned as what Schapiro called the "protective reactions" against inner disintegration.[34] Yet the flight to abstraction, and to the unfettered subjectivity that it formalized, were not only psychologically intolerable to van Gogh but were impeded by religious and social constraints against detachment from nature and collectivity. Van Gogh's craft habits of framing tools and woven facture offered some stylistic responses to multiple pressures to refer the self to the larger totalities of community and redemptive labor.

Van Gogh maintained his hope that the interplay of his truthful wrestling with nature—"a few clods of earth," he called them—and the binding force of modern emotions conveyed in and beyond nature would release the infinite in the tangible, a sacred modern art. But his own attempt to paint himself into a labor community by the tactile forms of his craft, weaving and plowing on the canvas, were accompanied, as they had always been, by a sense of their fragile, compensatory status. A woven canvas, however consoling, was not a piece of cloth that could be worn, like a shirt; the turning of clods of earth by working the canvas did not yield sustenance from God's bounteous nature. Van Gogh's own production quantity and production forms—canvases piling up and their physical tangibility—did not quell the unrelenting pressure for justification, for earning and deserving divine merit.

Van Gogh shot himself in the chest in Auvers by the fields where he had been painting in July 1890; he died a few days later with his brother Theo at his side. There was no dramatic event or single catalyst to his suicide, only an unrelieved despair that he was a burden to Theo. New circumstances in Theo's life did add weight to van Gogh's decision to end his life. In the months of May, June, and July when he stayed in Auvers, Theo had hinted to his brother that he was considering leaving the job he

had at the art gallery that employed him, Boussod & Valadon, to strike out on his own, which would necessitate a certain belt-tightening for all, including Vincent. And van Gogh was troubled by one interval when his baby nephew, named Vincent for him, became very ill. Both issues added intensity to van Gogh's sense that Theo and his wife, Johanna, needed to be free of other burdens, especially the ongoing financial load he placed on them. Theo and Johanna both reassured van Gogh that their baby was healed and their support for him unconditional, but he was unable to continue. Van Gogh's last letter praised Theo for his part "in the actual production of some canvases."[35]

MODERNIST RELIGIOUS REALISM

Pride, like drink, is intoxicating, when one is praised, and has drunk the praise up. It makes one sad, . . . but it seems to me that the best work one can do is what is done in the privacy of one's home without praise.[36]

Van Gogh's death came just after he had participated in his first exhibition showings in Brussels and Paris, and had received his first critical appreciation. In January 1890, Albert Aurier, the Neo-Platonist poet and art critic, wrote an exultant tribute to van Gogh, as he would a year later for Gauguin. A copy of this first major review reached van Gogh in the Saint-Rémy hospital. The following month he reacted politely but forcefully against Aurier's interpretation of his art as the apotheosis of symbolism. His response, written in a letter to Aurier, recapitulated his fundamental commitments to the themes of the relational ego, the métier, and the image as an agent of exchange and of communication of the good.

Aurier's review, entitled "Les Isolés, Vincent van Gogh," had set the terms for a modernist canonization of the artist which has proven irresistible into our own time. Aurier did gesture to van Gogh's Dutch heritage, but the main theme of his essay was the expressive frenzy of van Gogh's "maddened genius." He glorified van Gogh as an isolated, "mystic titan," a "hyperaesthete," a visionary bound only by the lineaments of his inner dream. Aurier did not explore specific works in any detail but celebrated van Gogh in the language of Neo-Platonism, as the epitome of an idealist, a "symbolist" who "clothes his ideas in tangible forms," in "material envelopes."[37]

This was an approach that van Gogh found dissonant and inappropriate. The terms of his response to Aurier exposed the distance between the world of French fin-de-siècle subjectivity and the enduring legacies of his Dutch modernist theological culture. He was uneasy, he told Aurier, in being singled out as an isolated, creative initiator. His place was "*very secondary*," and his contributions were really "only due to the work and insights of others," he wrote, yielding his singularity to an assertion of creative association and interdependence. Among those he credited as his co-equals or revered predecessors who made his own work possible were Monticelli, Delacroix, Gauguin, and the flower painters Père Quost and Jeannin. To Aurier's interpretations of his paintings as abstract, evocative forms of a transcendent, musical, and universal Soul, van Gogh countered: "Truth is so dear to me, and the search for being truthful too. I still prefer being a shoemaker to being a musician who works in colors."[38]

Like a shoemaker who feels pride in his completed product, van Gogh sent Aurier a gift of what he called his own "sound and faithful handicraft" as a statement of gratitude for the article. The gift offered a compelling antidote to Aurier's view of his titanic anti-naturalism. It was a small painting of cypresses—rough work, he called it, the result of wrestling with clods of earth and hand-to-hand combat with nature. The solid piece of nature was rendered, he explained to Aurier, in color tones that reminded him of the combinations of "those pretty Scotch tartans," green, blue, red, yellow, and black—again a woven canvas.[39]

CODA: ANGELS AND PORTRAITS, AFTERLIFE

Gauguin's private journal recorded his interest in the unconscious and in dreams. A few years before he died, he wrote of a dream of a "primordial time" when he was set "on the earth," "in the midst of strange animals and beings that might be men." The dream proceeded, Gauguin recounted, as "an angel with white wings comes smiling toward me, behind him an old man holding in his hand an hour glass." Then the angel spoke to him:

> "*Useless to question me,*" he says. "*I understand your thought. You must know that these beings are men such as you were once, before God began to create you. Ask this old man to lead you*

*later into Infinity, and you will see what God wishes to do with you and learn that you today
are far from completion. What would the work of the Creator be if it were all done in a day?
God never rests.*"⁴⁰

Gauguin, who had begun his modernist breakthrough by imagining a vision of Jacob and the angel,
ended his career still beset by dreams of and conversations with an angel. As a child of the Orléans sem-
inary, Gauguin had been one of Bishop Dupanloup's angels who had lost their wings, and had to be
trained to keep his eyes fixed heavenward to find them. Many years later, Gauguin's dream in Tahiti
ended with another vision, eyes raised heavenward, of an angel in flight: "The old man vanishes and I,
awakening, raising my eyes heavenward, see the angel with white wings mounting towards the stars. His
long, fair hair leaves in the firmament as it were a trail of light."⁴¹

During the time when van Gogh was unable to paint out of doors at the Saint-Rémy hospital and
was involved in his project of translating prints to paintings, he painted on one occasion a copy of an
angel by Rembrandt from an etching sent him by Theo.⁴² Van Gogh's version of the print showed a
heavily hatched and thatched angel with bright red hair and carefully rendered facial features, eyes cast
down, with a resplendent aureole that bore the typical features of van Gogh's suns, composed with
woven paint lines and beams of bright lines emitting outward (Fig. 198). Van Gogh had considered the
sacred images of Rembrandt and of Delacroix, with their plausible human likenesses and tenderness,
to be exceptions in the canon of a religious art that he rejected. His own single attempt at copying a
heavenly figure deepened the angel's humanity by the red hair and the emphatic grounded presence of
the pigment weave across the canvas.

But painting an angel was an exception for van Gogh. Unlike Gauguin, who gave visions a promi-
nent place in his art and consciousness, van Gogh in June 1890 asserted that one of the aims of his art
was to "paint *portraits* that would appear after a century to the people living then as apparitions."⁴³
These apparitions were not visions of otherworldly beings but vivid presences of real, feeling people,
whose immediacy, across time, was conveyed by expressive means, especially, van Gogh noted, by the
modern science of color, which intensified the character of the subjects beyond mere visual likenesses.⁴⁴
He considered this intensification or "exaltation" of character to be materialized by "our impassioned
expressions" (*nos expressions passionnées*)—realizing the Dutch modern theologians' sense that a

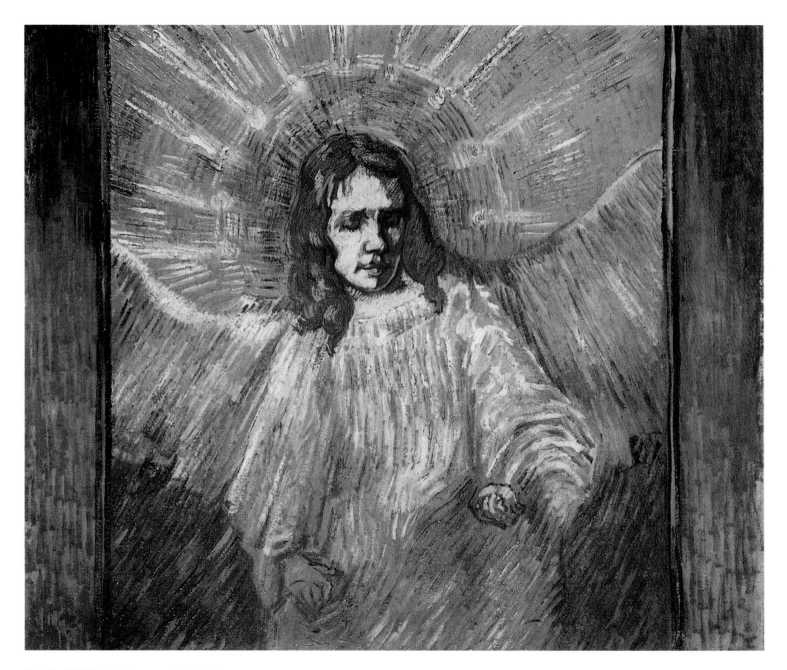

FIG. 198. **VINCENT VAN GOGH,** *ANGEL* (AFTER REMBRANDT), 1889, oil on canvas, 54 x 64 cm. Present whereabouts unknown

contemporary world might need the "passion for realism" unique to the arts as a source of emotional connection hitherto provided only by traditional religion. Van Gogh's sacred realism, impassioned by work and expressive color, aspired to a new source, but always *to* a source of totality and interdependence. In his last weeks in Auvers he devised a plan for his broad swath of canvas of the Auvers field (Fig. 192) to be an interlinking unit for one of his portraits, painted in deliberately vertical format so it would interlock with the horizontal landscape, what he called the unity of "one bit of nature and another."[45]

While he was trying his best to prepare for the grueling entrance examinations to divinity school in Amsterdam in 1878, van Gogh learned of the death of an artist he admired, the painter Charles Daubigny. His words then about Daubigny apply now to his own art, which is more accessible and popular than any other in the history of culture:

> *It must be good to die, conscious of having performed some real good and knowing that one will live through this work, at least in the memory of some, and will leave a good example to those who come after. A work that is good may not be eternal, but the thought expressed in it is; the work itself will certainly remain in existence for a long, long time. Later, others—if there are any—can do no better than follow in the footsteps of such predecessors and do their work in the same way.*[46]

BIOGRAPHICAL OUTLINE OF THE TWO ARTISTS

VINCENT WILLEM VAN GOGH, 1853–1890

1853

Born March 30, in Groot-Zundert, a village in the southern Netherlands, to Anna Cornelia Carbentus and Theodorus van Gogh; eldest of six children. Father is a minister in the Dutch Reformed Church, affiliated with a new wing of the church called the Groningen School.

1861–1868

Attends Zundert village school (1861), Protestant boarding school in Zevenbergen (1864–1866); and the Rijks Hogere Burgerschool Willem II, a state high school in Tilburg (1866–1868).

1869–1875

Works for the art dealer Goupil & Co., first at The Hague (1869–1873), then at branches in London and Paris. Begins regular correspondence with brother Theo (1872).

1876

Loses interest in art-dealing trade; has growing interest in religion. Dismissed from Goupil & Co. Returns to England; works as a teacher in Ramsgate and Isleworth and as a lay preacher with Methodists in Isleworth.

1877

Returns to the Netherlands. Works in a bookstore in Dordrecht, then moves to Amsterdam to live with an uncle, Johannes van Gogh; prepares for the entrance exam for university divinity school.

1878–1880

After abandoning plans for divinity school, moves to Laeken, a suburb of Brussels, to attend a missionary training school. Becomes lay evangelist among the coal miners of the Borinage; decides to become an artist.

1880–1883

After a short stay in Brussels to study drawing, spends eight months at his parents' home. Moves to The Hague in November 1881, takes lessons from his cousin, the painter Anton Mauve. Studies and collects popular prints and learns lithography; hopes to train as an illustrator.

1883–1885

Leaves The Hague for short stay in Drenthe, a desolate area of northern Netherlands; moves in with his parents in Nuenen, near Eindhoven, where his father has been appointed the village minister. Devotes himself to painting peasant life and work. Produces thirty-four images of weavers in all media; paints peasant heads and figures, culminating in *The Potato Eaters*.

1886–1887

Leaves Nuenen for short stay in Antwerp to study drawing and figure painting at the art academy; moves to Paris to stay with Theo, an art dealer at the Paris office of the former Goupil & Co., now known as Boussod & Valadon. Discovers the work of the Impressionists and the emerging Neo-Impressionists (or Pointillists); makes contact with Henri Toulouse-Lautrec, Emile Bernard, Paul Signac, Charles Laval, and Paul Gauguin.

1888

In February, leaves Paris for Arles, in southern France; paints orchards, drawbridges, sowing and harvest scenes, and portraits; hopes to establish artists' community; befriends Joseph Roulin and his family. Invites Gauguin to work together as a start to the group studio at the Yellow House; Gauguin arrives in late October and stays through December; they paint similar sites such as the Alyscamps, the vineyards, and women in the Arles park. Growing conflicts with Gauguin end in violent argument when van Gogh cuts off part of his left ear.

1889

Hospitalized in Arles; upon recovery returns to work on a series of portraits of Madame Roulin, *La Berceuse*; decides to become a patient at the asylum at Saint-Rémy, a town near Arles. Produces series of wheatfields, cypresses, and olive trees while able to work; beset by periods of breakdown. Paints oil versions of prints; two paintings are included in the fifth annual Paris exhibition of the Société des Artistes Indépendants.

1890

Exhibits six paintings at the annual show of Les Vingt in Brussels; receives first review article on his work, by Albert Aurier, at the hospital. Moves to Auvers-sur-Oise, a village northwest of Paris, to be cared for by Dr. Paul Gachet, a physician and occasional artist. Paints landscapes and worked fields. Increasingly despairing and concerned that he is a burden to his brother Theo, shoots himself in the chest on July 27 and dies two days later with Theo by his side.

EUGÈNE-HENRI PAUL GAUGUIN, 1848–1903

1848

Born in Paris on June 7 to Aline Chazal and Clovis Gauguin; younger of two children. His mother was the daughter of Flora Tristan; his father was a journalist and editor for *Le National*.

1849–1854

Fleeing Paris in the aftermath of the 1848 Revolution, the family sails to Peru to stay with Don Pio de Tristan Moscoso, a great-uncle from his mother's side of the family. During the journey Clovis Gauguin dies of a ruptured aneurysm.

1854–1862

The family returns to France to live with Gauguin's paternal grandfather and uncle in Orléans. After some time at a day school, Gauguin becomes a boarding student in 1859 at the Petit Séminaire de La Chapelle-Saint-Mesmin in Orléans.

1862–1864

Lives with his mother in Paris and hopes to prepare for entrance exams for the Naval Academy; final year in Orléans.

1865–1867

Unable to take the Naval Academy exam, Gauguin enlists in the merchant marine; twice sails to South America and back.

1868–1871

Joins the navy and participates in the Franco-Prussian War on the ship *Jérôme-Napoléon*.

1871–1873

Returns to Paris; through his godfather, Gustave Arosa, finds employment as a stock agent. Meets young Danish woman, Mette Gad, through the Arosa circle. They marry in 1873; over the next ten years they have five children. Takes up painting as "a serious hobby."

1874–1876

Begins collecting Impressionist works; is introduced to Camille Pissarro. A small landscape by Gauguin, *Sous-bois à Viroflay*, is exhibited at the annual state Salon in 1876.

1877–1883

Becomes interested in sculpture; is employed by the banker Bourdon. Participates in the fourth, fifth, sixth, and seventh Impressionist exhibitions; sells three paintings to the dealer Durand-Ruel. Paints with Pissarro and meets Degas, Manet, Renoir, and Cézanne. By 1883, has abandoned business employment and is a full-time artist.

1884–1885

Moves to Rouen with the family; sells life-insurance policy for cash; takes job as a salesman for a canvas-tarpaulin company; moves with his family to Copenhagen. In 1885, returns to Paris with son Clovis; works hanging posters in the train stations.

1886

Becomes interested in ceramics; shows nineteen paintings and one wood relief at the eighth Impressionist exhibition. Stays in Pont-Aven, Brittany, for the first time. Meets Emile Bernard. Refuses to exhibit in the Société des Artistes Indépendants; breaks with Pissarro and the Neo-Impressionists who are featured there.

1887

Travels with Charles Laval to Panama; works briefly as a navvy on the Panama Canal. Suffers from dysentery and malaria, but still manages to travel to Martinique and paint there. On return to Paris, meets and begins to exchange work with Vincent van Gogh. Vincent introduces him to Theo van Gogh, who takes Gauguin's paintings and ceramics to show at the Boussod & Valadon gallery; sells *The Bathers* painting soon after.

1888

Leaves Paris for Brittany in February and stays again in Pont-Aven. Joined by Charles Laval and Emile Bernard in Pont-Aven. Paints breakthrough canvas *The Vision After the Sermon: Jacob Wrestling with the Angel*. Exchanges self-portraits with van Gogh. Invited by van Gogh and supported by Theo, goes to Arles in late October and stays through end of December. Brisk sale of Gauguin paintings by Theo from October through December, and Gauguin exhibits works when invited by the Brussels art group Les Vingt. During time with van Gogh, produces works including *Les Alyscamps, Vendanges à Arles: Misères humaines*, and *Women from Arles in the Public Garden*. Collaboration with van Gogh ends in violent conflict.

1889

Alternates between Brittany and Paris; helps organize the Café Volpini exhibition at the 1889 World's Fair; exhibits seventeen works there and prepares zincograph album. Works in Le Pouldu with painter Meyer de Haan. Decorates dining-room walls of the Marie-Henry Inn; Paul Sérusier and Charles Filiger later join to complete the decoration. Paints *Yellow Christ; Green Christ; Christ in the Garden of Olives* among other works. Corresponds with van Gogh, who probably sends him a version of *La Berceuse*. Still sending paintings to Theo van Gogh; sales are slow.

1890

Van Gogh dies in July; Theo dies six months later. Gauguin returns to Paris; meets writer Charles Morice and, through him, Stéphane Mallarmé; frequents Symbolist gatherings at the Café Voltaire. Discourages Bernard from planning a first van Gogh retrospective.

1891–1893

Articles appear by Octave Mirbeau, Jules Huret, and Albert Aurier publicizing Gauguin's work and personality; thirty paintings are sold at the Paris Hôtel Drouot; requests and is granted government-funded artistic mission to Tahiti. Works in and around Papetee through 1893.

1893–1895

Returns to France; works in Paris and Pont-Aven.

1895–1900

Leaves France for final stay in Tahiti. Destitute and suffering from deteriorating health. Death of daughter Aline in Copenhagen from pneumonia. Writes polemical essay, "The Catholic Church and Modern Times" (1896–1897). Suffers mild heart attack; attempts suicide from arsenic. Completes "testament" painting, *Where Do We Come From? What Are We? Where Are We Going?* (1897–1898).

1901–1903

Leaves Tahiti for the Marquesas; settles on the island of Hivaoa. Buys land from the Catholic mission and begins to build a "House of Pleasure." Revises manuscript criticizing the Church, now titled "Modern Thought and Catholicism." Health deteriorating; has trouble with the authorities. Dies May 3, 1903; buried in the Catholic cemetery.

NOTES

INTRODUCTION

1. I am adapting here the notion of painting as a "deposit" proposed by Michael Baxandall, who analyzed the Florentine painting he studied as "a deposit of a social relationship"; I extend this framework to the modern period to suggest painting as a deposit of theological cultures and consciousness in specific nineteenth-century contexts. See Michael Baxandall, *Painting and Experience in Fifteenth-Century Italy: A Primer in the Social History of Pictorial Style*, 2d ed. (New York: Oxford University Press, 1988), pp. 1–108, 151–153.

Van Gogh's attempt at a "modern religious art" in France was first proposed by Griselda Pollock in her dissertation, "Van Gogh and Dutch Art: A Study in van Gogh's Notion of the Modern" (University of London, 1980). Gauguin's religiosity has been studied thematically and iconographically for the entire span of his career by Ziva Amishai-Maisels, *Gauguin's Religious Themes* (New York: Garland, 1985).

Three books devoted to van Gogh and Gauguin together are: Evert van Uitert's classic *Vincent van Gogh in Creative Competition: Four Essays from Simiolus* (Amsterdam: Zutphen, 1983); Victor Merlhès, *Paul Gauguin et Vincent van Gogh, 1887–1888: Lettres retrouvées et sources ignorées* (Taravao, Tahiti: Avant et Après, 1989), a document-based presentation; and a recent work that does emphasize religion, though in a different way from that presented here, Naomi E. Maurer, *The Pursuit of Spiritual Wisdom: Van Gogh and Gauguin* (Madison, N.J.: Fairleigh Dickinson University Press, 1998). Merlhès gives the most comprehensive presentation of mutual influence as well as the great differences between the two painters and discusses what he calls their "different perceptions of the world," though he does not analyze paintings or explore the cultural and religious sources of these differences.

Art historians still differ as to the degree of mutual influence, which will be discussed in later chapters; however, this book focuses more on differences than on mutual influence, suggesting some of the broader theological cultures that contributed to what I see as van Gogh's and Gauguin's incommensurate worldviews and artistic practices.

2. I developed the contours of this comparison in an article, "At the Threshold of Symbolism, 1888: Van Gogh's *Sower* and Gauguin's *Vision After the Sermon*," in Montreal Museum of Fine Arts, *Lost Paradise: Symbolism in Europe* (Montreal: Museum of Fine Arts, 1995), pp. 103–114; see also my "Weaving Paintings: Religious and Social Origins of Vincent van Gogh's Pictorial Labor," in *Rediscovering History: Culture, Politics, and the Psyche*, ed. Michael Roth (Stanford: Stanford University Press, 1994), pp. 137–168, 465–473.

3. These characterizations of Gauguin by his contemporaries and by recent scholars will be discussed in Chapters 10 and 12. Contemporaries who described Gauguin's bombastic "egotism" include Camille Pissarro and Charles Morice; the ambivalent colonialist is stressed by the art historian Stephen F. Eisenman in his book *Gauguin's Skirt* (London: Thames and Hudson, 1997).

4. "Spiritual combat is just as brutal as human battle," wrote Arthur Rimbaud in 1889 in his *Season in Hell*.

5. Throughout the book, my debts to and departures from these three literatures will be specified in notes.

6. Cornelia Peres, "On Egg-White Coatings," in *A Closer Look: Technical and Art-Historical Studies on Works by van Gogh and Gauguin*, ed. Cornelia Peres, Michael Hoyle, and Louis van Tilborgh (Zwolle: Waanders, 1991), pp. 39–43. I will discuss van Gogh's experiments with matte techniques and Gauguin's in Chapters 7, 8, and 9. A new study of Gauguin's experiments with

surface effects and meaning appeared too late for me to fully incorporate its findings, though I do rely on these scholars' earlier writings: Vojtěch Jirat-Wasiutyński and H. Travers Newton Jr., *Technique and Meaning in Gauguin's Paintings* (New York: Cambridge University Press, 2000).

7. Social historians of art and other writers have undercut, with historical precision, the nineteenth-century myth of the defiant avant-garde, exposing how deeply class, gender, and political strategies were inscribed in an ethic of social and spiritual deracination, and how the practice of self-invention exhibited a strikingly close fit with the marketing tactics of an emerging capitalist economy of spectacle. Yet these "ideologies of vision," as T. J. Clark defined them, have not included religion as part of the social ground shaping artists' lives and works. I have found studies of the painting and culture of the early modern period to be helpful and instructive if adapted to nineteenth-century contexts, and helpful also for broadening other accounts of the social meaning of modern visual forms: Michael Baxandall's analysis of painters' "cognitive styles" and "visual skills," and Lucien Febvre's emphasis on the "mental equipment" or "mental tools" of a given period. Febvre also identified culturally transmitted resources and constraints, what he called the "limits of the thinkable" in particular historical moments; his insights might be extended to explore the "limits of the paintable." See Baxandall, *Painting and Experience*; Lucien Febvre, *Le Problème de l'incroyance au XVIe siècle: La Religion de Rabelais* (Paris: Seuil, 1968, originally published 1942).

8. The transmission of idealism and Neo-Platonism to the cohort of young men at the Paris Lycée Condorcet that included Vuillard and Maurice Denis is part of Filiz Eda Burhan's important dissertation, "Vision and Visionaries: Nineteenth-Century Psychological Theory, the Occult Sciences, and the Formation of a Symbolist Aesthetic in France" (Princeton University, 1979). Burhan's findings, in the case of Vuillard, need to be related to his earlier years of religious training at the Marist seminary and the religious crisis his friends described as central to his formative years, which she does not discuss; interesting evidence exists of the ways that Vuillard, as his friend Romain Coolus wrote, "laicized into philosophical meditation" "the long-instilled habit of religious examination," which "still dominated his everyday life." Statements like these by Vuillard's contemporaries, along with Vuillard's style of introspection in his diaries, are rich sources for approaching this radically understudied element of Vuillard's self-development and artistic practice. For Rodin's mod-

ernism and the interiorization of Catholic hell, see my *Art Nouveau in Fin-de-Siècle France: Politics, Psychology, and Style* (Berkeley: University of California Press, 1989), chaps. 13 and 15. Artists themselves express growing self-consciousness about the particular role Catholic education played in their mental formation in the late nineteenth century, and its indelible imprint on their adult consciousness, with registers of both very negative and positive results, in such sources as an education survey of the period, Jean Rodes, "Enquête sur l'éducation," *La Revue Blanche* 28 (June 1902): 161–182.

9. Letter from Vuillard to Maurice Denis (1898) cited in John Russell, *Edouard Vuillard* (London: Thames and Hudson, 1971), p. 64. One painting of embodied mother and destabilized surfaces is the *Mother and Sister of the Artist*, ca. 1893, in the New York Museum of Modern Art collection, reproduced in Elizabeth Wynne Easton, *The Intimate Interiors of Edouard Vuillard* (Houston: Museum of Fine Arts, 1990), p. 85. For an interesting analysis of Vuillard's dematerialized world of women from another perspective, see Susan Sidlauskas, "Contesting Femininity: Vuillard's Family Pictures," *Art Bulletin* 79, no. 1 (March 1997): 85–111.

CHAPTER 1. SELF-PORTRAITS

1. Gauguin to Emile Schuffenecker, May 1885, in Daniel Guérin, *The Writings of a Savage, Paul Gauguin* (New York: Paragon, 1990), p. 7; the original French is in Victor Merlhès, ed., *Correspondance de Paul Gauguin: Documents, témoignages* (Paris: Fondation Singer-Polignac, 1984), p. 105, #78, May 24, 1885.

2. Vincent van Gogh, *The Complete Letters of Vincent van Gogh*, 2d ed. (Boston: New York Graphic Society, 1978), 3:163, LT 590, ca. May 3, 1889. I follow the dating of the Arles letters reconstructed by Ronald Pickvance in his *Van Gogh in Arles* (New York: Metropolitan Museum of Art, 1984), pp. 262–263.

3. A summary of these events, contacts, and sales is listed in the useful timeline in the Gauguin centenary catalogue by Richard Brettell, Françoise Cachin, Claire Frèches-Thory, Charles Stuckey, and Peter Zegers, *The Art of Paul Gauguin* (Washington, D.C.: National Gallery of Art, 1988), pp. 44–46, 82–83. See also Victor Merlhès, *Paul Gauguin et Vincent van Gogh, 1887–1888: Lettres retrouvées, sources ignorées* (Taravao, Tahiti: Avant et Après, 1989), pp. ii, 55–57; Belinda Thomson, *Gauguin* (London: Thames and Hudson, 1987), pp. 61–64; Douglas Cooper, "Les Relations entre Paul Gauguin et les frères van

Gogh," introduction to *Paul Gauguin: 45 Lettres à Vincent, Théo et Jo van Gogh* ('s-Gravenhage: Staatsuigeverij, 1983), pp. 15–18; and John Rewald, *Post-Impressionism from van Gogh to Gauguin*, 3d ed. (New York: Museum of Modern Art, 1978), pp. 39–40, 64. There is still some disagreement, and no definitive documentation, as to the precise date when van Gogh and Gauguin first met: Rewald asserts it to be November 1886, and the volume by Brettell et al. endorses this view; Cooper and Merlhès make a good case that even if a brief meeting took place earlier, it was only in November 1887 that the two painters connected in earnest through the exchange of work and ideas; I find this view plausible.

4. I discuss specific manuals and their artisanal language and methods in my "Weaving Paintings: Religious and Social Origins of Vincent van Gogh's Pictorial Labor," in *Rediscovering History: Culture, Politics, and the Psyche*, ed. Michael Roth (Stanford: Stanford University Press, 1994), pp. 150–155. In Chapter 2 below, I will return to the subject of drawing handbooks consulted by van Gogh. For other studies of van Gogh's early training and copies, see Charles Chetham, *The Role of Vincent van Gogh's Copies in the Development of His Art* (New York: Garland, 1976), pp. 12–77; Anne Stiles Wylie, "An Investigation of the Vocabulary of Line in Vincent van Gogh's Expression of Space," *Oud Holland* 85, no. 4 (1970): 210–222; Albert Boime, "The Teaching of Fine Arts and the Avant-Garde in France During the Second Half of the Nineteenth Century," *Arts Magazine* 60 (Dec. 1985): 53–54; Sjraar van Heugten, *Vincent van Gogh, Drawings*, vol. 1, *The Early Years, 1882–1883*, Van Gogh Museum (London: Lund Humphries, 1996); and van Gogh's own discussions of perfection through practice and rules rather than through "inborn" revelation, and of the skill of a job as illustrator and of "handicraft" in van Gogh, *Letters*, 1:217–218, 1:324–332, 1:368, 1:416–417, 1:438–439, 1:477–478, 2:176, 2:198, 2:297.

5. I explored this linkage of painter and lowly labor and its religious sources in my "Pilgrim's Progress and Vincent van Gogh's Métier," in *Van Gogh in England: Portrait of the Artist as a Young Man*, ed. Martin Bailey (London: Barbican Gallery, 1992), pp. 95–113. A full technical and iconographic study of *The Potato Eaters* can be found in Louis van Tilborgh, *"The Potato Eaters" by Vincent van Gogh* (Zwolle: Waanders, 1993); another perspective is offered by Griselda Pollock in her "Van Gogh and the Poor Slaves: Images of Rural Labor as Modern Art," *Art History* 11, no. 3 (1988): 408–432. Van Gogh likened his canvas to *"the color of a very dusty potato, unpeeled of course,"* in *Letters*, 2:372, LT 405; emphasis his.

6. For the end of the Impressionist exhibition group in 1886, see Bernard Denvir, *The Impressionists at First Hand* (London: Thames and Hudson, 1987), pp. 85–164; San Francisco Museum of Art, *The New Painting: Impressionism 1874–1886* (Seattle: University of Washington Press, 1986); and Rewald, *Post-Impressionism*, which still provides the most comprehensive narrative of the multiple tendencies within the painting avant-garde in the transitional years of 1886–1887, especially chaps. 1 and 2. See also Bogomila Welsh-Ovcharov et al., *Van Gogh à Paris*, exhibition catalogue, Musée d'Orsay (Paris: Editions de la Réunion des Musées Nationaux, 1988), pp. 10–34, and passim.

7. These visual responses and adaptations to Paris can be followed in the canvases featured in the Welsh-Ovcharov et al. exhibition catalogue *Van Gogh à Paris*, pp. 46–175; see especially his transformations of Monet's still lifes of grapes or of quinces and lemons, pp. 158–159, and the Signac-inspired *Factories at Clichy*, pp. 146–147. See also Richard Thomson, "Van Gogh in Paris: The Fortification Drawings of 1887," *Jong Holland* 3, no. 3 (1987): 14–25; and Rewald, *Post-Impressionism*, chaps. 1 and 2. Van Gogh's interest in Japanese prints, another feature of his Paris period, will be explored in a later chapter.

8. Gauguin's years as a stockbroker's agent, the different companies he worked for, and the specification of salaries, bonuses, and speculative trading have been documented extensively by David Sweetman in his *Paul Gauguin: A Life* (New York: Simon and Schuster, 1995), pp. 62–88; see also Brettell et al., *Art of Gauguin*, pp. 4–6. Sweetman's book also provides new material on the career and art collection of Gauguin's guardian Arosa, pp. 37–49.

9. This paragraph and the ones following, on Gauguin's early career, distill material that is well known; I have drawn my discussion from Robert Goldwater, *Gauguin* (New York: Abrams, 1983), pp. 43–44; Belinda Thomson, *Gauguin*, pp. 15–55; and Brettell et al., *Art of Gauguin*, pp. 5–8. Sweetman, *Gauguin*, p. 90, gives the monetary figures for the Monet and Renoir canvases, and details the 1881 sale to Durand-Ruel on p. 100; see also his pp. 89–171.

10. Van Gogh, *Letters*, 2:576, LT 493; see also the documentation in Cooper, *Gauguin: Lettres*, p. 37, indicating that it was Vincent's idea. Some writers still claim that the idea for combining forces was Theo's, but this is not the case.

11. See the discussion of the three-way dynamic in Cooper, *Gauguin: Lettres*, p. 11; he calls it a "tripartite relationship." For the range of Theo's activities as a dealer from 1886 to 1890, Vincent's ideas of association, and Theo's vexed role as both brother and agent to Vincent, see Carol Zemel, *Van Gogh's Progress: Themes of Modernity in Late Nineteenth-Century Art* (Berkeley: University of California Press, 1997), pp. 173–201.

12. Van Gogh, *Letters*, 2:577, LT 493, May 28, 1888.

13. Ibid., 2:579, LT 494a, to Gauguin.

14. Ibid.

15. Ibid., 2:580, LT 495; emphasis mine.

16. Ibid., 2:581, LT 496. Nothing did come of the plan.

17. In Chapter 6 I examine the misgivings van Gogh felt about this accelerating pace of requests for funds from Theo amidst the growing recognition of his lack of sales.

18. See, for example, the letter to Theo in Merlhès, *Correspondance*, p. 247, #167, October 7–8, 1888; Gauguin's demands for price adjustments and threats are noted in Cooper, *Gauguin: Lettres*, pp. 18–19.

19. Van Gogh, *Letters*, 3:40, LT 538, ca. September 17, 1888, emphasis mine. Gauguin himself used the language of speculation and playing the market to entice investors, on the model of his stockbroker experience, in letter #167 to Theo in Merlhès, *Correspondance*.

20. Ibid.

21. The dates of the letter about the self-portrait and receipt of the canvas are provided by Cooper, *Gauguin: Lettres*, p. 243.

22. Van Gogh, *Letters*, 3:60, emphasis mine; other quotes on 3:59, LT 544, dated by Pickvance as October 3, 1888.

23. Ibid., 3:62, 3:61. The shift in tone from the earlier letter to Theo proposing the Gauguin association (LT 493) to this one (LT 544) is quite striking.

24. Ibid., 3:60, LT 544.

25. Ibid., 3:61, LT 544.

26. Ibid., 3:62, LT 544.

27. Ibid., 3:63, LT 544a.

28. Ibid., 3:65, LT 544a.

29. Ibid., 3:64, LT 544a.

30. Ibid., 3:61, LT 544.

31. Ibid., 3:39, LT 538.

32. Ibid., 3:62, LT 544; emphasis mine.

33. The inscription and signature are not immediately visible, having been diminished in later restorations of the painting. The presence of the inscriptions has been examined in the article by Vojtěch Jirat-Wasiutyński and H. Travers Newton, "The Historical Significance of Early Damage and Repair to Vincent van Gogh's *Self-Portrait Dedicated to Paul Gauguin*," in *Center for Conservation and Technical Studies* (Cambridge, Mass.: Harvard University Art Museums, 1984), pp. 3–27.

34. "I have asked them for an exchange . . . I would very much like to have here the portrait of Bernard by Gauguin and that of Gauguin by Bernard." In van Gogh, *Letters*, 3:33, LT 535, about September 12, 1888. The original letter from van Gogh to Gauguin and Bernard is lost; Cooper, in *Gauguin: Lettres*, p. 225, suggests that the date van Gogh wrote it was September 10.

35. The utopianism of this project has been identified by Tsukasa Kōdera, who emphasizes the link with other precedents of artistic brotherhoods such as the Nazarenes, in "Japan As Primitivistic Utopia: van Gogh's *Japonist* Portraits," in his *Vincent van Gogh: Christianity Versus Nature* (Amsterdam and Philadelphia: John Benjamins, 1990), pp. 59–65; and by Carol Zemel, who highlights the commercial strategies and political resonance of the cooperative venture, in *Van Gogh's Progress*, chap. 5. Van Gogh discusses the profit-sharing possibility in such an association in *Letters*, 2:531, LT 468. One critical feature of van Gogh's communitarian project that is not sufficiently articulated is the blending of modern and anti-modern elements in his plan; another is the notion of art as a craft product with a social function, melding the commercial and the corporate, the religious and the fraternal, and the interdependence of different media of visual expression, from prints to paintings to maps and furniture decoration. These elements have important and underanalyzed sources in van Gogh's specifically Dutch legacies of seventeenth-century artistic culture, which he frequently invokes and which appear, for example, in his references in letters to the guild of Saint Luke, which continued to regulate the art market in the seventeenth century as a market for all the applied arts and crafts; in his appeal to the values binding artists, from Ostade to van Goyen, to their society; and in his emphasis on the practical and useful function of painting, which he compares at times to furniture and shoes. As Svetlana Alpers and Simon Schama have shown so persuasively, one dis-

tinctive feature of seventeenth-century Dutch visual culture was the role of the market as a commercial continuum integrating all the varied arts with other craft products for exchange, from shoes to crockery; see Alpers's *The Art of Describing: Dutch Art in the Seventeenth Century* (Chicago: University of Chicago Press, 1983); and Schama's *The Embarrassment of Riches: An Interpretation of Dutch Culture in the Golden Age* (New York: Knopf, 1987).

36. Van Gogh, *Letters*, 3:60, LT 544, October 3, 1888.

37. The interlinkage of rooms and the paintings as ensembles is painstakingly reconstructed by Roland Dorn in *Décoration: Vincent van Goghs Werkreihe für das Gelbe Haus in Arles* (Hildesheim: Georg Olms Verlag, 1990), pp. 334–475. See also Evert van Uitert, *Vincent van Gogh in Creative Competition: Four Essays from Simiolus* (Amsterdam: Zutphen, 1983).

38. Van Gogh, *Letters*, 3:485, B6, ca. June 5, 1888.

39. According to van Gogh's report to Theo, Bernard wrote him saying "he *dare not* do Gauguin as I asked him, because he feels afraid in front of Gauguin." In *Letters*, 3:44; see also 3:43, LT 539, September 17, 1888. Gauguin's comments on the difficulties of the Bernard portrait are discussed in his letter of September 22, 1888, to van Gogh, in Cooper, *Gauguin: Lettres*, pp. 225–227. Van Gogh comments on the already noticeable friction between the two painters in Pont-Aven as Bernard's "picking quarrels with Gauguin," in *Letters*, 3:43, LT 539.

40. Bogomila Welsh-Ovcharov, *Vincent van Gogh and the Birth of Cloisonism* (Toronto: Art Gallery of Ontario, 1981), p. 302; the Bernard self-portrait with Gauguin appended is also discussed here.

41. Documented in Cooper, *Gauguin: Lettres*, p. 243.

42. From the full letter and facsimile from Gauguin to Vincent van Gogh, in Cooper, *Gauguin: Lettres*, pp. 242–245.

43. Van Gogh, *Letters*, 3:66, LT 545, October 4, 1888.

44. The contrast of the *misérable* with van Gogh's "stoicism" is discussed briefly in Françoise Cachin, "Gauguin Portrayed by Himself and Others," in Brettell et al., *Art of Gauguin*, pp. xv–xxvi, especially p. xxii; Tsukasa Kōdera invokes the terms of optimism and pessimism to characterize the two canvases in "Japan As Primitivistic Utopia," pp. 63–64. Jirat-Wasiutyński and Travers Newton remind us that van Gogh's self-image as the placid bonze was nonetheless produced during a period of great difficulty and intense activity, in "Vincent van Gogh's *Self-Portrait*," pp. 5–7. Carol Zemel also notes this con-

text of adversity and the lack of traceable signs of distress in van Gogh's presentation as a composed bonze, and contrasts it to the suffering Gauguin. She relates the bonze canvas to a general interpretation of van Gogh's self-portraits as explorations of professional identity rather than as externalizations of internal states. See Carol Zemel, "Painting a Legend: Van Gogh's Self-Portraits," in *Van Gogh: The Songlines of Legend*, ed. Felicity St. John Moore (Melbourne: National Gallery of Victoria, 1993), pp. 7–15, especially pp. 12–13; and her *Van Gogh's Progress*, chap. 4. I want to extend this suggestion of constraints on van Gogh's self-expression by identifying the broader cultural barriers to introspective subjectivity created by van Gogh's particular Dutch Protestant formation, and I examine how Gauguin's immersion in tumultuous self-revelation expressed long-term and theologically specific attitudes of his particular Catholic formation and education.

45. I use the English translation of the letter included in Cachin, "Gauguin Portrayed by Himself and Others," in Brettell et al., *Art of Gauguin*, p. xx; the French is in Cooper, *Gauguin: Lettres*, pp. 243–245.

46. From the English translation in Herschel B. Chipp, *Theories of Modern Art* (Berkeley: University of California Press, 1968), p. 67; the French letter is in Merlhès, *Correspondance*, pp. 248–249, #168.

47. The French is "sale existence qui . . . me pèse"; in letter from Gauguin to van Gogh, September 1888, in Merlhès, *Correspondance*, p. 233, #165; see also the end of the letter from Gauguin to van Gogh about the *Misérables*, where he refers again to "quelle *sale* existence," in ibid., p. 235, #166, and Cooper, *Gauguin: Lettres*, p. 247. My interpretation of the chains and of Gauguin's quest to free painting from the shackles of worldly anchorage follows that of Mark Cheetham in his *Rhetoric of Purity: Essentialist Theory and the Advent of Abstract Painting* (Cambridge: Cambridge University Press, 1991), chap. 1. Cheetham sees Gauguin's themes of the artist's imprisoning chains and his quest for abstraction and metaphysical purity as evidence of general correspondences between Gauguin's thought and the major tenets of Neo-Platonism. While I endorse Cheetham's notion that the chains had idealist overtones for Gauguin, I want to relocate the specific sources of the theme of release from earthly shackles and of Gauguin's quest for an art of ascent and purification in the particular patterns of his Catholic theology and formation. These patterns emphasized, as we shall see, a fundamental resistance to materiality concordant with symbolist strains of Neo-Platonism. In the case of Gauguin, an account of

these Catholic patterns is particularly important in order to approach his persistent choice of a theologically charged language of contamination, corruption, and impurity in his writings.

48. The "stay in Hell" of the "contracted" clay is from Gauguin's 1889 essay in Guérin, *Writings of a Savage*, p. 31. In a later letter to Bernard, Gauguin writes again of the ceramic in the kiln as a substance "burned in hell" and compares it to "an artist glimpsed by Dante, in his visit in Hell." See Paul Gauguin, *Lettres de Paul Gauguin à Emile Bernard, 1888–1891* (Geneva: Pierre Callier, 1954), p. 102. Jirat-Wasiutyński also discusses Gauguin's creativity and ceramicism, relating it to a tradition of Romantic Orphism, in his *Paul Gauguin in the Context of Symbolism* (New York: Garland, 1978), pp. 320–323. I am emphasizing here the religious sources and resonances of Gauguin's linkage of the infernal and the internal.

49. I discuss Rodin's *Gates*, the *Thinker*, and the internalization of sin and hell, powered by contemporary clinical knowledge of mental medicine and theories of torsion and contortion, in my *Art Nouveau in Fin-de-Siècle France: Politics, Psychology, and Style* (Berkeley: University of California Press, 1989), pp. 256–269, 301–314.

50. Jirat-Wasiutyński, *Gauguin in the Context of Symbolism*, pp. 292–295.

51. Merlhès, *Correspondance*, p. 234, #166.

52. See Eric Hobsbawn, *The Age of Revolution* (New York: Vintage, 1996), pp. 268–270; and Carl Schorske, *Fin-de-Siècle Vienna: Politics and Culture* (New York: Knopf, 1981).

53. Merlhès, *Correspondance*, p. 249, #168. Note Gauguin's stress on sacrifice as being of his own volition. The sacrifice for style is also attached to Gauguin's other major picture of these months, *The Vision After the Sermon*, which I will explore in Chapter 3.

54. Ibid., p. 234, #166; facsimile in Cooper, *Gauguin: Lettres*, p. 242, with text on p. 243. My thanks to Sarah Maza for this rendering in English.

55. The martyr quote is from a letter to Schuffenecker of May 1885, citation in my n. 1 above. The calvary quote is from a letter to van Gogh in September 1888; in Merlhès, *Correspondance*, p. 220, #163; facsimile in Cooper, *Gauguin: Lettres*, pp. 220, 221. I will return to this theme in later chapters.

56. For the *Self-Portrait Jug* as an image of the martyred artist, see Ziva Amishai-Maisels, *Gauguin's Religious Themes* (New York: Garland, 1985), pp. 79–80, who also links Jean Valjean to Christ in Gauguin's *Misérables*,

pp. 74–76; Jirat-Wasiutyński, *Gauguin in the Context of Symbolism*, pp. 299–306; and Kirk Varnedoe, "Gauguin," in *Primitivism in Twentieth-Century Art*, ed. William Rubin (New York: Museum of Modern Art, 1984), 1:186. These authors offer essential points of departure for the themes of Gauguin's personal calvary; I am trying to defamiliarize this stance of Gauguin as martyred Christ by relating it to a particular nineteenth-century cultural and religious history that made such a stance possible as a model of artistic creativity, and exploring how it differed from the model of Christ defined by van Gogh with his very different cultural resources. For the way this type of analysis may illuminate the self-identification with Christ in another lapsed-Catholic modernist painter, see my "Pleasure and Misery: Catholic Sources of Picasso's and Gauguin's Abstraction," forthcoming.

57. Van Gogh, *Letters*, 3:67, 66, LT 545.

58. Ibid., 3:66, LT 545.

59. Ibid., 2:534, LT 470.

60. Ibid., 3:66, 68–69, LT 545, LT 546.

61. Ibid., 3:67, LT 545. The comments on hope breaking on the horizon are on p. 63, letter to Gauguin 544a, October 8.

62. For dating of the picture to the week ending September 16 and the dispatch to Gauguin, see Jirat-Wasiutyński and Travers Newton, "Vincent van Gogh's *Self-Portrait*," p. 3; and Pickvance, *Van Gogh in Arles*, p. 171. The painting can be seen in the Fogg Museum of Art collection, Harvard University.

63. Van Gogh, *Letters*, 3:66, LT 545.

64. Van Gogh, *Letters*, 3:37, LT 537, emphasis his; and 3:64, 66, letter to Gauguin, LT 544a; I am following here the re-translation provided by Jirat-Wasiutyński and Travers Newton in "Vincent van Gogh's *Self-Portrait*," pp. 3, 33, who make a substitution for what they document as the misleading translation of *veronèse* as "malachite" in the standard English edition of the *Letters*; they establish that the correct term for the pigment used by van Gogh is "veronese green," known today as emerald green.

65. Van Gogh, *Letters*, 3:6, LT 520; I use the translation in Evert van Uitert, Louis van Tilborgh, and Sjraar van Heugten, *Van Gogh: Paintings* (Milan: Arnoldo Mondadori Arte, 1990), p. 142.

66. Van Gogh, *Letters*, 3:67, LT 545.

67. Jirat-Wasiutyński and Travers Newton, "Vincent van Gogh's *Self-Portrait*," n.p., color insert entitled "Plate 4: Detail of the brooch."

68. Van Gogh, *Letters*, 3:25, LT 531, September 3, 1888.

69. Kōdera, "Japan As Primitivistic Utopia," p. 56; see also Jirat-Wasiutyński and Travers Newton, "Vincent van Gogh's *Self-Portrait*," p. 5.

70. This nineteenth-century Dutch "dominocracy" (the dominies', or ministers', culture) was first recovered for van Gogh studies by Tsukasa Kōdera; see his *Vincent van Gogh*, chap. 1. The larger pattern of a culture marked by what I call visual Calvinism has been emphasized by Simon Schama in *The Embarrassment of Riches* and by Svetlana Alpers in *The Art of Describing*. I relate this larger pattern of Erasmian legacies to nineteenth-century developments in my "Weaving Paintings," where I treat the Dutch clerical avant-garde in comparison to other secular European models after the French Revolution.

71. Pierre Loti, *Madame Chrysanthemum*, trans. Laura Ensor (London: KPI, 1985), p. 131.

72. Ibid., p. 190.

73. Ibid.; see also p. 207.

74. Ibid.; pp. 226–229; the whole section is of interest, pp. 221–232.

75. Cited in Kōdera, "Japan As Primitivistic Utopia," p. 57, who coined the term "religious hommes de la nature" to describe van Gogh's view of the Japanese. The van Gogh letter is from about September 25, shortly after the self-portrait.

76. Van Gogh, *Letters*, 3:516, B18, October 3, 1888.

77. Louis Gonse, *L'Art japonais* (Paris, 1886), pp. 324–325. Kōdera makes note of van Gogh's interest in this Japanese model of exchange but does not identify a source in Gonse.

78. Van Gogh, *Letters*, 3:47, LT 540, ca. September 22, 1888.

79. I present this process of French 1880s aristocratization of the Japanese model of arts and crafts in my *Art Nouveau*, chap. 6.

80. I will return to this public visual culture of Catholic piety in Arles, and van Gogh's evolving response to it, in the next chapters.

81. See quote, and n. 46, above.

82. "Cheerfulness" and work-as-remedy statement is in van Gogh, *Letters*, 2:620, LT 514, July 25, 1888.

CHAPTER 2. VAN GOGH'S *SOWER*

1. Vincent van Gogh to Emile Bernard in *The Complete Letters of Vincent van Gogh*, 2d ed. (Boston: New York Graphic Society, 1978), 3:518, B19.

2. Paul Gauguin to Emile Schuffenecker, January 14, 1885, quoted in Linda Nochlin, ed., *Impressionism and Post-Impressionism, 1874–1904: Sources and Documents* (Englewood Cliffs, N.J.: Prentice-Hall, 1966), p. 159. Original in Maurice Malingue, *Lettres de Gauguin à sa femme et à ses amis* (Paris: Grasset, 1946), p. 47.

3. Quoted in Richard Brettell, Françoise Cachin, Claire Frèches-Thory, Charles Stuckey, and Peter Zegers, *The Art of Paul Gauguin* (Washington, D.C.: National Gallery of Art, 1988), p. 103; Gauguin's quote about "the path of symbolism" is on p. 104. Original in French in Victor Merlhès, *Correspondance de Paul Gauguin: Documents, témoignages* (Paris: Fondation Singer-Polignac, 1984), p. 232.

4. Robert Goldwater, "Symbolic Form: Symbolic Content," in *Problems of the Nineteenth and Twentieth Centuries, Studies in Western Art: Acts of the XXth International Congress of the History of Art* (Princeton, N.J.: Princeton University Press, 1963), 4:111–121. See also the special issue of the *Art Journal*, edited by Sharon Hirsh and devoted to "Symbolist Art and Literature," 45, no. 2 (summer 1985).

5. This is identified as the central paradox of the symbolist generation by Jean Bouillon, "Le Moment Symboliste," *Revue de l'Art*, no. 96 (1992), special issue, pp. 5–11, especially p. 7.

6. Van Gogh to Bernard, end of July 1888, in van Gogh, *Letters*, 3:503, B12. The phrase "longing for the infinite" is van Gogh's in describing *The Sower*, in ibid., 3:492, B7.

The emphasis on van Gogh's "naturalizing" as a means of entry to the religious dimensions of *The Sower* was first developed by Tsukasa Kōdera, whose book *Vincent van Gogh: Christianity Versus Nature* (Amsterdam and Philadelphia: John Benjamins, 1990) was a point of departure for this one. Kōdera explores the religious symbols in the rural labor pictures of van Gogh's French period, and his analysis stresses iconographic substitution, such as the replacement of church motifs with the sun; see the chapter entitled "The Church Versus the Sun: Substitution of Motifs," pp. 27–39. I am approaching van Gogh's impulses to "naturalize divinity" from other directions, highlighting the stylistic forms of labor action, the comparison with Gauguin, and the development of van Gogh's efforts to naturalize divinity in the context of Arles's rural popular Catholic piety.

7. The basic lines of inquiry were originally sketched out in my article

"At the Threshold of Symbolism, 1888: Van Gogh's *Sower* and Gauguin's *Vision After the Sermon*," in Montreal Museum of Fine Arts, *Lost Paradise: Symbolism in Europe* (Montreal: Museum of Fine Arts, 1995), pp. 104–114. Other scholars who have included religion in their varying interpretations are, in the case of van Gogh's *Sower*, Kōdera, "The Church Versus the Sun" chapter in his *Vincent van Gogh*, pp. 27–39; Lauren Soth, "Van Gogh's Agony," *Art Bulletin* 68, no. 2 (June 1986): 301–313; and Judy Sund, "The Sower and the Sheaf: Biblical Metaphor in the Art of Vincent van Gogh," *Art Bulletin* 70, no. 4 (Dec. 1988): 660–676. In the case of Gauguin's *Vision*, they include Ziva Amishai-Maisels, *Gauguin's Religious Themes* (New York: Garland, 1985), pp. 18–32; Victor Merlhès, *Paul Gauguin et Vincent van Gogh, 1887–1888: Lettres retrouvées, sources ignorées* (Taravao, Tahiti: Avant et Après, 1989), pp. 91–98; and William Darr and Mary Matthews Gedo, "Wrestling Anew with Gauguin's *Vision After the Sermon*," in Mary Matthews Gedo, *Looking at Art from the Inside Out* (New York: Cambridge University Press, 1995), pp. 56–86.

8. The excavation and restoration of the Arènes began in 1825 and progressed rapidly as part of an emerging campaign for a national patrimony, which included the preservation of classical treasures around France. A national tourist base for Arles was really made possible when the town was granted a stop on the new Paris-to-Marseille railroad in 1842. See Rémi Venture, *Arles* (Marguerittes: Editions de l'Equinoxe, 1990), pp. 54–63; Raoul Busquet, V. L. Bourrilly, and Maurice Agulhon, *Histoire de la Provence* (Paris: Presses Universitaires de France, 1972), pp. 98–115. By 1888, the Arènes had become a venue for summer bullfights as well as folk festivals; see L. G. Pelissier, "Arles," *La Grande Encyclopédie* (Paris: Limrault, 1895), 3:973–974, and Jean-Paul Clébert, *La Provence de Mistral: Sur une collection de documents réunis par Michel Chrinian* (Aix-en-Provence: Edisud, 1980), p. 107, with photo.

9. From an 1852 legend to a photograph of the Arles Cathedral of Saint-Trophime, in the Musée Arlatan collection.

10. Fernand Benoît, "Arles, ville sainte," in Maurice Pézet, *La Cathédrale Saint-Trophime d'Arles* (Paris: Les Editions du Cadran, 1967), pp. 15–17; Fernand Benoît, "Arles," in *Villes épiscopales de Provence* (Paris: Librairie Klincksieck, 1954), pp. 20–21.

11. Mona Caird, *Romantic Cities of Provence* (New York: Scribners, n.d., [ca. 1900]), p. 165; T. A. Cook, *Old Provence* (New York: Scribners, 1905), 2:

78–79. Cook includes the version of the legend re-created by Frédéric Mistral and incorporated by him into the eleventh canto of his renowned book *Mireille*.

12. Joseph Pennell and Elizabeth Pennell, "The Maries' Story," in *Play in Provence* (New York: Century, 1892), pp. 167–193; M. le Chanoine A. Chapelle, *Les Saintes-Maries-de-la-Mer, L'église et le pèlerinage* (Marseille: Moullot, 1926), pp. 11–117; Claire Tiévant, *Almanach de la mémoire et des coutumes, Provence* (Paris: Albin, 1984), n.p., entries of May 25, 26; Michelle Goby, *La Provence: Art et histoire* (Paris: Arthaud, 1980), p. 89. I will return to the pilgrimage at Saintes-Maries-de-la-Mer in Chapter 11.

13. L.-J.-B. Bérenger-Féraud, *Les Légendes de Provence* (Paris: Leroux, 1888), p. 403 (my translation).

14. For a detailed description of the iconography of the tympanum and doorway, as well as the history of the Saint-Trophime Cathedral and its condition in the nineteenth century, with excellent photographs, see L. H. Labande, *L'Eglise de Saint-Trophime d'Arles* (Paris: Laurens, 1930), pp. 6–51; Goby, *Provence*, pp. 114–116; and Pézet, *Cathédrale Saint-Trophime*, pp. 2–8.

15. Tiévant, *Almanach*, entry of December 29.

16. Quote is from Cook, *Old Provence*, p. 5; see also Benoît, "Arles, ville sainte," p. 17; Frédéric Mistral, "Un Cimetière nommé Champs-Elysées: Les Alyscamps," in Jean-Paul Clébert, *Histoires et légendes de la Provence* (Paris: Tchou, 1968), pp. 178–182; and Ronald Pickvance, *Van Gogh in Arles* (New York: Metropolitan Museum of Art, 1984), p. 13.

17. Tiévant, *Almanach*, entry of December 29; Venture, *Arles*, pp. 63–65; Benoît, "Arles," pp. 20–21; Mistral, "Un Cimetière," p. 178; Pézet, *Cathédrale Saint-Trophime*, p. 9.

18. P. Marion and H. Vidal, *Les Alyscamps et leurs légendes* (Arles, 1994), pp. 43–46.

19. Bérenger-Féraud, *Légendes de Provence*, p. 376.

20. Venture, *Arles*, p. 62; see also Pickvance, *Van Gogh in Arles*, p. 17; Pelissier, "Arles," p. 975.

21. Venture, *Arles*, p. 64; Marion and Vidal, *Les Alyscamps*, pp. 43–46.

22. Tiévant, *Almanach*, entry of November 4; Benoît, "Arles, ville sainte," pp. 17–18. Toussaint was celebrated not only as a commemoration of all the saints and of Christ's return to Arles but as an important period of communion with the dead, who were honored as present among the living by

Provençal practices that persisted into the twentieth century. One of these was the special family meal readied before the Toussaint midnight mass, the *repas des armettos*—the meal of the "little souls" or the "wandering souls." Special foods were prepared and places reserved at the table for the dead relatives, who were further appeased by chestnuts placed under the pillows of all family members that night; the chestnuts prevented the returning dead from pulling their feet or wandering through and disturbing the family home. See Pierre Rollet, *La Vie quotidienne en Provence au temps de Mistral* (Paris: Hachette, 1972), p. 244; Regis Bertrand, Christian Bromberger, Claude Martel, Claude Mauron, Jean Onimus, and Jean-Paul Ferrier, *La Provence* (Paris: Bonneton, 1989), p. 227; Tiévant, *Almanach*, entries of November 1–4; and J. Bourilly, *Enquête ethnographique dans le Bas-Languedoc: Folk-lore dans le Gard et les Bouches-du-Rhône* (Nîmes: La Labrorieuse, 1913), pp. 12–13.

23. Venture, *Arles*, p. 63; Marion and Vidal, *Les Alyscamps*, pp. 43–46.

24. The term "Latin race" (*la race latine*) is from the 1878 Mistral poem "A la Raco Latino" in *Oeuvres poétiques complètes*, ed. Pierre Rollet (Edicioun Ramoun Berenguié, 1966), 2:36–41; the term "Provençal race" (*la race provençale*) was employed in 1888 by Bérenger-Féraud, a regional scholar and director of health at the Medical School of Toulon, who spent the 1870s and 1880s collecting, classifying, and republishing Provençal legends, folklore, and oral traditions as part of a project to specify what he called "the particularly Provençal ways of seeing, thinking, and acting." See Bérenger-Féraud, *Légendes de la Provence* (1888), especially pp. i–viii and 403–404; and the earlier volume, *Contes populaires des Provençaux de l'antiquité et du moyen-âge* (Paris: Leroux, 1887). Alternatively considering himself what he called an archeologist and a clinician of consciousness, Bérenger-Féraud anticipated, through his regionalist concerns, the core efforts of modern cultural historians, such as Lucien Febvre, Carlo Ginzburg, and Michael Baxandall, to investigate the mental cosmologies of ordinary people in particular historical circumstances—their distinctive "mental equipment" and ways of knowing the world.

25. Camille Mauclair discusses Mistral and "Francification" in his *La Provence* (Grenoble: Arthaud, n.d. [ca. 1912]), pp. 104–106. For Mistral's career, his critical shift from left to right after the Franco-Prussian War of 1870–1871, and his subsequent anti-republicanism, see Jean-Paul Clébert, *La Provence de Mistral*, pp. 34–36; Alphonse Roche, *Provençal Regionalism: A Study of the Movement in the Revue Félibrienne, Le Feu, and Other Reviews of*

Southern France (Evanston: Northwestern University Press, 1954); and Tudor Edwards, *The Lion of Arles: A Portrait of Mistral and His Circle* (New York: Fordham University Press, 1964).

On the language issue and initiatives, see Roche, *Provençal Regionalism*, pp. 129–131; and Pierre Rollet, *Vie quotidienne*, pp. 166–174; a good contemporary overview of the range of Félibrige activity in literature, theater, religion, and language can be found in Paul Mariéton, "Félibre, Félibrige," in *La Grande Encyclopédie: Inventaire raisonné des sciences, des lettres, et des arts* (Paris: Société Anonyme de la Grande Encyclopédie, n.d. [ca. 1899]), 17:128–133.

26. Busquet et al., *Histoire de la Provence*, pp. 104–105. A detailed and perceptive study of the divergent political affiliations of Arles and Aix in our period can be found in Wayne Michael O'Sullivan, "Electoral Sociology in Arles and Aix, 1870–1914" (Ph.D. dissertation, State University of New York at Buffalo, 1976), especially chaps. 5–10.

27. Venture, *Arles*, p. 49; Tiévant, *Almanach*, entry of August 26; Clébert, *La Provence de Mistral*, pp. 9–59.

28. Mistral, in *Oeuvres poétiques complètes*, 2:36–41. Translation from the French is my own; I have consulted the partial English translation of the poem in Caird, *Romantic Cities of Provence*, p. 18.

29. The term "poet of the soil" is in Alphonse V. Roche, "Frederic Mistral," *Columbia Dictionary of Modern Literature*, ed. H. Smith (New York: Columbia University Press, 1947), p. 545; Mistral received the Nobel Prize in literature in 1906. For Mistral's use of "empire of the sun" see Rollet, *Vie quotidienne*, pp. 7–8; and Edwards, *The Lion of Arles*, bk. 1. On Mistral's religious populism see the interesting monograph by Berthe Gavalda, *L'Inspiration biblique de Frédéric Mistral* (Paris: Collection des Amis de la Langue d'Oc de Paris, 1967).

30. On van Gogh's mixed and vague motives for choosing Arles, see Pickvance, *Van Gogh in Arles*, pp. 11–12; Ronald de Leeuw, *Vincent van Gogh: Pastels and Paintings from the Collection of the Van Gogh Museum* (Zwolle: Waanders, 1994), pp. 177–178; and Kōdera, *Vincent van Gogh*, pp. 32–33. It is Kōdera who suggests that van Gogh may have seen a Provençal folk festival, or the many popular prints and magazines devoted to it, among the *fêtes du soleil* staged in Paris in late 1886.

Alphonse Daudet's play *L'Arlésienne* was revived to great acclaim in Paris after 1885, and van Gogh may have known of this; Daudet's work was at

this time being compared for its resemblances, in plot and characters, to the work of Charles Dickens, another of van Gogh's favorite authors. See Frederick Davies, introduction to Alphonse Daudet, *Letters from My Windmill* (New York: Penguin, 1978), pp. 9–28.

Adolphe Monticelli (1824–1886) worked in Paris in the 1850s in the circles of realist landscape painters and returned to his native Marseille in 1871. Van Gogh became familiar with the still-life genre of flowers in vases by this "master of Marseille" while he was staying with Theo in Paris; Theo had sold at least three such Monticelli canvases in 1885, and had six of them in his collection in 1886–1887. Van Gogh admired what he considered Monticelli's expansion on Delacroix's theories of color and contrasts, as well as Monticelli's heavy, crusted applications of paint. Van Gogh partly associated his move to Arles with a move to the region of Monticelli, and with a desire to work in the tradition of this painter of the south, writing to his sister Wil that he felt as if he were "his [Monticelli's] son or his brother." On Monticelli and van Gogh, see Bogomila Welsh-Ovcharov et al., *Van Gogh à Paris*, exhibition catalogue, Musée d'Orsay (Paris: Editions de la Réunion des Musées Nationaux, 1988), pp. 21, 243–245; Aaron Sheon, "Monticelli and van Gogh," *Apollo*, no. 85 (June 1967): 444–448; and Pittsburgh Museum of Art, *Monticelli: His Contemporaries, His Influences* (Pittsburgh: Pittsburgh Museum of Art, Carnegie Institute, 1978).

31. Van Gogh, *Letters*, 2:525, LT 463. It was the brothers Goncourt who publicized the designation of Japan as the "empire du soleil" in works like *Chérie* and the *Maison d'un artiste*, with which van Gogh was familiar. For the Goncourts' ideology of Japan, see my *Art Nouveau in Fin-de-Siècle France: Politics, Psychology, and Style* (Berkeley: University of California Press, 1989), chaps. 1 and 6.

32. Van Gogh, *Letters*, 2:525, LT 463.

33. Ibid., 2:534, LT 470.

34. Ibid., 3:79, LT 552; 2:566, LT 488.

35. Rollet, *Vie quotidienne*, pp. 24, 87. Johan Huizinga identified the Dutch nation as "hydrographic," characterizing Netherlandish nature not as a given but as a feat of human skill and ingenuity as land mass was wrested from the sea and rendered cultivable, in his *Dutch Civilization in the Seventeenth Century and Other Essays* (London: Fontana, 1968), pp. 14, 16, 25–33, 38–43. Simon Schama provides a compelling account of the moral and cultural implications of the Dutch "flood society" in his *Embarrassment of Riches: An Interpretation of Dutch Culture in the Golden Age* (New York: Knopf, 1987), pp. 15–50. The dual process of reclaiming new land through drainage, pumping, and enclosure, and protecting existing acreage through diking, damming, and embankment continued unabated throughout the nineteenth century. See Max Schuchart, *The Netherlands* (London: Thames and Hudson, 1972), pp. 52–53, and Alan S. Milward and S. B. Saul, *The Development of the Economies of Continental Europe, 1850–1914* (London: Allen and Unwin, 1977), pp. 185, 195–197.

36. S. Baring-Gould, *In Troubadour-Land: A Ramble in Provence and Languedoc* (London: Allen & Co., 1891), pp. 84–85, 109; Caird, *Romantic Cities of Provence*, p. 160. O'Sullivan, "Electoral Sociology," pp. 6–33, contains an excellent discussion of the tactics of acreage recuperation in our period.

37. Rémi Venture, *Montmajour: Métamorphoses* (Marguerittes: Editions de l'Equinoxe, 1990), p. 6; for the description of "Penelope's web" and the Dutch as weavers of nature, see Henry Havard, *The Heart of Holland* (New York: Harper and Bros., 1880), pp. 23, 9.

38. Camille Mauclair, *La Provence* (Grenoble: Arthaud, n.d. [ca. 1912]), pp. 106, 108.

39. O'Sullivan, "Electoral Sociology," pp. 31, 33.

40. Ibid., p. 29.

41. Rollet, *Vie quotidienne*, pp. 246, 23–24; see also O'Sullivan, "Electoral Sociology," pp. 18–33.

42. O'Sullivan, "Electoral Sociology," pp. 27–29; Rollet, *Vie quotidienne*, pp. 19–22; see the map included in Roland Dorn, *Décoration: Vincent van Goghs Werkreihe für das Gelbe Haus in Arles* (Hildesheim: George Olms Verlag, 1990), p. xv, showing the canal at the town gates.

43. Pickvance, *Van Gogh in Arles*, p. 14; Pelissier, "Arles," p. 979; Rollet, *Vie quotidienne*, p. 23. Ronald Pickvance first pointed out the heightened significance of Arlesian canals, locks, and waterways for a Dutchman like van Gogh, though he does not give this issue extensive treatment.

44. Tsukasa Kōdera discovered this *Courrier Français* of 1886, and also identified the special Parisian Midi festival staged in the Paris Palais de l'Industrie, suggesting that van Gogh may have been aware of it. See his *Vincent van Gogh*, pp. 32–33, 40, 110–111.

45. "Fences" and "roofs" is from Van Gogh, *Letters*, 3:436, W4 (letter to

van Gogh's sister Wilhemina); "vast plains" about the Camargue, 2:582, LT 496; "panorama" and "breadth" about Montmajour, 2:575–576, LT 492; and "infinite as the sea" about Montmajour and La Crau, 2:610, LT 509.

46. Venture, *Arles*, p. 58. Van Gogh painted this very one—"I have painted the old mill on the rue Mireille"—*The Old Mill in the rue Mireille*, LT 535, September 1888, reproduced as F550, in J. B. de la Faille, *The Works of Vincent Van Gogh: His Paintings and Drawings*, rev. ed. (London: Weidenfeld and Nicolson, 1970). Another windmill, with sails intact, is included in the drawing of Arles viewed from the wheatfields, F1492, reproduced in Pickvance, *Van Gogh in Arles*, p. 106.

The Mousmée is, of course, the name of another painting by van Gogh of a young woman, which has its sources, according to scholars, in van Gogh's experiments with Japanese prototypes, but it may also have the resonance of a Dutchified Japan.

For the economy sustaining milling in Arles and its districts, see O'Sullivan, "Electoral Sociology," pp. 62–63; and Bertrand et al., *La Provence*, p. 151, with picture.

47. See the maps in Dorn, *Décoration*, p. xv, and Pickvance, *Van Gogh in Arles*, map, p. 1. Today the canal wash fronting the Porte de la Cavalerie is covered over.

48. The *zinkstukken* and their placement in the water were vividly described by Havard in 1878 as he traveled through the Low Countries, *Heart of Holland*, pp. 23, 27.

49. I cannot here do justice to exploring van Gogh's multiple models from Parisian avant-garde painting (Neo-Impressionist, Impressionist, and cloisonist), their relation to his particular idiom of Japonism, and his experimentation with them following the move to Arles. His letters register his euphoria for Japanese color effects in Arles, which he claims to understand for the first time, now stripped of the "veiled . . . mist of the north." (Van Gogh, *Letters*, 3:443, W7; 3:208, LT 605; see the other comments on bright color in 2:566, LT 488; 3:11, LT 522; 3:42, LT 539; 3:53–54, LT 542.) The exploration of varying techniques derived from competing Parisian avant-garde painting is provided, with different emphases, by a number of art historians. Among those essential treatments I have consulted are Bogomila Welsh-Ovcharov, *Vincent van Gogh and the Birth of Cloisonism* (Toronto: Art Gallery of Ontario, 1981); Cornelia Peres, "Van Gogh's Triptych of Orchards in Blossom: An Impressionist

Concept of Painting Technique," in *A Closer Look: Technical and Art-Historical Studies on Works by van Gogh and Gauguin*, ed. Cornelia Peres, Michael Hoyle, and Louis van Tilborgh (Zwolle: Waanders, 1991), pp. 24–38, an excellent analysis of the "dot and the patch" and of distinctive relief-like impasto in some of the orchard paintings; and the still-foundational source of John Rewald, *Post-Impressionism from van Gogh to Gauguin*, 3d ed. (New York: Museum of Modern Art, 1978), chap. 4. I suggest a distinctive feature of van Gogh's appropriation of Japanese arts in his emphasis on the textural qualities of Japanese *nishiki-e* brocade prints and crepe prints, rather than the flatness, asymmetry, and cropping effects borrowed by other Impressionists and cloisonists, from Manet to Gauguin, in my "Weaving Paintings: Religious and Social Origins of Vincent van Gogh's Pictorial Labor," in *Rediscovering History: Culture, Politics, and the Psyche*, ed. Michael Roth (Stanford: Stanford University Press, 1994), pp. 137–168, especially pp. 163–167, 472–473.

50. Part of their appeal, as van Gogh noted to Theo, was their link to his Dutch past; but he also believed that the reed pens resembled those favored by Japanese artists. Yet, as Fred Orton has pointed out, Japanese ink drawings were brushed rather than penned, defined by a fluidity, economy, and smoothness of surface that departed from the repertoire of van Gogh's profusely hatched, dotted, and dashed reed pen markings. And van Gogh's methods for making the pens exaggerated the thickness of the nibs: when he cut and shaped them, he explained, he molded "very thick reeds." The solidity and heaviness of the reed tip enhanced the visibility of physical contact between hand and paper, which reiterated an expressive imperative very different from that of his imagined colleagues in Japan. On the return of the reed pen, see Pickvance, *Van Gogh in Arles*, p. 54, who takes note of the reed pen as a signal of van Gogh's "tangible links with his Dutch past"; see also E. B. F. Pey, "Chalk the Colour of Plowed-Up Land on a Summer Evening," in Rijksmuseum Kröller-Müller, *Vincent van Gogh: Drawings* (Milan: Arnoldo Mondadori Arte, 1990); Jan Hulsker, *The Complete van Gogh: Paintings, Drawings, Sketches* (New York: Abrams, 1980), pp. 316–318; Fred Orton, "Vincent van Gogh and Japanese Prints: An Introductory Essay," in Rijksmuseum Vincent van Gogh, Amsterdam, *Japanese Prints Collected by Vincent van Gogh* (Zwolle: Waanders, 1978), especially p. 21; and van Gogh's own comments on the reed pen, *Letters*, 2:549, LT 478; 2:587, LT 498a.

51. Van Gogh first discussed building a perspective frame in 1882, *Let-*

ters, 1:383, LT 205, where he mentioned Dürer's screen, but we also know he studied the nineteenth-century art manuals of Armand Cassagne as a source for his tool. In the *Traité d'aquarelle*, which van Gogh read in 1881, Cassagne recommended the use of a frame sectioned into quadrants; van Gogh added another length of thread so as to include diagonals (see Fig. 25). Van Gogh continued to revise and adjust his perspective frame, commenting after a number of such refinements that it was "really a fine piece of workmanship." The early operation of the frame and the staked outdoor version are described and illustrated in *Letters*, 1:430–434, quote on p. 434, LT 222 and LT 223 (1882), and evidence from the sketchbooks—such as the 1884–1885 series of six sketches for constructing an adjustable four-legged wooden post for mounting the frame—reveals that van Gogh experimented with the perspective tool throughout his Dutch period.

My discussion of the frame is based on my earlier studies of the frame's central role in shaping van Gogh's craft artistic practice: see my "Weaving Paintings," especially pp. 150–160; and my "Pilgrim's Progress and Vincent van Gogh's Métier," in *Van Gogh in England: A Portrait of the Artist as a Young Man*, ed. Martin Bailey (London: Barbican Gallery, 1992), pp. 94–115. A systematic documentation of the sources and series of van Gogh's earliest perspective frames, and the editions of Cassagne with which he was most likely familiar, can be found in Sjraar van Heugten, *Vincent van Gogh, Drawings,* vol. 1, *The Early Years, 1882–83, Van Gogh Museum* (London: Lund Humphries, 1996), pp. 17–25. For the 1884–1885 sketches suggesting the status of the perspective frame as a mechanical work in progress, see Johannes van der Wolk, *The Seven Sketchbooks of Vincent van Gogh: A Facsimile Edition* (New York: Abrams, 1986), especially pp. 53, 60, 75, 76, 79, 265–267.

52. New evidence of the use of the perspective frame in the Paris period surfaced when experts from the Van Gogh Museum examined a pattern of underdrawing and markings that followed the lines of measurement and recessionals set by van Gogh's perspective frame. The results of their work are presented in Claas Hulshoff and Sjraar van Heugten, "Restoring a Forest Scene by Vincent van Gogh," *Van Gogh Bulletin* (1994/1), pp. 8–10. Many more such examples will surface, I believe, when curators and restoration experts are on the lookout for this type of practice by van Gogh.

53. Van Gogh, *Letters*, 2:533, LT 468.

54. He requested the book from Theo in *Letters*, 2:596, LT 502, and again in 2:601, LT 505; 2:612, LT 510; and 3:5, LT 519. In 3:10, LT 522, van Gogh indicated that he finally had the book. Sjraar van Heugten established that what van Gogh referred to in these letters as Cassagne's "ABCD of Drawing" was the 1880 *Guide to the Alphabet of Drawing* and its earlier installment version, *Drawing for All*, with which van Gogh was also familiar; in van Heugten, *Van Gogh Drawings*, pp. 17, 19.

The Cassagne drawing book, along with this same author's perspective manual and "how-to" books by Karl Robert and Charles Bargue, had formed the core of van Gogh's art training from 1881 to 1883. I discuss these manuals and craft training in my "Weaving Paintings," pp. 150–155. For van Gogh's early study of the Bargue manuals, see his comments in *Letters*, 1:153–239, 504; Charles Scott Chetham, *The Role of Vincent van Gogh's Copies in the Development of His Art* (New York: Garland Press, 1976), pp. 12–77; Anne Stiles Wylie, "An Investigation of the Vocabulary of Line in Vincent van Gogh's Expression of Space," *Oud Holland* 85, no. 4 (1970): 210–222; and Albert Boime, "The Teaching of Fine Arts and the Avant-Garde in France During the Second Half of the Nineteenth Century," *Arts Magazine* 60 (Dec. 1985): 53–54.

55. Van Gogh, *Letters*, 3:5, LT 519.

56. Ibid., 3:493, B7, from the June letter describing his work on *The Sower*.

57. See also *Orchard in Bloom*, F406, reproduced in Pickvance, *Van Gogh in Arles*, p. 52. While they are rightly recognized as a decorative ensemble and as evidence of van Gogh's experimentation with color and brushwork, the elements of continuity in the orchard series are also traceable, and less recognized, in the effortfulness of van Gogh's brush application, creating in some of the canvases a thick layer resembling sculptural relief, and in the compositional coordinates that he inscribes following the lines of the perspective frame, like sequential points along a geometric grid. Ronald Pickvance makes the point in passing that the careful plotting of pictorial space in the orchards suggests that van Gogh "must have used his perspective frame" (ibid., p. 46), an insight that I want to confirm and extend.

58. The dating of the trip is provided by Pickvance, ibid., p. 83, who notes the coincidence with the festival without relating it to the meaning of van Gogh's boats or the other images he produced at Saintes-Maries.

59. Evert van Uitert, Louis van Tilborgh, and Sjraar van Heugten, *Van Gogh: Paintings* (Milan: Arnoldo Mondadori Arte, 1990), p. 118.

60. This painting in of a frame resembling his own device in *Boats* is part of a long-term impulse in van Gogh's work of consistently visualizing a pattern of correspondences between his own craft practice and craft objects and artisans. Earlier examples include the notches van Gogh added to looms in the weaver series, notches resembling the ones on his own perspective frame; his notations in trees of poles and lines that evoke his own frame, such as the rectangular form on posts that appears on the tree at the back of the 1883 *Lumber Sale* (F1113); and the dangling lines that compose a similar pattern that van Gogh set into the Metropolitan Museum *Flowering Orchard* canvas of 1888 (F552). These notations were not necessarily conscious choices on van Gogh's part, but formative patterns of association between his labor and the worked nature of the outer world, which have stylistic consistency and significance. They are an essential part of the visual language of labor, and labor identification, in van Gogh's artistic development. I discuss this incorporation of component parts of the perspective frame into the pre-Arles *Lumber Sale* and the weaver series in my "Weaving Paintings," pp. 155–158, especially p. 158, where I show the way the configuration of a frame on wooden stakes in the back trees reveals a fundamental difference from the image van Gogh was attempting to copy: the *Lumber Sale* by his cousin and art teacher Anton Mauve.

61. The Arles bridge was indeed originally constructed by a Dutch engineer, according to William Uhde, *Van Gogh*, plate 13. The cutting through of the Arles–Bouc canal, and the name of the bridge after the bridgekeeper, are reported by Pickvance, *Van Gogh in Arles*, p. 14.

62. The figures are numbered to follow the likely chronological order of the pictures, composed from mid-March to early May. Exact dates are not known in all cases, but from van Gogh's letters and Ronald Pickvance's study, the order can be established with reasonable confidence. The images are F397, F400, F570, F571 (oils); F1480 (watercolor); F1470, F1471, F1416(v) (drawings); and B2 (ink sketch in letter).

63. In addition to using different media and different vantage points, van Gogh composed the images at different times of day and in various weather conditions with figures in different stages of passage through the bridge.

64. I discuss van Gogh's adjustments to the weavers' looms and threads and their correspondences to his perspective frame in my "Weaving Paintings," especially pp. 155, 161–163, 471 n. 39.

65. Van Gogh, *Letters*, 2:402, emphasis his (letter to Theo of summer 1885), LT 418. The relationship between the Arles *Sower* of 1888 and van Gogh's earlier attempts to render the Millet-inspired figure is discussed in Louis van Tilborgh, "The Sower," in *Van Gogh and Millet* (Zwolle: Waaders, n.d. [ca. 1988]), pp. 156–177.

66. Discussions of the alterations of the first to the second state of *The Sower* are included in Pickvance, *Van Gogh in Arles*, pp. 102–103; and van Uitert et al., *Van Gogh: Paintings*, pp. 128–129.

67. Van Gogh considered *The Potato Eaters*, for example, not an image of rest and repast but a visual statement of the "honest" labor process *preceding* the meal: "I want to make it clear that these people, eating their potatoes in the lamplight, have dug the earth with the very hands they put in the dish, and so it speaks of *manual labor*, and how they have honestly earned their food" (*Letters*, 2:370, emphasis his). The religious sources underpinning van Gogh's identification with labor are multiple and complex, deriving not from a unitary Calvinism but from a number of competing religious legacies within Calvinism that van Gogh absorbed in the Netherlands and in Great Britain. The importance of these religious legacies has been reemphasized in Kōdera, *Vincent van Gogh*, especially chap. 1. I explore the centrality of van Gogh's parents' Groningen School theology of service in my "Weaving Paintings"; I analyze the significance of the populist religious tradition of John Bunyan assimilated during van Gogh's English period in my "Pilgrim's Progress and Vincent van Gogh's Métier."

68. Van Gogh, *Letters*, 2:356, LT 398. Van Gogh had begun comparing aspects of his artistic process and progress with qualities of the weaver at the loom during his apprenticeship in The Hague in 1882–1883, such as, for example, in ibid., 1:467, LT 236; 2:5; 2:7, LT 274.

69. Van Gogh, *Letters*, 1:458–459, LT 232; see also the repetition about sowing studies and reaping pictures on p. 460, and the ideas of the studies "ripening" on pp. 445 and 460, LT 227, LT 233.

70. Ibid., 3:226, LT 612; 2:591, LT 501.

71. Ibid., 3:493, B7. The sketch of *The Sower* in the letter to Bernard shows the iron stakes and rope as if attached to the insert of the image, to demonstrate how the easel was doubly grounded, first with its own legs rammed down and then tied to the bolted iron stakes. The ingenuity and flexibility of this self-constructed tool for artistic practice recalls the qualities and

components of van Gogh's perspective frame, which (as noted above) he was using in these fields and during this period to give lessons to the soldier Milliet.

72. Ibid., 3:493, B7; the comment on the necessary "vigor" required to paint *The Sower* is on 2:591, LT 501.

73. Ibid., 3:14, LT 524; 3:438, W4.

74. Of *The Potato Eaters* of 1885, for example, van Gogh compared his choice of color to "a very dusty potato, unpeeled of course," thereby reattaching himself to the physical contact between hand and soil that had made the peasants' meal possible. Van Gogh also claimed this painting as "a real peasant picture" by comparing its "rough tissue" and "broken colors" to the "checkered cloth" and "Scottish plaids" woven by the weavers. See ibid., 2:372, LT 405; 2:369–370, LT 404; and my discussion of the emergence of this particular form of pictorial labor in my "Weaving Paintings."

75. The quote is from van Gogh's comments on the meaning of *The Potato Eaters*, in *Letters*, 2:370, LT 404.

76. "This blasted mistral makes it very hard to get one's brushwork firm," commented van Gogh to Theo in ibid., 3:57, LT 543; Pickvance discusses the compositional alterations on *The Sower* toward heightened density in *Van Gogh in Arles*, pp. 102–103.

77. Van Gogh, *Letters*, 3:226, LT 612.

78. Ibid., 3:233, LT 615.

79. Ibid., 3:492, B7.

80. Steeped in the New Testament, van Gogh was certainly familiar with the parable of the sower (Matthew 13:2–9, 18–23; Luke 8:4–15; and Mark 4:13–20) and it is significant that he does not invoke the biblical precedent explicitly; see van Tilborgh, "*The Sower*," p. 156. For accounts of the "religious overtones" of the image, see Evert van Uitert, "Van Gogh's Concept of His Oeuvre," *Simiolus* 12, no. 4 (1981–1982): 239; and Judy Sund, "*The Sower* and the Sheaf: Biblical Metaphor in the Art of Vincent van Gogh," *Art Bulletin* 70, no. 4 (1988): 660–676.

81. Van Gogh, *Letters*, 1:495, LT 248.

82. Ibid., 2:597, LT 503; 2:591, LT 501, emphasis his.

83. Van Tilborgh, "*The Sower*," p. 177.

84. Van Gogh, *Letters*, 2:597, LT 503.

85. Ibid., 3:44, LT 539.

86. Van Uitert et al., *Van Gogh: Paintings*, p. 128.

87. Pickvance, *Van Gogh in Arles*, p. 103.

88. In a later version of *The Sower*, painted in November 1888 (F450), van Gogh used the disk of the sun as a halo for the sowing figure, placing it directly behind him. According to Tsukasa Kōdera, this sun as halo may have originated in van Gogh's exposure to images of the sower and the sun and to depictions of solar festivals in the popular illustrated magazine *Le Courrier Français* of 1886. However, van Gogh's earlier invocation of Delacroix's exemplary "symbolic color" in Christ's aureole as a model for the evocative colorism of the June 1888 *Sower* suggests a more obvious and fundamental transposition of religious precedent to nature, and a rural form and content. For the Kōdera argument, see his *Vincent van Gogh*, pp. 27–39, especially pp. 30–33.

89. Art historians have identified the three-way dialogue of van Gogh, Bernard, and Gauguin in the summer of 1888, with different emphases; the accounts I have relied on are Darr and Gedo, "Wrestling Anew," pp. 64–67, which makes the case most forcefully; Ziva Amishai-Maisels, *Gauguin's Religious Themes* (New York: Garland, 1985), pp. 18–32; and Vojtěch Jirat-Wasiutyński, *Paul Gauguin in the Context of Symbolism* (New York: Garland, 1978), pp. 84–92.

Emile Bernard's religious crisis was first noted by Amishai-Maisels, *Gauguin's Religious Themes*, pp. 16–18, and expanded by Darr and Gedo, "Wrestling Anew," pp. 63–66, though treatments of Bernard are still dominated by the later conflict between him and Gauguin for priority of invention of "synthetism," with much still needed to be done with his early formation and career.

90. Emile Bernard, "L'Aventure de ma vie," in *Lettres de Paul Gauguin à Emile Bernard, 1888–1891* (Geneva: Callier, 1954), p. 12.

91. As Bernard wrote in the summer of 1888 from Saint-Briac, "The supernatural looms at every step; . . . there are enough calls to the mystic soul that it seems to ferment soundlessly in it." Quoted in Antoine Terrasse, *Pont-Aven et l'Ecole buissonnière* (Paris: Gallimard, 1992), p. 40; my translation. For Breton religiosity and Bernard, see Pierre Turaze, *Pont-Aven: Art et les artistes* (Paris: La Pensée Universelle, 1973), pp. 13–39, which treats issues and comments not located elsewhere. I will turn in the following chapter to a more extensive examination of Breton religion and the Third Republic.

92. Bernard, "L'Aventure de ma vie," pp. 14–15; see also Darr and Gedo, "Wrestling Anew," p. 66, which mentions the crisis but does not discuss

Bernard's frescoes. Bernard considered this decoration of his lodgings in Saint-Briac as an ensemble, melding frescoes with what he likened to "effects of stained glass." This decorative and integrated program predates and is a significant precedent for the later and more well-known decoration of the walls and spaces of the Maison Marie-Henry in Le Pouldu that Gauguin and his circle would undertake in 1889. In that instance, the painters also attempted to unify varied arts toward an ensemble that included both secular and religious motifs. To my knowledge there is no study of Bernard's early crisis and his decorative work in Saint-Briac. The fresco Bernard produced of *The Circumcision* is an unusual choice, representing the first time that the blood of the Redeemer, Christ, was shed, an image usually associated with Counter-Reformation, especially Jesuit, church imagery and frescoes.

93. Bernard, "L'Aventure de ma vie," pp. 15–19.

94. Among Bernard's favored referents was an eclectic mix of Byzantine arts, fifteenth-century religious art and prints, and Fra Angelico and Giotto. These and other sources are discussed in *Emile Bernard, 1868–1941: A Pioneer of Modern Art*, ed. Mary Anne Stevens (Zwolle: Waanders, 1990), with catalogue entries. Bernard also collected popular Epinal colored prints from different periods, which have not been inventoried, to my knowledge. Bernard ended his career as a church decorator, painting murals in Cairo cathedrals. The *Nativité* woodcut (Fig. 56) is included in Bernard's memoirs and dated there as 1885, though the 1990 Bernard catalogue and the Musée de Pont-Aven have it redated to 1889. See "L'Aventure de ma vie," p. 16; and *Emile Bernard*, p. 289. The *Yellow Christ* drawing is also reproduced on the frontispiece to the Bernard memoir and dated 1888, with the list of illustrations in this volume noting that the canvas of the same title was painted in 1886.

95. While Bernard's key role in shaping the emergence of symbolism in 1888 is always asserted, his development has never been studied in depth, particularly with regard to the interaction of emerging abstraction in painting, idealism, and neo-Catholicism in the critical decade of the 1880s. Bernard's poetry, memoirs, and letters from the period still need systematic exploration and analysis. The most important examination of Bernard's entire career to date is provided by the 1990 Bernard catalogue cited in n. 94 above.

96. This is described in van Gogh, *Letters*, 2:602, LT 505; the date is given by Pickvance, *Van Gogh in Arles*, p. 71, as about July 7. Van Gogh repeated this experiment in September/October of 1888, with the same results,

scraping off the paint. See van Gogh, *Letters*, 3:46–47, LT 540: "I cannot and will not paint any more without models."

97. Van Gogh, *Letters*, 3:503, B12. The discussion in the letter about Baudelaire seems to have been stimulated by van Gogh's sense that Baudelaire misread Rembrandt and misrepresented him in his poetry.

98. Ibid., 3:504, B12.

99. The permeation of supernaturalism in the rural life of nineteenth-century Provence was rooted in what historians and ethnographers describe as the expectation of direct, unmediated intrusion of heavenly powers in the ordeals of daily existence, and the concrete presence of those powers as personalized and familiar agents in the visible world. This commingling of the earthly and the heavenly realms was expressed not only in the matching of the agricultural cycle to the liturgical calendar but in a comprehensive symbolic system linking the material and the divine in concrete forms, in everything from particular foods, to the type of crops reserved as the specialty of one in a multitude of such specialized saints, to the festive celebrations in the labor fields recalling specific miracles or petitioning for new ones, to the regional arts of the ex-voto and the ceramic santons—little clay figurines of local types presented in mini-stage sets as attending the birth of the baby Jesus.

I was first introduced to this abundant supernaturalism of nineteenth-century Provençal popular Catholicism in the text by Claire Tiévant, *Almanach*, which has day-to-day entries of festive and devotional practices and their correspondences to the rural agricultural cycle. A number of other sources have been indispensable in reconstructing the local context of Catholic popular piety and miraculous supernaturalism that van Gogh encountered in Arles: Claude Seignolle, *Le Folklore de la Provence* (Paris: Maisonneuve et Larose, 1963); Christian Bromberger, "Ethnographie," section in Regis Bertrand et al., *Provence*, pp. 87–249; Rollet, *Vie quotidienne*, especially pp. 51–247; *Almanach des saints de Provence pour l'année 1905* (Marseille: Imprimerie Marseillaise, 1905); Jean-Paul Clébert, *Les Fêtes en Provence* (Avignon: Aubanel, 1982); and Jean Poueigh, *Le Folklore des pays d'oc: La Tradition occitane* (Paris: Payot, 1952), especially pp. 158–255.

100. I am relying on the dating provided by Pickvance in *Van Gogh in Arles* (pp. 102, 94, and 70) for the painting. The local context of the popular Catholic piety van Gogh encountered in Arles has never been attended to, and is particularly important, as I argue, because it coincides with the discussions

about idealism and religious art that van Gogh explored with Bernard and Gauguin, creating a dual pressure, in both avant-garde and social practices, toward a type of supernaturalism for which van Gogh, a Dutch Protestant trained in a new doctrine of "anti-supernaturalism," had little interest or affinity. In " 'Refiler à Saintes-Maries'? Pickvance and Hulsker Revisited," *Van Gogh Museum Journal* (1997–1998), pp. 14–25, Roland Dorn suggests a revision in the dating of the Arles harvest pictures and proposes an alternative to Pickvance's own revised chronology for them, but largely accepts the dating of *The Sower* that I use here. I remain persuaded by Pickvance's account and rely on it for my contextual analysis and dating. Neither Pickvance nor Dorn addresses what was happening in the local context of rural Catholic festivals in those weeks of June when van Gogh was producing his *Sower*.

101. Pickvance, *Van Gogh in Arles*, p. 94. These included the splendid panoramic *Harvest* (F412) in the Van Gogh Museum and the *Wheat Stacks near a Farm House* (F425) in the Kröller-Müller, a horizontal and vertical pendant that van Gogh intended as a complementary pair.

102. Pointed out by Pickvance, ibid., p. 99.

103. For the timing of sowing in October, see Bertrand et al., *Provence*, p. 113; Tiévant, *Almanach*, entries of October 5 and 6; and Rollet, *Vie quotidienne*, p. 65.

104. There has been no commentary that I know of on the dialectic of observation and invention with regard to this sower figure, and why van Gogh chose a labor type not present in that season at the scene. The connections and memories of rural Brabant may have been elicited by the archaic types of tools and techniques used in the region in the 1880s; according to historians, the areas around Arles and La Crau manifested little agricultural modernization since the 1830s, relying still on hand tools, animal-driven plows, and the use of seasonal harvesters. See J. Noel Marchandian, *Outillage agricole de la Provence d'autrefois* (Aix-en-Provence: Edisud, 1984), especially pp. 89–110; Rollet, *Vie quotidienne*, pp. 19–83; Bertrand et al., *Provence*, pp. 98–157; and Tiévant, *Almanach*, especially entries of October 2–6 on agricultural techniques.

105. Van Uitert et al., *Van Gogh: Paintings*, p. 128; Pickvance, *Van Gogh in Arles*, p. 103. The color contrast also extended to the frame, where van Gogh continued the brushing in of the same yellow and violet contrast colors that he used in the main canvas.

106. Rollet, *Vie quotidienne*, p. 61; Tiévant, *Almanach*, entries of June 23–30; Seignolle, "Le Cycle de la Saint-Jean," in *Folklore de Provence*, pp. 203–214, with proverbs and nineteenth-century sources, and quote on "the most popular saint in Provence"; Bertrand et al., *Provence*, pp. 110–112; Clébert, *Fêtes*, pp. 111–120; Poueigh, *Folklore*, pp. 224–230.

107. Tiévant, *Almanach*, entries of June 27–29; Rollet, *Vie quotidienne*, pp. 60–61; Bertrand et al., *Provence*, pp. 229–231; Seignolle, *Folklore de Provence*, pp. 214–216; Bérenger-Féraud, *Légendes de la Provence*, p. 215; Clébert, *Fêtes*, pp. 111–155; and Poueigh, *Folklore*, pp. 224–255.

108. This courtship ritual had its counterpart for the young women, who were presumed more desirable by their participation in the dances round the Saint John logs. On the bonfires and the many customs associated with the Saint John festivals, see Seignolle, *Folklore de Provence*, pp. 203–214; Tiévant, *Almanach*, entries of June 23–28; Poueigh, *Folklore*, pp. 224–230.

109. Seignolle, *Folklore de Provence*, pp. 203–213; Tiévant, *Almanach*, entries of June 23–26; see also Poueigh, *Folklore*, pp. 224–230.

110. Van Gogh, letter to Emile Bernard, in *Letters*, 3:518, B19, end of October 1888.

111. Ibid., 3:7, LT 520.

112. From Mistral, "A la Raco Latino."

CHAPTER 3. GAUGUIN'S *VISION AFTER THE SERMON*

1. Gauguin to Schuffenecker, August 1888, quoted in Robert Goldwater, *Gauguin* (New York: H. Abrams, 1983), p. 58; original in Victor Merlhès, ed., *Correspondance de Paul Gauguin: Documents, témoignages* (Paris: Fondation Singer-Polignac, 1984), p. 210, #159.

2. Van Gogh to Bernard in *The Complete Letters of Vincent van Gogh*, 2d ed. (Boston: New York Graphic Society, 1978), 3:511, ca. August 18, 1888.

3. Quoted in Mark Cheetham, *The Rhetoric of Purity: Essentialist Theory and the Advent of Abstract Painting* (New York: Cambridge University Press, 1991), p. 4; see also p. 7.

4. Unlike Provence, with its Frédéric Mistral, Brittany had no single figure to spearhead the Breton regionalist movement, which had decentralized hubs and leaders in the different areas after 1870. In Pont-Aven itself, Théodore Botrel, an avid follower of Mistral, began a series of local festivals mingling neo-Catholicism, processions in local costumes, and the recovery of special dialects, culminating in his "Pardon des Fleurs d'Ajonc" of 1905, for which

Mistral was listed as honorary president. Photographs of Botrel and the festival are displayed in the document room of the Pont-Aven Museum; other materials on Botrel and Catholic regionalism may be found in Bertrand Queinec, *Pont-Aven, 1800–1914* (Bannalec: Imprimerie Régionale, 1983), pp. 414–443, with photos. The best treatment of the politics and culture of regional religious revivalism is Caroline Ford, *Creating the Nation in Provincial France: Religion and Political Identity in Brittany* (Princeton, N.J.: Princeton University Press, 1993). For general accounts of the religious revival during the Third Republic, which include discussions of Brittany, I have relied on the splendid analytical history of Ralph Gibson, *A Social History of French Catholicism, 1789–1914* (London: Routledge, 1989), especially pp. 104–192, 227–273; Jean-Marie Mayeur, "Croyances et cultures," in *Les Débuts de la Troisième République, 1871–1898* (Paris: Seuil, 1973), pp. 134–161; A. Latreille and R. Rémond, "L'Offensive des républicains anticléricaux et les directions Léon XIII," in *Histoire du catholicisme en France: La Période contemporaine* (Paris: Spès, 1962), 3:455–486; and Pierre Sorlin, *Sociétés contemporaines: La Société française, 1840–1914* (Paris: Arthaud, 1969), pp. 207–233.

5. My discussion of Brittany's appeal in literary and intellectual culture is drawn from Antoine Terrasse, *Pont-Aven, l'Ecole buissonnière* (Paris: Gallimard, 1992), pp. 13–16, and Françoise Cachin, *Gauguin: The Quest for Paradise* (New York: Abrams, 1992), pp. 37–38. The most important argument for the mythification of Brittany by nineteenth-century urban elites may be found in Fred Orton and Griselda Pollock's article, "Les Données bretonnantes: La Prairie de représentation," *Art History* 3, no. 3 (Sept. 1980): 315–344. See also the nuanced analysis of Robert L. Herbert, *Peasants and "Primitivism": French Prints from Millet to Gauguin* (South Hadley, Mass.: Mount Holyoke College Art Museum, 1995).

The special Breton "calvaries" characteristic of the region were tiered, outdoor granite sculptures on stone platforms, usually in the parish close—a semi-protected outdoor enclosure outside the chapel—which represented scenes from the Passion and were usually marked at the summit by a representation of Christ on the cross. These narrative sculptures, most of them built in the eleventh and twelfth centuries, were originally related to outdoor preaching and teaching. Their coarse and rough-hewn qualities deepened with exposure to the elements over the centuries.

6. According to Ralph Gibson, Caroline Ford, and other social histori-ans of nineteenth-century French religion, Breton Catholicism intensified after 1875 and was "characterized by a taste for the mystical and the irrational, and above all by an obsession with death; the world of the dead was an integral part of that of the living" (Gibson, *Social History*, p. 176). Through maps, tables, and the famous Carte Boulard, Gibson and Mayeur demonstrate the vitality of Breton Catholicism from 1877 to 1909 through indices such as the practice of communion, attendance at mass, and number of vocations to the clergy. This quantitative evidence is complemented by discussions of the expansion and changes in popular piety, which included some regionally specific features, such as the extension of the "pardon" festivals and the raisings of the cross. These transformations, scholars argue, challenge the model of "linear decline" and secularization in late-nineteenth-century France, indicating an increase in the intensity of religious experience that may not be measurable by institutional statistics on conventional practices. See Gibson, *Social History*, pp. 170–273; Ford, *Creating the Nation*; Mayeur, *Troisième République*, pp. 134–161; Latreille and Rémond, *Histoire du catholicisme*, pp. 455–486; Alain Corbin, "The Secret of the Individual," in *A History of Private Life*, ed. Michelle Perrot (Cambridge, Mass.: Harvard University Press, 1990), 4:476–558; and Sorlin, *Société française*, pp. 207–233.

7. The Second Empire began the vogue for collecting and recording folk culture, which was pursued in official and avant-garde realism. See, for example, T. J. Clark, *Image of the People: Gustave Courbet and the 1848 Revolution* (Princeton, N.J.: Princeton University Press, 1985); and Albert Boime, "The Second Empire's Official Realism," in *The European Realist Tradition*, ed. Gabriel P. Weisberg (Bloomington: Indiana University Press, 1982), pp. 31–123. Third Republic emphasis on religious painting did not, to be sure, eliminate the folk culture interest of the earlier two decades, but directed it toward the subject of devotional practices. See the catalogue of André Cariou, *La Bretagne vue par les peintres au XIX siècle* (Collection du Musée des Beaux-Arts de Quimper, 1995); J. Chardronnet and D. Mignant, *Pardons et pèlerinages de Bretagne* (Rennes: Editions Ouest-France, 1996); and Gabriel P. Weisberg, *Beyond Impressionism: The Naturalist Impulse* (New York: Abrams, 1992). See also the article by Weisberg, which first situated Gauguin's Brittany paintings in the context of the academic vogue for Breton religious subjects, "Vestiges of the Past: The Brittany 'Pardons' of Late Nineteenth-Century Painters," *Arts Magazine* 55, no. 3 (Nov. 1980): 134–138.

Jules Breton's important paintings of religious subjects during the 1880s are presented in Hollister Sturges, *Jules Breton and the French Rural Tradition* (New York: The Arts Publisher, 1983), with sections on the Brittany pardons, 1868–1891, and on Breton's contemporaries.

Photography also took part in the discovery and representation of Breton religiosity in the Third Republic. See, for example, the images of the ceremony and procession of the 1911 raising of the cross included in Michel Thersiquel, René le Bihan, and Catherine Puget, *Mémoire de Pont-Aven, 1860–1940: Photographies recueillies par Michel Thersiquel* (Pont-Aven, Société de Peinture, 1986), pp. 98–101.

8. The term "photographic" was used by Weisberg to describe the style of Dagnan-Bouveret, who used photographs for study, in Weisberg, "Vestiges of the Past," pp. 136–137.

9. Orton and Pollock, "Données bretonnantes," pp. 325–331.

10. Ford, *Creating the Nation*, passim.

11. I have relied on the translation in William Darr and Mary Matthews Gedo, "Wrestling Anew with Gauguin's *Vision After the Sermon*" in Mary Matthews Gedo, *Looking at Art from the Inside Out* (New York: Cambridge University Press, 1995), p. 60; the original reads: "J'aime la Bretagne, j'y trouve le sauvage, le primitif. Quand mes sabots résonnent sur ce sol de granit, j'entends le ton sourd, mat et puissant que je cherche en peinture" (Merlhès, *Correspondance*, p. 172, #141, March 1888).

12. The Pont-Aven figures are in Queinec, *Pont-Aven*, p. 101; for Arles, see Karl Baedecker, *Southern France* (London: Baedecker, 1891), p. 420.

13. See Pierre Tuarze, *Pont-Aven, arts et artistes* (Paris: La Pensée Universelle, 1973), pp. 8–11; Ronald Pickvance, *Gauguin and the School of Pont-Aven* (San Diego: Museum of Art, 1994), pp. 18–24, who reprints the memoirs of three painters drawn to Pont-Aven from 1880 to 1894; Queinec, *Pont-Aven*, pp. 17–109, with descriptions of the circles of Americans, British, and French painters who discovered the hamlet from mid-century; see also the *Revue des Deux-Mondes* reporter André Theuriet calling Pont-Aven in 1881 a "picturesque hamlet that resembles Barbizon" and noting that he encountered groups of landscape artists from England and America there "noisily discussing" painting and other matters, as quoted in Thersiquel et al., *Mémoire de Pont-Aven*, p. 50. For other materials on the artists' colonies and Pont-Aven see the excellent essays and entries in Arts de L'Oeust, *Artistes étrangers: Pont-Aven, Concarneau, et autres lieux en Bretagne* (Rennes: Presses Universitaires, n.d.), passim.

14. The adjacent Hôtel des Voyageurs was the more expensive and elite of the hostelries, frequented by academic painters and travelers. "Bohemian home" is the term of Henry Blackburn's description of the Gloanec inn, from his *Breton Folk: An Artistic Tour in Brittany* (London: S. Low, Marston, Searle, & Rivington, 1880), quoted in Pickvance, *Gauguin and the School of Pont-Aven*, p. 19; see also Tuarze, *Pont-Aven*, pp. 17–23.

15. The "protectress of painters" quotation and discussion of Marie-Jeanne Gloanec is in Queinec, *Pont-Aven*, pp. 123–129; the record of the moderate costs and "creature comforts" is noted by Blackburn, 1880, quoted in Pickvance, *Gauguin and the School of Pont-Aven*, p. 19; see also Tuarze, *Pont-Aven*, p. 19, who discusses how Marie Pape nursed Gauguin back to health after a fight in Concarneau leading to a broken ankle. Thersiquel et al.'s *Mémoire de Pont-Aven* provides unusual contemporary photographs of the town inns and the Maison Gloanec during the 1880s, as well as group portraits of the artists who frequented the hotel in 1880, 1881, and 1886 (pp. 48–53).

16. Sérusier's encounter with Gauguin yielded the famous *Talisman* painting, created by Sérusier after Gauguin instructed him to paint in freeform colors—to "paint the tree blue if you see it blue." Sérusier treated this exercise as a breakthrough for liberating painting from the natural scene as given, and reported back to his friends at the Paris Académie Julien that Gauguin was a new seer of modern painting, freed from the shackles of realism. A good account of this episode is provided in Terrasse, *Pont-Aven, l'École buissonnière*, pp. 63–67; and Charles Chassé, *The Nabis and Their Period*, trans. Michael Bullock (New York: Praeger, 1969), pp. 7–14, 43. See also Catherine Puget, Wladyslawa Jaworska, and Denise Delouche, *Gauguin et ses amis à Pont-Aven* (Amen Mère: Editions La Chasse, 1989).

17. For Gauguin's donning the Breton costume, see the photographs in Thersiquel et al., *Mémoire de Pont-Aven*, cover and p. 47; Georges Beauté, *Gauguin vu par les photographes* (Lausanne: Edita, 1988), p. 13; and photos of Gauguin displayed in the document room of the Pont-Aven Museum. The wooden clogs that Gauguin carved and painted to wear in Brittany are reproduced in Christopher Gray, *Sculpture and Ceramics of Paul Gauguin* (Baltimore: Johns Hopkins University Press, 1963), pp. 200–201.

18. Ziva Amishai-Maisels, *Gauguin's Religious Themes* (New York: Garland, 1985), pp. 30–31. Darr and Gedo, "Wrestling Anew," endorses and builds on this company as a further indication of Gauguin's involvement with Breton Catholicism.

19. Gauguin described the scene in a letter to Theo van Gogh of June 15–18, 1888: "Je suis en train de faire une gavotte bretonne dansée par trois petites filles au milieu des foins," in Merlhès, *Correspondance*, p. 190. The painting was titled *La Ronde des petites bretonnes* and later exhibited as *La Ronde dans les foins*. See also Richard Brettell, Françoise Cachin, Claire Frèches-Thory, Charles F. Stuckey, and Peter Zegers, *The Art of Paul Gauguin* (Washington, D.C.: National Gallery of Art, 1988), pp. 94–97.

20. Belinda Thomson, *Gauguin* (London: Thames and Hudson, 1987), p. 58.

21. This is the position both of Thomson and of Darr and Gedo, who see this phase as a transitional one when Gauguin was aggressively resisting Neo-Impressionism without yet finding his own idiom.

22. Soon after the canvas was exhibited in November 1888, Theo van Gogh found a buyer on condition that Gauguin adjust the modeling of the girls' hands, which he readily accepted. See Brettell et al., *Art of Gauguin*, p. 95.

23. Thomson, *Gauguin*, p. 25; Charles Morice, cited in George Hamilton, *Painting and Sculpture in Europe, 1880–1940* (Middlesex: Penguin, 1967), p. 84.

24. Letter of January 14, 1885, quoted in Linda Nochlin, ed., *Impressionism and Post-Impressionism, 1874–1904: Sources and Documents* (Englewood Cliffs, N.J.: Prentice-Hall, 1966), p. 158, emphasis Gauguin's; original in Merlhès, *Correspondance*, p. 87, #65.

25. Quoted in Nochlin, ed., *Impressionism*, p. 159; original in Merlhès, *Correspondance*, pp. 87, 88, 89.

26. Quoted in Robert Goldwater, *Gauguin* (New York: Abrams, 1983), p. 58; original in Merlhès, *Correspondance*, p. 210, #159.

27. Mark Cheetham formulates this as Gauguin's way to "offer salvation from the ontologically wanting world of appearances," which he considers as evidence of Gauguin's intellectual debt to Neo-Platonist philosophy. This Neo-Platonism, according to Cheetham, is the source of Gauguin's drive toward aesthetic purism and abstraction (*Rhetoric of Purity*, p. 17). Cheetham's effort to take Gauguin seriously as a thinker is important, but I believe he oversecularizes Gauguin's modernism and overlooks the preexisting religious mentality that facilitated Gauguin's receptivity to Neo-Platonism in the 1880s.

28. Quoted in Cheetham, *Rhetoric of Purity*, p. 4.

29. Letter of October 16, 1888, to Schuffenecker, quoted in Brettell et al., *Art of Gauguin*, p. 104; original in Merlhès, *Correspondance*, p. 225, #172.

30. The precise dating of the painting is still the subject of some disagreement among scholars. Gauguin himself left no written record specifying the exact date but did refer to it in dated letters afterward. The 1988 major exhibition catalogue by Brettell et al. proposed that Gauguin probably began the painting in mid-August and completed it by mid-September (*Art of Gauguin*, p. 102). I follow the more recent account of Darr and Gedo, who argue, based on the letters of Bernard and van Gogh, that Gauguin probably produced the painting in the second week of September ("Wrestling Anew," pp. 66–67).

31. Ziva Amishai-Maisels, "A Gauguin Sketchbook: Arles and Brittany," *Israel Museum News* 10 (1972): 70, discusses Gauguin's titles for the painting. In my view, "vision *after* the sermon" implies discrete phases of before and after, the divisible stages of hearing the sermon followed by the projection of an inner image of it, while Gauguin's "vision *of* the sermon" suggests a more active and dynamic process of consciousness and the interplay of sermon and vision, word and image, vision and the visual, which are part of the immediacy and nonlinearity of the mental and spiritual states he explores. "Apparition," also used by Gauguin in his notebook, has connotations that I take up later in this chapter.

32. Quoted in Brettell et al., *Art of Gauguin*, p. 103; original in Merlhès, *Correspondance*, p. 248, #168.

33. A lightly painted black round of beads appears in the kneeling figure in the middle ground closest to the tree; the woman seems to be pulling the chain through one hand by the other. The seated woman at the upper left corner, on the edge of the picture plane, partly cut off, also holds her hands clasped around a black string that resembles the rosary.

34. Here I am extending the discussion of James Kearns, who specifies the importance of Gauguin's marked presentation of the majority of figures with their eyes closed, indicating a state of interiority, and the main female fig-

ure who appears with open eyes, directly experiencing the vision. See James Kearns, *Symbolist Landscapes: The Place of Painting in the Poetry and Criticism of Mallarmé and His Circle* (London: Modern Humanities Research Association, 1989), pp. 7–9, 175 n. 24.

35. Quoted in Brettell et al., *Art of Gauguin*, p. 103; original in French in Merlhès, *Correspondance*, p. 232, #165, September 1888.

36. From the account of J. B. Estrade, *Les Apparitions de Lourdes: Souvenirs intimes d'un témoin* (Lourdes: Imprimerie de la Grotte, 1911), p. 1. See also Philippe Boutry, "Marie, la grande consolatrice de la France au XIX siècle," *L'Histoire*, no. 50 (Nov. 1982): 30–39; and the discussion in Aimé Michel and Jean-Paul Clébert, "La France miraculeuse," in *Histoire et guide de la France secrète* (Paris: Editions Planète, 1968), pp. 416–428.

37. While scholars interested in the religious character of Gauguin's *Vision* have looked for specific Breton ceremonies as a source for the painting, no one to my knowledge has emphasized the link between the painting (recall Gauguin's use of the title *Apparition* in his notebook) and the widespread extension of popular piety in the 1870s and 1880s, in which the cult of miracles, visions, and supernatural eruptions had particular social significance. These phenomena deepened in rural areas in the immediate post-Commune phase of reparation and religious revivalism and in response to the anti-clerical offensive mounted by the Third Republic from 1884 to 1889. Gauguin's 1888 painting of praying peasants experiencing a vision of sacred figures thus has intense resonance, coinciding with the height of the secularizing republican campaign and rural pockets of resistance.

French social historians and historians of popular religion have characterized this expansion and emotionalization of popular piety after 1850; its varying components, including the new Marian cults, proliferating devotions to the local saints, apparitional cultures, pilgrimage movements, and calvaries; and the way clerical, monarchist, and conservative elites attempted to adapt it to their own needs. The sources I have found most useful for these issues are Gibson, *Social History of French Catholicism*; Thomas A. Kselman, *Miracles and Prophecies in Nineteenth-Century France* (New Brunswick, N.J.: Rutgers University Press, 1982); Mayeur, *Troisième République*; and Philippe Boutry, "Marie." For the 1888 Apparition in the Forez, see Boutry, "Marie," p. 35; for Marian miracles and the proliferation of popular visions and visionaries, see

Kselman, *Miracles*, pp. 112–121, and Michel and Clébert, "La France miraculeuse." On the visions and beatification of Marguerite-Marie Alacoque and the new pilgrimages at Paray-le-Monial after 1870, see Gibson, *Social History*, pp. 148–151; Kselman, *Miracles*, pp. 62, 125–127; and Michel and Clébert, "La France miraculeuse," pp. 427–428. An important new study of Lourdes appeared recently: Ruth Harris, *Lourdes: Body and Spirit in the Secular Age* (New York: Viking, 1999).

38. See Estrade, *Apparitions*, who relies on the terminology of the *faits surnaturelles* and the *surnaturel concret* (see pp. ii and 272, for example) and describes the commissions set up to test the Lourdes grotto waters by "hydrogeologists" and other specialists, as well as the way lawyers and clerical authorities vied with one another to scrutinize the testimony of witnesses and others affected by the "sighting" of the Virgin and the curative powers of the grotto fountain. See also Boutry, "Marie," especially p. 36; and Gibson, *French Catholicism*, pp. 148–149. The complex interactions of scientific and spiritual mentalities are also explored by Harris, *Lourdes*, especially chap. 10.

39. The section that follows relies on the research presented in Darr and Gedo, "Wrestling Anew," concerning the local devotional ceremony of the Pont-Aven pardon and its possible links to the content of Gauguin's *Vision*. While their article provides essential information about the ceremony and the types of community action during it, with some convincing affinities to the painting, Darr and Gedo direct their analysis to provide a psychological interpretation of *The Vision* as an image "encoding" Gauguin's repentance for his forbidden love for Bernard's sister, what they call a "psychoiconographic" study, which I find less compelling than their other evidence.

40. Darr and Gedo, "Wrestling Anew," p. 67.

41. Ibid., pp. 37–38, 253–254; I have also drawn from Weisberg's "Vestiges of the Past," pp. 134–138.

42. Ibid., pp. 253–254.

43. In the case of Pont-Aven, the men wore fur-edged caps and grew their hair to be cut off at the festival, and each unmarried woman displayed a forelock of hair from a lace cap to signal her availability (Darr and Gedo, "Wrestling Anew," p. 68).

44. Ibid., p. 70.

45. For prints of the period depicting the local wrestling, see Denise

Delouche, "Gauguin et le thème de la lutte," in Musée d'Orsay, *Gauguin: Actes du colloque Gauguin, 11–13 janvier 1989* (Paris: La Documentation Française, 1991), pp. 162–164.

46. Darr and Gedo, "Wrestling Anew," p. 69; for the link to Hokusai and Japanese prints for the fighting figures, see Musée Départemental du Prieuré, *Le Chemin de Gauguin: Genèse et rayonnement* (Saint-Germain-en-Laye, 1985), p. 46, and Delouche, "Lutte," p. 166.

47. Depictions of Jacob and the angel locked in battle that would have been known to Gauguin were the notable scene by Delacroix of 1861, included in a mural series in the Paris church of Saint-Sulpice and celebrated by Baudelaire; a canvas of the subject by Léon Bonnat shown at the Paris Salon of 1876; and two works on the subject by Gustave Moreau, one on canvas and one watercolor, both of 1878. These visual precedents are representations only of the two sacred figures in the fight, and lack the juxtaposition of the women and their vision of beholding the struggle so startlingly presented by Gauguin. The Delacroix and Bonnat versions are illustrated in *Chemin de Gauguin*, p. 46.

Amishai-Maisels suggested the mystery play source, but found no direct evidence; Darr and Gedo based their interpretation partly on the presumption that Gauguin must have heard a specific sermon on Jacob and the angel during the pardon period, but no evidence has surfaced. In any case, Gauguin's visual rendering is far removed from a literal record of a sermon on the Genesis passage.

48. Darr and Gedo, "Wrestling Anew," pp. 67–68, 253–254.

49. Ibid., pp. 67–68, 70, indicates that we still have no direct testimony from Gauguin about attending, but it is plausible based on Bernard's comments and the timing of the description of the painting to van Gogh. See also Brettell et al., *Art of Gauguin*, who disagree but who also present the Bernard letters regarding the pardon ceremony, pp. 102–103. Even if Gauguin did not attend this particular pardon, he would have had ample opportunity to see other local devotional festivals in Pont-Aven itself and the surrounding areas.

50. Here I have been aided in my reading of the picture by the insight of James Kearns, *Symbolist Landscapes*, p. 8, on the tie between the collapse of spatial zones and the collapse of sequential narrative, and by the comments of the art historian Richard Meyer, who discussed elements of *The Vision* with me.

51. Van Gogh, *Letters*, 3:508, B14, August 1888.

52. Brettell et al., *Art of Gauguin*, p. 104; Hamilton, *Painting and Sculpture in Europe*, p. 84.

To be sure, van Gogh and Gauguin shared this admiration for Japanese prints, and indeed Gauguin may have seen van Gogh's adaptation of Hiroshige's *Plum Tree*—the 1887 painting titled *Japonaiserie: The Tree*— before he began working on *The Vision After the Sermon*. Yet van Gogh and Gauguin translated their common interest in Japanese prints into their own idioms and preoccupations. Van Gogh's *Japonaiserie* was an exercise in viewing juxtapositions of near and far and in looking through keyholes in the branches or through flanked branch frames. This type of viewing accorded well with van Gogh's preexisting interest in similar juxtapositions in seventeenth- and nineteenth-century Dutch painting, as well as with the framed and telescoped viewing he practiced with his perspective frame. More generally, van Gogh assimilated Japanese prints to his abiding priority to enhance surface texture, evident in his attempt in Paris to develop brushstrokes emulating the rough fabric surfaces of Japanese *crépons*. Rather than texture, Gauguin celebrated the flatness and unmodulated color blocks of the Japanese prints. On the multiple possibilities of the Japanese model, especially the juxtaposition of near and far, see Kirk Varnedoe, *A Fine Disregard: What Makes Modern Art Modern* (New York: Abrams, 1990), pp. 55–78; on van Gogh's emphasis on Japonism as texture and cloth saturation, see my "Weaving Paintings: Religious and Social Origins of Vincent van Gogh's Pictorial Labor," in *Rediscovering History: Culture, Politics, and the Psyche,* ed. Michael S. Roth (Stanford: Stanford University Press, 1994), pp. 163–167; see also chap. 2, n. 49, above.

53. Other scholars, such as Mark Roskill and Kirk Varnedoe, have noted the importance of Degas's theatrical paintings in providing Gauguin with a model for splitting the picture into spatial zones across a divide for beholding. However, this compositional precedent is adapted to a fundamentally different meaning and purpose. Degas's subjects are spectators engaged in viewing the performances at the theater, ballet, and café-concert. Such arenas were central targets of the Impressionist discovery of secular occasions and bourgeois leisure as appropriate for visual representation. Gauguin's *Vision* inverts the Impressionist spectacle—his subjects are not the "permanent vacationists" of Impressionist pleasure culture but peasant women engaged in acts of worship

and penitence. Degas's subjects are secular viewers of the stage; Gauguin's prayerful women have their eyes closed, beholding an enactment of their inner vision. For the Degas connection and the issue of compression, see Kirk Varnedoe, "Gauguin," in *Primitivism in Twentieth-Century Art*, ed. William Rubin (New York: Museum of Modern Art, 1984), 1:184 and 206; he refers the reader there to the more extensive analysis of Roskill, who provides examples of Gauguin's many links to Impressionism.

54. Quoted in Brettell et al., *Art of Gauguin*, p. 103; original in Merlhès, *Correspondance*, p. 232, #165.

55. See Brettell et al., *Art of Gauguin*, p. 104; Goldwater, *Gauguin*, p. 58. It was the critic Edouard Dujardin who had characterized this approach as a new style he dubbed "cloisonism," resembling the *cloisonné* technique in enameling, "whereby metal partitions or *cloisons* are used to divide one area of brightly colored enamel from another"; Dujardin called this "painting by compartments." Gauguin's experiments with thirteenth- and fourteenth-century "glass design" and its translation into the medium of oil paint is noted by his contemporary, the painter A. S. Hartrick, in his *A Painter's Pilgrimage Through Fifty Years* (Cambridge: Cambridge University Press, 1939), p. 34. On the complexities of cloisonism see the discussion of Bogomila Welsh-Ovcharov, *Vincent van Gogh and the Birth of Cloisonism* (Toronto: Art Gallery of Ontario, 1981), pp. 19–51 and 168–226; for Dujardin, see Henri Dorra, *Symbolist Art Theories: A Critical Anthology* (Berkeley: University of California Press, 1994), pp. 178–181, and John Rewald, *Post-Impressionism from van Gogh to Gauguin*, 3d ed. (New York: Museum of Modern Art, 1978), pp. 143–144, 166.

56. Quoted in Brettell et al., *Art of Gauguin*, p. 103. The painting does show some areas of very dark blue on some of the women's clothing.

57. The classic works on this transformation are Meyer Schapiro, "Courbet and Popular Imagery: An Essay on Realism and Naiveté," in *Modern Art* (New York: Braziller, 1985, originally published 1940–41); and Clark, *Image of the People*, especially chaps. 5, 6.

58. The technologies, colors, and production series of the nineteenth century, including types and changes within secular and religious imagery, are discussed in Jean Mistler, François Blaudez, and André Jacquemin, *Epinal et l'imagerie populaire* (Paris: Hachette, 1961), especially pp. 82–173, with good color plates; François-Henri Courroy and Bernard Huin, "Traditions spinalliennes," in *Epinal*, ed. Michel Bur (Paris: Bonneton, 1991), pp. 162–189; and

François Weymuller, *Histoire d'Epinal: Des origines à nos jours* (Le Coteau: Horvath, 1985), especially pp. 259–280. An excellent study of the changes in religious imagery, treating the emergence of new colors and graphic suffering in relation to the new cults of the Sacré Coeur, is Catherine Rosenbaum-Dondaine, *L'Image de piété en France, 1814–1914* (Paris: Musée-Galerie de la Seita, 1984), especially sections on 1830–1900, pp. 49–176, with numerous illustrations. For French historians' discussion of new currents of emotional piety after 1850, see n. 37 above.

59. These prints were displayed at the Maison Marie-Henry, a historical reconstitution of the artists' house and atelier of 1889–1890 in Le Pouldu, which I visited. The pamphlet catalogue is listed as *Maison Marie Henry: Réconstitution historique* (Le Pouldu: Finistère, 1996).

60. Emile Bernard's collection of popular prints and his revival of religous imagery are important places to start, and little has been done to date. Bernard participated in a new journal, *l'Ymagier*, in the 1890s, which was dedicated to religious imagery and printmaking. *L'Ymagier* combined Bernard's own adaptation of premodern religious imagery, his enlistment of his friends to produce such images, including Gauguin, who obliged with a "Mary Magdalen" print of 1894–1895, and his republishing of exemplary engravings and woodblock images from the thirteenth through the nineteenth centuries. Some of these prints and images from *l'Ymagier* are also displayed at the Maison Marie-Henry.

61. Quoted in Brettell et al., *Art of Gauguin*, p. 103; original in Merlhès, *Correspondance*, p. 232, #165.

62. The terms of Brettell et al., *Art of Gauguin*, p. 104, who do not, however, discuss the contrasting color ranges between the drained women and the heated light of the supernatural figures and terrain.

63. Letter to van Gogh, Le Pouldu, October 20, 1889, quoted in Cachin, *Gauguin*, p. 142; original in Douglas Cooper, *Paul Gauguin: 45 Lettres à Vincent, Théo et Jo van Gogh* ('s-Gravenhage: Staatsuigeverij, 1983), p. 275.

64. The metapsychic and occult elements of Gauguin's painting and their relation to contemporary science and clinical psychology have been explored by Filiz Eda Burhan in "Vision and Visionaries: Nineteenth-Century Psychological Theory, the Occult Sciences, and the Formation of a Symbolist Aesthetic in France" (Ph.D. dissertation, Princeton University, 1979), especially pp. 227–337, where she discusses *The Vision* and the new psychology of dou-

ble consciousness. I want to try to redirect the discussion to explore the broader resources that Gauguin's Catholic formation offered him in terms of expanded subjectivity and ascent to the sacred realm beyond the visible; this material is not incommensurate with, and should be related to, the other evidence of Gauguin's philosophical and psychological idealism. I am stressing here the links between Gauguin's painting and a particular, culturally transmitted Catholicism of vision and the inward-looking interrogating self.

65. Van Gogh to Bernard, in *Letters*, 3:522, B21, December 1889.

66. This analysis is drawn from a very compelling article by Reinhold Heller, "Concerning Symbolism and the Structure of the Surface," *Art Journal*, special issue, "Symbolist Art and Literature," 45, no. 2 (summer 1985): 146–153, especially pp. 148–149, 153. Heller's article, brief but very important, recovers Gauguin's repertoire of techniques to diminish the "physicality" of the image, to "disguise the medium of oil paint," emulating frescoes, in a comparative context of symbolist pictorial innovation. A recently published study provides extensive evidence of Gauguin's experimental techniques of 1888 and after, such as his use of absorbent grounds, his interest in wax coatings and avoidance of varnish, and his adaptation to oil painting of the matte surface effects of the fresco. The two authors of this work suggest that Gauguin may have combined wax with the paint in *The Vision After the Sermon*, in order to achieve a "matte, non-reflecting surface like that found in frescoes." See Vojtěch Jirat-Wasiutyński and H. Travers Newton, *Technique and Meaning in the Paintings of Paul Gauguin* (New York: Cambridge University Press, 2000), especially pp. 98–100, 198, 201, 233.

67. Gauguin's technical experiments with leaner paint, absorbent ground, varnish substitutes, and "matte effects" had certain precedents, but he enlarged the repertoire and adapted them to new purposes. Gauguin's mentors Pissarro and Degas, as well as Monet and Renoir, attempted by 1881 to develop more matte surfaces by applying thinner, but visibly hatched, paint strokes and by leaving canvases unvarnished. These techniques, according to experts, formalized two central Impressionist goals: first, they announced the departure from the slickness and glossiness of academic painting; and second, the matte techniques were considered by the painters to be ways to maximize sensory immediacy, and to register more closely the vitality, delicacy, and reflection of colored light in nature, without the interference and discolorations created by the varnish coating. Gauguin's interest in the effects and purposes of "matte

surfaces," however, went in the other direction: not to enhance sensory immediacy but to elicit transcendent contact beyond the visible, to visionary release from the contingencies of physical materiality. The Impressionists' "matte effects" sought to close the gap between the eye and the range of nature's light; Gauguin's aimed to obliterate the distance between physical reality and the "noncorporeal" realm of the divine.

The importance of "matte surfaces" to the circles of late Impressionism is discussed by Cornelia Peres, who isolates the central goal of registering the delicate range of colored light and reflectivity, unimpeded by varnish, in "On Egg-White Coatings," in *A Closer Look: Technical and Art-Historical Studies on Works by van Gogh and Gauguin*, ed. Cornelia Peres, Michael Hoyle, and Louis van Tilborgh (Zwolle: Waanders, 1991), p. 41. Peres invokes these Impressionist matte surfaces as particularly challenging to van Gogh, who engaged in ambivalent and halting attempts to try them out. H. Travers Newton relates these technical precedents to Gauguin, and points explicitly to the influence of Pissarro and Degas, in his article "Observations on Gauguin's Painting Techniques and Materials," in *A Closer Look*, pp. 106–107; Travers Newton identifies the anti-academic impetus in the Impressionist rejection of varnish but does not explore the differences separating Gauguin from his Impressionist mentors.

While it is important to note that Gauguin's technical strategies had their antecedents in the Impressionist generation, I am emphasizing here Gauguin's radical transformation of the Impressionist techniques; the innovative qualities of his technical arsenal of the "matte"; and the way he directed it to emphatically anti-Impressionist goals of idealism and anti-naturalism, and to the purpose of navigating, with diminished paint surfaces, across the divide between the natural and the supernatural. Here I am following the lead of Heller, who relates Gauguin's fresco-like disguises of oil paint and matte surfaces to the quest for the symbolist dream, though I want to reinstate in this quest the theologically specific impulses for purification and spiritual transcendence emphasized in Gauguin's Catholic formation.

68. Gauguin to Charles Morice, July 1901, quoted in Paul Gauguin, *D'Où venons nous—Que sommes nous—Où allons nous* (New York: Marie Harriman Gallery, 1936), n.p.

69. Heller, "Concerning Symbolism," pp. 148, 149. Gauguin later extended these techniques by ironing over the surface of his canvases, another

way he experimented with formal methods to suppress and attenuate materiality. The technique of hot irons "to produce an unvariegated matte surface" was first brought to my attention in Belinda Thomson's *Gauguin*, p. 108; it is examined most comprehensively in Vojtěch Jirat-Wasiutyński and H. Travers Newton, "The Historical Significance of Early Damage and Repair to Vincent van Gogh's *Self-Portrait Dedicated to Paul Gauguin*," in *Center for Conservation and Technical Studies* (Cambridge, Mass.: Harvard University Art Museums, 1984), pp. 17–20.

Gauguin's techniques to diminish surface materiality included leaching out the oil from the paint base for thinner application; newspaper blotting; wax and gesso coating; application of special absorbent grounds; and washing the finished canvas to decrease shine and gloss. These formal strategies have been studied by restoration and conservation experts and some art historians; I have relied on Carol Christensen, "The Painting Materials and Techniques of Paul Gauguin," *Conservation Research* 41 (1993): 63–104; Travers Newton, "Observations on Gauguin's Painting Techniques," in *A Closer Look*; and Vojtěch Jirat-Wasiutyński, "Painting from Nature Versus Painting from Memory," in *A Closer Look*, pp. 90–102.

Gauguin's technical experiments need to be explored further in relation to the experiments of other painters of the 1880s who sought a new anti-Impressionist aesthetic for a variety of social and philosophical purposes. I am indebted to Robert Herbert for pointing out to me the Neo-Impressionist experimentation with flattening and "encaustic" finishes, a technique using colored beeswax, which is traceable, as he explained, in texts like the 1884 *L'encaustique* written jointly by the Neo-Impressionist painter Henry Cros and the psychophysicist and Neo-Impressionist theorist of scientific harmonics Charles Henry. Both Seurat and Puvis de Chavannes rejected varnish and tried out some of the whitening tactics of matte in the service of evoking a permanent, essential order beneath the surface of appearances; what I would call Seurat's technological utopianism maintained the visibility of the shimmering screen of microdots, while Puvis's art, between mural and canvas painting, may be closer to Gauguin's quest for new allegories, which attempted to match the exploration of transcendent themes with technical strategies of dematerialization. A fine and suggestive treatment of Puvis and Seurat's shared quest for stasis through "frescolike" painting surfaces is contained in Aimée Brown Price's article, "How the 'Bathers' Emerged," *Art in America* 85 (Dec. 1997): 57–63,

106; see also Brown Price's discussion of the fresco in *Puvis de Chavannes* (Amsterdam: Van Gogh Museum, 1994).

70. For van Gogh's choice of colors, see his statement in *Letters*, 3:492; for Gauguin's, see the quote in Brettell et al., *Art of Gauguin*, p. 104.

71. Gauguin's statement proposing the church site is quoted in Brettell et al., *Art of Gauguin*, p. 103; see the original statements about the "religious painting" and the church setting in letter #165 to van Gogh and #167 to Theo, in Merlhès, *Correspondance*, pp. 230, 247–248. According to Emile Bernard, Gauguin also tried to give *The Vision* to the small church of Nizon near Pont-Aven, whose wooden, highly colored saints' statues he believed would accord well with the canvas. See Emile Bernard, "L'Aventure de ma vie," in *Lettres de Paul Gauguin à Emile Bernard, 1888–1891* (Geneva: Callier, 1954), pp. 27–29.

72. The discovery of the Pont-Aven apse church windows and their possible harmonization with Gauguin's *Vision* painting was first presented by Amishai-Maisels, *Gauguin's Religious Themes*, pp. 28–31; Jirat-Wasiutyński and Darr and Gedo endorse this connection, in "Wrestling Anew," pp. 77, 258 n. 66, and 259 n. 72. The issue of stained glass is always invoked as a general source for *The Vision* and as being related to the experiments among the cloisonists, such as Louis Anquetin, with colored glass prisms. But the specifically clerical nature of the model for some of the painters is significant and underanalyzed, especially for Bernard and Gauguin, who make explicit connections to this precedent as sacred art.

73. Paul Gauguin, "On Decorative Art," published in Daniel Guérin, *The Writings of a Savage, Paul Gauguin* (New York: Paragon, 1990), p. 13.

74. See Michael Baxandall, *Painting and Experience in Fifteenth-Century Italy: A Primer in the Social History of Pictorial Style*, 2d ed. (New York: Oxford University Press, 1988), especially chap. 2.

75. The episodes of the offers and explanations to the curés, and their perplexed and diffident reactions, are noted in Brettell et al., *Art of Gauguin*, based on Emile Bernard's rendering, which can be found in his "L'Aventure de ma vie," pp. 27–29. Gauguin's plan to give *The Vision* to the local churches and his uncharacteristic lack of interest in selling the painting provide compelling evidence to counter those who overemphasize Gauguin's work in Brittany as a manipulative marketing strategy driven by self-promotion and the search for a new commercial niche unavailable to the Parisian-based avant-garde. The most forceful case for Gauguin as marketing tactician, set in a larger frame-

work of the ideologies of class division that necessitated a market for the representation of rural difference, is provided by Orton and Pollock, "Données bretonnantes"; another exploration of Gauguin's self-promotional tendencies, counterbalanced with a reading of *The Vision* as a serious metaphysical quest, can be found in Kearns, *Symbolist Landscapes*, especially chap. 1, though Kearns does not explore the religious frameworks of *The Vision* or of Gauguin's background.

The *Vision* was ultimately sent to Theo van Gogh in November 1888 to be sold in Paris, after Gauguin wrote of his failure to set it in the local churches (letters to Theo and to Schuffenecker, in Merlhès, *Correspondance*, pp. 247–248, #167 and #168).

76. Van Gogh to Bernard, in Van Gogh, *Letters*, 3:492, B7.

77. Quoted in Brettell et al., *Art of Gauguin*, p. 103, emphasis Gauguin's; original in Merlhès, *Correspondance*, p. 232, #165.

CHAPTER 4. A SEMINARY EDUCATION

1. Félix-Antoine-Philibert Dupanloup, *De l'éducation*, vol. 1 (1853), quoted in *Bishop Dupanloup's Philosophy of Education* (The Catholic Press, 1930), p. 5.

2. Félix-Antoine-Philibert Dupanloup, *L'Oeuvre par excellence, ou Entretiens sur le catéchisme* (Paris: Charles Douniol, 1869), p. 74.

3. Information on Gauguin's early life has been culled from Ursula Frances Marks-Vandenbroucke, "Gauguin: Ses origines et sa formation artistique," *Gazette des Beaux-Arts* 47 (Jan.–June 1956): 9–62; Victor Merlhès, *Correspondance de Paul Gauguin: Documents, témoignages* (Paris: Fondation Singer-Polignac, 1984), pp. 321–322; Paul Gauguin, *Paul Gauguin's Intimate Journals*, trans. Van Wyck Brooks (New York: Liveright, 1949), p. 153; Richard Brettell, Françoise Cachin, Claire Frèches-Thory, Charles F. Stuckey, and Peter Zegers, *The Art of Paul Gauguin* (Washington, D.C.: National Gallery of Art, 1988), chronology, pp. 1–3; and David Sweetman, *Paul Gauguin: A Life* (New York: Simon and Schuster, 1995), pp. 6–37.

4. Gauguin, *Intimate Journals*, p. 177.

5. Marks-Vandenbroucke, "Gauguin," p. 30; Ziva Amishai-Maisels, *Gauguin's Religious Themes* (New York: Garland, 1985), p. 11; Daniel Guérin, *The Writings of a Savage, Paul Gauguin* (New York: Paragon, 1990), p. 162; Sweetman, *Gauguin*, pp. 30–32. The record of Gauguin's stay at the Orléans junior

seminary from 1859 to 1862 was first presented in Marks-Vandenbroucke's article. Amishai-Maisels, noting Gauguin's religious education, lists the seminary as a Jesuit school, for which I have found no confirmation in the contemporary literature or sources.

6. On Dupanloup's career, importance, and political significance between 1840 and 1870, see A. Largent, "Félix Dupanloup," *Dictionnaire de théologie catholique* (Paris: Letouzey et Ane, 1911), 4:1949–1950; J. F. Sollier, "F. A. Dupanloup," *The Catholic Encyclopedia* (New York: Appleton, 1909), 5:202–203; Ralph Gibson, *A Social History of French Catholicism, 1789–1914* (London: Routledge, 1989); and two exhaustive accounts, F. Lagrange, *Vie de Mgr. Dupanloup, Evêque d'Orléans*, 3 vols. (Paris: Poussièlgue Frères, 1883); and Christianne Marchilhacy, *Le Diocèse d'Orléans sous l'Épiscopat de Mgr. Dupanloup, 1849–1878: Sociologie religieuse et mentalités collectives* (Paris: Plon, 1962).

7. See Dupanloup's pamphlet, *Joan of Arc*, trans. Emily Bowles (London: Burns, Oates, and Co., 1869).

8. The Bishop's extensive activities at the Saint-Mesmin junior seminary are discussed in Marchilhacy, *Diocèse d'Orléans*, who uses the term "ideal type" to define Saint-Mesmin's paradigmatic status as the new Catholic secondary school (pp. 82–83); Lagrange, *Vie de Dupanloup*, 2:107–123; Sweetman, *Gauguin*, who also describes Saint-Mesmin as Dupanloup's "laboratory" (pp. 30–32); and the indispensable text of Emile Huet, *Histoire du Petit Séminaire de La Chapelle-Saint-Mesmin* (Orléans: Pigelet et Fils, 1913), especially pp. 107–216. On Dupanloup's unusual rapport with his pupils, see Gabriel Monod, *Souvenirs d'Adolescence: Mes relations avec Mgr. Dupanloup* (Paris: Librairie Fischerbacher, 1903).

9. Monseigneur Dupanloup, Bishop of Orléans, *The Ministry of Catechising* (London: Griffith, Farran, Browne, 1890), p. 44.

10. Quoted in Marchilhacy, *Diocèse d'Orléans*, p. 239. (Translations of Dupanloup are mine except where an English-language version of his writings is cited.)

11. Dupanloup's concentration on "concupiscence" is contained in his book *The Child*, trans. Kate Anderson (Boston: Donahoe, 1875), pp. 126–146, 160–186. Here Dupanloup renders a "classification of defects" and details the "perils" and "fatal habits of vice" that act as ever-present evils threatening to "seize and devour" children's hearts and souls.

12. M. Dupanloup, Evêque d'Orléans, *Manuel des catéchismes, recueil des prières, billets, cantiques, etc.* (Paris: Rocher, 1866), p. 151.

13. Ibid., pp. 147–149.

14. Ibid., p. 227.

15. Dupanloup, *The Child*, pp. 126–186.

16. Dupanloup, *Manuel des catéchismes*, p. 343.

17. Ibid. The vision of the heavenly realm and its resplendent bursts of light is discussed in Dupanloup, *De l'éducation* (Paris: Douniol, 1862), 3:506–507; on purity and "possessing the heavens" see *Entretiens sur le catéchisme*, pp. 74–75, and *Manuel des catéchismes*, p. 343.

18. Dupanloup, *Manuel des catéchismes*, pp. 224–225.

19. Quoted in "Bishop Dupanloup's Philosophy of Education," pp. 5–6. See also the language of flight and the child's wings in *Manuel des catéchismes*, "Pour l'élévation," p. 22, and the chant "Pour t'élever de terre," p. 364: "To ascend from earth, man, you need two wings, / Purity of heart and simplicity; / They will transport you with facility / To the happy point of eternal brightness."

20. Dupanloup, *Ministry of Catechising*, p. 609.

21. J. F. Sollier, "F. A. Dupanloup," 5:203. Dupanloup's anti-positivism extended to the political arena, where he worked successfully, as a member of the Académie française, to overturn Emile Littré's admission to the prestigious organization in 1863. The philologist Littré, follower of Auguste Comte, was one of the founders of positivism.

22. Dupanloup, *Ministry of Catechising*, p. 2.

23. Ibid., pp. 609–612.

24. Dupanloup, *De l'éducation*, vol. 2, quoted in "Bishop Dupanloup's Philosophy of Education," p. 25.

25. Ibid., pp. 7, 22–25; see also *Ministry of Catechising*, bks. 1 and 6.

26. Dupanloup, *Ministry of Catechising*, pp. 114–115. The chapel and its paintings are described in Huet, *Histoire du Petit Séminaire*, pp. 125–127.

27. Ernest Renan, *Souvenirs d'enfance et de jeunesse, texte établi et présenté par Jean Pommier* (Paris: Colin, 1959), pp. 86, 89. Renan was a student of Dupanloup's at the Petit Séminaire de Saint Nicolas du Chardonnet, the junior seminary where the bishop-to-be taught for eight years before being appointed to Orléans.

28. Ibid., pp. 86, 87.

29. Ibid., pp. xxxviii–xxxix.

30. Quoted in Marchilhacy, *Diocèse*, p. 82.

31. Quoted in A. Largent, "Félix Dupanloup," 4:1949.

32. Dupanloup, *De l'éducation*, 3:633.

33. "Où Allons-Nous?" (referred to in the subhead above) was the title of a treatise by Dupanloup published by Douniol (Paris, 1876).

34. Gibson, *Social History*, p. 166.

35. Quoted in Marchilhacy, *Diocèse*, p. 243. See also her discussion, pp. 239–253; Lagrange, *Vie de Dupanloup*, 2:104–123; Gibson, *Social History*, pp. 23–24, 166–168; and Dupanloup, *Ministry of Catechising*.

36. These are included in the appendices to *Ministry of Catechising*, pp. 615–640.

37. Ibid., pp. 624, 615–620.

38. Quoted in Marchilhacy, *Diocèse*, p. 244.

39. Quoted in ibid., pp. 244, 245; drawn from Dupanloup's wide-ranging text, *Entretiens sur le catéchisme*, pp. 59–60.

40. Ibid., pp. 132, 133, 27.

41. Ibid., p. 132.

42. Ibid.

43. Cited in "Theodore Jouffroy," *Grand Dictionnaire universel du XIX siècle* (Paris: Slatkine, 1982), 9:1029.

44. *De l'éducation*, 3:506. The same terminology of the idea cloaked in material form was employed in the symbolist manifesto of 1886, to which I will return.

45. Ibid., p. 507, with discussion of the three *jets* on pp. 506–507.

46. Ibid., p. 508.

47. Dupanloup, *Ministry of Catechising*, p. 608.

48. Dupanloup, *De l'éducation*, 3:507.

49. Belinda Thomson, *Gauguin* (London: Thames and Hudson, 1987), p. 14; Brettell et al., *Art of Gauguin*, pp. 3–4; Marks-Vandenbroucke, "Gauguin," pp. 32–34; and Sweetman, *Gauguin*, pp. 49–58, who discusses Renan's presence on the ship. Gauguin's mother died in 1867, while he was at sea.

50. Thomas A. Kselman, *Miracles and Prophecies in Nineteenth-Century France* (New Brunswick, N.J.: Rutgers University Press, 1982), p. 225.

51. Cited in Linda Nochlin, ed., *Impressionism and Post-Impressionism, 1874–1904: Sources and Documents* (Englewood Cliffs, N.J.: Prentice-Hall, 1966), p. 159; See Chapter 2, n. 2, above.

52. Paul Gauguin, *Avant et après* (Paris: Crès, 1923), p. 235.

53. Ibid.

54. Merlhès, *Correspondance*, 1:256, #173, October 1888; emphasis his.

55. These included texts of 1897–1898, to which I will turn in Chapter 12.

56. Merlhès, *Correspondance*, 1:233, #165, September 1888.

57. Ibid., p. 249, #168.

58. In Guérin, ed., *Writings of a Savage*, p. 23; original in Merlhès, *Correspondance*, 1:216, #162, September 1888.

59. Merlhès, *Correspondance*, 1:256, #173, October 1888; emphasis Gauguin's.

60. Guérin, ed., *Writings of a Savage*, p. 33, September 1889; original in Maurice Malingue, *Paul Gauguin: Lettres à sa femme et à ses amis* (Paris: Grasset, 1946), p. 166, #87: "au fond, la peinture est comme l'homme mortel mais vivant, toujours en lutte avec la matière."

61. The symbolist manifesto is reprinted, with discussion, in Rewald, *Post-Impressionism from van Gogh to Gauguin*, chap. 3.

62. Charles Baudelaire, *Paris Spleen*, trans. Louise Varèse (New York: New Directions, 1970), p. 20.

63. Henry Dorra, ed., *Symbolist Art Theories* (Berkeley: University of California Press, 1994), pp. 193, 350.

64. See the discussion in Brettell et al., *Art of Gauguin*, p. 30; Christopher Gray, *Sculpture and Ceramics of Paul Gauguin* (Baltimore: Johns Hopkins University Press, 1963), p. 4; Amishai-Maisels, *Gauguin's Religious Themes*, p. 13; and Jirat-Wasiutyński, *Paul Gauguin in the Context of Symbolism*, p. 130. Merete Bodelsen was the first to make this suggestion.

65. Brettell et al., *The Art of Gauguin*, p. 30; Amishai-Maisels, *Gauguin's Religious Themes*, p. 13.

66. Dupanloup, "Sur les vanités du monde," in *Manuel des catéchismes*, pp. 147–149.

67. Quoted in "Emile Bernard on Vincent," in *Van Gogh in Perspective*, ed. Bogomila Welsh-Ovcharov (Englewood Cliffs, N.J.: Prentice-Hall, 1974), p. 38. (Originally published by Bernard in his memorial article "Vincent van Gogh" in *Les Hommes d'Aujourd'hui* 8, no. 390 [1891]).

68. Chevreul's color studies, first published in 1838 and extensively republished through the 1880s, were rapidly assimilated by artists beginning with Eugène Delacroix. Van Gogh was exposed to Chevreul's theories through the writing of Charles Blanc, one of the primary popularizers of Chevreul's discoveries. Van Gogh studied Blanc's Delacroix chapter in *Les Artistes de mon temps* (Paris: Firmin-Didot, 1876), pp. 23–88, and a larger treatise, the *Grammaire des arts de dessin* (Paris: Laurens, 1880), both of which featured Chevreul's experiments and highlighted their application to painting on canvas and to color saturation on draperies, cushions, and other fabric stuffs. These links to Chevreul, weaving, and craft art are the theme of my "Weaving Paintings: Religious and Social Origins of van Gogh's Pictorial Labor," in *Rediscovering History: Culture, Politics, and the Psyche*, ed. Michael Roth (Stanford: Stanford University Press, 1994), pp. 137–168 and 465–473.

69. From "The Weavers in Nuenen," in Saskia Juijn, *Thinking of Vincent . . . A Saunter through the Open-Air Museum* (Arnhem: Durkkerij HPC, n.d.), pp. 17–18, with thanks to Kees Rovers; see also Cor G. W. P. van der Heijden, "Nuenen Around 1880," in Noordbrabants Museum s'Hertogenbosch, *Van Gogh in Brabant* (Zwolle: Waanders, 1987), pp. 102–127, with charts on p. 114. Van Gogh's parents had moved to Nuenen, near Eindhoven, in August 1882, when his father had taken up a post as the local minister there.

70. In The Hague, in 1883, for example, when van Gogh struggled to master the skills of drawing, he compared the incremental and arduous process of composition to the work of the weaver at his loom, who had to keep so many threads separate while interconnecting them. See *The Complete Letters of Vincent van Gogh*, 2d ed. (Boston: New York Graphic Society, 1978), 1:467, 2:5, and 2:7.

71. Ibid., 2:369–370, LT 404.

CHAPTER 5. "A PASSION FOR REALITY"

1. Reverend Bernard ter Haar, "De lofzang der schepping" ("Song of Praise to Creation"), quoted in Frank Kools, *Vincent van Gogh en zijn geboorteplaats: Als een boer van Zundert* (Zutphen: De Walberg Pers, 1990), p. 64, translation mine; poem dating ca. 1840.

2. Reverend Allard Pierson, *Rigting en leven (Direction and Life)* (Haarlem: A. C. Kruseman, 1863), p. 260, translation mine.

3. Kools, *Vincent van Gogh en zijn geboorteplaats*, pp. 76–81. Kools has provided the first detailed archival study of van Gogh's first sixteen years in Zundert, offering essential information on the social, political, religious, and economic contexts of the village.

4. Ibid., pp. 5–6, 43–55, 74–81.

5. Ibid., pp. 48–49. For other examples of how piety subordinated individual profit among Reverend van Gogh's parishioners and his own contributions, see also pp. 50–80.

6. Johan Goudsblom, *Dutch Society* (New York: Random House, 1967), chaps. 2, 3, 4, and 6.

7. According to Kools, *Van Gogh en zijn geboorteplaats*, especially chaps. 4 and 6, Theodorus van Gogh's agricultural work derived in part from his involvement with the Brabant Protestant Rural Welfare Society, an organization committed to replenishing the dwindling ranks of Reformed communties by buying plots of land and leasing them to Protestant farmers, whom the society relocated in Brabant from other parts of Holland. The ideal of the project, begun in 1825, was to revitalize Reformed presence in the south by creating a prosperous and expanding peasantry; the reality, which set in quickly, was that the combination of poor skills and unfavorable land conditions meant that at best the program maintained a small number of homesteads at minimal levels of return. In the Zundert area, conditions were especially difficult; nonetheless, Theodorus van Gogh devoted himself energetically to the farming projects in his domain. It was he who located and assessed the vacant land plots to be purchased by the Welfare Society; and he worked closely with the families after they arrived. It was the Welfare Society–sponsored farmers who bolstered the thinning ranks of the small Zundert parish, supplying the community with a choirmaster, a church warden, and church elders.

8. Among the social events at the parish house were evening church council meetings, Bible readings, and coffee-hour receptions after Sunday services. The facade of the parish house, situated on the main road in the heart of the village square, offered a view of the busiest areas of Zundert life—the market, the local hall, and the postmaster's office—while also affording the neighbors direct access to the family's activities. See ibid., pp. 16, 56–58.

9. Elizabeth Duquesne–van Gogh, *Personal Recollections of Vincent van Gogh* (London: Constable, 1913), p. 6.

10. Vincent van Gogh, *The Complete Letters of Vincent van Gogh*, 2d ed. (Boston: New York Graphic Society, 1978), 1:120, LT 98.

11. Unlike another contemporary religious movement—the orthodox Netherlandish Réveil—the Groningeners remained bound to Dutch humanist legacies while celebrating Kempis, and rejecting John Calvin, as the basis for a revitalized national Reformed religion. And, unlike the Réveil challengers, Groningen theologians (also known as the "Evangelicals") were not anti-modernists, adapting their revival of Kempis to new ideas. On the Groningen School, see Albert Réville, "Les Controverses et les écoles religieuses du Hollande," *Revue des Deux-Mondes* 27, no. 8 (May–June 1860): 935–952; Eldred C. Vanderlaan, *Religious Thought in Holland* (London: Oxford University Press, 1911), pp. 14–19; and D. Chantepie de la Saussaye, *La Crise religieuse en Hollande* (Leyden: De Breuk & Smits, 1860), pp. 70–73. For Theodorus van Gogh and the Groningen School, see M. E. Tralbaut, *Vincent van Gogh* (London: Chartwell Books, 1969), p. 12; and Kools, *Van Gogh en zijn geboorteplaats*, pp. 9–14.

12. Petrus Augustus de Genestet, *Complete Gedichte* (Amsterdam: De Maatschappij voor Goede en Goedkoope Lectuur, n.d.), "De Practici," pp. 318–319 (1860); see also "Werken, Denken, Leeren," pp. 223–224.

13. This peculiarly Dutch Calvinist "visual culture" has been identified for the seventeenth century by the books of Svetlana Alpers, *The Art of Describing: Dutch Art in the Seventeenth Century* (Chicago: University of Chicago Press, 1983); and Simon Schama, *The Embarrassment of Riches: An Interpretation of Dutch Culture in the Golden Age* (New York: Knopf, 1987). Both of these works have shaped my approach to van Gogh, though nineteenth-century changes in religion and culture transformed this distinctive visuality in Dutch Calvinism in new ways for van Gogh.

14. Quoted in Jan Hulsker, "1878: A Decisive Year in the Lives of Theo and Vincent," in *Vincent, Bulletin of the Rijksmuseum Vincent van Gogh* 3, no. 3 (1974): 17. The other quotations in this paragraph are from the same article, pp. 18 and 22.

15. Ter Haar, "De lofzang der schepping," quoted in Kools, *Van Gogh en zijn geboorteplaats*, p. 64.

16. From ter Haar, "Proeve ter Beantwoording der vraag: 'Welken invloed heeft het Christendom gehad op de Poezij?,'" quoted in Kools, *Van Gogh en zijn geboorteplaats*, p. 67.

17. The ribbon design for the family Bible is preserved in the collection of the Amsterdam Van Gogh Museum. Archival descriptions of the interiors of the van Gogh Zundert house offer evidence of the patterns and textures that enlivened the family residence. An inventory of the van Gogh household compiled after Theodorus's death indicates the presence of prints and paintings in

many rooms of the house. Parson Theodorus's comfort with the visual world was also evident in the instances recorded by Vincent when the two visited museums together and discussed particular paintings and collections. The room-by-room description of the Zundert house is contained in Kools, *Van Gogh en zijn geboorteplaats*, pp. 16–22 and 75; the 1885 inventory of the household was republished in Hans van Crimpen, "The Van Gogh Family in Brabant," in Noordbrabants Museum s'Hertogenbosch, *Van Gogh in Brabant: Paintings and Drawings from Etten and Nuenen* (Zwolle: Waanders, 1987), pp. 86–89.

18. On the new education initiatives, the choice of Tilburg, and van Gogh's placement at the new HBS King William II in 1866, I have relied on G. H. Franssen, "De Rijks-HBS 'Konig Willem II,' Plannen, stichting en eerste jaren," *Tilburg, Tijdschrift voor Geschiedenis, Monumenten en Cultur* 8, no. 2 (May 1990): 42–51; H. F. J. M. van den Eerenbeemt, "The Unknown Vincent van Gogh, 1866–1868 (1), The State Secondary School at Tilburg," *Vincent* 2, no. 1 (1972): 2–12; van den Eerenbeemt, "Van Gogh in Tilburg," *Brabantia* 20, no. 6 (Nov. 1971): 212–223; Jan Meyers, *De jonge Vincent: Jaren van vervoering en vernedering* (Amsterdam: Uitgeverij De Arbeiderspers, 1989), pp. 70–76. Meyers notes that the HBS was created as a modern alternative to the elite Latin *Gymnasium* schools. The choice of the new Tilburg school for Vincent, which did not, like the *Gymnasia*, lead automatically to university admission, meant that his parents had in mind his placement, after high school, in the family art-dealing business of Theodorus van Gogh's two brothers, Cor and Cent. While a student at the HBS, van Gogh lived with the family of a civil servant whose son trained as a cabinetmaker.

Tilburg, a town of 18,500 in 1866, was a growing center of textile manufacture. The railway had come to Tilburg in 1863; a number of steampowered wool garment factories operated there. The traditional sector of the craft economy was still intact, however, with small workshops and individual linen and wool weavers and spinners. Historians note that Tilburg in the 1860s was a "village-like community" dominated by "farms and weaver cottages." See Henk van Doremalen and Ronald Peeters, " 'Het heeft wel iets van Tilburg of zoo . . .' Tilburg en Vincent van Gogh, 1866–1868," *Tilburg* 8, no. 2 (May 1990): 37–41.

19. Van den Eerenbeemt, "The Unknown Vincent van Gogh, 1866–68 (2), The Drawing Master Huysmans," *Vincent* 2, no. 2 (1973): 6–7, with schedule of classes; Meyers, *De jonge Vincent*, pp. 72–73; Anne Stiles Wylie, "Vincent's Childhood and Adolescence," *Vincent* 4, no. 2 (1975): 13–14.

20. C. C. Huysmans, "Eene vraag des tijds—kunst en industrie, II" ("A Problem of Our Time—Art and Industry"), *De Gids* (May 1864), p. 293.

21. Van den Eerenbeemt, "The Drawing Master Huysmans," pp. 2–10. Huysmans's manuals—*Het Landschap* (*Landscape*) (Dordrecht, 1840) and *Grondbeginselen der Teekenkenst* (*Fundamentals of Drawing*) (Amsterdam, 1852)—can be consulted at the Royal Library (KB) in The Hague.

22. Van den Eerenbeemt, "The Drawing Master Huysmans," pp. 2–5.

23. Quoted in Franssen, "De Rijks-HBS 'Koning Willem II,' " p. 46.

24. Huysmans's articles were published in the May 1853, March 1858, April 1864, and May 1864 issues of *De Gids*. In the last two articles, parts I and II of "A Problem of Our Time: Art and Industry," Huysmans was especially apprehensive about the quality of foreign crafts compared to those from the Netherlands, and called for government reform of drawing and industrial arts training. He invoked the designs of earlier Dutch painters, tilemakers, atlas draftsmen, and botanical illustrators as models to be reclaimed, with mention made of the van Eycks and Memling, and Elsevier, van Campen, and van Blaauw of the Blaauw atlas.

25. Huysmans's new "living method" is described by van Eerenbeemt, "Huysmans," pp. 2–10; Wylie, "Vincent's Childhood," pp. 13–14; Meyers, "Vincent's HBS," pp. 34–35; Huysmans, "Art and Industry, II," pp. 293–294.

26. Huysmans, *Grondbeginselen der Teekenkenst* (*Fundamentals of Drawing*), p. 5.

27. Van Gogh, *Letters*, 1:439, LT 226.

28. Van Gogh, *Letters*, 1:361, LT 195.

29. These are included in the Huysmans dossier of drawings and sketches in the Breda Municipal Archives, such as the "1861 Sketches for the 25 year jubilee of General J. E. C. van Overstratten"; drawings for decorations also include some for 1831 and 1853 festivals in Paris, where Huysmans had traveled and trained as a student.

30. Eldred C. Vanderlaan, *Protestant Modernism in Holland* (London: Humphrey Milford, Oxford University Press, 1924), pp. 70, 81, and 9–122.

31. Réville, "Les Controverses et les écoles religieuses du Hollande," p. 955.

32. D. Chantepie de la Saussaye, *La Crise religieuse en Hollande:*

Souvenirs et impressions (Leiden: De Breuk & Smits, 1860), p. 109. This book offers one of the best treatments of the modernist crisis by a contemporary.

33. Vanderlaan, *Protestant Modernism in Holland*, p. 63.

34. James Hutton Mackay, *Religious Thought in Holland During the Nineteenth Century* (London: Hodder and Stoughton, 1911), pp. 210–214. See also Vanderlaan's discussion of Hoekstra's theology of "representation" and the "poeticizing fantasy" in *Protestant Modernism in Holland* on pp. 82 and 77 as well as 58–72; S. Hoekstra, *Godsdienst en Kunst* (*Religion and Art*) (Amsterdam, 1859); and Golterman, *Theology of Hoekstra*, especially chap. 1, "Hoekstra realist," pp. 13–20; chap. 7, "Het geloof als postulaat," "Waarheid of illusie," and "Illusionisme," pp. 105–110.

35. A. Pierson, *Rigting en leven* (Haarlem: Kruseman, 1863), pp. 21–27.

36. Ibid., pp. 26, 27; see also p. 35.

37. Ibid., p. 256.

38. Charles Baudelaire, *Paris Spleen*, p. 56.

39. Pierson, *Rigting*, p. 256.

40. Ibid., pp. 28–29.

41. Ibid., pp. 26–27.

42. Ibid., p. 33.

43. Ibid., pp. 254–255.

44. A. Pierson, *De Beteekenis der kunst voor het zedelijk leven: Redevoering uitgesproken in een vergandering der Akademie van Beeldende Kunsten en Technische Wetenschappen te Rotterdam* (Haarlem: Kruseman, 1862), pp. 13–14, 15.

45. Pierson, *Rigting*, p. 393.

46. Ibid., p. 254.

47. Ibid., pp. 255–256.

48. Ibid., pp. 392–393, 254–255. Indeed, Pierson posed the formal, aesthetic powers of Christ and, by extension, of art directly against the traditional notion that only religious "symbolism" offered a route to "hallowed" art. See the whole section of *Rigting*, pp. 391–407, including "De kunst geen symboliek" ("Art, not symbolism").

49. Allard Pierson, "George Eliot," *De Gids* 1 (Feb. 1881), p. 267.

50. Pierson, *De Beteekenis der kunst*, pp. 16–17; *Rigting*, p. 388.

51. Pierson, *De Beteekenis der kunst*, pp. 17–19.

52. Pierson, *Rigting*, pp. 257, 400; *De Beteekenis der kunst*, pp. 27–32.

53. Pierson, *Rigting*, pp. 401–402.

54. Ibid., pp. 397–398; see also 400–407; *De Beteekenis der kunst*, pp. 14–15, 18, 21–22. On Pierson's aesthetic of sympathy see his "George Eliot," pp. 266–268.

55. Pierson, *Rigting*, pp. 397–398, 399.

56. Ibid., pp. 402–403.

57. Ibid., p. 259.

58. Pierson, *De Beteekenis der kunst*, pp. 34–35.

59. Ibid.

60. Pierson, *Rigting*, p. 260.

61. Ibid.

62. The debates generated by the Dutch modernists echoed throughout the varied regions and strata of the national culture. Between 1850 and 1880, the discussions of such issues as monism, science and faith, anti-supernaturalism, and divinity as representation extended well beyond the confines of the theological faculties and monopolized public opinion and polemic. C. Busken-Huet's best-selling book, *Letters About the Bible*, for example, published in 1858, popularized the first round of theological revision. From 1849 to 1880, representatives of the two generations of modernists waged their theological battles in the pages of the premier Dutch literary journal, *De Gids*. Hoekstra, Pierson, and de la Saussaye incorporated their ideas about art, faith, nature, and representation into more popular religious instructional manuals and brochures. Pierson spread his message about the religion of beauty not only in sermons to his own congregation but also through public lectures to local literary societies and *rederijkers*. Newspapers like the *Nederlander* and the *Morgenster* were also dominated by the modernist controversies. For indications of the extension of modernist ideas across Dutch culture, see Vanderlaan, *Protestant Modernism in Holland*, pp. 63–95; Allard Pierson, "Prof. Scholten's Monisme," *De Gids* 1 (1859), pp. 749–798; "Over Opzoomer," *De Gids* 1 (1893), pp. 413 and seq. *De Gids* index of 1859–1874; Chantepie de la Saussaye, *La Crise religieuse in Hollande*, pp. 131–164; and his *Een Woord Aan Dr. A. Pierson* (Rotterdam: E. H. Tassemeijer, 1864).

While he prepared for the clerical exams in Amsterdam, van Gogh's studies were supervised by his uncle Jan Stricker, an important Amsterdam

Reformed minister affiliated with the modernist movement (1816–1886). Stricker wrote books and articles on the new theology and textual criticism of Old and New Testaments. From 1874 to 1880 he also served on the editorial board of the *Volksbibliotheek*, a publication of popular pamphlets devoted to religious questions, including explications of "the new direction" and the "modern" controversies in Reformed theology. Along with Reverend Stricker a number of other representatives of the new theology appeared on the masthead, including Hugenholtz and C. Loman, who expounded a variant of Pierson's theology of art emphasizing the "symbolic" or "symbolistic" dimension of religious expression. I have traced Stricker's links to modernism in the *Nieuw Nederlandsch Biografisch Woordenboek* (Leiden: A. W. Sijthoff's Uitgevers, 1912), 2:1386; for the *Volksbibliotheek* editorial board of modernists, see *Brinkman's Catalogus Der Boeken, Plaat-en Kaartwerken 1850–1882*, vol. 1 (1850–1882), p. 1252; for Stricker's writings, see *Brinkman's, 1882–1891*, 1:519.

63. Van Gogh, *Letters*, 1:121, LT 99, Amsterdam, May 1877.

64. Ibid., 2:297, LT 371, Nuenen, 1885; emphasis his.

65. Ibid., 3:426, W1; emphasis mine.

66. Ibid., p. 427.

67. Ibid., 1:495, LT 248.

68. Ibid.; emphasis mine.

69. Ibid., 1:196, 198, LT 133.

70. Ibid., 1:198; emphasis his.

71. Ibid., 1:189, LT 130.

72. Ibid., 1:495, LT 298.

73. Ibid., 3:6, LT 520.

74. Ibid., 3:2, LT 518.

75. Ibid.

76. Ibid., 3:429, W2. (I am using the revised dating of this letter proposed by Ronald Pickvance, *Van Gogh in Arles* [New York: Metropolitan Museum of Art, 1984], p. 262.)

77. Ibid., 2:605, LT 506; dating of letter from Pickvance, *Van Gogh in Arles*, p. 263.

78. Ibid., 3:439, W5; 3:2, LT 518, emphasis mine; dating of letter is July 31, according to Pickvance, ibid.

79. Ibid., 2:605, LT 506, July 9, 1888.

80. Ibid., 3:2, LT 518, August 4, 1888; emphasis his.

81. Ibid., 2:605, LT 506.

82. Ibid., 3:496–497, B8, June 23, 1888, dated by Pickvance.

83. Ibid., 3:500, B9, June 24, 1888. The Michelet passage is quoted in A. M. Hammacher, "Van Gogh/Michelet/Zola," *Vincent* 4, no. 3 (1975): 7; for a good discussion of Michelet's theory of metamorphosis, and its reliance on natural science such as the Dutch writer Swammerdam, see Linda Orr, *Jules Michelet: Nature, History, and Language* (Ithaca, N.Y.: Cornell University Press, 1976), pp. 19–24.

84. P. A. de Genestet, *Complete Gedichten* (Amsterdam: Nederlandsche Bibliotheek, n.d.), "Leekedichtjes," originally published between 1857 and 1863, on pp. 271–326; quotes on science and faith on pp. 289, 285.

85. Douglas Lord, ed. and trans., *Vincent van Gogh, Letters to Emile Bernard* (New York: Museum of Modern Art, 1938), p. 46, emphasis his; Letter B8, June 23, 1888. As Albert Boime first pointed out, the *Collected Letters* translates the first passage incorrectly, so I have used the Lord translation.

86. Van Gogh, *Letters*, 1:189, LT 130, Wasmes, June 1879.

87. Ibid., 1:483, LT 242.

88. Ibid., 1:495, LT 248.

89. Ibid., 3:2, LT 518.

90. Ibid., 3:478, B3.

91. Ibid., 3:518, B19.

92. Ibid., 2:597, LT 503; 3:504, B12.

93. Lord, *Letters*, p. 44, B8.

94. Debora Silverman, "Pilgrim's Progress and van Gogh's Métier," in *Van Gogh in England*, ed. Martin Bailey (London: Barbican Gallery, 1992), pp. 104–116.

95. Van Gogh, *Letters*, 3:496, B8, June 23, 1888, all emphasis van Gogh's.

96. Ibid., 3:25, LT 531.

97. Gauguin, in Douglas Cooper, *Paul Gauguin: 45 Lettres à Vincent, Théo et Jo van Gogh* ('s-Gravenhage: Staatsuigeverij, 1983), p. 235.

CHAPTER 6. ECONOMICS

1. Daniel Guérin, *The Writings of a Savage, Paul Gauguin* (New York: Paragon, 1990), p. 27, from letter to Mette, Le Pouldu, June 1889.

2. Van Gogh, *The Complete Letters of Vincent van Gogh*, 2d ed. (Boston: New York Graphic Society, 1978), 3:94, LT 557, October 20, 1888.

3. Gauguin, letter to Schuffenecker, in Victor Merlhès, *Correspondance de Paul Gauguin: Documents, témoignages* (Paris: Fondation Singer-Polignac, 1984), p. 255, #172, October 16, 1888, emphasis Gauguin's.

4. Ibid., p. 248.

5. Van Gogh, *Letters*, 3:63, LT 544a, October 8, 1888. It was only in a memoir written many years later that Gauguin *retrospectively* reconstructed a role for Vincent van Gogh in his decision to go south, noting that he was "won over by Vincent's heartfelt protestations of friendship" and his "deep tenderness, or rather, the altruism of the Gospel" (*Avant et après*, cited in Françoise Cachin, *Gauguin: The Quest for Paradise* [New York: Abrams, 1992], p. 153). Douglas Cooper discusses the nondialogic quality of Gauguin's letters to van Gogh, and his failure to mention having received van Gogh's 1888 *Self-Portrait*, in his introduction to *Paul Gauguin: 45 Lettres à Vincent, Théo et Jo van Gogh* ('s-Gravenhage: Staatsuigeverij, 1983), pp. 14–15.

6. In Guérin, *Writings of a Savage*, p. 24, October 8, 1888.

7. Ibid., p. 25; see also the French in Merlhès, *Correspondance*, p. 255, #172.

8. Van Gogh had attempted such an explicit business arrangement early on in his painting career in 1884, when he proposed to Theo that the funds sent him be considered payment for pictures produced, even if not sold. But this initial business logic was articulated in the particular context of family arguments over van Gogh's system of support, and it subsided; it resurfaced in a new way in van Gogh's Arles letters just before Gauguin's arrival, sparked, I argue, by the role of Theo as Gauguin's commercial agent and successful salesman. Carol Zemel identifies this first business proposal in her *Van Gogh's Progress: Themes of Modernity in Late Nineteenth-Century Art* (Berkeley: University of California Press, 1997), chap. 5; see also van Gogh, *Letters*, 2:274, LT 360, for the language and early contentious context, which is quite different from van Gogh's Arles discussion of new contractual terms with Theo.

9. Van Gogh, *Letters*, 2:563, LT 486; 3:53, LT 542; 3:81, LT 552.

10. Number indicated in Richard Brettell, Françoise Cachin, Claire Frèches-Thory, Charles F. Stuckey, and Peter Zegers, *The Art of Paul Gauguin* (Washington, D.C.: National Gallery of Art, 1988), p. 117; see also Ronald Pickvance, *Van Gogh in Arles* (New York: Metropolitan Museum of Art, 1984), p. 94.

11. Van Gogh, *Letters*, 2:607, LT 507.

12. Ibid., 3:498–499, B9.

13. Pickvance, *Van Gogh in Arles*, p. 72.

14. Ibid., p. 159.

15. Van Gogh, *Letters*, 3:46, LT 540.

16. Ibid., 3:49, LT 541; list on pp. 48 and 51.

17. Ibid., 3:61, LT 544.

18. See Brettell et al., *Art of Gauguin*, pp. 44–46, for timetable and client lists.

19. Van Gogh, *Letters*, 3:39, LT 538; 3:49, LT 541; 3:77, LT 551; 3:94, LT 557.

20. Ibid., 3:67, LT 546, October 8, 1888.

21. Ibid., 3:74, LT 550.

22. Ibid., 3:38–39, LT 538.

23. Ibid., 3:126, LT 573, ca. January 1889.

24. Ibid., 3:46, LT 540.

25. Ibid., 3:52, LT 541a.

26. Ibid., 3:60, LT 544.

27. Ibid., 3:76, LT 551, list on p. 77; emphasis van Gogh's.

28. Ibid., 3:92–94, LT 557, dating of letter from Pickvance; emphasis mine.

29. Ibid., 3:74, LT 550.

30. Ibid., 3:38–39, LT 538.

31. Ibid., 3:49, LT 541.

32. Ibid., 3:76, LT 551.

33. Ibid.

34. Jeroen Strumpel, "The *Grande Jatte*, That Patient Tapestry," *Simiolus* 14, no. 3/4 (1984): 224.

35. In Guérin, *Writings of a Savage*, letter to Bernard, p. 24.

36. Van Gogh, *Letters*, 3:92–93, LT 557; emphasis mine.

37. Ibid., 3:533–534, T3, October 27, 1888, Theo's letter to Vincent.

38. Ibid., 3:537, T5, April 24, 1889.

39. See, for example, ibid., 3:126, 137, 162, LT 573, LT 577, LT 589, Jan.–May 1889.

40. Ibid., 3:159, LT 588; and see 3:176, LT 592.

41. Ibid., 3:95, LT 558.

42. Ibid., 3:95, LT 558; 3:108, LT 563; 3:176, LT 592.

43. Ibid., 3:92, LT 557; 3:95, LT 558; 3:97, LT 558b.

CHAPTER 7. THE *ALYSCAMPS* PAINTINGS

1. Gauguin described the 1,100-kilometer trip as very taxing, necessitating six changes for train connections. See letter to Schuffenecker, in Victor Merlhès, *Correspondance de Paul Gauguin: Documents, témoignages* (Paris: Fondation Singer-Polignac, 1984), p. 264, #174; and train changes and time of journey in Merlhès, p. 510.

2. Gauguin, *Avant et après*, in *Paul Gauguin's Intimate Journals*, trans. Van Wyck Brooks (New York: Liveright, 1949), p. 28.

3. Ibid., p. 32. Initially they ate at the café-restaurant but soon decided to save money by eating at home.

4. Gauguin, letter to Theo, in Merlhès, *Correspondance*, p. 266, #175; Gauguin, *Avant et après*, pp. 30–31.

5. Gauguin, letter to Vincent, ca. September 10, 1888, in Douglas Cooper, *Paul Gauguin: 45 Lettres à Vincent, Théo et Jo van Gogh* ('s-Gravenhage: Staatsuigeverij, 1983), p. 221, emphasis his. I have not located a translation of the entire passage. I relied on the translation of the first two sentences here in Richard Brettell, Françoise Cachin, Claire Frèches-Thory, Charles F. Stuckey, and Peter Zegers, *The Art of Paul Gauguin* (Washington, D.C.: National Gallery of Art, 1988), p. 104; the remaining translation is my own.

6. *Avant et après*, quoted in Françoise Cachin, *Gauguin: The Quest for Paradise* (New York: Harry Abrams, 1992), p. 153.

7. Van Gogh, *The Complete Letters of Vincent van Gogh*, 2d ed. (Boston: New York Graphic Society, 1978), 3:97, 99, LT 558b, dating from Ronald Pickvance, *Van Gogh in Arles* (New York: Metropolitan Museum of Art, 1984).

8. Quoted in Cachin, *Gauguin*, p. 52; see also the slightly different translation in Daniel Guérin, ed., *The Writings of a Savage, Paul Gauguin* (New York: Paragon, 1990), p. 25—"I am like a fish out of water." The French is in Merlhès, *Correspondance*, p. 284: "Je suis à Arles tout dépaysé, tellement je trouve tout petit, mesquin, le paysage et le gens."

9. Gauguin's caustic and contemptuous attitude toward the local scene and van Gogh's company there is discussed by Roskill, as cited in Brettell et al., *Art of Gauguin*, p. 115; see also John Rewald, *Post-Impressionism from van Gogh to Gauguin*, 3d ed. (New York: Museum of Modern Art, 1978), p. 221; and the

letter to Bernard in Merlhès, *Correspondance*, p. 275, #179, where Gauguin denigrates the Arles café and expresses distaste for its *couleur locale canaille*, "scummy local color."

10. Gauguin noted that "we did tremendous work there," "useful to both"; in *Avant et après*, in *Journals*, trans. Brooks, p. 32; see also Belinda Thomson, *Gauguin* (London: Thames and Hudson), p. 75; Cachin, *Gauguin*, p. 52; Cooper, introduction to *Gauguin: Lettres*. Robert Goldwater, *Gauguin* (New York: Abrams, 1983), is the most skeptical of the constructive qualities of the relationship for either artist.

11. See the discussion of the site, architecture, and legends in Chapter 2.

12. I rely on the dating coordinates provided by Pickvance, *Van Gogh in Arles*, pp. 198–199.

13. Van Gogh, letter to Bernard, as quoted in Jan Hulsker, *The Complete van Gogh: Painting, Drawings, Sketches* (New York: Abrams, 1980), p. 370.

14. See also the 1885 drawing, *Road with Poplars*, F1239, with a similar directional thrust.

15. Van Gogh, *Letters*, 3:49, LT 541.

16. The terms of Cornelia Peres discussing another example of van Gogh's thick impasto, in Cornelia Peres, "Van Gogh's Triptych of Orchards in Blossom: An Impressionist Concept of Painting Technique," in *A Closer Look: Technical and Art-Historical Studies on Works by van Gogh and Gauguin*, ed. Cornelia Peres, Michael Hoyle, and Louis van Tilborgh (Zwolle: Waanders, 1991), p. 31.

17. Each uses a near-identical *vertical* format of 36 × 28". The exact dimensions are: van Gogh's 36⅝ × 28⅜; Gauguin's 36¼ × 28¾. The exact dates for the pictures are not identified by experts, but most agree they were done in the last days of October or the first week of November. See Hulsker, *Van Gogh*, p. 370; Pickvance, *Van Gogh in Arles*, pp. 198–200; and Brettell et al., *Art of Gauguin*, p. 112.

18. A vantage point noted by Brettell et al., *Art of Gauguin*, p. 112, as "along the banks of the Craponne Canal"; also noted by Pickvance, *Van Gogh in Arles*, pp. 199–200.

19. Carol Christensen, "The Painting Materials and Techniques of Paul Gauguin," *Conservation Research* 41 (1993): 66; Brettell et al., *Art of Gauguin*, pp. 117–118.

20. Ibid., p. 117.

21. Additional examples are *The Harvest*, 1875–1877, where the trees arc to the shape of the hill at back; and *Mont Saint-Victoire*, 1885–1887, where the tree at the left creates a literal echo over the mountain. These canvases and *L'Estaque*, 1882–1885 (my Fig. 85), are reproduced in Richard Verdi, *Cézanne* (London: Thames and Hudson, 1992), pp. 73, 116, 117, 120.

22. Fénéon wrote, "A tree trunk, slender, rectilinear, and smooth, which we have already observed in a painting by Cézanne, separates the figures, dividing the canvas into two panels" (quoted in Brettell et al., *Art of Gauguin*, p. 83). Fénéon did not comment on the use of the foliage arc or canopy, another element of Gauguin's dependence on the Cézanne model.

23. Van Gogh, *Letters*, 2:583, LT 497.

24. Ibid.

25. Ibid., 3:499, B9; 3:227, LT 613.

26. In Merlhès, *Correspondance*, p. 284, #182; I rely on the translation of Goldwater, *Gauguin*, p. 28. "Messing" is H. Travers Newton's rendering in "Observations on Gauguin's Painting Techniques and Materials," in *A Closer Look: Technical and Art-Historical Studies on Works by van Gogh and Gauguin*, ed. Cornelia Peres, Michael Hoyle, and Louis van Tilborgh (Zwolle: Waanders, 1991), p. 106; Brettell et al. render the term "tampering" in *Art of Gauguin*, p. 113.

27. Brettell et al., *Art of Gauguin*, p. 113; Joan Minguet, *Gauguin: His Life and Complete Works* (Stamford, Conn.: Longmeadow Press, 1995), p. 35.

28. Goldwater, *Gauguin*, p. 28; Christensen, "Painting Materials and Techniques," p. 86.

29. Brettell et al., *Art of Gauguin*, p. 120, suggests the allusion to the Sérusier lesson in relation to another of Gauguin's paintings of the Arles period, the *Blue Trees*; see also the Sérusier incident and illustration of *The Talisman* in Bogomila M. Welsh-Ovcharov, *Vincent van Gogh and the Birth of Cloisonism* (Toronto: Art Gallery of Ontario, 1981), p. 371.

30. Cited in Brettell et al., *Art of Gauguin*, p. 108.

31. Van Gogh, *Letters*, 3:478, B3; see also comments on exaggeration and spontaneity in 2:589, LT 500; 2:580, LT 495; and 3:518, B19, on exaggeration, simplification, and amplification from nature.

32. Ibid., 3:478, B3; 3:499, B9; 3:518, B19.

33. Ibid., 3:517–518, B19.

34. The terms of Ziva Amishai-Maisels, "A Gauguin Sketchbook: Arles and Brittany," *Israel Museum News* 10 (1972): 72; and Vojtěch Jirat-Wasiutyński, "Painting from Nature Versus Painting from Memory," in *A Closer Look*, in discussing another Gauguin painting of the Arles period, *Portrait of van Gogh Painting Sunflowers*, pp. 99–101. In a related matter, Travers Newton emphasizes how little trace Gauguin left of any underdrawing, and how he was secretive about his working method and process (*A Closer Look*, pp. 103, 106, 109 n. 5). This is in sharp contrast to van Gogh, who habitually incorporated and even heightened attentiveness to the stages of his canvas preparation.

35. Noted by Brettell et al., *Art of Gauguin*, p. 113; the title is listed in Gauguin's letter to Theo in Cooper, *Gauguin: Lettres*, p. 75. Gauguin's classicism is also emphasized, more generally, in Thomson, *Gauguin*, p. 77.

36. Emile Bernard, "Vincent van Gogh," *Les Hommes d'Aujourd'hui*, no. 390 (1890), n.p.; cited in Musée d'Orsay, *Van Gogh à Paris* (Paris: Editions de la Réunion des Musées Nationaux, 1988), pp. 160, 164.

37. Van Gogh, *Letters*, 3:6, LT 520.

38. Here I follow Pickvance, *Van Gogh in Arles*, p. 198, who indicates that the vertical canvases preceded the horizontal ones, though precise dates cannot be pinpointed.

39. Evert van Uitert, Louis van Tilborgh, and Sjraar van Heugten, *Van Gogh: Paintings* (Milan: Arnoldo Mondadori Arte, 1990), p. 177; Welsh-Ovcharov, *Cloisonism*, p. 140.

40. Van Uitert et al., *Van Gogh: Paintings*, p. 177; the letter to Bernard from van Gogh and Gauguin describing the studies of the alleys is in Merlhès, *Correspondance*, p. 273, #177. See also the full reconstitution of the Arles decorative pairs and series in Roland Dorn, *Décoration: Vincent van Goghs Werkreihe für das Gelbe Haus in Arles* (Hildesheim: Georg Olms Verlag, 1990), pt. 3, p. 613.

41. Quoted in Pickvance, *Van Gogh in Arles*, p. 200; van Gogh, *Letters*, 3:100–101, LT 559. Pickvance suggests that the tilted space and high viewpoint resulted from van Gogh's placing of the easel in the bank between the Alyscamps and the Canal de Craponne.

42. The descriptions of van Gogh and Gauguin of the special canvas are in van Gogh, *Letters*, 3:100–101, LT 559; Gauguin's is also in a postscript to a letter to Bernard, in Merlhès, *Correspondance*, p. 273, #177. For discussions of the unusual canvas type, see Brettell et al., *Art of Gauguin*, p. 120; Pickvance, *Van Gogh in Arles*, p. 200; and the extensive analysis for Gauguin in Chris-

tensen, "Painting Materials and Techniques," pp. 64–70, who alerts us to the language of "coarse sackcloth," p. 65; Travers Newton calls Gauguin's roll "coarse sacking," in "Observations on Gauguin's Painting Techniques," p. 106.

43. Travers Newton, "Observations on Gauguin's Painting Techniques," p. 106.

44. I cannot do justice here to the full story of Gauguin's use of this new type of canvas and his experiments with it for particular creative effects by linking medium and support. However, it is an essential point of departure for understanding Gauguin's working methods, techniques, and intentions, as Travers Newton, Jirat-Wasiutyński, and Christensen have pointed out in their detailed studies, on which I have relied for a comparative analysis with van Gogh's. Gauguin's experiments with the sacking were limited to two phases in his career, according to Christensen: during the Arles stay with van Gogh, and when he later moved to Tahiti. Christensen's new research indicates that "at least *four* of seventeen paintings" Gauguin produced in Arles were painted on the very coarse sacking canvas ("Painting Materials and Techniques," p. 66); the earlier article by Travers Newton suggested "probably ten or fifteen" ("Observation on Gauguin's Painting Techniques," p. 110 n. 15).

45. Van Gogh produced a total of about six paintings on the heavier Gauguin roll (Travers Newton, "Observation on Gauguin's Painting Techniques," p. 110 n. 15). These include the *Alyscamps* we will analyze here, as well as *Sunflowers, Sower,* and *Gauguin's Chair,* all of 1888, and all of which display a variety of paint handling, brushwork, and interaction with the canvas support.

According to the articles by Peres and Travers Newton in *A Closer Look,* van Gogh typically pursued applying thick paint to conventional, commercially prepared canvas of plain, tightly woven linen or cotton. Gauguin's heavy sacking was a departure for van Gogh but fit his interest in experiments with the *métier mat*—matte surface effects that had been extensively explored by such Impressionists as Monet, Degas, and Pissarro. Peres and Travers Newton link both Gauguin and van Gogh to this Impressionist precedent of experimenting with thin, white primers, more absorbent canvas grounds, lean paint application, and rejection of varnish, which yielded varied and new types of matte surfaces (Peres, "An Impressionist Concept of Painting Technique" and "On Egg-White Coatings," pp. 24–43, especially pp. 26–27, 41–42; and Travers Newton, "Observations on Gauguin's Painting Techniques," pp. 103–111, especially p. 107).

While it is instructive to acknowledge the Impressionist roots of these techniques, it should also be said that van Gogh and Gauguin adapted them very differently from each other, and for different purposes from those of their Impressionist predecessors, a subject that will be explored in the next chapters. For the Impressionists, as Peres and Travers Newton indicate, matte effects expressed heightened immediacy, sensory vitality, and anti-academic finish. Gauguin, as we shall see, exploited matte techniques for greater absorption and lack of varnish for *anti*-Impressionist goals—to attenuate surface density and move painting to a meditative, symbolist fresco. Van Gogh, by contrast, mixed these matte techniques with maintaining varnish, and with his abiding craft practices that heightened surface physicality and tangibility: underdrawing, reliance on and visibility of the perspective frame, the use of egg-white coatings for temporary varnishes, and the search for coarser, brayed, and even self-ground paint pieces. In any case, for van Gogh it was a short-lived experiment; he did not seek out burlap-type canvases after Gauguin's departure, preferring instead to achieve a woven canvas through his fibrous, crossing paint strokes and interlocking planes.

46. Van Gogh, *Letters,* 3:100, LT 559. The original, in French, is "Or, le sol est couvert, comme d'un tapis, par une couche épaisse de feuille orangées et jaunes tombées," *Verzamelde Brieven van Vincent van Gogh* (Amsterdam and Antwerp: Wereld Bibliotheek, 1955), 3:355. The French thus offers a comparison, "comme d'un tapis," rather than a fact, "covered with a thick carpet."

47. This material identifying a literary and theological storehouse of van Gogh's reading habits that highlight nature and weaving is part of a larger study that I can only allude to here. It includes, for example, van Gogh's reading of Goethe's *Faust,* "the earth is a garment of God, contextured in the loom of heaven"; Longfellow's weavers' looms in "Evangeline"; the British minister G. H. Spurgeon's texts and sermons on "weaving the soul in the linen raiments of God's making"; and Thomas Carlyle's *Sartor Resartus (The Tailor Retailored, A Philosophy of Clothes),* a formative text of van Gogh's development that defined "*Clothes* as symbols," God's heaven as curtained vestment, embodied in earthly fabric and textures, and the artist as charged with both a sacred vocation and skilled craft production in forms that were both "hand-woven and thought-woven." These early thematic patterns in literary and religious texts provided an abiding mental system that interacted with van Gogh's early definition and practice of art as a craft, in which the figure and labor of the weaver were central.

48. Van Uitert et al., *Van Gogh: Paintings*, p. 156; see also Pickvance, *Van Gogh in Arles*, pp. 120, 148.

49. "De tapis velus / De fleurs et de verdures tissus / De Crivelli ou de Virelli peu importe." Van Gogh, *Letters*, 3:500–501, B10.

50. Pickvance, *Van Gogh in Arles*, p. 148.

51. See, for example, his *Still Life: Basket of Apples*, 1887, F378; and F379, same title and same date; an Arles example, done in March 1888, was the *Still Life: Basket with Six Oranges*, F395.

52. Travers Newton, "Observations on Gauguin's Painting Techniques," p. 106, who also notes that "brushwork plays no significant role in these paintings, as it had in the earlier impasted work by van Gogh." See also pp. 107, 109.

53. Such screening tree devices may be found in Hiroshige's *Inside Kameido Tenjin Shrine*; his *Kameyama: Rain and Thunderstorm*; and Hokusai's *Fuji from Hodogaya on the Tōkaidō*. The *Kameyama* print was in van Gogh's own Japanese print collection.

54. The red-parasol lady as Japonist is noted by van Tilborgh in van Uitert et al., *Van Gogh: Paintings*, p. 177.

55. The significance of fabric and framing in the forms and subjects of van Gogh's Japanese print collection cannot be fully explored here. For the depiction of the processes of textile production, woodblock prints as "brocade prints"—*nishiki-e*—and van Gogh's *crépons*, as well as his attempts to emulate the pliable textures of the *crépons* in his brushwork, see my "Weaving Paintings," pp. 164–165 and 472–473. For the general theme of van Gogh's and Gauguin's very different interests in Japonist space and surface, see Chapter 3, n. 52, above, where I discuss the Dutch affinities in van Gogh's topographic and panoramic Japanese prints, and his preference for visual plays of near and far and for texture over flatness and asymmetry.

The *Catalogue of the Van Gogh Museum's Collection of Japanese Prints* (Zwolle: Waanders, 1991) contains numerous prints in van Gogh's collection showing framing and bracketing, craft devices that focus the eye, and spatial plays of near and far; see, for example, the prints numbered 56, 70, 84, 85, 90, 248, 308, 366, 425.

56. The canvas I am describing here is Gauguin's *Blue Trees*, in the Copenhagen Ordrupgaard Collection, W311.

57. Quoted in Pickvance, *Van Gogh in Arles*, p. 183. Daumier's figures returned along with van Gogh's formative figural habits culled from the Cassagne and Bargue copybooks, and, as with the Japanese prints, represent the fluid interchange between graphic media and canvas practices. Moving from popular prints to painting, and back again, remained essential to van Gogh's painting production throughout.

58. Ibid., pp. 183, 200.

59. Cited in Guérin, *Writings of a Savage*, p. 26; Merlhès provides the correct date for the letter as being in the last days of October or the first four days of November, not the later time listed in Guérin; pp 269–270, #176.

60. Cited in Guérin, *Writings of a Savage*, p. 26; again, the correct dates are in Merlhès.

61. As argued by Thomson, *Gauguin*, p. 77.

62. Travers Newton, "Observations on Gauguin's Painting Techniques," pp. 103, 109 n. 5; Christensen, "Painting Materials and Techniques," p. 75; Amishai-Maisels, "Gauguin Sketchbook," pp. 68–74.

63. One example from the previous July in Arles was the pair of Montmajour panoramic drawings, which van Gogh compared to finished paintings in their format and quality.

64. This appears, for example, in the Paris painting *Sous-bois*, 1887, where pencil lines arranging elements in the landscape are visible to the eye, and were also studied under a microscope by Claas Hulshoff and Sjraar van Heugten in their "Restoring a Forest Scene by Vincent van Gogh," *Van Gogh Bulletin*, no. 2 (1994): 8–11. These experts note that they examined eight van Gogh paintings where the pattern of underdrawn pencil lines emerged as part of the composition, though these were not visible to the eye but were detected under conditions of infrared reflectography. See also the discussion of underdrawing in van Gogh's orchards by Peres, "An Impressionist Concept of Painting Technique," pp. 27–29.

65. For van Gogh's immersion in print culture, media, and models, see Charles Chetham, *The Role of Vincent van Gogh's Copies in the Development of His Art* (New York: Garland, 1976), who inventoried the enormous volume of prints, especially by Millet, that van Gogh copied as he trained himself to draw in his first years as an artist-draftsman, especially pp. 254–259; see also Ronald Pickvance, *English Influences on Vincent van Gogh* (London: Arts Council of Great Britain, 1975), who discusses and reproduces some of van Gogh's sizable clipping collection of prints from the *London Illustrated News*; and my "Weaving Paintings."

66. Welsh-Ovcharov, *Cloisonism*, p. 141; Pickvance, *Van Gogh in Arles*, p. 200.

67. Gauguin, *Intimate Journals*, p. 32; see also Thomson, *Gauguin*, p. 76; Welsh-Ovcharov, *Cloisonism*, p. 141.

68. Pickvance, *Van Gogh in Arles*, p. 200; van Uitert et al., *Van Gogh Paintings*, p. 177; Peres, "An Impressionist Concept of Painting Technique," pp. 32–33, notes that "when he was still in Holland," van Gogh had "characterized each season with a pair of complementary colors."

69. Van Gogh, *Letters*, 3:25–26, LT 531.

70. Pickvance, *Van Gogh in Arles*, p. 200.

CHAPTER 8. GRAPE HARVESTS

1. Paul Gauguin, in Douglas Cooper, *Paul Gauguin: 45 Lettres à Vincent, Théo et Jo van Gogh* ('s-Gravenhage: Staatsuigeverij, 1983), p. 75, December 4, 1888.

2. Vincent van Gogh, *The Complete Letters of Vincent van Gogh*, 2d ed. (Boston: New York Graphic Society, 1978), 3:425, W1.

3. Ibid., 3:478, B3; see also the discussion of Vojtěch Jirat-Wasiutyński, "Painting from Nature Versus Painting from Memory," in *A Closer Look: Technical and Art-Historical Studies on Works by van Gogh and Gauguin,* ed. Cornelia Peres, Michael Hoyle, and Louis van Tilborgh (Zwolle: Waanders, 1991), pp. 94–102, who clarifies some important differences between Gauguin's and van Gogh's attitudes toward painting from memory and imagination.

4. Van Gogh, *Letters*, 3:518, B9.

5. Ibid.

6. Carol Christensen, "The Painting Materials and Techniques of Paul Gauguin," *Conservation Research* 41 (1993): 74; van Gogh, *Letters*, 3:103, LT 561.

7. Van Gogh, *Letters*, 3:103, LT 561; the dating of the letter is from Ronald Pickvance, *Van Gogh in Arles* (New York: Metropolitan Museum of Art, 1984), p. 263.

8. Van Gogh, *Letters*, 3:106, LT 563, dated ca. November 23 by Pickvance, *Van Gogh in Arles*, p. 263.

9. Jirat-Wasiutyński, "Painting from Nature," especially p. 100; Pickvance, *Van Gogh in Arles*, pp. 194, 204; Gauguin, in Cooper, *Letters*, p. 71, to Theo: "Le sacre temps de pluie les embettent térriblement pour plein air et on se livre à la peinture de chic."

10. Van Gogh, *Letters*, 3:101, LT 559.

11. The two paintings are illustrated and examined together in brief treatments by John Rewald, *Post-Impressionism from van Gogh to Gauguin*, 3d ed. (New York: Museum of Modern Art, 1978), pp. 228–229; and Pickvance, *Van Gogh in Arles*, pp. 193–194, 205–206. Of the two paintings, the Gauguin has received slightly more attention than the van Gogh, partly from conservation specialists who have been interested in its unusual canvas type, such as Christensen, "Painting Materials and Techniques," pp. 64–65, 72; it is briefly and suggestively described by H. Travers Newton in "Observations on Gauguin's Painting Techniques and Materials," in *A Closer Look*, pp. 106–107; I have also consulted Vojtěch Jirat-Wasiutyński, *Paul Gauguin in the Context of Symbolism* (New York: Garland, 1978), pp. 157–162; and Bogomila M. Welsh-Ovcharov, *Vincent van Gogh and the Birth of Cloisonism* (Toronto: Art Gallery of Ontario, 1981), pp. 190–191. See also Jan Hulsker, *The Complete van Gogh* (New York: Abrams, 1980), p. 372.

12. As argued by Welsh-Ovcharov, *Cloisonism*, pp. 190–191, and Jirat-Wasiutyński, *Gauguin*, pp. 157–162; both painters can be said to be exploring the symbolism of color.

13. Letter to Bernard in Victor Merlhès, *Correspondance de Paul Gauguin: Documents, témoignages* (Paris: Fondation Singer-Polignac, 1984), p. 275, #179, ca. November 12, 1888; Gauguin went on to say he would send it to Paris as soon as it dried.

14. Emphasis his; translation in Rewald, *Post-Impressionism*, p. 228; see letter in French in Merlhès, *Correspondance*, p. 275, #179.

15. Welsh-Ovcharov, *Cloisonism*, p. 190.

16. Translation in ibid.; see also Rewald, *Post-Impressionism*, p. 228; French is in Merlhès, *Correspondance*, p. 275, #179.

17. Letter to Schuffenecker, in Merlhès, *Correspondance*, p. 306, #193, December 1888.

18. "Une pauvresse bien ensorcélée en plein champ de vignes rouges." In Cooper, *Gauguin: Lettres*, p. 71, Gauguin to Theo, November 16, 1888.

19. Merlhès, *Correspondance*, letter to Schuffenecker, p. 306, #193.

20. See the discussions of Belinda Thomson, *Gauguin* (London: Thames and Hudson, 1987), p. 76; Richard Brettell, Françoise Cachin, Claire Frèches-Thory, Charles F. Stuckey, and Peter Zegers, *The Art of Paul Gauguin* (Washington, D.C.: National Gallery of Art, 1988), p. 144; Jirat-Wasiutyński,

Gauguin, pp. 157–160, 197; Welsh-Ovcharov, *Cloisonism*, pp. 190–191; and Pickvance, *Van Gogh in Arles*, pp. 205–206.

21. Wayne Andersen, "Gauguin and a Peruvian Mummy," *Burlington Magazine* 109, no. 769 (April 1967): 238–242; Henri Dorra, "Gauguin's Dramatic Arles Themes," *Art Journal* 38 (1978): 12–17; Brettell et al., *Art of Gauguin*, p. 144; and David Sweetman, *Paul Gauguin: A Life* (New York: Simon and Schuster, 1995), pp. 84–85. The mummy was acquired in 1879 and exhibited in the Paris Trocadéro Museum as of 1880. Andersen identified the mummy as a visual source; Dorra suggested its relation to the Arles *Vendanges*. Another useful discussion of the Peruvian mummy, including a rare study drawing by Gauguin of it can be found in the exhibition catalogue, *Le Chemin de Gauguin: Genèse et rayonnement* (Saint-Germain-en-Laye: Musée Départemental du Prieuré, 1985), p. 66; see also the discussion of the mummy and the *Vendanges* by Welsh-Ovcharov, *Cloisonism*, p. 191.

22. Msgr. Dupanloup, Evêque d'Orléans, "Misères de la vie présénte," in *Manuel des catéchismes, recueil des prières, billets, cantiques, etc.* (Paris: Rocher, 1866), pp. 151–152.

23. Msgr. Dupanloup, Evêque d'Orléans, "Sur les vanités du monde," in *Manuel des catéchismes*, pp. 147–149. Gauguin's title, *Splendeur et misère*, is listed in the facsimile of the notebook, which was also a sketchbook, in R. Huyghe, ed., *Le Carnet de Paul Gauguin* (Paris: Quatre Chemins-Editart, 1952), n.p.; see also Ziva Amishai-Maisels, "A Gauguin Sketchbook: Arles and Brittany," *Israel Museum News* 10 (Apr. 1975): 68–75.

24. Gauguin, letter to van Gogh, November 1889, in Cooper, *Lettres*, p. 214; translation used is Welsh-Ovcharov, *Cloisonism*, p. 190.

25. Gauguin, letter to Schuffenecker, in Merlhès, *Correspondance*, p. 306, #193, December 1888; and letter to Bernard, ibid., p. 276, #179, November 1888.

26. This analysis is based on the writers as cited below, as well as my own close study of the painting in the Ordrupgaard Collection in Copenhagen, Denmark.

27. Christensen, "Painting Materials and Techniques," pp. 71, 65; Travers Newton, "Observations on Gauguin's Painting Techniques," pp. 106–107.

28. Thomson, *Gauguin*, p. 102; Travers Newton, "Observations on Gauguin's Painting Techniques," p. 107, discussing another canvas on jute; see also Christensen, "Painting Materials and Techniques," pp. 65, 72–73, 80–82.

29. Gauguin, in Cooper, *Lettres*, p. 75, to Theo from Arles, December 4, 1888.

30. Gauguin writes of the paint flaking off in his letter to van Gogh soon after leaving Arles in January 1889, noting that "the whole *Vendanges* has flaked because of the *white* [ground] which has separated [from the canvas]." In Cooper, *Lettres*, p. 251; cited in Christensen, "Painting Materials and Techniques," p. 72.

31. Such as, for example, in van Gogh, *Letters*, 3:440–441, W5; 3:447, W9. The drawing is in 3:487, B6.

32. Van Gogh used a similar device of a bending bow of space moving the eye along the canal of the Roubine du Roi in his F1444 pen and ink of July 1888; see also the same motif in F427 and F1473. See the entry and illustration in *Catalogue, Van Gogh, Collection of the Kröller-Müller Museum*, 4th ed. (Otterlo: Kröller-Müller Museum, 1980), pp. 100, 103.

33. Van Gogh, *Letters*, 3:509–510, B14, August 1888.

34. Ibid., 3:425, W1, emphasis his.

35. Ibid., 3:25, LT 531, September 1888.

36. Ibid., 3:23, LT 530, September 1888.

37. Ibid., 3:102, LT 560, November 1888.

38. Ibid., 3:110, LT 565, December 1888.

39. Ibid., 3:466, W19, January 1890.

40. Ibid., 3:102, LT 560, November 1888, emphasis his.

41. Ibid., 3:122, LT 570, January 1889.

42. Ibid., 3:534, Theo to Gauguin, November 12, 1888; Brettell et al., *Art of Gauguin*, p. 46; Pickvance, *Van Gogh in Arles*, pp. 194–195.

43. See Gauguin, in Cooper, *Lettres*, p. 75, December 4, 1888.

44. Van Gogh, *Letters*, 3:25, LT 531; 3:20, LT 527, September 1888.

45. Ibid., 3:433, W4, July 1888, emphasis his.

46. Ibid., 3:26, LT 531, September 1888.

CHAPTER 9. REMEMBERED GARDENS

1. Vincent van Gogh, *The Complete Letters of Vincent van Gogh*, 2d ed. (Boston: New York Graphic Society, 1978), 3:448, W9, second half of November 1888.

2. Ibid., 3:101, LT 560, November 1888. This point of a dialectical tension between the impulse to increase imagination and the need to reclaim con-

tact with human subjects is suggested by Vojtěch Jirat-Wasiutyński, "Painting from Nature Versus Painting from Memory," in *A Closer Look: Technical and Art-Historical Studies on Works by Van Gogh and Gauguin*, ed. Cornelia Peres, Michael Hoyle, and Louis van Tilborgh (Zwolle: Waanders, 1991), pp. 100–101.

3. Ronald Pickvance, *Van Gogh in Arles* (New York: Metropolitan Museum of Art, 1984), p. 217. Pickvance disagrees with this interpretation. Whether or not the bush resembled Gauguin precisely, it does configure an eye on its right side, with the exactness of an iris and pupil.

4. Gauguin, quoted in Linda Nochlin, ed., *Impressionism and Post-Impressionism, 1874–1904: Sources and Documents* (Englewood Cliffs, N.J.: Prentice-Hall, 1966), p. 158, letter of January 14, 1885; original in Victor Merlhès, *Correspondance de Paul Gauguin: Documents, témoignages* (Paris: Fondation Singer-Polignac, 1984), p. 87, #65.

5. Richard Brettell, Françoise Cachin, Claire Frèches-Thory, Charles F. Stuckey, and Peter Zegers, *The Art of Paul Gauguin* (Washington, D.C.: National Gallery of Art, 1988), p. 116.

6. Merlhès, *Correspondance*, p. 270, #176.

7. Ibid., p. 284, #182.

8. Significantly, in an 1890 letter to Theo often cited as evidence of his admiration for Puvis, van Gogh invokes Puvis in the context of commenting on fabric colors in the clothing worn by people he sees in Auvers: "In clothes you see combinations of very pretty light colors; if you could make the people you see walking past pose and do their portraits, it would be as pretty as any period whatever in the past, and I even think that often in nature there is actually all the grace of a picture by Puvis, between art and nature. For instance, yesterday I saw two figures: the mother in a gown of deep carmine, the daughter in pale pink and a yellow hat, . . . very healthy country faces, browned by fresh air, burned by the sun; the mother especially had a very, very red face and black hair and two diamonds in her ears" (*Letters*, 3:289, LT 645).

9. Merlhès, *Correspondance*, p. 270, #176, quoted in Brettell et al., *Art of Gauguin*, p. 116, emphasis Gauguin's.

10. Van Gogh, *Letters*, 3:54, LT 542 (September 24, 1888), emphasis his.

11. Quoted as corrected in Jan Hulsker, *Vincent van Gogh: A Guide to His Work and Letters* (Zwolle: Waanders, 1993), p. 67; see van Gogh, *Letters*, 3:105, LT 562, November 1888; and Pickvance, *Van Gogh in Arles*, p. 214.

12. Quoted in Pickvance, *Van Gogh in Arles*, p. 215; van Gogh, *Letters*, 3:104, LT 562.

13. Brettell et al., *Art of Gauguin*, p. 117; see also Pickvance, *Van Gogh in Arles*, p. 216, who notes that the "memory" of the family gardens is "evidently a conflation of those at Etten and Nuenen." Van Gogh had lived with his parents at Etten in 1881, and then in Nuenen from 1883 to 1885.

14. Van Gogh, *Letters*, 3:448, W9, November 1888.

15. Ibid., 3:447–448, W9, November 1888.

16. Ibid., 3:433, W4, June 1888.

17. Ibid. See the words of Charles Blanc discussing Chevreul's laws of color in a section on maximizing color effects for tapestries and weaving production: "Prenez deux couleurs complémentaires: juxtaposées, elles *s'exaltent mutuellement*" (Charles Blanc, *Grammaire des arts décoratifs: Décoration intérieure de la maison* [Paris: Laurens, ca. 1884], p. 93). As noted in Chapter 4, van Gogh was exposed to Chevreul's theories through the writing of Blanc, one of the primary popularizers of Chevreul's discoveries. Van Gogh studied Blanc's *Artistes de mon temps* chapter on Delacroix (Paris: Firmin-Didot, 1876), pp. 23–88, and a larger treatise, the *Grammaire des arts de dessin* (Paris: Laurens, 1880), both of which featured Chevreul's experiments and highlighted their application to painting on canvas and to color saturation on draperies, cushions, and other fabric stuffs.

18. Van Gogh, *Letters*, 3:433, W4, June 1888. The many applied arts enhanced by the laws of color contrast, from flower arrangement, to men's and women's clothing, to paper hanging, weaving, and painting, are discussed by Chevreul in his *Principles of Harmony and Contrast of Colours and Their Applications to the Arts*, 3d ed., trans. Charles Martel (London: George Bell, 1890).

19. Van Gogh, *Letters*, 3:441, W4, late July 1888.

20. Ibid., 3:444, W7.

21. Ibid., 2:369–370, LT 404.

22. These subjects joined others showing unusual attentiveness to subjects such as fishnets, wicker baskets, and the activities of sewing and knitting; see also the shawled figures in the 1883 *Public Soup Kitchen* (F1020b); *Seamstress* (F1025); and *Fisherman with Basket on His Back* (F1083). Van Gogh commented in his Hague letters on selecting paper with a quality of "unbleached linen or muslin," and intensified these effects by using thick carpenter's pencils. Selections from the early drawings which demonstrate the

appeal of woven subjects and sewing figures may be seen in the reproductions in the 1990 Kröller-Müller exhibition, *Vincent van Gogh's Drawings* (Milan: Arnoldo Mondadori Arte, 1990), especially pp. 62–118, though these choices and their meaning are not addressed; the full complement of these types of subjects is traceable in the reproductions in J. B. de la Faille, *The Works of Vincent van Gogh: His Paintings and Drawings*, rev. ed. (London: Weidenfeld and Nicolson, 1970), pp. 336–401, 565–569. Van Gogh's search for rough and textural paper recurs in the Hague letters; see some examples in *Letters*, 1:350, 360–361, 417, 423, 432. I treat these choices and their meaning more extensively in my "Weaving Paintings: Religious and Social Origins of Vincent van Gogh's Pictorial Labor," in *Rediscovering History: Culture, Politics, and the Psyche*, ed. Michael S. Roth (Stanford: Stanford University Press, 1994).

23. This technique is used again in the top hat of the almshouse man (F985) and other drawings where the figures' clothes are marked by similar scraping and creasing. See my "Weaving Paintings."

24. Jeroen Strumpel, "The *Grande Jatte*, That Patient Tapestry," *Simiolus* 14, no. 3/4 (1984): 214–224. My thanks to Carol H. Krinsky for clarifying this issue.

25. Van Gogh's terms in describing the nimbus for the June *Sower*.

26. Van Gogh, *Letters*, 3:448, W9, November 1888; in French in *Verzamelde Brieven van Vincent van Gogh* (Amsterdam and Antwerp: Wereld Bibliotheek, 1955), 4:163.

27. Van Gogh, *Letters*, 3:25, LT 531. In a letter to Theo some days later, van Gogh wrote that he had been exploring the links between music and painting back in Nuenen, when he tried "in vain" to learn music, sensing even then the links between "our color and Wagner's music" (ibid., 3:44, LT 539).

28. Gauguin in Merlhès, *Correspondance*, pp. 87–89, #65; see also excerpt in Nochlin, *Impressionism and Post-Impressionism: Sources and Documents*, pp. 158–159.

29. Gauguin, "Notes on Painting" (1890), in Nochlin, *Impressionism and Post-Impressionism: Sources and Documents*, p. 163; see also quotes in Robert Goldwater, *Gauguin* (New York: Abrams, 1993), pp. 42, 44.

30. See letter to Schuffenecker, in Merlhès, *Correspondance*, esp. p. 87, #65.

31. Gauguin in Herschel B. Chipp, *Theories of Modern Art: A Source Book by Artists and Critics* (Berkeley: University of California Press, 1968), p. 67; original in Merlhès, *Correspondance*, pp. 248–249, #168.

32. This discussion of the Neo-Impressionists' search for a universal language, their science of harmony, and their political radicalism is adapted from my *Art Nouveau in Fin-de-Siècle France: Politics, Psychology, Style* (Berkeley: University of California Press, 1989), pp. 212–214. Signac writes of the "aesthetic protractor" in Van Gogh, *Letters*, 3:153, LT 548a, first noted by John Rewald, who discussed Charles Henry, the Neo-Impressionists, and Symbolist anarchism in *Post-Impressionism from van Gogh to Gauguin*, 3d ed. (New York: Museum of Modern Art, 1978), pp. 88–90, 124–127, 133–166. See also the essential work of Eugenia Herbert, *The Artist and Social Reform: France and Belgium, 1885–1898* (New Haven: Yale University Press, 1961); and Michael F. Zimmermann, *Seurat and the Art Theory of His Time* (Antwerp: Mercator, 1991).

CHAPTER 10. GAUGUIN'S *MISÈRES*

1. "Rêve qui veut et qui peut," Gauguin cited in Françoise Cachin, *Gauguin: The Quest for Paradise* (New York: Abrams, 1992), p. 143, French in Douglas Cooper, *Paul Gauguin: 45 Lettres à Vincent, Théo et Jo van Gogh* ('s-Gravenhage: Staatsuigeverij, 1983), p. 279, October 1889.

2. Vincent van Gogh, *The Complete Letters of Vincent van Gogh*, 2d ed. (Boston: New York Graphic Society, 1978), 3:235, LT 615, November 1889, emphasis his.

3. Gauguin, in Daniel Guérin, ed., *The Writings of a Savage, Paul Gauguin* (New York: Paragon, 1990), p. 26; Victor Merlhès, *Correspondance de Paul Gauguin: Documents, témoignages* (Paris: Fondation Singer-Polignac, 1984), p. 284, #182.

4. Paul Gauguin, *Avant et après* (Paris: Crès, 1923), p. 15, cited in Cachin, *Gauguin*, p. 153.

5. Gauguin, *Avant et après*, quoted in Cachin, *Gauguin*, p. 153.

6. Gauguin, cited in John Rewald, *Post-Impressionism from van Gogh to Gauguin*, 3d ed. (New York: Museum of Modern Art, 1978), p. 241; see Cooper, *Gauguin: Lettres*, p. 85, for the French; I have altered a few words in the Rewald translation for accuracy.

7. Gauguin, in Guérin, *Writings of a Savage*, pp. 26–27; French in Merlhès, *Correspondance*, p. 305, #193. The dating and documentation of Gauguin's shifting plans are chronicled in Rewald, *Post-Impressionism*, pp. 240–242; Ronald Pickvance, *Van Gogh in Arles* (New York: Metropolitan Museum of Art, 1984), pp. 194–195; and Cooper, *Gauguin: Lettres*, pp. 84–86.

8. Van Gogh, *Letters*, 3:109, LT 564, emphasis his.

9. Ibid., 3:110, LT 565.

10. Ibid., 3:522, B21, December 1889.

11. Gauguin, in Merlhès, *Correspondance*, p. 275, #179.

12. For interpretations of the Madame Ginoux portraits, see Carol Zemel, *Van Gogh's Progress: Themes of Modernity in Late Nineteenth-Century Art* (Berkeley: University of California Press, 1997), pp. 121–130; and Judy Sund, *True to Temperament: Van Gogh and French Naturalist Literature* (Cambridge: Cambridge University Press, 1992), pp. 206–210.

13. Van Gogh, *Letters*, 3:108, LT 563.

14. Pickvance, *Van Gogh in Arles*, pp. 194–195; Richard Brettell, Françoise Cachin, Claire Frèches-Thory, Charles F. Stuckey, and Peter Zegers, *The Art of Paul Gauguin* (Washington, D.C.: National Gallery of Art, 1988), p. 46.

15. Pickvance, *Van Gogh in Arles*, p. 204.

16. For the events leading up to and including the episode of the severed ear, I have relied on Gauguin, *Avant et après*, pp. 33–38; Van Gogh, *Letters*, 3:110; Rewald, *Post-Impressionism*, pp. 240–245; Belinda Thomson, *Gauguin* (London: Thames and Hudson, 1987), pp. 81–82; and Pickvance, *Van Gogh in Arles*, p. 195.

17. Van Gogh, *Letters*, 3:119, LT 571.

18. Ibid., 3:122, LT 571.

19. Gauguin, Schuffenecker, Bernard, and others organized an exhibition of their works at a large café, the Café des Arts, in the fairgrounds. Gauguin showed seventeen works, Bernard twenty-three. See Ronald Pickvance, *Gauguin and the School of Pont-Aven* (San Diego: San Diego Museum of Art, 1994), p. 15; Thomson, *Gauguin*, pp. 91–93.

20. Bogomila M. Welsh-Ovcharov, *Vincent Van Gogh and the Birth of Cloisonism* (Toronto: Art Gallery of Ontario, 1981), p. 202; see also Wayne Andersen, "Gauguin and a Peruvian Mummy," *Burlington Magazine* 109 (April 1967): 238–242; Thomson, *Gauguin*, pp. 85–87.

21. Caroline Boyle-Turner, *Sérusier et la Bretagne* (Armen: La Chasse Marée, 1995), p. 27. For a fuller discussion of the zincograph sets, see Douglas Druick, foreword, and Catherine Boyle-Turner, "Paul Gauguin: The Volpini Show," in *The Prints of the Pont-Aven School: Gauguin and His Circle in Brittany* (New York: Abbeville Press, 1986), pp. 9–18, 35–46.

22. On the reception of the show and reviews, see Rewald, *Post-Impressionism*, pp. 259–265; Thomson, *Gauguin*, pp. 91–95; Antoine Terrasse, *Pont-Aven, l'Ecole buissonnière* (Paris: Gallimard, 1992), pp. 67–69. I am intrigued by the suggestion of Ronald Pickvance (*Gauguin and the School of Pont-Aven*, p. 10) that Gauguin may have exhibited *The Vision After the Sermon* at this time, as the picture, he argues, fits the description in the Volpini catalogue listing of his works under the title "Presbytère de Pont-Aven." There is, however, no definitive evidence that *The Vision* was included at the 1889 Café des Arts show, though the exhibit did feature others of his Breton and Arles pictures.

23. Brettell et al., *Art of Gauguin*, pp. 145–147, makes a strong case for the two canvases as a pair.

24. I follow the dating and clues provided in ibid.

25. Gauguin's letter to his wife describes the fishing village and mentions 150 inhabitants, included in *Le Chemin de Gauguin: Genèse et rayonnement* (Saint-Germain-en-Laye: Musée Départemental du Prieuré, 1985), p. 77; see also the memoirs and documentation of other contemporaries about the setting in this same catalogue, pp. 113–114. See Cooper, *Gauguin: Lettres*, pp. 165, 169, 275, 277, for Gauguin's descriptions.

26. On the press comments, lack of sales, and new financial problems for Gauguin after the 1889 fair, see Terrasse, *Pont-Aven*, pp. 74–75; Rewald, *Post-Impressionism*, pp. 260–266; and Thomson, *Gauguin*, pp. 91–102. The references to suffering, melancholy, and despair are registered in Gauguin's letters of these months. See, for example, Cooper, *Gauguin: Lettres*, pp. 165–179, 273–279; Maurice Malingue, ed., *Lettres de Gauguin à sa femme et à ses amis* (Paris: Grasset, 1949), pp. 170–175.

27. Noted by Rewald, *Post-Impressionism*, p. 284, and Brettell et al., *Art of Gauguin*, p. 157; this coloring is visible at the site.

28. Brettell et al., *Art of Gauguin*, p. 157; Welsh-Ovcharov, in *Cloisonism*, p. 208, also stresses the ambiguity of "the here-and-now and the eternal."

29. The quote about blotting is from Thomson, *Gauguin*, p. 108; Brettell et al. also note the newsprint pressing of the top of *The Yellow Christ*, in *Art of Gauguin*, p. 156; Reinhold Heller identified Gauguin's impulses to disguise the medium of oil paint in "Concerning Symbolism and the Structure of the Surface," *Art Journal* 45, no. 2 (summer 1985): 148–149.

30. Cited in Welsh-Ovcharov, *Cloisonism*, p. 214; Cooper, *Gauguin: Lettres*, p. 165. Other comments of Gauguin from these same months emphasized

the "sadness," "poverty," and relentless but resigned "struggle for existence" in the bleakness of the Le Pouldu setting, such as his statements in a letter to van Gogh, in Cooper, *Gauguin: Lettres*, p. 277, and one to Aurier, cited in Welsh-Ovcharov, *Cloisonism*, p. 216.

31. Terrasse, *Pont-Aven*, p. 76.

32. Gauguin wrote these comments, which included more statements on the suffering, poverty, and sadness of Breton life, on a calling card he apparently left with Albert Aurier, reproduced in Welsh-Ovcharov, *Cloisonism*, pp. 214–216, and cited in Terrasse, *Pont-Aven*, p. 77.

33. Cited in Welsh-Ovcharov, *Cloisonism*, p. 214; Cooper, *Gauguin: Lettres*, p. 165.

34. There is some discrepancy about the exact dating of the dining room and the stages of its production; I am relying on the information provided by Robert Welsh, "Gauguin et l'auberge de Marie Henry au Pouldu," *Revue de l'Art* 86 (1989): 35–43, which examines all aspects of the ensemble; *Le Chemin de Gauguin*, p. 124; Brettell et al., *Art of Gauguin*, p. 47; and Henri Dorra, "Le 'Texte Wagner' de Gauguin," *Bulletin de la Société de l'Histoire de l'Art Français* (1984), pp. 281–288. I cannot do justice here to the full range of contributions and the complexity of this decorative program. I will highlight three underemphasized qualities in the ensemble: the Marie-Henry Inn as a counter to van Gogh's Yellow House; the traces of Gauguin's concern with visionary experience and folk piety, and the presence of the theme of sin and affliction; and the explicit affirmation, through an inscription painted along the walls, of an art dedicated to transcendent purity, shorn of contact with a material world declared as fundamentally sullying and corrupting. The *Chemin de Gauguin* catalogue provides indispensable illustrations unavailable elsewhere, pp. 110–127; Terrasse, *Pont-Aven*, offers a reconstruction drawing and inventory, pp. 143–145. Visitors to Le Pouldu can now view the reconstructed rooms and some copies of the murals in the original setting, at La Buvette de la Plage, 10, rue des Grands Sables, Le Pouldu.

35. Roland Dorn reconstructed the full complement of canvases and groupings in his *Décoration: Vincent van Goghs Werkreihe für das Gelbe Haus in Arles* (Hildesheim: Georg Olms Verlag, 1990), pp. 601–613.

36. A Dutch Jew who abandoned his family's lucrative biscuit manufacture for painting, de Haan had a short career and died in 1895. He was romantically involved with the innkeeper Marie Henry and had a child with her. See Pickvance, *Pont-Aven*, pp. 105–111; Welsh-Ovcharov, *Cloisonism*, pp. 346–358.

37. Quoted in Welsh-Ovcharov from an unpublished letter, in which de Haan described his panel as "wholly and unbelievably different" from Gauguin's mural, in ibid., p. 350.

38. Gauguin, in Cooper, *Gauguin: Lettres*, p. 273, as emphasized by Welsh-Ovcharov, *Cloisonism*, who notes the "dissimulation" of religion, p. 210. The first scholar to take the mural seriously as a Joan of Arc figure was Vojtěch Jirat-Wasiutyński in his *Paul Gauguin in the Context of Symbolism* (New York: Garland, 1978), pp. 151–154.

39. Welsh-Ovcharov, *Cloisonism*, pp. 210–211.

40. See Chapter 5 at n. 64.

41. Félix Dupanloup, Bishop of Orléans, *Joan of Arc, a Discourse Delivered on May 8, 1869, in the Cathedral of Holy Cross, Orléans*, trans. Emily Bowles (London: Burns, Oates, 1869), pp. 1–14.

42. See Chapter 4 at n. 45.

43. Goldwater, *Gauguin*, pp. 31–32, and David Sweetman, *Paul Gauguin: A Life* (New York: Simon and Schuster, 1995), pp. 226–228, note Gauguin's interest in Javanese peoples, the temple at Borobudur, and the Cambodian pavilion. The melding of the Joan of Arc with Japonism and Egyptian hieratic poses is mentioned by Welsh-Ovcharov in *Cloisonism*, pp. 210–211. A recent study of Gauguin by Jirat-Wasiutyński and Travers Newton does treat the dining room decoration at the Marie-Henry Inn as a serious ensemble and offers new evidence of the ways that Gauguin adapted some traditional methods of fresco painting in his mural. See Vojtěch Jirat-Wasiutyński and H. Travers Newton Jr., *Technique and Meaning in the Paintings of Paul Gauguin* (New York: Cambridge University Press, 2000), pp. 176–181.

44. On Filiger see Musée de Pont-Aven, *Le Cercle de Gauguin en Bretagne* (Pont-Aven, 1994), pp. 16–20; comments on Filiger's fresco of the Virgin at the inn are noted in the 1890 memoirs reproduced in *Chemin de Gauguin*, pp. 114–115; this catalogue also has the only full list, with illustrations, of the range of Filiger's religious art in Marie Henry's collection, such as the *Angel, Martyrdom of Saint John the Evangelist, Christ and the Virgin*, and *Saint Francis*, pp. 120, 130–131, 212–213.

45. Cited in Terrasse, *Pont-Aven*, p. 144.

46. *Chemin de Gauguin*, p. 121.

47. Boyle-Turner, *Sérusier*, p. 48.

48. Welsh, "Gauguin et l'auberge," pp. 42–43, 38. Welsh lists the panel as being by Sérusier but emphasizes—to my view, rightly—that it has central thematic links to Gauguin's preoccupations and to his depictions of Eve and the Fall, and that it strengthens the totality of symbolic clusters in the room.

49. Welsh, "Gauguin et l'auberge," p. 42.

50. Illustrated in Brettell et al., *Art of Gauguin*, p. 468. On the inside *front* cover of the text Gauguin placed an illustration that included yet another figure of the hunched and open-mouthed *misères humaines*.

51. Paul Sérusier, *ABC de la peinture, suivi d'une correspondance inédite* (Paris: Floury, 1950), pp. 41–42. The dating of the inscription as fall of 1889 has been established by Boyle-Turner, *Sérusier*, p. 47; Dorra, "Le 'Texte Wagner' de Gauguin," p. 283; and Welsh, "Gauguin et l'auberge," pp. 36–37. The Pont-Aven Museum reproduces the inscription in its document hall and attributes it to Gauguin, though scholars consider Sérusier responsible for the inscription, based on shared ideas and shared reading of Wagner texts with Gauguin.

52. Cited in Terrasse, *Pont-Aven*, documents, p. 132.

53. For documentation of the passages from the Wagner texts, and Gauguin's manuscripts, see Dorra, "Le 'Texte Wagner' de Gauguin," pp. 281–287. These notes by Gauguin are in the manuscript collection of the Bibliothèque Nationale in Paris.

54. I have translated the full text from the French reproduced at the Pont-Aven Museum documentation gallery; see also Sérusier, *ABC*, p. 42. The French reads: "Je crois à un jugement dernier où seront condamnés à des peines terribles tous ceux qui en ce monde auront osé trafiquer de l'art sublime et chaste, tous ceux qui l'auront souillé et dégradé par la bassesse de leurs sentiments, par leur vile convoitise pour les jouissances matérielles . . . Je crois qu'en revanche les disciples fidèles du grand art seront glorifiés et qu'enveloppés d'un celeste tissu de rayons, de parfums, d'accords mélodieux, ils retourneront se perdre pour l'éternité au sein de la divine source de toute harmonie."

55. Cited in Michael Howard, *Gauguin* (London: Dorling Kindersley, 1992), p. 35.

56. Emphasis Gauguin's, quoted in Welsh-Ovcharov, *Cloisonism*, p. 218; I have altered the translation slightly to suit the French, which is reproduced on the calling-card original on p. 219; and in Howard, *Gauguin*, p. 35.

57. Malingue, *Gauguin: Lettres à sa femme et à ses amis*, pp. 171, 173–174.

58. Cited in Brettell et al., *Art of Gauguin*, p. 163; French in Malingue, *Gauguin*, pp. 173, 175. For other information on the circumstances of the self-portrait and Gauguin's sense of loss and betrayal, see Ziva Amishai-Maisels, *Gauguin's Religious Themes* (New York: Garland, 1985), pp. 80–86.

59. Gauguin to Schuffenecker, October 1888, cited in Brettell et al., *Art of Gauguin*, p. 104; Merlhès, *Correspondance*, p. 255.

60. "Je suis l'homme des sacrifices," Gauguin to van Gogh, September 22, 1888, in Cooper, *Gauguin: Lettres*, p. 215; Gauguin to Schuffenecker, October 1888, in Guérin, *Writings of a Savage*, p. 23: French in Merlhès, *Correspondance*, p. 249.

61. Gauguin, quoted in English in William Darr and Mary Matthews Gedo, "Wrestling Anew with Gauguin's *Vision After the Sermon*," in Mary Matthews Gedo, *Looking at Art from the Inside Out* (New York: Cambridge University Press, 1995), p. 67; French in Cooper, *Gauguin: Lettres*, pp. 221–222.

62. On *The Vision*, see Chapter 3; for the self-portrait, and the statement of colors "far from nature," see n. 46 in Chapter 1.

63. The quote on the incomprehensibility of the 1888 self-portrait is at n. 46 in Chapter 1; the new comments on the Christ painting's incomprehensibility, and its colors, are in Gauguin's letter to van Gogh, in Cooper, *Gauguin: Lettres*, p. 283.

64. All quotes in Chapter 1 at nn. 45, 46, 54.

65. Welsh-Ovcharov, *Cloisonism*, p. 218.

66. Cited in ibid., p. 219; the writer is Albert Aurier.

67. Gauguin, letter to Schuffenecker, quoted in Robert Goldwater, *Gauguin* (New York: Abrams, 1983), p. 58; original in Merlhès, *Correspondance*, p. 210, #159, August 1888: "L'art est un abstraction; tirez-la de la nature en rêvant devant et pensez plus à la création qu'au résultat c'est le seul moyen de monter vers Dieu en faisant comme notre divin maître créer—" (lack of punctuation Gauguin's).

68. Thomson, *Gauguin*, p. 116.

69. On the Renan postscript in Gauguin's manuscript, see Sweetman, *Gauguin*, p. 453; I will return to this in my final chapter. Bernard was critical of Gauguin's human Christ when he linked it to Renan, cited in Thomson, *Gauguin*, p. 118.

70. On Renan's history as offering a new form of empathic identification with Christ, see Thomas A. Kselman, *Miracles and Prophecies in Nineteenth-Century France* (New Brunswick, N.J.: Rutgers University Press, 1982), pp. 96–97.

71. Ernest Renan, *Vie de Jésus*, 13th ed. (Paris: Levy Frères, 1867), pp. 282–283.

72. Ibid., pp. 473–474.

73. Ibid., p. 474.

74. Ibid., pp. 461, 474. "Son parfait idealisme est la plus haute règle de la vie détachée et vertueuse. Il a crée le ciel des âmes pures, où se trouve ce qu'on demande en vain à la terre, . . . la sainteté accomplie, la totale abstraction des souillures du monde, la liberté enfin, que la société réele exclut comme une impossibilité, et qui n'a toute son amplitude que dans le domaine de la pensée. Le grand maître de ceux qui se refugient en ce paradis idéal est encore Jesus . . . En lui s'est condensé tout ce qu'il y a de bon et d'elevé dans notre nature."

75. See Chapter 4, at nn. 28, 29.

76. The phrase of Thomson, *Gauguin*, p. 116.

77. Rewald, *Post-Impressionism*, pp. 293–297; Pickvance, *Van Gogh in Arles*, pp. 239–241.

78. Van Gogh, *Letters*, 3:450, W11. See also 3:453, W12.

79. Ibid., 3:449–450, W11.

80. Ibid., 3:451, W11.

81. Ibid., 3:452; *petit travail* in French, in *Verzamelde Brieven van Vincent van Gogh* (Amsterdam and Antwerp: Wereld Bibliotheek, 1955), 3:479.

82. The passages copied out from Renan are in Fieke Pabst, ed., *Vincent van Gogh's Poetry Albums* (Zwolle: Waanders, 1988), p. 26. The particular Renan text is explained by Pabst and a co-author, Evert van Uitert, in an indispensable study that documents what van Gogh read, "A Literary Life, with a List of Books and Periodicals Read by van Gogh," in *Rijksmuseum van Gogh, Catalogue of the Collection* (Waanders, 1987), pp. 68–84, especially p. 80. This study, and Pabst's project of reconstituting van Gogh's library, now completed at the Amsterdam Van Gogh Museum, provide essential tools for studying not only what van Gogh read, but how he read, the patterns and themes of his choices and underlinings.

83. Van Gogh, *Letters*, 3:158, LT 587.

84. Ibid., 3:451, W11, emphasis his.

85. Ibid., 3:183; 3:188, LT 595, LT 597.

86. Ibid., 3:242, 241, LT 620.

87. The other work was an allegorical painted wood sculpture bearing the title "Soyez amoureuses, vous serez heureuses"—"Be in love and you will be happy." This allegory was explained sardonically by Gauguin in the same letter as depicting a monster with his own features forcibly pulling a nude woman up to him by the arm. The panel was divided into two zones, stated Gauguin; the upper part an urban "Babylon," and the lower area a rural setting where he carved a seated figure—another "desolate woman" of the *misères humaines*. This sculpture, with its divided panels, and themes of sexuality, debauchery, and desolation, show interesting continuities with the vanities box of 1884–1885. The panel is described and sketched by Gauguin in the letter to van Gogh in Cooper, *Gauguin: Lettres*, pp. 285–286, November 1889.

88. Bernard, forbidden by his parents to paint with Gauguin at Le Pouldu, was working in another part of Brittany, corresponding with Gauguin and exploring themes with him.

89. Van Gogh, *Letters*, 3:229, LT 614.

90. Ibid., 3:233, LT 615; French is "ils m'avaient fait enrager avec leurs Christs du jardin, où rien n'est observé" (in *Verzamelde Brieven*, 3:478). The English translation is not quite right—it renders the French as "gotten on my nerves" for "m'avaient fait enrager."

91. Ibid., 3:229, LT 614; 3:233, LT 615; 3:232, LT 614a.

92. Ibid., 3:233; LT 615.

93. Ibid., 3:229, LT 614. French in *Verzamelde Brieven*, 3:475.

94. Ibid., 3:234, LT 615; emphasis mine.

95. Ibid., 3:228, LT 614; 3:233–235, LT 615; emphasis his.

96. Ibid., 3:229, LT 614.

97. Ibid., 3:232, LT 614a.

98. Ibid., 3:522, B21; I have adjusted it with the French, in *Verzamelde Brieven*, 4:234. The terms "bizarre" and "highly debatable" are from van Gogh's letter to Wil about these biblical compositions, W16, November 1889, in the French, 4:176.

99. Ibid., 3:524, B21.

100. Ibid., 3:525, B21.

101. Ibid., 3:524, B21.

102. Ibid., 3:524, B21.

CHAPTER 11. VAN GOGH'S *BERCEUSE*

1. Vincent van Gogh, *The Complete Letters of Vincent van Gogh*, 2d ed. (Boston: New York Graphic Society, 1978), 3:101, LT 560, ca. December 4, 1888; emphasis his.

2. Dating and reconstruction of the exact timing and circumstances of the painting and the copies have been established by Jan Hulsker, "Van Gogh, Roulin, and the Two Arlésiennes: Part I," *Burlington Magazine* 194 (1992): 570–577, based on the testimony of van Gogh's letters. See also *Letters*, 3:123–147, LT 571a, LT 573, LT 574, LT 576, LT 578, LT 582, January–March 1889.

3. Van Gogh, *Letters*, 3:115–117, LT 570; 3:119–122, LT 571.

4. Ibid., 3:111, LT 566.

5. Ibid., 3:121, LT 571.

6. Ibid., 3:122, LT 571.

7. Ibid., 3:112, LT 567; 3:115, LT 570.

8. Ibid., 3:112–113, LT 567; 3:130, LT 574.

9. Ibid., 3:115–119, LT 570, LT 571.

10. Ibid., 3:120, LT 571; 3:124–126, LT 572; 3:130–131, LT 574.

11. Ibid., 3:127, LT 572; 3:130, LT 574.

12. As van Gogh noted, the increase in pay was microscopic but welcome, though he considered it poor compensation after so many years of Roulin's service. Interestingly, van Gogh specified in his letter that Roulin's salary in Arles was 135 francs per month, which he used to sustain a family of five. At an average rate of 50 francs per week sent to him by Theo, this would mean that van Gogh was receiving at least 65 francs more per month than Roulin. See ibid., 3:120, LT 571; 3:125, LT 572.

13. Ibid., 3:125, LT 572; 3:442, W6; 3:147–148, LT 583.

14. He concluded the ceremony with a rendition of the *Marseillaise*, and explained that he named the baby Marcelle after the daughter of General Boulanger, whom he supported in the election. Ibid., 3:442, W6. On Roulin and the family, see also J. N. Priou, "Van Gogh et la famille Roulin," *Revue de PTT de France* 10, no. 3 (May–June 1955): 26–32; and Pierre Michon, *Vie de Joseph Roulin* (Dijon: Verdier, 1988), which captures the tone and intimacy of the Roulin family life.

15. See *Letters*, 3:111–126, and the day-to-day calendar reconstituted by Ronald Pickvance, *Van Gogh in Arles* (New York: Metropolitan Museum of Art, 1984), p. 239.

16. See excerpts in Pickvance, *Van Gogh in Arles*, p. 239.

17. Van Gogh, *Letters*, 3:111, LT 566; 3:120, LT 571; 3:114, LT 569.

18. Ibid., 3:120, LT 571.

19. Ibid., 3:128, LT 573.

20. Here I follow the order established by Hulsker in his "Van Gogh, Roulin, and the Two Arlésiennes," pp. 572–576.

21. The model's hands are crossed with right over left in the Annenberg painting, while the other four show Mme Roulin seated with hands folded left over right, with the left hand uppermost and wedding band visible. See ibid., p. 573.

22. Van Gogh, *Letters*, 3:123, LT 571a.

23. Van Gogh's debt in *La Berceuse* to Gauguin's cloisonism is emphasized in *Vincent van Gogh: The Kröller-Müller National Museum* (Otterlo: Kröller-Müller Museum, 1980), p. 95; and Evert van Uitert, Louis van Tilborgh, and Sjraar van Heugten, *Van Gogh: Paintings* (Milan: Arnoldo Mondadori Arte, 1990), p. 196. The choice of the vermilion color for the floor is reminiscent of Gauguin's red field in *The Vision After the Sermon*; my thanks to Robert Herbert for reminding me of this.

24. Van Gogh describes the complexion as "chrome yellow" in *Letters*, 3:123, LT 571a.

25. "Bluish green" is van Gogh's choice of words in ibid.

26. Think of the oversize hands in Oscar Kokoschka's portraits, which were influenced by van Gogh's; but Kokoschka's figures' hands are animated by a pulsating, electric, nervous energy, rather than by the wearing and swelling effects of labor that van Gogh represented in his.

27. This same series of letters and commentaries was compiled and translated by Hulsker in his article "Van Gogh, Roulin, and the Two Arlésiennes"; I am revisiting the series for a different interpretive purpose.

28. Van Gogh, *Letters*, 3:123, LT 571a.

29. The Dutch terms are *de wiegster*, the woman who rocks the cradle, and *die wieglied*, the lullaby she sings beside it, as van Gogh writes in the Dutch letter to Koning in *Verzamelde Brieven van Vincent van Gogh* (Amsterdam and Antwerp: Wereld Bibliotheek, 1955), 3:376.

30. Van Gogh, *Letters*, 3:123–124, LT 571a.

31. The van Gogh letter is in Douglas Cooper, *Paul Gauguin: 45 Lettres à Vincent, Théo et Jo van Gogh* ('s-Gravenhage: Staatsuigeverij, 1983), p. 265. It

has not, to my knowledge, been translated into English. The passages on Joseph Roulin as *berceuse* and *nourrice* are on p. 265; the painting of Madame Roulin is introduced on p. 269.

32. Ibid., p. 269: "Comme arrangement de couleurs les rouges allant jusqu'aux purs orangés s'exaltant encore dans les chairs jusqu'aux chromes passant dans les roses et se mariant aux verts olives et véronèse Comme arrangement de couleurs je n'ai jamais inventé mieux." (Lack of punctuation his.) Slightly varying translations of this passage may be found in Pickvance, *Van Gogh in Arles*, p. 246; and Hulsker, "Van Gogh, Roulin, and the Two Arlésiennes," p. 570.

33. Van Gogh in Cooper, *Gauguin: Lettres*, p. 269; *Letters*, 3:26, LT 351, September 1888.

34. Van Gogh, in Cooper, *Gauguin: Lettres*, p. 269: "Et je crois que si on plaçait cette toile telle quelle dans un bateau de pêcheurs meme d'Islande il y en aurait qui sentiraient là-dedans la berceuse."

35. "Ah, mon cher ami faire de la peinture ce qu'est déjà avant nous la musique de Berlioz et de Wagner . . . un art consolateur pour les coeurs navrés!" In Cooper, *Gauguin: Lettres*, p. 269; translations vary, such as those in Hulsker, "Van Gogh, Roulin, and the Two Arlésiennes," p. 576; and Pickvance, *Van Gogh in Arles*, p. 246.

36. Van Gogh, *Letters*, 3:225, LT 531.

37. Ibid., 3:448, W9.

38. Van Gogh, *Letters*, 3:129, LT 574, January 28.

39. Ibid.

40. Ibid., 3:133, LT 576, February 3.

41. Ibid., 3:133, LT 576; 3:146, LT 582. Louis van Tilborgh has identified the chromos as "twopenny or halfpenny colored prints" in his notes in van Uitert et al., *Van Gogh: Paintings*, p. 196.

42. Van Gogh, *Letters*, 3:146, LT 582. I have inserted the corrected translation of Jan Hulsker, who pointed out that van Gogh's phrase is not, as in the English edition, pointing to the sailor's *wife* ashore but to a *woman* ashore: "je cherche à faire une image tel qu'un matelot, qui ne saurait pas peindre, en imaginerait lorsqu'en plein mer il songe à une femme d'à terre" (*Verzamelde Brieven*, 3:398); Jan Hulsker, *Vincent van Gogh: A Guide to His Work and Letters* (Amsterdam: Van Gogh Museum, 1993), p. 68.

43. For the British print genre and van Gogh's emulation of "heads of the people," see Ronald Pickvance, *English Influences on Vincent van Gogh* (Nottingham: Arts Council of Great Britain, 1975); and Charles Chetham, *The Role of Vincent van Gogh's Copies in the Development of His Art* (New York: Garland, 1976), chap. 2 and passim. Van Gogh calls the print genre "a noble calling," and it offers him both a form of service through art and the validation of tangible craft production, which I treat in my article "Weaving Paintings: Religious and Social Origins of Vincent van Gogh's Pictorial Labor," in *Rediscovering History: Culture, Politics, and the Psyche,* ed. Michael S. Roth (Stanford: Stanford University Press, 1994).

44. The catalogue entry to *La Berceuse* in the Philadelphia Museum of Art suggests that the image signaled the roles of the woman by her ring and rope. *Masterpieces of Impressionism and Post-Impressionism: The Annenberg Collection* (Philadelphia: Philadelphia Museum of Art, 1989), p. 103.

45. Van Gogh, *Letters*, 3:132, LT 575.

46. Ibid., 3:133; 3:137, LT 576, LT 578.

47. Ibid., 3:129, LT 574.

48. Ibid., 3:132, LT 575.

49. Van Gogh, in Cooper, *Gauguin: Lettres*, p. 267; *Letters*, 3:128, LT 573.

50. Van Gogh, *Letters*, 3:20, LT 527; 3:511, B15 (both letters from August 1888).

51. Ibid., 3:171, LT 592, May 1889.

52. Ibid., 3:171–172, LT 592.

53. Ibid., 3:257, LT 626a, ca. February 1890. Emphasis mine.

54. Van Uitert et al., *Van Gogh: Paintings*, pp. 194, 195.

55. W. Uhde, *Van Gogh* (Oxford: Phaidon, 1981), pl. 34.

56. Emile Bernard, "Vincent van Gogh," *Les Hommes d'Aujourd'hui* 8, no. 390, n.p.

57. Van Gogh, *Letters*, 3:211, LT 605.

58. The term and idea of *La Berceuse* as exemplifying a "chain of associations" rather than a clear "iconographic program" was suggested by Evert van Uitert in his "Vincent van Gogh and Paul Gauguin in Creative Competition: Vincent's Original Contribution," *Simiolus* 11, no. 2 (1980): 85. I use the concept here to identify a different "chain" from the one he proposed.

59. *The Annenberg Collection*, p. 102.

60. Musée Royal des Beaux-Arts, Anvers, *Catalogue descriptif: Maîtres*

anciens (Antwerp: Van Rijswijck, 1948), p. 101; Gustave Hermans, *Musée d'Anvers, Recueil de 200 photogravures d'après les chefs-d'oeuvres de la Galérie des Maîtres Anciens* (Antwerp: Hermans, 1925), p. 411; Charles D. Cuttler, *Northern Painting from Pucelle to Bruegel* (New York: Holt, Rinehart, 1968), pp. 100–102.

61. Ludwig van Baldaas, *Hans Memling* (Vienna: Schroll, 1942).

62. The original is in Bruges in the Groeningemuseum.

63. Red and green embroidered symbols of the Virgin Mary radiating out from a lively pattern of gilded, interlacing lilies and roses formed the chasuble rendered by Angélique, the apprentice embroideress of the contemporary novel van Gogh read in November 1888 by Emile Zola, *Le Rêve* (*The Dream*) (Paris: Fasquelle, 1911, first published 1888). This book, exploring what Zola called the turn beyond naturalism to the realm of the *au-delà* (the ideal), featured the sacrifice and sacred craft of Angélique as she devoted herself to rendering and emulating the lives of virgin saints. Zola's book gives extensive description of the color arrangements, techniques, and stitches used by the Hubert family embroidery workshop. Angélique's supreme artistry is defined through the book as embodying visions in cloth and threads, the materialization of the invisible in her skilled métier (pp. 29, 52, 55–56, 59, 65–66, 116). Zola studied embroidery manuals and histories, such as the 1770 *L'Art du brodeur* and the 1887 E. Lefébure *Broderie et dentelles* (Paris: Quentin), as he prepared the novel. Van Gogh mentioned reading the book in his letter to Bernard, B19a, ca. November 2, 1888, *Letters*, 3:518 (letter dated by Pickvance, *Van Gogh in Arles*, p. 263).

64. Metropolitan Museum of Art, *From van Eyck to Bruegel: Early Netherlandish Painting in the Metropolitan Museum of Art* (New York: Abrams, 1998), p. 220.

65. Based on excellent discussions of new figures, new cults, and a new humanization of the holy family with prominence given to the representations of Joseph, in ibid., pp. 90–91, 246–248; see also James Hall, *Dictionary of Subjects and Symbols in Art* (New York: Harper and Row, 1974), p. 335.

66. Eugène Fromentin, *The Masters of Past Time: Dutch and Flemish Painting from van Eyck to Rembrandt* (London: Phaidon, 1960), pp. 241, 245.

67. Ibid., pp. 246, 245.

68. Van Gogh, *Letters*, 2:294; see also 3:109; 3:111; 3:211; 3:407, for other comments on Fromentin.

69. A. M. and Renilde Hammacher, *Van Gogh: A Documentary Biography* (New York: Macmillan, 1982), p. 128. I rely on Hammacher's discussion and photograph of the Andrieskerk window, though he does not relate it to *La Berceuse*.

70. Van Gogh, *Letters*, 2:467, LT 443, January 1886.

71. Pierre Loti, *An Iceland Fisherman*, trans. James Cambon (New York: Collier and Son, 1932), p. 18.

72. Ibid., pp. 4, 5.

73. Here I use the translation cited in Judy Sund, *True to Temperament: Van Gogh and French Naturalist Literature* (New York: Cambridge University Press, 1992), p. 220, who also discusses the painting and the novel.

74. Loti, *Fisherman*, trans. Cambon, p. 72.

75. Ibid., pp. 16–19, 246.

76. Van Gogh, *Letters*, 3:97, LT 558b.

77. Van Gogh, letter to Gauguin, in Cooper, *Gauguin: Lettres*, p. 269.

78. Van Gogh, *Letters*, 3:129, LT 574; see also 3:171, LT 592.

79. Ibid.

80. See, for example, van Uitert, "Van Gogh and Gauguin: Vincent's Contribution," pp. 85–86; Sund, *True to Temperament*, pp. 220–221; van Tilborgh, *Centenary Catalogue*, p. 195; Zemel, *Van Gogh's Progress*, p. 119; and Uhde, *Van Gogh*, pl. 34.

81. Loti, *Fisherman*, trans. Cambon, pp. 17–19, 246.

82. Ibid., pp. 35, 271–272; see French in Loti, *Pêcheur d'Islande* (Paris: Hachette, 1974), pp. 31, 186–187.

83. Van Gogh, letter to Gauguin, in Cooper, *Gauguin: Lettres*, p. 217, January 24, 1889.

84. The schedule of the mounting of the crèches, the stages of installation and of the santons' staggered placement, the timing of the market, and the end of the crèche cycle are described in Claude Seignolle, *Le Folklore de la Provence: Contributions au folklore des provinces de France* (Paris: Maisonneuve et Larose, 1963), 7:219–222; A. Le Maréchal, "La Foire aux santons," *Les Santons de Provence* (Marseille: Editions PEC, 1993), n.p.; Jean-Paul Clébert, *Les Fêtes en Provence* (Avignon: Aubanel, 1982), pp. 11–15; and the indispensable G. Arnaud d'Agnel and Leopold Dor, *Nöel en Provence: Usages, crèches, santons, Nöels, Pastorales* (Marseille: Editions Jeanne Laffitte, 1975), pp. 63–66, 143–144.

85. See d'Agnel and Dor, *Noel en Provence*, pp. 75–105, with discussions

of individual workshops; Claire Tiévant, *Almanach de la mémoire et des coutumes, Provence* (Paris: Albin, 1984), n.p., entries of December 10–13; Regis Bertrand et al., *Provence* (Paris: Bonneton, 1989), pp. 233–234, 240; and Le Maréchal, *Santons de Provence*, passim. One of the best ways to consider the history and development of the crèches and the santons is to visit the installations in the Musée Arlaten in Arles, which chronicles the changing materials and types of this popular art. Unfortunately, the museum does not allow photographs to be taken.

86. D'Agnel and Dor, *Nöel en Provence*, pp. 107–108, 118–119; Bertrand et al., *Provence*, p. 234; Le Maréchal, *Santons de Provence*, passim. D'Agnel and Dor discuss how the crèches would incorporate the flora and sites of different towns, such as the re-creation of a miniature model of Daudet's windmill for the towns near Fontvieille, including Arles; this is illustrated in a photo of a crèche in Le Maréchal, *Santons de Provence*, n.p., "Au Pied du moulin."

87. Clébert, *Fêtes*, pp. 26, 12–14. See also Tiévant, *Almanach*; Bertrand et al., *Provence*, pp. 233–234; and Le Maréchal, *Santons de Provence*, passim.

88. D'Agnel and Dor, *Nöel en Provence*, p. 101; Le Maréchal, *Santons de Provence*, with excellent color photos and descriptions.

89. Le Maréchal, *Santons de Provence*, n.p., entries on the gypsies and the regional musicians playing the farandole; d'Agnel and Dor, *Nöel en Provence*, pp. 97, 101, 103, 108–113.

90. Cited in d'Agnel and Dor, *Nöel en Provence*, pp. 83, 93–94, 101–102, quote on p. 101.

91. Ibid., p. 95.

92. Seignolle, *Folklore de Provence*, pp. 219–220; Bertrand et al., *Provence*, p. 234; d'Agnel and Dor, *Nöel en Provence*, pp. 67–69.

93. Seignolle, *Folklore de Provence*, p. 220; d'Agnel and Dor, *Nöel en Provence*, pp. 56–57.

94. Tiévant, *Almanach de Provence*, n.p., entry of December 31.

95. Theodore Aubanel, *Feuilles perdues: Oeuvres complètes*, with notes and trans. by Claude Liprandi (Avignon: Aubanel, 1983; originally published in 1865 in *Li nouve de Micaulou Saboly di Felibre*), 3:70–73; notes on 3:206–207.

96. D'Agnel and Dor, *Nöel en Provence*, pp. 140–218; Clébert, *Fêtes*, pp. 26–31; Le Maréchal, *Santons de Provence*, n.p., "La Pastorale et les Nöels"; Bertrand et al., *Provence*, pp. 233–234; Tiévant, *Almanach*, n.p., entries of December 15–18.

97. D'Agnel and Dor, *Nöel en Provence*, pp. 199–214, with photos and discussions of the different acting troupes and their "stars."

98. Van Gogh, *Letters*, 3:131, LT 574, January 28, 1889.

99. The local Folies Arlésiennes theater in the late nineteenth century was reported in the local archives to seat eighteen hundred people. See the 1894 report of "Bail Dalbert concernant les Folies Arlésiennes," entry IV R8, R97, Archives Municipales, Arles, p. 3.

100. "Théatre d'Arles," *Le Forum Républicain: Journal de l'Arrondissement d'Arles* (January 13, 1889), n.p. For confirmation that this was the only Pastorale performed in Arles that winter, see Paul Mariton, "Chronique," *La Revue Félibréenne* (1889), p. 235; and the *Armana Provençau* (1890).

101. The play, with sketches of the characters and musical scores and lyrics, was later published in E. and A. Perret, *Riboun: Pastouralo, Opéra coumique en 5 ate* (Aix-en-Provence: Makaire, 1925). It is dedicated to Frédéric Mistral, and inscribed by the brothers with site and date: "Eyguières, 1888." I am indebted to Elizabeth Covington and Aaron Segal for helping me track down the play, which we could not find in the archives or libraries of Arles; it was found in the collection of the New York Public Library. Aaron Segal helped enormously in getting a copy of the play, deciphering the sections in the Occitan dialect, and identifying the subplots and themes.

102. Van Gogh, *Letters*, 3:131, LT 574. He thought, mistakenly, that the play was put on by the Félibres group. Though the Perret brothers admired Mistral, they were not official members of the Félibres society or movement. Interestingly, however, in one scene in the play there is a reference to a character becoming a member of the Félibres circle.

103. Ibid.

104. Van Gogh, *Letters*, 3:133, LT 576, February 3, 1888, emphasis his.

105. Ibid., 3:131, LT 574.

106. Joseph Pennell and Elizabeth Robins Pennell, *Play in Provence* (New York: Century Co., 1892), pp. 167–168; Tiévant, *Almanach*, n.p., entries of May 24, 25; Camille Mauclair, *La Provence* (Grenoble: Arthaud, 1935), p. 109.

107. Mauclair, *Provence*, p. 109; Tiévant, *Almanach*, entry of May 25, noting also the name "Notres-Dames-de-la-Mer"; Tudor Edwards, *Lion of Arles: A Portrait of Mistral and His Circle* (New York: Fordham University Press, 1964), p. 47; Seignolle, *Folklore de Provence*, p. 195.

108. For descriptions and history see Pennell and Pennell, *Play in*

Provence, pp. 170–173; Michelle Goby, *La Provence: Art et histoire* (Paris: Arthaud, 1980), pp. 241–242; M. le Chanoine A. Chapelle, *Les Saintes-Maries-de-la-Mer: L'Eglise et le pèlerinage, notice historique* (Marseille: Moullot, 1926), especially pp. 11–117; Pierre Dupuy, *Le Guide de la Camargue* (Lyon: La Manufacture, 1989), pp. 292–299.

109. Pennell and Pennell, *Play in Provence*, pp. 172–173, 175–192.

110. Edwards, *Lion of Arles*, p. 46; Marcel Brion, *Provence* (New York: Oxford University Press, 1963), pp. 105–107; Mauclair, *Provence*, pp. 106–108.

111. Pennell and Pennell, *Play in Provence*, pp. 172–173; Mauclair, *Provence*, p. 113.

112. I have relied on the descriptions of Pennell and Pennell, *Play in Provence*, pp. 175–192; T. A. Cook, *Old Provence* (New York: Scribner's, 1905), 2:110–113; Chappelle, *Les Saintes-Maries*, esp. pp. 90–117; Clébert, *Fêtes*, pp. 134–139; Mauclair, *Provence*, pp. 110–114; Goby, *Provence*, pp. 242–243.

113. Quoted in Clébert, *La Provence de Mistral* (Aix-en-Provence: Edisud, 1970), p. 41.

114. Pennell and Pennell, *Play in Provence*, pp. 180–189, quote on p. 189.

115. Quoted in ibid., p. 175.

116. Frédéric Mistral, *Mireille*, part 1, pp. 33–35; recounted in Edwards, *Lion of Arles*, pp. 68–71; see also the Palais de Chaillot, *Mireille: Le Chef d'oeuvre de Mistral dans l'histoire littéraire et dans son cadre provençal* (Paris: Editions des Musées Nationaux, 1960), pp. 68–94.

117. Recounted in Seignolle, *Folklore de Provence*, p. 195.

118. Ralph Gibson, *A Social History of French Catholicism, 1789–1914* (London: Routledge, 1989), p. 155.

119. The indispensable studies here are Bernard Cousin, *Le Miracle et le quotidien: Les Ex-Voto provençaux, images d'une société* (Aix-en-Provence: Société, Mentalités, Cultures, 1983), especially chaps. 1–7; Bernard Cousin, *Ex-Voto de Provence: Images de la religion populaire et de la vie d'autrefois* (Bourges: Desclée De Brouwer, 1981); and Bertrand et al., *Provence*, p. 241.

120. Bernard Cousin identifies the navigational ex-votos, and their producers and patrons, in *Le Miracle et le quotidien*, pp. 253–258, and in his *Ex-Voto de Provence*, pp. 145–164.

121. This panel from the church at Saintes-Maries-de-la-Mer is reproduced in Cousin, *Ex-Voto de Provence*, p. 111.

122. Cousin provides a complete inventory in his *Le Miracle et le quotidien*, pp. 56–73, with charts on pp. 58–61. One of the Saintes-Maries ex-votos, seen by Frédéric Mistral at the church and incorporated in his *Mireille*, describes in image and inscription the miraculous healing of the blindness of the child Marguerite Angélie in 1825. See the Palais de Chaillot, *Mireille*, p. 68.

123. Tiévant, *Almanach*, entry of May 25.

124. Pickvance, *Van Gogh in Arles*, p. 83; *Centenary Drawings Catalogue*, p. 223. According to Pickvance, van Gogh first wrote to Theo three days after the festival, on May 28, noting his plans to go to Les Saintes-Maries, and then left on Wednesday morning, May 30, arrived at midday, and stayed through Sunday, June 3.

125. Van Gogh, *Letters*, 3:490, B6.

126. Ibid., 2:588, LT 499.

127. Ibid., 2:589, LT 499.

128. Ibid., 2:589–590, LT 500; 3:490, B6; see also *Centenary Paintings Catalogue*, p. 118, and *Centenary Drawings Catalogue*, p. 224.

CHAPTER 12. GAUGUIN'S LAST TESTAMENT

1. First quote from "The Catholic Church and Modern Times," unpublished manuscript, 1897, excerpt in Daniel Guérin, *The Writings of a Savage, Paul Gauguin* (New York: Paragon, 1990), p. 164; second quote from "Modern Thought and Catholicism" ("L'Esprit moderne et le catholicisme"), unpublished manuscript, 1902, in typescript, translated and annotated by Frank Lester Pleadwell (St. Louis Museum of Art, 1927), p. 1.

2. First quote from Vincent van Gogh, *The Complete Letters of Vincent van Gogh*, 2d ed. (Boston: New York Graphic Society, 1978), 3:56, LT 543, September 1888; second quote from 3:208, LT 605, September 1889.

3. Charles Morice, in Marie Harriman Gallery, *D'Où venons nous? Que sommes nous? Où allons nous?* (New York: Harriman Gallery, 1936), n.p.

4. All quotes from Paul Gauguin, *Lettres de Paul Gauguin à Georges-Daniel de Monfried* (Paris: Crès, 1918), pp. 200–202, 206–207 (letters of February and March 1898). I will return to these letters and texts in greater detail in the last part of this chapter.

5. Belinda Thomson, *Gauguin* (London: Thames and Hudson, 1987), p. 124; see also the discussion in David Sweetman, *Paul Gauguin: A Life* (New York: Simon and Schuster, 1995), pp. 251–253.

6. Robert Goldwater, *Gauguin* (New York: Abrams, 1983), p. 17.

7. This chain of events and Gauguin's deft self-promotional tactics are well described by Richard Brettell, Françoise Cachin, Claire Frèches-Thory, Charles F. Stuckey, and Peter Zegers, *The Art of Paul Gauguin* (Washington, D.C.: National Gallery of Art, 1988), pp. 49–50; Thomson, *Gauguin*, pp. 124–125; Sweetman, *Gauguin*, pp. 251–270; and James Kearns, *Symbolist Landscapes: The Place of Painting in the Poetry and Criticism of Mallarmé and His Circle* (London: Humanities Research Press, 1989), pp. ix–xiii and chaps. 1, 2. Aurier's statement is in Albert Aurier, "Symbolism in Painting: Paul Gauguin" (1891), in *Symbolist Art Theories: A Critical Anthology*, ed. Henri Dorra (Berkeley: University of California Press, 1994), p. 197.

8. Reported by Thomson, *Gauguin*, p. 125.

9. In Brettell et al., *Art of Gauguin*, p. 50, cited from official documents in the French National Archives.

10. Ibid.

11. Camille Pissarro, *Letters to His Son Lucien*, edited with the assistance of John Rewald (New York: Pantheon, 1943), p. 170, letter of May 13, 1891.

12. For a summary of Symbolist aims and ideology, see Debora Silverman, *Art Nouveau in Fin-de-Siècle France: Politics, Psychology, and Style* (Berkeley: University of California Press, 1989), pp. 76–77; Robert Delevoy, "Manifestos and Demands," in *Symbolists and Symbolism* (New York: Rizzoli, 1982), chap. 3; John Rewald, *Post-Impressionism from van Gogh to Gauguin* (New York: Museum of Modern Art, 1978), chap. 3, which reproduces sections of the literary Symbolists' manifestos; special issue of *Revue de l'Art*, "Symbolisme," no. 96 (1992); Debora Silverman, "At the Threshold of Symbolism, 1888: Van Gogh's *Sower* and Gauguin's *Vision After the Sermon*," in Montreal Museum of Art, *Lost Paradise: Symbolism in Europe* (Montreal: Montreal Museum of Art, 1995), pp. 102–116.

13. On Morice see Paul Delsemme, *Un Théoricien du Symbolisme: Charles Morice* (Paris: Nizet, 1958), especially pp. 26–47, 171–189; with quotes used here from pp. 28, 183, 184; see also "Charles Morice," *Larousse du XX siècle* (Paris: Larousse, 1931), p. 987; and Charles Morice, *Du Sens religieux de la poésie* (Paris, 1893), and his *Il est réssuscité! The Reappearing: A Vision of Christ in Paris*, trans. Connigsby Dawson (New York: Hodder and Stoughton, 1911).

14. From Mirbeau's response to a 1902 survey on educational formation by Jean Rodes, "Enquête sur l'education," *La Revue Blanche* 28 (1902): 175; see also the chapter on Mirbeau's Jesuit education in the excellent biography by Jean-François Nivet and Pierre Michel, *Octave Mirbeau: Biographie* (Paris: Seguier, 1990), chap. 2. Mirbeau attended the Collège Saint-François Xavier from 1859 to 1863, the exact years of Gauguin's time at Saint-Mesmin.

15. Jules Huret, Gauguin's interviewer and Mirbeau's colleague at the *Echo de Paris*, described *The Calvary* as the "dolorous odyssey" of a sensitive soul locked in conflict with his sensual, "concupiscent nature." Quoted in Jules Huret, "Octave Mirbeau," *La Grande Encyclopédie* (Paris: Arroult, 1902), p. 1099. For an account of Mirbeau's literary "sexology," see Emily Apter, "Sexological Decadence: The Gynophobic Visions of Octave Mirbeau," in *The Decadent Reader*, ed. Asti Hustvedt (Cambridge: MIT Press, Zone Books, 1998), pp. 962–978.

16. Octave Mirbeau, "Paul Gauguin," in *Des Artistes, première série, 1885–1896: Peintres et sculpteurs* (Paris: Flammarion, 1922), p. 125. (This essay is the reprint of the February 16, 1891, article on Gauguin in the *Echo de Paris*.)

17. Ibid., p. 126.

18. Ibid.

19. Quoted in Kearns, *Symbolist Landscapes*, p. 31.

20. Ibid., p. 82.

21. Brettell et al., *Art of Gauguin*, p. 163.

22. The poem was published in December 1888. See G.-Albert Aurier, *Oeuvres posthumes* (Paris: Mercure de France, 1893), pp. 75–79; I have used the translation quoted in Brettell et al., *Art of Gauguin*, p. 162.

23. Aurier, "L'Oeuvre maudit," in *Oeuvres posthumes*, pp. 75–76, 78–79.

24. Ibid., pp. 86–94.

25. Albert Aurier, "Symbolism in Painting," pp. 197–202. Some of Gauguin's contemporaries, such as Camille Pissarro—who resented the article's attack on Impressionism—and some scholars, believe that Gauguin and Aurier discussed the key ideas for the article before it was completed.

26. Ibid., pp. 200, 201–202.

27. Ibid., pp. 198, 202.

28. Ibid., p. 202.

29. Ibid. For a full account of the range of Aurier's criticism, see Patricia Townley Mathews, *Aurier's Symbolist Art Criticism and Theory* (Ann Arbor, Mich.: UMI Research Press, 1986).

30. Robert Goldwater has a good discussion of the melding of visual

sources in his *Gauguin*. A provocative and original reinterpretation of the Tahitian period and Gauguin's ambivalent European and native explorations may be found in Stephen Eisenman, *Gauguin's Skirt* (London: Thames and Hudson, 1997).

31. Gauguin's ideas were expressed in the context of missionizing Catholicism in the South Seas, which I cannot examine here. The Church was not only a political and cultural power but an economic one, owning substantial property around the islands where Gauguin resided. He periodically became embroiled in conflict with local clerical authorities, alternating with episodes of attendance at daily mass and siding with the Catholic Church Party against other groups. Françoise Cachin emphasizes Gauguin's contradictory stances in her brief account in *Gauguin: The Quest for Paradise* (New York: Harry Abrams, 1992), pp. 116–117; Stephen Eisenman stresses Gauguin's progressive positions in his *Gauguin's Skirt*, passim. I am limiting my discussion here to isolating some important and overlooked continuities of Gauguin's system of thought, and examining how his enduring religious concerns were related to his search for the sacred in the new colonial setting.

32. Charles Morice, *Paul Gauguin* (Paris: Floury, 1920), p. 119.

33. Quoted in Goldwater, *Gauguin*, pp. 20–21.

34. Gauguin, *Lettres à de Monfried*, p. 186.

35. Quoted in Morice, *Gauguin*, p. 119. Gauguin's desperate circumstances from July to November are chronicled in Sweetman, *Gauguin*, pp. 450–451; and Brettell et al., *Art of Gauguin*, pp. 381–382.

36. "Art, the Catholic Church and the Modern Spirit" is the title Gauguin gave it in his November 1897 letter to Charles Morice, *Gauguin*, p. 119. The essay was also called "The Catholic Church and Modern Times" ("L'Eglise catholique et les temps modernes"), which Gauguin wrote into the blank pages at the end of his 1894 *Noa Noa* manuscript. This manuscript was never published and is now housed in the Graphic Arts collection of the Louvre. Small selections from these 1897 writings in English have been published in Guérin, *Writings of a Savage*, pp. 163–166. David Sweetman also includes some excerpts and translations of these texts in his biography, *Gauguin*, pp. 451–453. A revised version of this essay was written by Gauguin in 1902, when he added pages to the text and also prepared a set of transfer drawings for its front back and covers. This emended version, "L'Esprit moderne et le catholicisme," is now in the collection of the St. Louis Museum of Art. A typescript of the 1902 version is avail-able from the museum, as is a 1927 English translation and annotation of it by Frank Lester Pleadwell. I have consulted both the 1897 draft essay and the 1902 revised version, with thanks to Kelly Maynard in Paris and Professor Stephen Eisenman for helping me locate copies of the St. Louis Museum documents.

37. All quotes from the Guérin excerpts, *Writings of a Savage*, pp. 163–166.

38. Paul Gauguin, *Intimate Journals*, trans. Van Wyck Brooks (New York: Liveright, 1949), p. 177.

39. The episode with the Bishop, and Gauguin's reaction, are recounted in ibid., pp. 177–188.

40. I cannot do justice here to a full analysis of Gauguin's textual strategies and erudition. Examples of these can be readily appreciated in the 1902 manuscript version, "L'Esprit moderne et le catholicisme," trans. Pleadwell, pp. 9, 16, 32, 48–58.

Further evidence of Gauguin's religious concerns, textual methods, and range of knowledge is apparent in another set of writings that have never been published or discussed by scholars. These suggest again the long-term hold of his seminary formation. The Getty Research Institute Collections have a series of handwritten manuscript pages by Gauguin in which he presents discussions of the split between "matter and spirit"; the mystery of the "immaterial"; and the status of Christ as a "supernatural force." These pages include interpretations and quotations from St. Matthew, St. Paul, and St. Luke. The Getty manuscript papers are archived as "Paul Gauguin, Letters and Writings," i.d. #850329, undated.

41. Gauguin, "L'Eglise catholique et les temps modernes," in *Diverses Choses*, ms. (1897), pp. 291, 306–307; passage cited in English in Sweetman, *Gauguin*, p. 452; see also Guérin, *Writings of a Savage*, p. 167.

42. Félix-Antoine-Philibert Dupanloup, *L'Oeuvre par excellence, ou Entretiens sur le catéchisme* (Paris: Charles Douniol, 1869), p. 132. Here Dupanloup is quoting Jules Jouffroy as a way to underscore the foundational power of the catechism questions and answers for adult life.

43. Ibid., pp. 133, 27. Dupanloup considered the catechism "the source of all inspiration, all principles," the "purest essence of Christian dogma and morality," equivalent to "religion itself."

44. Thomson, *Gauguin*, p. 194. Gauguin's own account of his attempted suicide after the completion of the painting is in his *Lettres à de*

Monfried, pp. 199–200, letter of February 1898; and repeated to Charles Morice in Maurice Malingue, ed., *Lettres de Gauguin à sa femme et à ses amis* (Paris: Grasset, 1949) p. 300.

45. Gauguin, *Lettres à de Monfried*, p. 202, letter of February 1898.

46. Scholars have been interested, for example, in identifying literary sources for the painting. Richard Field and others see the impact of Swedenborg and Balzac's *Seraphita*; see Richard Field, *Paul Gauguin: The Paintings of the First Voyage to Tahiti* (New York: Garland, 1977), pp. 177–188. H. R. Rookmaker, Belinda Thomson, and Stephen Eisenman argue for the traces of Carlyle's *Sartor Resartus*, which had been recently serialized in the *Mercure de France*; see Thomson, *Gauguin*, pp. 194–199, and Eisenman, *Gauguin's Skirt*, pp. 144–147 and chap. 2. Eisenman also examines the painting in relation to the particularity of "neo-traditional Tahitian" cultural representations and to Gauguin's shifting and ambivalent relation to a changing colonial context as he melded European idealism with his perception of native myths, sexuality, and spiritual beliefs.

47. Gauguin, *Lettres à de Monfried*, pp. 201–202, letter of February 1898.

48. Malingue, *Lettres de Gauguin*, p. 301, letter of July 1901.

49. Gauguin, *Lettres à de Monfried*, p. 202, letter of February 1898.

50. Ibid.

51. Félix-Antoine-Philibert Dupanloup, *The Ministry of Catechising* (London: Griffith Farran, Browne & Co., n.d.), p. 609; see also Chapter 4 above.

52. Gauguin, *Lettres à de Monfried*, p. 201, letter of February 1898.

53. Dupanloup, *Ministry of Catechising*, p. 624; see also Chapter 4 above.

54. Malingue, *Lettres de Gauguin*, p. 301, letter to Charles Morice, July 1901.

55. Ibid., pp. 288–289, letter to André Fontainas, March 1899; emphasis mine.

56. Gauguin, *Lettres à de Monfried*, p. 201, letter of February 1898.

57. Ibid., pp. 200, 206, letters of February 1898 and March 1898.

58. Malingue, *Lettres de Gauguin*, p. 288, letter of March 1899; emphasis his.

59. Gauguin, *Lettres à de Monfried*, p. 200, letter of February 1898.

60. Ibid., p. 201.

61. The drawing is discussed and reproduced in Brettell et al., *Art of Gauguin*, p. 417; and Thomson, *Gauguin*, pp. 194–195.

62. See Chapters 1 and 3.

63. Malingue, *Lettres de Gauguin*, p. 288, from letter to André Fontainas, March 1899.

64. Dorra, *Symbolist Art Theories*, p. 205; Field, *Paul Gauguin*, pp. 177–188. Gauguin's familiarity with these myths, and their presentation to Europeans by the traveler Jacques-Antoine Moerenhout, is discussed in Stephen Eisenman, *Gauguin's Skirt*, passim.

65. Carol Christensen documents the timing and types of this coarse canvas and Gauguin's reasons for using them, which she argues were both economic and aesthetic. See her "The Painting Materials and Technique of Paul Gauguin," in National Gallery of Art, Washington, *Conservation Research* (Hanover, N.H.: University Press of New England, 1993), especially pp. 66–96.

66. Roger Fry, quoted in Harriman Gallery, *D'Où venons-nous . . .*, n.p., 1918; emphasis his.

67. Morice, cited in ibid., n.p., 1919.

CHAPTER 13. VAN GOGH'S MÉTIER

1. Vincent van Gogh, *The Complete Letters of Vincent van Gogh*, 2d ed. (Boston: New York Graphic Society, 1978), 2:572, LT 490, May 1888; 3:523, B21, December 1889.

2. Ibid., 3:260, LT 628; 3:523, B21.

3. Ibid., 3:208, LT 605.

4. Ibid.

5. See Chapter 10; van Gogh, *Letters*, 3:229–232, LT 615; 3:521–523, B21. It was in these circumstances and at this time that van Gogh also distanced himself from what he now believed to be the "abstraction" which he explored in *La Berceuse*; in the letter to Bernard in December (B21), he described it as belonging to a time in Arles when, spurred by Gauguin, he took up the "charming" and "enchanted path" of abstraction. But he now considered such a path an impasse, leading to "a stone wall." He turned his energies mainly to landscape instead.

6. Van Gogh, *Letters*, 3:173, LT 592.

7. Ibid., 3:217, LT 607; 3:234, LT 615.

8. Ibid., 3:217, LT 607; 3:226, letter to mother.

9. Ibid., 3:457, W14. The painting is F630 in the collection of the Van Gogh Museum. The likeness of the Mother Superior was suggested by Mark Edo Tralbaut, *Van Gogh* (New York: Macmillan, 1981), p. 290. Van Gogh's unusual choice of a religious image confirmed his earlier position, written in Arles to Bernard, that Delacroix and Rembrandt were distinct from all other practitioners of religious art in their humanized depictions. Van Gogh's version of this Delacroix proceeded further on these lines of humanized sacred subjects by rendering the hands as "the hands of a worker," and by projecting the face of the Virgin as that of a ministering woman he knew and observed.

The full count of the copies—twenty-eight in all—with twenty by Millet and three by Delacroix, is documented in Louis van Tilborgh, "Van Gogh's Copies of Millet," in *Van Gogh and Millet*, ed. Louis van Tilborgh (Zwolle: Waanders, 1989), p. 86. The other five were van Gogh's paintings after prints by Honoré Daumier, Gustave Doré, and Virginie Demont-Breton.

10. The full story of van Gogh and the Millet copies in the different phases of his career can be found in Charles Chetham, *The Role of Vincent van Gogh's Copies in the Development of His Art* (New York: Garland, 1976). For van Gogh's collection and copying after Millet in his first period of artistic work, see, for example, his lists of Millet reproductions in *Letters*, 1:201–204, LT 135, September 1880, which included "ten sheets of *The Labors of the Field* and four sheets of *The Four Hours of the Day*." For van Gogh's return in 1889 to Millet copying I have also relied on the excellent catalogue and essay of Louis van Tilborgh and Philip Conisbee, "Les Travaux des Champs," in *Van Gogh and Millet*, ed. van Tilborgh, especially pp. 122–123.

11. Van Gogh, *Letters*, 3:216, LT 607.

12. Ibid., 3:216, LT 607; 3:227, LT 613; emphasis his. Van Gogh also likened this process to musicians' interpretations of a composer's work, which would vary according to the interpreter. For another perspective on van Gogh's copies in the French period, see Cornelia Homburg, *The Copy Turns Original: Vincent van Gogh and a New Approach to Traditional Artistic Practice* (Amsterdam and Philadelphia: John Benjamins, 1996).

13. Ibid., 3:561, T24, January 1890.

14. Ibid., 3:218, LT 607.

15. Ibid., 3:235, LT 615. I have translated *tableaux* as "paintings" rather than "pictures."

16. According to Ronald Pickvance, in his *Van Gogh in Saint-Rémy and Auvers* (New York: Metropolitan Museum of Art, 1986), pp. 88–93, these two images formed a set of three, completed by a view of the window in van Gogh's studio in the asylum; see Fig. 183.

17. Van Gogh, *Letters*, 3:173, LT 592.

18. Ibid.

19. Ibid., 1:419, LT 219.

20. Ibid.; for van Gogh's other discussions of Dürer's frame, his own frame, and practicing through different windows, see 1:383, LT 205; 1:387–392, LT 208–210; and 2:12, LT 276.

21. Ibid., 3:524, B21.

22. Johan van der Wolk comments on van Gogh's interest in improving the frame and reproduces the sketch in *The Seven Sketchbooks of Vincent van Gogh* (New York: Abrams, 1987), p. 266 with facsimiles.

23. See, for example, the painting *Thatched Cottages in Auvers*, F780.

24. Pickvance, *Van Gogh in Saint-Rémy and Auvers*, p. 240.

25. Ibid., p. 139.

26. See the examples in *Catalogue of the Van Gogh Museum's Collection of Japanese Prints* (Zwolle: Waanders, 1991), pp. 91, 99, 101.

27. My thanks to the Philadelphia Museum restoration specialist Mark Tucker for allowing me to examine the back of the painting and for discussing these special qualities of its surface and support with me.

28. Van Gogh, *Letters*, 3:188, LT 597; 3:257, LT 626a.

29. Ibid., 3:228, LT 613; 3:296, LT 650. The French in the first passage uses the term *enchevêtrement des masses*, the crisscrossing or interlocking action linked to skeins or a maze, from the word *écheveau*.

30. Other examples, not reproduced here, are the Pittsburgh Carnegie Museum of Art's *Wheat Field at Auvers* and the Phillips Collection's *Fields*, both of 1890, F781 and F812.

31. Here I follow Hulsker's more plausible dating of this canvas to early summer of 1889, June or July, rather than to May 1890 as suggested by earlier datings. See Jan Hulsker, *The Complete van Gogh: Paintings, Drawings, Sketches* (New York: Abrams, 1980), p. 394.

32. Here I endorse, in the case of the frame, the insight of Jan Hulsker, who cautioned against seeing van Gogh's late work as the "highpoint" or final stage of a linear development toward a totalizing expressionistic vocabulary. Hulsker emphasizes how such tumultuous forms appearing in some of van Gogh's late work complemented others of the same period composing harmonic, tranquil renderings. The reliance on the habits of the frame, I maintain, as well as the regularity of weaving facture, were significant elements of this harmonic and tranquil repertoire that persisted in the late work. See ibid., p. 396.

33. Van Gogh, *Letters*, 3:525, B21; he again uses the French terms *enchevêtré*, with its connotations of skeins and ravels, and *métier*: *Verzamelde Brieven van Vincent van Gogh* (Amsterdam and Antwerp: Wereld Bibliotheek, 1955), 4:236.

34. Meyer Schapiro, *Vincent van Gogh* (New York: Abrams, 1950), pp. 11–34.

35. Van Gogh, *Letters*, 3:298, LT 652.

36. Ibid., 3:467, W20, February 1890.

37. Portions of Aurier's article are published in translation in Linda Nochlin, ed., *Impressionism and Post-Impressionism: Sources and Documents, 1874–1904* (Englewood Cliffs, N.J.: Prentice-Hall, 1966), pp. 135–139. I have also relied on the translation and excerpts of the Aurier article in the Dorra volume; see Aurier, "Symbolism in Painting," pp. 220–226.

38. Van Gogh, *Letters*, 3:254, LT 626, emphasis his. Van Gogh's response to Aurier was included in a letter to Theo, and he asked that Theo send it on to the writer.

39. Ibid., 3:257, LT 626a.

40. Paul Gauguin, *Intimate Journals*, trans. Van Wyck Brooks (New York: Liveright, 1949), pp. 97–98; see French in *Avant et après* (Paris: Crès, 1923), pp. 85–86.

41. Gauguin, *Intimate Journals*, p. 98.

42. Van Gogh, *Letters*, 3:544, T10; 3:194–195, LT 601. See also the entry in J. B. de la Faille, *The Works of Vincent van Gogh: His Paintings and Drawings*, rev. ed. (London: Weidenfeld and Nicolson, 1970), p. 250.

43. Van Gogh, *Letters*, 3:470, W22; French, *Verzamelde Brieven*, 4:183; emphasis mine.

44. Ibid.; French, 4:183.

45. Ibid., 3:288–289, LT 645.

46. Ibid., 1:163, LT 120, Amsterdam, March 1878.

ACKNOWLEDGMENTS

In my years of work on this book, I incurred many debts. Initial periods of research in the Netherlands, France, and local libraries were supported by the Academic Senate of the University of California, Los Angeles, the National Endowment for the Humanities, and the University of California President's Research Fellowship in the Humanities. A John Simon Guggenheim Memorial Foundation Fellowship enabled me to have a concentrated period of writing; a spring quarter grant at the University of California at Irvine Humanities Research Center also gave me valuable leave time.

At a later stage, I wrote much of the book and assembled many of the images for it while a Scholar at the Getty Research Institute for the History of Art and the Humanities in the "Representation of the Passions" program. The seminars, research facilities, and support system at the Getty contributed greatly to this project. I want to thank the then Associate Director Michael Roth and Director Salvatore Settis of the Getty Research Institute for giving me the opportunity to participate in such an extraordinary research environment, as well as the Scholars and Seminars staff members Charles Salas, Joanne Williamson, Sabine Schlosser, Brian Davis, and D'nez Westmoreland for facilitating my work in many ways.

Above all, I am deeply grateful to the University of California, Los Angeles, for its generous support, without which the book could not have been done. Provosts Raymond Orbach, Herbert Morris, and Brian Copenhaver encouraged my project in significant ways, as did my department chairs and colleagues. I especially want to thank Scott Waugh, whose humanist presence as historian and Dean of Social Sciences extends a spirit of tolerance and seriousness of purpose among the faculty, and who provided essential funding for museum work and the book's illustrations.

I was assisted by the staffs of many libraries and museums. The Inter-Library Loan Service of the

UCLA and Getty libraries gave me access to crucial sources, and the Getty Research Institute circulation librarians Jay Gam and Judith Edwards extended gracious service that was always appreciated. I want to thank Marie-Louise van den Wijngaard of the Breda Municipal Archives, Margaret Nab-van Wakeren of the Kröller-Müller Museum, Otterlo, and Monique Nonne of the Musée d'Orsay for responding so efficiently to my requests for photographs. William Chamberlin generously lent me his personal photos, CD-ROM, and videotape of the Gauguin box discussed in Chapter 4. Bob Walker, Don Williamson, and the staff of the Getty Visual Media Services supplied expert and timely service for which I am grateful. Michael Gallagher of the Conservation Department at the National Gallery of Scotland helped me enormously when he alerted me to the travels of the Gauguin *Vision* painting from Edinburgh to London. In my home department, the administrative efforts of Mary Pottala and Jackie Wong have been much appreciated.

I benefited from the hospitality and resources of the Van Gogh Museum, Amsterdam, and wish to thank former director Ronald de Leeuw, Hans van Crimpen, Director John Leighton, and Head of Exhibitions Andreas Blühm, as well as Josette van Gemert and Monique Hageman. Fieke Pabst, guardian angel of researchers and Documentalist at the Van Gogh Museum, shared with me her extensive knowledge of texts and images and was always ready to respond to my stream of inquiries about photos, collections, and van Gogh's reading habits.

I am grateful for the research assistance of Greg Kendrick, Patrick Van Eijk, Francis de Blauwe, Aaron Segal, Cynthia Chamberlin, Elizabeth Covington, Jim Lichti, Tal Gozani, Eric Weber, Andrea Mansker, Patricia Tilburg, Stavros Karegeorgis, Kelly Maynard, Amy Woodson-Boulton, John Hodder, and Adam Fukushima.

Many friends and colleagues read parts of the manuscript at different points; offered reactions, criticisms, and comments that stayed with me; or were helpful in ways I cannot detail here but deeply appreciate: Joyce Appleby, Emily Apter, David Blackbourne, Edward Berenson, Ruth Bloch, Albert Boime, T. J. Clark, Natalie Zemon Davis, Paige Dubois, Anastasia Easterday, Stephen Eisenman, Eva Forgacs, Saul and Hagit Friedländer, Anthony Grafton, Carlo Ginzburg, James Herbert, Robert Herbert, Thomas Hines, Albert and Sarah Hirschman, Lynn Hunt, Ruth Iskin, Robert Israel, Margaret Jacob, Ludmilla Jordanova, Temma Kaplan, Nikkie Keddie, Leila Kinney, Rachel Klein, Marion Lefebre, John Lithgow, Randi Markowitz, Arno Mayer, Sarah Maza, Ron and Anne Mellor, Richard Meyer, Gillian Naylor,

Nancy Perloff, David Corbett Peters, Susan Pedersen, Robert Pynoos, Peter Reill, Hans and Claire Rogger, Susan Rosenfeld, David Sabean, Richard Schiff, Carl and Elizabeth Schorske, Gary and Loekie Schwartz, Aaron Segal, Jerrold Seigel, Paul van Seters, Miriam Silverberg, Marjolijn Sorbi, Leslie Stern, Nancy Troy, Anthony Vidler, Joan and Scott Waugh, Eugen and Jacqueline Weber, Dora and Herbert Weiner, Joan Weinstein, Robert Westman, Cecile Whiting, Norton and Elaine Wise, Wim de Wit, Dorothy and Stanley Wolpert, and Mary Yeager.

I had the good fortune many years ago to have been contacted by Sandra Dijkstra; she placed my van Gogh project with Jonathan Galassi of Farrar, Straus and Giroux. I was more than fortunate that Jonathan was very patient as the research led me in unexpected directions and to a destination not quite anticipated at the outset. I want to thank Sandy for helping me as I reframed the book at a critical phase, and Jonathan for accepting its evolution and for challenging me in the editing process to aim for maximum clarity of expression. Jonathan urged me throughout the writing to allow the natural liveliness of the story to emerge and to stay focused on the two painters' relationship, which had important consequences as the book took shape. When the manuscipt moved into production at FSG, Karla Reganold, Abby Kagan, and Gretchen Achilles each extended their expertise and cooperation throughout, for which I am grateful.

Two years ago, Beth Allen began working with me as a research assistant, but she became more of a collaborator as she tackled a number of daunting tasks, including assembling the art, that made it possible for the book to reach production. She was meticulous and knowledgeable at every phase, and her contributions are fundamental to the final product.

I was extremely fortunate that I was able to persuade a good friend and freelance editor, Katarina Rice, to suspend her usual custom (and perhaps her better judgment) of not accepting projects from friends. Katya transformed an unwieldy manuscript into a publishable book, and she did so with a combination of blazing intellect, tact, and practical wisdom that often astonished me. Katya's ideas and suggestions indelibly shaped the manuscript, and her patience and encouragement at critical moments expressed her generosity of spirit, rare in any friendship.

My family gave me the space, and the courage, to keep going. Eve Silverman offered her discerning response to the type of book I had written. Ethan Silverman always took my work seriously, and Shira Silverman intuited things about the art in surprising ways. My parents, David and Ziona Silver-

man, are a sustaining force in my life, and they were always ready to move from cheering section to sharp-eyed critical readers when called on; they know I needed both.

The most important presence, in my work and life, is Jeffrey Prager's. As we both study from different vantage points the social elements of self-formation, I know that Jeff's writing and research on subjectivity and the "experience-near" construction of the modern self had significant, if implicit, impact on my thinking as this book was being written. But this is necessarily just a part of things, as Jeff's balance of empathy and distance conveyed an insistence on laughter and priorities even as van Gogh and Gauguin kept filling up more of our life together. Jeff's reading and conceptual powers always helped to cut through to what I was trying to communicate in the book. His willingness to take on more than his share allowed me to work through to that end.

Daniel Prager's keen eyes kept me honest more than once, as he noticed things I hadn't or had not described clearly enough. He challenged me to remember the joy, and to let the book go.

Brothers of the Common Life, 339
brushwork, 8, 37–39, 45, 97; in
 Alyscamps paintings, 199, 202, 205,
 206, 208–209, 214; in garden paint-
 ings, 250, 255; in grape harvest
 paintings, 229, 241, 243; labor
 embodied in, 81–82; and modern
 sacred art, 282; symbolism and,
 111–113; weaving and, 81–82,
 213–214, 269, 408–409
Bruyas collection, 268
Bunyan, John, *Pilgrim's Progress*, 175
Burhan, Filiz Eda, 430*n8*
Busken-Huet, C., *Letters About the
 Bible*, 458*n62*
Byzantine arts, 443*n94*

C

Café des Arts, 275–277, 428, 469*nn19,
 22*
Café Voltaire, 376, 428
Calvin, John, 456*n11*
Calvinism, 157, 161, 441*n67*; visual,
 148, 435*n70*, 456*n13*
Campin, Robert, Master of Flémalle,
 339
Carlyle, Thomas, 212; *Sartor Resartus*,
 463*n47*, 480*n46*
Cassagne, Armand, 77, 219, 394, 404;
 *Le Dessin pour tous (Drawing for
 All)*, 64, *76*, 77, 440*n54*; *Guide to
 the Alphabet of Drawing*, 64,
 440*n54*; *Traité d'aquarelle*, 440*n51*
Catholicism, 4–7, 11, 14, 89, 113, 143,
 234, 272, 373, 377, 379, 382, 384,
 387, 391, 433–434*n47*, 451*nn64, 67*;
 apparitional, 99–102, 135, 393; art
 in, 159, 161; avant-garde, 311; Bre-
 ton, 93, 95, 103, 104, 278,
 444–445*n4*, 445*n6*, 447*n18*; Dutch,
 145, 155; education and, 5, 10,
 122–136, 138, 150, 151, 302, 303,
 378, 430*n8*; ethos of *miséricorde* in,
 232; polemics by Gauguin on, 294,
 301–302, 373, 380–383, 428;

Provençal, 4, 7, 43–44, 55–57, 87,
 90, 102, 308, 312, 315, 334, 346,
 353, 359–360, 363, 368, 443*nn99,
 100*; rejection of, by modernist
 artists, 5, 178, 434–56; South Seas
 missionizing of, 479*n31*; spiritual
 resources of, 86; *see also* popular
 piety
Cézanne, Paul, 20, 95, 97, 205–206,
 208, 209, 218, 219, 227, 229,
 462*n22*; *L'Estaque*, *205*, 462*n21*;
 The Harvest, 462*n21*; *Mont Saint-
 Victoire*, 462*n21*
Chantepie de la Saussaye, D., 155, 169,
 458*n62*
Chateaubriand, Vicomte François
 August René de, 92
Cheetham, Mark, 433*n47*, 447*n27*
Chevreul, Michel, 113, 143, 154, 179,
 221, 222, 258, 261, 326, 340; as
 director of Gobelins Tapestry
 Works, 140, 257; Neo-Impression-
 ism and, 220, 260; popularized by
 Blanc, 455*n68*, 467*n17*; *Principles of
 Harmony and Contrast of Colours
 and Their Applications to the Arts*,
 467*n17*
Chicago Art Institute, 319
Christ, 85, 86, 89, 125, 147, 174–176,
 178, 382, 442*n88*, 458*n48*, 471*n69*;
 in Dutch modernist theology, 10,
 158–160, 168, 172, 264, 307, 311,
 367; enacted faith in imitation of,
 7; Epinal prints of, 106–107; lumi-
 nosity of, 269; newborn, 339, 347,
 349, 357–358, 443*n92*; Passion of,
 31, 33, 45, 52, 107, 124, 279, 283,
 307, 445*n5*; self-identification of
 Gauguin with, 10, 33–34, 179,
 295–305, 307–310, 378, 379,
 434*n56*; suffering of, 278–285; as
 supernatural force, 479*n40*; Tré-
 malo wood sculpture of, *278*, *279*,
 279, 281, 282; visions of, 54, 101
Christensen, Carol, 463*n44*, 480*n65*

Christianity, 88, 380; early, 41, 51–53,
 57, 85, 103, 199, 334, 360; symbol-
 ism of, 286, 291; *see also* Catholi-
 cism; Protestantism
Clark, T. J., 430*n7*
classicism, symbolist, 249–252
Clemenceau, Georges, 376
cloisonism, 105, 209, 214, 229, 322,
 343, 439*n49*, 452*n72*
Collège de France, 128
color, 8, 246–247, 286; in Alyscamps
 paintings, 202–203, 207–208, 212,
 217, 220–222; anti-naturalist,
 105–108, 113–114, 281; in *La
 Berceuse*, 322–323, 325, 326, 331,
 333, 368; brushwork and, 112; in
 copies of Millet prints, 396, 397;
 and cult of female saints, 366–367;
 in Dutch art education, 154; in
 Flemish Madonnas, 337; in garden
 paintings, 250, 253, 255, 256–258,
 260; in grape harvest paintings,
 228, 235–236, 242–243, 246; halo
 effects of, 40, 43–44, 242, 330; and
 modern sacred art, 282, 285, 297,
 299–300; music and, 261–264; of
 santons, 351–352, 354; of stained-
 glass windows, 341–343; symbol-
 ism of, 40, 49, 50, 82–83, 174, 178;
 yarn used for study of, 140–143
consciousness: pictorial depiction of,
 108–111; states of, 97–99
consolation, 8; *La Berceuse* as painting
 of, 326–329, 332, 343, 345–346,
 358–359, 368–369; color and, 261,
 263, 264; in Dutch modernist the-
 ology, 156; imaginary, 387, 391; in
 landscapes, 409; of traditional reli-
 gious beliefs, 143, 178
Cook, T. A., 436*n11*
Coolus, Romain, 430*n8*
Cooper, Douglas, 431*n3*, 432*n11*,
 460*n5*
Copenhagen Museum, 137
Corot, Camille, 403

Counter-Reformation, 348, 443*n92*
Courbet, Gustave, 86, 106
Courrier Français, Le, 442*n88*
craft production: and Dutch arts
 reform, 152–153; linkage of artistic
 work and, 139–143, 213, 261, 340, 374
crèches, 335, 347–349, *349*, 352–355,
 359; figurines for, *see* santons
Cros, Henry, 452*n69*
Cuyp, Aelbert, 340

D

Dagnan-Bouveret, Pascal, 446*n6*; *Bre-
 ton Women at a Pardon*, 92; *Pardon
 in Brittany*, 92
Darr, William, 447*nn18, 21, 30*,
 448*n39*, 449*n47*
Daubigny, Charles-François, 218, 251, 423
Daudet, Alphonse, 56–57, 92,
 437–438*n30*, 476*n86*; *L'Arlésienne*,
 437*n30*; *Lettres de mon moulin*, 60
Daumier, Honoré, 215, 218–220, 222,
 251, 464*n57*, 481*n9*
Degas, Edgar, 20, 21, 95, 97, 218, 219,
 245, 251, 380; ballet dancers of,
 137; matte surfaces of, 451*n67*,
 463*n45*; theatrical paintings of,
 449–450*n53*; women bathers of,
 277
Delacroix, Eugène, 57, 209, 310, 394,
 420, 421, 449*n47*, 481*n9*; *Christ
 Asleep During the Tempest*, 83, *84*,
 86, 174, 442*n88*; colorism of, 113,
 438*n30*, 455*n68*, 467*n17*
dematerialization, 107, 110–111, 283
Demont-Breton, Virginie, 481*n9*
Denis, Maurice, 430*n8*
Dickens, Charles, 257, 438*n30*; *Little
 Dorrit*, 258
Doré, Gustave, 481*n9*
Dorn, Roland, 444*n100*
Dorra, Henri, 466*n21*
Dujardin, Edouard, 450*n55*
Dupanloup, Bishop Félix-Antoine-
 Philibert, 5, 7, 121–127, *122*,

Amoureuses, 308; Still Life: Vase with Sunflowers, 368; Still Life with Fruits, 229; Two Girls Bathing, 16, 17, 205; *La Vie et la Mort (Life and Death), 276, 277*, 324, 389; *Woman in the Hay with Pigs: In the Full Heat of Day, 230, 231*, 236, 245, 275; *Women from Arles in the Public Garden: The Mistral, 248, 249–253*, 255, 258, 262, 428; *The Yellow Christ, 279, 280, 281–283*, 285, 293, 380, 428; *see also Self-Portrait: Les Misérables; Vision After the Sermon: Jacob Wrestling with the Angel; Vendanges à Arles: Misères humaines*
Gedo, Mary Matthews, 447*nn18, 21, 30*, 448*n39*, 449*n47*
Genestet, Petrus A. de, 147–148, 171–172; *Leekedichtjes (Layman's Poems)*, 171
Genouillade Chapel (Arles), 54
Gibson, Ralph, 445*n6*
Gillou, Alfred, *Return to Concarneau of the Pilgrims from the Pardon of Saint-Anne-de-Fouesnant*, 92
Ginoux, Madame, 268
Ginzburg, Carlo, 437*n24*
Giotto, 443*n94*
Gobelins Tapestry Works, 140, 257
Goethe, Johann Wolfgang von, 212; *Faust, 463n47*
Goldwater, Robert, 50
Goncourt brothers, 438*n31*
Gonse, Louis, *L'Art japonais*, 43
Goudsblom, Johan, 145
Goupil & Company, 17, 219, 394, 425, 426
Groningen School, 146–148, 150, 159, 425, 456*n11*
Guérin, Daniel, 116

H

Haan, Jacob Meyer de, 21, 94, 278,

286, 293, 294, 332, 428, 470*n36*; *Breton Women Scutching Flax, 286*, 287
Haar, Bernard ter, 144, 149; "Song of Praise to Creation," 149–150
Hatrick, A. S., 450*n55*
Havard, Henry, 58
Haydn, Joseph, 161
"heads of the people," 329
Heller, Reinhold, 112, 451*n67*
Henry, Charles, 452*n69*
Henry, Marie-Jeanne, 279, 470*n36*
Hens, Van, 58
Herbert, Robert, 452*n69*
Herkomer, Hubert: *Heads of the People: The Coast Guardsman, 329, 329*
Hermitage, 417
Heugten, Sjraar van, 440*n54*, 464*n64*
Heusden Drawbridge, *70*
Hiroshige, 215, 408; *The Auspicious Tanabata Festival in the City, 217; Fukoroi, 216; Plum Tree*, 449*n52*
Hoekstra, Sytze, 155, 156, 169, 458*n62*
Hokusai, Katsushika, 103, 215
Honorat, Saint, 54
Hooch, Pieter de, 340
Huet, Conrad Busken, *Letters About the Bible*, 171
Hugenholtz, Ph., 459*n62*
Hugo, Victor, *Les Misérables*, 31–34, 299
Huizinga, Johan, 336, 438*n35*
Hulshoff, Claas, 464*n64*
Hulsker, Jan, 474*n42*, 482*n32*
humanism, 148, 150, 360, 369, 456*n11*
Huret, Jules, 376, 428, 478*n15*
Huysmans, Cornelius C., 7, 151–154, 163, 457*nn24, 29; Drawing Plans for Festival Ornament*, 154

I

idealism, 7, 83, 86, 112–113, 430*n8*, 443*n95*, 444*n100*, 451*n67*; Catholic, 126, 135, 136, 302–303, 378; Neo-Platonist, 379, 380; rejec-

tion of, *see* anti-idealism; transcendent, 117
Illustration, L', 394
imagination, 199, 223, 253, 315; Catholic encouragement of, 125–126, 131, 134; color and, 228; Dutch attitude toward, 153–154, 163
Impressionism, 19, 32, 58, 168, 219, 426, 450*n53*; colorism of, 113, 143, 154; exhibitions of, 20, 427; Japonism and, 439*n49*; matte surfaces of, 451*n67*, 463*n45*; symbolism versus, 97, 99, 107, 112, 478*n25*
Ingres, Jean-Auguste-Dominique, 218, 219, 251, 380
introspection, 7, 44, 184, 198; in Catholic education, 126, 129, 131; constraints on, in Dutch theology, 147, 150
Isidore, Saint, 51

J

Japanese art, 27, 41–43, 57, 92, 103, 104, 239, 439*nn49, 50*, 449*n52*, 464*nn55, 57*; color in, 61, 106, 215–216; framing in, 404, 464*n55*; French literature and, 41–42, 438*n31*; *netsuke*, 137; rain in, 407
Japon Artistique, Le (art magazine), 43
Japonism, 43, 71, 215–216, 270, 291, 439*n49*
Jeannin, G., 420
Jesuits, 14, 122, 291, 378, 443*n92*, 453*n5*
Jirat-Wasiutyński, Vojtěch, 433*n44*, 434*nn48, 64*, 463*n44*, 466–467*n2*, 470*nn38, 43*
Joan of Arc, 122, 393, 470*n38*
John the Baptist, 87–90, 102, 285, 349
Joseph, Saint, 339, 347, 349, 353, 354
Jouffroy, Jules, 128–129, 479*n42*

K

Kearns, James, 447–448*n34*

Kempis, Thomas à, 146, 456*n11*
Kōdera, Tsukasa, 432, 433*n44*, 435*n6*, 437*n30*, 438*n44*, 442*n88*
Kokoschka, Oscar, 473*n26*
Koning, A. H., 325, 327, 336
Kools, Frank, 455*n3*, 456*n7*
Kröller-Müller Museum, 212, 215, 217, 220, 221, 320, 468*n22*

L

labor: pictorial language of, 79, 81–82, 89–90, 108–110, 243, 375, 392; sanctification of, 7, 146–148
Langlois Bridge, 59, 69, *70*, 71; paintings of, *71–76*
Laugier, Maria, 364
Laval, Charles, 21, 94, 229, 275, 426, 428
Lavieille, Jacques-Adrien, 394
Lazarus, Saint, 349
Leleux, Adolphe, *Une noce en Bretagne (Breton Wedding), 93*
Littré, Emile, 454*n21*
Loman, C., 459*n62*
Lombard, Jacques, 364
London Illustrated News, 464*n65*
London National Gallery, 337
Longfellow, Henry Wadsworth, 212; "Evangeline," 463*n47*
Loti, Pierre; *Madame Chrysanthème*, 41–42; *Pêcheur d'Islande*, 327, 336, 343–346
Louis Napoleon, 121
Lourdes, Festival of, 101

M

Mallarmé, Stéphane, 376, 428
Manet, Edouard, 20, 157–158, 380; *Déjeuner sur l'herbe*, 157
Maris Stella (Star of the Sea), 341–345
Martha, Saint, 51, 349
martyrdom, 35, 45, 310–311; Gauguin's sense of, 133, 179, 195, 295–301, 374, 379, 387; in religious art, 159, 160
Mary Magdalene, 51, 349